SIR JOHN SOANE

The Royal Academy Lectures

Sir John Soane: The Royal Academy Lectures contains the full text of Soane's lectures, carefully edited by David Watkin from the manuscripts at Sir John Soane's Museum in London. It is a revised and abridged edition of his award-winning book *Sir John Soane: Enlightenment Thought and the Royal Academy Lectures*. In his introduction to this new volume, Watkin explains the significance of Soane's approach to architectural history and theory, as expressed in the lectures delivered from 1810 to 1820 as Professor of Architecture at the Royal Academy. Providing a key that enables the modern observer to understand the work of an architect who is widely regarded as the most inventive of his day in Europe, the lectures enable us to enter Soane's private dialogue with an astonishing array of philosophers, architectural theorists, art historians, archaeologists, and anthropologists. They are accompanied by a selection of the beautiful watercolors that Soane prepared as illustrations.

David Watkin is Reader in the History of Architecture at the University of Cambridge. A Fellow of Peterhouse, Fellow of the Society of Antiquaries, and Vice Chairman of The Georgian Group, he is author of numerous publications, including *Sir John Soane: Enlightenment Thought and the Royal Academy Lectures*, which received the Sir Banister Fletcher Award from the Royal Institute of British Architects and the Authors' Club as the most deserving book in the fields of architecture and the fine arts published in 1996.

CONTENTS

~

List of Illustrations *page* vii

Introduction 1

THE ROYAL ACADEMY LECTURES

Lecture I 27

Lecture II 42

Lecture III 63

Lecture IV 89

Lecture V 116

Lecture VI 137

Lecture VII 156

Lecture VIII 176

Lecture IX 199

Lecture X 220

Lecture XI 239

Lecture XII 260

Bibliography 285

Index 315

ILLUSTRATIONS

❧

Illustrations appear following page 23

1 Egyptian capital with head of Isis, and Ionic capital from the Erechtheum. (Drawn 17 January, 1807.)

2 Primitive hut with pedimented roof. (Drawn May 1807.)

3 Trajan's Column, Rome. Part elevation and sectional details. (After G. B. Piranesi.)

4 Tomb of the Horatii and Curiatii on the Via Appia, Albano, Italy. Perspective view. (After a model by Turnerelli.)

5 Superimposed elevations of Temple Bar, London, the Arc du Carrousel, Paris, by Percier and Fontaine, the Porte S. Denis, Paris, by François Blondel. (Drawn 12 May, 1820.)

6 Comparative section of the Colosseum, Rome, and elevation of the Circus, Bath, by John Wood. (Drawn 5 November, 1814.)

7 Comparative elevations of St Peter's, Rome, and the Radcliffe Library, Oxford, by James Gibbs, with sections of the Pantheon, Rome, and the Rotunda at the Bank of England, London, by Soane.

8 Holy Sepulchre, Jerusalem. Interior perspective. (After de Bruyn.)

9 Pellegrini Chapel, S. Bernardino, Verona, by Michele Sanmicheli. Plan and section. (Drawn 3 December, 1811.)

10 San Carlo alle Quattro Fontane, Rome, by Francesco Borromini. Elevation.

11 Interior perspective of a typical Italian church.

12 Trevi Fountain, Rome, by Nicolà Salvi. (Drawn by Laurent Pécheux and William Chambers, 1753.)

13 Lighthouse at Cordouan, France. Elevation.

14 Place Royale (de la Concorde), Paris, by A.-J. Gabriel. Elevation.

15 House in Paris with concave façade. Perspective elevation. (Drawn by Henry Parke, 1819.)

16 Hotel de Thélusson, Paris, by C.-N. Ledoux. Perspective. (Drawn 23 November, 1819.)

17 Rue des Colonnes, Paris, by N.-J.-A. Vestier and J. Bénard. Perspective view. (Drawn by Henry Parke, 1819.)

18 Cemetery of Père la Chaise, Paris. Bird's eye view. Drawn by Henry Parke, September 1819. Detail.

19 Tower of the Orders, Schools Quadrangle, Oxford. Elevation.

20 Design attributed to Inigo Jones for Whitehall Palace, London. Detail of Persian Court. (After William Kent.)

21 Shaftesbury House, Aldersgate, London.

22 Assembly Rooms, York, by the Earl of Burlington. Interior.

23 Somerset House, London, by William Chambers. View in quadrangle. (Drawn by James Adams, after L.-J. Desprez, 23 July, 1807.)

24 Bank of England, London, Threadneedle Street front, by Robert Taylor, compared with Cortile del Belvedere, Vatican, Rome, by Bramante.

25 British Coffee House, Cockspur Street, London, by Robert Adam. Elevation. (Drawn by Robert Chantrell, 1813.)

26 Newgate Prison, London, by George Dance. Detail of façade with pump.

27 St Luke's Hospital, Old Street, London, by George Dance. Elevation. (Drawn 1813.)

28 Royal Opera House, Covent Garden, London, by Robert Smirke. Perspective view of east and north elevations. (Drawn 20 December, 1809.)

29 Perspective showing construction of modern shops.

30 Courier Office, Strand, London. Elevation. (Drawn by George Underwood.)

31 Pipes of the New River Company at Bagnigge Wells, London. (Drawn by George Basevi, 1813.)

32 Pipes of the New River Company at Spa Fields, London. (Drawn 1814.)

33 Design by Soane for a Triumphal Bridge.

34 Design by Soane for Opera House, Leicester Square, London. Perspective.

35 Design by Soane for House of Lords, London. Perspective of Ante Chamber to Royal Gallery.

INTRODUCTION

∾

John Soane (1753–1837) was appointed to the prestigious post of Professor of Architecture at the Royal Academy on 28 March 1806. The duties of the Professor were: "to read annually six public Lectures, calculated to form the taste of the Students, to instruct them in the beauties or faults of celebrated productions, to fit them for an unprejudiced study of books, and for a critical examination of structures; his salary shall be thirty pounds a year; and he shall continue in office during the King's pleasure."[1] Soane had long been connected with two of the founding members of the Academy, the architects Sir William Chambers and George Dance. Chambers was a Francophile who had himself been trained by Jacques-François Blondel, a future professor at the Académie Royale d'Architecture in Paris which he and Dance took as their model in founding the Royal Academy. England had been one of the last European powers to adopt the academies of arts, which, beginning in the Italian Renaissance, had been given a new lease of life by Louis XIV as part of his centralised control of art and production.

The Royal Academy, with a royal charter granted by George III who took a close personal interest in it, "sought to establish a new artistic hierarchy through the formation of an elite of forty like-minded academicians elected for life."[2] Soane entered the Royal Academy School of Architecture, where the teaching of architecture was organised by William Chambers, as one of only nine students admitted in 1771. His admission was probably on the suggestion of George Dance, the brilliantly inventive architect in whose office Soane had started his career in 1768. Though the Royal Academy was hardly a serious rival to its opposite number in Paris, Soane was, nonetheless, profoundly influenced by the illustrated lectures on architecture by the first Professor of Architecture at the Academy, Thomas Sandby, who stressed the importance of appropriate character in archi-

[1] Instrument of Foundation of the Royal Academy, 1768.
[2] Pierre de la Ruffinière du Prey, *John Soane, The Making of an Architect*, Chicago and London 1982, p. 56.

tecture. In 1776 Soane won the Gold Medal of the Academy for his visionary design for a Triumphal Bridge, and was awarded the King's Travelling Scholarship in 1778. He claimed that he owed the success of his career to this award, for it enabled him to make a Grand Tour in 1778–1780 which he would never have been able to make without financial assistance, having been humbly born as the son of a Reading bricklayer. The Tour was not only important for opening his eyes to the great buildings of antiquity and of the Renaissance, but also for enabling him to meet a succession of English noblemen and landowners of cultivated sensibility who became, or introduced him to, his architectural patrons.

Developing the ideas of Sandby, Soane was anxious from the start of his career to find the appropriate character for every commission. In his book, *Plans, Elevations and Sections of Buildings erected in the Counties of Norfolk, Suffolk . . . &c* (1788), in which he illustrated his own early works, Soane urged that ornaments should always be "characteristic of their situations." Thus, only those should be used "as tend to show the destination of the edifice, as assist in determining its character, and for the choice of which the architect can assign satisfactory reasons."[3] A no less significant indicator of his early belief in appropriate symbolism was his statement that,

> The ancients with great propriety decorated their temples and altars with the sculls of victims, rams heads and other ornaments peculiar to their religious ceremonies; but when the same ornaments are introduced in the decoration of English houses, they become puerile and disgusting.[4]

The preoccupation with character, which was to feature strongly in his Royal Academy lectures, bore fruit in his own architecture, ranging from the purist linearity of his entrance gateway at Tyringham, to the Corinthian splendour of his Lothbury Arch at the Bank of England of 1800, probably the first permanent triumphal arch erected in London. He chose to echo the arch in the façade of his own country house, Pitzhanger Manor, Ealing, which he conceived as a self-portrait.

By the time Soane was appointed a Professor in 1806, he was thus well known as an architect who had designed or worked at over eighty austerely elegant country houses, such as Letton Hall and Shotesham Park, Norfolk, Tendring Hall, Suffolk, and Bentley Priory, Middlesex. From 1788, he had also held the important post of surveyor of the Bank of England, thanks to the patronage of William Pitt. By 1800, in interiors, such as the Stock Office at the Bank of England, the Yellow Drawing Room at Wimpole Hall, Cambridgeshire, and the vestibule at Tyringham Hall, Buckinghamshire, he had established a personal

[3] John Soane, *Plans . . . of Buildings erected in the Counties of Norfolk, Suffolk . . . &c.,* 1788, p. 9.
[4] *Ibid.*

style characterised by vaulted, top-lit interiors filled with the "lumière mystérieuse" which was recommended by Nicolas Le Camus de Mézières in a book frequently studied by Soane, *Le génie de l'architecture; ou, l'analogie de cet art avec nos sensations* (1780). It was in the course of the extraordinary voyage of intellectual discovery on which Soane embarked in the process of preparing his lectures that he discovered authors as little known in this country as Le Camus de Mézières. It will be part of the purpose of this book to set out again with Soane on that fascinating journey.

A GUIDE TO THE CONTENTS OF THE LECTURES

Soane's lectures are important because they show the mind of a great architect wrestling with a topic of colossal scale, namely the history of world architecture, and the lessons we should draw from it. The lectures are sometimes confused and frequently repetitive, so in approaching them we should recall Soane's own statement in his first lecture that, "the main object of the lectures . . . is to trace architecture from its most early periods." He also argued that, "By referring to first principles and causes, the uncertainties of genius will be fixed, and the artist enabled to feel the beauty and appreciate the value of ancient works, and thereby seize the spirit that directed the minds of those who produced them . . . We shall thereby become artists not mere copyists."

It was thus Soane's aim not only to describe and illustrate the architectural master-pieces of antiquity and of subsequent periods, but to point out what he believed were the universal principles on which they were based. In accordance with the Enlightenment theorists of the eighteenth century whose work he studied in preparing the lectures, these principles were, he believed, in accordance with reason and nature. Close study of the greatest buildings of the past would enable the student to "thereby seize the spirit that directed the mind of those who produced" them, a process in which they must "be intimately acquainted with not only what the ancients *have* done, but endeavour to learn from their works what they *would* have done." The importance of this distinction to Soane was that, "We shall thereby become artists not mere copyists; we shall avoid servile imitation and, what is equally dangerous, improper application. We shall not then be led astray by fashion, and prejudice, in a foolish and vain pursuit after novelty."

Nature and the origins of architecture were thus the key themes of Soane's first lecture in which he began his grand historical survey of architecture with a reference to the cave, the tent, and the hut. These types of shelter were interpreted as the homes, respectively, of hunters and fishermen, shepherds, and husbandmen in India, China, Egypt, and Greece. The cave was thus the origin of the massive stone architecture of the Egyptians, the tent of the light architecture of the Chinese, and the hut of the trabeated temples of the Greeks. Derived from Quatremère de Quincy's study of the origin of Egyptian architecture and its

relation with Greek architecture,[5] this account was grafted on to the evocations of the primitive hut which Soane had imbibed from Marc-Antoine Laugier, Jean-Jacques Rousseau, Thomas Sandby, and William Chambers.

In his second lecture Soane continued the outline of the classical architecture of the ancient world with which his first lecture had concluded. In giving extensive consideration to the details of the orders, he stressed that, "We must be careful to distinguish those parts which are essential and have an immediate analogy with the primitive objects of imitation, from those which are introduced by necessity, by fancy, or by caprice." In our enthusiasm for Soane's frequently minimalist architectural style, as expressed in buildings like his Chelsea Hospital stables, we should not forget that in the hierarchy of building types which meant so much to him, buildings in the lavish Corinthian order occupied the highest place: as he put it in this lecture, "Art cannot go beyond the Corinthian order." Although the modern mind may respond sympathetically to the constructional diagrams in which Soane showed the bare brick and stone of his Bank interiors, Soane himself did not regard them as complete until the construction had been concealed beneath a plaster skin of poetic ornament.

At the end of the second lecture, Soane returned to his cherished belief that the adoption of appropriate character in architecture was akin to the choice of appropriate clothes. He drew on hints in the writings of the ancient Roman poet Horace, of Laugier, and of his masters at the Royal Academy, Thomas Sandby and William Chambers, to develop a theory of what he called "the costume of architecture," a process in which key attention was paid to the role of mouldings.

In the third lecture Soane continued his analysis of the orders and their application, beginning with the Tuscan and the Composite. With its astonishingly wide range of historical reference, Lecture IV, by contrast, must have had a powerful effect on its audience, especially those who could see the illustrations which had now risen to seventy, compared with fifty-five in Lecture III. This was the lecture in which, when first delivered on 29 January 1810, Soane's criticism of a work by a living architect, Smirke's Covent Garden Theatre, caused such an outcry within the Royal Academy that he suspended the course for two years. The ostensible subject of the lecture was the completion of his survey of the uses of the orders, though he also ventured into related fields such as balustrades, obelisks, and pyramids.

Lecture V, the penultimate one in the first course, was devoted to a history of architecture from Constantine the Great and the fall of the Roman Empire to the Italian Renaissance, followed by a survey of British architects from Inigo Jones to William Chambers. The sixth and last lecture of Soane's first course was one of the most ill-structured of

[5] Antoine-Chrysostôme de Quincy, *De l'architecture égyptienne considérée dans son origine, ses principes et son goût, et comparées sous le mêmes rapports à l'architecture grecque*, Paris 1803.

all. Indeed, no lecture indicated more painfully his lack of ability, despite constant rewriting, to organise and present coherently the vast mass of information he had so diligently acquired from his extensive and frequently arcane reading. Nonetheless, this lecture is of special interest for two reasons: (1) its obsession with the theory of symbolical ornament, particularly as illuminated by the theories of the eighteenth-century antiquarian known as Baron d'Hancarville; and (2) its startling confession that his course of reading had led him to condemn one of his own interiors at the Bank of England as betraying ignorance of "original causes and first principles."

Soane delivered his seventh lecture, the first of his second course of six, on 16 February 1815. He claimed that in this new series, "The great points or objects now to be considered might be classed, and separately treated of, under the heads of Distribution, Construction, and Decoration." For this tripartite division he was indebted to the classic French doctrine established by Augustin-Charles d'Aviler in his *Cours d'architecture* (1691–93). This remained a standard work for architects throughout the eighteenth century, inspiring the emphasis on Decoration, Distribution, and Construction, in Blondel's celebrated *Cours d'architecture* (1771–77), which was also a profound influence on Soane.

In Lecture VIII, less controversial than many others in the course, Soane was primarily concerned with the distribution of rooms and staircases. Despite its characteristically disparate contents, Lecture IX, like the preceding one, must have been helpful to the architectural student in providing many useful exemplars, both good and bad, for day-to-day matters such as the design of windows, doors, pilasters, roofs, and chimneyshafts.

The characteristically heterogeneous contents of Lecture X included an attractive opening section on landscape gardening and garden buildings, though curiously this was illustrated with very few drawings. By the time of the delivery of the lecture in 1815, the landscape tradition that Soane described had come to an end. Though Humphry Repton lived until 1818, his career was virtually over by 1810, and Soane's pupils were unlikely to be confronted with commissions for creating great landscaped parks dotted with follies, ruins, and temples. As is often the case, Soane's teaching was, albeit understandably, rooted in fundamentally eighteenth-century conceptions which many members of his audience did not share.

Soane opened his penultimate, eleventh, lecture with his customary lament that London, in painful contrast with the cities of the ancient world and, more humiliatingly, with those of modern continental Europe, was lacking in great royal and public buildings, churches, and palaces. Emphasising the important role of monumental public buildings as expressions of the might of Britain as a country which had recently defeated Napoleonic France, he showed little interest in modern functional and industrial architecture.

Lecture XII was, for the most part, sane and sensible, with Soane content, for once, to be an architect drawing on his own wide practical experience to talk about his craft. He thus turned to the topic of construction which, like Blondel in his *Cours,* he put at the end

of his course. Buried in the halting academic prose in which Soane thought it proper to address his audience, was a rage against the shallow standards and constructional methods of the modern world into which, seemingly reluctantly, he had survived. Towards the end of the lecture, he returned to a favourite theme, the superiority of the monuments of the ancient world to those of modern times. For example, he contrasted modern lighthouses such as those at Cordouan in France, and Eddystone in England, unfavourably with Ptolemy's celebrated lighthouse on the island of Pharos at Alexandria. One of the most memorable aspects of the lectures was the enormous body of illustrative material which Soane prepared to accompany them. To this we should now address our attention.

THE LECTURE ILLUSTRATIONS

In Soane's lifetime his lectures were perhaps best known for their illustrations, all of which survive in the Soane Museum. Over a thousand of these water-colours were prepared between 1806 and 1820, many of them as much as three or four feet long, each of which took his pupils at least a week's full-time work. Constituting a comparative history of world architecture which was unique in their day, they were the product of a public-spirited gesture for which he received no payment but which was part of his endorsement of the Enlightenment cult of civic virtue. Most of the drawings were produced between 1806 and 1815 at a time when the Napoleonic Wars had drastically reduced the number of architectural commissions which even an architect of Soane's standing could expect to receive. Soane may have felt that the production of these huge, meticulously detailed, coloured drawings at least helped train the young men in his office in the absence of real jobs, or perhaps just kept them out of mischief.

Soane's great architectural library came to life as his pupils pulled folios off the shelves and turned the engravings which they contained into vivid perspectives animated with colour. The sources on which they drew included the illustrated folios of travellers, architects, and archaeologists such as Cornelis de Bruyn, Antoine Desgodetz, Fréart de Chambray, Fischer von Erlach, Colin Campbell, William Kent, Giovanni Battista Piranesi, Frederic Norden, Richard Pococke, Robert Wood, James Stuart, Robert Adam, Julien-David Leroy, M.-G.-A.-F. Choiseul-Gouffier, Victor Louis, Jacques Gondoin, William Wilkins, and Baron Dominique Vivant Denon. Not surprisingly, the drawings in which Soane showed his own buildings, above all the Bank of England, were among the most memorable.

On Soane's last visit to Paris in 1819, he took Henry Parke with him to make a stunning series of drawings of major Parisian monuments and street scenes. Sometimes, he sent his pupils from his office to make perspective views and measured drawings in London. On their numerous site visits they built up a unique visual record of the city as it was in the first two decades of the nineteenth century. It seems that a wave of enthusiasm led

Soane to make a topographical survey of London in excess of anything that could have been required by the lectures. With Soane as guide, we travel around the city seeing hospitals, almshouses, churches, shops, banks, public houses, the premises of livery companies, private houses, docks, and pumps. Soane's merciless eye was quick to record whatever was mean or pretentious, absurd or inappropriate, banal or inconvenient, as well as, more rarely, whatever was grand, elegant, or fitting.

Soane's comparative approach anticipated by many years the parallel, but less vivid, technique adopted by Banister Fletcher in his *History of Architecture on the Comparative Method* (1896). Soane was something of a pioneer in this approach, which had first been hinted at in Fischer von Erlach's *Entwurff einer historischen Architectur* (1721). Soane also knew Leroy's plates giving the comparative plans, sections, and elevations of the temples and churches of the ancient and modern world in his *Les ruines des plus beaux monuments de la Grèce* (2nd ed., 1770). In addition, Soane owned the great work to which this technique had given rise, J.-N.-L. Durand's *Recueil et parallèle des édifices de tout genre, anciens et modernes* (1799–1801). Apart from these sources, Soane had little guidance in the preparation of drawings such as that made in December 1811 in which he compared the plans of the Pantheon, the Basilica of Constantine, Hagia Sophia, Florence and Milan Cathedrals, St Peter's, and St Paul's.[6]

No less memorable were images such as the superimposed elevations of the great pyramid at Giza and St Paul's Cathedral; the comparisons between the Erechtheum and St Paul's Covent Garden, and between the Colosseum in Rome and the Circus in Bath; and the striking assembly on a single sheet of the Pantheon, St Peter's, the Radcliffe Camera at Oxford, and Soane's own Rotunda at the Bank of England.[7] Such juxtapositions were the more stimulating for being unexpected. His drawings always showed the monuments of the ancient world as larger and more imposing than those of his own day: for example, his Consols Transfer Office at the Bank of England nestles almost ludicrously within the vast spaces of the Baths of Diocletian. Not foreseeing the great scale of nineteenth-century buildings, he was still a child of the ancien régime, with a consciousness of the issues of the Querelle des Anciens et Modernes, and a sense of the superiority of antiquity.

THE INTELLECTUAL BACKGROUND TO THE LECTURES

Thomas Sandby's successor as Professor, appointed in 1798, was George Dance whose unexpected failure to deliver any lectures encouraged the ever ambitious Soane to begin plotting to succeed him as early as 1804. His efforts were rewarded with success in 1806,

[6] SM Drawer 23, Set 2, no. 6.
[7] SM Drawer 23, Set 2, no. 2.

but two years earlier he had begun preparing himself for this role by translating the essay on the history of architecture in the second edition of *Les ruines des plus beaux monuments de la Grèce* by J.-D. Leroy, Professor of Architecture at the Académie Royale d'Architecture in Paris.[8] Soane followed his translation from this epoch-making study of Greek architecture by translating between October 1805 and March 1806 much of the introduction to the first volume of J.-F. Blondel's celebrated *Cours d'architecture,* the summary of his teaching, first at the Ecole des Arts in Paris, where Soane's master William Chambers had been his pupil, and later at the Académie Royale d'Architecture.

Such a course of reading set a pattern which he was to follow until the 1820s during which time he provided himself with the education that his humble upbringing had denied him. In this process, he became a belated and lonely English student of Enlightenment thought, more preoccupied than any other British architect with the ideals of the *Encyclopédistes* and the French Enlightenment. At the same time, he studied the sensationalist and associational philosophy of the Picturesque movement in Britain.[9] The eighteenth century was marked by an attempt to escape from the conventional in both verbal and visual languages so as to pursue "unmediated nature."[10] Soane identified with the combination of reason and nature which had led Enlightenment thinkers to believe that truth could be attained by reason, rather than, as the church had taught, by faith, and that problems could be solved by a return to origins. The origins of language were thus sought by Etienne Bonnot de Condillac; of society by Rousseau; of architecture by John Wood and Laugier; of sexual symbolism by d'Hancarville and Richard Payne Knight; of primitive customs, laws, and religion, by Joseph François Lafiteau, Antoine-Yves Goguet, and Quatremère de Quincy; of music by Jean-Philippe Rameau; and even of plant forms by Goethe.

The *Encyclopédie,* which Soane owned in thirty-three stately volumes,[11] was not commonly found in English private libraries at this date.[12] The first volume contained an important engraving of a secular tree of knowledge headed by the three mental faculties, memory, reason, and imagination.[13] These three faculties were related, respectively, to the

[8] SM Al Soane Case 161, fols. 1–155.

[9] In particular, Edmund Burke, *A Philosophical Enquiry into our Ideas of the Sublime and Beautiful* (1757), 1801; Henry Home (Lord Kames), *Elements of Criticism,* 1762; and Richard Payne Knight, *An Analytical Inquiry into the Principles of Taste,* 1805.

[10] Barbara Maria Stafford, *Voyage into Substance: Art, Science, Nature, and the Illustrated Travel Account, 1760–1840,* Cambridge, Mass. 1984, p. 1.

[11] *Encyclopédie ou dictionnaire raisonné des sciences, des arts et des métiers,* 33 vols, Paris and Amsterdam 1751–77.

[12] See also, John Lough, *The* Encyclopédie *in Eighteenth-century England* (1952), Newcastle-upon-Tyne 1970, pp. 1–24.

[13] This large fold-out diagram, described as "notre Arbre encyclopédique" (vol. I, p. xviii), and titled *Système figuré des connoissances humaines,* accompanied the *Discours préliminaire des editeurs, Encyclopédie,* vol. I, 1751, pp. i–xlv.

three activities of history, philosophy and poetry, which comprised all known arts and sciences. Architecture was included under the heading of imagination, as were poetry, drama, allegory, music, painting, sculpture, and engraving.[14]

Sharing d'Alembert's view that "everything man knew derived from the world around him and the operations of his own mind,"[15] Soane was obsessed by a belief that architecture was an essentially intellectual art. Constantly claiming that architecture "cannot fail of creating sensations in the mind,"[16] Soane referred to the operations of the mind on over one hundred and sixty times in the course of his lectures at the Royal Academy. Moreover, d'Alembert's belief that knowledge came from the senses not from Revelation, helped open the way to the tradition represented by the new confessional literature of Rousseau and Goethe who, like Soane, were preoccupied with analysis of their own feelings. It seems that Soane identified with Rousseau as the victim of organised persecution which, for the latter, came from his former allies such as Diderot.

Along with Soane's belief in public architecture as the expression of civic virtue, a tradition with classical roots in the ethical writings of Aristotle,[17] went the call for architecture to appeal to the spectator, to instruct and move him. This doctrine of architectural eloquence, central to Soane's belief in the expression of appropriate character in architecture, had underlain seventeenth- and eighteenth-century literary theory. Soane was familiar with the origins of this tradition in classical rhetoric and in the writings of Horace and Longinus.

All this we know not only from his library but from over twenty manuscript volumes, and thousands of loose sheets, containing Soane's own thoughts on architecture and his notes from other authors from antiquity to his own day. Written between 1804 and 1821, these survive as the record of his search for truth down the complex paths of architectural history and theory. Much of the impetus behind this laborious yet passionate process of self-education, unique in the history of English architecture, and revealed in this material, was provided by Soane's response to two of his favourite authors, Vitruvius and J.-F. Blondel. He was evidently impressed by Vitruvius' insistence that the architect should be a man of great education, well versed in topics such as history, philosophy, and music, as well as in architecture. A pioneer in the education of architects, Blondel founded his own

[14] In the tree as originally published in the *Prospectus,* civil, naval, and military architecture had all been included under the heading of reason. For an explanation of the shift of civil architecture from reason to imagination by the time volume I was published, see Kevin Harrington, *Changing Ideas on Architecture in the* Encyclopédie, *1750–1776,* Ann Arbor 1985, pp. 21–28.

[15] Robert Darnton, *The Business of the Enlightenment: A Publishing History of the* Encyclopédie *1775–1800,* Cambridge, Mass., and London 1979, p. 7.

[16] David Watkin, *Sir John Soane: Enlightenment Thought and the Royal Academy Lectures,* Cambridge 1996, Lecture III, p. 524.

[17] Soane owned and studied the works of Aristotle, his copy of the *Ethics and Politics,* 2 vols, London 1779, bearing occasional underlinings in his hand.

school of architecture in 1743, thus giving practical expression to the belief in improvement characteristic of the *Encyclopédie* to which he was an important contributor.

Regarding himself as alone, misunderstood, and attacked, even by his own younger son, Soane identified with Rousseau whose *Confessions* and *Rêveries du promeneur solitaire* were among his favourite reading. Rousseau's narrative of his inner life, a turning point in the development of modern consciousness, was essentially the invention of the character, the spiritual and artistic character of "Rousseau." So Soane, by adding the "e" to his original surname, Soan, in 1783, invented a new person. The intense subjectivity and self-preoccupation of Rousseau and Soane meant that they approached culture, with its inherited traditions and values, as something which could not be imposed from outside but which had to be constantly tested in order to be made personally authentic.

This was the solitary process of testing in which Soane indulged, day and night, in his library, recording and querying the theories of writers such as Blondel, Winckelmann, d'Hancarville, Henry Home (Lord Kames), Le Camus de Mézières, Durand, and Claude-Nicolas Ledoux. His constantly growing library was an amalgamation of the collections he had begun forming at his house at no. 12, Lincoln's Inn Fields, and at Pitzhanger Manor. The former, consisting of the Greek and Roman classics, poetry, painting, sculpture, history, music, and architecture, reflected an ultimately Renaissance approach to knowledge. This was the conception that d'Alembert, as we have already noted, had been codified recently under the heading "imagination."

He claimed to have created Pitzhanger with the architectural education of his elder son in mind, but when both sons turned out as disappointments, he sold Pitzhanger in 1810 and united the two collections at no. 13, Lincoln's Inn Fields, in 1814. The library was now to serve as an educational tool in his role as Professor of Architecture at the Royal Academy: indeed, in the year of his appointment as Professor, 1806, he began to rearrange and enlarge the collection, setting his reluctant younger son, George, to prepare a catalogue of it. But there were never enough shelves for the books in Soane's lifetime, so we must imagine him surrounded by confusing piles of books, overflowing from tables onto the floor. It was in this setting that, during many years of study and note-taking, he constructed an intellectual labyrinth in which he constantly wandered alone, vainly seeking an exit. Soane's position was close to that of d'Alembert who, at the start of the *Encyclopédie,* had explained how, "The general system of the sciences and the arts is a kind of labyrinth, a twisting road which the mind enters without really knowing the route it ought to take."[18]

With a worried, questing mind, as though he were some kind of secular priest, Soane found himself in especial sympathy with those actual priests, Jean-Louis de Cordemoy, Laugier, Louis Avril, and Charles-François de Lubersac, whose architectural theories were

[18] *Encyclopédie ou dictionnaire raisonné des sciences, des arts et des métiers,* vol. I, Paris 1751, p. xiv. My translation. D'Alembert had already referred to his concept of a labyrinth on p. vii.

a fundamental part of the French Enlightenment. It is a measure of the intellectual isolation of Soane from the mainstream of continental thought that he could light upon authors such as Cordemoy and Leroy long after their books were published, and approach them as though they were contributing to contemporary debate.

This anomaly is partly the consequence of his ambition to conquer the intellectual world of the 1760s and 1770s to which he regarded himself as having been denied access as a boy and young man in those decades. His attempt to turn himself into a new person socially by "improving" his surname, was paralleled by the intellectual transformation which he hoped would be affected by his frenetic course of reading in European architectural literature and theory. Yet the enormous dependence on authorities, revealed in his notes, suggests the inner uncertainty which underlay his concern to carve out a place for himself in the world of ideas as it existed in his early manhood. That complex intellectual world spanned deism, freemasonry, the academic theory of the *ancien régime,* conveyed in the architectural doctrines of Blondel, as well as the new romantic sensibility, expressed in the writings of Rousseau and Goethe. Soane's library contained works by the philosopher Helvétius,[19] the father of Utilitarianism, for whom religion provided an inadequate basis for morality, and by Bernardin de Saint-Pierre,[20] the pastoral novelist of Rousseauesque sentiment. Soane's changeful architecture, by turns minimal and poetic, may seem to belong to the world of 1800. His equivalents in other contemporary arts may seem to be Wordsworth and Coleridge, on the one hand, with their new vernacular theory of diction, and Turner on the other. This is to say nothing of the new challenge afforded after 1815 by political and social reform. But none of this represented the world which, ostensibly, Soane sought to join or even to master. It was thus not with quotations from Wordsworth's contemporary *Lyrical Ballads* with which he peppered his lectures, but from Pope's *Essay on Man,* sixty-five years earlier.

Obsessed by the fundamentals of architecture, by the origins of architectural language, and by the attempt to separate the essentials of architecture from the accidents of style, he was constantly worried by the propriety of introducing details of the orders into interiors. The history of his discovery of the fact that all these problems had been continuously debated in France since the initiation of the Querelle des Anciens et Modernes in the late seventeenth century is one of the most fascinating episodes in British architectural history. It is nothing less than the belated impact of Enlightenment architectural thinking on one of the most inventive and original of all British architects.

Finding that his hero, Laugier, believed that French architects, in their century-long attempt to equal the ancients, had now risen to the level of achievement reached in Rome

[19] Claude-Adrien Helvétius, *De l'esprit* (1758), 3 vols, Paris 1768, annotated by Soane, and *De l'homme, des ces facultés intéllectuelles, et de son éducation* (1772), 2 vols, London 1775.

[20] Jacques-Henri Bernardin de Saint Pierre, *Paul et Virginie* (1788), Paris 1795.

at the time of Vitruvius,[21] Soane resolved that England should follow the same path. Taking, like Laugier, the side of the moderns in the Querelle, Soane showed how it was possible to enter into a cosmopolitan debate with authors whom he would not expect to meet personally. His view of the past was influenced in various ways by his francophile tastes. He believed, following Voltaire, in the existence of four great periods: the reigns of Pericles, Augustus, the Medici, and Louis XIV. As a demonstration of his sense of closeness to French architectural and intellectual life, he chose to publish French translations in 1832–1833 of his books on Pitzhanger Manor and on Sir John Soane's Museum. Donaldson described his "indefatigable desire for improvement" in languages, claiming that, "it was not unusual to hear him converse with ease, in their own tongue, with Italian and French Architects, who were introduced to him."[22] The distinguished French classical architect Jacques-Ignace Hittorff, in turn, published an account of Soane, praising his handling of light, mirrors, and coloured glass, as well as citing his gift of the Soane Museum to the nation as an "object lesson in the exercise of civic virtue."[23]

Soane felt that he belonged to the Gallic tradition of encyclopaedism with its concern, of ultimately antiquarian origin, to make lists of data and to organise this information for presentation to the public. The numerous notes which he left are full of attempts to compile indices. In France, this approach was expressed not only in the sequence of dictionaries, of which Diderot's and d'Alembert's *Encyclopédie* was but one, but in the assemblage of so-called encyclopaedic collections of plants, animals, and minerals, as well as of inscriptions, coins, medals, and urns. The fruit of this outlook was the didactic approach which not only presented models as precedents for architectural *bienséance,* but also, through the concept of commemoration, provided models of moral behaviour.

The work of eighteenth-century antiquarians, historians, and anthropologists created a framework of exploration in which architecture could be interpreted as the product of the social customs and cultural identity of a nation or people. This was eventually to lead, after 1800, to the interpretation by J.-N.-L. Durand of architecture as a product of its function, as merely fulfilling a social and practical need. Soane studied Durand, professor of architecture from 1790 to 1830 at the newly founded Ecole Polytechnique in Paris, but Soane's belief in the poetic capabilities of architecture led him to reject the Frenchman's functionalist doctrines.

Study, as Soane found, is an essentially solitary activity. For years, he must have sat up, long after the young men in the office had gone home, reading and scribbling alone in a silent, darkened house that seemed especially deserted after his wife's death in

[21] Marc-Antoine Laugier, *Observations sur l'architecture,* The Hague 1765, p. xi.

[22] Thomas L. Donaldson, *A Review of the Professional Life of Sir John Soane,* London 1837, p. 8.

[23] "Rapport fait par M. Hittorff sur la Maison et le Musée du Chevalier Soane, Architecte à Londres," *Annales de la Société Libre des Beaux-Arts,* 1836, pp. 194–205 (SM Archives Private Correspondence XIV.A.10).

1815.[24] In this heightened state of physical and intellectual isolation, he sympathised with Rousseau's claim on the opening pages of his *Confessions* that, "I dare to believe that I am not made like anyone else who exists."[25] Soane evidently wrestled with the seemingly divergent messages of two of his heroes, Winckelmann and Rousseau, the former reflecting the classic eighteenth-century view that art should express general truths not individual whims, the latter romantically stressing the primacy of the inner soul.

We must also appreciate the high idealism of the lectures. This was reflected, in strictly architectural terms, in his passionate belief in a building's total integrity. Hence his criticism of Smirke's Covent Garden Theatre, a building that offended him greatly, was not only devastating but was perceived to be devastating at the time. When Soane complained of the lack of relation between the architectural ornament and the building over which Smirke had loosely and intermittently stretched it, he was expressing a conviction that lay at the heart of his philosophy of design.

Soane's own position was, as usual, self-contradictory. On the one hand, he wanted to proclaim a set of universal axioms that would guarantee permanently correct proportions, and on the other hand, he was deeply conscious of the contingency of our preferences conditioned, as they are, by accidents of climate and inherited assumptions. Sometimes he wanted to follow the relativist line which some of the theories of Claude Perrault seemed to suggest, sometimes the reductionist rhetoric of Laugier or even the mechanistic doctrines of Durand, and sometimes the rhapsodic poetry of Ledoux. He tortured himself by seeing both sides of the question; for example, when noting that his hero, Laugier, condemned the use of columns in domestic interiors, Soane observed, "Some architects say (certainly without reason) that the column can *never* be used for decoration only. If this is admitted we should lose many of the chief opportunities of delighting the eye or showing the powers of architecture."[26]

It is clear that, coming somewhat late in life to theory, he never quite conquered it. Here, he compares interestingly with two Prussian architects and architectural teachers who were in some way his parallels, Friedrich Gilly (1772–1800) and his disciple, Karl Friedrich Schinkel (1781–1841). In his brief career, Gilly, more naturally gifted as a writer than Soane, struck a happy balance between design and theory. Conceiving, like Soane, an architecture which could stir the emotions through effects of light, his principal design was for a dramatically top-lit mausoleum, a characteristically Soanean concept.[27] At the same time, Gilly sought a "remythologization" of the art of construction through the

[24] His papers occasionally contain references to nocturnal study, e.g., "12 September, 1809. [Notes made] At night, poisoned with the smell of paint!" (SM Archives, 1/164/6).

[25] Jean-Jacques Rousseau, *Les confessions . . .* , 2 vols, Geneva 1783, vol. I, p. [1]. My translation.

[26] SM AL Soane Case 174, Portfolio 3, f. 206, and Laugier, *Observations*, p. 110.

[27] See Friedrich Gilly, *Essays on Architecture 1796–1799*, transl. by D. Britt with Introduction by F. Neumeyer, Santa Monica 1994, pp. 38–47 & 129–138.

primacy of poetry so as to restore art to its "ancient" rights.[28] In this context, both Gilly and Soane were attracted by the reductionist architecture of the rue des Colonnes, Paris, (1793–95), by Vestier and Bénard. Gilly made a beautiful drawing of this street on his visit to Paris in 1797,[29] while Soane, in Paris twenty-two years later, had a drawing of it made from the same angle for his Royal Academy lectures.

Schinkel, a Professor of Architecture in Berlin, failed to cut a coherent path through the forest of notes which he produced.[30] In the field of theory, Schinkel and Soane were poised uneasily on the divide between poetry and function, though they transcended this problem in their buildings. Devoted absolutely and entirely to the cause of architecture, and to the idealist eighteenth-century belief in the ennobling cultural role of architecture, they lived and died in what was wholly, in Schinkel's case, and effectively, in Soane's, a school of architecture.[31]

THE CONNECTION BETWEEN SOANE'S LECTURES AND HIS ARCHITECTURE

Soane, it is agreed, is ultimately important as an architect, not as a theorist or historian, so one of the first questions asked by anyone reading the lectures is, "How far do they reveal his own personal design philosophy?" The complicated connection between Soane's extensive reading, his observation of nature, and his own architectural language, can be suggested as follows. In translating Quatremère de Quincy's study of Egyptian and Greek architecture, Soane made a drawing of reeded columns, tied together with horizontal rings or bands, resembling a synthesis of Egyptian and Gothic, and based on an illustration by Quatremère.[32] That was in September 1806. In another Commonplace book, he recorded in February 1807 how the sight of reeds growing near Stowe gave him the idea that large bundles of reeds tied together at the top and bottom might have been the origin of columns, illustrating his point with sketches.[33] Meanwhile, in yet another set of notes, written at

[28] *Ibid.,* p. 67.

[29] Reproduced in Alste Oncken, *Friedrich Gilly, 1772–1800,* Berlin 1935, Pl. 42.

[30] See Goerd Peschken, *Karl Friedrich Schinkel Lebenswerk, Das architektonische Lehrbuch,* Berlin and Munich 1979, and Alex Potts, "Schinkel's Architectural Theory," in Michael Snodin, ed., *Karl Friedrich Schinkel: A Universal Man,* New Haven and London 1991, pp. 47–56.

[31] Soane presumably met Schinkel on his visit to no. 13, Lincoln's Fields on 11 June, 1826, when Schinkel described the museum as "ingenious," and full of "little deceptions" (Karl Friedrich Schinkel, *"The English Journey": Journal of a Visit to France and Britain in 1826,* David Bindman and Gottfried Riemann, eds., New Haven and London 1993, p. 114).

[32] SM AL Soane Case 175, *Architecture. Extracts, Crude hints . . . J. Soane 1818,* f. 85, and Quatremère de Quincy, *De l'architecture égyptienne,* Pl. V, no. 34.

[33] SM AL Soane Case 168, *Architecture Commonplace Book Z,* 24 February 1807, f. 186.

about the same time, in January or February 1807, Soane brought these themes neatly together in a rare and uniquely valuable reference to his own personal style:

> One easily accounts for the 3 small sinkings on the Doric capital: they repre-
> sented the strings that tied the original bundled reeds together to make them
> strong to bear great weight. From considering attentively the three sinkings
> round the capital of the Doric column and the works of the Egyptians I was led
> to the practice of sunk mouldings which were at first everywhere abused and
> now they are as generally often absurdly adopted.[34]

Soane's frequent use of "sunk mouldings," well exemplified in the sharply incised lines which run round his entrance lodge and gateway at Tyringham, Buckinghamshire (c. 1800), is thus revealed as part of the return to roots which we have seen as characteristic of the Enlightenment. His observations on plant forms were close to Goethe's who, on his tour of Italy to study the origins of classicism, was preoccupied with his search for the *Urpflanze,* "the primal plant" or archetype of all vegetation.[35]

It is thus possible to argue that, hidden in the lectures which Soane delivered at the Royal Academy, and in the vast mass of notes which he made in preparation for them, is a key that will help decipher his complex architectural language. The thousands of surviving notes for his lectures, sometimes reflecting contradictory views, in which we can chart the painful, labour-intensive activities of a perfectionist, suggest that he may have adopted a similar approach to architectural design. One clue was provided in 1965 by Dora Wieben-son who, describing the eighteenth-century "search for essentials" as rooted in "the conception of nature as an essential, first principle," speculated that, "The work of C. N. Ledoux, E. L. Boullée, John Soane, and Friedrich Gilly would be unthinkable without the background of theory and practice in the 1750s which is reflected in the work of Laugier and Soufflot."[36] Now that we know the extent of Soane's reading, it is clear that even the perceptive critic Wiebenson had greatly underestimated his familiarity with the corpus of Enlightenment history and theory.

To explore the possible relation between Soane's ideas and his architecture, is to become aware that his architectural style, as personal as that of any British architect, was developed over a long period and was no more consistent than his lectures. If we feel daunted by the task of analysing Soane's architectural language, we may take heart that

[34] SM AL Soane Case 161/1, Portfolio 2, *Detached Parts of the lectures,* ff. 21–22.

[35] For Goethe's search, see his *Italienische Reise,* in *Werke,* Erich Trunz, ed., vol. XI, Munich 1989, pp. 266 & 324.

[36] Dora Wiebenson, "Greek, Gothic and Nature: 1750–1820," in *Essays in Honor of Walter Friedlander,* New York 1965, p. 192.

even the great scholar Rudolf Wittkower once confessed, "I must say frankly that I always dreaded the idea of studying Soane, because of the complexity of his architecture."[37]

However, we have absorbed, perhaps unconsciously, Sir John Summerson's account of Soane in a lecture delivered as long ago as 1950.[38] Here, he followed a traditional path of postulating a period of progress followed by one of decline. According to this, the most "creative" or "Middle Period," was the one in which Soane produced the pared-down language that seemed to have a special message for architects in the midtwentieth century. Wittkower's just quoted remark was, in fact, made at the discussion following Summerson's lecture. In 1963, Summerson was still arguing for Soane to be hailed as a harbinger of modernism. Writing of Peter Behren's Turbine Hall of 1908 in Berlin, he claimed that it,

> is really a neo-classical building designed on the lines of a temple but with all the stylistic signs and symbols left out or changed. You may remember that Sir John Soane was doing something like this more than a hundred years earlier. And in a sense Behrens in 1908 was not much more advanced than Soane (at Dulwich) in 1811.[39]

For Summerson, the most important aspect of Soane was his proto-modernist radical abstraction: "Soane is remembered," he argued, "for his personal and unique mode of abstraction from Neo-classicism." His fully articulated classicism did not matter because, "Soane, it would seem, knew intuitively that the last great chapter in the history of classicism since the Renaissance was closed. There was nothing to add."[40]

This interpretation of Soane has been condemned by Giles Worsley who argues, convincingly, that the variety of languages adopted by Soane, ranging from the most magnificent Corinthian to the simplest stripped style, was related to his understanding of *convenance* which led him to search for the appropriate character for every commission.[41] His stripped, reductionist language, Worsley claims, was not necessarily dependent on Laugier but could have been found in the stripped or astylar episodes in the work of architects such as Vignola, Giulio Romano, and Ammanati. We might here add Raphael's stables for the Villa Farnesina with the blank, framed panels which Soane illustrated and admired in Lecture V. At the same time, Laugier was more influential than Worsley

[37] *R.I.B.A. Journal,* 3rd series, vol. LVIII, January 1951, p. 90.

[38] John Summerson, "Soane: The Case-history of a Personal Style" [paper read before the R.I.B.A., 12 December, 1950], *R.I.B.A. Journal, loc. cit.,* pp. 83–91.

[39] John Summerson, *The Classical Language of Architecture* (1963), 3rd ed., London 1980, p. 110. Walter Gropius had hinted that he saw himself as in some sense an heir of Soane (*The New Architecture and the Bauhaus,* London 1935, p. 80).

[40] John Summerson, *Architecture in Britain 1530–1830* (1953), 9th ed., New Haven and London 1993, p. 470.

[41] Giles Worsley, "Soane was no faint-hearted Classicist," *Georgian Group Journal,* 1994, pp. 43–50.

suggests, for Soane's use of the orders was undoubtedly influenced by Laugier's view that, "The great orders properly belong only to great churches, royal palaces, and public buildings. For all other buildings it is necessary to adopt simpler and less expensive decoration. Attractive and even beautiful buildings can be built without the help of entablatures and columns."[42]

To accept Summerson's interpretation might lead one to denigrate Soane's later period where, in his remodelling of the Soane Museum in 1823-1824, his interiors at the Law Courts and House of Lords, Freemasons' Council Chamber, Privy Council Chamber, and gallery for Sir Francis Chantrey, he seemed to reverse much of the abstract clarity of his earlier work. Indeed, in the 1820s he produced ever more experimental interiors with complex spatial and lighting effects, involving domes and skylights. It is significant, for our purposes, that all these interiors were designed *after* he had written his lectures.

The extreme difficulty of interpreting Soane's architecture led one anonymous critic of his lecture course in 1819 to complain that, "his theory is in opposition to his practice."[43] It is certainly possible to interpret Soane's abstract, astylar work at Chelsea Hospital and Dulwich College, designed while he was writing the lectures, as a response to his realisation, from reading d'Hancarville, that all ornament should have a symbolical meaning, and his associated discovery that the orders should be treated with greater caution than in the work of his contemporaries and of many of his predecessors. Sensitive to criticism that his buildings conflicted with the advice given in his lectures, Soane was quick to condemn his own buildings which he believed fell short of his ideals. Surprisingly, he focused his criticisms on his most famous work, the Bank of England, where he condemned the Lothbury Arch as inappropriate to its setting and function, since no soldiers would return in triumph beneath it; he dismissed the Prince's Street vestibule and the Accountants' Office for improperly introducing into interiors details of the orders which should only be used in exteriors; he explained that the mean centrepiece of the Lothbury façade was due to circumstances beyond his control; and he noted that the iron railings on the Threadneedle Street front had corroded the adjacent stonework. He also criticised his exteriors at Bentley Priory for lacking the character appropriate to the residence of a marquess, illustrating its blank façades with ruthlessly honest drawings.

Before taking these criticisms too seriously we should recall the perverse streak in Soane's character which led him somehow to revel in persecution, even self-persecution. He did not, however, criticise his own buildings for their decorative use of emblems such as bucrania, the caduceus, and caryatids, which his oft-quoted theorists urged should only be used in symbolically appropriate situations. Indeed, he illustrated in his lectures a wide variety of his buildings as exemplars, suggesting that he did not see a fundamental gap

[42] Marc-Antoine Laugier, *Essai sur l'architecture* (1753), 2nd ed., Paris 1755, p. 105. My translation.
[43] *Annals of the Fine Arts,* vol. IV, 1820, p. 102.

between his theory and his practice. He thus showed his early design for a Triumphal Bridge; his Three Per Cent Consols Transfer Office, Stock Office, Reduced Annuities Office, and Rotunda, at the Bank of England; his extensive designs for a new House of Lords; Buckingham House, Pall Mall; entrance hall and music room at Bentley Priory; Dulwich College Picture Gallery and Mausoleum; and Chelsea Hospital Infirmary. According to one recent interpretation, his work at Dulwich incorporates primitive, Egyptian, and Gothic references, so that it should, perhaps, be seen as intimately connected with the reading he undertook while researching into first principles in preparation for his lectures.[44]

Soane frequently expressed contempt in his lectures for the London building world, dominated, not by trained and educated architects, but by building contractors governed entirely by considerations of commercial gain. Instead of the rows of featureless houses which he so much despised, he wanted London to rival Paris and other continental cities in the number of modern public buildings appropriate to the national prestige. This ambition was not only in accordance with the civic preoccupation of the French writers he had studied such as Pierre Patte, Antoine-Yves Goguet, and Charles-François de Lubersac, but was also related to his own practice as an architect, and particularly to his failure to put up a great public monument himself. It is impossible to underestimate the influence of the resentment he felt when his plans for the new House of Lords of 1794 were unfairly dropped. He endured further humiliation in 1824 when the Palladian façade of his New Law Courts was vilified in Parliament and in the Press, and he was forced, following the report of a hostile Select Committee, to rebuild it in the Gothic style.[45] Soane's rage at the authorities in London may have been heightened by his sense that his own gifts did not, in fact, lie in the composition of large free-standing public buildings. His buildings frequently seem designed as though they were part of something larger which, indeed, they often were.

We also know from his lectures that Soane admired Napoleon's contributions to urban planning in Paris from 1802 which he saw on his visits in 1814 and 1819. The monuments by architects such as Jacque Gondoin, J.-F.-T. Chalgrin, Pierre-Alexandre Vignon, and Percier and Fontaine made him even more impatient with the modest improvements with which he had been associated during the three-decade-long clearance of New Palace Yard, Westminster, under the Westminster Improvements Commission.[46] His idealised plans for this historic centre of London can be seen in his book, *Designs for Public Improvements in London and Westminster* (1827). As well as illustrating the public works in Westminster which he had executed under royal patronage, including his New Law

[44] Andrew Ballantyne, "First Principles and Ancient Errors: Soane at Dulwich," *Architectural History,* vol. 37, 1994, pp. 96–111.

[45] *The History of the King's Works,* Howard M. Colvin, ed., vol. VI, *1782–1851* (by J. Mordaunt Crook & M. H. Port), London 1973, pp. 506–10.

[46] *The History of the King's Works, loc. cit.,* pp. 512–25.

Courts and Royal Entrance for George IV at the House of Lords, he included designs for a new ceremonial centre at the heart of London. This was associated with the route to be taken by the King from Windsor Castle to his new palace in London, through St. James's Park and Downing Street transformed with triumphal arches, and finally to the House of Lords for the State Opening of Parliament.[47]

One final way in which the lectures were related to his buildings was the existence of Sir John Soane's Museum which was described as early as 1812, in the first printed notice of it, as "an Academy for the study of *architecture* upon principles at once *scientific* and *philosophical*."[48] In the bizarre manuscript history of his house, which he never completed, Soane himself speculated that future visitors might regard it as an attempt "to exemplify the later changes in architecture and to lay the foundations of a history of the art itself, its origins, progress, meridian, splendour and decline!"[49]

Partly conceived as a setting in which students could learn about architecture through casts, models, books, and drawings, the building thus became a three-dimensional version of the lectures. Hittorff, who grasped its didactic role, described how the varied architectonic qualities of each object represented the particular character of the period of art to which it belonged, so that an assembly of antique columns took the form of a colonnade; mediaeval fragments were arranged to suggest the oratory of a ruined monastery; tombs and funerary urns were displayed in a catacomb; the Belzoni sarcophagus had its own sepulchral chamber; while the bust of Shakespeare and the monument to William Pitt were surrounded by appropriate works of art.[50]

The Museum was described in 1837 as resembling "a temporary experimental trial or model of what was intended to be executed on a large scale,"[51] once again suggesting an educational role akin to that of the Royal Academy lectures. It contains hints of primitive, Egyptian, Greek, Roman, Pompeiian, and Gothic design, interwoven suggestively in a kind of garden of association, reminiscent of eighteenth-century landscape gardens. Bathed in a coloured light evocative of the lighting effects of the Gothic church and the Baroque stage, it incorporates dramatic and theatrical effects such as hanging arches, rooms within rooms, and walls dissolved in a spatial play in which architecture seems turned inside out. Contrasts of darkness and light, of expansion and constriction, constantly stimulate specu-

[47] See Sean Sawyer, "Sir John Soane's Symbolic Westminster: The Apotheosis of George IV," *Architectural History,* vol. 39, 1996, pp. 54–76.

[48] *European Magazine,* vol. LXII, 1812, p. 382.

[49] John Soane, *Crude Hints towards an History of my House in L[incoln's] I[nn] Fields,* SM AL Soane Case 31, f. 47.

[50] "Rapport fait par M. Hittorff, sur la Maison et le Musée du Chevalier Soane, architecte à Londres," *Annales de la Société Libre des Beaux-Artx,* 1836, pp. 100–1.

[51] *Civil Engineer and Architect's Journal,* vol. I, 1837–1838, p. 44.

lation as we follow what can seem like a path of initiation, or of an unfolding course of instruction.

Soane's extreme reluctance to show visitors around his house and museum on dark days not only indicates the extent to which lighting effects were integral to his architecture, but also suggests that he envisioned the building as a garden. His preference for showing the museum in sunlight also underlines the importance to him of coloured light, in which he was the heir to the post-Newtonian poets, such as James Thomson in *The Seasons* (1730), who shared a similar obsession with colour and light. To Thomson, as to Newton, the golden light of yellow was the most luminous and beautiful of them all.[52] This is the light with which Soane bathed interiors such as his Mausoleum at Dulwich College Gallery, while the final edition of his description of his museum included Leigh Hunt's resonant claim that, "We feel as if there were a moral as well as material beauty in colour."[53]

The concern with colour harmony had also been given expression towards the mideighteenth century by Père Louis-Bertrand Castel in the form of a bizarre ocular harpsichord. Soane's interest in this device derived from the account of Castel by Le Camus de Mézières in *Le génie de l'architecture* (1780). It was from Le Camus de Mézières, a major influence on Soane's conception of architecture in his Royal Academy lectures, that Soane derived his belief in this union as well as his use of light to create "the poetry of architecture." We should recall that Soane's stated architectural aim in creating his museum was not to pare down architecture to essentials, but to demonstrate the unity of the arts of painting, sculpture, and architecture. This was the ideal he had found proposed by Le Camus de Mézières who, seeking the causes of the different "affections of the soul," asked, "if we united Architecture, Painting and Sculpture . . . Who could then resist this triple magic whose illusions make the mind feel almost every sensation which is known to us?"[54] Thus Soane did not describe his house and museum as an architectural museum but chose to think of it as a "union of the arts." Indeed, in the final edition of his *Description of the House and Museum on the North Side of Lincoln's Inn Fields* (1835–36), he expanded this phrase by explaining that the purpose of the book was, "to shew, partly by graphic illustrations, the union and close connexion between Painting, Sculpture, and Architecture, Music and Poetry."[55]

[52] See Marjorie Hope Nicolson, *Newton Demands the Muse: Newton's* Opticks *and the English Eighteenth Century Poets,* Princeton 1946, p. 45, and Isaac Newton, *Opticks,* Book I, Part 1, Proposition VII.

[53] John Soane, *Description of the House and Museum on the North Side of Lincoln's Fields,* 1835–1836, p. 44.

[54] Soane's translation in 1807 of N. Le Camus de Mézières, *Le génie de l'architecture,* pp. 4–5, in SM AL Soane Case 160, ff. 9–10.

[55] Soane, *Description,* 1835–1836, p. [vii].

THE DELIVERY AND INFLUENCE OF THE LECTURES

The lectures were delivered in the Great Exhibition Room of the Royal Academy at Somerset House in the Strand, executed from designs by Sir William Chambers in 1776–1796. It survives today as one of the rooms of the Courtauld Gallery. Intended for Royal Academicians and students at the Academy Schools, Soane's lectures were also open to members of the general public, though not to ladies, and were usually attended by large crowds. Members of the public applied for tickets which had to be signed by a Royal Academician. Seats were reserved at the front for the Royal Academy students, who were obliged to attend. They sat grouped according to their school, either Antique, which included the architects, or Living Model, with those who had won gold medals for their work sitting in the front.[56] However, the best places were sometimes occupied by older guests since it was difficult to hear Soane from the back of the room.

After an initial trial lecture in March 1809, Soane delivered the first four lectures of the first series in 1810, breaking off when his criticism of Smirke's Theatre Royal, Covent Garden, led to his suspension. He did not lecture again until January 1812 when he delivered the last two of the first series. He repeated this series in 1813, did not lecture in 1814 because his wife was ill, and delivered the second series for the first time in 1815. He did not lecture in 1816 because of his wife's death in November 1815. He delivered the first series in 1817; did not lecture in 1818; gave a revised version of the first series in 1819; and lectured for the last time in 1820 when he delivered Lectures 7 to 9 of the second series. No lectures were delivered until 1832 when, his eyesight having failed, they were read for him by Henry Howard, Secretary of the Royal Academy. Howard delivered the first series in 1832, 1834, and 1836, and the second series in 1833 and 1835.

It is one of the paradoxes of Soane's career that, having given so much time to writing the lectures and preparing their illustrations, he should have given them so infrequently. Lectures X to XII were delivered on only three occasions during Soane's thirty-year tenure of the Professorship, while only the audience of March 1815 will have heard Soane personally give his opinions on current topics such as landscape design, town-planning, construction, and fire proofing. This goes some way to explain why he seems to have had so little influence on Regency and Early Victorian architects.

However, it should be remembered that other lecturers at the Royal Academy, notably J. M. W. Turner, Professor of Perspective from 1807 to 1837,[57] and John Flaxman, Professor of Sculpture from 1810 to 1826, reflected something of Soane's outlook. Soane attended lectures by Flaxman, Henry Fuseli, and Turner of whom he had been a close

[56] See *Royal Academy of Arts in London: Laws relating to the Schools, the Library, and the Students,* 1814, p. 24; and Neil Bingham, "Architecture at the Royal Academy Schools, 1768–1836," in *The Education of the Architect,* Neil Bingham, ed., Society of Architectural Historians symposium, London 1993, p. 9.

[57] See Maurice Davies, *Turner as Professor: The Artist and Linear Perspective,* London 1992.

friend from 1792. Flaxman, like Soane, painted an idealised image of ancient Greece as a way of condemning modern art and culture, while Soane and Turner shared a common aesthetic based on an obsession with light, shadow, colour, and the artistic centrality of the poetic.

The most distinguished followers of Soane were C. R. Cockerell (1788–1863) and Soane's favourite and most gifted pupil, George Basevi (1794–1845), whose Fitzwilliam Museum, Cambridge (1836–45), went some way to fulfilling Soane's own expectations of what defines a monumental building. Cockerell, who succeeded Soane as architect to the Bank of England in 1833, was appointed Professor of Architecture at the Royal Academy in 1839, and President of the Royal Institute of British Architects in 1860. Delivered from 1841 to 1856,[58] his Royal Academy lectures enshrined, like Soane's, a humanist view of classical architecture as an image of ideal beauty serving to rebuke the modern world for its meanness and commercial priorities.[59]

Cockerell had attended some, if not all, of the five lectures which Soane delivered at the Royal Academy in 1809–1810.[60] Moreover, one of his first acts on his appointment as Professor was to ask the Trustees of Sir John Soane's Museum if he might borrow some of Soane's lecture drawings to exhibit in his own lectures.[61] He may well have imbibed from Soane his belief in the separation of the architect from the builder, and of art from trade, as well as the linked principle that the fine art of architecture should be distanced from the confusing and the ordinary in every day social life.[62]

However, Soane's individual style of architecture fell markedly out of favour towards the end of his long life. Thus, unlike Schinkel in Germany, Durand in France, or Benjamin Latrobe in America, he founded no school of disciples. Perhaps the principal long-term impact of his lectures lay in the granting of professional status to the architect, as demonstrated by the establishment of the Institute of British Architects in 1834. Soane was invited to become the first president of what became the R.I.B.A.,[63] partly in recognition of his promotion of the cause of professionalism through the constant and devastating attacks in his lectures on the increasing dominance of architectural practice in London by uneducated

[58] For Cockerell's lectures, see David Watkin, *The Life and Work of C. R. Cockerell, R. A.,* London 1974, ch. VIII, and Peter Kohane, *Architecture, Labor and the Human Body: Fergusson, Cockerell and Ruskin,* Ph.D. thesis, University of Pennsylvania, 1993. An edition of Cockerell's lectures is a *desideratum.*

[59] For a general discussion of this topic, see Frnak M. Turner, *The Greek Heritage in Victorian Britain,* New Haven and London 1981.

[60] Cockerell, then in Smirke's office, was reported as having been one of a group of students hostile to Soane's attack on Smirke.

[61] SM Archives Minute Book Trustees 1, p. 113/4, 9 December, 1839. The Trustees declined, but gave him permission to make copies of a selection of them.

[62] On this interpretation of classicism, see Alexander Tzonis and Liane Lefaivre, *Classical Architecture: The Poetics of Order,* Cambridge, Mass., and London 1986.

[63] Soane was unable to accept because, by the then laws of the Royal Academy, he was debarred from membership of any other Society of Artists.

and untrained builders and surveyors. Indeed, his complaint that architecture had become a trade, and therefore lacked poetry, richness, and appropriate character, was widely and increasingly shared by critics from the 1830s onward, including W. H. Leeds, Archibald Alison, Francis Palgrave, and, even more significantly for the future, by those powerful Gothic propagandists, A. W. N. Pugin and John Ruskin.

CONCLUSION

To summarise, Soane's lectures, everywhere reflective of an Enlightenment mentality, are related to his personal design theory in numerous complex and intimate ways: they demonstrate his wish to return to first principles, especially as influenced by his reading of Laugier, and to avoid reliance on fashion; his belief, revealed in his devotion to writers such as Blondel, Lord Kames, and Le Camus de Mézières, that the appropriate character should be found for every commission; his related obsession with the meaning of ornament, as evidenced in his study of d'Hancarville's writings on symbolism and in his own use in tombs and monuments of the snake biting its tail, a pagan symbol of eternity; his stress on civic virtue, as represented in public buildings; his associated passion for Greece, yet his veneration for the supremacy of the eye in making aesthetic decisions, bolstered by his reading of Perrault and Leroy; his feeling for Edmund Burke's Sublime, as demonstrated in his aesthetic reaction to Egyptian, Indian, and even Gothic architecture; and his love of "the poetry of architecture." To this should be added his emotional identification with Rousseau, and his interest in the visionary work of Ledoux, though these were resonances which were scarcely allowed to surface in the lectures.

Soane was obsessed by these issues throughout the whole period of preparing and delivering his lectures. His dependence on ideas associated with the previous century was linked to his disillusionment with contemporary British architecture and its dominance, in London, by the speculative building system. Soane hated modern architecture for its meanness, its shoddy materials, and its lack of poetry: his lectures and his architecture are nothing other than the attempt to revitalise the modern world with richness and meaning by one of the greatest imaginative geniuses in the history of British architecture. His achievement continues to instruct and inspire us.

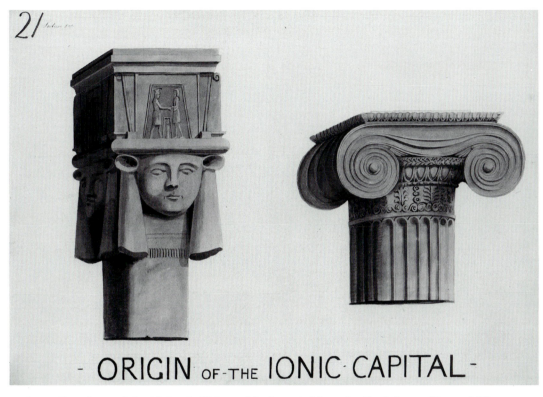

Plate 1 Egyptian capital with head of Isis, and Ionic capital from the Erechtheum. (Drawn 17 January, 1807.)

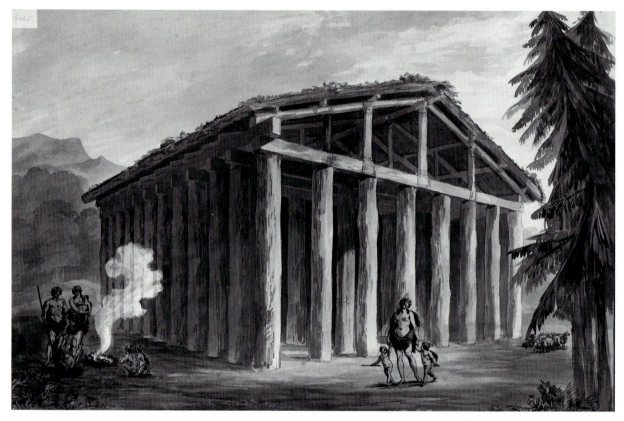

Plate 2 Primitive hut with pedimented roof. (Drawn May 1807.)

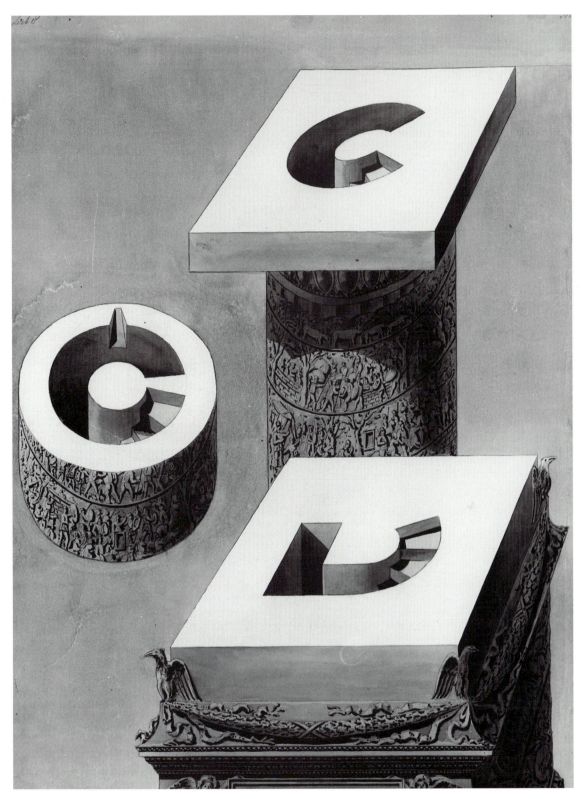

Plate 3 Trajan's Column, Rome. Part elevation and sectional details. (After G. B. Piranesi.)

Plate 4 Tomb of the Horatii and Curiatii on the Via Appia, Albano, Italy. Perspective view. (After a model by Turnerelli.)

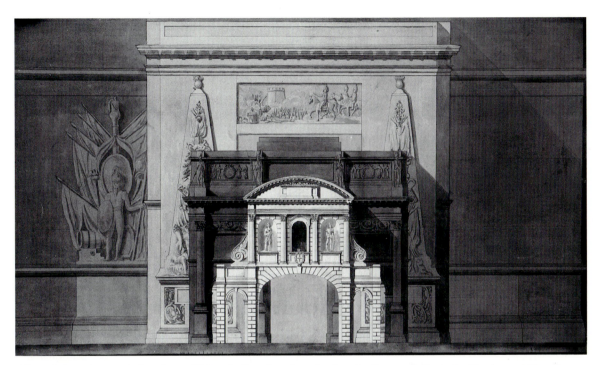

Plate 5 Superimposed elevations of Temple Bar, London, the Arc du Carrousel, Paris, by Percier and Fontaine, the Porte S. Denis, Paris, by François Blondel. (Drawn 12 May, 1820.)

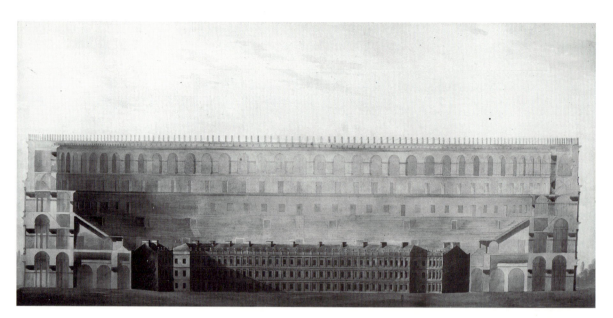

Plate 6 Comparative section of the Colosseum, Rome, and elevation of the Circus, Bath, by John Wood. (Drawn 5 November, 1814.)

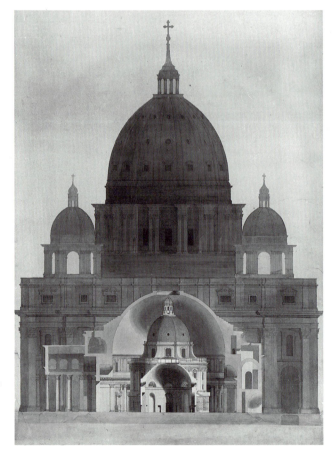

Plate 7 Comparative elevations of St Peter's, Rome, and the Radcliffe Library, Oxford, by James Gibbs, with sections of the Pantheon, Rome, and the Rotunda at the Bank of England, London, by Soane.

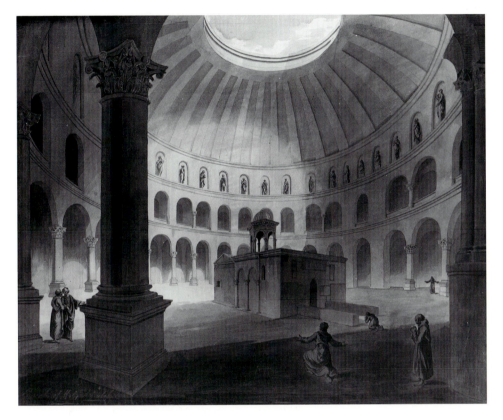

Plate 8 Holy Sepulchre, Jerusalem. Interior perspective. (After de Bruyn.)

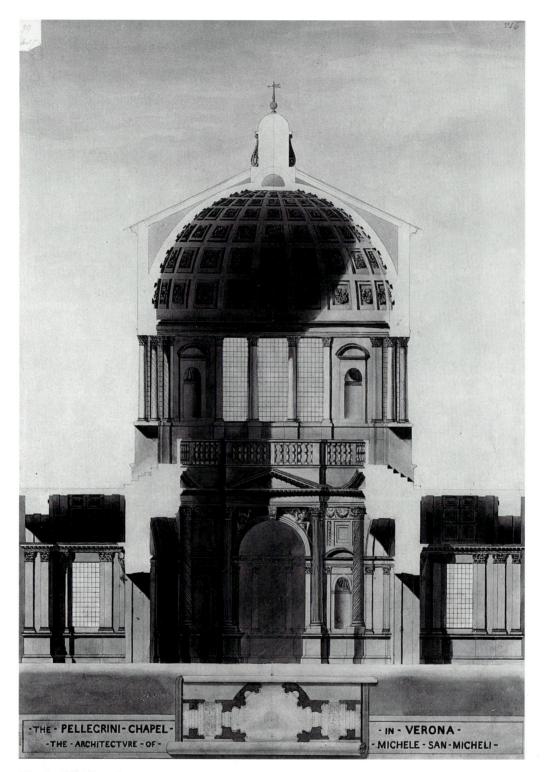

Plate 9 Pellegrini Chapel, S. Bernardino, Verona, by Michele Sanmicheli. Plan and section. (Drawn 3 December, 1811.)

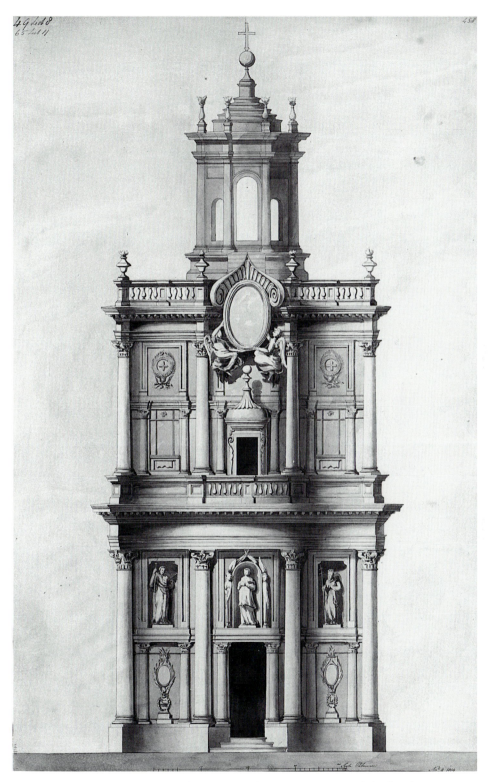

Plate 10 San Carlo alle Quattro Fontane, Rome, by Francesco Borromini. Elevation.

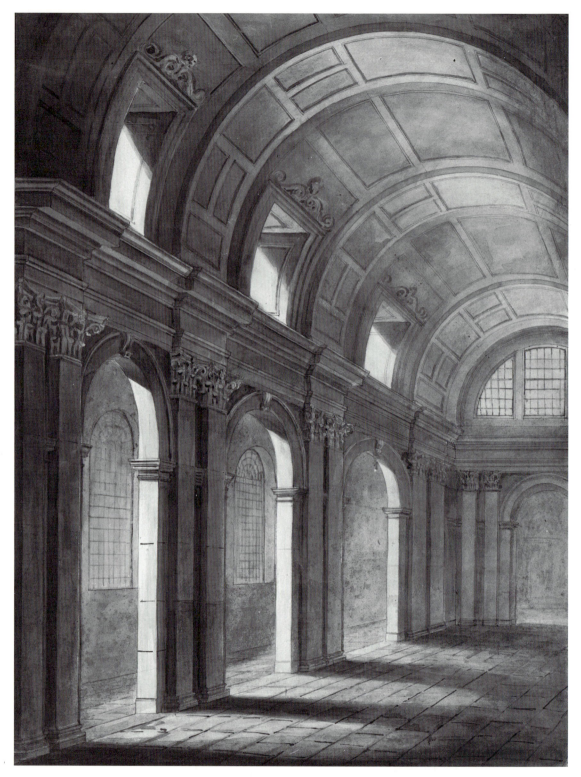

Plate 11 Interior perspective of a typical Italian church.

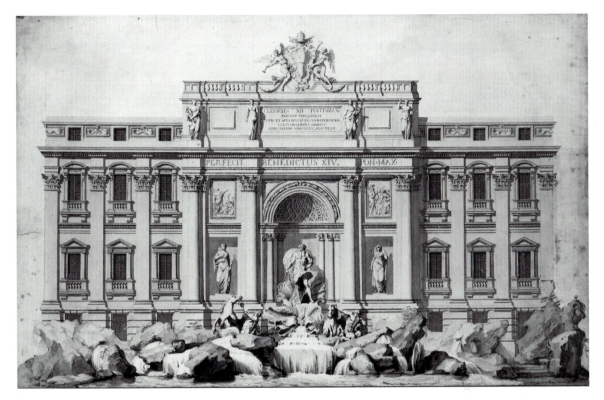

Plate 12 Trevi Fountain, Rome, by Nicolà Salvi. (Drawn by Laurent Pécheux and William Chambers, 1753.)

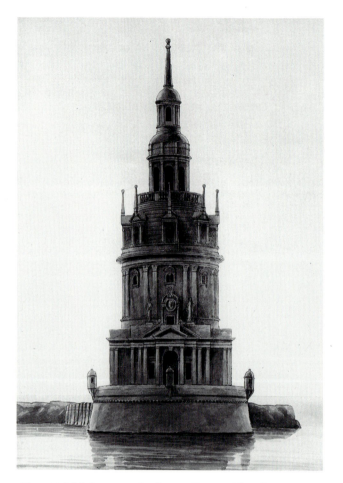

Plate 13 Lighthouse at Cordouan, France. Elevation.

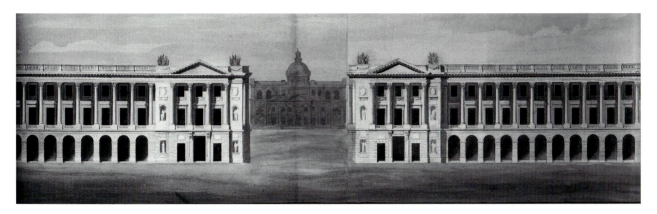

Plate 14 Place Royale (de la Concorde), Paris, by A.-J. Gabriel. Elevation.

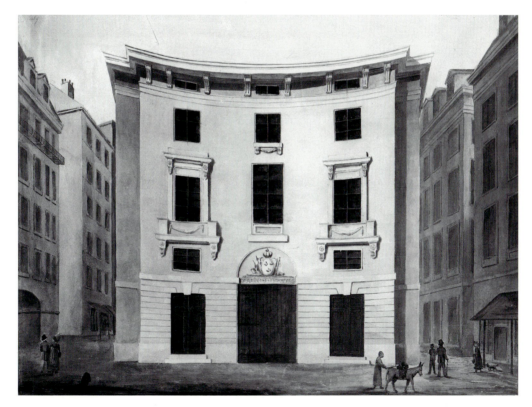

Plate 15 House in Paris with concave façade. Perspective elevation. (Drawn by Henry Parke, 1819.)

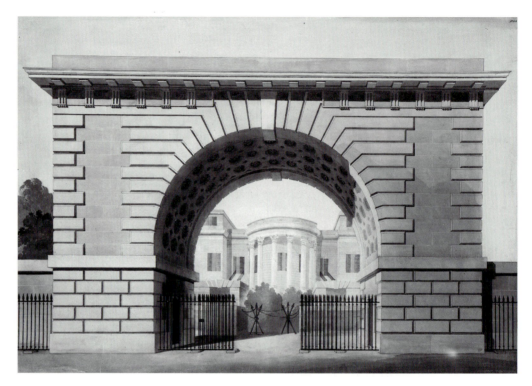

Plate 16 Hotel de Thélusson, Paris, by C.-N. Ledoux. Perspective. (Drawn 23 November, 1819.)

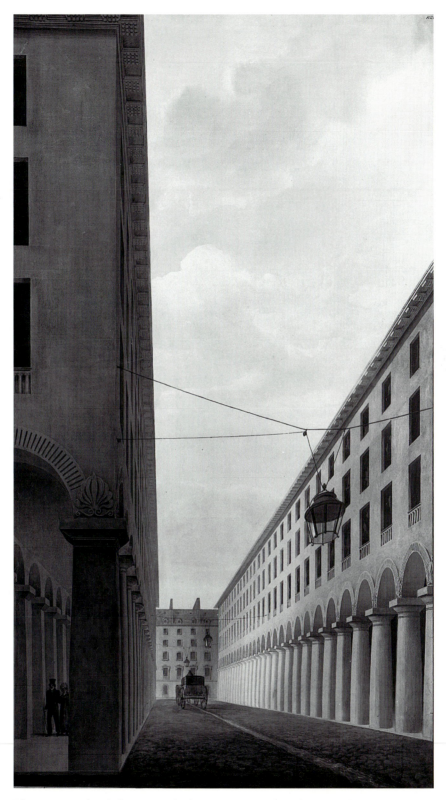

Plate 17 Rue des Colonnes, Paris, by N.-J.-A. Vestier and J. Bénard. Perspective view. (Drawn by Henry Parke, 1819.)

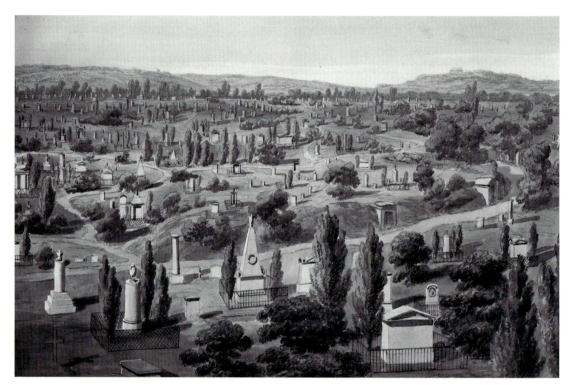

Plate 18 Cemetery of Père la Chaise, Paris. Bird's eye view. Drawn by Henry Parke, September 1819. Detail.

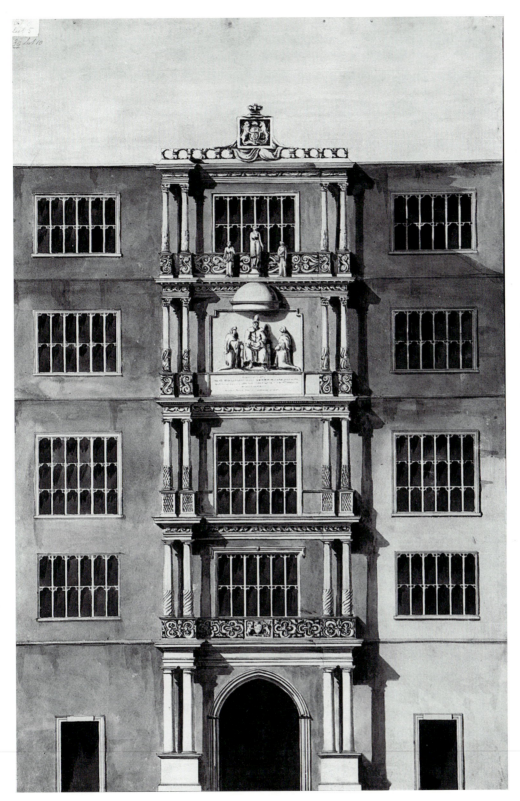

Plate 19 Tower of the Orders, Schools Quadrangle, Oxford. Elevation.

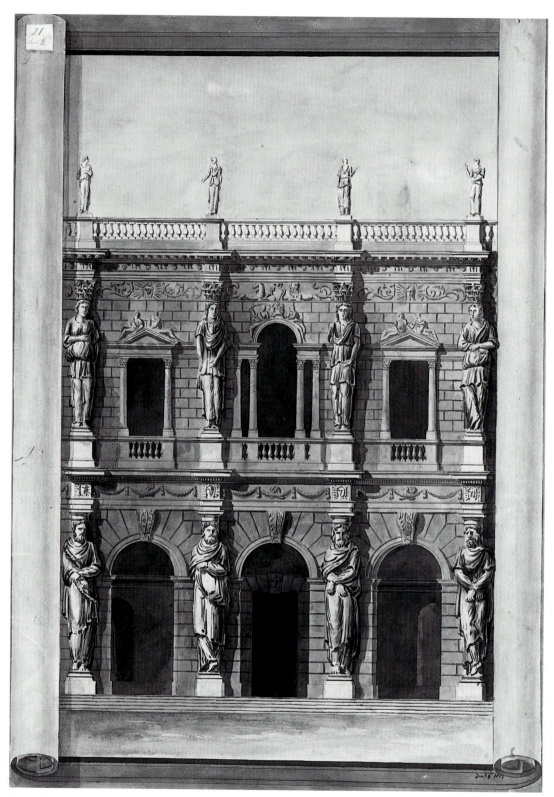

Plate 20 Design attributed to Inigo Jones for Whitehall Palace, London. Detail of Persian Court. (After William Kent.)

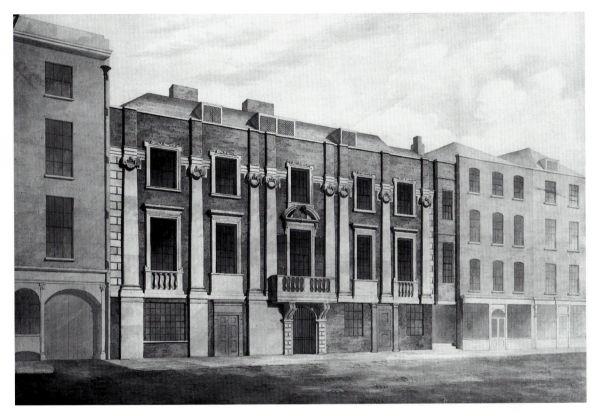

Plate 21 Shaftesbury House, Aldersgate, London.

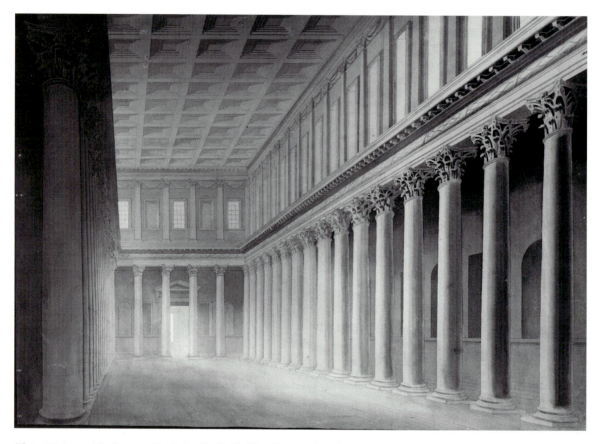

Plate 22 Assembly Rooms, York, by the Earl of Burlington. Interior.

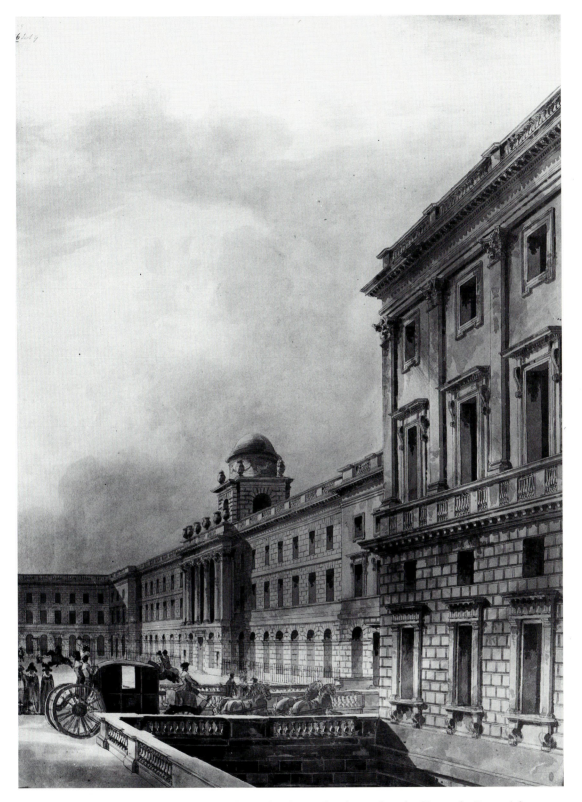

Plate 23 Somerset House, London, by William Chambers. View in quadrangle. (Drawn by James Adams, after L.-J. Desprez, 23 July, 1807.)

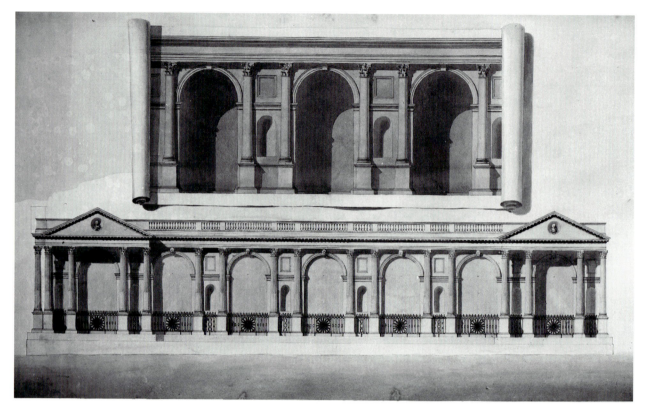

Plate 24 Bank of England, London, Threadneedle Street front, by Robert Taylor, compared with Cortile del Belvedere, Vatican, Rome, by Bramante.

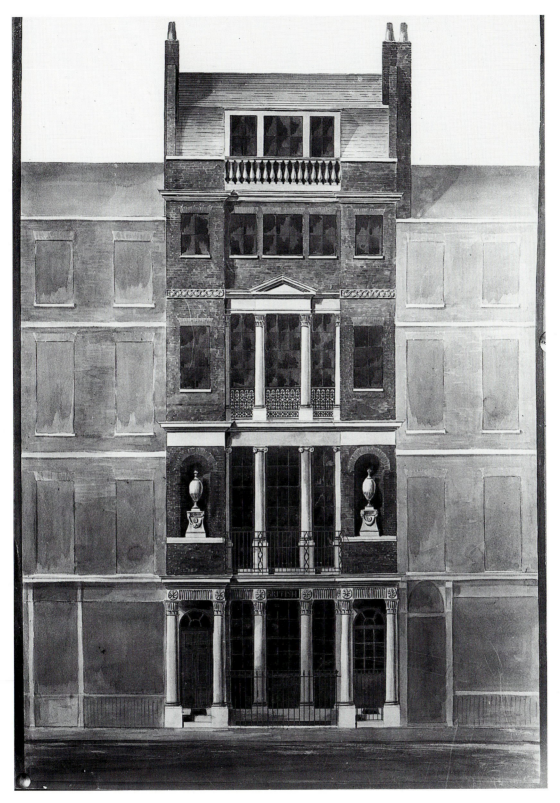

Plate 25 British Coffee House, Cockspur Street, London, by Robert Adam. Elevation. (Drawn by Robert Chantrell, 1813.)

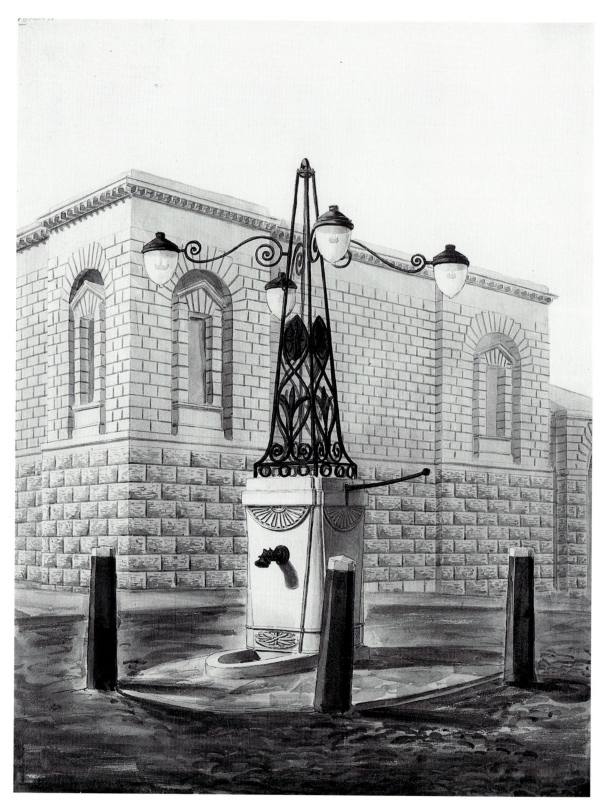

Plate 26 Newgate Prison, London, by George Dance. Detail of façade with pump.

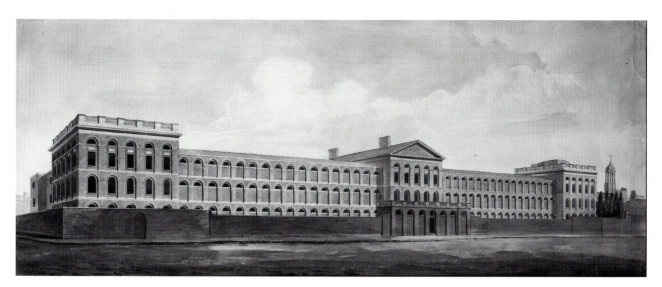

Plate 27 St Luke's Hospital, Old Street, London, by George Dance. Elevation. (Drawn 1813.)

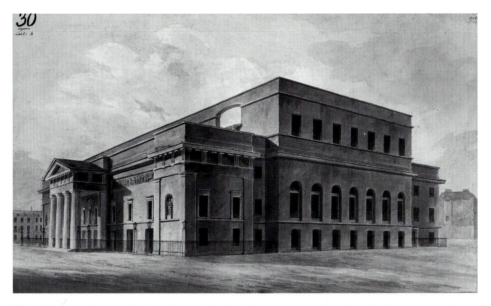

Plate 28 Royal Opera House, Covent Garden, London, by Robert Smirke. Perspective view of east and north elevations. (Drawn 20 December, 1809.)

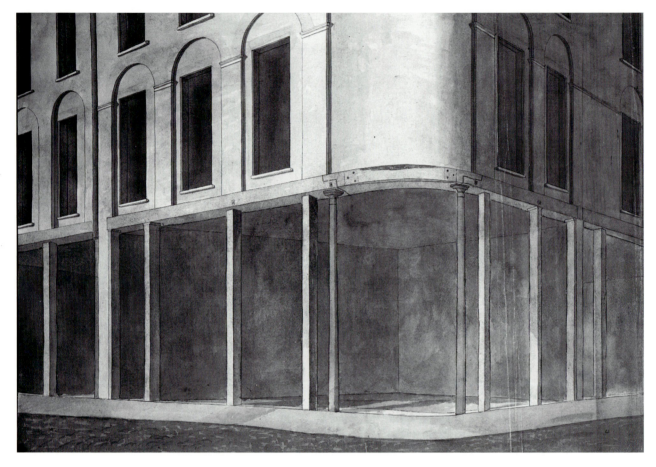

Plate 29 Perspective showing construction of modern shops.

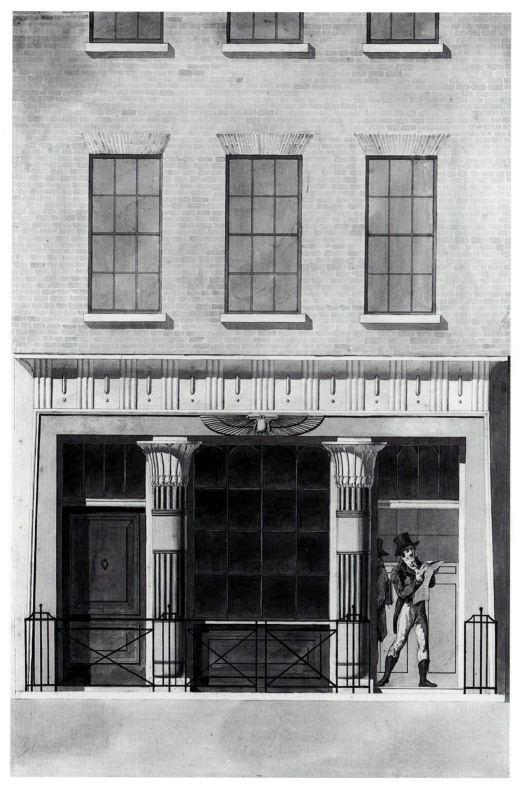

Plate 30 Courier Office, Strand, London. Elevation. (Drawn by George Underwood.)

Plate 31 Pipes of the New River Company at Bagnigge Wells, London. (Drawn by George Basevi, 1813.)

Plate 32 Pipes of the New River Company at Spa Fields, London. (Drawn 1814.)

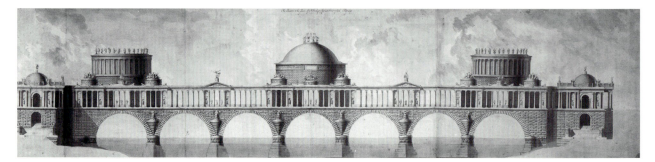

Plate 33 Design by Soane for a Triumphal Bridge.

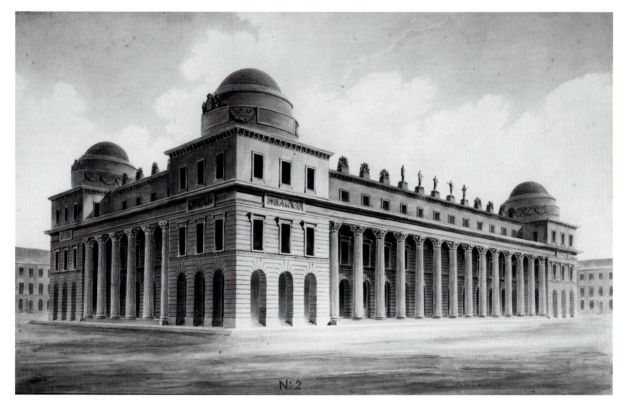

Plate 34 Design by Soane for Opera House, Leicester Square, London. Perspective.

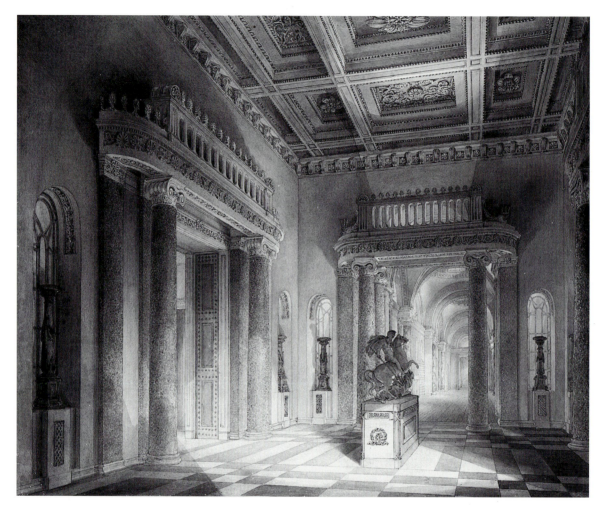

Plate 35 Design by Soane for House of Lords, London. Perspective of Ante Chamber to Royal Gallery.

THE ROYAL ACADEMY
LECTURES

∼

INTRODUCTORY NOTE

The following text of the lectures, unlike Bolton's transcript published in 1929,[1] reproduces exactly that in the original manuscript volumes, written for Soane by his pupils.[2] Bolton omitted certain extended passages, amounting to about two and a half thousand words, and made constant changes to word order as part of an attempt to 'improve' Soane's grammar and language; in this process he also introduced, changed, or eliminated numerous prepositions. I have returned to the original text in all cases, although this inevitably results in occasional infelicities such as singular verbs following plural nouns.

Soane's scribes divided the text into paragraphs, frequently of considerable length, which were divided, not into sentences, but into long phrases separated only by semicolons and dashes. Like Bolton, I have turned these phrases into sentences, for the sake of clarity, but, unlike Bolton, I have not introduced any linking words of my own. It is thus possible to retain the rhythm of Soane's prose which, it should be remembered, was written to be spoken not read. I have occasionally modernised spelling where the original might lead to confusion, and have also removed the capitalisation, since this was arbitrary, varying from lecture to lecture.

Soane introduced numerous footnotes of his own. To avoid competing with these, and to leave Soane's text to speak for itself, I have kept my own footnotes to a minimum. In the following text of the lectures, Soane's footnotes are numbered with letters of the alphabet, mine with arabic numerals.

[1] Arthur T. Bolton, ed., *Lectures on Architecture by Sir John Soane . . . As delivered to the Students of the Royal Academy from 1809 to 1836 in Two Courses of Six Lectures each,* London 1929.

[2] SM AL Soane Case 35–43.

LECTURE I

~

MR. PRESIDENT, – Architecture in particular, and the arts and sciences in general, for their great use and ornament in civilised society have in all ages been cultivated and cherished; and although the decision of the famous question proposed more than half a century past by the Academy at Dijon, 'Respecting the good or bad tendency of the Arts and Sciences', was against the received opinion of their being beneficial to society; the Romans, however, in common with all enlightened nations thought so differently from J. J. Rousseau (who gained the prize on that occasion) and the Academy at Dijon that, even in the time of Septimius Severus, they were anxious to preserve at least the knowledge of architecture, that the most able architects were invited to Rome from every part of the empire, and entrusted with the care of the public works. Schools of design were also established with the laudable intention of forming artists who might hereafter in their works emulate the perfection of those majestic edifices which had been raised in the times of Pericles and Augustus.

In subsequent times, in different countries, academies have been established, professors appointed, and public lectures and practical instructions given in the most liberal and extensive manner; and in this country, soon after the accession of his present Majesty, a Royal Academy was instituted for the especial encouagement of the arts of design. And amongst the laws of this Institution it is declared that, 'There shall be a Professor of Architecture who shall annually read six lectures, to form the taste of the students, to interest them in the laws and principles of composition, to point out to them the beauties or faults of celebrated productions, to fit them for an unprejudiced study of books, and for a critical examination of structures.'

The duty here imposed on the Professor of Architecture is no inconsiderable task, yet I have ventured to meet the frightful responsibility of this arduous and, to me, painful situation from my love for the art and regard for this Institution, and from another motive, perhaps equally powerful, namely that no other member would encounter the difficulties.

The student in architecture has also many and great difficulties to encounter, but they may be all overcome by reasonable assiduity, and proper application. He must be conversant in arithmetic, geometry, mechanics, and hydraulics; and [be able] to explain his ideas with clearness, correctness, and effect. He must be familiar with the use of the pencil; he must not be satisfied with geometrical delineations, for the real effect of a composition can only be correctly shown by perspective representations. The student must therefore be fully acquainted with the theory and practice of perspective, and be able to sketch his ideas with facility and correctness.

Our late ingenious Professor of Architecture, Mr. Sandby, particularly recommended to the young student to accustom himself to draw after real buildings and natural objects, without rulers and compasses, that he might acquire a facility of drawing by hand, and correct that hardness that generally predominates from the habit of using rulers and compasses only. By this method of study, the young artist would at the same time observe the natural effects of light and shade, in the various tints produced by different objects. Such was the advice of Mr. Sandby, a man whose name must live in his works, when the many amiable qualities of his mind shall cease to be remembered.

> 'Tread lightly on his ashes ye men of
> 'Genius – for he was your kinsman;
> 'Weed his grave clear, ye men of
> 'Goodness – for he was your Brother.'[1]

The student must also draw the human figure with taste and correctness, and have a competent knowledge of painting and sculpture. He must read much and reflect more. He must live in the bosom of his profession, for architecture is too coy a mistress to be won without constant attention.

The mind of the student should be impressed with the absolute necessity of close and unremitted attention, of deep and indefatigable research. From earliest youth not a moment must be lost by him who desires to become a great artist. He who seeks superior excellence must search deeply into the motives and principles which directed the minds of the great artists of antiquity who produced those works of elegant fancy, of true refinement, and correct taste, which have done so much honour to the human mind and will ever be the admiration of enlightened people of all ages and of all countries. By referring to first principles and causes, the uncertainties of genius will be fixed, and the artist enabled to feel the beauty and appreciate the value of ancient works, and thereby seize the spirit that directed the minds of those who produced them. We must be intimately acquainted with

[1] Laurence Sterne, *The Life and Opinions of Tristram Shandy, Gentleman*, 6 vols, London 1773, vol. v, p. 11 (GL 28H).

not only what the ancients have done, but endeavour to learn (from their works) what they would have done. We shall thereby become artists not mere copyists; we shall avoid servile imitation and, what is equally dangerous, improper application. We shall not then be led astray by fashion and prejudice, in a foolish and vain pursuit after novelty and paltry conceits, but contemplate with increased satisfaction and advantage the glorious remains of antiquity.

I must caution my young friends not to expect great novelty in these discourses, for novelty and flights of fancy, however amusing, cannot be very instructive, and of course not very conducive to the main object of these lectures which is to trace architecture from its most early periods, and to show its various stages of progressive improvement in different countries, as well as the causes thereof. And this investigation, I trust, will show why most nations have adopted different ideas of building, depending on climate, materials, and other considerations, and that architecture does not owe its origin to any particular people, which I hope will be fully established from the descriptions of ancient writers, the remains of antique buildings, and the works of the great restorers of art, in subsequent times.

I shall endeavour to make the works of the ancients and moderns familiar to the student, and point out to him, according to the best of my judgement and experience, their beauties and defects, and the various means by which the great masters of antiquity attained such superior excellence and such high pre-eminence. The mind of the student cannot be too much impressed with the intimate connection between architecture, painting, sculpture, and decorative landscape gardening. From the study of these arts, architecture derives much of its powerful effect, mighty grandeur and fascinating scenery. By these means I hope the student will not only be enabled to pursue his studies with full confidence, on sure and rational principles, but that the latent seeds of genius will be called into action, and the power of architecture to affect the mind be fully known and felt, as well as its use to civilized society.

I trust that all defects, whether in language and arrangement, or in the drawings and models, will be imputed, not to any want of zeal and application on my part, but to the difficulty and extent of the task I have undertaken. And if in the endeavour to discharge the duties of my situation, as pointed out by the laws of this Institution, I shall be occasionally compelled to refer to the works of living artists, I beg to assure them that, whatever observations I may consider necessary to make, they will arise out of absolute necessity, and not from any disposition or intention on my part merely to point out what I may think defects in their compositions. For no man can have a higher opinion of the talents and integrity of the architects of the present time than myself, nor be more anxious on all occasions to do justice to their merits and fair pretensions to fame.

Architecture from the earliest periods has engaged the attention of mankind, nor can this be wondered at when we see how necessary and how useful it is. It protects us from the shivering lightnings and furious tempests, from the heats of summer and the severities

of winter; and by its powers the comforts, conveniences, and refinements of life are increased.

Architecture likewise defends us from ambitious neighbours; it instructs us also in the art of building ships, by whose assistance we are enabled, in defiance of winds and waves, to penetrate into the most distant parts of the globe, and to enrich our country with the various productions of other climes.

Hence we may derive the origin of civil, military, and naval architecture.

Civil architecture, which alone will be the subject of these lectures, is both essential and ornamental; it is partly an art, and partly a science; it consists of the theory and practice of building.

The term building at first presents to the mind little more than the idea of something merely mechanical, to be done by line, level, and compass. But this is only the first impression. When we penetrate into the recesses of this noble and useful art we are equally surprised and delighted; we soon perceive that its leading principles are founded on the immutable laws of nature and of truth; that in many of the great works in architecture there is a sublimity of thought, a fertility of invention, and a boldness of design, which exalted minds alone could produce; whilst the variety, elegance, and characteristic propriety of the ornaments evince the most solid judgement and the most correct taste; indeed, the harmony and superior charms that we see in many of the works of antiquity almost realise the fabled power of Amphion's lyre.[2]

If through the medium of those works we consider the subject, we shall then do justice to the wonderful powers of architecture and place it in the first rank of refined art and exalted science.

Nature in every country indicated the necessity of shelter, and if, according to some writers, we suppose mankind in their most early and uncivilised state divided into different classes, namely, hunters, fishermen, shepherds, and husbandmen, each of these would have different ideas of comfort and convenience. And if we consider the local circumstances of the materials of different places, we shall easily see why the architecture of some countries resemble (although very remote from each other) whilst in others it is totally dissimilar.

The hunter, having pursued his game, takes for his resting place the first cavern that presents itself, so does the fisherman also; the shepherd, who attends his flock from place to place, takes with him his tent of skins; the husbandman alone is fixed: he must watch the seasons, wait his harvests, and gather the fruits of his industry. The husbandman therefore requires a permanent dwelling for himself, and fit places to receive his stores. Thus we have the first use of the cavern, the tent, and the hut. To these different modes

[2] In Greek mythology, Amphion was a harpist of such skill that the stones of the walls of Thebes were drawn into place by his music.

of sheltering mankind we owe most of those marked characteristic distinctions to be found in the works of India, of China, of Egypt, and Greece.

In all countries natural caves in the rocks exist; but, as nature did not always keep pace with the population of mankind, and more habitations became necessary, men themselves then formed caves in the rocks similar to the models which nature had provided for them; for man is such a creature of habit that, even when he quitted his caverns and shady retreats, and formed habitations in the open fields, he still worked from the same prototypes, and from them formed dwellings of the most simple kind.

Man, by nature a social being, can only exist in society; we can therefore readily suppose that he soon added hut to hut, and tent to tent, and that from such feeble beginnings arose towns and cities.

From ancient writers we can form some idea of the nature of the dwellings of which the first towns and cities consisted. Diodorus tells us that the early dwellings were formed chiefly of reeds and of wood.[3] According to Strabo,[4] the primitive people having felled a quantity of trees and enclosed therewith a large wood, they raised a number of huts for themselves, and hovels for their cattle.

Cæsar, in his Commentaries, speaking of the ancient Britons, says: a thick wood surrounded with a ditch and rampart was by them called a town.[5] Vitruvius tells us that in the first ages men lived in forests, woods, and caves;[6] and in Genesis we are told that Abraham and his successors followed a pastoral life, and lived in tents.[7]

The first city we read of was built by Cain, and probably consisted of little more than huts and tents of the most simple kind. The first house we have on record was erected by Jacob; after this we are told of the city of Babel, built with bricks; and in the sacred writings also we read of the superb and mighty city of Nineveh, which was so extensive in the days of Jonah that its streets were in length three days' journey.

Semiramis likewise founded the proud city of Babylon which was surrounded with lofty walls having gates of brass, and being enriched with public buildings of the most costly and extensive kind.

Among the great works of antiquity the Mausoleum of Ninus is spoken of as an edifice of almost incredible extent, and as rich as art, unfettered by expense, could make it. But this building, however magnificent, was far surpassed by the mausoleum, mentioned by Vitruvius, built by Artemisia to the memory of her beloved husband Mausolus, which building, from its great superiority over all others, gave the name of mausoleum to all such edifices.

[3] Diodorus Siculus, i, xliii, 1–5.

[4] Strabo, iv, v, 2.

[5] Julius Caesar, *De bello Gallico*, v, 21.

[6] *De architectura*, ii, i, 1–3.

[7] *Genesis*, xi–xxv, *passim*.

Pliny the elder also speaks of this proud edifice in high terms, and describes it pretty much at large in the 36th book of his Natural History.[8] This would be a fine subject to exercise the mind of the artist, and I therefore refer my young friends to Pliny's description.

Of the great and stupendous buildings with which Nineveh, Babylon, Troy, and many other mighty cities of antiquity, were once adorned; of the great and numerous works ascribed to Sesostris; the immense Labyrinth of Egypt, the Lake of Moeris, with its magnificent mausoleum, and mighty pyramids, nothing remains of their ancient splendour, not even a stone or inscription, to point out their situation. The palace of Priam, also, with its pavilions and domes, lives only in Homer's song; nor have the brazen walls, the silver pillars, and the golden doors of the palace of Alcinous been able to withstand the ravages of time and the enmity of rival nations. All is buried in the silent grave.

> 'Jam seges est ubi Troja fuit resecandaque falce
> ' ruinosas occulit herba domos.'[9]

It is to the ancient historians and poets that we are indebted for all we know of these great works, as well as of the wonderful costliness and surprising magnitude of many others.

Of the accuracy of their descriptions we might sometimes doubt, if we had not still remaining such very extensive ruins of some of the works of ancient times in India, Persia, Syria, and Egypt, as well as in Greece and Italy. Of these numerous and mighty ruins, perhaps those of Palmyra and Baalbec will be sufficient for my present purpose, which is chiefly to impress the minds of the young students with the utility and necessity of consulting ancient authors.

In these drawings (copied from Wood and Dawkins)[10] are shown the remains of many magnificent temples, colonnades, and other buildings crowded together, most of them of prodigious magnitude, of costly materials, and expensive execution. These mighty ruins do not rest on description; of their existence we can have no doubt, and surely they will justify us in giving full credit to the existence of many of those wonderful and mighty structures which we only know from the descriptions of ancient writers.

Among the various stupendous works of the ancients, the prodigious excavations in rocks and mountains demand our attention; many of them are of such a remote antiquity as baffle every attempt to ascertain the period of their formation. We know indeed that the custom of forming such excavations, whether as dwellings for the living, depositories for the dead, or as temples to the gods, prevailed in countries remote from each other, and moreover in nations separated by great differences of government, customs, climate, and religion.

[8] Pliny, *Historia naturalis*, xxxvi, 30–31.

[9] Ovid, *Heroides*, I, 53, 56.

[10] Robert Wood, *The Ruins of Palmyra*, London 1753, and *The Ruins of Balbec*, London 1757.

The excavations in India claim great attention; those of Elephanta, Salsette and Ellora produce the most lively sensations, sometimes by the simplicity of their forms, often by their magnitude and grandeur, and sometimes by their similarity to the works of the most polished nations in the most enlightened times.

The cavern of Elephanta is a square excavation of about 120 feet, and 15 feet high. The ceiling is flat, supported by immense pillars and decorated with colossal sculpture. The quantity, the masses, the gloom, the breaks of light and shadow, must altogether produce a most aweful and sublime effect.

The excavations at Salsette are even considerably larger and more imposing than those of Elephanta. A great number of immense pillars, with bases and capitals richly sculptured, support the vaulted roof of this prodigious work, and also the mountain over it. In the plan of this excavation we see a great similarity to the forms used in Roman buildings.

But these excavations fall very short indeed of those in the mountains near Ellora. We there have a town of them of prodigious grandeur and elegance. They are in general crowded with columns and colossal sculpture, all cut out of the solid granite rock. In these works, whether we consider the great labour and difficulty of execution, the symmetry and variety in the plans, the breadth of light and shadow, the aweful gloom, the happy and powerful combination of forms, we are highly interested, and the effect of the whole almost surpasses the utmost extent of our imagination.

The pagodas and many other great buildings in India are also astonishingly curious. They are in mass, figure, and extent equal to the buildings of the Egyptians; nor can this be wondered at, for in general they owe their origin to the same causes.

These works are proper subjects for the contemplation of the artist who will from them enlarge his stock of ideas.

I shall therefore refer him to the superb views of India now publishing by a member of this Institution,[11] regretting however that we are not yet in possession of geometrical drawings of the parts from actual mensuration, without which no correct judgement can be formed of their true value to the architect.

In the mountains near Persepolis are likewise many sepulchral chambers cut out of the solid rock.

I have given a drawing of one of them from Le Brun,[12] which is decorated with pillars whose capitals are composed of busts of bulls surrounded with a large quantity of allegorical sculpture.

[11] Thomas and William Daniell, *Oriental Scenery*, 6 vols, London 1795–1801.

[12] Soane made great use of the author he knew as Le Brun, in fact Cornelis de Bruyn (1652–1726 or 1727). On 23 May 1806 he bought copies of his *Voyage au Levant* (Paris 1714, translated from the Dutch edition, Amsterdam 1698), and *Voyages de Corneille Le Brun par la Moscovie, en Perse, et aux Indes Orientales* (2

The sepulchral chambers at Termissus are also cut out of the solid rock. Two of them in particular attract our attention, whose fronts of Grecian design are characteristic of their destination.

Before I quit the subject of excavations, I shall produce a drawing of one of those at Corneto, the early works of the Etruscans, for which I am indebted to a member of this Institution.[13] These works are particularly interesting from their resemblance to some of those already spoken of, and likewise from the decorations of monochromatic paintings like those on some of the Etruscan vases. One of these excavated chambers is of a quadrangular figure with a flat roof supported by four massive pillars finished with capitals, composed of a few simple parts with painted ornaments. On the wall is a deep frieze enriched with paintings. The roof is curious from being formed by beams into panels with square risings like those in the ceilings of some of the Greek temples.

At Palazzolo is a monument of the elder Tarquin cut out of the solid rock, in which some have imagined they discovered in the roof thereof a groined arch.[14] I shall probably speak of this monument as well as those at Corneto more at large in a subsequent lecture.[15]

Egypt abounds with natural excavations from which the Egyptians seem to have taken their taste as well as the first ideas of their building; and we may also observe that even in their subsequent and most splendid works they never lost sight of their primitive model. The cavern is perpetually the type of their architecture, and from the extensive remains of their works as represented by Norden, Pococke, Denon, and other travellers, its progress may be traced from the most simple constructions to the highest degree of excellence that the Egyptians ever attained.

The temple at Syene may be taken as a work only one step removed from the primitive cave. It is of the most simple kind, consisting of a porch with a single row of pillars, and two rooms behind them.

At Esna is another work of a more enlarged disposition. The porch is composed of two rows of pillars, and the interior has a greater number of divisions than the building at Syene.

At Edfu is a disposition yet more enlarged: the porch has four rows of columns with

vols, Amsterdam 1718), which contained over 320 plates. The *Voyages de Corneille Le Brun* seems subsequently to have passed out of Soane's possession, for he bought a replacement copy on 3 November 1814.

[13] It was probably Flaxman who gave Soane the drawing of the tomb at Corneto. In an allusive note in SM Archives MBiii/10/1, f. 19, Soane referred to this tomb as well as to the cave at Wookey Hole, Somerset, and also reminded himself to 'Speak to Mr Carter [presumably the antiquarian, John Carter] respecting chapels &c in rocks'.

[14] This rock tomb was traditionally supposed to be that of Consul Gnaeus Cornelius Scipio Hispallus (died 176 BC).

[15] Soane did not cite Corneto or Palazzolo by name in subsequent lectures.

a spacious area before it. These three buildings may be considered as so many examples of the earliest efforts of the Egyptians.[16]

At Luxor is a temple [of Amenhotep III] far exceeding the buildings already spoken of; it is a wonderful proof of the perseverance and industry of the Egyptians, and also of the sublimity of their ideas. At the entrance is a hall of immense grandeur, with a flat ceiling supported by an immense quantity of pillars. Beyond this hall is a peristyle whose columns of prodigious diameter lead to an open court. In the front of this court is the porch of the body of the temple with four rows of columns in depth, and double colonnades on each side. There are also other rows of columns in the part before you reach the sanctum, wherein was placed the statue of the god.

Herodotus, who travelled over Egypt, and whose accuracy is generally admitted, speaks of a temple to Diana in the city of Bubastis as a most uncommon and beautiful edifice which he describes as being disposed in a manner very unlike any of those he had before seen.[17] It was placed in the middle of an enclosed area of 625 feet square, surrounded with magnificent porticoes, and the walls richly adorned with sculpture. From the description of Herodotus we may presume that the temples of Jupiter Serapis in Pozzuoli, of Isis in Pompeii, and of the Sun in Palmyra, were very like in their form and disposition to that of Diana in Bubastis.

But grandeur and enormous masses were not confined to the architecture of their temples and palaces. Their sculpture was generally colossal; nay, even their obelisks, apparently only for decoration, were frequently of prodigious and gigantic dimensions. Of the origin, figure, and general application of obelisks, as well as of the amazing powers used in moving them, I shall have occasion to speak at large hereafter.[18] The pyramids, likewise, from their number and prodigious magnitude, claim no small degree of our attention, and admiration. Their forms, although of the most simple kind, produce the greatest variety of effect. They are sometimes conical at their bases, but in general square.

At Cairo are three pyramids of surpassing extent, placed near each other. The largest of them is about 700 feet at its base, and about 500 feet high, gradually diminishing to a flat space at the top, of some few feet only in extent, probably intended to receive a statue. But notwithstanding this flat space, the pyramid, from its great height, seems to finish in a point. This amazing structure occupies a space of about eleven acres which is almost as large as the whole area of Lincoln's Inn Fields. Three hundred and sixty thousand men are said to have been engaged seventy years in erecting this enormous pile. Indeed, the pyramids alone would have been sufficient to immortalize the sovereigns of Egypt, and to have proved the ardent and successful desire of the Egyptians to transmit their names to

[16] Ptolemaic temples were, in Soane's day, thought to be of a much earlier period.

[17] Herodotus, ii, 137–138.

[18] Lecture iv, pp. 105–6, and xii, pp. 257–7.

posterity. Such indeed is the solidity of the public works in general of the Egyptians that neither time nor the convulsions of nature, nor the revolutions of empires have destroyed them, nor the power of merciless and extirpating conquerors removed. Many of their prodigious works still exist, and will exist, in aweful ruin and majestic state to the last moment of recorded time, even to that general convulsion of all things when, in the language of our immortal bard,

> 'The cloud-capt Towers, the gorgeous Palaces,
> 'The solemn Temples, the great Globe itself –
> 'Yea, all which it inherit shall dissolve.'[19]

It is impossible not to be impressed with the grandeur and magnitude so peculiar in the works of the Egyptians in general, but particularly in their sacred buildings: the extensive approaches to some of their temples, formed by avenues of colossal sphinxes and other animals, the long unbroken lines of the architecture, the large quadrangular pillars of gigantic dimensions placed near each other in single, double, triple, and sometimes in quadruple rows, always supporting flat roofs and forming deep recesses. The extent of these structures tires the eye, their grandeur and unaffected simplicity fire the imagination, whilst the varied play of light and shade, bursting through different parts in every direction, and occasionally falling upon the colossal sculpture on the walls, must always produce the most powerful effects on the beholders. But although we may be dazzled and surprised by the magnitude and solidity of these works, yet we are by no means satisfied; for, instead of those varied and characteristic modifications, instead of that beauty and variety which grow out of correctness of design, instead of the graceful and harmonious disposition of parts so visible in Grecian works, we have in these only uniformity and tiresome monotony in the general forms as well as in the details. Nor can we be surprised at this when we recollect that the principal features of the Egyptian architecture were taken from caverns formed in the rocks, to which they adhered so rigidly that even when round pillars were used internally, as they sometimes were decoratively (not constructively), they were rounded for use, and not for beauty. Nay, even when we see pillars in the fronts of their temples they are always confined by massy piers at the angles, like those before shown in the front of one of the sepulchral chambers at Termissus.

The essential qualities of Egyptian works are prodigious solidity and wonderful magnitude. These are the leading objects and prominent features in their architecture and sculpture. Indeed, in all their works everything seems calculated for eternity; and if solidity,

[19] Soane was fond of Prospero's words from Shakespeare's *The Tempest*, quoting them again in Lecture viii, and even appending them to Gandy's remarkable painting of the Bank of England in ruins, 'Architectural Ruins – a vision', when he exhibited it at the Royal Academy in 1832 (see the Royal Academy Exhibition Catalogue, London 1832, p. 42).

quantity, mass, and breadth of light and shadow, were the only requisites in architecture, we should find all that could be desired in the works of the Egyptians.

If I have been correct in describing the characteristic and essential features of Egyptian architecture, what can be more puerile and unsuccessful than the paltry attempt to imitate the character and form of their works in small and confined spaces? And yet, such is the prevalence of that monster, fashion, and such the rage for novelty, that we frequently see attempts of this kind by way of decoration, particularly to many of the shop fronts of the metropolis.[20] Nor does this evil of applying without recurrence to first principles end here. The Egyptian mania has spread further: even our furniture is decorated with the symbolical forms of the religious and other customs of Egypt.

Grecian architecture, which now claims our attention, owes its origin and perfection to causes very different from these already spoken of. The Greeks were the fathers of science and of art. Their climate, their laws, their mode of life, all contributed to gain them a superior rank in the higher walk of intellect. The principles of their architecture must be sought for in other prototypes than in those which gave birth to the great works of Egypt, India, and Persia. Heaviness and monotony must now give place to elegant conceptions and correct conclusions drawn from philosophical reasonings. The Greeks, it must be admitted, cultivated architecture so successfully that they left to succeeding ages only the humble task of imitating their works, works which will be ever admired but perhaps never be equalled.

Greece abounded in timber proper for building, more than in stone and marble; and if we examine their early works we shall see what effect materials had on their manner of building.

Their first dwellings were doubtless of the most simple kind, probably a few trees, conical on the plan, placed in the ground, reclining against each other, and meeting at their tops in a point, with merely a space left for entrance, and the rest of the outside covered with clay, leaves, rushes or reeds. Such most likely, was the extent of their first essays, not unlike what we see in our hop grounds wherein the poles (at one time of the year) are set up preservation, and occasionally used for shelter.[21]

The conical figure being found inconvenient, other insulated huts, whose ground plan formed a square or parallelogram, soon succeeded. A few trees, placed perpendicularly in the ground, and others laid across, formed the outsides and roof, and, like the former,

[20] George Underwood, Soane's pupil from 1807–15, made a lecture illustration for Lecture I, apparently not used, of the neo-Egyptian *Courier* newspaper office in the Strand (SM Archives, Drawer 27, set 6, no. 11), reproduced in Celina Fox, ed., *London – World City 1800–1840*, New Haven and London 1992, pl. 294.

[21] In a rare manuscript note in his own hand in this fair version of the lectures, Soane here added in the margin: 'add a description of Fishermen's Huts at Walmer'. It is attractive to find his interest in the origins of building extending from the primitive hut to modern fishermen's huts and hop shelters. The note was probably added in 1812 when he was making designs for Lord Liverpool at Walmer, Kent.

were covered with reeds and clay. The roof being laid nearly flat soon admitted the weather. This inconvenience once felt, the active powers of the human mind soon suggested the idea of a more elevated or pointed roof, in which the origin of the pediment, as well as other constituent parts of the succeeding architecture of the Greeks, is easy to be seen (pl. 2).

Thus huts were formed sufficiently capacious to receive a few persons; but, as families became larger, the buildings were necessarily extended, although the same manner of constructing them continued. The horizontal beams, in particular, being of course considerably lengthened, curved downwards and threatened ruin. A row of posts or supports however, placed from front to rear, dividing the entire space into two equal parts, removed the defect and gave security to the inhabitants. This mode of construction probably suggested the idea of that particular manner of using columns to be seen in one of the temples at Paestum, and in an Egyptian temple, of which I shall have occasion to speak hereafter.

A row of pillars dividing a large room into two equal parts might be necessary for strength and security, yet the inconvenience and awkwardness of such an arrangement must have been soon seen and felt; and the transition to another, namely that of two rows of pillars dividing the room into three equal spaces, would soon follow. Three equal spaces were a great improvement on the first idea, but they did not give all the advantages required. Another alteration therefore succeeded by making the centre space considerably larger than the sides. This gave the idea of those beautiful peristyles in Grecian and Roman buildings hereafter to be spoken of.

By increasing the dimensions of these early buildings we have seen one difficulty arise out of the great length of the horizontal beams, which has been removed by rows of posts placed under them from front to rear; but another difficulty arose from the increased magnitude of these habitations. The rafters, as well as the horizontal parts, were increased in length, and therefore wanted supports. These supports were placed immediately over the others, under the beams, and probably gave the first indication of pillars placed upon pillars; and in this early work we perceive the reason why the Greeks, faithful to their primitive model, made the upper pillars in the hypaethral temples so very short in proportion to those immediately under them. Of this disposition I shall have occasion to speak more at large hereafter.

Thus much for the origin and progressive improvement of the simple insulated hut. If we now suppose it surrounded with a large area for convenience and security, as well as to determine the extent of each man's occupancy, and further suppose this space enclosed with a hedge or wall, we shall then have the progressive state of primitive buildings.

From such simple ideas and almost imperceptible changes we owe all the beauty, scenery, and enchantment in the forms of the great Grecian edifices whose stately structures, whose elegant forms and magnificent appearance, have been for ages the delight,

wonder, and admiration of the most refined minds of all countries, and will continue to be so long as any knowledge of pure art remains, or superior intellect is cultivated and respected.

It cannot however be supposed that Grecian architecture assumed at once the perfection which it attained in the time of Alexander the Great. There must have been many progressive steps between the primitive buildings and the Temple of Minerva in the Acropolis of Athens, the Temple of Theseus, and such like structures.

Yet the progress from the hut to the elegant structure must have been rapid, for, to the honour of architecture, it should be remembered that there was no town in Greece that had not some public monument frequently constructed with the most costly materials, and adorned with ornaments of the most exquisite taste and correct fancy. These superb monuments, although we must not suppose all of them of equal importance and extent with the temples just mentioned, were, when in their perfect state, a source of glory to the Greeks; and their invaluable remains serve us for models and cannot fail of exciting the most enthusiastic admiration. In these ruins we perceive those elegant forms and beautiful combinations which the most solid and correct judgement and the most refined taste could produce.

How much it is to be regretted that Wheler and Spon were not architects.[22] They visited Greece more than a century ago when many buildings were in existence that are now entirely destroyed, and others were then of course in a much less dilapidated state. It is to the laborious accuracy of the classical Stuart and the indefatigable Revett,[23] and their associates, that we are indebted for our knowledge of the remains of Grecian architecture. Since their time, I regret to say, many of those glorious ruins have been entirely destroyed, some by the barbarous inhabitants of Greece, for ignoble purposes, and others, shameful to relate, have been first mutilated by mistaken zeal, and the precious fragments afterwards conveyed to foreign climes.

When the Grecian states lost their liberty and became colonies to their successful rivals, the Romans, they likewise lost in a great degree their love for the arts, but not entirely so long as the empire of their conquerors continued. Indeed, Hadrian found in Greece artists that would have done credit to the best times of Athens and Corinth.

The buildings of ancient times show the splendid effects of architecture, and its power to affect the mind. They also show the prodigious attention paid to the art, an art of all others the most useful, the most costly, and the most laborious. The influence of architecture on the minds of men appears to have been general in all ages. Not only Alexander, Pericles, Augustus, Hadrian, and such wise princes, felt its beauties and powers,

[22] Jacob Spon and George Wheler, *Voyage d'Italie, de Dalmatie, de Grèce et du Levant . . . 1675 et 1676*, 3 vols, Lyon 1678. Soane did not own this but its translation as *A Journey into Greece by George Wheler, Esq., in company with Dr Spon of Lyons*, London 1682.

[23] James Stuart and Nicholas Revett, *The Antiquities of Athens*, 4 vols, London 1762–1815.

but even the minds of Domitian and Nero were so occupied with it as to be frequently turned from the pursuit of their brutal and diabolical purposes. Indeed, their disgraceful and disgusting scenes of depravity were suspended whilst they erected works of such magnitude and public utility as would have done honour to the taste of Pericles or to the policy of Augustus.

When we reflect on the innumerable and mighty monuments which history informs us the industry of men have raised in all parts of the globe, we are anxious to inquire into the causes that have operated so generally on the minds of men to make such sacrifices to adorn their countries. We are filled with enthusiastic emotion at the amazing time and expense that must have been consumed, with the millions of money that must have been expended, together with the constant exertion of body and mind to produce such prodigious works, works whose very ruins fill us with respect and veneration for their godlike founders. And if the ruins only of a small number of these mighty works produce such emotions, what would the sight of Nineveh, Babylon, Troy, Athens, and Rome have produced when in their most perfect state?

If the noble and useful arts of engraving and printing had been known to the Greeks and Romans, what treasures we should now possess. The great works of antiquity would have been familiar to us; we should have had the invaluable treatises on architecture of those great men whose names alone are now all we know.

Vitruvius would not have been left to his commentators: we should have had his full thinking. Alas! this is in vain. Let us therefore profit from the labours and zeal of those who have endeavoured to preserve and make us acquainted with the precious fragments of antiquity; let us tread in their paths; let us from their labours endeavour to discover the principles that directed the great artists of antiquity; and when we have no remains of their splendid and glorious works to direct our studies, and to animate our minds to exertion, let us consult the poets, historians, and orators, wrecks of whose works have happily reached us. From them we shall collect great and useful information such as will enlarge and exercise the minds of real artists, notwithstanding what has perished of ancient works, from various causes; enough yet remains, if we have industry and application, to make us acquainted with the grand, sublime, and beautiful in architecture; enough yet remains to enable us to restore the art to at least a large portion of its ancient glory.

Yet with all these opportunities and facilities, many and very great sacrifices must be made to acquire superior excellence, which I trust the young artist will readily submit to, when he recollects the honours that have ever attended high acquirements, and that it was by the possession of great talents and probity that Dinocrates became the constant attendant on Alexander, and Apollodorus on Trajan. And to the eternal honour of our art let it be remembered that Semiramis made the plans and assisted in the execution of many of her great works, and that Pericles, Hadrian, and many other great princes of ancient times not only patronized and loved the arts but many of them were themselves artists. Indeed, in all

ages and in all countries architecture has been frequently practised and always encouraged by the most powerful princes and by the most able statesmen.

Let the young artist treasure up in his mind the advice of the father of architects, namely, that he prefer a little with a good name to abundance attended with infamy. That he be docile and not intent on gain; that he wait until he be sought for, and not by intrigue attempt to grasp at everything; that he be extremely careful as to the expense of his works, and keep in remembrance the Ephesian law by which, when an architect received the charge of a public building, he was obliged to deliver an estimate of the expense, and to assign over his goods to the magistrates until the work should be completed. If the expense agreed with the estimate he was rewarded with high and distinguished honours. If it did not exceed more than a fourth part, the excess was added to the estimate, and supplied by the public, but if more than a fourth part was expended, his goods were most justly seized to make up the sum.

In this country we have long had too much reason to complain of mechanics of every description from the bricklayer to the paper-hanger being identified with architects; and, of what is equally fatal to the advancement of the art, that architects, who ought always to be the intermediate persons between the employer and the employed, lose that high distinction and degrade themselves and the profession by becoming contractors, not only in the execution of their own designs but like-wise those of others. Let our young artists follow closely the precepts of Vitruvius: they may then reasonably expect that these and many other such evils will cease; that none but men of talents will be sought for; that their names will be transmitted to posterity; and that our great public and private works will no longer be entrusted to ignorant mechanics, nor our streets and public places disgraced by the errors of mercenary men, nor by the mistaken and ill-applied fancies of speculators, but instead of their abortions such edifices will be raised as would have done honour to Greece and Italy in the highest periods of their splendour and glory.

This Institution will, I hope and trust, ever stimulate the young artists to high emulation and inspire them with a true regard for the arts; and when we recollect the elegant fancy and classical purity displayed in many of those works for which premiums have been adjudged, as well as the great and progressive improvements so very visible in our annual exhibitions, we may with the poet reasonably expect that

'The time, not distant far, shall come
'When England's tasteful youth no more
'Shall wander to Italia's classic shore,
'No more to foreign climes shall roam
'In search of models better found at home.'

LECTURE II

∽

Mr. President, – In the first lecture, the origin of architecture and the great works of different nations until the time of the entire subjugation of the Grecian states by the Romans were treated of, and the subjects were elucidated by drawings where any remains of the works spoken of existed, in order to fix the attention of the students and to make the stronger and more lasting impression on their minds. Drawings of buildings, however slight, give clearer and more permanent ideas than can be obtained from the most detailed, correct, and elaborate descriptions; on most occasions drawings of the objects are as much superior even to the best descriptions as models are superior to drawings.

We must now follow the arts into Italy. Rome, however, in her early ages gave no proofs of knowledge or regard for the liberal arts. In the first six hundred years A. U. C. even their temples were neither larger nor more magnificent than the private houses of the citizens. The Temple of Jupiter Feretrius,[1] one of their principal divinities, built during that period, was only fifteen feet square; and, according to Pliny, almost another century passed away before marble columns were used in any of the public edifices.

Conquest and plunder alone engaged their minds. The arts of war were all the arts they thought of: indeed, so little were the fine arts known or felt by the Romans that even when Mummius sacked Corinth and sent its spoils to Rome, he threatened those who had the care of the pictures and statues that if any were lost or purloined, they should produce him others. But when all Greece was completely reduced into a Roman province, architecture soon entered into the policy of the Romans, who,

'Inspired by the study of the fine Arts
'That civilise mankind'

[1] Soane derived the measurements of the Temple of Jupiter Feretrius (not Teretrius, as in Bolton's transcription, *Lectures*, p. 26), on the Capitoline, from Dionysius of Halicarnassus, *The Roman Antiquities*, ii, 34, 4, which he owned in a (now lost) French edition, *Les antiquités romaines*, 2 vols, Paris 1723.

caught from the Greeks the passion for erecting magnificent buildings for the honour of their gods, for the glory of their city and for the accommodation of their citizens. Thus, animated with the laudable design of transmitting the Roman name through the medium of architecture to the latest posterity, 'Cities rose on Grecian models formed,' and so zealously was this object pursued that in the time of Augustus Rome, by the aid of Grecian architecture, became a city of marble.[a]

The immediate successors of Augustus, feeling the importance, and having likewise the great advantage of Grecian artists, continued to embellish Rome and other parts of Italy with the most splendid monuments of their power.

Nothing could surpass the splendour of the public and private buildings of the Roman emperors. They were all crowded with the most exquisite sculpture and painting. Nor can this be wondered at when it is recollected that Egypt and Greece had been plundered of everything valuable that could be removed for the embellishment of Imperial Rome. We must also recollect the mighty resources of that extensive empire as well as the anxiety of this powerful people to surpass all other nations in works of utility and magnificence.

Nor were the Romans satisfied with embellishing Italy. They erected trophies and superb buildings of every kind in all those countries which had felt the power of their arms, hoping to familiarize the conquered nations to their new masters by introducing among them Roman works and Roman manners; and perhaps it is to such influence, and to such motives, that we are indebted for those great works the remains of which are yet to be seen in most of the countries which acknowledged the empire of Rome.

But of the Temple of Solomon at Jerusalem, however, so completely have the prophecies been fulfilled that not one stone is left upon another. In the sacred writings and in the works of Flavius Josephus[2] we find some partial, obscure, and contradictory descriptions of this famous structure.[b] From these data, Villalpandus, a learned father of the sixteenth century, has in three mighty folio volumes restored the whole building with all its

[a] Indeed Augustus is said to have boasted that he found the seat of empire a city of bricks, and that he made it a city of marble.

It must be added that their love for building continued in full splendour until the time of Diocletian. Taste, it is true, had declined long before his reign, but the passion for large and magnificent buildings remained, of which his palace at Spalatro and his baths at Rome are striking proofs. It is with pleasure we read of their great public and private works, their superb temples, their theatres, amphitheatres, triumphal arches and palaces, their villas, more like towns, their aqueducts and extensive baths, calculated not only for the purpose of bathing and exercises of every kind. They also contained libraries of books of all descriptions as well as spacious porticoes and magnificent halls wherein the learned read their compositions, harangued, disputed, and instructed the Roman youth.

[b] We are told that the whole design of this fabric was revealed to Solomon in a dream, and we are further informed that he entrusted the execution thereof to Adonisam, the chief architect of Hiram, King of Tyre.

[2] Soane owned two editions of the 'Early History of the Jews' by Flavius Josephus (AD 37–*c.* 100) in English translations published in 1737 and 1814, and also a fifteenth-century MS of the same text, *Histoire des juifs.*

most minute parts and decorations of every kind. The entire ordonnance of this wonderful building he describes as Corinthian. If the zealous father be correct in his conjecture, Callimachus must resign his long established claim to the invention of the Corinthian capital. This will not be easily admitted, at least by those whose minds have not been formed in the school of Villalpandus.

Notwithstanding all the light thrown on the subject by the enthusiasm, by the elaborate researches, great zeal and profound erudition of Villalpandus, I should doubt the possibility of tracing the most minute part of the plan and superstructure of this once mighty edifice with any degree of certainty; much less of delineating the appearance of the entire temple in all its glory. Nay more, I cannot conceive it possible for two persons, equally gifted and equally anxious in their inquiries after truth, to compose from all the descriptions and aids now to be had even a capital of the order without deviating from each other in many essential and material parts.

Many ingenious men, visionary and enthusiastic like Villalpandus, have exercised their talents in attempting to give an idea of the Temple of Solomon in its pristine glory; but having no other data beyond those Villalpandus possessed, however much we may feel inclined to praise their ingenuity, we can only consider their works, like those of Villalpandus, merely as flights of fancy, the offspring of heated imaginations. The Temple of Solomon is said to have surpassed in magnitude, splendour, and beauty, every building that preceded it. Nor can this be wondered at when we learn from Holy Writ that the whole design was revealed by the Almighty Architect of the Universe, to that great and wise monarch in a dream. From all these circumstances the want of correct information respecting this wonderful building must be matter of serious regret, as this work alone would have been sufficient to guide us in our inquiries; but as we have no remains of this great work we must search the ruins of the great works of the Greeks and the Romans for information in whatever relates to architecture.

Happily of the public and private works of the Greeks and Romans enough is yet remaining to form our taste, to assist us in constructive knowledge, to enable us to appreciate their magnificence, and in many cases to determine their uses and extent.[c]

To the orders of architecture all buildings are indebted for the highest magnificence of decoration. To them the architect is obliged for many of the great effects in his art. The student must therefore be well acquainted with all the varieties in the work of the ancients, and acquire the fullest knowledge and most clear and correct ideas of their constituent

[c] Note. Indeed one proof of the great excellence of ancient works is that, frequently from very small remains, so well has character been attended to in every part, we are enabled to judge of the taste and destination of the edifice to which they belonged.

By the knowledge and proper application of these treasures, the architect will be enabled to show his superiority over the pretender to the art; he will display the powers of architecture, and by the taste and elegance of his works his name will be transmitted to posterity.

principles. They form, as it were, his alphabet, and have indeed been by many considered as the standard of taste never to be altered. But were this opinion well founded there would be little study required to make an architect: the practice of architecture would then be merely mechanical, little more than routine.

Of the orders of architecture there are three different systems: first that of Vitruvius, taken, as he admits, from Greek authors; secondly: that which is founded on exact measurements of the ruins of the ancient buildings of Greece and Italy; thirdly, that system which we find in the works of the most celebrated artists of the 15th century, composed from the remains of ancient buildings, from the writings of Vitruvius, and from their own fancy, taste and judgement.

Most writers on architecture speak of five orders: the Tuscan, Doric, Ionic, Corinthian, and Composite, thus arranged in proportion to their character of strength and delicacy.

Vitruvius, the only ancient author on the art, admits only of four orders, the Ionic, the Doric, the Corinthian, and the Tuscan.[d]

Indeed, when it is considered that every order must contain a positive, sensible, and distinct character, and that each has its particular and characteristic parts, we can scarcely admit more than three orders, the Doric, Ionic, and Corinthian. These three orders perhaps will be found to express every quality that can be made sensible by architecture. They have been generally supposed to have been invented, or at least improved from time to time, by the Greeks; and these three orders, although not of the same period, have been handed down to us in so perfect a state that all the ingenuity and powers of man have not been able to make any improvement therein, nor even to add a single member to either of them.

In the orders we must be careful to distinguish those parts which are essential and have an immediate analogy with the primitive objects of imitation, from those which are introduced by necessity, by fancy, or by caprice. By these means we shall avoid all striking deformities, gross errors, and fanciful deviations.[e]

No. 1. Every order of architecture consists of three principal parts: the pedestal, column, and the entablature. The pedestal may be considered as an accessory, and the column and entablature are essential.

No. 2. Each of these parts have three large divisions: the pedestal has its base, die and cornice; the column, its base, shaft, and capital; and the entablature its architrave (called by Vitruvius epistylium), its frieze or zophorus, and its cornice. These are again subdivided into many lesser parts.

[d] Note. We are at a loss to account for this arrangement; it is neither according to the times in which the orders were supposed to have been invented, nor agreeable to the different characters they were made to assume.

[e] Note. In the essential parts are the beauties. In the parts introduced by necessity as [blank] are the licences and deviations. In the parts introduced by caprice as [blank] are the defects. (See Laugier, *Essai*, p. 10.)

Although the columns to the orders are here described to consist of bases, shafts, and capitals, yet it must be observed that in most of the early and superior works of the Greeks, as well as in the best works of the Romans, the Doric order is executed without a base. Some have considered the suppression of the base as sufficient to establish the antiquity of the order; but that cannot be, for columns without bases were used in the time of Pericles, as well as in the most early examples.

I rather imagine the Greeks considered a base to this order as unnecessary, from the great superficies of the lower diameter of the columns which were always placed on a species of continued stylobate, consisting of three steps, sometimes exceeding two feet in height, the whole proportioned to the great simplicity and massive character of this order, and better calculated to accord with the largeness of the other parts of the works than suitable to convenience.

The shaft of the column makes an essential part of every order. Some suppose the idea of columns to have been taken from the trunks of large trees; others from an assemblage of trees or reeds. This latter kind of column could only have been for decoration, and never for an original construction. In Grecian works the column owed its origin to the rudely shaped timbers which were placed as supports to the roofs of the early habitations, and we shall likewise find bases and capitals owe their origin to early constructions in timber.[f]

According to Vitruvius, columns derived their name from the word culmen, which signifies a part of the roof called by us the king post.

Bases, capitals, and entablatures are all formed by assemblages of different parts, or mouldings, which are called the listel or fillet, the astragal, torus, scotia, ovolo, cavetto, cyma reversa, cyma recta.

The fillet and scotia are chiefly to separate other mouldings; to give grace and variety to the whole profile, and to prevent the confusion of joining several curved members together.

The torus and astragal are intended to bind and fortify the parts on which they are applied.

The ovolo and talon, being strong at their extremities, are used for supporting other members.

The cyma and cavetto are used for coverings to other mouldings, and are calculated to throw off the water.

These are all the mouldings admitted into regular architecture. They are either flat surfaces or composed of portions of the circle or the ellipsis. At first they may be described with the compasses, but when the student has attained a full knowledge of their powers, he should then draw them by hand to give them more grace, variety, and character.

[f] The origin of the entablature was spoken of in the first lecture, and was accounted for in the imitative system of the Greeks. So it is with the bases and capitals.

Of these mouldings, although almost endless combinations may be made, yet the application of them is not arbitrary. They cannot be used indiscriminately in buildings of every description, as many have imagined, and as has been too often practised, particularly in modern works: for the character of the mouldings used in the different orders and in different buildings must be particularly attended to, and must in all cases accord with the character of strength, or delicacy, richness, or simplicity intended to be produced.

Mouldings form a very important part of architectural decoration. By closely observing the superior elegance and variety of effect in the form of Grecian mouldings, over those used in the Roman edifices, and by contrasting the hardness of the square members with the softness and gracefulness of those which are curved, by a judicious combination of both, elegant assemblages are formed which create in the mind that interest, that pleasing impression, which all feel; whilst on the other hand the want of this knowledge of profiling produces dulness and insipidity.[g]

When mouldings are enriched, great care must be taken to preserve proper contrast and repose between the several parts, for however great the opposition of figure, however great the degree of enrichment required may be, there must always be intervals or plain parts to produce necessary repose, as well as to preserve the outlines of the forms enriched. Without this repose, the very principle and essence of ornament is destroyed. Sculpture is to architecture what lace is to dress: if it is judiciously introduced, it enriches and pleases by its contrast; if injudiciously, it only produces confusion, and disgust.

Thus we see in many of the cornices and other enrichments in the lower time of the Roman Empire, every member so profusely loaded with ornament that no trace of the outline is to be discovered; there is no contrast, no repose, and consequently the whole presents a mass of confused forms; whilst in the works of the Greeks the enrichments never produce confusion, but always increase the general effect of the whole composition.

The art of profiling and enriching the different assemblages of mouldings, although now much neglected, is of the highest importance to the perfection of architecture. Perhaps the mind of a great artist is never more visible to the judicious observer than in the practice of this part of his profession, for profiles and assemblages of mouldings are in architecture similar and of equal importance with those indescribable elegancies in poetry and painting which are not always sufficiently felt nor duly appreciated.

I shall now show how the component parts of the orders have been applied according to the doctrines of Vitruvius, and also in the remains of the most celebrated buildings in Greece and Italy, as well as in the works of the great masters and restorers of architecture in the 15th and 16th centuries, confining myself to general proportions and divisions of

[g] The climate of Greece and the materials they used allowed of more delicacy perhaps in their mouldings than we can use.

parts, referring for the details of each order to the works of Vitruvius, Palladio, Scamozzi, Vignola, Alberti, and Serlio; likewise to the modern Italian, French and English writers on the art, and particularly to an excellent treatise on civil architecture compiled by the late Sir William Chambers.

The Doric order is the most ancient, simple, and impressive, which the Grecian architects improved from time to time. They became so much delighted with it that very little use was made of any other until the time of Alexander the Great.

According to Vitruvius this order was first employed by Dorus, King of Achaia, in a temple erected to Juno. From the labours of Stuart, Revett, and Le Roi, we are enabled to trace the progress of this interesting order in the Grecian works. This order may therefore be considered in different periods of its progressive improvement.

In the first state the columns were about four diameters high, as may be seen in the ruins of a temple at Athens, and in another example at Corinth. There is a third example at Paestum, where the column is 4¼ diameters in height. The entablature is somewhat more than ⅖ths the height of the column.

Of the second state, the Temple of Theseus, built ten years after the Battle of Marathon, is an example. The columns are very near 5¾ diameters in height, and the entablature exceeds ⅓ thereof.[h]

The Temple of Minerva, in the Acropolis of Athens, may be taken as another example. The columns are something more than 5½ diameter in height, and the entablature is two diameters.[i]

The Temple of Augustus at Athens[3] may be chosen for the third state.[j]

In this structure the columns are six diameters high, and the entablature is 2⅔ths the height of the columns.

In these examples the transitions from heavy to light are extremely gradual, and show by what slow and certain steps the ancients proceeded. Even ages were necessary to enable the Greeks, with all their wonderful acuteness, to produce such models of beauty, harmony, and perfection which, notwithstanding the alterations and progressive improvements, pre-

[h] In this temple the architrave, when compared with the small elevation of the cornice, is excessively high, and we also observe a triglyph is placed exactly on the angle of the frieze. In the profiles of this capital the mouldings under the abacus are different from the former examples and become more like the ovolo used in later times.

[i] Note. A triglyph, as in the last example, is placed on the extremity of the frieze, and in both the architraves and friezes are on the same face with the lower diameter of the columns, and although the entablature is very high, yet the height of the pediment is only ⅖₁₅ths of its base, which indeed is the usual proportion for the height of the pediment in Grecian works, and which proportion was established by the climate, the propriety added to its beauty.

[j] Note. In this building the order begins to lose some of its original character of masculine robustness and unaffected simple majesty.

[3] In fact, the Roman gateway into the Agora of Caesar and Augustus.

served most of the essential characters of the orders. Let us be careful, then, how we deviate from them or adopt them improperly.

The metopes and triglyphs of this order present many serious and some very considerable restraints to the architect. To arrange these essential parts with correctness and taste requires great study and sound judgement. It must be remembered that they form the strong and marked features of the order. The proportions of these parts are not arbitrary, for as the triglyphs represent the ends of the beams or joists, they must therefore be made higher than wide. In like manner the metopes are to be square because the spaces between the joists ought to be of the same depth as the joists themselves.

The face of the architrave was, by the Greeks, placed directly over the lower diameter of the columns, probably because in the primitive construction the uprights from which they took their idea of columns were of equal breadth at top and bottom. A triglyph is also properly placed at each extremity of the frieze, whereby if the metopes are all equal, as they should be, the outermost intercolumniation must of course differ from the others.

Vitruvius, to obviate this defect, and to make the intercolumniations equal, tells us that the metopes next the external columns of porticoes should be made wider than the others; but this perhaps only produces a greater defect, and is by no means satisfactory. Indeed, if we had not an example of this practice in the Temple of Concord at Agrigentum, the text of Vitruvius might have been thought incorrect, which conclusion we are ready to admit when we cannot exactly comprehend his meaning, and thereby fall into the same sort of error as was done on another part of his text where he directs mutules to be placed not only over but also between each triglyph. This, the commentators thought, could not be his meaning, and the text accordingly proved a stumbling block to them, and was considered as totally impossible of conveying his meaning until Stuart's delineations of the Grecian Doric temples solved the difficulty and made the text of Vitruvius clear, for in all those works, mutules of equal breadths are placed over, and between, each triglyph.[k]

In the early works of the Greeks the metopes were left open, and it is to this practice that Euripides refers in the 'Iphigenia in Aulis' where Pylades advises Orestes to make his way into the Temple of Diana through the open spaces between the triglyphs; but in the later works of the Greeks, and in many of the Roman buildings, the metopes are often enriched with sculpture.[l]

Vitruvius gives this order without a base, and makes the column with its capital seven diameters high, and the entablature ¼ thereof. He also directs the face of the architrave to be placed over the upper diameter of the column, unlike the general practice of the Greeks.

[k] Note. It is curious to observe the different manner in which each different writer has twisted and tortured the text of Vitruvius in order to establish the probability of his own hypothesis.

[l] Note. Those who admit the excellence, but who wish to detract from the originality of Grecian architecture, fancy the origin of the metopes and triglyphs to have been borrowed from Egypt, from a species of double frieze in a building at Tentyra.

In one part of his works he directs the triglyphs to be placed over the extremities of the frieze, and in another part he says they should be placed over the axis of the column.

Beside the ancient examples of the Doric order already given, there are yet remaining in Greece, and in different parts of Italy, many others. At Cori, near Veletri, is a temple to Hercules of this order very inferior in its character to, and very unlike, those noble examples now remaining in Greece. The order in this work has greatly degenerated by being transplanted: that manly robustness and severity, so strongly marked in Grecian works, is entirely lost.[m]

At Albano is a building of this order which has something of the simplicity of the Grecian Doric. The columns are without bases, and the shafts are plain. There is also at Albano an entablature of the Doric order, worthy of attention. It is well conceived in a grand and majestic style.

The Doric order in the Theatre of Marcellus is a noble example of elegant simplicity. The columns are without bases, the shafts are plain, and project from the wall only half a diameter. The column is 7½ diameters high, and the entablature one quarter thereof. The architrave, unlike the practice in the works of the Greeks, consists of several parts. Dentils are likewise used in the cornice, the bed-mould of which only remains. Enough of the order, however, is preserved to give an idea of its original splendour and magnificence: it is a glorious example of the power of large and simple parts to affect the mind.

Some have ascribed the work to Vitruvius; but when it is recollected that he expressly forbids the use of dentils in this order, and that all the proportions of this work are unlike those directed by him, we can scarcely suppose it possible for it to be his, even if there were no other reasons against such a supposition.

The lower order of the exterior of the Colosseum has been generally called Doric, a name it does not deserve, for the triglyphs and metopes of the frieze, and the mutules of the cornice, the great features of the Doric order, are there entirely suppressed.

In the Baths of Diocletian is another example, full of enrichment in every part, and entirely destitute of that grand simplicity which the order assumes in the Grecian works.

Many other examples might be produced, but these will be not only sufficient for my purpose, but as many as the time for one lecture will admit of, and they show the great difference in the character and effect of this order as used by the Greeks from the same order as used by the Romans. In the former it was all true majesty and unaffected dignity; in the latter, it was capricious in the extreme, in some cases even uncharacteristically plain, and in others ridiculously enriched. The Greeks always adhered most zealously to their imitative system, whilst the Romans either did not know, or else disregarded entirely, the first principles which directed the minds of the former enlightened people.

[m] Note. The columns have small bases, something like those of the Temple of Minerva at Syracuse.

Let us now see the Doric order in the works of later times when the great restorers of art under the auspices of the Leos and Medicis produced so many splendid monuments of their superior talents. For this purpose examples are selected from the ten different masters given in De Chambray's Parallel: viz., Palladio, Scamozzi, Serlio, Vignola, Barbaro, Cattaneo, Alberti, Viola, Bullant, De l'Orme. Each of these authors have their particular merits, but Palladio, Scamozzi, and Vignola are superior to the others, and are consequently more entitled to the consideration of the artist.

Palladio has been called the Raphael of architecture;[4] in all his compositions there is a certain simplicity and character resulting from his close application to the study of the remains of ancient structures. He possessed many of the requisites to make a great architect, yet it must be observed that he had but few fixed principles, and seems to have been fully satisfied with following, both in public and private works, whatever he had seen in the remains of ancient buildings, not considering that what suited the solemnity of temples ill accorded with the cheerfulness of private dwellings. He therefore frequently falls short of our expectations.

In the example he gives of the Doric order, although it will be admitted that there is a certain grandeur and quantity, yet the whole falls very short indeed of what we have already seen. In the example before us[n] he has triglyphs and metopes in the frieze, but in some of his other works he takes great liberties and omits them altogether, and introduces the heads and skulls of oxen tied together with festoons of flowers, and puts dentils in the cornice.

Scamozzi applied himself diligently in storing his mind with the knowledge of the antique, but he chiefly owes his reputation to the attention he paid to the works of Sansovino and Palladio. His book on the orders of architecture places him high in the estimation of architects.

The Doric entablature [of Scamozzi] is superior to that of Palladio although the architrave is too high, the frieze too low, and the cornice is ornamented with dentils which are not applicable to this order.

Vignola pursued the same manner of study as Palladio and Scamozzi. He professes to have composed his Doric from different antique fragments. There is a peculiar grandeur and dignity in the whole design, and all the parts of which this composition is formed demand our decided attention.

In the works of these great men, and of others associated with them, as well as in the examples taken from the remains of the celebrated structures of Greece and Italy, we see many and essential deviations from each other, and, in the application of this order particularly, we find many strange contradictions and many unaccountable deviations from

[n] The column with its attic base is 8½ diam. high, and the entablature 3¾ modules.

[4] By Francesco Milizia in his *Vie des architectes* (J.-C. Pingeron transl.), vol. ii, Paris 1771, p. 68.

the first principles by which the Greeks attained superior distinction, which I shall endeavour to reconcile and account for in the course of these lectures.°

In the Ionic order the severity of the Doric is softened into elegant simplicity, and like the Doric it rests on the imitative system of construction in wood. All the constituent parts may be found in the imitative system, although some parts of the original construction are here, as well as in the Corinthian order, to a certain degree disguised. The great differences are first seen in the capitals, then in the greater or less degree of elegance in the proportions, and in the greater or lesser quantity of ornaments introduced.ᵖ Vitruvius tells us that this order owed its origin to the followers of Ion who, in a temple to Diana, copied the gracefulness of women, in like manner as they had before in the Doric order adopted the robustness of men. They made the thickness of the column one eighth part of its height; thus, says Vitruvius, arose another species of decoration which was called the Ionic order.�q

The eyes of the volutes are sometimes enriched with a small rose; in others we observe deep holes to receive ornaments used on particular festivals. The Abbé Winckelmann speaks of an example of a frog and a lizard being introduced into the eyes of the volutes as a monogram of the name of the architect.[5] A specimen of this kind of pun may be seen in the Abbot Islip's monument in Westminster Abbey.

The base assigned to this order by Vitruvius is so contrary to every idea of beauty, fitness, and elegance, that it might not have been incorrect to suppose the text much corrupted and the intention of Vitruvius misunderstood, if we had not examples of such unaccountable compositions even in some of the remains of Grecian works.

It is true the ancients have taken great latitude and shown uncommon variety in the composition of the bases to their columns. They are indeed without number. Besides those just mentioned I shall select some examples from different fragments of antiquity, many of

° In these examples the Doric order is shown in its different stages from the earliest works of Greece and Italy, wherein the simplicity and correctness of the primitive model directed the minds of the great artists of those countries unto its climax of richness and degeneracy in the Baths of Diocletian, a period wherein every idea of characteristic simplicity seems to have been entirely forgotten, and no recollection remained of this important truth, namely, that all the essentials of the Grecian orders, more especially those of the Doric, might and must be explained by the imitative system of construction in timber.

ᵖ Ionic capital, Qua[tremère de Quincy, *De l'architecture égyptienne,*] p. 260. Base. Vitruv[ius *De architectura* Book iii, v, 1–3,] p. 78. This base would not be believed but for examples now remaining, like the mutules. Vitruvius tells us that the Greeks never used dentils under modiglions, because the common or small rafters (have a model [made]) which are represented by the dentils can never be placed under the principal rafters which in like manner are represented by the modiglions.

�q The base represented the shoe or sandal, the volutes the tresses of their hair, dropping to the right and left, and the channels in the shafts of the columns designated the plaits of their gowns. Notwithstanding the opinion of Vitruvius as to the origin of the volutes, it is probable that the idea of them as suggested by something the Greeks had seen in nature, such as the cornuammonis. At least that is more likely than that the Egyptian capitals with the heads of Isis should have given rise to this beautiful invention (pl. 1).

[5] J. J. Winckelmann, *Monumenti antichi inediti* (1767), 2nd edn, Rome 1821, vol. ii, pp. 269–70 and pl. 205.

which are so extremely rich, beautiful, and elegant, that we must admire them, although at the same time whatever their merits may be, it will be admitted that even their admirers look down upon them.

Of the Ionic order, there are many considerable remains. The little temple on the banks of the Ilissus at Athens, so accurately described by Stuart, is a beautiful example. Nothing can surpass the extreme simplicity and elegance of this composition. The beauti- ful[ly] proportioned columns, the angular capitals, and simple entablature are most happy effects of the refinement and elegant taste of the enlightened people to whom this work owes its origin.[r]

To the extreme plainness and elegant simplicity of the Ionic order, as used in the temple just mentioned, may be contrasted the same order in the Temple of Erechtheus, Minerva Polias, and Pandrossus.

In this example the base is Attic, without a plinth, and it is to be observed that the thickness, or diameter, of the column is varied in the different parts of this building in proportion to the greater or lesser spaces between them, agreeable to the doctrine of Vitruvius. This particular attention to optical effect at the same time shows the wonderful attention that the Greeks paid to every part of their compositions.

The capital, which is of a singular and beautiful form, differs materially from any other in antiquity: it is much more decorated, and has been preferred to that described by Vitruvius.

The architrave and frieze are both remarkably high in proportion to the cornice which is very low with a large projection; but the effect of the whole entablature is singularly striking.

On the model of the Ionic order the Greeks erected many magnificent fanes, such as the Temple of Bacchus at Teos, of Minerva Polias at Priene, of Apollo Didymaeus near Miletus, of Diana at Ephesus, of Ceres at Eleusis, whose architects, Vitruvius tells us, wrote strictures on their constructions, all of which have perished. We must lament with the deepest regret the loss of such invaluable treatises, but at the same time we have great consolation in reflecting that fragments of these sublime works yet remain. Our satisfac- tion is nevertheless much lessened and our indignation roused when we are told that Turkish gravestone makers and mistaken connoisseurs are daily destroying these beautiful ruins.

The Romans also made considerable use of this order, of which the Temple of Fortuna Virilis is the most ancient example now remaining in Rome; but as it is built with coarse stone, and most of it has been covered from time to time with stucco, we cannot place any great dependence on the correctness of the contours of the mouldings; yet

[r] Of the entablature, graceful beyond measure, we must not however judge from seeing it placed over flimsy pilasters and heavy plain moulded capitals, of which this metropolis has several examples. This is barba- rous, and only to be equalled by the still greater barbarism of the Turks who, ever since Mr. Stuart's visit to Athens, have destroyed the whole edifice, merely to convert the materials into lime.

Palladio and P. Ligorio speak much in praise of this edifice. The frieze is remarkably high, very much enriched, and the cornice is composed of many small parts.

Here we have an example of the great difference between the height of the Grecian and Roman pediments, arising out of the dissimilarity of climate.

The Ionic order of the Theatre of Marcellus is placed over a Doric order, and the cornice (of which only the bed-mould remains) seems proportioned, not to the height of the semi-columns which support it, but to the height of the entire building.

In the Ionic order of the Baths of Diocletian, the architrave is very high, the frieze is swelled, and the cornice is much higher than in the Grecian examples. The whole entablature, although profusely enriched, is too masculine, and in that respect more fitted to the Doric than Ionic.

The Temple of Concord is likewise of this order. The architrave is omitted to make room for an inscription, and modillions and dentils are introduced in the cornice. These modillions are of large parts, and of course they produce broader shadows and give more effect and movement to the cornice than dentils; and if modillions are used with this order they should be accompanied with the capital of Michael Angelo, or Scamozzi, but we must remember that dentils and modillions are not to be used arbitrarily.[s]

I shall now show examples of the Ionic order from the ten masters in the Parallel of De Chambray.[6]

In the composition by Palladio the cornice is bold and well fitted for external decoration. The architrave has great merit, but the low and swollen frieze is clumsy, inelegant, without any pretensions to true taste, and is unsanctioned by sound judgement, although it is often seen in the later works of antiquity.[t]

Scamozzi has made the architrave too high, the frieze too low, and the cornice not high enough, with too many members, better calculated for internal than external decoration.

The capital of Scamozzi, however, demands our attention. It differs from the antique, and also from his contemporaries. The four faces are all alike, and it has been frequently executed with great success.[u]

[s] Of the Colosseum, the volutes of the capitals are not traced out, nor the echinus cut, nor are the mouldings of the cornice finished.

[t] Palladio has made his column 9 diameters high, and the entablature is somewhat more than 3½ modules.

[u] Scamozzi makes the column 8½ diameters high, the entablature ⅔ths thereof. I cannot think the essential parts of this capital unknown to the ancients.

[6] Roland Fréart de Chambray, *Parallèle de l'architecture antique et de la moderne*, Paris 1650, translated by John Evelyn as *A Parallel of the Antient Architecture with the Modern*, London 1664. Soane owned Sir William Chambers' copy of the French edition (1702) of this work, no less than five editions of Evelyn's translation, and two manuscript copies of the French edition: an unfinished duodecimo (AL 35F), and folio (AL 14D), bought on 11 April 1821.

Vignola's Ionic is inferior to his Doric, although he gives it as an imitation from Vitruvius.

The other examples are sufficiently explained by an inspection of the drawings.

The Corinthian order makes the Grecian architecture complete. The Doric and Ionic convey correct ideas of masculine strength and female gracefulness, and in the Corinthian we trace the highest degree of elegant decoration that architecture can produce. It is delicate, gay, and impressive.

Art cannot go beyond the Corinthian order: the whole composition is of the most correct proportions and of the greatest variety, its members are enriched with ornaments of the most exquisite fancy and chaste selection.

The capital of this order is of peculiar and enchanting beauty, it is really fascinating; it owes its origin, according to Vitruvius, to the following circumstances:

A Corinthian maid, on the eve of marriage, was seized with a disorder and died. After her internment her nurse collected and disposed in a basket those trinkets which best pleased her when alive. She carried the basket to the tomb, placed it on the top thereof, and covered it with a tile that it might not be injured by being exposed to the open air. The basket chanced to be placed over the root of an acanthus. The leaves and stalks, in the spring season, issued outwards, and grew round the sides of it, and, being pressed by the weight of the angles of the tile, convolved at the extremities. Callimachus, happening to pass by the tomb, observed the basket, and, being pleased with the delicacy of the foliage growing round it, as well as with the novelty of the whole form, caught the idea, and from this model composed a capital which, being first used at Corinth, was therefore called the Corinthian capital.

Some have supposed this account to be a fable and that the Greeks stole the idea of their capital from the Egyptians.[7] But in the Egyptian capitals there is very little resemblance between them and the composition of Callimachus, except in the bell shape; and if we compare the poverty and tameness of the first with the grandeur and expressive elegance of the latter, it cannot be seriously supposed that the one was copied from the other. And if we consider by what slow steps men attain perfection, even in a very limited degree, and that painting, sculpture, and architecture were allowed in all ages to keep pace with each other, from what we know of the knowledge and taste of the Egyptians in the two first arts, we can scarcely think it possible for them ever to have reached the sublimity of the capital of Callimachus. At all events, there is something so poetical and so truly interesting in the supposed origin of this capital that we must lament that any attempt should be made to shake its authenticity, particularly when the fable, if you please, has existed so long, and

[7] In an early draft, Soane added, 'after speaking of the Corinthian capital. It has been said that the Greeks borrowed from the Egyptians because in both architectures they used columns, capitals and entablatures. This does not prove any imitation or uniformity. To do this the parts must have a character evidently similar. Qua[tremère de Quincy, *De l'architecture égyptienne*, p. 238]' (SM Archives MBiii/10/1, fol. 59).

when the attempt to destroy it is so very weak, and the case so little made out to our satisfaction.

Those who never felt the beauties of Grecian architecture cannot be expected to appreciate its merits, and may sneer at the absurdity which they think they have discovered in the use of the Corinthian capital which they represent as a basket of flowers applied to the support of a massive entablature. Had these critics gone a little deeper they would have perceived that the bell is the real pillar of support to the entablature, and which appears distinctly marked between all the great divisions of the leaves, in which themselves are merely decorative; nay, the abacus itself even to the most fastidious must appear to have very sufficient support from the large volutes which otherwise adorn it.

If Pythagoras offered an hecatomb of oxen to the immortal gods for having enabled him to produce the famous proposition (the 47th in Euclid's First Book), what sacrifice must Callimachus have made for such wonderful favour as led him to the invention of the most beautiful and complete ornament that antiquity can lay claim to?

In the porch of the Tower of the Winds is a faint example of the Corinthian order. The columns are without bases, and the singularity in the flutings is puerile and bad. The cornice has dentils instead of modillions, very unlike the other correct and elegant productions of the Greeks.

Of the Corinthian order there are many examples in the remains of Grecian buildings.

In the Lanthorn of Demosthenes the order, although very light and fanciful, is extremely licentious; the dentils in the cornice are misapplied, and the whole composition is only adapted to small works.

In the Temple of Jackly[8] is another example of this order. The base is beautiful, the capital much superior to the former, the architrave is loaded with small members, the frieze swollen, the cornice poor, and, like the others, has dentils.

The Stoa, or Portico, at Athens, described by Stuart, presents another example of the Grecian Corinthian order. The abacus of the capital is pointed, and there is a kind of modillion in the cornice. It must be acknowledged that all the Grecian examples of this order, now remaining, are very inferior to many in the buildings of Italy. But in judging of the Corinthian order from what is now remaining in Greece, I should not suspect any of the Grecian examples I have exhibited could have been produced from those Villalpandus supposes to have been in Solomon's Temple. Let it however be remembered that it was at Corinth that Callimachus exerted the mighty powers of his mind in adorning his native city with the most superb monuments of refined taste. When this city was taken by Mummius, the Romans, possibly struck with the elegance of the works of Callimachus, feeling at the same time the difficulty in the execution of the capitals and other enrichments, might probably have removed them as they did the obelisks from Egypt; and it is perhaps chiefly

[8] Jackly or Iackli, the modern Ayalki in Turkey.

to that circumstance that the examples of the Corinthian order now remaining in Greece fall so very short of that characteristic variety, sublimity and perfection of the other orders. Indeed when we examine the Corinthian order in some of the buildings of Italy, the most zealous admirers of Grecian art must give them a decided preference and admit, judging as we must of the Corinthian order of the Greeks from their works now remaining, that the Romans far surpassed them; but at the same time it must be recollected that the works referred to, although erected in Italy, were produced by Grecian artists.

From the ruins of ancient buildings in Rome several drawings of the Corinthian order materially different from each other in many essential parts will be now shown.

In the portico built by Augustus in honour of his sister, Octavia, the entablature is of the plainest kind: neither dentils nor modillions nor any other embellishments is to be seen in any part of the entablature.

In the Temple of Antoninus and Faustina the cornice has neither dentils nor modillions, yet it has many beauties, although not quite applicable to this order; but it must be observed that the extreme plainness of the architrave does not in any degree harmonize with the beautiful capital and the highly enriched frieze and cornice.

In the Temple of Vesta the columns are uncommonly slender. They are very near eleven diameters high, and the abacus of the capital is very weak in appearance, being continued to a point as in most of the Grecian works. The ruins of this temple present an idea of peculiar elegance and rich taste, and make us lament the entire destruction of every part above the columns.

In the Temple of Mars the Avenger the columns are beautiful, the execution of the capital and architrave is most exquisite; the frieze, as in most of the best examples of antiquity, is flat. Of the cornice there are no remains, and a large part of the column is entirely buried. There is such taste in the composition and such correctness in the execution, as make us lament the loss of any part of this exquisite work.

In the garden of the Colonna Palace are some fine remains of prodigious magnitude and uncommon grandeur, from which this drawing has been made.[9] In the cornice is a kind of double modillion very like what has been shown in the order of the Stoa at Athens.

The Corinthian order in the portico of the Pantheon is extremely beautiful. The architrave and frieze are of great height, the cornice has modillions, but the dentils are not cut. The order of the interior is also Corinthian, and by its grandeur keeps up the interest created on viewing the external order.

The Corinthian order of the Temple of Jupiter Tonans [Vespasian] is grandly conceived and finely executed. The height of the architrave is about one eighth part less than the frieze, and the cornice, with its cymatium, is about a quarter part higher than the

[9] These were thought to be the cornice from Aurelian's Temple of Sol.

frieze. In the cornice are dentils and modillions, and in this example the Romans began to deviate most materially from the practice of Greeks.

But of all the examples of this order now remaining, that of three columns in the Campo Vaccino, supposed to have been a Temple to Jupitor Stator,[10] is the most sublime and awefully grand and impressive, whether we consider the excellence of the execution, the largeness of its general parts, the uncommon taste and elegance in the various enrichments, or the great breadth of light and shadow of this noble composition. The transition from one beauty to another is so great that we forget the impropriety of modillions and dentils being found in the same cornice, and we are lost in silent admiration of its uncommon beauties. The capital also of this stupendous work keeps pace in beauty and effect with the other parts of the order: it is full of originality and peculiar grace; the effect of the caulicoli, entwined in each other, is uncommonly beautiful, and highly rational, whilst the playfulness of the ornaments rising between them and the volutes which support the abacus cannot be sufficiently admired.[v] One lecture would be too short to point out the beauties of the entire composition.

Of this mighty fabric only three columns and the entablature over them are now remaining. All lovers of art must regret its buried and dilapidated state.

The last example shows what may be produced by exquisite taste and correct combination assisted by quantity. I shall contrast with this another example of the Corinthian order in the little temple at Tivoli which, although of very small dimensions, compared with the last examples, is perhaps equally interesting from the singularity and charming effect of most of its parts, particularly those of the capital which is of very singular fancy and invention. The architrave is plain, one face whereof is omitted to make room for an inscription. The frieze is enriched with festoons of flowers passing over the heads of bulls, whilst the cornice is quite plain without either modillions or dentils. Yet the uncommon taste, lightness and elegance of every part of this beautiful composition has never been surpassed, nor can be sufficiently admired.[w]

The building affords many proofs of the inaccuracy of Desgodetz, which it is the more necessary for me to notice to prevent the young artist from placing too great a confidence in his representations, which he might be led to do from observing every page filled with pointing out the errors of those who preceded him.

From the different examples of the three orders produced this evening, it must have

[v] According to Desgodetz, the columns are considerably buried, the architrave and frieze are each 3 ft. ⅝ ins., and the cornice, which is only in two pieces, is 5 ft. 11 ins. high, making the height of the whole entablature 12 ft. 9¾ ins.

[w] The diameter of the column is 2 ft. 6 ins., the height of its shaft, including base and capital is 23 ft. 4 H ins. It is wonderfully adapted to its situation; it is circular, its columns are short, only 9 ½ diam. high; its capital low.

[10] In fact, the Temple of Castor.

been seen that in the best works of antiquity the Doric cornice is distinguished by its mutules, the Ionic by its dentils, and the Corinthian by its modillions.

In the various examples of the Corinthian entablatures selected from the remains of Grecian and Roman magnificence we perceive such material deviations in the general proportions, and even in the essential parts and characteristic decorations, that it would be impossible to persuade ourselves that such very rich and such very plain, such very light, and such very clumsy, compositions were ever intended to have been placed over Corinthian capitals, if the examples were not still in existence. Yet however great and unaccountable these deviations may appear, I shall now show three other examples of still more strange and extraordinary composition.

The first is in a triumphal arch at Aosta in Piedmont, where triglyphs of the Doric order are placed over columns whose symmetry and capitals are Corinthian.

The second, at Tarragona, at the Tomb of the two Scipios, where Doric triglyphs are placed over pilasters with Corinthian capitals.

The third, at Agrigentum, at the Tomb of Theron, [where] Doric triglyphs are placed over I columns of the Ionic order.

It may perhaps be said that these examples are the works of bad times, composed of fragments taken from the ruins of ancient buildings. Every age has produced bad artists and ignorant imitators, men who preferred novelty to any other consideration, like the architect of the church of S. Romolo at Florence who, being desirous to surpass all his contemporaries, made the bases of his columns similar to the capitals of the Ionic order. I can readily suppose that men who lived in the early ages before architecture attained the polish and purity of the time of Pericles, that men who lived antecedent to the age of Augustus, might have been ignorant of many of the essential parts of the orders, but that architects of the Augustan age should have been so very uninformed as to have blended the essential parts of the orders so strangely together is not to be credited, and yet Vitruvius, who has been generally supposed to have lived in the time of Augustus, or of Titus, tells us that 'Corinthian columns are of the same proportion as the Ionic, but that the members which are placed above the column are taken either from the Doric or the Ionic order, for the Corinthian order has no cornice or other ornaments peculiar to itself, but it has either triglyphs and mutules in the cornice and guttae in the epistylium, as in the Doric manner; or else according to the Ionic manner, the zophorus is ornamented, and dentils are placed in the cornice, so that by these two orders, i.e., the Doric and Ionic, joined with a different capital, a third order is produced.'ˣ

ˣ Now how is it possible to suppose this to have been the language of an architect who lived in the time of Augustus, during whose reign not only the portico of the Pantheon was built by Agrippa, but also the Temple of Jupiter Stator [Castor], Mars the Avenger, and many others in which the Corinthian entablature, as shown in different drawings this evening, assumes a decided and characteristic form totally different from

Such is the description Vitruvius has given us of the Corinthian order, and it must be here noticed that it corresponds most exactly with two of the last examples, the arch at Aosta and the tomb at Tarragona.

If Vitruvius lived, as has been generally supposed, either in the reign of Augustus or of Titus, it is impossible not to feel considerable surprise at his description of the Corinthian order, so unlike what it was in the buildings erected in the periods just mentioned. If the Corinthian order, as practised by the Romans in the time of Vitruvius, answers to this description of it, how is it possible to suppose that he flourished in the time of Augustus?

On this point many learned men of different countries have exercised their minds with great ingenuity, and they have generally concluded by placing him, as before mentioned, either in the reign of Augustus or of Titus. For each of these conclusions they have assigned their reasons; but perhaps, after all that has been said, the most certain, at least the most probable, mode to establish the particular period in question would be by ascertaining the precise state of the arts in general, and of architecture in particular, in the age of Augustus, and to compare the practice of that period with the doctrine of Vitruvius.

It has been generally admitted that many buildings of the Corinthian order, the temples of Jupiter Tonans [Vespasian], Jupiter Stator [Castor], Mars the Avenger, and many others whose ruins are yet to be seen, were erected in or about the time of Augustus, and the portico of the Pantheon was without contradiction of that date. All these buildings were of the Corinthian order of the most exquisite execution and design. Their entablatures, as shown in the drawings this evening, instead of being compounded indiscriminately of the Doric and Ionic according to Vitruvius, on the contrary assume a decided and characteristic form, totally different, in many of the most essential parts, from the other orders. With these data how is it possible to reconcile the text of Vitruvius with the sentiments of a writer on architecture of the Augustan age, and that writer, not only an architect, but one that professed to compile a complete treatise on the art, founded on the works of the Greeks? These circumstances are, with me, conclusive as to his not living in either of the reigns before mentioned. In what age he did live I leave to be determined by those who have more leisure and ability for such discussions than myself.

Having in the course of this lecture spoken of Villalpandus who in his great work on Solomon's Temple has given us his ideas of the order used in that edifice, I have made a drawing thereof for the satisfaction of my curious auditors. It must be admitted that there is a peculiar grandeur in the composition; at the same time there is that strange mixture of the orders which neither the text of Vitruvius nor the three ancient examples last produced will justify or render tolerable to minds accustomed to judge of architecture from the pure sources of Grecian excellence.

the other orders, and surely Augustus might have been complimented without any imputation of vanity on the magnificent and elegant works of his son-in-law.

I shall now proceed to show examples of the Corinthian order from the ten masters in the Parallel.

In these examples of the ten masters we find the same or even greater dissimilarity than in the Doric and Ionic orders of the same masters.

Palladio sets out with declaring his full approbation of the order of the three columns in the Campo Vaccino. He observes that all its parts are beautiful in form, correct in proportion, and combined with a thorough knowledge of composition and effect. Yet with this opinion, in the example before us, there is no resemblance to the perfection of this work.

Scamozzi makes his order higher than Palladio, but falls short of him in merit. The lower part of the frieze being connected with the architrave by a curve, separated from the cavetto of the architrave by a small fillet only, produces a degree of confusion.

In Vignola's composition there is a grandeur, [he] having closely studied and happily blended and combined the beauties of the antique, and the results of his exertions are commensurate and most happy. His general proportions are taken from those of the three columns in the Campo Vaccino. Indeed, upon the whole, on this trial, he has been more successful than either of the preceding masters.[y]

Alberti, following the text of Vitruvius and the example of the little temple at Tivoli, has made the capital to his order only one diameter in height, and in the cornice he has omitted the corona, as in the Temple of Peace. Alberti's treatise on architecture, written expressly to rival Vitruvius will be read by the student with advantage.

I have pointed out many of the prodigious differences in the proportions and combinations of the parts of the several orders as used by the ancients.

In the orders likewise, as given by the modern masters, we find material deviations from the practice of the ancients.

The fact is that modern artists have often copied and applied whatever they found in the works of antiquity indiscriminately whether good or bad, without considering or examining the principles by which they were produced, oftentimes confounding together the works of different and remote ages as well as the works of different character, unmindful that every architect was not an Hermogenes, a Dinocrates, or a Ctesiphon; no more than every painter was a Zeuxis, a Protagenes, or an Apelles; or every sculptor a Glycon, a Phidias, or a Praxiteles. Every age has had its Borrominis, its Vanvitellis, its Fugas, who bewildered themselves with childish conceits, which others blindly following, error was heaped upon error, and conceit upon conceit, until the first principles of art were totally lost, and every idea of good architecture sacrificed at the shrines of whim, folly, and

[y] Palladio makes his column 9½ diam. high, and his entablature ⅕th of its height. Scamozzi makes his column 10 diam. high, and his entablature ⅕th. Vignola gives to his column 10 diameters, and to his entablature 2½ thereof.

caprice. Costume is as necessary in architecture as in painting, and if we were accustomed to reason closely and to criticise seriously we should feel, and be as much displeased with, the impropriety of placing Corinthian columns and statues in the front of a prison as with the picture of a painter who had clothed the figure of a Grecian sage with the motley jacket of a merryandrew.

The varieties and seeming contradictions in the great and component parts of the orders may be at first discouraging; but let not the young artist be dismayed with difficulties; rather let him consider them as the means of calling forth all the energies of his mind, all the powers of his imagination, and the exercise of his judgement.

In the course of these lectures will be shown the causes to which these great varieties in the orders as used by the ancients, are to be attributed, and that they are not always the result of mere chance or caprice, but frequently produced by sound judgement, correct reasoning, and deep reflection on the great principles of art; and I shall zealously strive to convince the student that all the great and essential principles of architecture, whether decorative or constructive, are alike founded on a close imitation of the works of nature, and on the immutable laws of reason and of truth.

LECTURE III

⁓

MR PRESIDENT, – Having in the last lecture shown many different examples of the three Grecian orders, the Tuscan and Composite are now to be considered.

It has been generally supposed that the Tuscan order was first used in the Grecian colony of Etruria. It is also recorded that in the most early period of Rome the Etrurians had so much distinguished themselves by their taste and knowledge of the arts in general and of architecture in particular, that when Tarquinius Superbus proposed to erect a temple to Jupiter, workmen were procured for that purpose from Etruria, Rome not possessing at that time any competent to the undertaking.

The buildings wherein the Tuscan order was used, being from necessity constructed chiefly of timber, we have no remains of them; and it is therefore to Vitruvius we must refer for information on the subject as far as relates to the entire order. According to this great architect, the Tuscan column should be seven diameters high, and the diminution one fourth part of its diameter; and over the columns beams, or architraves, are to be laid of the same thickness as the hypotrachelium at the top of the column; and over these beams mutules are placed projecting one fourth of the entire height of the column. This great projection for a long time perplexed all his commentators, and many ingenious suggestions were unsuccessfully formed to reconcile the text of Vitruvius with their different ideas of his meaning. Inigo Jones, however, in the church of St. Paul, Covent Garden, has fully explained the intention of Vitruvius and established the correctness of his text. The proportions used by Inigo Jones in this justly celebrated work correspond most admirably with the precepts of Vitruvius.[a]

The Composite or Roman order is now to be considered. The Arch of Titus in Rome offers one of the best examples of this order, whose origin is thus related: Titus

[a] Note. He has in this work completely refuted all the chimeras of the commentators; and, as has been before observed respecting the placing of the mutules over the metopes, the doctrine of Vitruvius is made clear.

having taken Jerusalem and destroyed the Temple of Solomon, the Senate and People decreed a triumphal arch to be erected on the occasion; and to make this honour still more important the building was to be adorned with a new manner of building which their vanity called the Roman order, although in fact the capital was little more than a clumsy mixture of the Ionic and Corinthian, and the whole of the entablature in its character and proportions was merely borrowed from the Corinthian order.[b]

The next example of the Composite order is taken from the Baths of Diocletian, wherein the parts are still more enriched.[c]

These two examples are sufficient to show how completely the Romans failed in the attempt to produce a new order, and from what has been said respecting the composition of the Greek orders, I think it will be in vain to seek for any addition to their number. There may be, as in colours, many shades of difference very visible to the eye of taste and feeling, yet we can scarcely admit the number of the Greek orders to be increased, either by capitals of a different kind, or by altering their general proportions, or by omitting some parts and transposing others. All such partial changes in the combinations of the mouldings and other ornaments are more likely to spoil the effect of the original design and to render the sensation of the whole composition more feeble. This, however, was all that the Romans did in forming what they called the Roman order.

Respecting this attempt of the Romans to produce a new order, Vitruvius, who by many has been supposed a native of Rome, is completely silent. It has been generally supposed to be important to art to know in what age this great architect flourished. In the last lecture I gave my reasons for supposing that he did not live in the reign of Augustus, and, had he been contemporary with Titus, it is impossible that this great effort of the Romans to produce an Order of their own should have been unnoticed by him.

The ignis fatuus of philosophy was the discovery of the philosopher's stone: with architects, it has been the invention of new orders of architecture to rival those of the

[b] Note. This order, however inferior to that of the three columns, is certainly more worthy of attention than the Corinthian order of Vitruvius, consisting of an architrave, frieze, and cornice taken indiscriminately either from the Doric or Ionic, and placed over a Corinthian capital. Hence it follows, either that the text of Vitruvius must be grossly corrupted, or he must have lived long before art attained the perfection of the time of Augustus, or else so long after that time that all traces of good architecture had been lost in the barbarism of the dark ages.

[c] Note. Vitruvius is silent respecting the Composite order, and when we recollect how anxious the Romans were to have an order of their own and to rival those nations in the arts whom they had conquered by their arms, it will appear strange if he lived in the age which he has now been generally placed in, that he should not only have neglected this opportunity of rendering a compliment to his country, but also that he should be so deficient in common justice and policy, for at all events the attempt was laudable and the motive correct, however deficient the execution might have been, but perhaps the silence of Vitruvius is assignable to another cause: although a Roman citizen, he might not think the Composite order, such as is now to be seen in the remains of ancient buildings, entitled to the high distinctive appellation of an order, every part of it being entirely borrowed from the Ionic and Corinthian.

Greeks. The Romans set the example, and some of the architects of the fifteenth and sixteenth centuries, not satisfied with their fruitless attempts, amused themselves most unprofitably with this visionary phantom of the brain. From them the rage showed itself in France, in the reign of Louis the Fourteenth, where the feeble efforts of the French architects had still less pretensions to originality and ingenuity.

I wish the mania had stopped in France, but the cacoíthes for producing new orders has reached this country, and we have also had many attempts to attain that object. I shall only notice two of them.

In a work entitled '*A Proposition for a New Order of Architecture*,'[1] the author, after speaking of the feeble, injudicious and unsuccessful endeavours of those who preceded him, treats us to what he calls a Sixth Order, '*absolutely new in its proportions, its ornaments, and all its parts, the whole forming a composition suitable to the glory of his country*.' Such is the author's description of this singular composition, the effect of which may be seen (however incredible it may appear) in an expensive villa, with a large portico of this order, that has been erected in the neighbourhood of Windsor.[2]

Another specimen of a new order in this country owes its rise to the following circumstances. About forty years ago a Monsr de la Roche (a priest I believe)[3] discovered, like some of our mechanic architects, that it was from 'self-taught' and not, as he calls them, 'mere bred architects,' that art must receive every considerable improvement. And having further discovered 'that the man who could not do anything without studying the antique remains would never do anything great, even were he to pass three-fourths of his life in the contemplation of the ruins of antiquity', fired with these ideas the visionary priest turned his mind to architecture, and having composed an essay on the subject, in one moment, in the next produced a new grand order, which he called 'the Britannic Order.' The invention of this order he ascribes to an incident in the English history, far more inviting, says he, than even the basket of Callimachus. 'In the reign of Edward the Third, the Prince of Wales, at the Battle of Crecy, amongst other successful darings, killed the King of Bohemia and took his banner, whose ensign was the royal diadem of Bohemia with three ostrich feathers placed in it. With this princely badge,' says Monsr de la Roche, 'I adorn the capital of my new order, and in nature nothing can be more fit for the purpose. The feathers, bending tenderly in the manner of volutes, give it a superior delicacy to the Corinthian capital, and from this delicacy in the capital, and the nobleness of its origin, it must rank above the gorgeous Corinthian.' From this description it appears that Monsr de

[1] Henry Emlyn (*c.* 1729–1815) was the author of *A Proposition for a New Order of Architecture*, London 1781. Soane owned the 1st edition; there were further editions in 1784 and 1797.

[2] Beaumont Lodge, Surrey, *c.* 1790. See S. Blutman, 'Beaumont Lodge and the British Order', *The Country Seat*, H. M. Colvin and J. Harris, eds, London 1970, pp. 181–84.

[3] Peter de la Roche, a native of Geneva and not a priest, was the author of *An Essay on the Orders of Architecture and the Introduction of a New Great Order. Called the Britannic Order*, London 1769.

la Roche had read not only the English history, but also the late Mr. Hogarth's 'Analysis of Beauty,'[4] in which work it is gravely asserted that 'a capital composed of the forms of hats and periwigs in a skilful hand might be made to have some beauty.' Monsr de la Roche further tells us that he has made this composition a real order of architecture, different from any other in all its parts. This 'new order,' says the reverend and unassuming priest, only wants antiquity; and when hereafter it is found among ruins, it may then perhaps please many whose genius would have condemned it at its birth. He then modestly adds: 'The present age may not have sufficient liberality to approve my design, but posterity will most certainly do it justice.' If Monsr de la Roche had recollected the conduct of Michael Angelo he need not have waited for the praise of posterity. It is related of that great artist that, having made a statue of Bacchus, he broke off one of the arms which he retained in his studio, burying the other part of his work in a place that he expected soon to be the scene of exploration, which accordingly happened, and the mutilated status being then found, it was supposed to be an antique, and was sold to an eminent connoisseur of that day for a very large sum of money. Michael Angelo then produced the arm and triumphantly claimed the whole work for his own. Had this contrivance occurred to Monsr de la Roche he might most easily have made a small model of his great work, and having buried a part of it in excavations near Cheltenham or in the environs of Bath, it might then have been there found with tessellated pavements and other valuable fragments, to the inexpressible delight of the antiquarian. And when ushered into the world by the man of superior skill, with elaborate descriptions of its beauties and splendid engravings, Monsr de la Roche might have produced his fragment, proclaimed himself the author of the work and have given full scope to his vanity. But Monsr de la Roche was no Michael Angelo, and his great work, instead of obtaining for its author immortal fame, agreeably to his expectations, has long since been consigned to oblivion. His contempt, however, of 'mere bred architects' has been adopted by another self-taught architect, who tells us 'he was obliged to relinquish the practice of a favourite profession and to sink into a mere architect because he found architects in general such dull, ignorant, and obstinate animals as could neither comprehend nor do justice to his decorative powers.' I am led to expect from these general and harsh epithets that this last gentleman's ideas of the professors of our art arose from his habits of intimacy with ornamental plasterers and speculative architects, for I am sorry to say we have but too many of that description of self-constituted artists.

I trust these examples will be sufficient to satisfy us of the imbecility of the attempts, and the folly of endeavouring to produce, new orders of architecture capable of vying with those of antiquity. Let it not be supposed that I wish to discourage the creative flights of

[4] In his frontispiece to Joshua Kirby, *The Perspective of Architecture deduced from the Principles of Dr Brook Taylor* (London 1761), Hogarth showed a column in a new order, incorporating the Prince of Wales' coronet, plume of feathers, and Star of St George. See R. Paulson, *Hogarth's Graphic Works*, 3rd revised edn, London 1989, pp. 192–93 and pl. 235.

real genius; its efforts, when properly pursued, lead to fame and fortune.[d] The beautiful capital in the drawing before you[5] is so well conceived in all its parts, and so truly in the grand style of antiquity that it is impossible for any man with the least spark of knowledge of architecture, or with any love for the art, not to feel highly gratified with this production of successful genius.[6]

To return to the works of the ancients. Instead of columns the Greeks, and the Romans after them, sometimes substituted statues for the support of the entablatures and roofs of their public buildings. This custom among the Greeks, according to Vitruvius, owed its origin to the following occasion. The people of Caria having joined the Persians against the Grecian states, and the Greeks having put an end to the struggle by a glorious victory, declared war against the Carians, and having taken and destroyed their chief city, they slew the men and led the matrons into captivity. This event suggested to the architects of that time the idea of applying statues of the Carians to support the entablatures of buildings, in order that the remembrance of their defeat might be transmitted to the latest posterity. In the Temple of Erechtheus at Athens is a fine specimen of caryatides, although the architrave and cornice over them (for the frieze is omitted) seem heavy, being nearly equal to the half of the entire height of the statues.

The Lacedemonians also, having defeated the Persians in the Battle of Platea, erected as a trophy of their victory a portico decorated with groups of armour, the roof of which was supported by statues of the chief Persian captives. They in this manner terrified their enemies with the idea of their power, and at the same time inspired their citizens with a love of glory and made them more animated in the defence of their liberties.

I am fearful that the beautiful example of Grecian art in the Temple of Erechtheus has been much mutilated since the time of Athenian Stuart. One of the caryatides is now in England, and probably the entablature has also been removed. However gratifying the sight of even parts of the ancient works may be, yet the destruction or the removal of the remains of ancient buildings must be matter of serious regret, let the motive be what it will. We may remove parts of these buildings, but the sentiment will not follow, and the judgement thus partially and incorrectly formed from such fragments without reference to situation, and without having the accompaniments, must be very short of the sensation we should feel on viewing the whole together.

Of the caryatides in the Pantheon, mentioned by Pliny, there are no remains; nor is

[d] Note. The late ingenious Mr. Adam exercised his talents on this subject and composed a new order which is recent and known to all of us.

[5] Dance's ammonite capitals on the façade of his Shakespeare Gallery, Pall Mall, London (1788–89), possibly inspired by a suggestion in Piranesi's *Diverse maniere d'adornare i cammini*, Rome 1769, p. 20.

[6] In Soane's version of this lecture as delivered in 1819, he added the following sentence, 'The late Mr Adam, with an inventive and elegant fancy produced a Britannic order, but like the Roman, the French, and the Spanish orders, the great novelty is the capital.' On these orders, see J.-M. Pérouse de Montclos, 'Le sixième ordre d'architecture', *JSAH*, vol. 36, December 1977, pp. 223–40.

it easy to conjecture in what part of that building they were introduced. There is also a species of caryatides in the Incantada at Salonika. This work is a very peculiar instance of statues used in architectural decorations.[e]

The Greeks[f] were not the only people who substituted statues for columns. At Memphis the roof of the portico of Psammetichus was supported with statues eighteen feet in height, and the peristyle of the mausoleum of Osymandias was sustained by statues of sacred animals. The Egyptians also decorated many of the extensive avenues leading to their great temples with statues of sphinxes,[g] lions, and other animals of gigantic dimensions placed in parallel lines near together and facing each other. These works could not be unknown to the Greeks, for many of their philosophers visited Egypt. The Grecian architects also sought improvement, and pursued their studies in that country, in like manner as the Romans did afterwards in Greece, and as the artists in our days do in Italy. With these facts before us, how can we reconcile the text of Vitruvius and ascribe the invention of Persians and caryatides to the Greeks? The Greeks doubtless felt at first sight all the force, beauty, and advantages of these dispositions, although their enlightened minds, sound judgement and correct taste would not allow them to adopt this singular style of applying statues, until they were in some degree justified in so doing by the circumstance mentioned by Vitruvius.

We have now seen how the Greeks added to their orders of architecture Persians and caryatides, a practice sanctioned by Vitruvius who tells us that many architects of his time introduced statues to support the epistylium and ornaments, and thereby made an excellent variety in their works, giving playfulness and richness of fancy to their architecture without offending propriety. Although propriety of application might not be offended, it was

[e] Note. To what purpose the building of which this drawing shows a part was destined is not known. The Greeks who now inhabit Salonika say it was produced in the time of Alexander the Great, and they ascribe the work to the magic of a necromancer from Pontus, and to Aristotle, a conjurer who attended Alexander. From this account, which is given at length in the third volume of Stuart's Athens, it should seem that the modern Greeks possess all the marvellous, and all the fire of invention so peculiar to their ancestors.

[f] Note. That I may not be accused of blindly sacrificing truth to prepossession in favour of the Greeks I have given examples from the works of the Egyptians.

[g] Note. This practice not coinciding with the mythology of the Greeks, although in a great degree borrowed from the religion of Egypt, we do not see any example thereof in Grecian works.

These sphinxes were of gigantic dimensions. I cannot say colossal, for I do not know of any scale in nature to determine the point or to remove the difficulty, or to form a standard by. They are like the column; the term 'colossal column' is an absurdity.

Piranesi has likewise caught this idea, and made the most of it in a magnificent dream.

The Egyptians likewise used in the ornamental decorations of some of their sacred buildings a sort of frieze enriched with the representations of fishes and birds which, being either held sacred or considered as symbols of their religion, were therefore properly introduced by them in such places and for such purposes; but I believe there is only one instance in this country of large birds employed to support, although it was merely a balcony [by Henry Holland, at Albany, Piccadilly, London, 1803–4].

inflicting a very severe punishment on posterity, subjecting them to perpetual disgrace, thus visiting the sins of the fathers upon the children even beyond the third and fourth generation. But, admitting the Greeks to be justified in this mode of proceeding with their vanquished enemies, how will our architects justify a similar adoption in modern works? Upon what principle can we reconcile the introduction of male and female figures to support the entablatures of our buildings?[h] or introduce them with lamps in our houses, for the lighting of rooms, although Homer himself frequently alludes to this latter use of the human figure.

If caryatides or Persians are admitted in modern works, it must be as the late Pope has done at the entrance of the door into the Museo Pio Clementino,[7] or as Cardinal Albani did at his villa near Rome,[8] where four antique male statues supported a fountain. In any other case it is merely the act of a copyist who introduces that which he has seen, not because it is characteristic, nor because it is proper, but because when considered abstractedly it, to him at least, appears beautiful.

Besides Persians and caryatides, Pliny speaks of an attic order, a creature of necessity unknown in the best compositions of the Greeks, although in Roman works it assumed great importance, being used as a finishing to many of their buildings, as may be seen in the Piazza di [Forum of] Nerva, likewise in most of the triumphal arches, as well as in many other ancient works.

Modern architects have confounded the attic with the orders themselves, possibly from the text of Vitruvius who speaks of an attic but is silent respecting the ordonnance thereof. All we know of the attic is that it was a sort of short square column or pilaster with a base and capital.[i] The attic and pedestal are both accessories, and never to be used but from absolute necessity.

[h] Note. Certainly not. Not even the superior execution of the celebrated statues [by Jean Goujon, 1550–1] in the Salle des Suisses at Paris will plead an apology for so gross an offence against the decorum and propriety of our days. Let us remember the axiom that everything in architecture is to be accounted for, and we shall avoid such errors. Indeed, this axiom should be as fully impressed on the mind of the student in architecture, and as much revered as the 'nosce teipsum' ['know thyself'] of the Oracle of Delphos was in ancient times. Not even that gigantic and classical idea of Inigo Jones of a Persian Court in his design for a Royal Palace at Whitehall [pl. 20]; nothing can be more noble or magnificent and at the same time more absurd. However great the idea, it cannot be tolerated, unless in those countries which have declared eternal war against each other, and this would be against every principle of the laws of nations and of civilized society.

[i] Note. Particularly in the Pantheon of Agrippa, where it has a regular base and capital, and a cornice proportioned rather to the height at which it is seen from the pavement than to the attic itself.

　　　　Note. Compare the effect of the porch of St. Paul's finished with a blocking course or plain parapet, with the peristyle of the temple at Tivoli where, notwithstanding what Desgodetz says, there is no trace of any blocking or plain parapet over the entablature. If there had been any it would have altered the effect of the entablature materially, and the character of the order would have been changed from beautiful lightness to disgusting heaviness. (*continued on next page*)

[7] Sala a Croce Greca, Vatican, by Michelangelo Simonetti, 1776, for Pope Clement XIV.

[8] Soane made detailed drawings of the Villa Albani, Rome, on his visit to it in *c.* 1779.

However exceptionable the attic may be, the plain parapet or blocking course is still more so. This practice, however general in modern buildings, can never be admitted in any composition where an order of architecture is used. It alters the whole composition, it enfeebles the sensation, it destroys the proportion and character of the order entirely, and is unwarranted by the practice of antiquity.

I have now described the different orders of architecture, and also the origin and application of Persians and caryatides, and likewise what is called the attic order. I have endeavoured to point out the principal varieties, general characters, and proportions of the different orders of architecture as practised in the works of the ancients. These are the fertile sources of information to which we must look for correct ideas and a standard of taste; in each of them we find great beauties and some defects. The precepts of Vitruvius touching the orders have been also considered, as well as the works of the great masters of the fifteenth and sixteenth centuries. These orders from simple beginnings, enriched from time to time, have finally attained the utmost perfection; [so] that it is now dangerous to make any deviation from them without injuring them, and without doing too much or too little. Indeed, all the attempts to produce an entire new order have only disgraced the puny minds of those who flattered themselves with achieving such an object and have established the truth of what I have advanced.

The application of columns and entablatures is now to be considered. These noble parts of architectural decoration, when well proportioned as to strength and delicacy and properly arranged, can assume any character, and make the most powerful impression on the mind.

The column, one of the great features of every order, owes its origin to necessity, and its importance to utility and beauty. Whether it is considered for use or beauty, the truncated cone presents itself as the best fitted for those purposes; and the laws of nature, gravitation, and solidity direct it to be placed perpendicularly, yet Vitruvius says the columns of circular peristyles should be placed with an inclination towards the walls of the cella of temples, and in some ancient works they are so placed.

The magnitude and destination of the buildings must determine the order to be used, as well as the thickness and height of the columns. Situation, whether external or internal, must be attended to. If the column is too large, as at the portico of [blank][9] or too small,

Is this blocking course of modern invention, or is it the parapet which Moses directed the Israelites to add to their dwellings? I know not. Before our adoption of this mode of finishing the outsides of our houses, a large cornice was used which, at the same time that it concealed, it also contained the gutter. This species of cornice was not only useful but also produced a breadth of light and shadow and gave an appearance of grandeur and meaning to the whole front, whereas the blocking course only produces a heavy, clumsy, unmeaning effect. It is not only unsanctioned by any ancient example, but is against every principle of Grecian architecture.

[9] Perhaps the Admiralty, Whitehall (1723–26), by Thomas Ripley.

as in alcoves in bedrooms, then notwithstanding its tapering figure, easy and gradual transition from light to shade, and flowing outline of its swelled shaft, we shall be in all cases disappointed with the effect.

The dimensions or magnitude of the column is of importance. A column should never be really small, as in chimney-pieces, door dressings and such like. It must always be a principal actor in the drama, or it will become puerile and trifling.

The shaft of the column is frequently left plain, oftentimes fluted and cabled and otherwise enriched. In some examples it is rusticated, in others decorated with the prows of ships and similar devices fancifully imagined. The Egyptians, instead of flutes, used hieroglyphics to decorate the shafts of their columns. On these different modes of treating the shaft it may be observed that the column is *grand* in its simple state, *elegant* when fluted, and *degraded* when rusticated, or when its plan deviates from a circle, as in some modern works; but the quintessence of absurdity in form is complete when we use a twisted shaft.

To what strange caprice is the origin of twisted columns to be ascribed? It has been supposed that the twisted flutes in the shafts of some antique columns suggested this idea. Others have imputed the origin to the ivy and other shrubs twining round the majestic oak. Be it so; but will this, to sound taste, justify the introduction of such difficult and expensive deformity? The adoption of such forms would be as fatal in their effects and as repulsive to taste as the ivy is to the growth and health of the tree. The twisted column, says its admirers, has variety; so have the distortions in the works of Borromini, but it is a species of variety that gives pain, not pleasure.

Columns with twisted shafts are in architecture what deformed nature would be in painting and sculpture.

Bernini thought differently, and introduced these deformities in the Baldaquin of St. Peter's, and from the love of novelty all the world for a time followed the example.[j]

Is it not astonishing that with so many beautiful examples of shafts of columns formed by truncated cones,[k] gradually diminishing from bottom to top, and occasionally still more gracefully lessened by the entasis or swelling described by Vitruvius, that this form, so well fitted for beauty and for use, will not satisfy us? Man seems to delight in distorting all

[j] Note. Our disgust and mortification are increased at the sight of these columns because we cannot refrain from associating with them another idea, namely, that the Pantheon was shamefully robbed of many of its most beautiful antique metal ornaments to be thus strangely metamorphosed.

[k] Note. It was reasonable to imagine that the truncated cone, by its natural adaptation to the duties required of it, as well as by its fitness and beauty of figure, would have satisfied every mind. Yet such is the restless disposition of man, such his passion for novelty, and such the ascendency of false taste, that he is easily led astray by the dangerous beauty of some meretricious examples. Even among the ancient works are to be found deviations from this elegant and appropriate form of columns, whose shafts are twisted or otherwise distorted.

the works of nature: his horse, his dog, everything according to his language must be improved.

Too much attention cannot be paid to columns. According to Vitruvius they should be proportioned to the character they are to represent. Those for places of worship should give an appearance of solemnity, but those used for theatres, and such works, should be of a lighter proportion and different character. Symmetry and proportion should likewise be regulated by the intercolumniation. In proportion as the distance between the columns is enlarged, so the thickness of their shafts should be increased also; for, according to the width of the intercolumniation, the air, in appearance, lessens, and diminishes the thickness of the shafts. The columns at the angles of buildings are therefore made one-fiftieth part of the diameter thicker than the others; and for the same reason the second row of columns in porticoes should be smaller than those in the front row, because they are surrounded with a less quantity of air. In these cases judgement must correct the deficiency of sight.

In proof of this doctrine we may observe that small masses, viewed at a distance, diminish in a greater proportion than large masses; this optical effect, so well understood by the ancients, is of the greatest use to the architect, and the fact will perhaps be more strongly impressed on his mind if his attention is directed to the effect of a single column placed on an elevated situation. He will find that it appears more slender in proportion to the distance and medium at and through which it is viewed; i.e., if a column placed near the spectator appears to be seven diameters in height, the same will seem of eight, nine, or more diameters in proportion to its local distance and the atmosphere in which it is viewed. And from hence we see why objects of the same quantity and form, if used in different situations, produce different effects on the mind, and why many things which we view with such exquisite delight in the works of the ancients, produce a contrary effect when improperly applied by the unskilful; nor will the same objects succeed equally well in different scales: certain figures and forms require certain dimensions.

Let us now consider the application of the great treasures of our art according to the practice of the ancients in their temples and other works.

Vitruvius describes five species of temples, viz.,

the pycnostyle, in which the columns are placed 1½ diameters from each other, chiefly used with columns of the Corinthian order;

the sistyle, of two diameters;

the eustyle, of two and a quarter diameters;

the diastyle, of three diameters;

the areostyle, of four diameters.

From a view of these different species of temples it will appear that the pycnostyle and sistyle are too close and the areostyle too wide, and consequently deficient in strength. There remains only the diastyle, the latter of which on most occasions has been preferred.

These intercolumniations do not apply exactly to the Doric order; in that order the intercolumniations are regulated by the triglyphs.

These intercolumniations have a reference to insulated columns in peristyles, porticoes, and such like edifices, where they are necessarily placed near each other both on account of real and apparent solidity as well as beauty. But when columns are partly engaged in walls their intercolumniations are not so limited; they may be enlarged as in the theatres, amphitheatres, and other buildings of the ancients. The centre intercolumniations of porticoes and peristyles are for convenience, also occasionally made wider than the others, particularly in temples of the pycnostyle species, where the closeness of the columns was found inconvenient. But if some of the intercolumniations of the same building are made considerably wider than the others, the uniformity of the composition is interrupted and the effect of the whole is destroyed.

Besides the different intercolumniations spoken of, columns are in some ancient edifices placed at the angles of porticoes and peristyles, grouped or coupled together,[1] and they are sometimes arranged with pilasters. There is likewise another disposition of columns where the spaces are alternately equal. Some of the temples of Palmyra and Baalbec are composed in this manner, yet, notwithstanding these examples of remote antiquity, the French arrogate to themselves the invention. The ancients were doubtless well acquainted with the advantages, beauties, and defects of this arrangement, as well as with the superior effect of columns placed at equal distances. They likewise felt how much wide and unequal spaces weakened the sensation, and therefore rejected them.

The different aspects and figures of temples, as practised by the ancients, are thus described by Vitruvius, viz., in antis, prostyle, amphi-prostyle, peripteral, and dipteral.

Temples in antis are those which have two or more columns in front and an anta at each of the angles of the wall of the cella, with the entire entablature continued the whole extent of the walls of the temple. That of Victory without wings at Athens is an example of this species of temple. In a recent publication of Grecian antiquities, the Temple of Diana, mentioned in the 'Iphigenia' of Euripides, is described as being of this species. For which conclusion the reason given is that Pylades proposes to Orestes that they should enter the temple through the spaces between the triglyphs, which, as has been before observed, in the most ancient temples (according to Vitruvius) remained open. This circumstance is, however, no proof of what is advanced, for in the Temple of Concord at Agrigentum (which is peripteral), the entablature, with its metopes and triglyphs being continued all round the walls of the cella, would thereby offer the same facility in entering through the open spaces between the triglyphs, as [with] temples in antis.

[1] Note. In the Temple of the Clitumnus we find pilasters at the external angles grouped with columns. This may give an appearance of strength, but at the same time the pilaster viewed on the angle assumes a different proportion from the front view and offends the eye by its heaviness.

The prostyle temple differs from the temple in antis by having columns opposite the antae at the angles.

The amphiprostyle temple has the same parts as the prostyle, with the addition of columns in the portico.

The peripteral temple is surrounded with columns, leaving a walk all round between the columns and the cella, equal in width to one of the intercolumniations.

There are also pseudo-peripteral temples, that is, where the walks between the columns on the flanks and the cella are omitted, as at Fortuna Virilis and La Maison Carrée at Nîmes.

The dipteral temple is surrounded with two rows of columns forming double spaces or walks between the external columns and the walls of the cella. These spaces or walks are of the same width as the intercolumniation. This species of temple has generally eight columns in front and fifteen on each flank, reckoning those at the angles.

Pseudo-dipteral temples also occur in antiquity. They are similar to the dipteral, except in the omission of the inner row of columns, whereby more room is left for the sacrifices and ceremonies. This was an invention of Hermogenes, the architect of the Temple of Bacchus at Teos, of whom Vitruvius speaks most highly. Vitruvius tells us that in this disposition of columns there is to be eight columns in each front.

The ancients were particularly attached to circular peripteral temples, of which there is a beautiful example at Tivoli, and another dedicated to Vesta at Rome. No composition can be more attractive and pleasing than the circular peripteral temple. The variety and smooth graduation in the perspective, the different quantity of air which surrounds each column, the change produced by the fore-shortening of the capitals and the ornaments of the frieze, together with the accidental play of light and shadow, make the effect of the whole composition irresistible.

Vitruvius speaks of other temples whose plans form a perfect circle, and which are denominated monopteral, that is, with columns [but] without walls, of which I do not know of any ancient example now in existence.

There is also another species of temple called hypaethral, sacred to Jupiter, to the Sun, and to the Moon. These temples have peristyles externally and internally. The space between the internal peristyles were left open at the top because the ancients judged it highly improper to confine those divinities within walls. This reason is much more satisfactory than the motive assigned for this mode of construction by a late English writer on architecture who ascribes it to their ignorance of construction.[10]

Of hypaethral temples, the great temple at Paestum is a fine example. We have also another in the Temple of Jupiter Olympius at Athens (not that temple in which was placed the celebrated statue of Phidias, made of gold and ivory, sixty feet in height, where the god

[10] Chambers, *Treatise*, p. 23.

being represented in a sitting attitude, it was observed that if he chose to alter his situation he must infallibly strike his head against the ceiling). If the sculptor had not invaded the architect's province, this absurdity would not have happened. This is one of the proofs of the truth of the poet's observation.

'One Science only, will one genius fit.
So vast is Art, so narrow human wit.'[11]

Of this species of temple [hypaethral] there was another in the Island of Aegina in a temple to Jupiter, and another to the same divinity at Selinunte in Sicily, both of the Doric order.

The Pantheon in Rome is another example of the hypaethral temple. This stupendous structure, though stripped of its precious ornaments, and despite all the alterations it has undergone, is yet the most perfect and magnificent temple now to be seen.[m]

The portico[n] produces a depth and breadth of light and shade which astonishes the beholder, and prepares him for the sublime effect which the interior of this superb edifice presents. The paving of the portico and of the temple itself are now on the same level; formerly there was a descent of several steps which materially increased the solemn effect of this prodigious edifice.[o]

Besides the aspects of temples already mentioned, there were many others of singular beauty and happy invention, some of which were of amazing extent, such as the Temple of Diana at Ephesus, of which there are no remains, although its extent and richness [were] such as to occupy two hundred and twenty-five years in building, and to exhaust all the resources of Asia in its construction. Vitruvius has recorded the name of the architect, and many of the great writers of antiquity have been warm in their praises of this extensive structure, one of the wonders of the world. The Temple of Fortune at Praeneste[p] was

[m] Note. The roof of the temple was formerly covered with plates of brass gilt, and the enrichments of the interior were of silver and of other rich material, most of which were taken away by Constans the Second about the year 655. The ornaments of the portico were chiefly of brass: these Pope Barberini (Urban the 8th) removed and used in forming the Baldaquin in St. Peter's and some of the cannon at the Castle of St. Angelo.
'Quod non fecerunt Barbari, Romae, fecit Barberini.'

[n] Note. How strange it is that this noble portico has never been imitated. The French stumbled on it in the front of Ste. Geneviève, but love of novelty prevented Soufflot from fully availing himself of the opportunity. How flimsy do all the porticoes of modern times with a single row of pillars, however large, appear when compared with the portico of the Pantheon.

[o] Note. This practice [of a sunk floor] often occurs in ancient buildings and it has been successfully followed in the church of the Invalides.

[p] Note. Praeneste, or Palestrina is about 22 miles south-east of Rome. Carneades, the Athenian Philosopher, after visiting this extensive and magnificent assemblage of buildings observed: 'Nunquam se fortunatiorem quam Praeneste vidisse Fortunam.' [Cicero, *De Divinatione*, 2, 87]. (*continued on next page*)

[11] Alexander Pope, *Essay on Criticism*, lines 60–61.

also distinguished for its beauty, richness and magnitude. This building, which resembled a city rather than a temple, was considered by the ancients of the first importance. Built on the side of a mountain it formed several distinct stages, rising theatrically above each other, the whole terminated in a semi-circular form, decorated with columns whose capitals were different from those of the Greek orders. The remains of this proud fane are yet very considerable, and many have thereby been induced to attempt to trace its original plan, and to give an idea of the whole assemblage when in its perfect state.[12]

The Temple of the Sun, in the city of Palmyra,[q] like the Temple of Diana in Bubastis, is placed towards the middle of an immense quadrangle surrounded with magnificent rooms and lofty peristyles of Corinthian architecture. The grandeur of these buildings contrasted with the miserable hovels raised by the Arabs in the great area of the temple, shows at once the vanity of all sublunary things, and mocks, as in derision, the ancient splendour of this mighty edifice.

'There in the ruins heedless of the dead,
The shelter-seeking peasant builds his shed,
And, wondering man could want the larger pile,
Exults, and owns his cottage with a smile.'[13]

The great temple in Baalbec,[r] with its porticoes and courts, occupies several acres and offers another example of the honour paid by the ancients to their divinities, and to the priests who performed their sacred functions. The remains of this building are very

Pliny speaks of the mosaic pavement of the cella as being about eighteen by fourteen feet. This pavement was discovered in the time of Cardinal Barberini and removed by him into his palace built on a part of the site of the ancient temple, where it is carefully preserved. The Etruscans are said by some to be the inventors of this laborious art. Others ascribe it to the Persians, and in the Book of Esther, Chap. I, verse 6, we read that in the time of Ahasuerus, or Artaxerxes, mosaic pavements were in use.

[q] Note. Palmyra once boasted of a Zenobia [Queen of Palmyra] and a Longinus [her counsellor], and many of the great works of this famed city, of which a general view was given in the first lecture, claim the attention of the architect, more from variety of form, picturesque effect, elegance of decoration, and richness of materials, than from the purity of the architecture, which is almost entirely Corinthian. Palmyra seems to have been raised for superior beings; there is no space left for inferior dwellings, the whole site is filled with temples and palaces of such magnitude and splendour as induce the Arabs to ascribe the origin of those mighty works to the power of magic.

[r] Note. The buildings now remaining in Baalbec partake of the same character and extent, the same grandeur and solidity of execution, as those at Palmyra.

[12] In response to Soane's request for an illustration of Praeneste, Joseph Gandy sent him a rough sketch, adding that, 'my memory says it had the same Capitals and Columns as those of Tivoli . . . there were Arches combined with the Columns and Pilasters . . . it was an immense pile of architectural design on the side of the Hill . . . ascended by many zig zag staircases and terraces' (Gandy to Soane, 23 February 1813, SM Archives Private Correspondence III.G.1.8).

[13] Oliver Goldsmith, *The Traveller*, lines 161–64.

considerable and claim our highest admiration: the extended line of front, through whose centre you enter a large hexagonal court, leading into another of a quadrangular form, both of them surrounded with noble colonnades and sumptuous apartments for the priests and sacred ceremonies. At the further end of the great court is a temple worthy of pagan worship. Such an assemblage of grand and imposing forms cannot fail of creating sensations in the mind, easier felt than described.

There are two other temples in this celebrated city which merit attention. The first is octastyle peripteral: it is two hundred feet in length, with fifty-six columns, each forty-five feet in height. The other temple, formed by a portion of a circle, is a great curiosity. It attracts notice from the singularity of its plan, and from the peculiarity in the arrangement of the entablature. Much cannot be said for the correctness of this composition, but the variety and playfulness, due to the effect of light and shadow produced by the plan and elevation, is deserving of attention and praise. There is another singularity in the interior of this temple, which is decorated with the Corinthian and Ionic orders, and is, I believe, the only instance of the Ionic order to be found at Baalbec.[s]

The aspect of the Temple of Jupiter Serapis at Pozzuoli is, in many respects, like one of those in Baalbec, although on a smaller scale. The remains of this building are sufficient to impress us with an idea of its former grandeur.

The Temple of Isis in Pompeii[t] is an interesting structure. The drawings here exhibited were made from sketches made by stealth by moonlight, and are, I believe, accurate.[14] The temple itself is placed in the middle of an elegant court. The apartments for the priests, the purification altars, and other appendages of heathen worship, are worthy of the best attention of the architect and the antiquary.

The Temple of Peace in Rome, by some supposed to have been a part of the Imperial Palace, was built by Vespasian, and is one of the largest temples in that great city. Its figure is quadrangular, with three niches or tribunes on each side, and another opposite the entrance. Of this magnificent pile enough remains to enable us to ascertain its plan and style of decoration which, in point of execution, by no means keeps pace with the grandeur of the composition.

Other examples of ancient temples might be exhibited; I shall, however, only produce one more, the Temple of Minerva Medica in Rome. The plan of this edifice is uncommonly beautiful, and there is a peculiar lightness and skill in the construction of the dome that demands the consideration and serious attention of the young architect who is desirous of distinguishing himself in constructive knowledge, that very essential and necessary part of

[s] Note. This temple has been copied in Kew Gardens. [Temple of the Sun, 1761, by William Chambers]

[t] Note. This temple is of the Corinthian order, and it is worthy of observation that the capitals resemble those of the temple at Tivoli.

[14] Soane referred to the drawings he had made at Pompeii in January 1779, but he was wrong in claiming accuracy for them. See du Prey, *Making*, p. 137.

his professional pursuits. Many of the temples spoken of in these lectures were of such prodigious dimensions and embellished with such an immense number of columns, statues, basso-relievos, pictures, and every other decoration suitable to the genius and character of each building that, without those stupendous ruins of them now remaining, we should be justified in doubting their having ever existed. But we must not imagine, however, that all the ancient temples were equally magnificent and extensive. We must distinguish the body of the building from that which was only an accessory, and we shall then see that the temple itself made but a very small part of the entire assemblage,[u] and, moreover, that few of the ancient temples were really of such extravagant dimensions as even the works of later times. If, in speaking of the extent of the church of St. Peter at Rome we take into the description the area before it, the colonnades leading thereto, the Vatican Palace, the Sacristia and other buildings connected there-with; or if in describing a Gothic cathedral we include the immense cloisters and the religious edifices attached to them, such descriptions might in after ages, when the ruins of those buildings only existed, be equally a subject of surprise and doubt.

Although the temples of antiquity seem to have been without number,[v] it has been said that there was but little variety in their plans; but if Soria, who lived in the sixteenth century and professed to have measured and delineated many of them from ancient ruins, of which no remains are now to be seen, can be depended on for correctness, the plans of many of them were full of rich fancy and elegant contrast.

It is of great importance to the young artist to be well informed of the practice of the ancients in all cases, and although temples are now only required, and that but occasionally, in pleasure grounds, yet such principles of beauty, proportion, and harmony will be acquired from the study of them as will apply generally. The student, therefore, should be fully acquainted with the different forms and constructions of ancient temples. In them he will discover many of the great principles of his art; in them he will learn many of the laws of composition; he will observe the beauty of form, and the correct application of the sublime to architecture, the effect of the whole being so well understood in those great works. These principles must be so far applicable in every species of building, whether public or private, whether great or small, as to amply reward him for his labours. For be assured, my young friends, that the hand of the artist and the mind of genius are as

[u] Note. If we look at the Temple of the Sun at Palmyra, the great temple at Balbec, Jupiter Serapis at Pozzuolo, Isis in Pompeii, and others now remaining, we shall see that the temple itself made but a small part of the entire edifice. The Egyptian temples also consisted of a prodigious assemblage of buildings with avenues of very considerable extent, often decorated with sphinxes, lions and other animals of gigantic dimensions.

[v] Note. This cannot be matter of surprise: the ancient conquerors were ambitious to transmit their achievements to posterity by erecting public porticoes, or temples to the gods. Pompey, after the eighty years wars, built out of its spoils a temple to Minerva. Pliny has handed down to us an inscription it contained giving a summary of his victories. Pliny, Nat. Hist., Book vii, ch. 26.

correctly traced in the humble dwellings of individuals as in the magnificent palaces of the great. Nay, to give an interest to small edifices of moderate expense requires more than common knowledge, judgement, and taste. In the temples of the ancients we saw the different manners in which they introduced entire columns in the external decorations of those structures; and although entire insulated columns are always to be preferred, yet from motives of economy and other causes, they cannot always be admitted in modern works. And even the ancients sometimes deviated from the use of the entire or insulated column.[w] In various celebrated works of antiquity we find portions of columns used in situations where only one order occurs, as well as in others where several orders are placed over each other, as in the Theatre of Marcellus and in the Colosseum of Vespasian. At the same time it must be allowed that mutilations of every kind are defects in art, which on all occasions are to be avoided.

The ancients sometimes placed insulated columns on pedestals. The buildings at Palmyra and Baalbec, the stoa or portico at Athens, and the triumphal arches of Italy and Greece, furnish examples. Palladio also gives an instance of this mode at Scisi [Assisi], a city of Umbria. All these examples, however, will not justify the practice, which is contrary to first principles and which reason must condemn. However improper it may be to place detached columns on pedestals, detached columns or corbels (as in Diocletian's Palace at Spalatro and in the Baths at Rome) are still more licentious, and more painful to the sight. In spite of all precedents, whether ancient or modern, this practice cannot be justified.

In the first lecture I endeavoured to show the probable causes which first led to the introduction of that noble and most useful part of architectural decoration, the column, into the interior of ancient edifices. We have a very singular example of this practice in one of the temples at Paestum [Hera I], where the entire building is divided into two equal parts by a line of columns placed longitudinally. Some have supposed that columns were thus used in temples where two divinities were worshipped under the same roof, as in the Temple of Erechtheus. But admitting this conjecture to be right, it will not account for the placing a column in the centre of the front of a building, as in the front of the Temple of

w Note. Examples of portions of columns [i.e. engaged columns] occur in the Temple of Erechtheus at Athens, in the Temple of Æsculapius at Agrigentum, in the flanks of the Temple of Fortuna Virilis at Rome, and in La Maison Carrée at Nîmes, built in the time of Antoninus. This building is considered, by some, as of the most perfect kind; it certainly is entitled to great praise; although in this particular it is deficient, it is much less so than in many others, inasmuch as there are no imposts or fascias to destroy the swelling outline of the column. The whole space between the base and capital is in the true style of antiquity, without fascia, impost, or any other interruption, for when an impost occurs, and the column projects from the wall only half its diameter, its simplicity and grandeur is materially injured, as may be seen in the Theatre of Marcellus and in the Colosseum. In a work of high antiquity, the sepulchre at Albano, and a mausoleum in France [Monument of the Julii, Saint-Rémy], the mouldings are returned to preserve the outline of the columns. Semi-columns are also used in the Arch of Titus in Rome and in the Arch of Trajan at Beneventum, which latter is in many parts an exact copy of the Arch of Titus.

In the Arch of Ancona, erected to Trajan, semi-columns are also used.

Victory, or for the same singularity in the Monument of Thrasyllus. These practices, however sanctioned by antiquity, whether occasioned by any religious motive, by necessity, or by whatever other cause the ancients were actuated, is contrary to the general laws of nature as well as to our ideas of convenience, which invariably directs the entrance to be in the centre of the building; yet, strange to say, this example of remote antiquity has been copied in some late works without any apparent motive than the love of what is uncommon. This circumstance is another proof of the necessity of our recurring to first principles.

In the Egyptian Temple of Canopus or Knuphis[15] there is a column in the centre of the front, and it is worthy of remark that even this circumstance has been brought in proof of the Greeks having taken many of their ideas from the Egyptians. (When once we have adopted an hypothesis, what lengths we go to support it). Surely if we recur to the primitive model of the Greeks we shall see that this practice, with them, was at first the off-spring of necessity, and afterwards continued by a religious adherence to first principles, and to their imitative system.

When either of the orders of architecture are used in the interior of buildings, such parts of the entablature as apply exclusively to external decoration should be suppressed. Thus the ancients preserved the characteristic beauty of the column, and at the same time pleased the eye, and satisfied the most correct judgement. The text of Vitruvius and the primitive model agree with this doctrine.

In the best works of the Greeks, where entire columns or parts of columns are used internally, the frieze and cornice are omitted. Indeed, the Greeks were so mindful of the origin of the entablature that they rejected the frieze and cornice, not only in their internal decorations, but also in the interior of their peristyles, as in the Temples of Minerva at Athens, and at Syracuse, in the Temple of Concord at Agrigentum, in the great Temples at Paestum, and in the Propylaea.[x]

The suppression of those parts of the entablature which can only apply to external decoration is also attended to in many of the Roman buildings. In the interior of the Portico of Octavia there is an architrave only above the column.

Within the portico of the Pantheon, the finishing over the columns is little more than an architrave and a small cornice.

[x] Note. The regular entablature cannot be retained in internal decoration without sacrificing all pretensions to propriety of application. That which has not propriety and truth for its basis, though it may please the unskilled, yet it cannot fail of disgusting the judicious. If we follow the best examples of antiquity, we shall please the eye and satisfy the most correct judgement without destroying any of the characteristic beauties of the orders.

[15] Mammisi Temple, Island of Elephantine. Soane was wrong in supposing that the building contained a centrally-placed column.

At Tivoli, under the ceiling of the inside of the peristyle, there is a small cornice only, ranging with the external cornice, as directed by Vitruvius.

In the Temple of Mars the Avenger, the finishing to the inside of the portico, above the columns, is not contrary to first principles.

In the Basilica of Antoninus [Constantine] there is only an architrave above the column, but in the Temple of Concord at Rome there is an architrave and an enriched frieze.

It gives me great pleasure to produce an example in a modern work wherein this propriety of application has not been overlooked.[16] The student will also perceive other circumstances in the work now exhibited deserving his most serious consideration.[y]

But even the ancients were not always mindful of first principles. Every ancient artist was not able to bend the bow of Ulysses to wield the club of Hercules, or to contend for the armour of Achilles. If we examine further into the remains of antiquity we shall find examples wherein the regular entablature, originally used for external decoration only, is placed over columns in the interior, not only in the buildings at Palmyra and Baalbec, but also in others erected in better times.

In the Temple of Peace, the entire entablature (with the omission of the corona) is placed over insulated columns, from whence the stupendous vaulted ceiling springs; and the vaulted ceiling of the great hall in the Baths of Diocletian was likewise supported by insulated columns, with entablatures breaking over them.

Although in these examples we find both modillions and dentils, yet as those parts owe their origin to the roofs of buildings they can never be used with propriety in the interior; and although custom may familiarize us to such absurdities nothing can justify them. Unfortunately we are prone to take the bad, and hence we see not only modillions and dentils in the interior decoration of many modern works, but also the heads of lions,[z] which latter (according to Vitruvius),[17] were never used by the ancients except to carry off the water from the roofs of buildings, as may be seen in the Tower of the Winds at Athens and in the Temple of Minerva in the Acropolis.

[y] Note. I am the more anxious to fix the attention of the student on the interior of this particular building because in the early part of my studies, being accustomed to see in books of architecture, the same entablatures in the interior as in the exterior, the deviation shown in this drawing I could not account for; and therefore, like a young man, supposed it defective: but as soon as I was led to consider the principles of Grecian construction, not only the eye was pleased, but the judgement was satisfied with this example of refined taste.

[z] Note. Among the Egyptians the lion was a type of an inundation. Herodotus [Beloe's edition, vol. i, p. 323].

[16] All Hallows, London Wall (1765–67), by George Dance who employed an enriched frieze in the interior instead of a full entablature, in conformity with much antique practice.

[17] *De architectura*, vii, 5.

In the Pantheon also, as well as in the last examples, the regular entablature with modillions in the cornice, is placed over columns, but I think under such circumstances as will justify the application. I shall give my reasons for this opinion when speaking of the altars in that celebrated work.[18]

It has been already shown that the ancients sometimes used portions of columns in external decoration. I shall now give examples. The ancients did not always use entire columns internally any more than externally: portions of columns also occur in some of their best works.

In the Temple of Erechtheus there is an example of this kind, and I think the Choragic Monument of Lysicrates may be quoted as another, and in the magnificent remains of Palmyra and Baalbec frequent instances of semi-columns occur in the interior of those stupendous works.

Whether columns in the interior are for ornament or use, the regular entablature cannot be applied, for many of its parts can have no analogy with the interior but refer to external decoration only. For instance, the modillions and mutules which represent the principal rafters; the dentils which represent the common rafters, and also the upper parts of the cornice intended to carry off the rainwater, etc., these parts refer only to the exterior of buildings. In this opinion also we are strengthened by the text of Vitruvius who expressly says that in the interior of peristyles the regular entablature is not to be used, and of course this precept will apply in a still greater degree to the interior of rooms.

Columns, both in external or internal decoration, make, as it were, the scale for all the rest of the building. Their relative magnitude therefore is of the greatest importance, for if they are introduced either externally or internally for the decorations of dwelling houses or other buildings of moderate extent, unless particular attention is given to determine their relative magnitude, the work will not only appear less than it really is, but convenience also will be frequently sacrificed. This will in a great measure justify the observation of some fashionable builders of the present day who speak of columns as things now out of fashion.

Private houses are in general not sufficiently large for the admission of columns. If of small dimensions, as in the alcoves of bedrooms, all the parts being brought near the eye, the whole appears heavy and misplaced, although with the same proportions on a larger scale, they would appear light and pleasing. Whoever compares the external effect of St. Paul's Church, Covent Garden, with the same design on a smaller scale at Claremont,[19] will be convinced of this very important truth. And we may further observe that however suitable and well calculated the Doric order may be for the external decoration of large buildings of a particular character, yet from the small number of parts of which it is

[18] Lecture iv, p. 99.

[19] Soane here referred not to Claremont House, Surrey, but to a now disappeared temple in the garden.

composed, together with the great projection of the cornice and the massiveness of the columns, it becomes totally improper for the internal decoration of houses, except in large halls and in subterranean places. And although the Greek Doric column, with its massive entablature, as used in the early temples of the Greeks, is occasionally seen in the dwelling rooms and galleries[20] in the houses of men, in many respects distinguished for classical knowledge and correctness of taste, yet such practice is contrary to every rational principle of internal decoration, and also to the text of Vitruvius who expressly directs the proportions and symmetry of columns in such situations to be of a light gay character, and not solemn and heavy like those used in temples. By these errors we misplace the noble ideas of the ancients, and make (by improper application) things in themselves noble, grand, and impressive, merely mean, paltry, and disgusting, and sometimes even ridiculous.

It is doubtful whether the Greeks and Romans used columns in the interior of their houses. There is no such example to be found at Pompeii, nor in the remains of the villa of Hadrian, nor does Pliny speak of them when describing his villa. And the reason seems obvious: the column presents, as it were, a scale, and ought always to convey an idea of magnitude, of superiority, and of marked distinction, calculated to command attention, consideration, and respect.

Columns upon columns frequently occur in the remains of Roman grandeur. In the Theatre of Marcellus we have two orders one above the other; in the Colosseum four orders, surmounted with a pilastrade. These are only portions of columns attached to the walls, of which many other examples may be quoted, but I do not know of any example in antiquity of insulated columns placed upon columns in peristyles and colonnades, not even at Palmyra, Baalbec, or Spalatro. Indeed, there is so much difficulty in introducing two orders of insulated columns, without committing such dreadful outrages on propriety, that two orders on all possible occasions are to be avoided.

It is true insulated columns above columns are to be seen at Athens, particularly in the Arch of Theseus, or Hadrian, for it is known by both names, but this building is of the worst time of architecture. I know not the age of this work, but it is full of absurdities. It is my duty however to point out those examples which the student is to shun as well as those on which he must establish his ideas of true taste.

Vitruvius tells us that the Greeks placed insulated columns above columns in their forums and basilicas, and he directs the upper columns to be made one-fourth part less in

[20] Soane doubtless had in mind Thomas Hope's gallery in his mansion in Duchess Street, London (*c.* 1800). Soane wrote in 1813, in the course of notes on ceiling design: 'what a difference between the monotonous, cold and frightful sight of those [modern] plastered ceilings and the view of the ancient majestic ceilings, so calculated to animate the artist, so varied, whose beams and joists forming compartments were decorated with the greatest care and protected from damp and insects by fine colour . . . Oh Mr Hope why did you in your new gallery forget the beautiful ceiling of Minerva [ie. the Parthenon]' (*Extracts Hints etc for Lectures on Architecture 1813–1818*, SM Soane Case 170, fol. 238).

height than the order over which they are placed. The intention of Vitruvius seems to be to make the upper columns a continuation of the lower. This is consistent with his ideas of the origin of columns, which he supposes to have been from trees. The great disproportion between the two orders of columns in the great temple at Paestum, is sufficiently accounted for by a recurrence to the imitative system of the Greeks, and from which they never departed, wherein we see the flatness of the roof produced the shortness of the columns; and it is worthy of observation that wherever insulated columns above columns were used in ancient buildings, whether in external or internal decoration, there is always a very great disparity between the two.

From the difference in the climates of Italy and Greece, the Romans made their pediments higher than those in Grecian works; from hence it follows that in Roman buildings, where insulated columns were placed above insulated columns, the upper order would be higher in proportion to the order on which it was placed, but that this was not the case may be seen in the Temple of Jupiter at Spalatro. But this is only another proof of the blind manner in which the Romans followed the Greeks.

Columns placed upon columns, whether insulated or attached to walls, produce some serious difficulties, glaring absurdities, and striking contradictions. The cornice belongs exclusively to the roof of a building; it must therefore be entirely suppressed between the two orders, and if this be done, although propriety is in some degree preserved, an essential beauty is destroyed; yet if the building shows more than one storey in height, this is better than having two or more storeys included in the height of one column, as frequently occurs in modern works. But if two or more orders of columns are to be used, they must be of large diameters, as at the Theatre of Marcellus, the Colosseum, and many other ancient buildings. The two orders of columns in the front of the Banqueting House at Whitehall, are sufficiently large as to the relative proportions of the whole front; but those at Castle Ashby are so small as to make the warmest admirer of columns regret to find them there.[aa]

In this latter example we have many of the striking defects of placing columns above columns without suppressing all the cornices except the last. Here we see the cornice to the upper order, which is the farthest from the eye, being proportioned in a great degree to the height of the column, does not project sufficiently to throw off the water from the roof to a sufficient distance from the foundation of the walls so as to secure them from damp, but on the contrary it falls on the cornice of the order beneath it. To avoid this evil, and also in some measure preserve propriety, the cornice of the upper order at the Theatre of Marcellus is much heavier than the cornice beneath it. If, however, columns must be

[aa] Note. Michele Sanmicheli in the Grimani Palace at Venice has felt this impropriety; so likewise in the cornice over the attic pilasters in the Pantheon.

placed upon columns, we cannot do better than to follow the ancient practice in the hypaethral temples, and also in the text of Vitruvius: that is, to suppress the cornice of the first order altogether.

I have endeavoured to show the principal examples of the manner in which the Greeks and Romans used the orders at different periods for external as well as for internal decoration, and we may observe that in the works of the Greeks (until their subjugation by the Romans) mutilated forms seldom occurred. The Romans were not so nice, and we see how little attention they paid, even in many of their great works, to the examples of Greece, executed on the principles of their primitive model. Hence architecture degenerated most rapidly as will be shown in the next lecture.

Many persons have considered the orders of architecture as unalterably fixed by the ancients,[bb] and therefore on every occasion most religiously to be adhered to, in all their proportions, forms, and ornaments, whether they were used in town or country, whether public or private works, whether in great or small buildings, let the situation, destination and character of the structure be what it will, let the materials be of what quality soever, still the orders were to be the same. This is directly contrary to the doctrine of Vitruvius, who expressly says that the proportions of columns in theatres and private buildings are to differ in their proportions, forms, and ornaments from those used in sacred temples. Had not this variety been necessary, architecture would have been mere matter of routine. The most ignorant mechanic and the first genius might have exercised the profession with equal success. Others have held opinions directly opposed to those just mentioned, and having observed in many ancient buildings prodigious differences, even in the essential parts of all the orders, they therefore concluded that everything in architecture was only matter of whim, caprice, and fancy, unrestrained by rules and unregulated by any fixed principles. Nothing, however, can be less founded than this doctrine, nor more fatal to art. I shall conclude this discourse with a few general observations.

The ancients have not in any two edifices used the same orders with the same proportions, forms, and ornaments, nor without great variations and marked modifications. Indeed had not this been the case, few if any of their works would have had any pretensions to character, nor would have gained the admiration and approbation of mankind as they have done in all succeeding ages. The fact is that of the ancient buildings now remaining, the Arch of Titus at Rome and the Arch of Trajan at Beneventum excepted, there are no two of them with the same order without the most striking differences.

Architecture, whose importance and honour my situation in this Institution requires

[bb] Note. No two examples of the same order in antiquity were alike, unless all the circumstances were alike also. This fact is well worthy of the most serious attention of the architect. It may be considered as an axiom, inattention to which has produced prodigious mischief in architecture, and occasioned the introduction of as much bad taste as almost any circumstance whatever.

me to defend, has not since the time of Lord Burlington kept pace with painting and sculpture. These arts have a Buckingham, a Hardwick, a Beaumont, and a Damer,[21] who not only encourage but really exercise them with a distinguished success. There is likewise a British Institution for the express advantage of painting and sculpture.[22] Until architecture has a Burlington, a Pembroke or a Camelford[23] to direct the public taste, we can have but little hope. Indeed, until those who build are competent to judge of art, however we may lament the circumstances we must not be surprised at seeing so many works of high importance and of great expense entrusted to bricklayers and carpenters, even buildings wherein the national taste is implicated. In my last lecture I recommended to the students the serious perusal of the works of Vitruvius and those of the great Italian architects as well as the French and English writers. Piranesi alone will afford a mine of information to the studious inquirer, and from his overflowing much may be gleaned; and although L. B. Alberti failed in his attempt to rival Vitruvius, his work is too full of erudition and deep inquiry not to be read without great advantage. By the attentive reading of these works, by measuring and drawing the remains of antiquity, and by serious reflecting on the principles on which those edifices have been produced, the taste of the student will be formed, but unless practice is added to his theory he will be little more than a fine draughtsman. Drawing, although a desirable and most necessary qualification, makes a very small part of the requirements requisite to form an architect.

The students in painting and sculpture have many facilities afforded them which those in architecture are deprived of. Plaster casts from many of the finest statues and basso relievos of antiquity are constantly before them, and many of the most scientific pictures of the great masters are likewise in this country, whereas the architect has no models of ancient buildings to consult, nor plaster casts of their ornaments and component parts to refer to. His only acquaintance with the remains of the structures of the ancients must be obtained by a great sacrifice of time and expense, often beyond the ability of many of the students; and when this is not the case the student can only contemplate the works of antiquity through the medium of prints and drawings, of which, it must be admitted, we have abundance, but frequently differing so much from each other that it is impossible for the artist to know on which he is to rely for fidelity of representation.

Will the most accurate and perfect drawings of the celebrated statues and basso-relievos of antiquity give adequate ideas of them to the painter or sculptor? No, and it is

[21] Soane's distinguished patrons and practitioners of the arts were Charles Lennox, 3rd Duke of Buckingham (1735–1806); Philip Yorke, 2nd Earl of Hardwicke (1720–90); Sir George Beaumont, 7th Bart. (1753–1827); and the sculptress, Mrs Anne Seymour Damer (1749–1828).

[22] The British Institution opened in 1806 in the former premises of Boydell's Shakespeare Gallery in Pall Mall.

[23] Soane's noble practitioners of architecture were Richard Boyle, 3rd Earl of Burlington (1694–1753); Henry Herbert, 9th Earl of Pembroke (*c.* 1689–1750); and Thomas Pitt, 1st Lord Camelford (1737–93).

the same with the architect. Drawings and prints, however correct they may be, can give but very imperfect ideas of real and relative quantity; nor will they show the great varieties in the effects produced by the same objects when seen with different lights and shadows upon them, and even if correct representations were sufficient for every useful purpose of study where are they to be found – how are they to be obtained? Will the works of antiquity as shown by Palladio, Scamozzi, and Vignola give artists correct ideas of the original building? Can he depend on the delineations of Desgodetz?

Towards the end of the seventeenth century a more correct knowledge of the ancient buildings than the works then published afforded being found necessary, the great Colbert, at the expense of the French government, sent Monsr Desgodetz, a celebrated architect, to Rome, to measure with the utmost accuracy whatever he found worthy of notice in the remains of antiquity. On his return to France the results of his industry and application were published at the expense of the French Government.[24] In this splendid work all the ancient buildings are most judiciously shown in the state Desgodetz found them without any attempt at restoration, the rock on which Palladio[cc] and others had split. Amidst the merits of it must be noted that in almost every page we find the errors of Palladio and others pointed out. Of course, it might be expected that the labours of Monsr Desgodetz would have been the great desideratum required for correctness; but the reverse will be found to be the fact. In proof of this assertion I shall exhibit a drawing of the temple at Tivoli as given in his book, and likewise a drawing of the same building from my own mensurations which have been collated with those of several other persons. The uncommon accuracy of one of them in particular, who is a member of this Institution, is well known.[25]

Other examples of the inaccuracy of this celebrated architect might be given,[26] but these are sufficient to show the serious difficulties the student in architecture has to

[cc] Note. Palladio, it must be admitted, took great liberties, and gave us what he thought the buildings should have been rather than what he found them. In the Temple of Antoninus and Faustina, Palladio tells us he did not find the least trace of any foundations beyond those of the temple itself, nor any ornaments whatever, yet he concludes there must have been many very magnificent ones therein, and without any data other than the wildness of a heated imagination, in his rage for composition he imagines a grand cortile surrounded with niches and statues without number, forgetting that to obtain sufficient space for his plan many buildings which were known to have been in existence long before and after the Temple of Antoninus and Faustina must have been completely removed.

[24] Soane bought his first copy of Antoine Desgodetz's *Les édifices antiques de Rome* (Paris 1682) in September 1786, subsequently acquiring a further three copies, one of which he annotated heavily.

[25] The Royal Academician to whom Soane referred was George Dance. Soane was here somewhat disingenuous, as his drawings of the Temple of Vesta at Tivoli were, in fact, copies of those by Dance. See du Prey, *Soane Making*, pp. 148–51.

[26] In his edition of Soane's Lectures, Bolton speculated that *The Architectural Antiquities of Rome measured and delineated by G. L. Taylor and E. Cresy*, 2 vols, London 1821–22, may have been inspired by Soane's criticisms of the inaccuracies in Desgodetz's *Les édifices antiques de Rome*.

encounter, more than those which attend the painter and sculptor; and I think it will be admitted that however arduous the undertaking may be to form a painter or sculptor, to make an architect is not less so.

Painting and sculpture are arts of imitation and have always a model in nature before them which is only to be copied, whereas architecture being an art of invention has no such models to refer to. Architecture owes its origin to necessity, and its high rank as an art to its power of pleasing and of contributing to the accommodation and convenience of all mankind; whilst the other arts are chiefly indebted to luxury only, for the estimation they are held in by society. As far as intellectual satisfaction is considered all the fine arts have equal power to please.

I have been induced to make these observations to counteract any ill effects that might arise out of some distinctions lately made in a public institution, the object of which seemed to be to treat architecture as an inferior brand of the fine arts, a mere mechanical art within the grasp of any common mind.

Against all such novel illusory and unfounded opinions, I wish to protest; and at the same time to point out the rank which architecture has always held among the liberal arts. We have only to recollect that in grammar the climax of excellence is marked by the positive, comparative, and superlative. We likewise say, our king, our country, and our god, and by a similar arrangement when speaking of the fine arts, we say, painting, sculpture, and architecture.

LECTURE IV

~

MR. PRESIDENT, – The origin, proportions, and application of the different orders of architecture, and also of Persians and caryatides, as used in the external and internal decoration of temples and other public works of the Greeks and Romans, having been already considered, I shall now subjoin a few observations on the further use made by the ancients of that noble part of architectural decoration, the column, a leading feature of each order.

Columns were not limited to the purposes already mentioned; they were often applied to record the actions of great men.[a]

From Homer we learn that Ulysses raised a column on a hillock in memory of Elphenor who broke his neck by falling over a staircase in the Palace of Circe.[1]

Pompey the Great, as we are told by Pliny, erected many trophies and triumphal columns commemorative of his splendid victories.[2] And in another period a column decorated with prows of vessels was dedicated to Duilius, in honour of his having gained the first naval victory[b] over the Carthaginians. These instances and the column erected in the centre of Trajan's Forum (pl. 3)[c] as well as the Column of Antoninus at Rome, and

[a] Note. If a column is used for such purposes, in such cases we are not confined to the strict rules of the order: it would be absurd to introduce frieze or cornice. Perhaps the pedestal may be used with peculiar advantage to raise the base of the column at least as high as the eye of the spectator.

For want of recurring to first principles, when I built the column for Mr. Evelyn at Felbridge Place, Surrey, the column there was surmounted with an architrave, frieze, and cornice.

[b] The first pillar or column on which a statue of brass was placed was of P. Minutius, the expense of which was defrayed by the people of Rome, each subscribing voluntarily the value of an ounce of brass coin. Pliny, Book XXXIV, ch. 5.

[c] Dion Cassius says that the pedestal of Trajan's column was intended for his monument (then it must have been for a cenotaph), and the column to record his actions. Or perhaps, as others have supposed, the (continued on next page)

[1] John Ogilby, *Homer, his Odyssey translated*, London 1669, book 12, p. 164.

[2] Pliny, *Historia naturalis*, vii, xxvi, where Pompey is recorded as 'erecting trophies in the Pyrenees'.

that of Theodosius at Constantinople, together with the Temple of Juno, supported by columns on which, according to Pausanias, different traits of fable and history were represented, explain the uses made by the ancients of columns, and may be at the same time considered as so many historical records of antiquity.

So great was the love of the ancients for columns, and so necessary were they considered to the decoration of their temples, that historians tell us it was very common for several of the small Grecian states to join in the expense of building a temple to their favourite divinity, each state separately not having the means of erecting a suitable building. This relation is in some degree established by the remains of a temple at Jackly, where on the shaft of each column there is a small tablet on which is inscribed the name of the person at whose expense it had been presented. So fully impressed were the ancients with the superior beauty of columns that they endeavoured to use them on every possible occasion. In the works of the Egyptians we frequently see porticoes of four, five, and sometimes six rows of columns disposed in parallel lines. At Palmyra are the prodigious remains of a most magnificent portico of several thousand feet in extent. In Rome, Agrippa erected a noble portico of marble columns round the Septa,[d] or Comitia, which had been previously only surrounded with wood. There was also another portico in Rome of uncommon grandeur, erected at the expense of Pompey the Great, for the accommodation of the Roman people, and of which considerable remains were to be seen in the seventeenth century. Of the Portico of the Argonauts, attached to the Temple of Neptune, in which Agrippa[e] placed pictures representing the expedition of the Argonauts, unfortunately there are no remains. The Portico of Octavia, erected by Augustus in honour of his sister,

ashes of Trajan were preserved in an urn, and deposited in the centre of the pedestal of this column. In order to perpetuate the memory of the victories of Trajan over Decebalus, King of Dacia, and to transmit to posterity the history of his Dacian conquest, the Senate and people of Rome caused this column to be erected, on which the progress of Trajan's Wars in Dacia are represented in basso relievo.

Without the examples of sculpture introduced in this manner on the Trajan and Antonine Columns, we should perhaps have had some difficulty as to the practicability of such records.

The Column near Assinaris [the modern Asinaro] in Sicily is another example of an historical column [known as La Pizzuta].

Plutarch in his life of Nicias says that great man erected a pillar in the Isle of Delos, and inscribed on it an account of his benefactions. Plutarch [J. & W. Langhorne, ed., 1774], vol. III. p. 254.

[d] Note. The Septa, or Ovile, so called from its resemblance to several sheepfolds, was a place in the Campus Martius where the Comitia, or assemblies of the people, were held for the election of magistrates. The Curia of Tullius Hostilius has been by many considered as the ruins of an ancient portico. Others have supposed it to have been the Nympheum of Nero. Piranesi, in particular, was of this opinion, and his inventive fancy has accordingly from these ruins formed a most elegant plan of what it was. Piranesi, *Le Antichità Romane*, tom. I, tav. 41.

[e] Agrippa composed an oration pointing out the advantages to art, and to the public taste, if pictures and statues were considered as belonging to the public, and not dispersed over the country or hid, as it were, in private dwellings.

is a work of great beauty and extent. In it were contained the temples of Jupiter and Juno.[f] Of these buildings parts are yet remaining.

From columns the transition will be to the antae, or pilasters,[g] of the Greeks and Romans, a part of my subject which requires particular attention. The Greeks seem to have confined the antae chiefly to decoration, and to make their appearance pleasing, and to harmonise them with the columns, they assigned to them a base and capital, analogous to the order they accompanied, only less decorated. And as the antae represented the ends of walls, we therefore, in all the best works of the Greeks and Romans, find them undiminished. According to Vitruvius, the Grecian architects made the antae as wide as the diameter of the columns they accompanied. In the remains of Grecian structures they sometimes correspond in their width with the inferior, and sometimes with the superior, diameter of the columns, agreeably to the character of the order with which they are used. And here be it particularly noticed that in Grecian structures antae were never used without columns to accompany them.

In the inestimable remains of Grecian architecture, antae are seen wherever the walls of the cella form salient angles, and also at the ends and returns of those projecting walls which form part of the pronaos of their temples. The antae are also returned on the sides or flanks of prostyle temples. In such cases the mouldings of the capitals of the antae are continued under the architrave from one anta to another. When antae are employed in this manner, as in the Temple on the Ilissus, they are generally made narrower on the flank, or

[f] This portico and the two temples are shown on the ancient marble plan of Rome (tab. 2). Some remains of these buildings still exist in the Pescheria and in the Church of Sant' Angelo. See Piranesi, *Ant. Rom.* tom. IV, tav. 39, and Desgodetz, [*Edifices antiques de Rome*].

In one of these temples the celebrated Venus de Medicis was found, and also a sitting statue of Cornelia, the mother of the Gracchi, was also found in the same place.

Pliny also informs us that the temples within the porticoes of Octavia were created by Scarurus [Sauras] and Petrarchus, [Batrachus] two Lacedaemonian architects, who offered to perform the work at their own expense if they were allowed to inscribe their names to that effect. This request was refused, but they contrived to preserve their names by an hieroglyphical or symbolical engraving, 'in spiris columniarium,' of a lizard and a frog, the Greek names of these animals being the same as those of the two architects. Pliny, Book XXXVI, ch. 4, and Winckelmann, *Mon. Inediti*, [1767, vol. II], p. 270.

[g] Note. Pilasters, properly speaking, are square columns, that is to say when detached, and the antae are the flat projections used to strengthen the Greek buildings, and which were frequently less in width on the flanks than in the fronts. In the front view the diameter of the column usually determines the width of the antae, but in the flank the object of strength is obtained with less superficies, and consequently heaviness avoided.

Pilasters, properly so called, do not exist in the Egyptian architecture. It is too much perhaps to look at the solid masses at the extremities of some of their temples as pilasters, or the small square projection in the sepulchral chamber of one of the great pyramids. These projections are only six inches on the face, and about three feet apart from each other.

Qua[tremère] de Quincy,[*De l'architecture égyptienne*,] p. 114.

side face, than on the direct front view.[h] The reason of this is obvious, namely, to prevent that unavoidable disproportion which in some oblique views would be apparent to every eye if the front and flank, or return face, of the antae were of equal width.

Antae are sometimes placed behind columns to receive the ends of the entablatures, as in the triumphal arches. We also see them in the peristyles of peripteral temples facing the columns at the external angles of the walls of the cella, to strengthen those parts and to shorten the bearings of the transversal architraves, and for other purposes, and on other occasions.

In all the examples referred to the antae are introduced more for decorative appearance, and to preserve the symmetry of the whole composition, than for any real strength or advantage. From these circumstances we are led to conclude that the Greeks considered them not as principals or essential ornaments, but merely as accessories. In the latter ages, as taste declined, the application and original uses of the antae, founded on sound judgement, and in the spirit of the true Greek imitative system, ceased to be adhered to. Of this truth, although we have innumerable examples, I shall only show one, in a temple at Palmyra, where the antae are placed at the angles of the cella, and are also continued at equal distances on the whole extent of the flanks.[i] This abuse of the antae by some of the ancient architects has been almost universally adopted by the moderns.

In the porticoes of the churches of St. Martin in the Fields, and St. George, Hanover Square, and in many other buildings, pilasters are placed, not behind the external columns only, as in the ancient buildings, and for which a reason has been assigned, but are also placed behind each column of those porticoes. In the portico of the church of St. George, Bloomsbury, three-quarter columns are attached to the walls behind those in front. In these examples simplicity has been entirely neglected, and first principles dispensed with.

In the circular peripteral temple at Tivoli, and in that of Vesta in Rome, there are no pilasters answering to the columns, yet Bramante, with these fine examples before his eyes, has not scrupled in his celebrated little circular peripteral church of San Pietro in Montorio

[h] When this is not done, some have supposed them to appear larger at the top than at the bottom. This is contrary to every idea of optical effect.

[i] Note. Thus the antae have been added without meaning or propriety to supply the want and deficiency of taste. So in the entablatures, and other enrichments of later times, every part is crowded and generally confused with a multiplicity of different ornaments, without any of the taste and elegance of design or execution so visible in the works of the Greeks. The moderns, unable to produce the powerful effects so visible in Grecian works, were determined at least to surpass them in the richness and quantity of the decorations of every kind. Like the painter who, failing to represent Helen beautiful, adorned her most magnificently with jewels and embroidery, Apelles, being asked by the painter his opinion of the picture, replied, 'I cannot say that you have made Helen handsome, but it must be confessed you have made her uncommonly rich.'

to crowd pilasters behind each column.[j] These practices are contrary to every principle of good architecture, and to every idea of simple beauty and utility. We too often forgot:

'It is use alone that sanctifies expense
And splendour borrows all her rays from sense.'[3]

From these and similar abuses and misapplications of antae and pilasters, war has been declared against the use of them in any case and on any occasion. A series of antae, or pilasters, cannot be admitted where grandeur of effect is required, yet surely many examples might be produced where pilasters, when correctly proportioned, properly disposed, and suitably accompanied, have great merit, and strong claims to the approbation of the most fastidious admirer of antiquity. And most particularly so when they are combined judiciously with columns where the abrupt transition of light and shade of the former is powerfully contrasted with the smooth, gradual, and almost imperceptible changes of the latter. The Temple of Victory without Wings at Athens is a fine example of what is here advanced; so is the Temple of Esculapius at Agrigentum, the temple on the banks of the Clitumnus between Foligno and Spoleto, the Portico of Octavia in Rome, and the never sufficiently to be admired portico of the Pantheon, and the interior of the same edifice, as well as many of the ancient examples, may be adduced on this occasion. When, however, pilasters interrupt a range of columns, as in the chapels of Versailles and Caserta, and as in the screen in front of Carlton House, they so entirely destroy that unity in composition, so well understood and practised by the ancients, and so seldom seen in the great works of succeeding times.[k]

Pilasters when used with columns, as in many of the ancient buildings, must unavoidably have the same entablature continued over them as over the columns they accompany. If pilasters, however, are used alone, as principals in a composition, as in some of the ancient brick temples in Italy, and as in the monument of Caius Bibulus in the Corso in Rome, the entablature must be made much lighter than if placed over columns of the same height. The same entablature differently accompanied, although similar in quantity and profile, always produces very dissimilar effects. If, for example, the simple entablature over

[j] In this building the blocking course is most properly omitted, which produces a difficulty as to the balustrade which is here placed immediately on the cornice, upright with the face of the frieze, and, of course, the balusters appear mutilated. All this proves the impropriety of placing a balustrade in such a situation, i.e., with columns. It is worthy of remark that Raphael, in his St. Paul at Athens, has placed the balustrade in one of his Grecian buildings in the same manner as in this work of Bramante.

[k] Note. This continuity is most happily exemplified in Drury Lane Theatre. How much it is to be lamented that it had not been continued in the entrance front where the plastered antae with enriched capitals break in very much on the grand and noble simplicity of the other parts of the composition.

[3] Alexander Pope, *Moral Essays*, Epistle IV, lines 179–80.

the columns of the Ionic temple on the banks of the Ilissus at Athens is placed over slender pilasters, as frequently occurs in modern works, instead of being over columns, as in its original application, although the extent of the whole mass, and the height and projection of each part[l] should be the same, the effect will notwithstanding be very different. And how much more apparent will this difference be when the massive entablature, designed for the Doric column, is placed over slender pilasters. The effect of the whole must then indeed be preposterous; but, however unaccountable this may be, such practice is but too common, and I shall be obliged in the discharge of my duty to produce in the course of these lectures different examples[m] in modern works of this strange and extravagant absurdity which is daily increasing. I lament to observe that the practice of transposing from the antique without regard to character and propriety, if not checked, must in a short time destroy every idea of Grecian architecture.

Pilasters, entirely detached, showing four equal faces, seldom occur in the remains of antiquity. There is, however, an instance in a monument at Mylasa,[n] another in the temple of the Clitumnus before quoted, and yet others at Palmyra and Baalbec. The advocates for these insulated square pilasters, at the extremities of porticoes and such like situations, say that columns at the extremities of peristyles and other buildings give the entablature the appearance of being left hanging in the air without any apparent support. This in some oblique views is partly true, yet in many Greek works the lower face of the architrave is made upright with the inferior diameter of the column, which must materially increase the effect of leaving the entablature unsupported. Some have therefore concluded that the Greeks did not consider this appearance so defective as it is in the eyes of modern artists.

Pilasters, in different periods of antiquity, assumed different degrees and shades of importance. In the Curia of Tullius Hostilius, and in the Monument of Caius Bibulus in the Corso in Rome, they are prominent features. They are also to be seen in the exterior of the Colosseum and in other ancient structures, particularly in those of Palmyra and Baalbec. In the works of Palladio pilasters frequently occur. Scamozzi and Serlio were likewise particularly attached to them. In England the great expense of building occasions even a more general and often successful use of pilasters.

In the exterior and interior of St. Paul's it is, however, impossible not to lament the

[l] Note. This bad effect is particularly evinced in a large building [at] the corner of Great Russell Street, next [to] Bloomsbury Square, and also in the front of the Duke of Queensberry's house in Burlington Gardens, as built from the designs of Giacomo Leoni and since added to.

[m] Note. The front of the British Institution [former Shakespeare Gallery] in Pall Mall. The front next Portugal Street of Surgeons' College.

[n] Note. This work must be of the low times after the subjugation of the Greeks. [Choiseul Gouffier], *Voyage Pittoresque de la Grèce*, vol. I, p. 144.

almost general substitution of pilasters for columns. The fronts of Shaftesbury House in Aldersgate Street (pl. 21), Lindsey House in Lincoln's Inn Fields, and the houses in Great Queen Street are well-known examples of the use of pilasters. In these buildings, although we may regret the absence of columns, yet the simple and pleasing effect of the pilasters almost makes us advocates for them. At least there is more interest produced by them than by the cold monotony of plain unbroken surfaces, but when a series of slender pilasters are placed on high basements and continued in a building of considerable extent,° the appearance of the whole front appears flat and insipid. And if they are executed without bases, contrary to the example in the Temple of Theseus, the whole composition is thereby rendered meagre and unfinished.

In modern buildings pilasters and columns are often seen mixed in the same front, as at the Banqueting House at Whitehall, the front of the Treasury next the Park, and in many others. The column and pilaster both suffer by such combinations. This sort of composition may show great attempts after novelty, but it is destructive of every idea of continuity and harmony of parts.

Vitruvius, in his Fifth Book, speaking of the Basilica at Fano, describes a sort of pilaster, parastata, as he calls it, attached to columns, which Palladio and his imitators have often used.ᵖ This deviation from the pure system of the Greeks, by such high authority, will be more particularly noticed in a future discourse.

After all that has been said against the general and improper use of pilasters, yet they are certainly entitled to consideration, particularly when used judiciously with columns, as in some of the examples already noticed. And although pilasters have neither the elegant flowing outline nor the graceful variety of the column,�q yet we have many examples in the remains of ancient edifices of the later ages, where the antae or pilasters have been preferred to the column. This cannot be wondered at when we consider how much less time, difficulty and labour, and consequently how much less expense, is required in making a

° Note. See front of a house in Bedford Street, Covent Garden.

In the front of General Hornby's house in Portman Square.

In the front of the 'Crown and Anchor' Tavern, Arundel Street, Strand.

ᵖ Note. In the villas and other designs of Palladio and his contemporaries, as well as in the works of succeeding ages, we find not only this defect but also pilasters and columns blended together in the same front, sometimes where the entire façade is of limited dimensions. (If this practice arises from economical motives, in all such cases it will be better to omit the order altogether.) This makes a division of parts in many cases very prejudicial to the general effect, and creates littleness where grandeur to a certain extent might have been expected. In this country the same practice is very common, as at the Banqueting House at Whitehall, and in other works of Inigo Jones and his followers. This too great subdivision of parts is one of the great errors of modern Architecture, and should be contrasted with the contrary practice in the exterior of the Farnese Palace, the Farnesina, Stoppani, etc.

�q Note. To show the superiority of columns, contrast the façade of the Louvre with columns with the other in which pilasters predominate, or draw the same front with pilasters instead of columns.

pilaster than in shaping a column. Columns, comparatively speaking, demand the abilities of a Ctesiphon[4] and the purse of an Herodes.[5]

I have endeavoured to show the origin and also the application of pilasters in ancient and modern works; and I have enlarged more particularly on the use and abuse of this part of architectural decoration from observing the misapplications and absurdities produced by the improper introduction of pilasters in many modern buildings.[r] These abuses are daily increasing, and if persisted in must ultimately produce serious innovations and fancies, which cannot fail of being destructive of true taste, prejudicial, if not fatal, to the taste of the young architects, and reduce architecture to little more than a system of mere whim and caprice.

We now come to the pedestal, another accessory in architecture, and which is used, not only with each of the orders, but likewise on many other occasions.[s]

Vitruvius speaks of the stereobate, which probably refers to the plain zocle placed under detached columns, of which we have many examples at Palmyra and Baalbec. Vitruvius also mentions the stylobate or continued pedestal, used to support a peristyle of columns, as in the circular peripteral temple at Tivoli, in the pseudo-peripteral temples of Fortuna Virilis at Rome, and in the Maison Carrée at Nîmes, an edifice likewise pseudo-peripteral.

This species of continued pedestal is highly proper; it gives the peristyle [an] elevation, which contributes most essentially to increase the grandeur and general effect of the entire edifice. But pedestals placed under detached columns cannot be admitted in regular architecture, notwithstanding many examples of this practice occur in Grecian and Roman edifices, as in the Stoa at Athens, in the Incantada at Salonika, in the front of a temple at Scisi [Assisi] in Umbria, and most of the triumphal arches. In all these works the pedestals are very considerable features. How are we to account for the frequent recurrence of this strange practice in ancient buildings, so repugnant to the general principles of solidity? Are we to suppose that pedestals were thus used because they could not be supplied with stone, granite, and marble of sufficient dimensions; or was it occasioned from an idea that, if the height of the pedestal had been added to the height of the column, it might have lessened the symmetry of the whole building? This latter conjecture, for it is no more, is at least probable, for Vitruvius tells us that in temples the height of the column

[r] Note. These and similar absurdities, and deviations from the practice of antiquity and the observance of first principles, may be traced chiefly because those who build are deficient in taste, and instead of employing men of science and skill they confide in workmen to form, direct and execute many both public and private buildings. On this infatuation, which I trust will not continue, I shall have occasion to enlarge in a subsequent discourse [Lecture XI].

[s] Note. Pedestals are very properly applied for the support of statues and groups of figures. Laugier, [*Observations*,] p. 71.

[4] Ctesiphon, or Chersiphron, was the architect of the Temple of Diana at Ephesus.

[5] Herodes Atticus (AD 101–177), a wealthy Greek orator and patron of architects.

is to be proportioned to the whole length of the front. But it must be admitted that pedestals are an insufficient expedient at best, for they destroy in part the beautiful character of the column, and give it a ricketty and gouty appearance. Notwithstanding all the precedents quoted, pedestals should only be used from absolute necessity, where the site of the building is fettered with irregularities.

In the works of Palladio we sometimes see the columns of colonnades placed on pedestals with balustrades between them. This practice is also very common in buildings erected since his time, generally from the taste of the architect, although sometimes from necessity, as at Lord Bessborough's beautiful villa at Roehampton, a work of that great architect, Sir William Chambers, where the marble columns brought from Italy being too short, pedestals were added to lengthen them.[t] I shall not in this place speak of the relative proportions of the pedestal to the column: much may be learned on this head from books on architecture, and much more must be acquired by attending to the local circumstances, which will occasionally compel the architect to use pedestals in his composition.

Having disposed of the orders of architecture and their principal accessories, the pediment, which owes its origin to necessity, now presents itself. This important feature in architectural composition, by its beautiful and impressive form, becomes peculiarly interesting when classically and correctly introduced. The imitative system of the Greeks led them to treat this noble decoration as a principal feature in their architecture. Among the Romans the pediment was so much respected, and considered so important, that it was confined entirely to buildings sacred to their immortal gods. And we are told that Julius Caesar was allowed, by a special decree of the Senate and People, to have his palace decorated with a pediment as a mark of high distinction and particular respect. It is worthy to be remarked that, notwithstanding this latter fact, Vitruvius complains against the improper and general use of pediments, which may be considered as another proof of his not having lived in the age of Augustus or Titus.

In Grecian architecture every form and proportion grew out of the most refined and correct ideas of utility and beauty in their buildings. The pediment, therefore, was low and extended over the entire front of the edifice. The Romans, likewise, in many of their buildings followed the example of the Grecian architects, as in the Temples of Antoninus and Faustina, of Fortuna Virilis, of Concord, and of the Clitumnus; also in La Maison Carrée at Nîmes (built in the time of Antoninus Pius), and in many other monuments now remaining. It is, however, to be observed that in Roman buildings the height of the

[t] Note. All these expedients are bad, although less intolerable than that adopted in the flank of the late Drury Lane Theatre where the bases of the columns followed the declivity of the ground, and the entablature was kept in an horizontal direction. This idea was probably borrowed from Bernini's staircase at the Vatican and from Blackfriars Bridge. At Blackfriars Bridge the bases of the columns are in the same line, and the entablature follows the curvature of the superstructure, and by breaking over the columns of each pier in some measure justifies the irregularity.

pediment was considerably increased, from being considered by the architects of Italy as being more suitable to their climate. From the same consideration and regard to climate we see that the roofs of buildings in northern climates [are] very considerably higher than even those of the Romans.

No form can be truly beautiful that is inapplicable to its situation. By an association of ideas, the flat pediment of the Greeks, when used in this country, must appear to the most superficial observer, and indeed will soon be found, insufficient to protect the building from the effects of snow, rain, and tempest, and consequently cannot be pleasing.

The extraordinary height of the roofs in most of our old Gothic buildings has been supposed to have been occasioned by the impression arising from the powerful effect of height on the minds of the architects of those times. This was probably one cause, but there was another not less powerful, the species of materials, and for the roofing of many of those buildings, namely reeds or straw; and such is the force of habit, in all ages, that in succeeding times when the power and riches of the church had increased and lead was used for the covering of sacred buildings the same passion for high roofs still continued.[u] Pausanias tells us that in his time some of the temples in Greece were covered with reeds and straw, and in the very heart of the city of Norwich there is to this day a church to be seen whose roof is of straw.

In many modern works the roof is often considered as a secondary object, whereas in fact, whether it be flat or pointed, it must always be an essential part of every building. And so much is the character of the structure itself identified in it, that if roofs, originally calculated to be covered with reeds, straw, or tiles, are afterwards covered with materials which do not require the same degree of elevation, fitness is thereby violated, without which no form can satisfy the eye of judgement and reflection. The roof of Covent Garden church, originally tiled, being now slated, the whole building has thereby lost much of its appropriate beauty and character by this innovation of modern refinement.

The pediment of the portico of the Pantheon makes a noble finish to that glorious work. It was enriched with sculpture in the tympanum, and a triumphal car over the centre. This portico was an addition only to the main building, and therefore when speaking of it, must be considered by itself, and not in proof of a practice which, under those circumstances, it will not justify:[v] I mean such applications of pediments as Palladio has adopted in finishing the porticoes of the Villa Capra.

When the beauties of architecture were not appreciated, and correctness of application forgotten, we find every kind of capricious use of the pediment occurred in the exterior of

[u] This is exactly conformable to what has been before observed of the Greeks who, in their buildings of stone and marble, placed a column in the centre because in their primitive huts it had been so placed from necessity.

[v] Note. This portico, with its pediment, being decidedly of the Augustan age, it has therefore been quoted to sanction the modern practice of raising a spire over the pediment of a portico, and for placing a portico in the centre of a building with a pediment over it.

ancient works. The Roman Baths, the Palace of Diocletian at Spalatro, the temples at Palmyra and Baalbec, are full of examples of this bad practice and disregard to fitness and propriety. Nor is the misapplication of pediments confined to the exterior of ancient buildings. Pediments frequently occur in the interior of several of the ancient works already mentioned, particularly in those at Palmyra and Baalbec. Indeed, the mania extends not only to the triangular and circular forms, but also to broken and open pediments. But these circumstances cannot be matter of surprise to us when we so completely lose sight of fitness and propriety as to use the pediment, that is, strictly speaking, the roof, in the interior of our own buildings. Who will say where such absurdities will cease? In the decline of taste we may expect, and indeed are prepared to encounter these and every other deviation from classical purity and correctness, but how are we to account for the alternate, triangular, and round pediments over the altars in the Pantheon? This work, being undoubtedly of the Augustan age,[6] has by some been supposed to have been the great hall of entrance to the Baths of Agrippa, although from the plan it is clear there could have been no communication opposite the door of entrance. And if it had formed a part of the Baths of Agrippa how could pediments have been admitted when (as has been already observed) we are told in the preceding reign it was permitted to Caesar only to roof his house with a pediment?

Many modern architects, of no small celebrity, have quoted the pediments over the altars in the Pantheon, to sanction (from ancient examples) the use of them in the interior of buildings. The Pantheon, correctly speaking, is an hypaethral temple, of course open in the centre. The altars therefore required roofs to protect them from the weather, and thereby justify the architect in placing pediments over them, but these pediments can never be brought in proof that the ancients used pediments in the interior of their buildings. And even if this were not the fact, no example, however respectable, can justify the adoption of that which is repugnant to common sense, and to those first principles which every man should comprehend. If precedents alone were sufficient to guide us, architecture is at an end, there can be no respectability attached to it, for the remains of antiquity, of the low times at least, will give examples to justify every extravagant fancy and wild vagary of the most contemptible dabbler in architecture.

The pediment[w] represents the roof; accordingly, in the best examples of Grecian and Roman antiquity, it extends over the entire building, and is always of the triangular form, a figure the most simple and natural, and perfectly conformable to first principles. From the pure remains of ancient edifices we are taught that only one pediment can be introduced in

w Note. The origin of the pediment is to be traced in the gable ends of the primitive hut of the Greeks. It was the most natural and simple manner of covering the whole structure, as in the Temple of Minerva and in most of the ancient temples. Thus we see why the pediment can have no building above it, as in the Triumphal Arch at Orange, and in many other ancient works, without violating every principle of characteristic correctness and true effect. When the pediment is used in a manner for which no good reason can be assigned, it is a defect, and not a beauty, to which we are reconciled by want of reflection and by having such deformities too often before us.

6 The present Pantheon is, of course, now known to be not Augustan but Hadrianic in date.

the same front, and that no pediment, of whatever form it may be, can ever be used in the interior of a building.

Although the pediment is an important and beautiful feature in every composition, yet it brings with it some contradictions, difficulties, and varieties in connecting the horizontal cornice over the columns with the raking cornice of the pediment. As the cornice in its essential parts refers to the roof, the Greeks were aware of the impropriety of continuing it under the pediment. And when they admitted it, it was from preferring the sacrifice of a propriety which the million could not be expected to comprehend, to a beauty that all must feel. There was a stronger reason for omitting the upper member [cyma] than the whole cornice because, according to Vitruvius (and as may be seen in the Temple of the Winds at Athens) in this upper member heads of lions were introduced to carry off the water from the roof, and which, according to Vitruvius, was the invariable practice of the Greeks in all their most perfect works.

In the pediments used in Roman buildings, we have the same bed-mould to the raking as to the horizontal cornice. The tympanum is likewise placed upright with the frieze. In the Grecian pediment the bed-mould in the raking cornice is omitted: no more of the cornice is retained than is absolutely necessary. The tympanum of the pediment stands considerably before the face of the frieze, to prevent the projection of the horizontal cornice from hiding any part of the sculpture with which the Greeks usually adorned the tympanum of their pediments. Thus we see that on this, as on all other occasions, the Greeks had substantial reasons for whatever they introduced. These are so many proofs of the sagacity of the Greeks. They saw how much the sculpture of the tympanum would be injured by the projection of the horizontal cornice under it, and that the most superficial observer could not fail to perceive the impropriety, and yet if that part was omitted, although propriety was preserved, beauty would be lost.

In the temple on the Clitumnus the same cymatium is continued in the horizontal part as in the inclined cornice of the pediment; but in the best works of antiquity the upper members of the cornice are omitted in the horizontal part, which many have hastily supposed to have been from mere matter of fancy or chance.

In the loggia of the Duke of Queensbury's house at Ambresbury,[7] Inigo Jones has omitted on each side of the pediment the upper moulding of the raking cornice. This is contrary to every idea of beauty, and to those principles which formed the basis of Grecian architecture. This circumstance is the more necessary to be noticed as the same deviation from classical purity has been followed in a recent work of a justly celebrated architect, and immediately after indiscriminately copied in two other buildings of great expense.[x]

Nothing can be more beautiful than the pediment when properly introduced; nor is any

[x] Note. In the front of Covent Garden Theatre and of the Excise Office on Tower Hill.

[7] Amesbury Abbey, Wiltshire, is now known to be by John Webb, not Inigo Jones.

part of architectural decoration so often misapplied, not only as has been shown in some of the ancient but almost generally in modern constructions. There can be no doubt about the pediment: it represents the end of a roof, and of a roof only. When it is used in a manner that destroys that idea, it is improperly placed and becomes a defect instead of a beauty.

The church of St. Paul, Covent Garden, is a noble example of the appropriate application of the pediment, and there is another equally deserving of praise in the drawing which accompanies this work of Inigo Jones.

A pediment introduced to mark the centre of a building is not justifiable, as in the celebrated front of the Louvre, in the front next the Park of Lord Spencer's house, in Devonshire House, and in many other examples. A pediment at each end of a building, as in the partly executed street front of Lord Spencer's house, leaving the space between as if intended to be without any roof, is equally objectionable. And we have also many examples of three pediments in the same front, one at each end, and another in the centre, of two different dimensions.[y]

In the front of the new church in the Strand, Gibbs (the immortal Gibbs according to Morris)[8] has introduced a series of pediments. Another proof of our fondness and blind attachments to pediments may be seen in the front of Stafford House; we have here two pediments placed above each other.[9]

Possibly I may be told the Pantheon justifies this fancy. Many other examples might be produced of the licentious introduction of pediments, perhaps even worse than the new church in the Strand, which the severity of the poet has given greater notoriety to in this building (on which Pope observed) it was [blank]

The pediments appear as the representation of a series of gables such as we see introduced into many of our old buildings for the purpose of introducing light into rooms behind them.

Other examples might be here adduced where the great line of the front is broken by various parts receding and projecting although but little from the general line of the front, and the centre raised higher than the parts on each side and finished with a pediment as at St. Luke's (pl. 27). Or when the centre and end pavilions project considerably beyond the main body of the building. This last mode may give more movement and more effect of light and shadow, but it does nothing for the pediment. We are equally unsuccessful as to the unity: the pointed and flat roof cannot be used in the same building, at least not

[y] Note. One example in particular of this last defective manner of composition will naturally present itself to my auditors, it being situated near another work of the same artist which cannot be unnoticed and will be the admiration of every lover of architecture who has the least taste for correct and powerful genius, or any knowledge of those principles which directed the great architects of antiquity.

[8] Robert Morris, *Lectures in Architecture*, Part I, London 1734, p. 58.

[9] By Stafford House, Soane referred to Cleveland House, home of the Marquess of Stafford, as remodelled by James Lewis in 1795–97. For his lecture illustration of the offending façade, drawn in July and August 1809 (SM Drawer 27, set 6, no. 7), see *Survey of London*, vol. XXX, London 1960, pl. 233b.

with propriety. It brings discordant parts together. It breaks that unity and connection which ought to reign throughout the whole, without which the whole composition appears to be a patchwork of different ages and erected for different purposes. It is in fact combining the manners of different ages in the same buildings, in which, although the parts are beautiful in themselves, yet from want of fitness and proper connection they can no more please the judicious than a picture expressive of the glorious deeds of a Cymon, or Themistocles,[10] would do, if the painter had jumbled into his composition the boors of Teniers. Notwithstanding they were represented with all the force of his magic pencil, still we should be disgusted in spite of the abstract beauty of those incoherent parts. Or in another way of putting the case, it is like blending the events of one period with those of another.

In some of the foregoing examples in which pediments are shown, it may be said that the building being plain and of brick, architectural effect and propriety were not consulted, and the pediment was merely introduced to produce at least some movement in the front, columns and pilasters being rejected on a principle of economy. Be it so; but then take an example of very late date, in which an attempt, most unsuccessful indeed, has been made to introduce something like architecture. Here is a pediment in the centre of the front, over this another roof; then come skylights formed on the inclined roof à la Mansard, and then roofs upon them. This is a climax indeed.[11]

In all these examples the effect of the pediment is less and less impressive, propriety of application is sacrificed; the requisite gradation of parts, the unity of design, so essentially requisite to produce that harmony and effect, that perfect whole, which all feel and admire, is here sought for in vain.

In many buildings, both ancient and modern, pediments have been used in situations still more objectionable than those already mentioned, and in others an attic or even an entire order of architecture is placed over them.

In modern works pediments abound; they are of all dimensions and forms and in every situation, seldom with any regard to fitness of application: Lord Burlington's villa at Chiswick, Lord Bessborough's at Roehampton and [Lord] Scarsdale's at Kedleston. At the Villa Capra near Vicenza Palladio has placed a pediment in each front under the great entablature and the same is done in front of the Pantheon in Oxford Street. This is placing the roof within the house and the floor above the roof. We also place pediments under spires or steeples of churches. See St. Martin's, etc.

[10] Celebrated Athenian statesman who secured the Greek victory over the Persians at Salamis in 480 BC.

[11] The clumsy neo-Palladian building Soane pilloried in these words was the Auction Mart, Bartholomew Lane, London (1808–9, dem. 1865), by John Walters (1782–1821). Once again, Soane was breaking Academy conventions by criticising the work of a living artist. For his lecture illustration of the Auction Mart, dated 29 January 1810, see SM Drawer 76, set 3, no. 11. The building was also illustrated in Thomas Shepherd and James Elmes, *Metropolitan Improvements*, London 1827, pl. facing p. 161.

It would be tedious and not absolutely necessary to point out more examples of these improprieties,ᶻ so glaring that they could not be endured even in scenic representations. Of this fact Vitruvius gives the following instance:

Apaturius of Alabanda having painted a scene for a theatre in which he had placed statues and centaurs to support the roof and the projecting extremities of the pediments, and also ornamented the cornice with lions' heads, these parts having reference to the roofing and eaves of edifices, nothing could be added without the most evident violation of propriety. Apaturius, however, being a better painter than an architect, repeated upon this work in the episcenium all the various parts of another building. And as the whole was executed in a masterly manner, general approbation would have been given to it by the multitude, had not Licinius, the mathematician, condemned the work as a public disgrace upon the city. For, said he, how can columns and pediments be placed with propriety upon the tiles and the roofs of houses? And although, men being accustomed to view absurdities, the judgement may be depraved, yet we must not approve in painting what cannot be in fact. And to the honour of Apaturius, it is added that instead of defending his work he removed the scene and by proper alterations made it consistent with truth.[12]

The public condemnation of this impropriety, although committed in a scene only, could not fail of making a strong impression on the minds of the architects of those days, and was perhaps one of the great causes of the superior excellence of so many of the ancient edifices.

If Licinius was justly offended with this extravagance in a mere scenic representation, what would he have said of the distorted architecture in some of the great compositions of Rubens, or of the twisted columns in one of the cartoons of the divine Raphael, or of the Roman architecture in another of the cartoons, where the different styles of various ages are blended together although the scene represented [is] the Areopagus at Athens?

If we had a Licinius among us he would be fully employed. I know not whose works would escape just censure.

The balustrade, another decoration connected with the roof, is not only useful but likewise beautiful. The application of this part of a building is often as absurd as that of the pediment itself which it frequently accompanies.

ᶻ Note. It would be endless and, after what has been already said, in some degree useless, to point out all the different places and different modes in which pediments have been improperly introduced even by artists of most distinguished and superior talents. Many of the great artists of Italy who united painting and sculpture with architecture were less attached to the pediment than those of succeeding times, not because they were not sensible of its beauties, but because they, like the Egyptians, delighted in large simple parts and long unbroken lines, and because those great artists felt the difficulty of placing the pediment with propriety without sacrificing magnificence. The Farnese Palace, the Pitti Palace, the Farnesina, the Stoppani, the Palazzo Massimi, are proofs of what is here advanced.

[12] *De architectura*, vii, vi, 5–7.

I doubt whether a balustrade can ever be introduced with the orders of architecture or the sides of a pediment, and certainly it can never be used with success to hide part of an inclined roof. The experiment was most confessedly made for this purpose in the building here represented, which was originally finished with one of the illegitimate blocking-courses already spoken of. The balusters to the windows on the first floor of this building are most unhappily introduced: even from the greatest extended point of view the projection of the lower order hides at least half their height.

In the exterior of this building, among many things to be avoided, I must observe on the great number of different apertures in the entrance front, amounting to nine or ten. This kind of composition has been particularly noticed by the late Sir William Chambers in his excellent Treatise on Civil Architecture, as follows: 'The common sort of builders in this country are extremely fond of variety in the ornaments and dimensions of the windows, and indeed in every other part of their buildings. In the front of a house in Berkeley Square, which has only eleven windows, they are of seven different sorts. The front of Ironmongers' Hall has seven different kinds of windows, and the same variety is to be met with in many other buildings both in town and country.' 'I would recommend,' continues Sir William, 'to these inventive gentlemen to give their attention to the tailor, who does not employ six or seven sorts of buttons on the same coat; nor does the cabinetmaker introduce different kinds of chairs into the same room. This foolish hankering after variety arises from our not feeling any of that amazing greatness and noble simplicity to be seen in the works of the ancients.'[13]

I am indeed disposed to think that balustrades can never be used with propriety except with a flat roof, as at the Queen's House at Greenwich; and for this reason we see balustrades used more frequently on the continent where the roofs are more generally flat.

When balustrades are used on terraces and as a protection to flat roofs, we then perceive their fitness, and are pleased with the lightness and elegant effect produced, but I doubt whether it is correct, that is, whether the eye of taste and reason will be satisfied in introducing balusters in the finishing of bridges. They seem to want the essential massiveness, but this may in some degree be a prejudice derived from a study of the antique bridges, all of which have solid parapets.

If balustrades to bridges are made proportionally massive as in some degree to justify their use, by such an increase of scale the relative magnitude of the bridge would be lessened, as may be seen by comparing the superstructure of the bridge at Blackfriars and that over the same river at Westminster.

The abuses of the pediment and balustrade are serious and growing evils which have increased, are increasing, and ought to be diminished. There is also another practice, if possible still more fatal to good architecture, in many of the buildings of this metropolis. It

[13] Soane's paraphrase of Chambers, *Treatise*, pp. 118–19.

is no uncommon thing to see one of the fronts enriched with columns, pilasters, and other architectural ornaments, whilst the flanks are left plain, as if belonging to other buildings, or erected by different persons at different times.

This practice of sacrificing everything to one front of a building is to be seen, not only in small houses where economy might in some degree apologize for the absurdity, but it is also apparent in large works of great expense, both public and private, even in works where in a great degree the national taste is implicated. The front of Lansdowne House, in Berkeley Square, equal in extent to one entire side of that area, is a striking example of this inconsistency. Uxbridge House is another melancholy instance of this false taste or false economy. And these two drawings of a more recent work (pl. 28) point out the glaring impropriety of this defect in a manner if possible still more forcible and more subversive of true taste. The public attention, from the largeness of the building, being particularly called to the contemplation of this national edifice.[14]

It is extremely painful to me to be obliged to refer to modern works, but if improper models which become more dangerous from being constantly before us are suffered, from false delicacy, or other motives, to pass unnoticed, they become familiar, and the task I have undertaken would be not only neglected but the duty of the Professor, as pointed out by the Laws of the Institution, becomes a dead letter, for the Professor of Architecture is directed 'to read annually Six Public Lectures, calculated to form the taste of the Students, to instruct them in the Laws and Principles of Composition, to point out to them the beauties or faults of celebrated productions, to fit them for an unprejudiced study of books on the Art, and for a critical examination of Structures.'

But returning to the works of the ancients, I shall now, according to my promise in a former lecture,[15] speak of obelisks.

The origin of obelisks was in Egypt; in that country they abound and are frequently of enormous dimensions. They were sometimes triangular, and at other times conical, but in general square at their bases and gradually diminishing upwards. Obelisks entered into the religious opinions of the Egyptians, and probably were first used in honour of the worship of the sun, to whom they were consecrated. We are told by Diodorus Siculus that Sesostris caused two of them to be set up in the city of Heliopolis, to decorate the entrance to the Temple of the Sun.[16] And they were also applied, in a similar manner, to enrich the approach to many other temples of the Egyptians. Obelisks, like columns, were also considered as a species of historical monument. They were sometimes plain, like the stones set up in early times as monuments, and sometimes decorated with hieroglyphics. But it does not appear that obelisks were ever used in Egypt (by their inventors), as some have

[14] This is the passage to which exception was taken, causing Soane to suspend his lectures for two years.

[15] Lecture I, p. 35.

[16] In fact, Diodorus Siculus described Semiramis as having erected obelisks at Babylon, rather than at Heliopolis.

imagined, to embellish the monuments of the dead. In the Roman works, however, we are told that two obelisks of red granite, brought from Egypt, were set up before the entrance into the Mausoleum of Augustus in the Campus Martius, one of which is now in the front of the church of Sta Maria Maggiore, and the other at Monte Cavallo.

By others, the origin of obelisks has been ascribed to those heaps of stones which the Phoenicians and other early nations placed by the sides of their highways as symbols of their idols, as memorials of the dead, or as an expression of their gratitude for benefits conferred upon them by some particular god or hero, to whose honour they were erected, and for other purposes mentioned in Holy Writ.

From these circumstances the moderns, forgetting the origin of obelisks, have frequently placed them indiscriminately as decorations to buildings of various descriptions, and for other purposes. These errors show the propriety and necessity of our attending to the observation of Vitruvius, namely that the architect, by close study and unwearied attention, should be learned in history, well informed of the primitive destination and origin of things, and on all occasions be able to trace every invention up to first principles and original causes.

We have already seen the column at different times twisted, rusticated, and tortured in various ways; nor has the obelisk (beautiful in its simple form and situation) been treated with more attention; for at different periods and in different countries obelisks have been placed on different substructions without any regard to their origin. Pliny speaks of an obelisk elevated on balls, and at Constantinople there is such an example. We have no instance in antiquity of an obelisk placed on an upright pedestal, nor any reason to suppose that manner existed, except from such a representation on a medal of unknown date, and from supposing that the pedestal near the fallen obelisk in the Campus Martius at Rome had been used in Egypt with the obelisk itself; but this last circumstance is by no means ascertained. The moderns, however, from these precedents, have taken uncommon latitude and placed them not only on pedestals of various descriptions in form and relative dimensions, but also on pyramids and upon the back of animals. But notwithstanding the sanction of all these great examples, an obelisk placed upon an upright pedestal can never please the judicious eye. It gives a ricketty, weak, disgusting appearance to the whole composition, and is directly contrary to every idea of propriety, and also to the great principles of Egyptian architecture.

The Egyptians, to whom their origin is ascribed, placed them either on the ground, or raised upon one or more steps, or square plinths. This was consistent with the rest of their architecture, which is constantly declining from the upright. Their apertures of every kind were diminished upwards (not like modern termini broader at top than at bottom). The walls of their buildings were likewise sloping in order to give the greatest idea possible of duration. This form was one of the characteristic distinctions in all their architecture; it was a part of that general and universal system, which the Egyptians successfully copied from nature.

The Fontana nella Piazza Navona[17] is the work of a bold and daring mind.[aa] It is impossible not to be pleased with this mighty flight of genius. The placing of an immense obelisk on an artificial rock, perforated with four large openings, was worthy of such an artist. It produces in the mind that sort of mixed emotion of pleasure and pain, similar to that which is felt on viewing the spire of St. Dunstan's in the East, that celebrated piece of mechanism of Sir Christopher Wren.

From obelisks we naturally pass to pyramids[bb] which are generally supposed to be of Egyptian origin and to have been used for different purposes. Some have imagined that those at Cairo in particular were originally erected for astronomical purposes; but if the extreme difficulty of ascent, the great height of each stone with which these buildings are constructed, the enormous height of the whole mass and the smallness of the interior void are considered, it is impossible for any rational being to suppose such edifices to have been constructed for astronomical observations.

Others have supposed pyramids to have been originally intended as depositories for the dead,[cc] for it is well known that the veneration and respect of the Egyptians were so great that it made a part of their religion to protect the remains of their dead from neglect and insult. We are also told that these people considered this world as a passage to some other existence, and therefore paid no regard to the stability of their dwellings but were anxious to make the mansions of the dead eternal. With this idea they made their pyramids generally square, although sometimes round and generally diminishing to the top, leaving only a small flat space of a few feet to receive a statue of the deceased or other decoration. If, with these circumstances, the immense solidity of these structures is considered, it is impossible to imagine any composition so well calculated to brave the efforts of time, and

[aa] Note. The four figures represent the Nile, Danube, Euphrates, and the Niger; the various animals and plants are characteristic of the four quarters of the globe.

[bb] Pyramids have been considered among the most ancient buildings of Egypt chiefly because they are without hieroglyphics which are by many considered as the first characters used by the Egyptians. For the origin of the pyramids we are probably indebted to their religious veneration and respect for the dead, and to their desire of making the mansions thereof eternal. And indeed no figure, nor mode of construction, could be better calculated to attain that object, and [be] at the same time so simple, so grand, and so awefully impressive. The base of the pyramid is square, and fire, one of the emblems of eternity, probably suggested the tapering form of its sides, consisting of large and rectangular courses of masonry disposed in level lines, forming a long but narrow walk by which, as by so many steps, the summit may be ascended, that summit not ending in a point but forming a flat, square superficies.

[cc] Note. This idea is at least further strengthened when we examine the Great Pyramid at Cairo whose base is seven hundred feet square. We find in the interior only one small, solemn and solitary chamber in the very centre of the dark bosom of this gloomy recess whose floor, sides, and roof are entirely of marble, the latter formed with stones of stupendous length, like so many beams laid flat, traversing the space and supporting the prodigious mass and weight of the mighty work above it. This chamber is said to be 34 feet in length, 17 feet in width, and 19½ feet high. In the interior of the Pyramid of Caius Cestius at Rome there is only one small chamber, and in the Capo di Bove, near Rome, the space or void was only large enough to contain a single sarcophagus.

[17] Fountain of the Four Rivers, Rome (1648–51), by Bernini.

which is likewise so simple, characteristic and awefully impressive that we can have little or no doubt of pyramids being originally and exclusively intended as receptacles for the dead.

The Greeks were as anxious as the Egyptians to honour the dead. Cicero tells us that each side of the public road from Athens to the Piraeus, a distance of six miles, was crowded with tombs and sepulchral buildings in honour of deceased illustrious statesmen and heroes.[dd]

The Romans were equally mindful to honour their dead. The roads leading to Rome, particularly that from Albano (a distance of about fifteen miles) were lined with magnificent monuments on each side thereof. Nay, they are interspersed all over the Campagna of Rome.[ee] The immense and mighty ruins yet remaining justify the poet's description, and make,

'Rome her own sad monument appears.'[18]

The Pyramid of Caius Cestius at Rome is very small when compared with those at Cairo; and the sepulchral chamber in the Roman work is equally small in proportion to the extent of the entire edifice. This building was repaired some years past, and the workmen in digging found at two of the angles, pedestals, upon one of which was a foot of bronze. At the other angles they discovered two marble pillars thrown down, which were then repaired and replaced. These pillars do not appear to have had any immediate connection with the pyramid itself.[ff] They possibly owe their introduction in

[dd] Note. Would to God this practice of placing tombs and sepulchral buildings on the sides of our public roads existed amongst us instead of hiding them in Westminster Abbey.

[ee] Note. Indeed, so great was the respect which the ancients had for the dead that Solon made a law to restrain the great expense of mausoleums. The Thebans had a law forbidding them to erect any dwelling without building at the same time a tomb for the dead. The spirit of Solon's law was to prevent the fields necessary for agriculture from being covered with tombs which were sometimes so extensive not only by the site they occupied, but also by the woods planted about them, and thereby rendered sacred and consequently useless to the living. How wonderfully the towns of magnificent buildings in honour of the dead inspire the soul and prepare the mind for those grand effects produced by the steeples, towers, spires, and domes of great cities, when viewed at a distance.

[ff] Note. These columns have no apparent connection with the building. Admitted, but we must recollect that whether the ancients burned or interred the bodies of the dead, the remains were deposited in cinerary urns, or sarcophagi of various forms and dimensions occasionally representing temples, altars, and houses. These were occasionally placed in subterranean catacombs or hypogea, and heaps of small stones or columns were placed over them and groves of cypress planted about them in order that the mansions of the dead might be respected and that all persons might be warned against trespassing on the depositories of the dead which were considered as consecrated to the gods. And it was for this reason, not only that the sepulchral stones but also the buildings in which they were enclosed frequently partook of the forms of altars and sometimes temples.

Obelisks were in like manner placed before the portals of Egyptian temples dedicated to the sun; and in front of the Great Pyramid at Cairo there is a colossal sphinx. (*continued on next page*)

[18] Alexander Pope, *Moral Essays*, Epistle IV, *To Mr Addison*, line 2. Pope wrote 'sepulchre', not 'monument'.

this place to the practice of some of the early nations before mentioned, who set up stones or columns to caution persons from approaching without due reverence the sepulchres of the dead.

In many ancient edifices consecrated to the dead, other forms besides the pyramid are used, of which the remains of several are yet to be seen, both round and square, particularly in the neighbourhood of Rome. Those of a circular figure are supposed to have originated from the very ancient and general custom of raising mounds of earth over the sepulchres of the dead, round which groves of cypress were frequently planted to decorate and to render those places more sacred.

The Sepulchre of Plautus on the road to Tivoli, and that of Cecilia Metella near Rome, are examples of circular figures, or towers.[gg] In this latter we observe another instance of the desire of the ancients to make the sepulchres of the dead of eternal durability. The space or void in this large building is merely sufficient to receive a single sarcophagus which contained the body of Cecilia. This building, like the pyramids of Egypt, might have defied the power of time but no construction can resist the power of barbarism.

Of the mausoleum built by Augustus in the Via Flaminia for himself and family there are yet some remains. It was divided into three storeys, each receding from the other very considerably as it rose, on which were planted groves of cypress and other trees, and the whole was terminated with a dome, on which was placed a colossal statue of Augustus.

The Mausoleum of Hadrian, built during his lifetime, was the most magnificent sepulchral monument of all antiquity. It was formed by an immense square basement upon which was raised a peristyle of lofty Corinthian columns of the richest marble, and over each column a statue was placed; a dome, surrounded with statues, terminated this part of the building whose extremity was finished with a pineapple of bronze. This edifice, worthy of a Roman Emperor, was by Constantine, to his eternal disgrace, plundered of its noble columns and many other parts to enrich his Basilica of St. Paul which the wretched artists of his time could not do.

The strange ornaments carved on many of the ancient urns and sarcophagi will be noticed and explained in a subsequent lecture [No. xi].

Many of the ancient tombs are in the form of a house because they considered this kind of monument as a dwelling which was to have no end, and they therefore designated such tombs by the name of everlasting dwellings. In the pediments of some of these ancient tombs the disc is represented without rays, as some imagine to express this idea.

[gg] Note. Some have supposed that the conical pyramid and the circular form of many of the ancient mausolea arose from the custom of raising large mounds decorated with cypress over the dead. The bases of these mounds being circular and naturally diminishing upwards might reasonably have been supposed to suggest these ideas.

See Qua[tremère de Quincy], pp. 154, 256.

Laug[ier, *Observations*], p. 241.

[d'Hancarville], *Recherches*, [vol. II], pp. 126, 134, 138.

The Mausoleum of Theodoric at Ravenna has been celebrated more for its external covering, which is of a single piece of stone, than for any particular beauty in its form.[hh]

In all the remains of early antiquity, the pyramid was applied in its simple and natural state, but according to Pliny it was not always used by the ancients as an entire work. He tells us that the mausoleum which Artemisia[ii] caused to be erected was surrounded with a peristyle, over which was placed a pyramid,[jj] consisting of twenty-four courses of stone equally receding towards the top where part was left flat to receive a marble car with four horses.[kk]

Thus the ancients, not regarding the origin, misapplied the pyramid in some of their works, and set the example to the moderns who, always ready to take advantage of ancient practice without considering whether that practice was sanctioned by first principles, have merely availed themselves of ancient errors.

The magnificent mausoleum erected a few years past in the park of a nobleman in Kent, is enriched with the modern Doric order, and the whole work finished with a pyramid, not from the taste of the architect but pursuant to the will of the noble personage to whose memory it was erected.[19] So likewise, over the arched side entrance into the park at Holkham, pyramids are also introduced without any better reason.[20] And yet the late Lord Orford [Horace Walpole] in some measure may be considered as the panegyrist of the first misapplication, although he does not suffer the other to pass without censure. These noblemen were better classical scholars (it may be presumed) than architects. In these modern works the order of things is inverted: what the Egyptians, the inventors, produced as a principal, is here used as accessory only. There is no end to the evils of servile imitation.

[hh] Note. I regret that my limits will not allow me to speak of the mausolea of India, and the pagodas of China, buildings of prodigious grandeur and expense.

[ii] Note. The first mausoleum recorded in history was that erected by Artemisia, Queen of Caria, in honour of her beloved husband Mausolus, a structure which, from its prodigious extent and grandeur, gave the title of mausoleum to all such buildings.

[jj] Note. 'Supra pteron pyramis altitudine inferiorum aquavit [aequat] viginti quatuor gradibus in metae cacumen se contrahens', etc.

 See Pliny's *Natural History*. vol. XXXVI. ch. 5.

 See Choiseul[-Gouffier], *Voyage de la Grèce*, vol. I, p. 159.

[kk] Note. What prodigious advantages did those mighty, splendid, and numerous works of the ancients give their artists over those of our times? What a field for study, what a source for emulation did their respect alone for the dead produce. But the important advantages possessed by the artists of antiquity were not confined to one species of building, they were general. Public and private works were equally attended to. Materials, climate, and above all the knowledge which the great princes and statesmen of those days had of architecture and the arts, gave the ancient artists every advantage. It may be said they owe their celebrity and the respect paid them, as well as the perfection of their works, almost exclusively to this fact.

[19] Soane referred to James Wyatt's mausoleum of *c.* 1783–4 at Cobham Hall, Kent, for the 4th Earl of Darnley.

[20] The pyramids shown in William Kent's drawing were modified in execution into pediments.

Architecture could not fail of deriving the most solid and brilliant advantages from the respect paid by the ancients to the dead. Their great public and private works were equally calculated to call forth the exertions of genius, and to give the artists of antiquity the most decided superiority over those of our days.

In these discourses I have endeavoured to impress the minds of the students with the great advantages to be attained from a thorough knowledge of the origin and progressive improvement of the ancient buildings of India, Egypt, Greece and Italy. The knowledge of these works will be found of as much use in forming the taste and directing the judgement of the architect as the works of Homer and Virgil [are] to the poet, Demosthenes and Cicero to the orator, or of Livy and Tacitus to the historian.

Upon this view of the subject, it would be very desirable to enter more fully into the details of the buildings of the countries just spoken of, that from those inexhaustible sources we might collect the most useful knowledge of architecture, both in theory and practice. In them we see that infinite variety and knowledge which calls forth talents, quickens invention, and thus enables the artist to pursue his studies with every reasonable hope of success. Although this inquiry would be by far too extensive, I shall nevertheless add a few observations on some further examples of the mighty works of antiquity, many of which are entirely perished or have been destroyed, while others remain merely as ruins.

The Forum of Trajan, one of the most beautiful and perfect works that Roman antiquity could boast of, was equally calculated for the accommodation of the Roman citizens and for the splendour and decoration of the city. This superb assemblage of buildings exhibits a most melancholy proof of the instability of all sublunary things. Of its basilica, gymnasium, library, triumphal arches, and historical columns, the isolated column alone remains (pl. 3), and our regret is heightened by recollecting that it is not to time that we owe the destruction of this wonderful work, but to barbarism. Some of its finest sculpture was removed to enrich the Arch of Constantine, and to supply that which the wretched artists of his day were unable to perform. And in later times half the Amphitheatre of Vespasian and the Septizonium of Septimius Severus have been destroyed, and the materials applied in building the Farnese Palace and the Cancellaria. The drawings will give but faint ideas of the Colosseum, a magnificent and mighty structure in its perfect state, worthy of the majesty of ancient Rome. What a splendid sight must it have been when eighty thousand spectators were seated within its walls; but how changed, how melancholy in its present wretched state, majestic, however, even in its venerable ruins.

Of the basilica, built by Vitruvius at Fano,[ll] there are no remains, but the description given of it in his book is of particular importance, as it points out the manner in which the

[ll] Note. This basilica seems to have been the chief work in which Vitruvius was engaged. He seems to have been persecuted by his contemporaries and to have composed his treatise more from ingenious theory and philosophical research than from extensive practice.

ancients placed columns upon columns, so unlike the modern practice; and at the same time it corresponds most correctly with the imitative system of the Greeks, and with the example in the great temple at Paestum. The drawing by Palladio differs so materially from the other [restoration] that I must refer the studious artist to the description given by Vitruvius,[mm] which he will find most worthy of serious consideration.

The triumphal arches are likewise entitled to our attention. They are not composed with the sublimity and purity of ancient architecture, but there is a grandeur and fancy in them that cannot fail to make the study of them highly useful.

The execution of the Arch of Titus is of a superior kind but its semi-columns are much inferior in general effect to the insulated columns of the Arch of Constantine. The chief beauties of the Arch of Constantine are derived from the spoils of Trajan's Forum which was plundered of its sculpture to enrich it. Nothing can mark the decline of art more conclusively than the parts that were added by the artists of Constantine's time to make out what the Forum of Trajan could not supply. Indeed, nothing can be more ridiculous than the blending of the works of ages so very different. It is the daw dressed in the feathers of the peacock.

The Arch of Septimius Severus perhaps shows a still greater degree of inferiority[nn] in art. The columns on each side of the great arch are without meaning when connected to the whole design, but columns had been introduced in former arches of triumph, and therefore the architect of those times thought he must continue the practice.

The ruins of the villa of Hadrian at Tivoli, like those of the Imperial Palace [in Rome], are of very considerable extent, although too much scattered to leave any possibility of restoration but from fancy and conjecture. Yet the studious artist will glean from those ruins very material information in his art, both as to convenience and the application of beautiful forms. From these prodigious and extensive stores he will likewise increase his knowledge in decoration, as well as from the rich fragments of sculptured friezes and cornices which are scattered over the whole of the ancient site of these immense buildings, all of which should be the meditation of the artist by night and by day.

The public baths of the emperors were prodigious masses of immense extent and surprising grandeur.[oo] The great hall in the Baths of Diocletian, now a church of the

[mm] Note. It must be observed that the description of Vitruvius of the ancient basilicas, differs materially from his account of that which he built at Fano.

See Newton's Vitruvius, vol. 1, p. 93.

See *Hints, C*, p. 9. Pingeron, [*Vie des architectes,*] vol. 1, pp. 87–8.

[nn] Note. Septimius reigned about 195 A.D. The arts are much indebted to Septimius Severus. He collected the portraits of great princes and of other celebrated persons and has been mentioned as establishing schools of art and for restoring the ancient buildings, but in the architecture of his arch, and in that of the Goldsmiths, we see a great falling off indeed from the purity of former times.

[oo] Note. These mighty works were calculated not only for bathing, but for exercises of every kind. Here the learned found libraries of books of all descriptions, with spacious porticoes and magnificent halls for them to read their compositions in, as well as to dispute, harangue and instruct the Roman youth. The baths of

Carthusians, will give some idea of the extent and splendour of the entire building. I have not time to enter into a description of the names and uses of the several rooms. The great use to the artist of this and such plans is to study the effect of forms.

The Palace of Diocletian[pp] at Spalato was of immense extent and grandeur, occupying a space of between nine and ten acres, and contained apartments for the emperor and for his officers and attendants. Halls and open spaces for exercise of different kinds, as well as two temples of considerable dimensions, added to the magnificence of this mighty edifice, of which enough remains to determine with tolerable accuracy the forms and dimensions of the principal apartments. At the same time it makes a most excellent commentary on that part of Vitruvius [concerning domestic architecture].

The plan of this building as well as those of the baths is full of beautiful forms ingeniously combined. The intricacy, elegance, variety, and taste in the disposition of the several parts can never be sufficiently appreciated. Too much study cannot be given to their plans. The artist will be amply compensated for all his time bestowed on them, but it is the plans only that I am speaking of; these buildings were chiefly constructed in the decline of art, and although the munificence and example of Diocletian revived the love and taste for architecture, superior to that of his own time, and formed artists capable of imitating with success the style and manner of a purer age, yet the decline of art and its struggles to preserve existence, is but too often visible in their works. From the time of Diocletian the degradation of art was most rapid, and in proportion as the other arts declined they drew architecture with them, and although many of the buildings erected after his time were large and expensive, yet they had little more to recommend them.[qq]

The period I have now reached is certainly not the most favourable for architecture, and in the next lecture I shall be compelled to follow our art into the barbarism of the dark ages. I hope and trust that architecture will always keep pace with the sister arts, and maintain the rank assigned to it from the earliest periods of antiquity, one to which it is pre-eminently entitled from its great and general utility, as well as from the mighty powers of this art to please and fascinate mankind. If this had not been the case, the great princes and statesmen of antiquity would not have understood the principles of architecture and

the Romans are peculiarly worthy of the most serious attention of the architect for the beautiful and varied forms they contain, and for the uncommon grand and magnificent style in which these towns of buildings are composed.

[pp] Note. Diocletian, the 39th Emperor of Rome, began his reign A.D. 284, and was associated with Maximian. They both resigned their power on the same day, and retired into private stations in 304. Diocletian died at Spalato, his favourite residence, where he spent the last nine years of his life, in 313 A.D.

[qq] Note. The aqueducts should not pass without notice. It is said that they are proofs of the ignorance of the ancients in hydraulic architecture. Be it so, and that they destroy and disfigure the face of the country and give facility to an enemy; but it must be admitted that they are grand features and employ (perhaps) the soldiers in time of peace.

felt its beauties; nor would the ancient artists have found powerful patrons in Pericles, Alexander, and the Caesars, as well as in Agrippa, Lucullus, and Pliny.

Architecture is a beaten road but not a dull pursuit. I wish discourses on the subject could be made amusing and at the same time instructive in order to attract the attention of those who should be the patrons of architecture. I did hope this end would have been attained by the interesting discourses on this art delivered by my learned friend, Mr. Crowe, at the British Institution and at Oxford.[21] I regret extremely that they are not to be continued, for I must repeat that, unless those who build are acquainted with the beauties of the art and are able to discriminate, they will be equally pleased with the new orders shown in my last discourse, as with the order of the three columns in the Campo Vaccino. Until the knowledge of this, I had almost said divine,[rr] art is generally diffused, we must not be surprised at being obliged to seek for patrons among the ephemeral fashionable upholsterers, popular auctioneers, and decorative landscape gardeners.

I feel, Sir, that from an enthusiastic zeal for my art I have again trespassed, as in my last lecture, too much on your patience. A large portion of the time generally supposed to be allowed to discourses of this kind would have been barely sufficient to show and explain in the manner I could wish the necessary drawings for the elucidation of my subject. I trust, however, to be indulged with a few minutes to express my heartfelt satisfaction in observing the great and splendid efforts so visible in the architectural designs for the Gold Medal of last year, in which the young artists have shown so much knowledge in the arts of design, and their zeal to continue architecture in her pre-eminent situation. Each of the designs possessed great and distinct merit, and some discovered such seeds of future improvement that it was matter of regret that more medals could not have been given consistently with our laws. I regret to add that painting and sculpture, to whom the arts are said to look exclusively for rank and independence, and the Exhibition of the Royal Academy for its support, produced only a solitary specimen in each of these departments of art, and even these were considered undeserving of the Premium.[ss]

[rr] Note. And why not? God himself revealed to Solomon the idea of the Temple at Jerusalem; and the Goddess Diana held nocturnal meetings with the architect of her Temple at Ephesus.

[ss] Note. Pliny tells us that in times past painting was reputed so noble and so excellent an art, that kings and emperors thought so highly of it, and those only were thought ennobled and immortalized that painters vouchsafed to commend by their works to posterity.

 The Egyptians boast of painting 6000 years before it was known in Greece. As for the Greeks, some ascribe the invention of painting to the Sicyonians, others to the Corinthians; but all agree that the first portraying was the drawing only of the shadow of a person to his just proportion and lineament. This first draught they afterwards laid with one colour, which they therefore called 'Monocromaton.' After this, the first who painted with colour was Cleophantus the Corinthian. Pliny, Book XXXV, ch. 3.

[21] Soane's friend, William Crowe (1745–1829), Fellow of New College, and Public Orator at the University of Oxford, was a poet, a preacher, a revolutionary of near Republican views, and a friend of the poet Samuel Coleridge. He gave now lost lectures on architecture at both New College and the British Institution.

But notwithstanding all these gigantic efforts, and however much they are entitled to praise, the students in architecture have still much to acquire. They must persevere in their studies with unremitting and indefatigable application, and add to their architectural stores the utmost knowledge they can possibly acquire of painting and sculpture. Without these advantages architecture can never show the full extent of its mighty powers. Let the young student therefore zealously endeavour to appreciate correctly the value of the sister arts, always remembering that it is in the well and correct placing of pictures and statues, more than on the quantity of them, that the success of his exertions depends. The best works of painting and sculpture, if improperly placed, lose their effect, but if introduced into our buildings with correctness and taste, the architecture of this country may be fairly expected to rival the most celebrated productions of Greece and Italy.

LECTURE V

~

MR. PRESIDENT, – The rise, progress, and meridian splendour of architecture, and likewise its decline until the time of Diocletian, having been traced in the preceding discourses, I shall now briefly show its further declension from the accession of Constantine till the knowledge of this noble art, as perfected by the Greeks and sometimes successfully imitated by the Romans, was completely obscured.

Constantine, having defeated his rival Maxentius, openly declared himself a proselyte to Christianity and, having no weak feelings for established opinions, resolved to root out every vestige of those pagan principles upon which the mighty fabric of Roman greatness had been raised.

The death of Maxentius afforded Constantine full leisure for such a purpose, and the zeal of Constantine began to manifest itself more decidedly by his converting many of the temples of paganism into places of devotion for the exercise of the new religion. His zeal afterwards shone with an increased lustre, as it was evinced by the entire demolition of many of the most superb monuments of the heathen world. Even the magnificent Mausoleum of Hadrian was stripped of its beautiful columns to decorate the church of San Paolo fuori le Mura which, from its resemblance in form and proportion to the basilicas of the ancients, was called the Basilica of St. Paul.

The Temple of Venus at Jerusalem was likewise destroyed, it being supposed that our Saviour had been buried under that very spot; and on that sacred ground, so far as expense could command, a magnificent church was erected. The drawings of this edifice, copied from Le Brun, show the degraded state of the arts at that period (pl. 8).

The church of Sta Sophia at Constantinople, erected by Justinian about the middle of the sixth century, is another striking example of the rapid decline of architecture and the arts connected therewith. The plan of this celebrated structure is, however, grandly conceived, although the execution and taste in the finishing is very defective and little calculated to satisfy our expectations.

On the completion of this mighty edifice, executed to rival the great works of antiquity, the emperor, who had constantly superintended its progress, was so astonished at contemplating its magnitude and so dazzled with its splendid decorations that he repeatedly exclaimed with ecstatic delight: 'This surpasses the Temple of Solomon.'

The churches of St. Mark at Venice, of St. Anthony at Padua, and many others erected about the same time, in design and taste of execution are very like the church of Sta Sophia. These buildings, crowded with the most expensive decorations, like those erected subsequently for public and private uses in the principal cities of Italy, exhibit proofs of great wealth, but are melancholy examples of the decline of the arts which Constantine and his immediate successors greatly accelerated by destroying the ancient buildings, the sight of which would have retarded or perhaps entirely have prevented the total degradation of architecture which followed. For taste in a great degree depends on the examples we have before us; however bad they may be, if sanctioned by success, they become objects of general imitation. Thus the church of San Paolo and the other large basilicas of Constantine, are to be traced, though on smaller scales, in most of the subsequent works which, like those of Constantine, being richly decorated with the plunder of ancient buildings, assume an air of magnificence, and even of interest. If richness of materials and profusion of ornaments could compensate for those real beauties which classical forms and a due mixture of solids and voids alone produce, these buildings would be entitled to general approbation; and however essentially they deviate from the purity of classical architecture, those erected afterwards were still further removed from the taste, harmony, and proportion of ancient works. Indeed, we must now take leave of the charms of Grecian art and proceed to what is called 'Gothic Architecture.'

Although treading on tender ground, yet having attentively and duly considered the subject, I shall endeavour to discharge my duty to the young students by delivering my opinions on this system of building freely and with as little as possible of the prejudices acquired by long habits and early attachment to Grecian and Roman architecture.

The term 'Gothic Architecture' designates in this country and upon the continent that manner of building which, as will be shown in a subsequent lecture, succeeded and in some degree grew out of the architecture of the Romans, and which, after the subversion of the Roman Empire, became the general system of building throughout Europe.

From the neglect of the sciences connected with architecture, and from the degraded state of the art, as already shown in the later works of the immediate descendants of the Greeks and Romans, it follows that the want of scientific knowledge would be still greater amongst other nations.

Confining ourselves to this country, the early Saxon buildings were little more than clumsy imitations of Roman works, and when the power of the Saxons gave way to the proud and expensive Normans, no material progress or improvement had been made in architecture. They retained in their buildings the Saxon manner in most of its essentials, such as the cir-

cular arch, round-headed windows and doors, and massive pillars, with a kind of regular base and capital, the shafts sometimes plain, sometimes enclustered with small semi-columns, and at other times adorned with spiral grooves winding round, and net and lozenge-work over-spreading them. These, with the thick walls and other characteristics of the early Saxon manner, were generally used until the middle of the twelfth century (1154).

The great characteristic differences between the Saxon and Norman architecture may be traced in the quantity of the ornaments and the increased magnitude of the buildings, particularly of the churches. The latter were often so large that their founders did little more than lay the foundations of the entire work and finish the east end, leaving the rest of the sculpture to be completed by their successors. Hence, it may be presumed, arose those discordant mixtures of different styles and ages so apparent in most of the great Norman buildings.

The prodigious clumsiness of composition and gloominess of effect, so strongly marked in the Saxon and Norman edifices, cannot be attributed solely to a deficiency of mathematical and mechanical skill in the builders of those ages. There must have been other causes, probably very remote ones, for

'The first Almighty cause
Acts not by partial, but by gen'ral laws.' Pope, Essay 1, line 145[1]

It has been already noticed that the temples erected by the Hindus and Egyptians to their divinities, as well as the dwellings for their families, were little more than copies of their former caverns and sombre retreats in the rocks and mountains. When the Greeks constructed buildings with stone and marble, they adhered as nearly as possible to a faithful imitation of their early works in timber. When Christianity first appeared, its votaries were compelled to perform their devotions in dark subterranean places, in the most retired and gloomy recesses. From these circumstances may we not conclude that as soon as free permission was allowed to the public exercise of the sacred functions of Christianity, that even then the primitive Christians, led by religious veneration and respect for early habits, endeavoured to display in their buildings above ground much of the heaviness, gloom, and intricacy of the subterranean sepulchres, and concealed places, wherein they had at first sheltered themselves from persecution and had exercised the rites and ceremonies of the Christian religion?

If the style in which so many Christian churches were built owes its origin to this sort of respect, to this kind of imitation, too much praise cannot be given to the artists of those days. Everything they aimed at was completely obtained, and if in the blind bigotry of early times fear and terror were to be excited, and gloom and melancholy were mistaken

[1] Alexander Pope, *Essay on Man*, Epistle I, lines 145–6.

for zeal and devotion, it did not lessen the merit of the builders of those sacred edifices so admirably calculated are they to impress the beholder with awe and respect.

Such was the architecture of this country at the beginning of the thirteenth century when the windows, heretofore narrow and low, were then made wide and high, consisting of various parts, and different ramifications. The solids were made as small as they had been excessive; the round arch, springing from an impost, or from the capital of a low truncated cone or pillar, entirely disappeared, and the large truncated shaft itself was now formed by a cluster of columns, or divided into various parts by mouldings placed vertically on the pavement, and from thence continued uninterruptedly into the vaulted roof of the nave.

Thus we have a new and singular system of building, on the origin of which many ingenious conjectures have been made, and by some attributed to the ancient and venerated custom of worshipping in groves.

This is a very natural suggestion, for it is easy to suppose that after it became the custom to worship the deity in covered buildings, pious men of deep reflection and superior science, warmed by the contemplation and aweful effects produced by the varied play of lights, and the deep tones of the shadows in groves of trees, were tempted to realise those scenes of nature in buildings of stone. If such was their object it must be admitted that they were as successful in this system as in the former.

To whatever causes the origin of this novel and imposing system is to be attributed, all agree that long avenues of trees, of different growths, disposed in parallel lines, intersected by others at right angles, whose branches meeting, and, as it were, crossing each other, always remind us of the side aisles, transepts, and other parts of a Gothic cathedral.

The introduction of this new system may be considered as an epocha or revolution in architecture. Whether it originated in, or was introduced into, this country is a point I shall leave to the determination of others, presuming that it is not so probable that a new system of building should have originated with us as on the continent, where the minds of men were more directed to the improvement of architecture and of scientific construction, and a society was actually formed for those purposes, long before this new system of building was known in England.

This society, or band of associated brothers, kept to themselves all the laws and regulations of their proceedings. The members, being divided into bodies or classes, travelled through Europe, building churches, monasteries, and other edifices.[2]

To keep their science to themselves they dwelt in huts near the buildings on which they were engaged, and for the same reason they conversed with each other chiefly by signs understood only by themselves. Hence mankind, not having free access to the real source

[2] Soane here echoes Christopher Wren in *Parentalia*, London 1750, pp. 306–7.

from whence this society derived its knowledge, knows so little with certainty of the origin of this peculiar style of building.

Salisbury Cathedral, erected by some of this fraternity, being entirely unmixed with any antecedent manner of building, has many advantages over the great structures of the Normans. And as this work was begun and finished without any interruption, its plan possesses that superior degree of symmetry that is sought for in vain in buildings erected at different times and on the systems of different ages.

The comparative beauty of this mode was soon lost in the subsequent works by a lightness of construction bordering on temerity,[a] and in a blaze of ornaments crowded together, the details of which, resting on what is absolutely arbitrary, occasioned all the irregular whimsicality of form and capricious disposition so prevalent in the decorations of some of our great Gothic buildings.

Although in the structures raised after the Saxon and Norman manner, as well as in those which succeeded them with the pointed arch, we do not trace the elegant fancy of classical forms, nor the purity and chaste simplicity of Grecian intellect, yet the most enthusiastic admirers of Grecian and Roman architecture must admit that many of our great cathedrals have in combination, length and height, intricacy and solemnity, qualities which are the great sources of true sublimity. Nor will it be denied that the early works of the Saxons and Normans are particularly calculated to increase that gloom and melancholy which entered so powerfully into the devotion of bigotry of monkish times. The lighter and more elegant examples which followed also claim our attention, and command no small portion of general approbation.

Is it possible for the most unobservant spectator on entering Westminster Abbey, Salisbury Cathedral, and similar edifices to be deceived as to their destination, or can they fail to be impressed by their magnitude and solemn appearance? The amazing extent, astonishing height, and the interesting effects produced by the continuity of the vaulted roofing and other features of these buildings, create in every mind awe and respect for those whose piety, genius, and talents raised such mighty structures. Structures wherein the eye, unable to take in at one view all the different parts, wanders with inexpressible delight through the lofty nave, the extensive side aisles, the deep and unequal recesses of the choir, the sanctuary, the Lady Chapel, and when satiated with this rich banquet, and recovered from the delirium produced by such a blaze of effect, if the spectator places himself, as on a pivot, in the centre of the space where the nave intercepts the transept, he

[a] Note. Procopius, describing the church of St. Sophia at Constantinople, speaks of the east front so contrived as to inspire both fear and admiration; for though it is perfectly well supported, yet it is suspended in such a manner as if it would tumble down the next moment. This conceit is a sort of false wit in architecture which men were fond of in the infancy of art. A turret jutting out from an angle in the uppermost storey of a Gothic tower is a witticism of this kind.

[Kames,] *Elements of Criticism*, vol. II p. 482.

then perceives all the astonishing variety, harmony, and grandeur of the different masses, as well as the intricacy and movement of the whole assemblage, the play and contrast of light and shadow, together with the exclusion of all glaring lights. From all these circumstances combined together he feels the full power of the aweful and pleasing gloom, which occasionally pervades every part of the sacred edifice, and which, thrilling through his whole frame, produces, as it were irresistibly, sentiments of the most elevated description, and make him

> 'love the high embossed roof,
> With antic pillars, massy proof
> And storied windows, richly dight,
> Casting a dim religious light.'[3]

In none of the large splendid buildings raised by the pious zeal of our forefathers does the Gothic architecture appear more captivating and perfect than in King's College Chapel at Cambridge, the vaulted roof of which is admirably and geometrically constructed, affecting the imagination with pleasure and surprise; whilst the decorations of the roof, the painted windows, the gloom and perspective, the harmony and general proportions of this chapel contribute to place this justly admired edifice amongst the most elegant and magnificent structures.

In doing justice to the merits of Gothic edifices, it should be remembered that those who erected them possessed many advantages over the artists of succeeding times. By the piety of the early ages of Christianity the wealth of the kingdom flowed most rapidly into the huge coffers of the church. Power, of course, followed, and how could wealth, assisted by intellect (which the church then nearly monopolized) be so well and so effectually used to increase that power as by the display of structures of the most expensive kind, calculated to dazzle the eyes and astonish the minds of the multitude? In those days it seems to have been very well understood that a building must be large to produce strong emotions, and grandeur, of all emotions, was that which produced the greatest influence on the mind.

On this mighty principle our forefathers raised in every part of the kingdom magnificent cathedrals, splendid churches, and monastic institutions of every description, constructed with costly and appropriate materials, and endowed with princely establishments. Some of these buildings, to the disgrace of succeeding ages, have entirely disappeared; others are in ruins, and the rest only partially upheld, and in many cases are disgraced with modern improvements.

Whilst such were the efforts of our forefathers, and such the advantages enjoyed by

[3] John Milton, *Il Penseroso*, lines 157–60.

priestly architects of former times, the piety of succeeding ages has only erected one cathedral and, out of the fifty churches directed to be built by an Act of Queen Elizabeth [Anne], not more than ten or twelve have yet been erected. Instead of the others we have only paltry chapels, built on speculation, whose whitewashed walls of brick, and roofs of tiles and slates, convey no ideas that can interest the mind or give any character appropriate to designate places of worship.

The Gothic architecture, however happily adapted to religious purposes, is little calculated for the common habits of life. Its thick walls and small windows (admitting light as it were by stealth) are more suitable to Montezuma's house of affliction.[b] The features and general character of this mode of building are not expressive of cheerfulness or comfort. The fine dressed lawn with its enlivening rivulet,

'The bank whereon the wild thyme blows,
Where oxlips and the nodding violet grows,'[4]

require a different style of architecture; and although in grand, romantic, mountainous parts of the country, enriched with torrents, lakes, and rivers, castellated mansions,

'. . . . with their ancient towers,
And roofs embattled high,'[5]

may bring back the pleasing recollections of ancient times, and make the spectator feel the pleasure of concordance, from the similarity of the emotions produced by the two objects, yet even in such situations, thus enriched with a profuse variety of wild and grand objects, unless genius, taste, and feeling assist in designing edifices suitable to those situations, unless the architect has an intimate acquaintance with the several modifications and changes in the Gothic architecture of different ages, and thereby learns to avoid those incongruities, so frequent in modern Gothic buildings, his work will never interest the real admirers of that true, legitimate Gothic architecture which the young architect should study with the most serious attention, not for its taste, but for its effect in mass and detail.

In our great religious edifices he will discover many rich materials to assist his imagination, and by close examination of the extraordinary mechanism of those stupendous piles, his knowledge of construction will be considerably increased. He will perceive in

[b] Note. In the City of Mexico there was a palace termed 'the House of Affliction', where Montezuma retired upon losing any of his friends, or upon any public calamity.
 See [Kames,] *Elements of Criticism*, vol. II p. 484.
[4] *Midsummer Night's Dream*, ii. i. 249.
[5] William Cowper, *The Task*, ii, lines 121–22.

many of those buildings a boldness and lightness unknown, or at least unpractised, in any of the great works of antiquity.

To judge of the merits of Gothic buildings, and to show how far the young artist will be benefitted by studying them, it will be necessary previously to inquire minutely into their origin and principles, as well as into the aims and objects which the persons who raised those edifices sought to achieve. Such researches must be particularly useful to the young students, and they will be made hereafter. I shall, however, purposely refrain from every attempt to ascertain the comparatively greater or lesser degree of intellect in Grecian or Gothic architecture. Such discussions would not be productive of any practical good, nor compatible with the objects of these lectures, nor in unison with my feelings, which I trust will ever lead me to respect the opinions of others, however different from my own. With these sentiments I shall only add that no system of architecture can produce such forcible effects on the intellectual mind as that which combines the fascinating powers of the sister arts. And as the Gothic architecture in its general distribution leaves only very inconsiderable spaces wherein paintings, sculptures and mosaics can be introduced, it must therefore be considered by all inferior to the Grecian.

With this important truth the great artists of the fifteenth and sixteenth centuries seem to have been so fully impressed that no Gothic buildings were erected in those happy periods. Had those who succeeded them looked as far into the tendency of this species of building on the general interests of the higher departments of art, they would have seen that notwithstanding the blaze of its architectural beauties, this system was not calculated to call forth the energies of the painter and sculptor. Painting would have been confined to little more than portraits, and sculpture to busts and single statues. This opinion is strengthened, nay confirmed, by a circumstance within the recollection and knowledge of many living artists. I allude to the costly abbey at Fonthill which, being partly finished and the mansion house in consequence pulled down, the pictures by ancient and modern masters were sold, being found too large, and unsuitable to the decoration of a modern Gothic abbey.

It has been said that those powerful and imposing effects so visible in the exterior and interior of many of our Gothic cathedrals, cannot be obtained by any other mode of building. I would ask those who instance St. Paul's Cathedral in proof of this assertion whether a large portion of the solemnity and character so justly admired in Gothic works was not produced by the studied exclusion of all glaring lights; in the Saxon and Norman buildings by the smallness of the apertures and by the depth of light and shade, and in later works by the admission of stained glass. No person will deny these facts. Let us therefore suppose the windows of St. Paul's Cathedral glazed with scriptural subjects represented in strong and glowing colours, and then let us ask if there is any want of solemnity. But let the result of such an experiment be what it may, it could not be considered as decisive of the powers of ancient architecture, for St. Paul's, with all its

merits, has too many of the defects of the Italian churches to be compared with the sublime conceptions of Grecian architecture. And on this occasion it might fairly be asked what example have we in this country of sufficient magnitude and correctness of composition to give an adequate idea of those great and solemn effects, produced by the ruins even of the sublime exertions of Roman and Grecian talent? Where shall we see buildings in this country capable of giving a correct impression of the magnificence of the Pantheon, the simple grandeur of the temples at Paestum, the sublime and imposing effect of the remains of the Temple of Minerva at Athens, the aweful and terrific grandeur of those at Segesta, Selinunte, and Agrigentum, particularly the Temple of Jupiter, which in its perfect state must have been the admiration of every beholder? The columns of this immense building, none of which are now standing, exceeded forty feet in circumference, and each flute, almost two feet in its concavity, presents a cradle of repose to the traveller wearied with wanderings over the frightful ruins of that stupendous pile!

Will porches, or porticoes of two, four, or six clumsy Doric columns of a few feet in height; will the porticoes of our churches, or those of any of the other buildings in this great metropolis, give even a faint idea of the grandeur of the portico of the Pantheon? Certainly not.

I have wandered so far out of the road and digressed so much from Gothic architecture, that what I proposed to say further on that mode of building must be deferred to another opportunity. So irresistibly am I now within the magic circle of Grecian and Roman art that it is impossible for me to look back and retrace my steps. Let us therefore once more turn our eyes towards Italy, that classical ground abounding with so many rich treasures of the ancient architecture, the powers of which may be obscured by ignorance and prejudice, by fashion and caprice, by improper models and tasteless patrons, but cannot be annihilated. Grecian art may be concealed as fire under embers, but be assured, my young friends, on the first favourable opportunity it will burst forth like the glorious sun from behind clouds of darkness and show itself in all the splendour of eternal truth, and again become the admiration of mankind.

Early in the fifteenth century, when ignorance and caprice seemed totally to have eradicated from men's minds every idea of the beauties of ancient architecture, when there were no fixed principles in our art recognised, when he that wished to surpass others had only to do something more preposterous and more whimsical than his predecessors and contemporaries, at this very period a fortunate circumstance directed the artists of Italy to explore the remains of ancient taste and science.

The church of Sta. Maria del Fiore at Florence, when raised to the roof in 1262, had been left incomplete, in consequence of the death of Jacopo Lapi, the architect, and from the deplorable state of art at that time remained in an unfinished state until the beginning of the fifteenth century when men of skill were invited to Florence to point out the best method of completing the fabric. This fortunate circumstance brought into notice Filippo

Brunelleschi who paved the way for the restoration of the ancient architecture. Let me hail this propitious term with rapture and delight, after having so long wandered in the mazes and capricious uncertainties of degraded art!

Brunelleschi, fired with the idea of covering the church of Sta. Maria with an internal and external dome, leaving a free passage between them, hastened to Rome to prepare himself for the arduous undertaking by studying in the ruins of ancient works the principles on which they had been constructed by the mighty masters of antiquity.

Those prodigious ruins he examined with enthusiastic ardour, and not like many who saw in them merely masses of marble, stone, and brick, this indefatigable artist measured the remains of antiquity and studied every part of their construction. To Brunelleschi the smallest details were of importance, and having thus acquired that perfect knowledge of superior construction which enabled him to complete his models for the great work in contemplation, he returned to Florence, and after experiencing many of those difficulties and mortifications that men of science and modest worth have but too frequently had to encounter, he was entrusted with the entire management of the building which, to the discomfiture of his enemies, and to his own eternal glory, he had the happiness to complete.

The success and the fame that Brunelleschi acquired created a spirit of research, and revived a true relish for the works of the ancients. To be distinguished as an architect it was now deemed necessary to measure and study assiduously the remains of ancient magnificence.

Vitruvius, long neglected, was now diligently read; the torch of truth and of taste was lighted; a noble spirit of enthusiasm was created; and each artist endeavoured to rival, and if possible to excel, his neighbour. That thirst after knowledge, and that noble ardour for architecture were revived, which ultimately produced those great artists, the boast of Italy and the pride of human nature.

Contemporary with Brunelleschi came Leon Battista Alberti, a noble Florentine who, like that great man, applied himself most diligently to the improvement of his mind, and became eminently distinguished as a philosopher, a poet, a painter, a sculptor, and an architect. His works in Rome, Florence and Mantua, and the church of S. Francisco at Rimini are proofs of his great talents as an architect, whilst his treatise on architecture will be a lasting monument of his intense application, zeal, and learning.

In the fifteenth century 'Il sogno di Polifilo,' a work of extraordinary merit made its appearance. The author of this ingenious and singular production, Francisco Colonna, by pointing out the defects of the fashionable artists of his time, and by showing the necessity of diligently studying the works of the ancients, contributed most essentially to the advancement of the arts. The judicious reflexions of Colonna cannot be too highly appreciated. He established most clearly that nothing can be allowed in good architecture, for the introduction of which a good reason cannot be assigned, that it is not enough that a building has

beautiful, well balanced, and duly enriched parts, but all the ornaments that are introduced must, according to the learned father, be necessary and suitable to the use and character of the edifice. Even the solidity of the work must be analogous to the character and destination of the fabric. Such, however, was the ignorance of the great mass of the soi-disant architects of that period, that Colonna was at first persecuted for the very opinions for which he ultimately received praise.

The foundation for the revival of the fine arts thus happily commenced, Julius the Second completed. The glorious idea of rebuilding the Basilica of St. Peter could not fail of bringing together all the energies of the Italian artists, and from this mighty assemblage of talent and high intellect the architect of the intended edifice was selected in the person of Bramante Lazari, a most happy choice, for the powers of Bramante to conceive and execute great works could only be equalled by the decided taste and exalted mind of his highly gifted patron.

The impetuosity of the reigning Pontiff and the enthusiasm of the architect kept pace. Plans were immediately made and the stupendous work commenced without delay which, after engaging successively for a century and a half, the great artists of Italy, and consuming the immense resources of the Holy See, exhibited such mighty proofs of the highly daring and gigantic powers of art that all mankind were lost in admiration. It is impossible to contemplate the unrivalled splendour of the stupendous structure, enriched with every decoration that costly materials and the combined powers of the arts could produce, without feeling most exquisitely its great and unparalleled beauties. With all these happy combinations the church of St. Peter has its defects. On first entering this mighty fabric, it appears smaller than it really is. Many have considered this as a great defect, whilst others have looked upon it as a positive beauty produced by the harmony of its parts. This effect, from its very great importance to art in general, and to the young student in particular, will justify a very minute investigation in a subsequent lecture, wherein I shall endeavour to account for it by exhibiting models of three different modes of treating the same area, viz., as at St. Peter's, as in the temples of antiquity, and as in the Gothic cathedrals.

Unfortunately the defects of St. Peter's Church are not confined to the composition and arrangement of its parts. To the great regret of the lovers of architecture, the foundations of that prodigious pile (the largest edifice in Europe) were laid with such improper haste and the work carried on with such celerity that, even before the dome was begun (which was intended to represent that of the Pantheon, suspended in the air), serious and alarming defects appeared, defects greater than the united powers of the most consummate constructive knowledge of subsequent times has been able effectually to remedy. The means applied to lessen these defects are very important to be known to the student, and will therefore be particularly noticed hereafter.

From the failings of Bramante, let our young architects learn to avoid all improper

haste, to consider thoroughly and maturely digest every part of their designs, and likewise to feel the great importance and absolute necessity of attaining, like Brunelleschi and the other great restorers of art, the most correct and extensive knowledge of construction in all its details, as well as the qualities and powers of the materials to be employed. Without this knowledge the architect is little more than a mere draughtsman, and his works frequently become disgraceful to himself, his patron, and his country.

The young architect must not only be well acquainted with the works of the great restorers of architecture; he must follow them into their studies and examine most minutely the means whereby they attained the mighty pre-eminence which they have so long enjoyed.

To assist the young architect in this pursuit, I shall now produce drawings of some of the best works of those celebrated artists who, fortunately for art and for themselves, lived in a happy era when intellect was cultivated and protected by the great, whereby the talents, the energies, and the mighty powers of their minds, happily united, were called forth to adorn their country.

The pomp and splendour of the Roman Catholic religion and the riches of the Papal See afforded during many ages the most glorious opportunities for the exercise of the talents of the architect, the painter, and the sculptor. And although the magnificence and richness of Catholic churches cannot be exceeded, yet it is painful to trace a tiresome and unaccountable monotony in the architecture of so many of those religious structures, wherein we have eternally the nave and side aisles separated by clumsy piers, meagre pilasters, and large arches (pl. 11). These works are strong proofs of the power of example and show the necessity of having correct models for imitation.

In the great work of St. Peter's, Michael Angelo Buonarotti succeeded Bramante, and it is much to be regretted that the suggestions of the former were not more generally adopted. The daring mind of Michael Angelo is visible in many parts of the Palazzo Farnese, in the Mausoleum and Library of the Medici at Florence, the Sacristia of San Lorenzo, and many other important edifices.

Balthazar Peruzzi succeeded Michael Angelo in the construction of the church of St. Peter, and Bramante's plan being then considered too large, Peruzzi produced another full of ingenious thinking, worthy of the attention of the architect. In another of his works, the Palazzo Massimi, by making an unfavourable situation contribute to the beauty of the design, he has shown the power of his invention and the soundness of his judgement, whilst the different enrichments equally manifest his knowledge of the antique and the correctness of his taste.

The comprehensive mind of Raphael (who was likewise employed in the Basilica of St. Peter) was not confined to painting only. Sculpture and architecture successfully engaged his attention. The front of a building in the Longara is a simple and pleasing composition, and the unbroken lines of the exteriors of the Palazzo Stoppani (formerly the Palazzo Cafarelli) are productive of that continuity, so justly admired and so worthy of

being contrasted with the broken lines, general in most of the works in architecture of this country.

Of the numerous works of that great architect and engineer, Michele san Michele, the contemporary and friend of Michael Angelo, little is known in this country. The chief productions of this eminent man are the Cappella Pellegrini, the Church of La Madonna, the Palaces of the Cornari and Grimani, the Piazza Bra, and the Porta Palio, and other entrances into Verona. Although these works do not possess the purity of those of Palladio, yet they exhibit such boldness of execution and originality of invention as has seldom been surpassed.

To Giulio Romano, the pupil of Raphael, we owe the Villa Madama, the general plan of which, the beautifully composed loggia, painted most enchantingly by himself and his scholars, together with its grottoes, are in themselves sufficient to establish his pretensions to architectural fame.

The Villa Madama is particularly interesting by its singularly beautiful situation and from the remains of the rural theatre, wherein the Pastor Fido of Guarini was first represented.[6] The Palazzo del Te at Mantua was likewise designed by Giulio Romano, and has great claims to the attention of the architect. Of this building I made drawings some years since, which I regret are lost, as there is no complete publication of it. I am indebted to the Professor of Painting (Mr. Fuseli) for the general plan of the building.

Sebastian Serlio, the pupil of Peruzzi, is a name well known. He was a zealous admirer of the ancient architecture whose imposing remains he assiduously measured. His treatise on the ruins of Roman grandeur is alone sufficient to recommend him to the notice of the young student.

To the labours of Serlio we may add those of Vignola who, by diligently studying the writings of Vitruvius, and by accurately and repeatedly measuring the remains of ancient buildings, attained the highest honours that could be bestowed on an architect. Incessant in his studies, his works were, of course numerous. The unfinished Ducal Palace at Modena has some fine parts. The church of Sant' Agostino at Bologna,[7] although little known, is grandly conceived. It has great originality and differs most happily from the general monotony of Italian churches. The beautiful plans and exterior of the [Villa] Papa Giulio at Rome and the Farnese Palace at Caprarola, can never be sufficiently admired or too

[6] Giovanni Battista Guarini's pastoral play, *Il Pastor Fido*, of which Soane owned a French translation (The Hague 1702), and another copy with a text in Italian and English (London 1736). It was well known in England where it was turned into an opera by Handel.

[7] Soane was wrong in his attributions to Vignola. The Palazzo Ducale at Modena post-dates Vignola. Can Soane have been remembering the uncompleted Palazzo Farnese at Piacenza, on which Vignola worked? Also, there is no church of S. Agostino at Bologna. Soane was doubtless thinking of S. Agostino at Piacenza, by Bernardo Panizzari, which Anna Miller had misattributed to Vignola (*Letters from Italy*, vol. I, London 1777, p. 250). In Lecture V, Soane therefore showed a plan of Brunelleschi's S. Spirito, Florence, in its place.

much studied. Nor should the magnificent church of the Jesuits in Rome and the little church of Sant' Andrea in the Via Flaminia pass unnoticed.

Vignola possessed great knowledge of the remains of antiquity, but it is to Palladio we must look for classical purity. This truly great architect, struck, like Brunelleschi, with the majestic ruins of ancient splendour, searched most assiduously into those remains in every place where Roman works existed, and from a close acquaintance with them he infused into his own compositions a large portion of their correctness and produced that noble simplicity, that chaste style, so visible in most of his works. He has, however, been accused of following the antique blindly and of introducing indiscriminately into private dwellings whatever he considered beautiful in the works of the ancients.

The churches of San Giorgio and Il Redentore at Venice, and the Convent of La Carita, are most beautiful specimens of refined taste; his noble design for the Rialto claims our admiration; the Basilica and Olympic Theatre at Vicenza are works of elegant fancy; the Villa Capra, and many other buildings after his designs, are justly celebrated for that noble simplicity, which can only be acquired by close attention to the works of the ancients.

Scamozzi likewise applied himself to the study of the ancient buildings and, if his compositions are inferior to those of Palladio, they are, however, often well conceived and truly majestic. His idea for the restoration of Pliny's villa at Laurentinum is not without merit, and his treatise on architecture, although unfinished and full of promises far beyond what he has performed, has very great merit and should be attentively read.

Having mentioned the Laurentinum of Pliny, I cannot resist the opportunity of showing an idea for the restoration of that celebrated villa by the late Mr Stevens.

Of the other great artists of this happy age I shall only mention Bernini and Salvi. Bernini had in early life imbibed this noble and useful maxim 'Man never attains perfection, and might, by study, always do better.' The works of Bernini are very numerous but not all equally entitled to praise and imitation. The Baldaquin of St. Peter's with its twisted columns, formed of the metal ornaments plundered from the Pantheon, will be a lasting reproach to his memory.

The noble colonnades that form the approach to St. Peter's is a work well known and justly appreciated. Some have considered the order which is there used as not being sufficiently rich; but the astonishing effect of light and shadow on such an immense number of large masses, changing in effect every moment, scarcely leaves coldness itself power to censure the work. The church at La Ricci [Ariccia] is another justly celebrated work of Bernini with which the young artist should be acquainted.

Nicola Salvi designed and executed many considerable works. The church of the Dominicans at Viterbo and the Fontana di Trevi in Rome (pl. 12) are entitled to the attention of the young architect.

The works of Salvi have many beauties accompanied by some striking faults. The Fontana di Trevi is grandly conceived and the general effect truly interesting. Its columns

and pilasters of dissimilar heights, its semi-pilasters attached to columns, although contrary to every principle of good architecture, create great variety and interest, and tend to produce picturesque effects particularly fascinating to the eyes of young artists. In no building are pleasing effects produced from false principles more conspicuous than in the Fontana di Trevi. And no building affords stronger proofs of the fallacy of that dangerous principle in architecture, namely, that the beauty of a design consists chiefly in its picturesque appearance.[8]

I wish to call the attention of the student to the elevation of the Fontana di Trevi, as a drawing, which I regret is not in perspective. This drawing was made by the late Sir William Chambers whilst pursuing his studies in Italy. There is a chasteness in the manner and an effect produced without much labour which makes it more desirable to the architect than the present more elaborate mode of treating architectural designs. A superior manner of drawing is absolutely necessary; indeed, it is impossible not to admire the beauties, and almost magical effects, in the architectural drawings of a Clérisseau, a Gandy, or a Turner, but few architects can hope to reach the excellency of those artists without devoting to drawing too much of that time which they ought to employ in the attainment of the higher and more essential qualifications of an architect.

Sir William Chambers, however, excelled not only in drawing. His designs for the church for the parish of St. Marylebone, and the mausoleum designed for the late Prince of Wales, show that he possessed no small portion of architectural knowledge. If the magnificent assemblage of buildings forming Somerset Place (pl. 23) are not composed in all the purity of ancient architecture, and likewise shut out the view of the River Thames from the great quadrangle (a circumstance that must always be deeply regretted), yet the beauties of many of the great features of that noble pile are so strongly marked that the fame of Sir William Chambers will live as long as the work remains. Nor is this the only monument he has left. His Treatise on Civil Architecture, the result of close application, deep, erudite, thinking, and zeal for our noble art will always be read with pleasure and profit.

These observations are perhaps somewhat misplaced, but having mentioned the name of Sir William Chambers, I could not resist the temptation of paying my humble tribute of respect to the memory, talents, and integrity of an architect, who never omitted any opportunity of aggrandizing the art.

But whilst in Italy the ancient architecture was revived and duly appreciated, in England we had only some faint glimmerings of Roman architecture in the Duke of Somerset's palace in the Strand, and in some other edifices erected in the time of King Henry the Eighth and in succeeding reigns. Of the latter I shall hereafter give specimens,

[8] For the numerous architectural resonances of this building, see John A. Pinto, *The Trevi Fountain*, New Haven and London 1986.

from monuments and buildings of those periods now remaining, and likewise from original designs in my possession, made by John Thorpe, an architect who lived in the time of Queen Elizabeth.

In these works the Roman and Gothic architecture is so fantastically blended, in consequence of the introduction of Italian artists into this country, that we see in them the most extraordinary absurdities. In the exteriors of some of them columns alternating in black and white are introduced; in others, the five orders of architecture are jumbled together, and the flat surfaces of the walls crowded with every species of grotesque ornament. Indeed, so completely was the veil of ignorance and the clouds of darkness spread over the land that this licentious, whimsical and capricious mode continued unrestrained by scientific laws and unfettered by reason until the time of Inigo Jones who, having formed his taste on the works of Palladio and those glorious monuments of antiquity which had been raised on the eternal basis of reason and philosophy, infused into his own designs lightness with solidity, elegant decoration with classical simplicity, and majesty and dignity with correct taste.

To show the different manners of this great architect who in his works treated architecture sometimes as a useful and sometimes as a pleasing art, I shall select from his numerous buildings, Castle Ashby in Northamptonshire, and the [Queen's] House in the park at Greenwich, regretting that I have no drawing of Coleshill in Berkshire which, to the honour of its successive owners, remains exactly in the same state in which it was left by Inigo Jones, whilst the alterations made in the Banqueting House since his time have given the coup-de-grâce to one of the finest rooms in Europe.

To this celebrated architect we owe Lindsey House in Lincoln's Inn Fields, the Water Gate at York Stairs,[9] the beautifully-proportioned arcades of Covent Garden Piazza, and the church of St. Paul, Covent Garden, which for simplicity and correctness of design may vie with the great works of antiquity. Part of the front next the river of Somerset House, since pulled down, was likewise designed by Inigo Jones, but his great work was the intended Palace at Whitehall, of which the Banqueting House forms only a very small part. The Persian Court (pl. 20) in this design is a noble thought that would have done honour to a Dinocrates, or a Hermogenes.

Had the entire design of the artist been completed it would have established in this country the mighty powers of ancient architecture and fixed its principles and taste on such a basis that innovation and fashion, those powerful monsters, would not have dared to have shown themselves. Notwithstanding the peculiarly promising period when this design was begun, civil war, that scourge of the human race, finally prevented the execution of this grandly conceived composition.

[9] Castle Ashby, Northamptonshire, Coleshill, Berkshire, and the York House Water-Gate, London, are no longer attributed to Inigo Jones.

The entrance into the Physic Garden at Oxford, and Shaftesbury House in Aldersgate Street (pl. 21), have been erroneously ascribed to Inigo Jones. These buildings are of his school, and the latter, even in its dilapidated state, creates an interest in the mind of the artist very unlike the sensations produced by the modern works that surround it.

The taste for good architecture, thus happily introduced, was followed by Sir Christopher Wren whose talents were called into action by the Great Fire in London. The Monument, St. Dunstan's in the East, and Bow Steeple are amongst his successful efforts. The interior of the church of St. Stephen, Walbrook, with all its beauties, is licentious in composition and deficient in apparent solidity of construction, but St. Paul's Cathedral, with all its defects, is sufficient to eternalize the name of this most justly celebrated architect.

Contemporary with Sir Christopher Wren was Sir John Vanbrugh whose numerous and extensive works show the versatility of his talents; and, if he wanted the grace and elegance of Palladio, he possessed in an eminent degree the powers of invention.

His works are full of character, and his outlines rich and varied; and although few of his compositions show any great knowledge of classical correctness, yet the mausoleum in the park at Castle Howard executed by his pupil, and the Temple of Concord and Victory at Stowe[10] are proofs that he occasionally felt the force of the simplicity of the ancients, whilst his house at Whitehall, in spite of the alterations and additions it has undergone, shows that he had the power of making small things interesting. His great work is Blenheim. The style of this building is grand and majestically imposing, the whole composition analogous to the war-like genius of the mighty hero for whom it was erected. The great extent of this noble structure, the picturesque effect of its various parts, the infinite and pleasing variety, the breaks and contrasts in the different heights and masses, produce the most exquisite sensations in the scientific beholder, whether the view be distant, intermediate, or near.

The delightful scenery on first entering this noble park, the immense sheet of water, which so entrancingly enriches the landscape, the princely palace, the great Column, and that magnificent feature, the Bridge, taken altogether produce the very climax of excellence.

It was once, sarcastically, said that the Bridge at Blenheim designated the ambitious mind of the Duke of Marlborough, whilst the rivulet beneath (alluding to what it was originally) indicated the smallness of his liberality. Such were the observations of a peevish satirist. How unlike the noble-minded Bolingbroke who, being asked his opinion of the Duke's failings, replied, with all the feelings of a great mind that 'he was so fully impressed with the good qualities of the Hero of Blenheim that he could not recollect that he had any faults.'[11]

[10] The design of the Temple of Concord and Victory at Stowe is now attributed to Richard Grenville and Giambattista Borra, not to Vanbrugh.

[11] This seems to be a paraphrase of a passage in Bolingbroke's essay on Marlborough in *The Craftsman*, no. 252, Saturday 1 May 1731.

It is impossible to contemplate the works of Sir John Vanbrugh without feeling those emotions which the happy efforts of genius alone can produce. In his bold flights of irregular fancy, his powerful mind rises superior to common conceptions, and entitles him to the high distinctive appellation of the Shakespeare of architects. To try the works of such an artist by the strict rules of Palladian tameness would be like judging the merits and mighty darings of the immortal bard by the frigid rules of Aristotle.

At the same time with Sir John Vanbrugh lived that great luminary of architecture, the Earl of Burlington, whose exquisite taste for the arts is most admirably evinced in his elegant villa at Chiswick which Lord Hervey wittily said was 'too small for any man to inhabit, and too large to hang to his watch.'[12] Every part of this beautiful composition is classically correct. Rules and symmetry are closely attended to; the taste of the ornaments is exquisite, although many of them, copied from the soffits of arches, the ceilings of colonnades, and other parts of ancient temples, are somewhat misapplied.

Since the introduction of good taste into this country by Inigo Jones, to the time of Lord Burlington and his immediate successors, architecture made rapid and progressive improvement; but since those happy periods many of the most classical buildings and princely mansions of our ancient nobility have been altered, and others have been entirely demolished according to an economising system which has produced a rage for speculative building that fatally tends to root out every vestige of good taste and sound construction.

When the poet, alluding to the magnificent residence of the Duke of Chandos at Canons, tells us that

'Another age shall see the golden ear
Imbrown the slope and nod on the parterre,'[13]

the bard seems to have been prophetic. The poet's vision has been realised and that noble pile has been destroyed. The superb mansion of Sir Gregory Page at Blackheath, has likewise been pulled down.[14] Gunnersbury House, that celebrated Palladian work, with its spacious and ample hall, its extensive and noble apartments, is no more[15]; and, what is worse, these fatal examples have led to the demolition of many others.

Alas! the metropolis also has felt the baneful effects of this system of demolition and fashionable improvement. Somerset House, Ely House, Leicester House, Bedford House,

[12] Horace Walpole, *Anecdotes of Painting in England*, J. Dallaway, ed., 5 vols, London 1828, vol. IV, p. 221.

[13] Alexander Pope, *Moral Essays*, Epistle IV, *To Richard Boyle, Earl of Burlington*, lines 173–74.

[14] Wricklemarsh, Blackheath, Kent, an early Palladian mansion of *c.* 1725 by John James, was demolished in 1787. Soane reused some chimney-pieces from it at Shotesham Park, Norfolk (1785–88).

[15] Gunnersbury House, Middlesex (*c.* 1658–83), by John Webb, was demolished in 1801.

Foley House, and many others, are no longer in existence. Some of those magnificent mansions until a few years past boasted of their grand and imposing courts, spacious apartments and extensive gardens. All are now swept away, and their sites, with the exception of Somerset House, are occupied by miserable, monotonous, paltry, plastered dwellings.

In a few generations, nay, probably in a few years, the very existence of these princely palaces with their noble appurtenances will be forgotten. Even Ely House, with its avenue of lofty trees and its extensive gardens, might at this time have been unknown had not Shakespeare preserved at least the recollection of the garden by making the Duke of Gloucester remind the Bishop of Ely of the excellence of the fruit it produced.

> 'My Lord of Ely, when I was last in Holbourne,
> I saw good strawberries in your Garden there.'[16]

The economising system of our days, so destructive, so fatal to every principle of good architecture, has, I fear, doomed Burlington House likewise to destruction. Will not the grandeur of the superb portal, the elegance of the classical colonnades, and the magnificence of the princely mansion prevent the ruin of this noble residence? At least, let us hope those beautiful colonnades will be spared, of whose effect the late Lord Orford thus expressed himself: 'Having passed the evening at a ball, at day-break, looking out of a window to see the sun rise, I was surprised with the vision of the colonnade that fronted me: it seemed one of those edifices in fairy tales, that are raised by genii in a night's time.'[17]

The drawings of this superb pile now exhibited, only faintly and imperfectly show the beauties of the entire composition. The endless variety in the play of light and shadow, the masterly effects, and powerful mind, are visible in every part of these noble colonnades. So extensive and so varied is the scenery, so great is variety of the different masses of which it is composed, that it would require language that I cannot command and a much greater number of views than I am provided with, to do justice to the beauties of this noble specimen of Palladian architecture.

Amongst the drawings with which my predecessor enriched his lectures, was a design for a magnificent Bridge over the Thames, near Somerset House. Recollecting the powerful impression the sight of that beautiful work produced on myself and on many of the young artists of those days, I am happy in the opportunity of exhibiting a copy of the drawing of Mr. Sandby's Bridge this evening, and if it gives my young friends in this Institution as much satisfaction as it did the students in my early days, I shall think myself amply compensated.

[16] *Richard III*, act III. iv. 31.
[17] Walpole, *Anecdotes*, vol. IV, pp. 218–19.

On this occasion I cannot avoid regretting that the time usually taken up by the lecture will only admit of a cursory display of the drawings, and of course they can only leave a very faint impression on the minds of the students. I trust, however, that in the next season this deficiency will be corrected by the drawings for each lecture being left in the Academy for the inspection of the students.

In all architectural compositions the solids and voids should be in due proportion to each other, and to preserve proper balance of parts is perhaps more difficult in a design for a bridge than in most other subjects. In this composition Mr. Sandby has been particularly successful. The principal masses are disposed with peculiar judgement and propriety, not over the arches, but at the extremities on the solid earth, in form and quantity harmonizing and contrasting most admirably with the lighter parts over the centre arch which, although of sufficient extent to assimilate with the large masses at the extremities, are, however, so judiciously conceived and broken, and the whole so light, that the mind is pleased with the general effect and practicability of the whole. The parts, likewise, which connect the centre with the two ends form a pleasing gradation, seeming to grow out of the other, thereby producing that continuity, that harmony, so essentially requisite in architectural compositions.

Thus much in justice to the memory of my esteemed friend. But however grandly conceived his design may be, no powers of invention, no elegance of architectural composition, could possibly atone for the destruction of the beauties of nature and of art that would be occasioned by the erection of a bridge in the situation intended for the realising of this noble design. A bridge thus placed would destroy the present enchanting effect of that beautiful reach of the river which, when viewed from the Temple Gardens, presents a scene of the most fascinating and magnificent kind. The fanciful playfulness and elegant outline of Blackfriars Bridge, the solidity and simplicity of Westminster Bridge, the noble terrace and superb buildings of Somerset Place and the Adelphi: all these objects, on the banks of one of the finest rivers in the world, with the moving scenery it presents, all seen at one view, produce such an uncommonly extensive assemblage of grand, interesting and pleasing effects as sets all description at defiance and surpasses even the powers of imagination itself.

If, instead of the general disposition as in Mr. Sandby's design, the primary or principal masses had been placed over the arches without affecting the practicability of the design, the effect would have been less satisfactory, as will be seen in the next drawing (pl. 33) [Soane's Triumphal Bridge, the RA Gold Medal Design of 1776].

This composition, like the preceding, consists of seven arches, and the sub-divisions are not unlike those in the former design. Here the similarity ceases. In this design the large masses are placed, not like Mr. Sandby's, on the solid earth, but over each of the extreme arches, and the centre, still heavier in appearance, staggers the mind as to its practicability. These three large features, not assimilating with each other nor sufficiently

connected with the intermediate parts, look more like so many distinct masses than one great building. Thus the whole design becomes deficient in that continuity and harmony so happily preserved by Mr. Sandby.

These observations are not to the credit of my own design, but the Professor of Architecture is called upon to communicate such observations as are likely to tend to the improvement of the students. On this principle these designs are here introduced and their merits and demerits pointed out. The young student cannot be too often cautioned against being too easily satisfied with his first essays, although they may have been sanctioned not only with private esteem but likewise with a large portion of public approbation.

A few words more on this subject may be useful. When a student gains the Prize Medal of the Royal Academy (an honour some years since conferred on this design), a value is stamped upon his work, not only in the estimation of others but in his own mind. It is therefore of great importance that the students in painting, sculpture, and architecture should be well informed of the beauties and defects of the designs of the successful candidates. For this purpose it will not be presuming perhaps to recommend to the members of this Institution that on or before the day appointed for the Academicians to examine the merits of the different works offered for the Premiums, a public discourse be given by the different Professors, pointing out the beauties and defects of each composition, likewise showing wherein it might be improved. Such observations would be particularly useful to the students.

These remarks will not, I trust, give offence, for where is the architect who will presume he is as competent a judge of the merits of historical pictures, or academical figures, as a painter; or what painter or sculptor is equally capable with the architect of pointing out the beauties and defects of architectural compositions?

One word more. Allow me, Sir, to observe that the academies on the continent retain the designs of the successful candidates, and thereby the honours they bestow on the young artists are considerably increased. On this principle it appears to me very desirable that the designs for which the Medals are given in this Institution should be deposited for a limited time in the Royal Academy, and the whole or a selection of them occasionally exposed to the students and the public. Such exhibitions would show the progress of art, and point out (reference being made to the subsequent works of the successful competitors) those who have realised the expectations of the Academy in the promise indicated in their first designs, and thereby render the most essential benefits and serious advantages to the young students.

I should wish to enlarge on this subject, but I have already trespassed too much on your time, and shall therefore conclude by offering my best thanks for the indulgent hearing that I have received.

LECTURE VI

~

MR PRESIDENT, – In the preceding discourses I have pointed out the great principles, and shown the feeble beginnings, the meridian splendour, and the decline of our noble art. The subject has also been continued through the Dark Ages until the revival of the ancient architecture in the fifteenth century. Its progressive improvement has likewise been noticed in the work of the great masters of the fifteenth and sixteenth centuries, as well as its introduction into England, and its state from that time until the close of the eighteenth century where I shall, for the present, leave the architecture of this country. I must also defer any discussion on the effects produced in different countries and in different ages by the decline, subversion, and renovation of the fine arts, and proceed to an enquiry into the origin and application of arches which confer almost as much honour on the human intellect as the discovery of the laws of gravitation, of the circulation of the blood, or the successful labours of Galileo. The transition by the means of arches from the horizontal construction used by the Hindus and Egyptians, and likewise by the Greeks in their early works, produced no inconsiderable change in the practice of architecture.

We must distinguish between arches formed by excavation and those subsequently constructed. In the very early works of the ancients, excavated arches were not uncommon, excavation being the most simple and natural resource in ages devoid of science. The four Indian Kings, on viewing St. Paul's Cathedral, unable to comprehend its construction, one of them (according to Mr. Addison) described this great effort of human talent as being probably at first 'a huge misshapen rock, which the natives bored, and hollowed out with incredible pains and industry 'til they had wrought it into all those beautiful vaults and caverns into which it is divided at this day.'[1]

[1] *Spectator*, no. 50, 27 April 1710–11. Soane was fond of this key text in the process of conceding validity to apparently alien cultures. Addison concluded it with the claim that, 'I cannot likewise forbear observing, That we are all guilty in some Measure of the same narrow way of Thinking, which we meet with in this

Many ingenious enquiries and learned disquisitions have been made respecting the origin of arches. These drawings from works of very remote antiquity faintly show the progressive advance towards the regular arch, but do not materially assist in ascertaining either where, or by what nation, the arch was first used constructively.

Arches by many enlightened persons are supposed to have been constructed in the most early ages. The bridge over the Euphrates is mentioned as evidence of their having been known to the Babylonians, and the entrance into the chamber of the Great Pyramid at Cairo is likewise advanced in proof of the same knowledge being possessed by the Egyptians. And it is worthy of notice that Homer, who so frequently refers to the customs of Egypt, often alludes to arches and vaulted roofs.

Aristotle has also been quoted to establish the early acquaintance of the ancients with this method of construction; but I cannot consider these authorities, however respectable, nor the remains of the early works of the Greeks, nor the entrance into the city of Paestum, nor the Cloaca Maxima of the Romans, as sufficient proofs of the early existence of arches amongst those nations. The masonry of the embôchure of the Cloaca Maxima, on which great stress has been laid, is evidently of very late date compared with the other parts of that prodigious undertaking.

On the subject of arches Vitruvius leaves us very much in the dark, which tends to prove their being unknown in his time, or at least that they were not in common use in Greece, the source of his information. From all we know on the subject with certainty, it is most probable that arches were not in general use even by the Romans anterior to the age of Augustus.

Arches form a very important part of architectural construction and naturally lead me to speak of bridges which combine the knowledge of the architect and engineer. In the execution of the various tasks imposed on the architect, the building of bridges is one which requires the most serious application, sound judgement, extensive knowledge, and deep reflection.

Bridges unite with the natural and created scenery of situations most admirably. The rude stepping stones, a few planks, or even a single tree, thrown accidentally across a stream or rivulet, have peculiar beauties, but a magnificent bridge over a wide and rapid river, forming a secure communication from shore to shore, is a grand and imposing object. Perhaps none of the superb buildings of antiquity claim our admiration more than bridges.

The bridges of the Chinese are represented as of such marvellous dimensions as far to surpass all others in magnitude and extent. The bridge at Ispahan, we are told, is three hundred geometrical paces in length, and twenty in width, with a passage in the middle

Abstract of the *Indian* Journal; when we fancy the Customs, Dresses, and Manners of other Countries are ridiculous and extravagant, if they do not resemble those of our own.'

sufficiently wide for several carriages to pass abreast, and a vaulted gallery on each side for persons on foot. The bridge at Loyang is still more extraordinary than the last, but that at Kingtung far exceeds them both in its romantic situation. This bridge, by means of a number of chains suspended from the opposite mountain, covered with planks, forms a communication across a valley of frightful depth.

The Chinese boast likewise of other bridges more than four miles in length; these, as well as the bridges of India and those made of boats in Italy, are curious and interesting, and some of them will be later more particularly noticed.

Of the bridges of the Romans we have many, and also some considerable vestiges. Of that over the Nar, at Narni, although enough yet remains to impress us with its prodigious dimensions and magnificence, yet in importance it is much inferior to Trajan's bridge over the Danube which was more than a mile in length, and consisted of twenty arches, one hundred and sixty feet in span, and one hundred and fifty feet high. When we consider the prodigious dimensions of this stupendous work, and the rapidity and depth of the river over which it is raised, it requires a mind of uncommon vigour to meet the difficulties of such an undertaking with any rational expectation of success. This bridge, especially raised to facilitate the passage of the Roman armies into the countries of the barbarians, was destroyed by the immediate successor of Trajan to prevent those very barbarians from making inroads into the heart of the Roman Empire.

The bridge at Rimini is nearly in the same state as in the time of Augustus, and of the Senatorial bridge at Rome, over which the conquerors of the world passed in all the pomp of proud triumph, attended by captive monarchs loaded with chains, the remains are yet considerable, as well many others over the Tiber and in different parts of the Roman Empire, all of which are entitled to the most serious investigation of the student.

But whilst we give due praise to the bridges of the ancients let us do justice to those of later times. The bridge over the Allier at Brioude in Auvergne is perhaps the largest arch now existing, the chord line being about one hundred and eight feet. To this great work may be contrasted the elegant bridge of La Trinità at Florence, composed of three arches, nearly similar, and formed by portions of the cycloid.

The noble bridges over the Thames at Blackfriars and Westminster, and the Pont de Neuilly, near Paris, are masterpieces of different kinds and of original imagination. Blackfriars Bridge will, I trust, long remain a monument of the artist-like mind of the architect. Its lightness, fanciful originality and picturesque appearance will always command the approbation of those who consider architecture as a pleasing as well as a useful art. Westminster Bridge can only be regarded for its utility and characteristic marks of massive strength.

The Pont de Neuilly is a work in which the great mathematical powers of the artist will be duly appreciated but, as Perronet and Labelye, although excellent engineers, were very bad architects, it is in vain to expect in their works either beauty or elegance.

The bridge built by Inigo Jones over the Conway[2] is a work so bold and so marked with superior skill that it would alone have been sufficient to have immortalised his name.

The great bridge over the Taaffe[3] is worthy of observation; it is a work well known and which will be hereafter considered together with other bridges of stone, wood, and iron.

Nothing can exceed the beauty of the semi-circular arch when properly introduced, but arches, like columns, are only pleasing to the eye of taste and judgement when disposed in proper situations. In bridges we have seen them so applied, and nothing can be more beautiful, but if arches of any kind are used in compositions wherein the early Greek orders are introduced, no beauty of form can justify such an anachronism. Such flagrant violations of propriety may be avoided, and example being more powerful than precept, I shall instance a building which has received no small portion of approbation, and had I not been led by the composition of these lectures to search into original causes and first principles, the defects in this design would not have been noticed. The defects of this work are not confined to the arches for, although it professes to be an imitation of Grecian architecture, yet those very parts are here introduced into an interior which, according to the constructive system of the Greeks, belong exclusively to the exterior. It is impossible for me to impress too much on your minds that modillions, mutules, dentils, and triglyphs cannot be admitted in the interior of any edifice with even a shadow of propriety. Instances, however, of these violations of correctness in design frequently occur in other modern works as well as in this composition, and I fear they will continue to be adopted so long as we are satisfied with copying the works of the ancients servilely, without recurring to the first principles on which they were raised.

I shall for the present dismiss the further consideration of arches and proceed to speak of domes and cupolas.

The ancient architects, fully impressed with the beauty and importance of domes, constructed them with durable materials and in the most scientific manner. Had it not been so the astonishing dome of the Pantheon, the light and elegant dome of the Temple of Minerva Medica, those in the Baths of Diocletian, that at St. Rémy, as well as many others, would only have been known to us in the annals of the historian.

There is also a very uncommon specimen of dome at Ravenna which forms the roof of the Basilica of Hercules or, as called by others, the Mausoleum of Theodoric. This dome, although nearly twenty feet in diameter and weighing between eight and nine hundred tons, is notwithstanding formed out of one piece of marble.

[2] The three-arched stone bridge of 1636 at Llanrwst has sometimes, though with no documentary evidence, been attributed to Inigo Jones.

[3] The celebrated bridge over the Taff at Pontypridd, Glamorgan, is a single masonry span of 140 feet with haunches pierced with cylindrical holes. It was completed in 1756 from designs by William Edwards (1719–89).

The ancients confined the domical form of covering to buildings whose plans are either square, polygonal, or circular. These hemispherical roofs were sometimes left open at [the] top for light, as in the Pantheon and in other ancient buildings, but the domes of the Temple of Minerva Medica and of the Mausoleum at St. Rémy, as well as those of the Baths of Diocletian, are all complete hemispheres, whilst in other buildings domes are terminated, as directed by Vitruvius, with some characteristic ornament: at the Mole of Hadrian with a pineapple, and at the Tower of the Winds with a Triton holding in his hand a wand. There is also a very distinct species of dome to be seen in the church of Sta Sophia at Constantinople, for which happy invention we are indebted to two Grecian architects, Anthemius and Isidorus. This dome, though less simple than those in ancient buildings, is far superior in lightness of appearance and boldness of construction. This dome, resting on four arches, springing from as many large piers, makes on its ichnographic projection a perfect square, whose concave surfaces gradually increasing from its base, form a complete circle, on reaching the crown of the four arches. Thus the entire dome, reposing on four points, seems rather suspended in the air than supported by the piers.

The domes of the ancients seem always to grow out of the substruction and to harmonize and unite with it in the most gradual and pleasing manner, forming as it were a canopy to the entire edifice. In many modern structures domes seem to be placed on the roofs without any visible support, and without any apparent connection with the other parts of the edifice, as at St. Peter's in Rome, St. Paul's in London, the church of the Invalides in Paris, and other examples. It must likewise be remarked that modern domes, instead of being terminated with light appropriate ornaments, as in ancient works, are now often surcharged with lanterns of very considerable dimensions, both in bulk and height. However general this fashion may now be, it is not less deserving of censure, for as the dome represents the roof of a square, polygonal, or circular building, in the manner as the pediment designates the roof of a rectangular structure, how can we add a lantern, or any other building, on a dome? If the architects at Tralles were formerly reproved for having represented in a scene only, columns and pediments on the roofs of their buildings,[4] if one of these barbarous monstrosities had been raised upon the dome of the Pantheon, would not every man of taste in antiquity have exclaimed against such a preposterous addition? Such an addition, however, was only prevented by the death of Alexander the Seventh.

Domes have given place to spires, a singular species of composition, supposed to have sprung out of Gothic architecture, or from the remains of early superstition. It is not improbable that the obelisks of Egypt suggested the idea of spires; whatever partakes so distinctly of the pyramidal form may be reasonably supposed to refer to the worship of the sun.

[4] *De architectura*, VII, v, 5.

Bow steeple, a fine example of this species of composition, is full of rich fancy. The well-proportioned arched entrances must satisfy all beholders, and from the square pilastrade upwards nothing can be more pleasing, light, and elegant. The Gothic spire of St. Michael, Coventry, is another fine example; each part seems to grow out of the other until the whole mass finishes in a point.

The steeple of St. Dunstan's in the East, like its twin brother at Newcastle, is uncommon in its design and bold in its construction. The effect is light and pleasing and it must be considered amongst the many proofs of the skill and mathematical knowledge of Sir Christopher Wren.

When spires unite and make a part of the buildings they accompany, as in these examples, they are entitled to all the praise that such fanciful compositions can claim; but when instead of rising, as it were, out of the ground, they take their bases on pediments of porticoes, and upon the tops of roofs, as at the church of St. Martin in the Fields, St. George, Hanover Square, St. Leonard, Shoreditch, and many other examples, no elegance of form, no variety of outline, can make such compositions at all bearable.

Spires blended with towers, domes, and other objects of different heights, forms, and magnitudes, when seen at a distance, strike us most forcibly and altogether produce a perspective of the most pleasing kind, but, as we approach nearer, and find these large objects apparently unsupported and seeming to grow out of pointed roofs, these pleasing sensations gradually subside, and end in disappointment.

Spires, towers, domes, have been considered as the great characteristics, and even necessary appendages to places of public worship. Staircases in the same degree are also said to designate the convenience and importance of public and private edifices.

In places of public worship, staircases are but secondary objects, but in palaces, theatres, and noblemen's mansions, they are most important features. On this part of our art we shall derive but little information from the ancients.

We are told by Le Brun[5] that in the palace of the Median kings at Persepolis, partly destroyed by Alexander, there are ninety-five steps of a staircase of white marble so broad and flat that twelve horses might without difficulty go up abreast.

If we examine the dimensions of the steps leading into the peristyles of ancient temples they will be found to be proportioned rather to the ordonnance, magnitude, and character of the building rather than for ease of ascent. Indeed we cannot expect to gain much information on this head from the ancients, when it is considered that their buildings in general, both public and private, consisted of a ground floor only.

Staircases are mentioned by Homer, and Lysias in one of his Orations, describing the

[5] Soane referred to the lavishly illustrated account of Persepolis in *Voyages de Corneille le Brun par la moscovie, en perse, et aux indes orientales*, 2 vols, Amsterdam 1718, vol. II, pp. 261–91.

House of Euphiletes, speaks of two storeys,[6] and at Pompeii there is an instance of a house with a second floor; but as Pliny and Varro do not mention staircases in the descriptions of their villas, it is reasonable to conclude that they were of very inconsiderable extent. For the construction of staircases, Vitruvius applies the invention of Pythagoras for the formation of a right angled triangle. The ascent of the steps of staircases, thus constructed, so far from having a moderate inclination, must be very inconvenient and even dangerous. We may therefore conclude that the text of Vitruvius has been corrupted.

In modern works, both public and private, staircases are the very touchstones of sound knowledge and real merit in the architect. In every building they are features of such importance that to determine their proper situation, character, and extent, as well as their most suitable forms and proper decorations, requires all the experience and judgement of the most able architect.

The magnificent staircase at Caprarola by Vignola, and its companion in the Barberini Palace, show great invention combined with rich and elegant fancy. The Scala Regia in the Vatican being perspectively treated, claims admiration for the singularity of its invention.

Palladio has been particularly happy in many of his designs for staircases; they are simple and ingenious, magnificent and useful, with the same classical purity, they display the elegance and simplicity of his other works.

Inigo Jones walked in the steps of Palladio, with what success, the staircase in Dr. Bell's House in Dean's Yard, Westminster, will evince.[7]

The staircases by Kent in Lord Clermont's House in Berkeley Square, and in Lord Camden's house in Arlington Street, are works deservedly praised and worthy of imitation. To these examples may be added another of the same superior style of composition, formerly in Melbourne House. This work of the late Sir William Chambers, worthy of being placed in competition with the finest productions of Italy, is no longer in existence. This beautiful staircase has been destroyed by that fatal spirit of alteration that has within these few years deprived us of many of the most successful efforts of English genius.

Staircases, vestibules, saloons, and galleries, offer a wide field for the exercise of talent in sculpture, painting and architecture. Sir James Thornhill, Verrio, and Kent, availed themselves of such situations, and if these examples had been followed by the artists who succeeded them, instead of the present fashion of crowding on to flat monotonous ceilings of our public and private buildings with plaster ornaments and small compartments occasionally spotted with an unimportant picture; instead of walls covered with fine papers, with a portrait or a bust occasionally interspersed, according to the whim of the fashionable decorateur of the day; instead of all these colifichets, we should have had seen decorations

[6] *The Orations of Lysias and Isocrates*, transl. John Gillies, 'In Defence of Euphiletus', London 1778, p. 420.

[7] The house in Dean's Yard, i.e. Ashburnham House, is now attributed to John Webb, not to Inigo Jones.

that would have done honour to an Algardi or an Albertolli; we should have seen the walls of the principal rooms of the mansions of our nobility dressed with rich hangings, and enriched with all the charms of historical pictures, and with all the powers of the sculptured breathing marble.

Our climate will not admit of external paintings. Statues and relievoes are the highest decorations that the architect can call to his aid in the exterior of his works. Wherever placed, however composed, they must be proportioned to the magnitude, as well as correspondent to the architecture and character of the edifice. 'The Alabandines (says Vitruvius) were censured for placing statues in the Gymnasium, in the attitude of pleading causes, whilst those in the Forum were holding the discus, or expressing the action of running or playing with balls.'[8]

In modern works, statues are variously introduced, generally with as little regard to situation as to character; sometimes on the extremities, or centres of pediments; sometimes in recumbent attitudes on the inclined sides of pediments, and frequently half concealed in niches. The summit of the steeple of Bloomsbury church is crowned with a statue of King George the Second, which occasioned the following epigram.

'When Harry the eighth, left the Pope in the lurch,
His Parliament made him the head of the Church,
But George's good subjects, the Bloomsbury people,
Instead of the Church, made him head of the Steeple.'

Statues thus placed are as deserving of censure for the impropriety of situation, as those of the Alabandines for impropriety of character.

We have not been more successful in our imitation of the Greeks who, as has been observed already, used on different occasions representations of male and female slaves instead of columns. Homer speaks of the statues of slaves supporting silver lamps in the Palace of Alcinous; and in imitation of these examples we employ not only the divinities but canephora and slaves of antiquity to support lamps, to sustain the roofs of verandas, to adorn the exterior of fashionable shops, and for other menial offices.[a]

To statues and relievoes may be added the termini of the ancients. Termini owe their origin to the rude memorials used by the ancients to mark the boundaries of each man's possessions. They are of very early antiquity; in Holy Writ, Moses is directed to set up stones as landmarks which the Hebrews considered sacred, and held that man accursed who removed his neighbour's land-mark.

[a] Note. I know not how these fancies are to be reconciled to the practice of antiquity and to the precepts of Vitruvius who says the architect should be learned, that he may introduce into his works only those decorations for which a satisfactory reason can be given. Nothing but custom can reconcile these absurdities: what is frequently seen is seen without emotion.

[8] *De architectura*, VII, v, 6.

Numa Pompilius, to render these memorials inviolable, built a temple to Terminus and instituted festivals and sacrifices in honour of him. In this temple he was first worshipped under the form of a large mis-shapen stone, whereunto a human head was afterwards added, which on solemn days was decorated with garlands of flowers. If such was the origin of termini how are we to account for their being so often seen in our parks, and pleasure grounds,[9] on the fronts of houses instead of attic pilasters, in niches, both externally and internally, as substitutes for lamp irons? To what base uses the noblest ideas are applied!

> Well might the poet sing,
> 'Imperial Caesar dead, and turned to clay
> Might stop a hole to keep the wind away.'[10]

Leaving the consideration of statues, bassi relievi, and termini, let us enquire into other modes of decoration used by the ancients. According to Vitruvius the interior of their houses were embellished with the representations of edifices with columns and pediments, and the fronts of scenes, tragic, comic, and satiric. The walls of their large apartments were decorated with landscapes, and paintings of figures representing the gods, fabulous histories, the Trojan War, the wanderings of Ulysses, and other subjects conformable to the nature of things. By such practices the ancients attained their high celebrity. In the 15th and 16th centuries the great patrons of the arts, the Leos and Medici, entered fully into this spirit of the ancients, and by decorating the ceilings and walls of their churches and palaces with painting and sculpture formed those great artists whose works have since been the wonder and delight of the enlightened of all nations. Let us hope the time is not far distant when the same spirit will arise in this country, our artists enjoying those opportunities that so successfully called into action all the mighty powers of the Italians. England will then boast of her Raphaels, her Titians, and her Michael Angelos.

In the works of the Greeks, decoration of every kind may be traced chiefly to the symbolical representations of their divinities, to their religious ceremonies and sacrifices, their fabulous histories, their imitations of the infinite variety in the vegetable and fossil world, and to their architectural constructions. The decorative system of the Egyptians also may be found in the same causes, except that with them all ornament is independent of construction.

In the best works of antiquity propriety of decoration has been particularly attended

[9] Soane will have been aware of Payne Knight's attack in *The Landscape* (1794) on Repton's recommendation that milestones bearing the proprietor's arms should be erected at Tatton Park.

[10] *Henry IV, Part I*, VI. i. 235. Shakespeare wrote 'Imperious' not 'Imperial'.

to. The ancient architects, fully impressed with its importance, seem always to have been desirous of using such ornaments only as were analogous, and which tended to determine the character and destination of the edifice. Of these truths we have sufficient proofs in the different ornaments to be seen, not only in the ceilings and soffits of the peristyles and other parts of ancient buildings, but likewise in the innumerable fragments of cornices, friezes, and capitals, in the different Italian villas, and in the various ruins so abundantly scattered all over the Campagna of Rome.

Among the different decorations adopted by the ancients, the serpent, one of their emblems of eternal duration, is very often seen. In Holy Writ we are told that Moses set up a brazen serpent whose virtues, to those who were within view of it, were so great that even the bite of the python himself would have been harmless.

In Egypt the God Knuphis was worshipped under the form of this reptile. So likewise in Greece and Italy was Esculapius whose statue is always represented with a serpent twisted round a staff. The Indians also place a serpent in the hands of their divinities. From the serpent of Eden to the serpent of Achmin, this reptile, for beauty of form and for wisdom, has maintained an uninterrupted celebrity. Hence we may account for the very frequent representations of the serpent in the decoration of the temples, altars, and tripods of antiquity; and by referring to first causes we shall perceive the same propriety in the other ornaments used in ancient works. In a future discourse [Lecture xi], therefore, I shall endeavour to point out the origin of the various ornaments to be found in the remains of ancient works, that the student may be enabled to distinguish that which ought to be rejected and that which should be admitted, without violating the principles of Grecian architecture, or in other words, without offending against the laws of nature, propriety, and just character.

Propriety in decoration was not, however, always strictly attended to; the ancients had their bad artists as well as the moderns. Vitruvius complained that in his time the manners of men were so changed and depraved that in the decoration of their buildings, instead of introducing subjects copied from nature, monsters, rather than the resemblance of natural objects, were painted on the stucco, and reeds and candelabra substituted for columns. How is it possible, exclaimed that great architect, for reeds to support roofs, candelabra buildings, or soft and slender stalks entire figures, or the flowers of stalks to produce demi-figures? Yet men being accustomed to the sight of these absurdities instead of censuring, become pleased with them.

If these absurdities in the works of antiquity received such censure from the father of architects, what would he have said on seeing the exterior of a modern building decorated with the caducei and other attributes of Mercury, or of an interior enriched with the representations of winged figures, and with lions' heads in the cymatium of the cornice? In what terms would he have expressed his disapprobation on seeing the outsides of many of our buildings disfigured and disgraced with expensive, wooden, oil-cloth verandas, or

Mary-bone bird-cages?[11] What would have been his mortification on seeing our halls of justice, gloomy prisons, solemn places of worship, baronial castles, magnificent mansions, elegant villas, private houses, and even the fronts of our shops, crowded indiscriminately, not only with these fantastical inventions which he has so justly condemned, but likewise with the wings, globes, serpents, and other symbols of heathen worship, as well as with the crowns and wreaths bestowed on the victors in the Olympic Games, with the representations of animals, partly human, partly beast, partly bird, and partly fish; with griffons, sphinxes, and serpents, with the sculls and heads of oxen, rams and goats; with the eggs and darts of the mundane system, and with every other species of decoration to be found in ancient edifices?

However beautiful the forms of such decorations may be, as they are only applicable to the mythology and particular customs of the ancients, it follows, therefore, that they cannot be admitted into the decoration of modern buildings without violating every principle of sound judgement and correct taste.

However great and fascinating the powers of decoration may be, when the architect, painter, and sculptor unite their talents in the same work, yet ornaments, although characteristic and of the most exquisite execution, will be of small value if the edifice is in other respects deficient in character and justness of proportion.

The ancients were so fully sensible of the necessity of a thorough knowledge of the harmony of proportion, and of the concord of sweet sounds, that the poets feigned Amphion to have built the walls of Thebes by the powers of music; and Vitruvius tells us that an architect should not be ignorant of music.

Galiani[12] adopts this idea and attributes the degeneracy of architecture to our neglect and ignorance of that science. Others have considered architecture as a species of ocular music, and, according to Bianchini,[13] all the proportions in the Sepolcro degli Liberti d'Augusto are exactly the same as in music.

To these authorities may be added the opinion of Monsr Ouvrard,[14] the ingenious author of a treatise on the application of harmonic proportions to architecture, who declares that all architectural effect depends entirely on harmonic proportions, and on the analogy of those proportions with our senses. These ideas have been so far misunderstood that some of our writers have maintained that no building could be beautiful if all its parts were not in arithmetical and geometrical proportion. This, however, is not the case. These

[11] By 'Marybone birdcages', Soane referred to Regency ironwork balconies of which he had an irrational dislike.

[12] Berardo Galiani, *L'Architettura di M. Vitruvio Pollione nella tradizione Italiana e commento del Marchese B. Galiani*, Naples 1758.

[13] Francesco Bianchini, *Camera ed inscripzioni sepulcrali de'liberti, servi, ed ufficiali della Casa di Augusto scoperto nella Via Appia*, Rome 1727.

[14] René Ouvrard, *Architecture harmonique, ou l'application de la doctrine des proportions de la musique à l'architecture*, Paris 1679.

fanciful opinions, these wanderings of the imagination, like the ocular harpsichord, invented by Père Castell[15] to demonstrate the analogy between sounds and colour, may show great ingenuity, and originality of thinking, but are neither applicable nor useful.

According to Claude Perrault, the learned translator of Vitruvius, and architect of the celebrated façade of the Louvre, architecture is not confined to any shackled mechanical system.[16] It has no fixed proportions: taste, good sense, and sound judgement, must direct the mind of the architect to apply harmony and justness of relative proportions, that correlation of parts with the whole, and of the whole with each part. Let the young student consult incessantly, and endeavour to infuse into his own compositions, that harmony, fitness and mutual relation of parts in the great productions of nature and experienced in the magical effects in the sublime works of the ancients.

In no part of the practice of the profession of architecture will the artist be more distinguished from the patronised pretender to architectural knowledge than in the correct application of relative proportions and fitness of parts. The architect who is master of these powerful means may, without the aid of sculpture, columns, and costly materials, please the eye, and even satisfy the minds of those who possess elegant fancy, classical taste, and sound judgement.

The following examples will be sufficient to establish this important truth: the front of General Wade's house, by Lord Burlington, and the lawn front of Wilton House, and Lindsey House in Lincoln's Inn Fields, the admired works of Inigo Jones.[17]

The latter mansion, with its plastered front, and its common red tiled roof, from a certain harmony and fitness in its parts, commands attention and excites pleasurable sensations in the mind of the spectator, whilst the adjoining house, built many years afterwards, with every advantage of materials creates disgust, from lack of that harmony of proportion so visible in Lindsey House. In this work of our great architect, the roof, in quantity, is just what it should be; even the chimney shafts contribute to the beauty of the building. In the adjoining house the roof is so preposterously high, and the chimney-shafts so out of all proportion, that these parts seem to overload and crush the whole front.

It must be observed that in many modern buildings the roofs and chimney shafts are not considered of so much importance in the effect of a composition as they formerly were. To treat the roof merely as a protection from the weather, and the chimney shaft only as a tube to convey away the smoke, is not sufficient. These parts are decidedly of great value in the general effect of a building, and that chimney shafts have been so considered I need only refer the student to the 'Architectural Antiquities of Great Britain,'[18] a very ingenious

[15] Louis-Bertrand Castel, the eighteenth-century French Jesuit scientist-philosopher, invented a 'clavecin oculaire' as part of his investigation, influenced by Newton, of the relation between colour and tone.

[16] Claude Perrault, *Les dix livres d'architecture de Vitruve, corrigez et traduits nouvellement en François, avec des notes et des figures* (1673), 2nd edn, Paris 1684, p. i.

[17] Lindsey House is now attributed to Nicholas Stone, not Inigo Jones.

[18] John Britton, *Architectural Antiquities of Great Britain*, 5 vols, London 1807. Vol. III was dedicated to Soane.

and useful work, wherein are shown several curious and beautiful examples of chimney shafts well deserving the attention of the young artist who should never forget that no part of his composition must be neglected; for, however small, it will be of importance in the eye of true taste. In these buildings by Lord Burlington and Inigo Jones there are no prominent features, no richness of materials, yet the effect is more than satisfactory, whereas on the other hand, if columns are disproportioned, as in the portico of the Admiralty, where although the features are large and ought therefore to command respect, yet being squeezed in between the sides of the building, from the total want of relative proportion in the parts of the portico, the whole is uninteresting.

If columns are mis-placed on a high basement, perforated with apertures of different kinds, they become rather defects than beauties. It is worthy of remark that in all the works of Palladio, so truly has that great architect adhered to the practice of antiquity, there are only three examples of isolated columns placed upon perforated basements, and only one of the three with a projecting or open portico.

In this country, where the difference of climate renders projecting porticoes on high basements less convenient, and consequently less pleasing, they are but too common.

Lord Burlington's Villa at Chiswick, Cusworth Hall in Yorkshire [by James Paine], the Mansion House in London, are examples, amongst many others of this mis-application of columns.

Inigo Jones, Perrault, and other great architects, whenever they have introduced into their works a high basement, feeling the impropriety of perforating what may be called the base of the column, always made their porticoes recede from the front line of the wall, thereby rendering the defect of apparent instability less conspicuous, as may be seen in Perrault's celebrated work, the Louvre, and the Garde Meuble in Paris (pl. 14); the Queen's House at Greenwich, and until lately in the front of Gunnersbury House, the two latter, the work of Inigo Jones.[19]

Contrast columns thus elevated with those forming the semi-circular porticoes of St. Paul's Cathedral, and the portico of St. Paul's, Covent Garden, or perforate the continued basement of the little temple at Tivoli, and compare the design as thus altered with the original, the truth of what has been advanced will be too apparent! and the student more forcibly impressed with respect to the proper and improper application of columns.

In the architecture of the Chinese which has not been changed for thousands of years, columns, which are at least as frequent as in the buildings of Europe, are almost invariably used as in the best examples of the Greeks and Romans; and Sir William Chambers tells us that the Chinese architecture has a remarkable affinity to the antique.[20] The general form

[19] Gunnersbury House is now known to be by John Webb.

[20] William Chambers, *Designs of Chinese Buildings*, London 1757, p. [i].

of almost every composition has a tendency to the pyramidal figure. In both, diminished columns, with bases resembling the attic bases of the ancients, are employed for supports. The disposition of the Chinese Ting is not much different from the peripteros of the Greeks. The atrium, the monopteros, and peristyle temple, are forms of buildings resembling some used in China. Let me not be suspected, however, he adds, 'of an intention to promote an art so much inferior to the antique, and so very unfit for our climate. I look upon the Chinese buildings as toys in architecture, that may be sometimes allowed, and therefore, in compliance with the desire of several lovers of the art, I have published designs of their buildings that they might be of use in putting a stop to the extravagancies that daily appear under the name of Chinese.'[21]

If, to the different attainments and extensive studies required by Vitruvius to form an architect, we subjoin the various difficulties he has to encounter in the exercise of his profession, we cannot be surprised either at the very limited number of regularly educated architects, or at the present state of the art. Architects have difficulties to encounter unknown to painters and sculptors. Painters and sculptors can exhibit their works in whatever stage of progress they please, whilst those of architects are viewed from day to day and false impressions are taken from unfinished works. Architects are likewise frequently trammelled by circumstances which they cannot control, and often censured for what has been done, not from their own choice, but from necessity, as will be seen from the following examples.

In the cymatium of this building[22] lions' heads were placed to carry off through their mouths the water from the roof, in imitation of the cornice of the Tower of the Winds at Athens. An attic being afterwards added, that which was before conformable to the nature of things became an absurdity. The north front of the Bank of England is another more striking instance of the censure to which architects are liable from local causes. This façade was originally constructed agreeably to the drawing before you, but sometime afterwards it became necessary to enlarge the building on the site of old houses. A design was accordingly made with a large portico in the centre. On removing the old houses the space would only admit of the contracted centre here shown. Hence originated the narrowness of the centre, so disproportionate to the entire front. From these and other examples which might be produced, it may be concluded that for many of the defects in our buildings, if traced to their real causes, architects would receive praise where they now receive censure, and, what is of more consequence, their imperfections would not be considered beauties, and so often copied by their followers, as the wry neck of Henry the Fourth was imitated by his courtiers.

[21] *Ibid.*, pp. [i–ii]. This 'quotation' is an amalgam from various passages in these two pages.
[22] The building Soane illustrated was his own Barracks at the Bank of England with lion heads in the cymatium of the cornice.

I shall now make a few observations on theory and practice. Nothing can be more useful to the student than his own theoretical dreams of magnificent compositions produced by a warm imagination.

'............................ in the morn of life,
When hope shone bright, and all the prospect smil'd.'[23]

When lively fancy, attended by flattering hope, direct the young artist to the means of storing his mind with those ideal designs, with those fascinating treasures, which create that true love for his art, and those enthusiastic sensations which stimulate him to exertion, and teach him to enjoy by anticipation all that fame and fortune can bestow, and which can only cease with his existence.

But however useful the early theoretical compositions of the young student may be in forming the great architect, his judgement cannot be matured by such studies. Nor will they sufficiently prepare him to venture on that tempestuous sea of troubles which the practice of architecture presents, and on which he must commit himself with the greatest caution and due mistrust of his own powers. Other studies, other thoughts, must now occupy his mind. The delightful visions of early youth must now give place to the choice of materials, to solidity and practicability of execution, sometimes to the shackles of building in a great city, and always to the restraints of economy, and finally to that correctness in calculation of expense, so necessary to the moral character of the man, and so important to the architect in the discharge of the great trusts reposed in him.

The young artist is apt to imagine that, when he is able to combine together a great number of complicated forms, each well balanced with the other and making together a magnificent whole, that then he is prepared to meet all the difficulties of a professional life. Alas! he will soon find that much remains to be acquired. He must distinguish between that which is useful, and that which is merely ornamental. He must have a perfect acquaintance with all the details and with all the different uses of the work on which he is engaged. Without these requisites, although his composition may be strikingly characteristic, strongly marked with the mind of genius and the fascinating powers of elegant fancy, it will be little calculated for the purposes required, and therefore inferior in consideration and value to other designs of much less merit in point of invention and classical taste.

To apply these remarks, let us suppose that it was in contemplation to build a bridge over the Thames, or any other great river. Let us suppose four designs offered by different competitors: two of them composed without any regard to expense, the third uniting beauty and utility, and the fourth formed with an eye to convenience only. On this occasion the two first designs would be treated as theoretical visions, as pleasing pictures, as mere portfolio

[23] Mark Akenside, *The Pleasures of the Imagination* (1757), book III, lines 346–47.

drawings; either of the others having practicability and characteristic propriety must be entitled to superior considerations. In further elucidation of the difference between theoretical and practical designs, and likewise to point out another species of disappointment and vexation to which the architect is exposed, I shall subjoin two designs for a Senate House. The first, composed as a study in the quiet moments when the youthful mind, unshackled and unsicklied with the frequent disappointments of a professional life, was only occupied in the contemplation of the magnificent remains of palaces, temples, baths, triumphal arches, and other objects interesting to the artist and firing his imagination. This design, although made under such advantages, had it been offered as a fit model for such an edifice, persons conversant with the business of parliament who would soon have discovered in the plan such want of convenience, and so many deficiencies in the most essential requisites, that they would only have considered this composition as an effort of fanciful imagination, little adapted to the purpose required. In the second design (pl. 35), subsequently made in advanced life, in obedience to a command of a Committee of the House of Lords, appointed to alter and improve the buildings then used as the Lords' House of Parliament, it was proposed to make the present House of Commons, a central object between the two Houses of Parliament, and to restore that noble building to its original appearance, as a chapel for the members of both houses. Of this room I have no drawing, but the plan of the design and the elevations next the river and Abingdon Street, when compared with the first and earlier composition, will be sufficient to offer another striking example of the difference between theoretical and practical designs. And I trust it will not be considered irrelevant to state that in this great national work, the interests of the sister arts, so essential to the honour of a great and civilised nation, had been particularly attended to, as far as that prescribed economy which too often fetters the mind and disturbs the ideas of the artist, would allow.

On this principle the Scala Regia, or Royal Entrance, was to be adorned with the statues of our Kings and relievoes of marked events in the history of our envied country. Another idea which promised to be more than commonly favourable to the advancement of historical painting and sculpture, was likewise suggested. Namely, that instead of continuing to place our public monuments in Westminster Abbey, where nurses and children are the principal visitors, and where the remains of any person may be honoured with interment who leaves a sufficient sum of money to purchase that distinction, it was proposed to decorate the Court of Requests, the Painted Chamber, the Great Vestibule, and the other great rooms intended to form the principal avenues into the House of Lords, with painting and sculpture to commemorate the splendid achievements of our heroes by sea and land. The subjects introduced into this great national edifice would have been of the most elevated and dignified kind, calculated to call forth the most sublime conceptions of English artists who would have been further stimulated to great exertions by knowing that their works would be in the view, not only of the public in general but likewise of the highest authorities of the country; of those best enabled by powerful and commanding situations,

by great opulence, and by superior taste to promote the interests of art in general. The painter and sculptor, animated by those powerful incitements, all the energies of their minds would have been called forth in the recording of the splendid and glorious deeds of patriots and heroes worthy of having their names rendered immortal.

Such were the objects of this design which, after having been honoured with the approbation of the first authorities, and in every respect prepared for execution, was finally laid aside from a suggestion that Grecian architecture was less appropriate to the situation and subject than Gothic, and that a Gothic structure would better assimilate with the Chapel of Henry the Seventh, and Westminster Abbey, and thereby produce a burst of architectural scenery as yet unparalleled in any part of Europe. How far these magnificent expectations and promises have been realised, the building itself will best determine.

Had this disappointment happened to a young artist it might have checked the rising energies of his mind, palsied his pursuits, and perhaps have rendered the remainder of his life inactive.

In these lectures, architecture has been several times spoken of as a pleasing as well as a useful art. I shall now produce examples to mark these important distinctions, and to impress them more forcibly on the minds of the students. To this end I shall exhibit drawings of three of the triumphal arches.[24] In these buildings the columns are merely ornamental, calculated to please the eye at the expense of the judgement, by breaking the flat surface and producing an effect of light and shade; and in this view of these compositions even the pedestals are admissible and become beauties.

In the Banqueting House at Whitehall by Inigo Jones two orders of columns with the entablature breaking over them produce on a surface almost flat as great a variety of different and striking painter-like effects as could be expected from objects on different planes. In this building, as in the last three examples, architecture is little more than a pleasing art, but in the church of St. Paul, Covent Garden, another work of the same inimitable architect, architecture assumes another character. The columns, the great architrave, the cornice with its cantilevers, and the pediment are in every respect the offspring of utility, and thus, by blending together utility and beauty in the same composition, little short of a perfect work has been produced.

The columns in the two fronts of Blackfriars Bridge, like those in the triumphal arches and in the exterior of the Banqueting House, are objects of decoration only. These compositions must be considered as the playful fancies of genius, unfettered by rules, calculated to increase the pleasing effects, and likewise to show the varied powers of architecture, to interest the mind, but such designs will never reach true sublimity.

Time will not permit me to enlarge further this evening on this important part of my subject, but I shall be anxious hereafter to resume the topic.

[24] The Arches of Constantine and of Septimius Severus in Rome, and of Hadrian in Athens.

This lecture completes the number required by the Laws of the Academy, yet much remains to be done to fulfil the duty that the Professor of Architecture owes to the rising generation of artists, who, in their various works, exhibited on different occasions in this Academy, have evinced such talent and promise as entitle them to all the assistance this Institution can afford. From the increasing energies of the students and their finer feelings for the art it may be fairly expected that ere long the respective and distinct duties of the architect, the surveyor, the measurer, the builder, and contractor will be properly distinguished from each other. If then the young students pay a due regard and consideration to the moral character of the architect in the just discharge of his numerous and very important duties, particularly as respects correctness in the estimated expense of works, we may reasonably expect that all the mischievous tendencies, and sometimes fatal consequences, of the present ruinous system of building will be effectually checked, and the profession restored to its purity and former importance.

Let the young architects therefore keep in their minds how much depends on them. It is by their zealous attention to the general duties of the architect; by their persevering in the arduous task they have undertaken; by their pursuing their studies with unabated zeal and unremitting application, that we can hope for any improvement in architecture. As 'no profit grows where is no pleasure ta'en,' let me, therefore, my young friends, repeat to you my most earnest recommendation to labour successfully, and to consider your most laborious and painful exertions, nay, even your privations to attain superior knowledge, as your greatest and only real pleasures, well assured that complete success must ultimately crown your endeavours.

With my view of the importance of the subject, instead of the lectures you have already heard, I shall endeavour as far as health and the unavoidable interruptions of professional practice will permit, to compose for the next session other lectures in continuation of those delivered this year.

In them, the qualities, powers, and choice of materials, the principles and application of carpentry, la coupe des pierres, and construction in general, both ancient and modern will be fully discussed.

I shall likewise endeavour to explain the laws and principles of composition which have been only briefly touched on, and point out the manner in which the component parts of buildings, already described in these lectures, have been applied in ancient and modern works. The knowledge of these laws and principles is most important to the best interests of the young students who aim at superior distinction, and who are not satisfied with transferring from the rich stores of antiquity, moulding for moulding, and form for form, but who, like Brunelleschi, Palladio, and their fellow labourers in the vineyard, feel desirous to apply the principle on which the mighty works of the ancients were constructed, and thereby infuse into their own compositions the very spirit and classical correctness of ancient architecture.

The state of architecture in this country will be resumed and continued down to the demise of Sir William Chambers. Drawings of some of the principal designs and buildings erected under the direction of different artists will be produced, and the obligations of art to their successful efforts particularly pointed out to the young student.

The decorative parts of our art, already briefly noticed, will be enlarged on in this course, for it is the most serious import to the artist to be able to trace every species of decoration to its source, and likewise to be well acquainted with the different styles of executing ornaments found in ancient works. This knowledge will be most effectually attained by attentively studying the taste, character, and expressions of the original works, but as some of the young architects cannot have this advantage, casts in plaster carefully made from them must in such cases supply that deficiency. Impressed with these truths, and enthusiastically attached to the profession, I have often lamented that in the Royal Academy the students in architecture have only a few imperfect casts from ancient remains, and a very limited collection of works on architecture to refer to. I have, therefore, never lost any opportunity of collecting casts from the ruins of ancient structures, marble fragments, vases and cinerary urns, as well as every book and print that came within my reach on the subject of architecture, and the arts relating thereto.

On my appointment to the Professorship I began to arrange the books, casts, and models, in order that the students might have the benefit of easy access to them. The drawings now offered to your inspection[25] are part only of what is already done for that purpose and which makes only a portion of the entire plan, will give some idea of the means by which I proposed to discharge the duties of my situation to the advantage of the students, for whose improvement the Professor must always in a very considerable degree be held responsible.

Before I conclude I must beg to observe that the lectures I propose for the next year will, like those already delivered, require a very considerable number of drawings in elucidation of the different subjects that will be brought under consideration. And it having been noticed to me that the unavoidable haste in which the drawings, from their great number, have followed each other, time enough has not been allowed for the students to consider them sufficiently. To prevent this inconvenience, and that they may avail themselves of every effort in my power to assist them in their studies, I propose in future that the various drawings and models, shall, on the day before, and if necessary, the day after the public reading of each lecture, be open at my house for the inspection of the students in architecture, where at the same time, they will likewise have an opportunity of consulting the plaster casts and architectural fragments.

[25] Soane here illustrated his museum with a perspective view by Gandy and with two sections, one drawn by George Bailey.

LECTURE VII

～

MR PRESIDENT, – By the Laws of this Institution, six lectures on architecture are to be delivered annually therein, and two years (1813–1814) having elapsed since I had the honour of addressing you as the Professor in that branch of the fine arts, I feel it to be incumbent on me to state that the omission has not arisen from any intentional neglect of duty, but from a severe and tedious illness which confined me to the house at the very time fixed by the Council for the reading of the lectures. I have stated the reason of my absence, to show my respect for this Institution and likewise to prevent my young friends, the students in architecture, from considering me deficient in that zeal towards them that I had pledged myself to exert, until the Academy selected some other person, better prepared than myself to discharge the important office of Professor who, by the regulations of the Academy, is directed 'to form the taste of the Students, to instruct them in the Laws and Principles of Composition; to point out to them the beauties or defects of celebrated productions, to fit them for an unprejudiced study of Books on Art, and for a critical examination of Structures.' These are the duties imposed on the Professor of Architecture, duties far beyond my powers, except in point of zeal and enthusiastic admiration of our noble art, I shall be amongst the first to declare myself little prepared to perform. Yet I must take encouragement to hope that my present labour will find favour with others, since it has been undertaken for no person's sake less than mine own.

In the lectures on architecture before delivered, I endeavoured to trace that most ancient and most useful of the fine arts from infancy to the best times of its perfection, and from thence through its different stages of decline and almost total state of darkness in the Middle Ages. After that eventful, that melancholy period, the state of architecture was shown in its happy revival under the auspices of the enlightened Leos and the liberal Medici; and from that splendid epocha, the subject was continued down to the present time.

In those discourses I attempted to show the young students the utility and importance

of our art, and that all its great and leading principles were to be found in the immutable laws of reason, nature, and truth; in the works of the great architect of the universe; and in the practice of the ancients, so fortunately preserved to us in the inestimable remains of many of the superb structures of antiquity.

Much, however, yet remains to be done, and for this reason at the end of the sixth lecture, a promise was made that, instead of reading again those already delivered, the subject would be continued, and six additional discourses given on those points which had only been briefly touched on, as well as upon others, which, although important to the advancement of architectural knowledge, yet from want of time had been entirely unnoticed.

I now proceed to redeem that pledge and to discharge the duty I owe to the students in architecture by pursuing the arduous and difficult task I have undertaken. Happy, most happy shall I ever consider myself in any opportunity of evincing my gratitude and regard for a profession to which I owe all the advantages I now possess. And let me add it is not the least satisfaction of my life to have the pleasure of addressing the young students in architecture.

> 'In their gay season of ingenuous youth,
> While in born honor points the road to truth,
> While the pure soul in search of science flies,
> And the first hopes are to be lov'd and wise.'[1]

I must premise that in this and the following discourses I may occasionally refer to, or even repeat, some parts of subjects that have been already noticed in the former lectures. In those I am now to read, examples will be exhibited to show the application of the various materials which were the subject of the preceding discourses, together with such observations and practical remarks on buildings of different kinds and of different countries, as I have been able to collect from the works of those authors who have written upon architecture, and the arts and sciences connected therewith, and likewise from my own reflections on their opinions and practice.

This view of my subject will involve a comparative consideration of the buildings of different countries, a very difficult but, I trust, a very useful part of my duty.

The great points or objects now to be considered might be classed, and separately treated of, under the heads of distribution, construction, and decoration, hoping however to avoid prolixity and confusion in imparting to the students such observations as appear to me the best calculated to show the importance and to promote the advancement of architectural knowledge.

[1] These lines are from a poem published in the *Annual Register*, 1771, vol. 14, p. 244, where they are attributed to 'the Rev. Mr Pratt of Peterborough'.

Distribution comprehends the divisions and arrangements of the various parts of buildings of every kind as to solidity, convenience, elegance, and beauty. Distribution must therefore be viewed as one of those essential and important objects of architectural study that must claim the most serious consideration of the architect, and require the fullest exertion of his talents and genius.

Construction is another very necessary and useful part of our art. By the knowledge of construction, the architect is enabled to direct and instruct the artificers, instead of being controlled by them. By a knowledge of construction he also becomes capable of discharging that most important and most necessary, although sometimes neglected part of his professional duty, namely, the correct ascertainment of the expense of the designs proposed to be put into execution. From a deficiency in practical knowledge the greatest evils have often been entailed on the artist, and the most severe disappointment on the employer who, delighted with the rich fancy and classical taste displayed in the composition of the architect, has afterwards had to deprecate the miseries he has been led into by erroneous calculations and mistaken ideas of expense. If these are amongst the effects of a want of constructive knowledge the young architect cannot be admonished too frequently, nor taught too plainly to consider his plans maturely and reflect deeply on whatever relates to the most correct, ready, and effectual execution of his inventions, as well as the necessity of giving the most assiduous and indefatigable attention to the just discharge of all his professional duties. The duties of the architect extend beyond the employer, to the employed. He must never forget that he is the intermediate agent between the employer whose interest he is to study, and the mechanic whose rights he is to defend. To discharge these important, useful, and honourable duties, the architect must acquire a thorough knowledge of the qualities of the different species of materials he has to use, and likewise a large portion of constructive knowledge of every kind. Without these acquirements, elegance, ingenuity, and classical purity in his compositions, facility and effect in drawing, and every other attainment connected with his art, will be of no avail. Without this knowledge and feeling of his situation, all his inventive powers and correct taste become useless, if not dangerous, as tending to disappoint the patron, to dishonour the architect, and to disgrace the profession.[a]

[a] Note. We are continually reminded of the dreadful consequences and mischievous tendency of defective, hasty, and incorrect estimates; for it is from the consideration of these circumstances that those who wish to build, apply rather to builders, who have houses ready constructed to dispose of, than to architects regularly educated for the profession. How many of those who have built under the direction of architects (even in our days) have unhappily had to deprecate the miseries they have been led into by erroneous calculations and mistaken ideas of expense? This is certainly a sore evil, and which to the disgrace of the profession has existed in different countries.

In England it has now subjected our art almost entirely to the control of speculative mechanics and must ultimately, unless checked by the zeal and industry of the rising generation of artists, occasion the ruin of the profession. This lamentable failing in our duty is not, however, of modern growth: it existed

However important distribution and construction may be, decoration is no less worthy of our attention. Decoration, in its most general acceptation, when applied to architecture, comprehends, according to most writers on the art, the union of the different ornaments with which buildings of every denomination are enriched. In decoration the orders of architecture are prominent features, they are as essential to the architect as colours are to the painter. The student therefore must not consider the acquisition of a thorough knowledge of the details and proportions of the orders as unnecessary, nor can their importance be too much impressed on his mind. Strange as it may appear to some of my auditors it has been supposed possible, nay various attempts have been made, to reduce each of the ancient orders to some general standard in its constituent parts, so that the order to be used being determined upon, the student need only refer to his book and there find an example suitable to the exterior or interior of every description of building whatever.

Whilst this suggestion has been justly treated by many as a ridiculous fancy, the ridiculous chimera of a disordered mind, others on the same principle have gone further, and in an anonymous work published a few years ago on 'Designs in Painting, Sculpture and Architecture',[2] there seems to be an endeavour either serious or satirical to show that the same style of composition is applicable to the church, the mausoleum, or the royal palace, the town mansion or villa, the picture gallery or lady's boudoir, the hall of justice or the prison, the theatre or the warehouse, without any regard to situation, class, or magnitude of the structure. In elucidation of this hypothesis, three designs are particularly alluded to: namely, a temple to Northern patriotism, a temple of virtue, and a section of a lady's dressing room. These compositions, whether real or imaginary, are stated to be the inventions of two very eminent architects and upon them the following very curious remarks are made: 'In these works those great artists have shown that they possess the peculiar felicity of adapting the same noble style to exterior and interior decoration, to public and private works in so eminent a degree, that if we change the titles and remove the attic or pediment, the fronts of the temples are sides either of dressing or drawing rooms', and so on.

Lucubrations like these will neither advance the interests of art nor improve the minds of the young artists. Such comments or criticisms, whether on the works of the living or the dead, from whatever source they originate, are alike injurious to the higher feelings of the artist, and only tend to paralyse his best exertions and to render art itself contemptible.

amongst the Romans. How many fathers of families, exclaims Vitruvius, have to complain of being led into great and unexpected expenses and to impute their ruin to an ill-placed confidence, and a want of constructive knowledge; or to speak in plainer language, to the ignorance or criminal inattention of their architects?

[2] Soane is referring, obscurely, to the critical pamphlet, *The Exhibition, or a second anticipation; being remarks on the principal Works to be exhibited next Month at the Royal Academy, By Roger Shanhagan, Gent.* (1779).

I have noticed this work chiefly to guard the young and inexperienced mind against the effect of such unfounded assertions, and let me add that could this royal road to science be attained, could one style of composition be formed to suit the different characters of buildings of every kind, architecture, instead of being the most noble of the fine arts, would be merely mechanical.

How different from this amalgamation, this generalising of things, is the doctrine derived from the remains of antiquity, the writings of Vitruvius, and the works of those great masters of art to whose zeal and enthusiasm we owe the revival of the ancient architecture. In the remains of ancient buildings we shall see that particular consideration has been given to the locality as well as to the nature of the materials, and that all the variations, nice distinctions, and shades of character, have been constantly attended to. If we direct our attention to the three orders of architecture in those remains, we shall not find any two examples without great differences in quantity and character, and, if we apply to the text of Vitruvius, we shall learn that columns must be diminished or enlarged in their proportions according to the nature of their situations. And further, if we examine the writings and works of the great masters of our art we shall discover in them very considerable deviations, not only from the practice of the ancients whom they profess to copy, but likewise amongst themselves. From these examples it is evident that any attempt to establish one general standard of proportion for either of the orders indicates a total disregard of the principles on which they were produced.

The tyrant Procrustes, by shortening or lengthening his guests at pleasure, might make the same bed suit any of them, but architecture cannot be so tortured; there can be no common scale, the same proportioned columns and entablature, nay even the same kind of materials cannot be applied indiscriminately in every situation and in every class of building.

In the application of the orders of architecture and of the other rich stores of antiquity, if the student does not look back to primary causes, he will often be misled by the prejudice of custom, and by the recurrence of licentious examples, and perhaps attribute to design what was in fact produced by accident alone. Thus, for instance, in the Doric temple at Segesta the shafts of the columns are finished at the top and bottom only, sufficiently to determine the magnitude of the inferior and superior diameters. Likewise, in Attica, there is an example of remote antiquity in which the columns of the temple appear in an unfinished state, having only the indication of flutings for a few inches under the capitals; and in the temple at Delos, the flutings in the columns are expressed both at the top and bottom, and the remainder of the shaft is left quite plain. In succeeding times these works have been looked upon as models for imitation, forgetting that it was the practice of the ancients to leave the fluting of the columns and other decorations until the building was completely formed. The great masters of our art in Italy, having probably stumbled upon these and similar works, used imitations thereof in many of their great productions in

preference to the simplicity of the ancient orders. And this deviation from the purity of ancient examples, this fashionable mania for mutilating the simple and natural outline of the column and pilaster became general. Michael Angelo and Pietro da Cortona, Ammanati, Michele san Michele, Vignola and Palladio, alike sacrificed at the shrine of false taste. In many of the works of those great masters, the shafts of the columns and pilasters were from time to time so tortured, in every possible manner, until at last the beautiful swelling contour was metamorphosed into a series of distortions which, however inconsistent with every principle of beauty, were cherished and used, not only by Borromini and his school, but by Raphael, Bernini, and other distinguished artists.

Whether rusticated columns and pilasters owe their adoption in modern works to the causes already suggested, or to ancient examples, to the Curia of Tullus Hostilius, to that part of the Castellum of the Claudian Aqueduct now called the Porta Maggiore, or to the contemplation of, and wish to transpose into architectural compositions, the resemblances of crystalizations, and other natural productions, is not to my immediate purpose. The fashion for rustication was not long confined to columns and pilasters: the dressings of doors and windows soon partook of the same style of decoration, as well as the substructures, and other parts of great works. Lastly the entire surfaces of buildings of every description were adorned either with smooth or vermiculated rustications, or with others of a ruder description, such as the Pitti Palace in Florence, the Luxembourg in Paris, the grotto in the garden thereof, and other works of great magnificence. This idea of rusticating the entire surfaces of buildings was probably taken from the walls of the Temple of Vesta, and of Mars the Avenger, the Piazza of Nerva, and other vestiges of antiquity.[b]

To the examples of rusticated work already exhibited, I shall add the exterior of the house which Frederigo Zucchero designed and built for himself in Florence as an uncommon and singularly curious specimen of the rusticated system of building.

Zucchero, having read in the Gospel of St. Matthew that our Saviour had declared that man to be wise who built his house upon a rock, resolved to act accordingly, but failing in his endeavour to find such a foundation, like Alexander the Great (who when not able to untie, satisfied himself with cutting the Gordian knot), Zucchero in like manner determined that his house, if not really placed upon, should at least appear, as if it had been cut out of a solid rock. He accordingly made the base of stone work, in figure a perfect cube, the Grecian emblem of solidity, and durability, and upon this he raised a superstructure of brick.

The exterior of this whimsical and capricious composition was intended not only to attract attention, but likewise to show by practice and theory that Zucchero was an

[b] Note. The great Italian architects carried this idea still further, and fancied that if they left part of the front of their buildings unfinished, like their prototypes, the columns at Segesta, it would not only remove the necessity for and the expense of the columns and other decorations, but likewise add grace and novelty to their works. Hence arose the Palazzo Curia in Rome and other similar works.

architect, sculptor and a painter. To this effect the doors, windows, and pilasters, were left unfinished as indicative of his knowledge of architecture. The pieces of sculpture, sketched and traced on the rock, pointed him out as a sculptor, and the finished picture in the centre proclaimed him a painter.

From Italy these modes of improving the shafts of columns and pilasters, and the different manners of rusticating the exterior of buildings in general passed into other parts of Europe, and found admirers everywhere. In England, amongst other great architects, they were sanctioned by Inigo Jones, Lord Burlington, Sir Christopher Wren, Sir John Vanbrugh, Kent, and Sir William Chambers.

These different modes of decoration, however applicable to stables and entrance gateways into fortified towns, ill accord with the simplicity of private buildings, the elegance of sumptuous mansions, and still less with the magnificence and splendour of royal residences. They are melancholy proofs of the dangerous tendency of innovation without reference to first principles.

When we re-trace our steps, and reflect on the prodigious changes the column has undergone from its classical purity and correctness, we tremble for the fate of the ancient orders of architecture. Fortunately for our art they can only be obscured for a time. They are so strongly established, so firmly placed on the solid basis of philosophy and truth that, notwithstanding all the convulsive attacks made to obscure their beauties, they still retain their importance, and so often appear not only in ancient ruins, but in modern structures, which the student is taught to respect, that he considers the ancient orders as his architectural grammar, and as his sure and certain guide in establishing his principles. So impressed is his mind with the power of these noble and fascinating objects that he does not suppose any composition without them to be worthy of his attention. But this is an error, like many others against which the student cannot be too strongly guarded, and it may be further observed that neither columns nor the higher decorations of sculpture can be indiscriminately used either as to quantity or situation.

The gigantic statues of children in the interior of St. Peter's lessen to the eye the real dimensions of that superb structure, and statues like those on the exterior of St. Paul's Cathedral, from their too great magnitude, tend rather to diminish than to increase the grandeur of the building.

In like manner the Doric screen in the front of the Admiralty, a composition in itself light and elegant, and the Ionic portico in the court of the same building, although of large and imposing dimensions, create no interest in the mind of the beholder, because in both cases the columns are misapplied, unconnected, and totally disproportioned to the masses they accompany.

The ancients allowed themselves great latitude in the use of the orders, sometimes indeed to an extent not easily to be accounted for.

In many parts of the Baths of Diocletian, columns, instead of being applied as

supports, are themselves supported on corbels, whilst in another part of the same building, now the church of the Chartreux, the enormous vaulted roof is supported by eight columns of Egyptian granite, those in the four angles, having Corinthian capitals, and being less in diameter than those between them, which are of the Composite order. The entablature, however, is the same to each of the orders, and, of course, the distinctive features of both are blended together.

This singular union of two different orders Desgodetz[3] accounts for by telling us that the columns in the angles required less strength, having only the pressure of two arches to bear, whilst those of the middle have the burden of three. If this was the cause which, however, I much doubt, it can only be said that the architect, by deviating from the more ancient examples in the Temple of Peace (the mighty roof of which was likewise supported by eight columns), in removing one imperfection, which very few indeed would have felt, has created another, which even the most negligent and superficial observer must perceive and perhaps regret.

The hall of the Baths of Diocletian is the only ancient example of this mixture of different orders of columns on the same line that I recollect. It is true that the capitals to the columns of one of the temples at Paestum partake of the singularity that they are varied from each other, whilst the other parts of the order are the same.[c] Desgodetz, however, tells us, from the text of Vitruvius, that the practice of using columns with different capitals, of different magnitudes, and different proportions, was in common use long before the time of Diocletian. In this he appears to be mistaken. Vitruvius, in no part of his work that I can discover, speaks of different columns on the same line, but only when describing the porticoes occasionally built near, and for the accommodation of the Roman theatres, says, 'These porticoes should be double and have outwardly Doric columns, and middle columns either of the Ionic, or Corinthian ordonnance, made one fifth part higher than those of the exterior.'[4]

The learned Perrault, in commenting upon this part of Vitruvius, observes that porticoes, built according to this description, must make a most strange composition, such as to induce him to suspect some corruption of the text.

Perrault, it appears to me, mistook the meaning of Vitruvius, and it may first be observed that in the peristyles of many of the Greek temples, columns of different heights,

[c] Note. This mixture of capitals of different orders occurs in our Gothic cathedrals, and we justly condemn the practice.

> I cannot see any beauty in such variety: it is like Mr. Knight's Grecian inside and Gothic outside.
>
> The same singularity may be observed in the capitals of one of the temples at Paestum. Is not this somewhat in favour of the idea maintained by some persons that columns were kept prepared and sold complete?

[3] *The Ancient Buildings of Rome; by Anthony Desgodetz*, transl. by George Marshall, 2 vols, London 1771–95, vol. II, p. 60.

[4] *De architectura*, V, ix, 2.

although not of different orders, do frequently occur; and in the Propyleum of Athens we have an example of such a composition with an assemblage of orders such as Vitruvius describes.

I must, however, remark that at present, according to Stuart and Le Roi, there are no remains of any capital to either of the inner columns, but the proportions of the shafts now remaining correspond with the proportions of the Ionic order, and Wheler, who visited Greece about a century before Le Roi and Stuart, expressly shows the roof of the pronaos of the Propyleum supported by four beautiful Ionic pillars, a point in which he could not easily be mistaken, whilst the external columns are of the Doric order.

These are some of the difficulties that arise in the use of columns in the exterior of buildings. When used internally there are other difficulties, many of them irreconcilable to common sense, and which were noticed in a former lecture.

It has been doubted whether the regular orders were ever introduced into the interior of any of the private structures of the ancients until the decline of taste. From the writings of Vitruvius, from the ruins at Herculaneum and Pompeii, from the remains of many of the Roman villas and other extensive edifices, however, we are led to believe that the orders were, in the best times of architecture in Greece and Italy, confined exclusively to the exterior of their buildings. And it may be presumed, for reasons assigned in a former lecture, that the ancients never used either of the regular orders in the interior of their buildings.[d]

In modern architecture columns are frequently used in the interior as well as the exterior, and a celebrated modern writer on architecture justifies this deviation from the ancient practice by telling us that the origin and reason of the guttae, triglyphs, metopes, mutules, dentils, modillions and similar details are remote and known to but few; if therefore deviating from what is little known and less felt will eminently contribute towards the perfection of that which all see and all approve, it cannot be justly censured.[e]

[d] Note. The reason is obvious when it is recollected that according to the primitive system of the Greeks every order of architecture to correspond with its origin must have its architrave, frieze and cornice properly distinguished with its guttae, its triglyphs and metopes, its mutules, dentils, and modiglions. Now, on the great primitive principle on which the architecture of the ancients rests, all these parts can apply only to the exterior of buildings, and therefore it may be presumed that the ancients never used either of the orders in the interior of their buildings.

[e] Note. The student who expects to produce in his own works the same grand effect of columns, as is seen in the ancient buildings, wherein he will often find even in an assemblage of those of small dimensions and formed of common materials, [columns] are not only highly interesting but create a strong impression of grandeur on the mind of the spectator, because in these works the columns are disposed to advantage, and are duly proportioned to the masses they accompany, whilst in many of the works, even of the great restorers of architecture, and in those of the architects who succeeded them, columns are too often introduced merely because they are beautiful, without due regard to the situation and character of the structure.

If the student, to produce the same effects as in the works of the ancients and to ground his

To be sure, if all see and all approve, there will be none to censure. This reasoning is, however, dangerous in the extreme; it will sanction every deviation from first principles and reconcile us to every absurdity. It may perhaps content those who do not wish to take the trouble to account for what they adopt, as Vitruvius directs, but it would not have satisfied the architects of that enlightened people whose refined taste and consummate skill required a different proportion to be observed in the diameter of the external columns of a portico, because they considered that the difference in the quantity of air that surrounded the inner columns would have made them (although really of the same dimensions) in appearance different. Some modern writers on the art have ascribed this inequality to chance or accident, instead of considering it as the result of a deep reflection on optical effects. To support this idea, they beg the question by telling us it might have been the ancient practice to have columns ready for use, as we prepare gravestones and monuments in this country, and which being prepared by different workmen, occasioned these irregularities. But this does not accord with the great attention paid by the ancients to every part of their architecture, and it is, likewise in direct opposition to the text of Vitruvius.

In buildings of every description, whether intended for public or private purposes, whether great or small, whether magnificent, or merely strictly useful, three things are indispensably necessary, viz., solidity in construction, convenience in distribution, and beauty in its characteristic decoration.

To entitle a building to consideration all these requisites must be united, for if an edifice be commodious, but not substantial; if it be substantial but at the same time not convenient, or lastly, if it possess both solidity and convenience, and be destitute of symmetry and uniformity, it cannot claim the approbation of the judicious. Solidity, convenience and beauty are the three essentials of architecture.

The solidity of a building depends on the goodness of the materials and their application, the sufficiency of the foundations and the walls raised upon them, all of which must be made regularly decreasing in thickness as they advance in height, and raised truly perpendicular in every part. All the openings of every kind must be placed exactly one above the other, so that in every part solid may rest upon solid and void be seen over void,

pretensions to public approbation, does no more than barely copy the orders as left us by the ancients, he will find himself egregiously mistaken. It is only by closely studying the remains of antiquity and the writings of Vitruvius, and by referring to those self-evident principles by which the minds of the great artists of antiquity were directed that the student will be able to proceed with any degree of certainty. From these sources he will learn that the orders are not applicable on every occasion, or of any dimension, as some have erroneously supposed.

The student in architecture must not conclude that whatever is beautiful per se must be always so without reference to situation or dimensions. The great masters of antiquity will teach him that if an order of architecture does not please, interest, and strike the imagination, it is because it is disproportioned in its quantity or misplaced as to character, as when used in prisons, warehouses and on the inclined planes of staircases and on many other occasions.

and not, as is too frequently the practice in modern constructions, where massive, solid piers over large windows and doors, and voids over solids. Lastly, an edifice to be beautiful must be perfect in its symmetry and uniformity.

Beauty in the abstract is a general term, vague, extensive, and not always clearly defined or understood.

Beauty is either intrinsic, relative, or compounded of both. Intrinsic beauty determines certain forms and proportions to be beautiful, such as the circle, the polygon, the square, the parallelogram, the cube, the double cube, and others. And as no object, strictly speaking, can be relatively beautiful, without reference to use and character, relative beauty therefore determines, amongst other things, the dimensions of doors, windows and chimneys, the length, breadth, and rise of the steps of staircases, etc.

Intrinsic beauty combined with relative beauty produces that symmetry and proportion which distinguish the works of real artists from those of humble copyists. In a word, an edifice can only be considered beautiful when all its parts are in exact proportion, well balanced and combined together with proper quantities of light and shadow, richness and repose. It must form an entire whole from whatever point it is viewed, like a group of sculpture, and not be like some of our houses, where one front is decorated and the other quite plain, nor like some designs, one front being Gothic, another Chinese, Egyptian, or even Grecian.

Buildings may be divided into three distinct classes: the useful, such as cottages, small dwelling-houses, warehouses, shops, hospitals, prisons, and the like; the ornamental, such as temples, garden recesses, alcoves, triumphal arches, obelisks, insulated columns supporting statues and vases, and others of the same description; to these may be added the third class consisting of buildings combining the useful and the ornamental. Of this class are those destined for public worship, courts of justice, royal palaces, noblemen's hotels, town houses, villas, and bridges over wide and rapid rivers.

This great variety in the uses of buildings makes it difficult to form a correct standard in architecture, and is one of the causes that produces that constant change in opinion and taste which occasions our edifices, whether public or private, to be imitations of the Indian, Chinese, Egyptian, Grecian, Roman, or Gothic according to the fashion of the day. But whatever style may be prevalent, in buildings of every kind the most simple forms will always be best fitted and the most proper for the purposes required. Whim and caprice, attended with irregularity and singularity, may, for anything that appears to the contrary, be consistent with Indian, Chinese, and Gothic structures. But in Grecian architecture the labour of the artist and the skill required in designing is infinitely greater. There must be order and just proportion; there must be intricacy with simplicity in the component parts, variety in the mass, light and shadow, so as to produce the varied sensations of gaiety and melancholy, of wildness, and even of surprise and wonder. Forms must be combined together with taste, beauty, convenience and solidity, producing all those different effects

which constitute the perfection and extent of the powers of architectural composition. Such is Grecian architecture.

As the country offers in most respects the greatest facilities, and provides more scope than populous towns for the exercise of the talents of the architect,[5] and for displaying the powers of his art, it may be proper, therefore, to treat first of villas, and such other buildings as country residences require.

In villas, the first point to be considered is the situation. Situation often determines the choice of the materials to be used, and both must fix that necessary character and expression of the composition, without which no building however rich and expensive can please. The architecture suited to unite with the quiet scenes of Claude, or Poussin, would ill accord with the grand and fearful, nay terrific, imagery of Salvator Rosa.

A villa should not be placed too near a city or populous town,[f] nor in a barren dreary desert far removed from the haunts of men, nor amongst rocks and mountains of dangerous and difficult approach: the grand romantic and wild features of nature, the craggy rocks from whose dizzy summits,

'The crows and choughs, that wing the midway air
Show scarce so gross as beetles.'[6]

And the frightful cliff, whose high and bending head looks fearfully on an immeasurable space of sea and air, will certainly interest the spectator and excite in his mind the most awful sensations of the great power of the Almighty Architect of the Universe. Yet, unless these sublime objects are contrasted with the gayer scenes of nature, and enlivened with the charms of polished society, they will fail to raise that succession of pleasing and rational reflections which are necessary to satisfy the philosophical mind in retirement.

Vitruvius, speaking of the aspects of buildings, directs that those in northern climes should have only such apertures as are absolutely necessary; that they should be of the smallest dimensions practicable; and that they should be turned to the warmest aspects,

[f] Note. The situation of a villa to be truly desirable must be where there is plenty of good water, a dry, temperate, and salubrious soil, with a certain and easy conveyance of such articles of consumption as are not produced on the spot or in the neighbourhood. There must be a variety and beauty in the prospects, in the home domain, and highly cultivated fields, rich meadows, and distant effects in the surrounding country.

 A villa should not be placed too near a city or populous town so as to occasion those who occupy it to be eternally annoyed by troublesome visitors. How many of the great buildings near London and other populous cities have been pulled down chiefly for this very reason, and amongst others, Sir Gregory Page's house, Peterborough House, and Canons.

[5] A point made earlier by Sandby in his fourth lecture.

[6] *King Lear*, IV. vi. 12.

whereas in southern regions the openings should be large and exposed to the north and east.

To render apartments convenient and healthy, libraries should look to the east, and picture galleries to the north, winter dining rooms to the west, those for spring and autumn to the north, and bed chambers towards the east. On this point, as well as many others, regard must be had to climate and local circumstances: a good living room in Egypt might, as it has been well observed, make an excellent wine cellar in England.

In the general figure and outline of buildings, the most simple forms, such as the square and parallelogram, have been most frequently employed. Those geometrical figures, when well arranged and duly blended with portions of the ellipsis, the circle, or any of the polygons, admit of an almost endless variety of shape. They are the most pleasing, the most useful and most economical forms that the imagination has devised. Such combinations have many advantages over those that are more complicated; they admit of the greatest facility in their internal sub-divisions into rooms, passages and staircases; they occasion no irregularity, nor any loss of space; and, what is particularly important, the light may be equally and pleasantly distributed into every part of the composition, as will be shown hereafter.

The surrounding scenery having determined the architectural character of the villa, the particular ideas of convenience and manner of living of the individual who is to occupy the edifice when completed, must be consulted, for on this result, in a great degree, depends the magnitude, number, form and disposition of the several rooms, as well as the extent of the entire edifice.

Having advanced thus far, the attention of the architect must be directed to form the plans of the internal divisions, the arrangement of the several stories, and likewise of the substructions. Such elevations and sections must likewise be made as will show the practicability and effect of every part of the building proposed to be erected.

To these designs must be added correct models, and above all accurate estimates of the expense that will be incurred in the execution of the work.

Although in the interior distribution as well as in the external forms of buildings in general, rectangular figures more frequently occur than any other, yet I must recommend the young student to omit no opportunity of collecting and arranging every different form or figure, however simple or however complex, that he discovers in his reading or observation; and if he looks into the great book of nature he will find in fossils, leaves, incrustations, and other natural, or artificial, objects of every kind, many valuable materials for this purpose. The student should likewise omit no opportunity of noting down from time to time the proportion of length, breadth, and height of as many different rooms, and entire buildings as possible, those which, at the time, he may not consider pleasing, as well as those which appear to him beautiful.

He will thus form in his mind an inexhaustible magazine of ideas which cannot fail to

render very material assistance to a young architect in the course of his studies, and give him such facilities as will amply repay him for his trouble.

Vitruvius, describing the proportions of private buildings, says, 'nothing ought to be more the care of the architect than that the several parts of an edifice be in exact proportions.' Living rooms, he says, should be thus regulated, 'If the length of the room be divided into five parts, three should be given to the breadth. If the length be divided into three parts, two are to be allowed to the breadth, and when a square of equal sides is formed on the breadth and in that square a diagonal drawn, the length of the room should be made equal to that diagonal line and whatever the breadth of any room may be, twice so much is the greatest length to be allowed.'[7]

Palladio, Scamozzi, and other great architects have observed that there are seven beautiful proportions and forms of rooms, each of them different and perceptible, namely, the circle, the square, the diagonal of a square, the square and one-third, or sesqui tertia, the square and half, or sesqui altera, the square and two-thirds, or superbi partiens tertias, and the duplex, or double square.

These are the different proportions of the geometrical figures usually adopted in practice, and it may be added that among quadrangular figures, any proportion from the square to the double square will be found useful and pleasing. These proportions, however, can never be exceeded, for if a room is more in length than twice its breadth, it becomes a mere gallery or corridor of communication. According to Palladio these proportions are the greatest that convenience requires, and Sebastiano Serlio adds, that, those architects who are wise will not exceed these proportions in halls, and habitable rooms. And perhaps it will be still safer and more prudent to stop at the sesqui altera; for in rooms wherein there is a much greater disparity between the length and the breadth than the square and a half, it becomes difficult, nay almost impossible, to accommodate the three dimensions of length, breadth and height, which it is absolutely necessary to be done.

To the simple figures already enumerated may be added an almost infinite variety of others of the most beautiful kind, such as the ellipse, the circle, the triangle, the different polygons, and likewise forms compounded of portions of some of them connected together by means of straight Lines.

In quadrangular rooms, which admit of the introduction of columns, we may increase the variety and movement of our plans and at the same time combine much of the beauty of the ellipse and the circle, with the utility of the parallelogram and the square by disposing the columns in the manner shown in these drawings.[8]

By a judicious combination of the different geometrical figures and their compounds,

[7] *De architectura*, Book VI, iii, 3.
[8] Interiors for the Bishop of Derry, designed by Soane when in Rome in 1777–78.

our plans will exhibit much elegance and classical purity with an endless variety and inexhaustible novelty.

It must at the same time be recollected that however beautiful these or any other figures may be, and however happily combined, yet as one of the great essentials of beauty, and the merit of every plan, arises out of the fitness and convenience of the parts composing it. The young architect must be careful that the power of intrinsic beauty does not lead him into the adoption of beautiful forms in situations where attention to convenience and locality would dictate the propriety of simple figures.[g]

The ellipse and the circle, however beautiful, are better suited to public buildings and temples than to habitable rooms. In the early periods of the heathen world the circular figure was assigned exclusively to temples, and moreover to temples only dedicated to particular divinities such as Vesta and Cybele, and amongst the Persians it was confined to the temples erected to the god of fire only.

In later times the circular figure became general in the mausolea and public buildings of the Romans, as well as in their great private works, as may be seen in the remains of the villas of Hadrian, and Lucullus, and others.

It must be recollected that the climate of Italy and the manners of the Romans made them prefer rooms lighted from above, as producing that repose, and as if it were half-tint, which in warm climates is peculiarly pleasant. This kind of light is well suited to study and reflection, but is not calculated for living rooms in a northern climate.

But although these figures, however beautiful in themselves, cannot be properly applied to rooms for habitation, yet in extensive magnificent houses, opportunities will occur of introducing them with great propriety, advantage to the general effect, and even to the convenience of the whole arrangement; particularly for vestibules, tribunes, staircases and saloons, because in rooms for these purposes there is no reason against lighting them from above through apertures in the ceiling, as in the great saloon at Stowe, the saloon at Kedleston, and the tribune at Chiswick. In these parts of a large building, the young architect may exercise his ingenuity, taste and talents; he may use his inventive faculties, indulge his love of variety, and show his knowledge of the ancient architecture, provided the forms he selects and the dimensions he adopts harmonize and contrast with the other parts of his plan and are fitted for the purposes for which they are destined. But neither the ellipse, the circle or polygon, circumscribed, as in these examples, within parallelograms or squares, can ever be considered as suitable for habitable rooms, excluded from all prospect, and lighted as in the examples before you they must produce a gloomy and sombre effect: they can only be considered as suitable to the grandeur of extensive mansions.

[g] Note. In the arrangement of a plan, variety and beauty of form is not sufficient: convenience, and fitness must likewise be conspicuous.

If the ellipse, the circle, or any of the polygons, are to be applied to the purposes of living rooms, a portion of each of these figures must be made to project beyond the general outline of the external walls in which they are introduced. This projection, although it may in some degree destroy the architectural effect, increases the variety of the outline, adds to the richness of the perspective, and at the same time occasions the light to be more equally diffused into every part of the room.

By a due admixture of these latter forms with the parallelogram and square we shall avoid that excess of simplicity, or rather tameness, so manifest in some of the designs of Palladio, Scamozzi, and others, their contemporaries, who, in order to produce a due balance of parts and a proper simplicity, have sometimes adopted a needless and studied uniformity, injurious to convenience and monotonous in effect.

In this attention to an excess of uniformity these great artists have been frequently followed by Inigo Jones, Lord Burlington and others, forgetting that it is not necessary that in the two equal divisions of a plan, each half should exactly correspond. This is a species of regularity as insipid, and tiresome as that of a garden wherein,

'Grove nods at Grove, each Alley has a brother,
And half the Platform, just reflects the other.'[9]

But although it may be right to avoid this scrupulous attention to uniformity in plans, yet too much variety of figure is perhaps less worthy of imitation. The young architect must be careful that in avoiding one error he does not fall into another. He must remember that in the internal distribution and divisions of buildings there should be a gradation in the dimensions, and a variety in the forms of the rooms; from the hall of entrance[h] to the lady's boudoir, each part should be distinctly marked by quantity, proportion, and progressive enrichment.

In the general combination of the plans of buildings of every kind the artist will receive most effectual and powerful assistance in the knowledge to be obtained from the remains of the Baths of Titus, Caracalla, Diocletian, and Paulus Emilius, from the parts still

[h] Note. In many of the old houses, particularly in those of Inigo Jones and his scholars, there is a large hall occupying two storeys in height. This, although a magnificent feature in itself, generally raises our expectations beyond what the other parts of the house can realise. And what is worse, it likewise destroys much of the convenience of the chamber storey. If magnificence requires a large portion of the entire superficies of the building to be swallowed up by a single room, it should be for the purposes of society, and not as a mere passage room of entrance. And it must be remembered that such a room destroys that regular gradation of space, that continuity of interest, an essential to be observed in the ground plan of a building, as in the exterior appearance. It is likewise injurious and lessens the more permanent and desirable comforts which constitute the charms of an English house, and is therefore never to be adopted but from positive necessity.

[9] Alexander Pope, *Moral Essays*, Epistle IV, *To Richard Boyle Of the Use of Riches*, lines 116–17.

in existence of the Villas of Hadrian and Lucullus, and others[i] in different parts of Italy. The works of the great painter architects of the fifteenth and sixteenth centuries will be likewise of much value.

In them will be found rich mines of information as will enlighten the mind of the young artist, and add materially to his stores of intellectual acquirement. From these sources he will learn to compare and to combine, he will discover the safest as well as the surest tests of truth; he will perceive the just and nice proportions that must be maintained between solids and voids; he will learn to appreciate that succession and variety of forms, that contrast of balance and movement in the different parts of a composition on which distinctive character so much depends. The terrific boldness of Michael Angelo, the luxuriance and rich fancy of Michele, and the extravagance of Borromini, will be corrected and duly tempered by the quietness and elegant simplicity of Palladio and Vignola.

The young artists of the present day have many facilities in attaining knowledge over those who preceded them: the road to fame is open to all,

> ' take the instant way,
> For honour travels in a strait so narrow
> Where one but goes abreast; keep then the path,
> For emulation hath a thousand sons,
> That one by one pursue: if you give way
> Or edge aside from the direct path right,
> Like to an enter'd tide, they all rush by
> And leave you hinder most;
> Or like a gallant Horse, fall'n in first rank
> Lie there for pavement to the abject rear
> O'er run and trampled on.'[10]

The young artists by exerting themselves to store their minds with the beauties and splendid effects of the magnificent works of the ancients, will be enabled to rescue the art from the hands of ignorant mechanics and speculative theorists. And henceforward let us hope that the young professors of the fine arts, instead of employing their cultivated talents and highly fraught intellectual minds on portfolio drawings, will be called upon to erect

[i] Note. Of the palaces of the Roman emperors on the Palatine Mount and of Diocletian's palace at Spalatro there are considerable remains, as well as of the Baths of Diocletian, Caracalla, Titus, and Paulus Emilius. Of the villas of Hadrian, Lucullus, and others, there are still considerable vestiges of the most beautiful forms and rich combinations. From these and other remains of the great works of antiquity the artist will become acquainted with that secret charm produced by a necessary and proper contrast, balance and movement in the different parts of every composition.

[10] *Richard III*, III. iii. 153–60.

churches, palaces, and national edifices commemorative of the glorious achievements of our Nelsons and Wellingtons. And may the genius of Banks, Flaxman, Nollekens, Chantrey, and other great sculptors of the age, be infused into the minds of the young aspirants in that noble art. Taught by such examples may their talents animate the marble so powerfully and so effectually with the features and minds of our heroes and statesmen, that admiring spectators may exclaim,

'Would you not deem it breath'd and that those veins,
Did verily bear blood.'[11]

and,

'if towering Architecture still
Can boast her old creative skill,
Let great majestic Structures rise to view
Worthy them and worthy you.'

In this country various causes co-operate to prevent the erection of great national works. We must not expect to raise many large churches worthy of our religion, nor monuments, trophies, and cenotaphs, to the dead; nor a variety of magnificent palaces for the living. Yet let us hope that whilst our painters and sculptors are recording on the almost speaking canvas, and in the 'breathing marble,' the splendid achievements of our illustrious men, and the glorious transcendent exploits of our heroes by sea and land; let us hope, the magic powers of architecture will be called into action to raise structures for use, and magnificence, in grandeur and extent, commensurate with the national glory and character, and such as may vie with the proudest monuments of our art. No longer let foreigners reproach us with the total want of great national monuments; let us, in this respect, imitate our Gallic neighbours, let us look at their Pantheon, an edifice dedicated exclusively to the honour of great men. This superb fane, calculated to immortalize the memory of its architect, Soufflot, will ever be ranked amongst the finest specimens of modern art that Europe can boast. In the portico and in the interior of this superb structure the classical elegance and refined graces of Grecian architecture are united with all the intricacy, variety, and pleasing effects of the finest examples of our Gothic cathedrals.

The erection of a few such buildings in this country, although they would not call forth the exertions of every artist, would, nevertheless revive the drooping spirits, and give new energies to all the votaries of architecture and, from our natural love of improvement, it would soon raise the art to its ancient glory. But let not the young architects be dismayed

[11] *The Winter's Tale*, V. II. 64–65.

and despair of success because all of them cannot have the control and direction of great national or great private works. Rather let them feel proud of a profession, wherein a man of genius and superior intellect will create an interest, display as much talent, and show the powers of his art as effectually in small buildings, even in confined situations, as in works of great magnificence and expense.

The British Coffee House at Charing Cross (pl. 25) shows more novelty and fancy and does as much honour to the memory of Robert Adam as the great structure he raised to contain the public records of Scotland. The small building called York Stairs likewise shows what can be effected by genius and taste in works of limited extent, and will add more to the fame of Inigo Jones than will the immense Triumphal Arch of L'Etoile at Paris to that of its architect, even when finished with all its intended magnificence.

That every architect cannot be employed on great works is no proper subject for regret, but when the young architect sees that the immense sums that have been voted by Parliament to commemorate heroic deeds, have been almost exclusively devoted to sculpture, he, as well as the lovers and professors of architecture in general, must be dismayed. It is from this circumstance, and from judging of the state of our architecture from the miserable abortions of speculation, and above all, from the want of public buildings, that foreigners in general, and many of our own connoisseurs, have concluded that architecture in this country is an art little understood and less felt, merely competent to provide convenient dwellings, but incapable of producing any great effects, and very inferior to the other arts in its powers to interest the mind. Let us hope that this feeling is not correct.

Painters and sculptors have generally the originals before them of what they are required to do; even if ideal beauty is to be represented, it is collected from a variety of sources and objects, all of them to a certain degree, or extent, in existence. Thus painting and sculpture, with all the mighty and justly admired powers they possess, are arts chiefly of imitation, but architecture is an art purely of invention, and invention is the most painful and the most difficult exercise of the human mind.

The sister arts, although often employed on subjects of high intellectual interest, are sometimes engaged on objects of luxury, or pleasure, but architecture is the child of necessity, and the parent of general utility. It has therefore in all ages and in all countries particularly interested every class of men, the most humble and the most exalted of mankind; kings, heroes, and private individuals have all, to a certain degree, cultivated this noble art, and acknowledged its superior influence, its great utility, and its manifold benefits to society. If the possession of one single picture by Protagenes stopped the career of the conqueror and saved the Rhodians and their city from destruction, architecture did as much for Athens and for Pericles who, when accused of lavishing the public treasures in erecting splendid public monuments, boldly defended himself and satisfied the Athenians of the policy and wisdom of his conduct, more by pointing out [that] the utility and great national advantage of such undertakings were greater than from the glory that accrued to

the Athenians from the possession of the finest works of art in painting, sculpture, and architecture.

Passing from Plutarch to the sacred writings we learn that whilst the sister arts of design were prohibited by divine command, and the making 'the likeness of any thing in the Heavens above or in the Earth beneath'[12] forbidden, architecture was encouraged, and Noah was instructed by the creator of the universe himself to build an ark of such enormous vastness and difficulty of execution as leaves us in silent admiration of the extraordinary power by which it was finally completed, and ultimately proved the means of preservation to all animated nature.

Noah likewise, immediately after the Flood, was directed to raise an altar to commemorate that great event; and such was the high estimation in which our art was held in those early periods of the world that Bezaleel and Aholiab, two of the most ancient artists mentioned in Holy Writ, are there said to be endowed by the great Creator of the Universe himself with all kinds of knowledge useful to mankind. In like manner we are told from the same high authority, that in succeeding ages, King David, and his son Solomon did nothing in the construction of the Holy City of Jerusalem, or in the building of the temple therein, but in conformity with those ideas which the Almighty Creator himself was pleased to reveal unto them.

If we consult profane history we shall learn that Ctesiphon, when building at Ephesus the magnificent Temple of Diana, was supposed to have been assisted in the construction of that stupendous work by more than mortal intelligence.

Thus much for the powers and importance of architecture, and for the respect in which it has been held. As to its antiquity, that is to be traced to the earliest period of recorded time. It was not only the first born of the sister arts, but it boasts an origin almost divine and, when aided by the powers of painting and sculpture, it becomes irresistible in its effects. Well has Sir Henry Wotton observed, that 'Architecture can never want recommendation, wherever there are noble men and noble minds.'[13] I conclude by saying that I think it must be admitted that, amongst all the arts of useful and elegant refinement, architecture, whenever and wherever its laws and principles are well understood and truly observed, must always stand pre-eminently distinguished.

[12] *Exodus*, 20, 4.
[13] Henry Wotton, *Elements of Architecture*, 1624, p. [i].

LECTURE VIII

~

MR PRESIDENT, – If in these discourses on architecture, a subject, as many suppose, exhausted, I venture to trespass on your patience, and on that of the members of the Institution who occasionally attend from a sense of duty, and as an example to the young students, I hope to stand excused from a due consideration of the importance of architecture from a political and moral point of view, and likewise from the duty I am called on to perform towards my young friends, the students in architecture.

From the remains of the great works of Greece and Italy, once the glory of Athens and the boast of Imperial Rome, the students in architecture must form their principles of sound construction and classical taste. To build for an eternal duration was the great object, and true wisdom of the early nations.

Among the Egyptians, the Greeks, and the Romans, this glorious principle was carried out to an almost incredible extent. On this principle, regardless of expense and difficulties of every kind, the great works of remote antiquity were raised. With this feeling for eternity the pyramids of Egypt were constructed, those stupendous monuments of human perseverance, calculated to defy the ravages of all devouring time and the convulsions of empires till that period shall arrive, when

> 'The cloud-cap't Towers, the gorgeous Palaces,
> The solemn Temples, the great Globe itself,
> Yea all which it inherit shall dissolve
> And like the base-less fabric of a vision,
> Leave not a rack behind.'[1]

The ancients, in order to render their works eternal, were not satisfied with using immense blocks of granite and marble; entire buildings were sometimes formed of a single stone.

[1] *The Tempest*, IV. i. 52–56.

Amasis, King of Egypt, formed an edifice measuring, on the outside, twenty one cubits in length, fourteen in width, and eight in height, of one single stone, and a fact which increases our admiration is that this mighty mass was conveyed to a distance of twenty days' journey.

The mausoleum at Ravenna of Theodoric, King of the Visigoths, is crowned by a dome of one entire piece of granite, thirty feet in diameter.[a]

The immense obelisks, the columns of the Pantheon, and many other shafts now existing in Rome are of single blocks of granite, or marble, brought with incredible labour and difficulty from quarries in Egypt and other remote places.

To this class of construction may be added the historical columns of the ancients, particularly that noble monument erected in the Forum of Trajan, the whole formed out of immense blocks of marble, with a staircase worked out of the solid mass (pl. 3).

Such were the principles on which these and other ancient buildings were constructed, wherein symmetry, continuity, and character pervaded even the most minute parts, forming (like a statue, or group of sculpture) one entire and consistent whole, so that if any part of the structure escaped destruction, the destination and character of the work, when in its perfect state, could be satisfactorily ascertained. And let me add that the merit of a building is very questionable unless, when looking at it as a statue, the parts unite and form an entire whole. When that is the case, all that can be expected from the artist is attained, and if these invariable principles of the Greeks and Romans which apply to painting, sculpture, music, and poetry, as well as to architecture, be correct, how can we tolerate such capricious deviations from them as were particularly noticed in the three distinct styles of whimsical composition in a former lecture.

Architecture must be considered under two distinct heads, the Utile and the Dulce; these can never be separated, for if the exterior be neglected, or the interior does not keep pace in character and importance with the exterior, the judgement and taste of the architect will be questioned.

It is not sufficient that all the parts of the exterior shall harmonize with each other and are well combined together: the interest created from viewing the exterior must be carried on gradually through the entire work, as has been already noticed.

It is from the great stores still existing of Grecian architecture that the student must form his taste, and by exploring the 'Urbis Eternae Vestigia,' he will be materially assisted in acquiring correct ideas of solid construction.

These are the objects our young artists should have in view in visiting the classical shores of Greece and Italy where, by close study and application, they will learn to infuse into their own compositions all the gay dreams of early fancy acquired from those true sources of knowledge. This indeed their portfolios amply testify, and that there is no

[a] See Gibbon, vol. 7, p. 52.

deficiency of native talent and powerful genius in the young artists of Great Britain, our annual exhibitions and the designs offered for the premiums have frequently shown. The young architects, having formed their taste on the classical remains of Greece and Italy, they only want patrons to call forth the exertion of their talents, but how seldom does it happen that the artist is allowed the free exercise of his taste, beyond the decorating the centre of his design with four small columns surmounted with a pediment?[2] More frequently he is restricted to a porch of two columns, or to mutilated statues supporting a terraced roof. In many of the great mansions erected for the residences of noble families, the centre of the entrance front is distinguished by three-quarter, or semi-columns, finished with a pediment, or with pilasters and sometimes with less important decorations, whilst the other fronts are left quite destitute of any corresponding character. Buildings formed of such heterogeneous parts are irreconcilable with the true principles of architecture.

Thus is the noble ardour and the finer feelings of the artist too often repressed, smothered, and paralysed, by the chilling parsimony, ill-judged economy, or bad taste of his employer. Oh, Architecture! once the mightiest among the mighty, Architecture, thou lovely Queen of the Fine Arts, how art thou fallen since the days of Pericles and of Augustus!

In the former lectures I endeavoured to give such a series of observations on building for domestic purposes as appeared to me to be most useful, and the students were likewise directed as to the proper choice of situations for houses in the country. The figures, and proportions of rooms best suited to such buildings were enumerated, and their application shown from various works by the best masters.

Previously to the student being led to the consideration of the application of forms and proportions in general, and in the detailed combinations of buildings, as lengths and breadths have been noticed, heights must now be considered, and the forms and proportions of windows, doors and chimneys will necessarily follow.

The heights of rooms depend on climate, the character of the building, the uses to which they are destined, and likewise the manner in which they are to be finished.

If in fixing the proper heights of rooms convenience were the only object to be attended to, ten or twelve feet in rooms of moderate dimension would be sufficient for every useful purpose but, when elegance and magnificence are consulted, the height of a square room with a flat ceiling is usually not less than four-fifths of its breadth, nor more than five-sixths. And if the ceiling of such a room be coved, the height should be equal to one side of the square.

In a room the length of which exceeds its breadth, the height should be equal to the

[2] Soane illustrated his point about modest porches with drawings of Stafford, Lansdowne, Carrington, Melbourne, and Schomberg Houses, Lord Kinnaird's house in Berkeley Square, and the Pantheon in Oxford Street.

latter dimension, and if the room be one-third or one-half more than its width, the two dimensions should be added together and half the total allowed for the height. But if the room be coved, one-fourth or one-fifth more must be allowed.

Galleries are generally made one-fourth higher than their breadth and, when the height is increased to one-and-a-half the width, the disparity in length and breadth will be less conspicuous, and at the same time the convenience and beauty increased.

For rooms of moderate dimensions the cube will on most occasions be found the most pleasing figure, and for many ages it was a received opinion that a room formed of a double cube was of the most perfect proportion that could be devised, but this applies only to rooms of certain dimensions such as the Banqueting House at Whitehall, which is one hundred and ten feet long, fifty-five feet wide, and fifty-five feet high. The great eating room at Wilton House is sixty feet long, thirty feet wide, and thirty feet high.

On rooms of these, or nearly similar dimensions, the best informed mind in art dwells with delight; the most correct eye is pleased with the proportion; there is a powerful charm that never fails to excite approbation. But the sensations would be very different on entering a room, or rather passage, of half those dimensions, namely, thirty feet long, fifteen feet wide, and fifteen feet high: the reason is obvious, the eye more easily compares the disparity between the length and width.

Rooms formed either of the cube, or of the double cube, or of any other figure, can neither be pleasing nor convenient unless the chimneys, windows and doors are properly placed, duly proportioned, and of dimensions adapted to the uses to which the rooms are destined.

Due consideration must likewise be given to the general extent and character of the whole building, so that the precise dimensions of each of the component parts of the structure may be regulated by the strictest rules of symmetry.

Our obligations to the ancients are on most occasions very great, but there are some points, particularly appertaining to private houses, on which we can derive little, or no useful information from the remains of ancient buildings, or from the precepts of Vitruvius; and perhaps in no part of our art less than in what which respects the due warming and lighting of rooms.

The climates of Greece and Italy rendered fires less necessary than they are in ours: Vitruvius, Pliny, Varro, and Columella, all speak of the great care taken in planning their triclinea, cubicula, and other habitable rooms to face such aspects that, from the rays of the sun darting into every part of them, those apartments might be sufficiently warmed.

Seneca tells us that even this mode of warming rooms (if it can be so called) was a luxury unattended to in the early times of the Romans, and in describing the retirement of Scipio Africanus at Linternus,[3] the philosopher laments the degeneracy of the age, contrast-

[3] *Oeuvres de Sénèque, traduites en François par la Grange*, 6 vols, Paris 1794, vol. II, p. 493.

ing the simplicity of that building with those of his own times, and remarking with severity that formerly windows, or rather slits, were made to introduce light only, without injuring the solidity of the building, whereas now, continues Seneca, we should think ourselves in a dungeon if the windows in our rooms were not sufficiently large, and so disposed as to admit the sun into them every hour in the day.

The ancient writers speak of the Heliocaminus as a favourite mode of warming their rooms and, according to Piranesi, there is an example thereof amongst the remains of Hadrian's Villa at Tivoli.

This mode of warming rooms might suit hot climates and ancient customs, but in England it is not sufficient that our houses are well warmed: we must see the fire, or no degree of heat will satisfy us.

With respect to fires in open chimneys such as are now used, the ancients afford us little or no useful information. Whilst Blondel and Salmathius contend that open chimneys were unknown to the Greeks and Romans, Pancirolus[4] and other writers maintain a contrary opinion. But from all that is now to be collected on the subject, although it may be justly doubted whether open chimneys were ever in general use in early times, it is certain from the testimony of Suetonius, Horace, and Cicero, that they were occasionally used in the living rooms of the ancients. Vitruvius likewise, in describing the manner of decorating different apartments, directs that in those wherein fires are to be made in open chimneys, the cornices of the rooms should be made without any enrichments, so that they might be less injured by the smoke from the chimneys.

At Baiae, near Naples, were found the remains of an ancient chimney, placed in the middle of the room with four columns supporting a pyramidal top, but I do not remember to have seen among the ruins of ancient structures any vestige of an open chimney in the thickness of the walls, as is the present custom. And from the frequent recurrence of flues to convey heat from the hypocaustum into the habitable rooms of the ancients, it is reasonable to conclude that the Greeks and Romans were less anxious than ourselves to have the appearance of fire, provided they had the comfort of warmth.

In Russia, Germany, and France, close stoves, elegant in form and rich in decoration, are chiefly used in large rooms, in preference to open chimneys, as giving a more certain and regular heat.

In this country, before coals were known, wood was burned on dogs placed on the hearth; this was succeeded by open grates for burning wood and coals, or coals only. Some years past a close stove called the Pensilvanian Stove, an invention of Dr. Franklin, was much used. This stove, from the celebrity of Dr. Franklin, attracted particular attention, and it had many desirable qualities. It prevented the smoke from forcing its way into the

[4] Guido Pancirollus, *The History of Many Memorable Things Lost, which were in Use among the Ancients*, 2 vols, London 1715.

room, and increased, by the medium of rarefied air, the warmth and temperature of the internal atmosphere, to a greater degree than any other mode that had been practised prior to that period.

Besides these modes of warming rooms, from the labours and talents of Messrs. Boulton, Watt, and others, steam has been most usefully and successfully applied, not only in our manufactories, but likewise for the warming of apartments of different magnitudes. And perhaps for halls, galleries, corridors and such like parts of our houses, no mode yet discovered has been more safe, economical, or better adapted for the purpose, although no method is more dangerous, expensive, or ineffectual, than steam, when improperly used by ignorant persons.

The general application of steam to useful purposes has unquestionably been the work of the present age, but that its powers were not unknown to the ancients, the following incident will prove.

Anthemius, the architect of the church of Sta Sophia, had a dispute with his neighbour Zeno, relative to the walls, or windows of their contiguous houses. And Anthemius, being unsuccessful in this dispute, retaliated on his antagonist by placing in a lower room of his own house several vessels filled with water, each of them covered by a tube of leather which, being made wide at the bottom and gradually diminished to a narrow tube at the top, was artfully conveyed amongst the joists and rafters of the adjacent buildings. A fire being then kindled beneath the cauldron, the steam of the boiling water ascended through the house which was shaken by the efforts of the imprisoned air, producing all the alarm attendant on an earthquake.

A much more simple and perhaps equally effectual mode of warming buildings, wherein open fires can be dispensed with, is that which has been introduced within these few years by means of heated water which may be so applied that the various rooms in public buildings and private dwellings, hot houses, green houses, and such like structures, may be heated so as to produce any general temperature that may be required.

The due and equably warming of rooms in cold climates, it must be admitted, is of great importance to the health and comfort of the inhabitants of every dwelling, from the cottage of the servant to the palace of the sovereign. So necessary is warmth to existence that we cannot be surprised at the various inventions that have been produced for the better and more economical warming of our houses.

The effectual distribution of warmth is very much assisted by the relative situation of the chimneys with respect to the doors and windows. The Italians frequently place their chimneys between two windows, a mode which has been followed by Lord Burlington in his celebrated villa at Chiswick, as well as by others; but this disposition of the chimneys should never be made except in very large rooms.

In Sweden and Muscovy the chimneys are often made round in front and are very commonly placed in a corner or angle of the room; although this arrangement deviates from

strict regularity, yet it throws out the heat more equally and admits of great variety in the decoration.

Chimneys thus placed in the angles of rooms were formerly very general in England, but they are now seldom constructed in this manner except from necessity.

In Venice the chimneys are very frequently placed in the external walls with projections on the exterior surface, of sufficient thickness to contain the funnels.[5] These projections on the outside appear like so many buttresses, and generally produce a clumsy and bad effect, although if properly treated they might be made highly ornamental. Examples of this Venetian practice may be seen in the exterior of some of the old English houses. The placing of the chimneys in the external walls often contributes very much indeed to the convenience and comfort of the interior, although it creates difficulties in houses having pointed roofs.

At Coleshill in Berkshire the artist may see an example of chimneys thus disposed, in which our great architect, Inigo Jones,[6] has so judiciously arranged the shafts that he has created a beauty out of parts which in inferior hands always produce deformity.

Two other admirable examples of this manner of applying chimney shafts may be noticed, viz., at Wotton House, the seat of the Marquess of Buckingham, and Buckingham House, formerly the Queen's palace, which has recently been taken down.[7]

Scamozzi describes three different modes of forming the apertures of chimneys, namely, the Roman, the Lombard, and the French. The Roman chimney is that which is contained entirely within the thickness of the walls; the Lombard chimney has part of its depth in the thickness of the wall and the remainder projecting into the room; the French chimney has usually, according to Blondel,[8] a projection or breast into the room beyond the general line of the wall, sufficient to contain the entire funnel.

Chimneys in their plans should not be made rectangular as they usually are in our buildings, but they should be formed of regular or irregular semi-hexagons, as is the almost universal practice at Turin and in other places on the continent. The apertures should be of such dimensions as to admit grates or stoves, sufficiently large to contain a proper quantity of fuel to warm the apartment completely. The funnel, or tube to carry off the smoke, is another necessary part to be particularly attended to, so that no sudden check in its construction, nor any irregular current of air, may divert the passage of the smoke out of its proper direction and force a portion of it into the room.

It was formerly very much the practice in this country to make the flues of chimneys

[5] Soane illustrated this point with a drawing of Palladio's Villa Malcontenta.

[6] Perhaps designed by Roger Pratt, not Inigo Jones.

[7] Soane referred to the transformation by John Nash of Buckingham House into Buckingham Palace from 1825–30.

[8] See 'De la construction des cheminées', in Jacques-François Blondel and Pierre Patte, *Cours d'architecture*, vol. VII, Paris 1777, pp. 396–407.

in the different storeys one before the other, and to continue them upwards in straight lines. This caused a very considerable, and inconvenient projection into the room, which led to the practice, now almost general in this country, of making them pass in oblique directions by the side of each other.

Palladio also speaks of the flues of chimneys made in oblique directions, so that the smoke, being driven upwards by the flame and heat of the fire, was by the sinuosity of the funnel prevented from returning back into the room. Latterly the idea of twisting the flues of chimneys has been treated somewhat ludicrously, yet it is right in principle, however unpleasing it may be in appearance.

Having thus disposed of chimneys we now come to windows. Windows are considered by Scamozzi of as much importance in a building as the eyes to the animal, and it may be added that the equal distribution of light is as necessary to the comfort and convenience of an apartment as the equal distribution of warmth. Windows therefore require a great degree of attention as to situation, form, magnitude, and proportion.

Vitruvius is not silent on the subject of windows, yet as he is rather considering the light suited for temples, we shall, on this point, gain but little useful information from his writings.

Palladio, Scamozzi, Philibert de l'Orme, and many other great architects, have given their different opinions on the forms and proportions of windows but, as windows must be of dimensions suitable to the particular climate in which we are to build, and as the observations of those great men referred to a warmer climate than ours, their directions will be of little avail to us.

It may be noticed that windows in the ancient temples, and in most of the sumptuous palaces and villas of Italy are usually very small in proportion to the magnitude of the spaces they light. They are likewise placed at such a distance from the floor as to impede the sight when sitting, and in many cases to materially obstruct the due circulation of the air. Examples by these great architects have nevertheless been generally followed by Inigo Jones, Lord Burlington, and others.

The French mode of lighting rooms with windows down to the floor has of late been frequently adopted in this country, and certainly produces a cheerful effect. Our windows are likewise now made of larger dimensions than they were formerly and, being constructed so as to open in the middle, the general effect is much improved; more light and air is admitted thereby, and a more habitable appearance is given to the apartment.

Rooms are sometimes lighted by two tiers of windows, as in the Banqueting House at Whitehall, but this mode should be adopted with caution.

In galleries, and extensive rooms with large cornices and coved ceilings, light is often introduced very advantageously above the cornice, so that the window is not seen from below: by this contrivance a pleasing kind of demi-tint is thrown over the whole surface of the ceiling.

The architect will do well to examine and reflect on the different modes adopted by painters of introducing light into their studios. The 'lumiere mysterieuse,'[9] so successfully practised by the French artists, is a most powerful agent in the hands of a man of genius, and its power cannot be too fully understood, nor too highly appreciated. It is, however, little attended to in our architecture, and for this obvious reason, that we do not sufficiently feel the importance of character in our buildings, to which the mode of admitting light contributes in no small degree.

Windows are in general either rectangular, circular, or compounded of both these figures. The openings are seldom made higher than twice their width, frequently considerably less. The ancients often made their windows similar to their doors, narrower at the top than at the bottom, as in the little temple at Tivoli, and in the Temple of Erechtheus at Athens. In this peculiarity, in some instances, they have been followed by succeeding architects, yet generally in modern works windows are made with parallel sides, and with either straight or circular heads.

There is likewise what is termed the Diocletian window which deserves the attention of the artist, and besides windows of these different forms and proportions there are many others, whereof those denominated rusticated, Palladian, and Venetian are the most useful, and are frequently introduced into modern works.

Rusticated windows and doors were much used in the last century. This kind of decoration can only assimilate with those works wherein the orders of architecture are omitted, or at least they never should be used with other than the Tuscan order. With the Corinthian, as in the front of St. Martin's church, they produce a very bad effect, as will be more particularly noticed hereafter.

The Palladian window, although more applicable with the orders than the preceding, is nevertheless deficient in that necessary elegance which is required with whatever accompanies either of the orders of architecture.

Venetian windows are extremely beautiful when a series of them occur in the same front, and of which there existed some years ago a pleasing example by Mr. Paine in the front next the park, of the late Sir M. Featherstone's house at Whitehall (now the residence of Lord Dover) which, every lover of architecture must regret, has since been mutilated.[10]

Scamozzi and other architects have frequently marked the centre of a building with one of these Venetian windows, but this practice, however sanctioned by great examples, is too incompatible with the great principles of architecture to be tolerated.

Palladio has availed himself very successfully of the beautiful and elegant figure of the Venetian window in the basilica at Vicenza. There is a peculiar degree of gaiety and cheer-

[9] Soane here echoes Le Camus de Mézières who argued of a building that, 'la lumiere [*sic*] encore plus interceptée, il est mystérieux' (*Génie*, p. 43).

[10] A verandah, a thing always objectionable to Soane, had been added to Dover House. It has since been removed.

fulness in this kind of composition, admirably adapted to the exterior of theatres, far preferable to the style generally adopted in such structures, contrary to the principles of Vitruvius.

The doors in the interior of every building are important features and, like chimneys and windows, much of the magnificence and convenience of the apartments depend on their situation and due proportion.

In all the remains of antiquity the lintols of the doorways are square, although in modern works they are frequently circular. The dimensions of doors must be determined by the magnitude of the rooms to which they give entrance, but single doors, whatever their Width, should never be less than two widths in height, and folding doors, however wide, should not in any situation be much less, for if a room be too low to admit of those proportions, the width of the door should be lessened accordingly. And this is the constant practice of the French architects, from whom we have borrowed the idea of large folding doors. The modern fashion consists of making very wide folding doors, frequently six or seven feet in width, in rooms that will not allow them to be more than seven or eight feet at most in height. This is extremely offensive to the eye, however much custom may induce us to tolerate such proportions.

The different parts of internal distribution, to be well proportioned and properly combined together, require from the artist a thorough knowledge of whatever relates to convenience, economy, and beauty. An arrangement of rooms congenial to one situation, and suitable to one man's habits of living, will be totally different in other situations and with other men.

On the subject of internal distribution and the proper arrangement and combination of the various and complicated parts of the plans of buildings, the young architect will gain much information from the works of the French artists. In their houses convenience and effect are never neglected, although they are sometimes deficient as to preserving the character and gradation of richness, between internal and external decoration. This is, however, essentially requisite; the same feeling that is produced by the first sight of a building should be preserved even in the inferior offices; nay the furniture itself should partake of the decorative character of the building. It may be remembered that the late Messrs. Adam generally gave designs for the furniture of the principal rooms of those houses that were constructed under their direction.

From a want of attention to character and this feeling of propriety, the ferme ornée, the cottage, the hermitage, instead of being confined to retired situations, are sometimes placed contiguous to the approaches into great cities. Instead of being composed of two or three rooms of moderate dimensions, as their titles import, they often form large buildings. Their external appearance, likewise, instead of being distinguished by uniform simplicity or even rusticity, are frequently plastered to resemble the most delicate stone, with a portico in the centre to protect a fine mahogany door and sash window, whilst the interior is completed in the most finished style, with the most elegant, fashionable and expensive furniture of every

kind. And lastly, that such structures should not be mistaken, or passed unnoticed, letters conspicuously large announce that this is a ferme ornée, this a cottage, this a hermitage.

Architectural inconsistency does not stop here. A celebrated writer on the principles of taste tells us that he 'ventured to build a house, ornamented with Gothic towers, battlements, pinnacles, and flying buttresses, without, and Grecian columns and entablatures, within,'[11] and although this example, the author adds, has not been much followed, he has every reason to congratulate himself on the success of the experiment, he having at once an elegant and convenient dwelling, though less perfect than if he had executed it at a more mature age.

Under the sanction of this and such-like examples with their Gothic towers, battlements, pinnacles, flying buttresses, Grecian ceilings, columns, and entablatures, we have innovations of a still more dangerous tendency, calculated to destroy all relish, even for the finer efforts of Gothic architecture, so happily and successfully displayed in some of our ancient structures, the beauties of which, if felt, are certainly not often transferred into modern buildings.

From the same causes we see in many modern buildings called Gothic, not only the improvements and changes made in different Gothic edifices in different ages and under peculiar circumstances, blended together in the exterior of the same building, but likewise without any attention to priority of invention.

The advocates for the mixture of the works of different ages and styles justify this manner of building from the examples of our ancient cathedrals. Some of those edifices, from their great extent, occupied several ages in their completion, and consequently were under the influence of different opinions and feelings, the architects frequently introducing such variations and improvements, as they observed in other works subsequently raised.

How these deviations from correct feeling can be tolerated, nay approved, by the admirers of the pure Gothic architecture, I know not. Inigo Jones, Sir Christopher Wren, and Kent have been justly blamed, their taste arraigned, their judgement doubted, because they sometimes blended Roman and Gothic architecture in the same structure. Is there any man so devoid of taste and feeling of art, that with all his love and attachment to the sublime effects of Grecian architecture, he can bear to look at the screen, erected by Inigo Jones in Winchester Cathedral, or at that by Kent in Gloucester Cathedral, or who does not deprecate the sacrifice made by Inigo Jones, in the alterations he made to old St. Paul's, and more particularly at the principal front?[b]

[b] Note. Yet viewed as a composition what could be more beautiful than the portico of Old St. Paul's? It must have cost Sir C. Wren a pang to destroy so fine a model. Such indeed must have been the case with Sir W. Chambers when he destroyed the Water Gate in Somerset House Gardens, the front of the Royal Academy, the chapel, staircase and other parts of that structure built by Inigo Jones.

[11] Richard Payne Knight on Downton Castle in his *Analytical Inquiry into the Principles of Taste* (1805), 4th edn, 1808, p. 223.

I trust these examples will serve as beacons to point out to the young students what they are to avoid, rather than be looked upon as models for imitation, and when they are required to restore, or stop the ravages of time in any of our ancient buildings, or to alter any parts of one of those splendid structures, so admirably calculated for the purposes of devotion, let their first care be to study the style and character of the work in all its nicest particulars, so that the new parts may only be distinguished from the old by the freshness of the materials wanting the mellow tints of time. And above all, let the young architect in all cases consider how he can best preserve the works of former ages. Let him beware of destroying that which is not absolutely beyond the possibility of restoration, to make way for novelties of any kind. Let not the rising generation of artists be told that the architects' motto was from early times, and will ever be.

'Diruit aedificat mutat quadrata rotundis.'[12]

I trust it is not necessary for me to caution the students further from being led astray by authorities, however great, to the adoption of such false taste. Such ineffectual attempts at contrast and variety must be fatal to every sound principle of good architecture. Without descending to unjustifiable innovation the artist will have sufficient opportunities to display the richness of his fancy, the fertility of his invention, and his classical taste in the exterior of his buildings, and the plan will furnish him with innumerable occasions of showing his knowledge of ingenious combination and convenient distribution.

It is not only in the exterior of a building that the abilities of the architect are to be displayed. The ichnographic projection must not be considered or treated as a secondary object. In this part of the design, as well as in the exterior there must be a regular gradation of parts from the smallest to the largest. Beauty in the exterior, unattended with internal propriety and convenience, and a judicious, artist-like arrangement of the different rooms and communications suitable to the character of the building, produces nothing but disappointment. If, in painting, fine colouring, without correct drawing, character and expression, can never make a fine picture, so in architecture, the real artist, the man of superior talent, shows his taste, genius, and sound judgement, not by placing an arcade, portico, or colonnade as spots in the centre of his composition, nor by a rapid mixture of circles, polygons, and mixed figures in his ground plots, but by preserving in every part of his work consistency, harmony, continuity and character. A building to please those who are acquainted with the great fundamental principles of architecture, those who are capable of feeling the powers of symmetry and continuity, must have all its different parts in perfect unison.

The fireplaces must all throw out sufficient heat, the windows admit a due quantity

[12] Horace, *Epistles*, I, 1. 100.

of light, and the doors, passages and staircases, must afford easy communication with every part of the structure.

The student in composing his plan must be mindful to avoid irregularity. He must look at nature, imitate her simplicity, and follow her symmetry. He will there learn that contrast with a balance of parts is as essentially requisite to form a well-composed plan, as a strict attention to the uses to which the different parts of his work are destined, are to produce a convenient dwelling. Nor should it be forgotten that it requires as much or even more attention and study, and will redound as much to the fame of the great architect, to arrange a kitchen, laundry, and other inferior offices, in the most convenient and proper manner, as to design the most magnificent apartment.

The inferior offices of every kind, nay even those least likely to be generally noticed[c] must be as much the object of his attention, as the principal parts of his composition.

The magnificent exterior, the spacious and lofty hall, the noble eating room, the superb drawing room, the classical library, and the extensive picture gallery, will lose their effect if the other parts of the building do not accord with them.

A suite of magnificent rooms on the ground floor requires the chambers and the access to them to correspond. All the domestic offices of every kind, as well as the servants' lodging rooms, must be so combined as to make them parts of the great whole. And it may be added that, if the stables and even the out offices of the most inferior kind are neglected, the architect of such a building will deserve but little praise.

In composing the plan of a building, therefore, the architect emulous of fame will never consider the most minute part of his composition unworthy his notice.

In speaking of the uniformity or regularity of plans, I mean that happy balance of parts, that due relation of solids and voids, which are equally compatible with beauty and propriety.

I could have wished to have led the young student by degrees from the most simple compositions, contained within the limits of plain figures, to the consideration of those of the most varied and complex; to have made them acquainted with the various beauties and conveniences, in the different distributions, from simple square figures, and to those more complicated and varied; but this, the time allotted for these lectures will not permit. But I trust to impress on the minds of the young artists those sure and fixed principles which the best works of antiquity and a recurrence to the great works of nature, can alone teach. Such work alone will stand the test of truth.

Economy, utility, and convenience, which are never to be neglected in private dwell-

[c] Note. Dean Swift, when first introduced at Burlington House, in order to judge of the lady's good housewifery, ran up into the garrets to see if they were clean and well arranged, observing that any lady would have her drawing room in order. In like manner, to judge of the merit of the architect, I should first examine his offices, and if they were neglected or not understood, as economy and comfort are essentials in an English mansion, I should hold that architect at a low rate.

ings, invariably require rooms and communications of every kind to be as much as possible of rectangular forms. Otherwise the expense of the building will be materially increased, and void spaces be left of little or no use, as in these drawings of Gorhambury and Wardour Houses. Hence it happens that the plans of English houses in general are so frequently formed of squares and parallelograms. And it must be admitted that this great want of variety in the forms of our rooms proceeds in a great degree from a disposition to be satisfied with servilely copying those who went before us. Nothing proves so much the want of genius and a barrenness of ideas as the insipid uniformity which so generally prevails in the plans of our houses, and for which foreigners condemn us. This will be more fully noticed in a subsequent lecture.

In treating on this part of our art, as the most minute description of the plans of edifices will convey but little practical information to the young student, I shall therefore endeavour as far as possible to exemplify this part of my subject by drawings of buildings already executed, and to which the students can easily refer. And when examples from real structures do not occur I must then be allowed occasionally to offer to your notice designs of my own.

The most simple and at the same time the most useful figure or form for the outline of a building for domestic purposes is the perfect square, or the parallelogram.

I noticed in my last lecture that rooms formed of the entire ellipse, the circle, the triangle, and the different polygons, may be very properly and advantageously introduced into the interior of buildings. But any of these figures, however beautiful and pleasing in their outlines, can never be applied to form the great outline of any space that is to be divided and sub-divided into a great number of different rooms for the purposes of habitation, without a more considerable sacrifice of expense and a greater loss of space than employers in general would judge prudent to adopt, or the generality of architects think proper to recommend.

Many examples of houses whose outlines are of the entire ellipse, the circle, the triangle, or the different polygons, may be seen in the works of great architects of different countries and different ages. But it should be observed that wherever the experiment has been made to form a dwelling-house whose general outline is a complete ellipse, circle, triangle, pentagon, hexagon, or any other figure, polygonal or mixed, the attempt has completely failed.[d]

As far as external appearance is considered either of these forms may succeed perfectly well, but as houses are made to live in (as Lord Bacon justly observes) more than to be looked at, it follows therefore that in the internal arrangement of the plan, as well as in the

[d] Note. The student will do well to enrich his portfolio with studies of these forms of ground plans to enlarge his mind, not as being applicable to modern buildings, but as extremely useful to him when he has an irregular space to build on.

necessary and various divisions, there should be convenience, utility and variety, with as little loss of space as possible.[e]

Palladio, Scamozzi, Serlio, and others of the Italian school seem to have been fully impressed with these truths, and to have been aware that in the divisions of circles and polygons into different apartments there would be, unavoidably, a want of convenience, great monotony and prodigious loss of space, with a large increase of needless expense.

Vignola, however, at Caprarola has indulged his fancy[f] and shown what great knowledge and ingenuity can achieve. The whole design is inimitable; it is convenient as a house; it is magnificent in appearance, and admirably suited to the scenery, and genius of the situation, in which this excellent specimen of superior talent is now to be seen.

The architects of our own country, even before the time of Inigo Jones, evinced no inconsiderable powers of invention in their designs. From among them I shall select some by John Thorpe who lived in the reigns of Queen Elizabeth and James the First. Of his labours I have a large volume, consisting of original designs, many of them very ingenious and whimsical studies for houses, some of which he carried into execution. The following specimens will I trust be found not unworthy the consideration of the young students.

To judge of the merits of these plans we must refer to the habits of living in the days of Queen Elizabeth and King James the First. The false wit of the age of James the First was not confined to any particular species of composition: it entered into architecture. Hence we owe the origin of buildings confined to the form of the letter D, the half H, the entire H, and others. To these instances may be added Abbot Islip's architectural pun, expressed in a piece of ornament.[13] Thorpe, however, was not satisfied with these witticisms. He composed a design, intended for his own residence, making out on the ground plan the initials of his name,

'These letters I and T, joined together as you see,
Make a dwelling house for me: John Thorpe.'

Inigo Jones, in many of his designs for houses, has confined the outline to a circle, an octagon, and such-like forms, but therein he has shown more ingenuity and contrivance than sound judgement or a desire to convey useful information.

In these fancies he has been followed by others with as little success, and I think it

[e] Note. Simple figures, in a word, simplicity, is always preferable to too much wildness. Simplicity may be produced without monotony, and pleasing movement without excess of variety.

[f] Note. Is it not probable that the peculiar character of the situation influenced the architect, rather than caprice? Vignola treated a different situation, the [Villa] Papa Giulio, in a very different manner, and yet in the same spirit of artistlike feeling.

[13] See Lecture II, p. 52.

will be admitted that the best combinations from such outlines will always evince more fancy than good sense, and more ingenuity than correct taste.

That men unacquainted with the remains of ancient buildings should indulge in licentious and whimsical combinations is not matter of surprise, but that a man who had passed all his life in the bosom of classic art, and in the contemplation of the majestic ruins of ancient Rome, observing their sublime effects and grand combinations, a man who had given innumerable examples how truly he felt the value of the noble simplicity of those buildings, that such a man, with such examples before his eyes, should have mistaken confusion for intricacy, and undefined lines and forms for classical variety, is scarcely to be believed; yet such was Piranesi. That great artist, to convince his foreign enemies, as he called them, of the knowledge he had acquired from his study of the plans of the ancients, produced this design for a Roman College.[14] How it is possible to account for this production, so unlike any part of the remains of the Roman Baths, the Imperial Palace, or any of those great vestiges of antiquity which had been constantly before his eyes, and which he had so successfully represented in his drawings?[g] This failure, by such a great artist as Piranesi, a man so justly celebrated for his knowledge and feeling of the antique, at first sight rather tends to lessen the value and importance of studying the remains of those ancient structures, which we have been taught to revere as the results of the combination of superior wisdom and refined intelligence and as the great foundation, the solid basis of all our architectural knowledge. But before we form this conclusion, let us pause and examine the works of other artists who have had the same advantages as Piranesi possessed.

Lady Miller, in her 'Letters from Italy,' after speaking of a great variety of architectural prize designs, preserved in the Academy at Parma, which do honour to their authors, particularly notices a composition for a royal establishment for painting, sculpture and architecture by the late Mr. Dance as a work wherein 'the architect has united great judgement with an excellent taste.'[15]

As some of my young auditors may possibly not have an opportunity of seeing the original design, I feel particularly happy in being able to show them correct copies of the drawings here alluded to.[16]

[g] Note. There is likewise a church [Sta Maria del Priorato, Rome] built after the designs of Piranesi, which is another proof that it is not enough to have fine examples before our eyes. Indeed Piranesi seems not to have felt those beauties of the antique which he has so ably delineated, beyond the power of making out of ruins, bold and imposing pictures. In that view, his labours, by giving a true splendour and value to the antique, deserve the admiration and gratitude of the artist, but when he forgets himself, and despises the Greeks, from whose works the Romans derived all their knowledge of architecture, his conduct is mischievous, for Piranesi must have admirers, and men are more prone to imitate defects than beauties.

[14] Piranesi, *Opere varie*.

[15] Soane's paraphrase of Anna Lady Miller, *Letters from Italy*, 3 vols, London 1777, vol. I, p. 277.

[16] Soane presumably borrowed the drawings from Dance to have copies made of them. He did not acquire the originals until the sale of Dance's drawings in 1836.

In the exterior there is that successful variety in outline, largeness of parts, and uniform simplicity throughout the whole, that would not disparage the best works of Palladio. In the plan there is a most happy combination of legitimate forms; in the transition from room to room, the uninterrupted succession of new ideas keeps attention alive, and increases the interest first excited. There is a most complete balance of parts between solids and voids and the whole breathes the true spirit of the finest examples of Greek and Roman architecture.[h]

In the interior the same variety of forms and combinations is kept up, whilst the rich assemblage of decoration of every kind, selected from the remains of ancient magnificence, are so happily introduced that each part seems to be in its original situation. And when we recollect that this design was made for an Italian climate, what can be more grateful to the senses in warm and sultry weather than the sight of fountains playing in various directions? What can be more congenial with the classical soil of Italy than colonnades forming the two noble cortiles, which at the same time that they bring to our recollections the glorious peristyles of antiquity, by an association of ideals lead our imaginations to fancy that we are conversing with the great heroes, legislators, historians, poets, and artists of antiquity?

But if a design, thus admirably composed for Italy, is to be transposed into a northern climate, the elegant and classical fountains would tend rather to make the beholders shiver with cold, than create pleasing sensations. Those beautiful colonnades, composed with all the feeling of ancient art, and enriched with the most exquisitely sculptured statues and busts of illustrious men, and with basso relievoes of their great achievements, would produce sensations very unlike those we should experience in a more genial climate.

The design before you is rich in fancy and full of imagination; every part of it shows a perfect knowledge of the ancient architecture; it presents to the young student a rich field of instruction, and I cannot quit it without observing that, if in our buildings we are a century behind the French nation, this composition alone, if others were wanting, would be sufficient to prove that the too manifest neglect and decay of our architecture is not from a want of talent in our artists, but from other causes, and some of these have been more than hinted at already, and which I hope to see removed.

In many of our buildings there is much originality, novelty and variety but it must not be forgotten that novelty, although a bewitching siren, has bounds; variety, with all her charms, has limits. In both, the artist must show moderation and sound judgement, not overstepping the modesty of nature lest he should fall into the excesses of Borromini and those of his school who, like Piranesi, passing by the fine examples of antiquity, carried what they called the powers of invention so far as to lose sight entirely of the simple and

[h] Note. These plans are so highly esteemed in Parma that they have been frequently copied by students, and I fear almost exact copies of them (how obtained I know not) have gained the first premium in this Institution.

unaffected grandeur of those ancient compositions which have stood the test of ages, and will continue to be admired as the standard of pure taste so long as any true feeling for art remains.

The works of Borromini and his followers, on the contrary, can only be looked upon as mighty mazes of chaotic confusion, wherein nothing is defined, one form constantly running into another, without taste, use, or meaning, works frivolous, and expensive beyond measure.

In this country we have occasionally had our Borrominis, but latterly, in the greatest part of our buildings, both in town and country, we have fallen into the opposite extreme, and by a too frequent recurrence of rectangular figures, unmixed with other forms, we have justified the observations of foreigners that there is so much sameness and insipidity, and such a total want of variety, intricacy, and movement in our architecture, that it almost seems as if all other forms were banished and excluded and none but rectangular figures were considered fit to be used in the public and private buildings of this country. Such monotony and tame repetition is to be avoided, as much as the unnecessary extravagance of Borromini and Fuga. This system is not only shackling genius, but it is at the same time directly contrary to that happy system pursued by the ancient architects who never lost sight of the laws which they had observed in the works of nature. Accordingly in all the superb remains of antiquity we discover an inexhaustible store, a splendid assemblage, a noble mine of talent and high intellect. In the works of the Greeks and Romans, there is a happy and quick succession of varied forms, a constant and regular movement in the parts, the whole calculated to keep the imagination awake, and to give the most lively interest to all their compositions.

I hope not to be understood from any observations I have made as wishing to confine our buildings to a succession of rectangular figures. That is by no means my intention. My object is to warn the young artist against confusing his compositions by a too frequent adoption of complicated forms in the same design. Every part must be distinct, rectangular rooms should communicate with circular rooms, and those in their turns with rectangular, those again with others of mixed forms, the whole in regular gradation as to quantity as well as shape. Always remembering that it is in the judicious combination of different figures that the mind of a great architect shows itself, and that too much variety is as cloying as too much monotony, and only leads to the admiration of the paltry conceits of a Borromini, whilst too much sameness banishes every idea of true taste, and renders torpid all the powers of genius. Let the young artist in his study exercise his mind by combining together in his plans every form that strikes his imagination, but he must be careful how he attempts to carry them indiscriminately into execution; what is fit for the study and calculated to accustom the artist to difficult combinations, is not always the best fitted for real use.

The designs of Borromini may occasionally, on paper, appear ingenious and please

the admirers of whim and caprice, but they will not fail to disgust those who can appreciate the unaffected grandeur of those superb remains of antiquity wherein we discover an inexhaustible store, a splendid mine of talent and high intellect, that happy and quiet succession of varied forms, the contrast and regular movement in every part, that keeps the imagination awake, and creates the most lively interest. Those works of the Greeks and Romans that have stood the test of ages and will continue to be admired as the standards of true taste so long as any higher feeing for art remains.

In the plan of every modern building, whether great or small, public or private, the staircase is always a useful, and on most occasions a very important feature. The ancients in this intricate part of our art, excepting in the triangular staircases at the Pantheon, and the circular staircase in the Column of Trajan (which cannot be regarded with too much attention) (pl. 3), give us but little assistance. Indeed in the houses of the Greeks and Romans, the principal apartments, being chiefly if not entirely on the ground floor, staircases must have been but secondary considerations.

Vitruvius, in describing the houses of the Greeks and Romans, does not even speak of a staircase, and the only information we can obtain is from the ruins of the staircases in the remains of the amphitheatres, theatres, baths, and temples.

In some of these buildings the dimensions of the steps seem to be founded on the proportion of the sides of the triangle of Pythagoras (agreeably to the text of Vitruvius when speaking of staircases in the Second Chapter of the Ninth Book), whereby the height of them is such as leads to a belief that convenience and ease of ascent was not the chief object in those works. Whether the same proportion was used in their private houses it is difficult to be ascertained.

There are two distinct species of staircases: those, the entire flights of which were formed by continued slopes, consisting of equal spaces of about six feet in length, and the rise of which never exceeded one-sixth, nor was ever made less than one-eighth part of the base line, and wherein, for greater safety, at every rise of a foot and a half, or of two feet, a piece of stone, somewhat raised above the level of the slope, was placed as a curb, the whole thus making a very safe, easy, and gradual ascent. The other kind of staircase, and which is in more general use in this country, is formed of perpendicular risers and steps.

In the staircases with steps, the width, rise, and number of steps in each flight must be separately considered.

The steps, as to width, must be made conformable to the extent, quality, and magnitude of the building. In large houses they should never be less than four feet wide, so that if two persons meet they may pass without incommoding each other.

The steps of staircases, considered on the principle of relative beauty, must be accommodated to the most usual heights of the human figure; therefore, the rise and tread of steps will be nearly the same in all buildings. The rise of the steps and the space from one to the other should be equal to the common step of a man on level ground; which,

taken at two feet, gives six inches for the rise, and twelve inches for the tread, or five inches for the height, and fourteen inches for the tread; or four inches for the rise, and sixteen inches for the tread, which is rather too much. Hence it follows that the steps in any principal staircase should never rise more than six inches nor less than four inches.

As to the number of steps in a flight, Vitruvius is silent. He only says that the steps to temples should always be of unequal numbers in order that you might enter with the right foot, which the ancients considered as a favourable omen. But whether the number of steps in a flight be equal or unequal, according to the practice of the best architects there should never be more than thirteen nor less than seven steps without a landing, or a resting place.

The steps of staircases, whether straight or circular, are usually placed level, although sometimes they are made a very little lower in the front, which makes them more easy and convenient of ascent. In the great staircase in the Pope's Palace at Monte Cavallo,[17] the reverse of this has been practised and it has succeeded admirably. In that staircase the steps are very long, they rise very little, and are somewhat lower behind than in front, so that in ascending, the point of the foot is lower than the heel.

This seems against all rule, but it is certain that this declivity from the front to the back of the steps assists the ascent so much that you do not feel you are ascending. It is curious to conjecture what could have led to this idea: was [it] the effect of a desire for novelty, or the result of deep reflection? At all events, success has attended the execution. It is the only example I have ever seen of the kind, and however satisfactory the effect may be to my own judgement, I am not sure that I should be bold enough to follow, in practice, the example of the architect of the Pope's Palace at Monte Cavallo.

Staircases are of various forms and admit of a great variety of figure; almost any shape, from the most simple to the most complicated, whether large or small, may be adapted to the uses of a staircase.

Palladio notices a very singular species of staircase, as existing in his time in the Portico of Pompey, wherein three winding staircases were supported upon columns, and so constructed that the light was equally diffused over every part thereof.

This ancient composition, it has been conjectured, suggested to Vignola the idea of his great staircase at Caprarola, a work that has been most justly praised, and as justly censured; it has many beauties, and likewise many defects. It is large and capacious, suited to the other parts of this noble production; it is light and easy of ascent. Like Bernini's staircase at St. Peter's, it is very ingenious, and very artistlike, and full of bold invention. At the same it is extremely difficult of execution, consequently highly expensive, and nothing can be more improper than the introduction of the orders of architecture in such situations.

[17] The staircase of 1583–85 by Ottaviano Mascherino at the Palazzo del Quirinale, Rome.

Palladio describes a beautiful staircase of four circular flights, passing one over the other and making, as it were, four staircases, and it being placed in the centre of the building ready access is thereby given to the different apartments, and the area of the staircase being open in the middle, whoever passes in either of the staircases is seen without difficulty. This most happy and successful combination cannot fail to produce the most pleasing effect.

In circular staircases the same great architect recommends the fronts of the steps to be curved, as being beautiful in appearance, and longer as to utility, than if they were made straight. The inconvenience and expense of such steps can never be balanced by any supposed or real beauty. This kind of curvilinear step is often used at the beginnings of staircases with great success, particularly by the French architects who have given more variety and shown more ingenuity in their staircases than English architects generally have done. French works, on this part of our art, are greatly deserving of attention.

Palladio, in his treatise on architecture, has given the plans of ten different designs for staircases, some on a rectangular, and others on a circular plan.

Scamozzi tells us the staircase is as essential in a building as the veins are in our bodies, or the eyes in our heads. In his 'Idea dell' Architettura Universale,' he gives ten different designs for staircases, and although some of them differ in form from those of Palladio, yet the general principles of these great architects on the subject are the same.

In staircases, six things are essentially requisite to be attended to, viz., situation, magnitude, form, lighting, decoration, and construction.

In the situation of the principal staircase, architects differ widely; some directing it to be placed as near as possible to the middle of the building, that it may easily lead to the different rooms, and be seen from the entrance; whilst others recommend it being placed in one of the extremities of the edifice, that the vista formed by the suite of rooms, may not be interrupted.

The ichnographic magnitude of the staircase depends on the largeness and quality of the fabric, and the manner in which the steps are disposed, whether in two, three, or more flights.

The circular form or figure of the staircase, where the area is large, is particularly beautiful, but notwithstanding its beauty, the waste of space and the difficulty and expense of execution have occasioned the preference to be given to the square and parallelogram, as being more easy in execution, more economical, and at the same time suitable to buildings of every class.

The lighting of staircases is of great importance: those placed in the middle of houses are best lighted from the top, provided due attention is paid to the ventilation. Conical skylights illuminate the whole staircase more powerfully and equally than any other mode, but the use of them is attended with many disadvantages, so that lantern-lights, although they do not admit so much light, are to be preferred in most cases.

The decoration of staircases has been already described in a former lecture, and their construction will be treated of here-after.

In country houses, the staircase is a secondary consideration, as it generally leads to inferior apartments, but in large towns, where the best rooms are chiefly on the first floor, a necessity arises of giving to the staircases, form, dimensions and beauty suitable to the rest of the structure, and so placed to be easily seen, and constructed in such a manner as to form an easy and general communication with the different parts of the house, without interrupting the different suites of apartments.

I shall now show some of the plans and the distribution of those staircases that appear to me the most conducive to the instruction of the student.

The staircase has justly been considered as the most embarrassing circumstance in the arrangement of the plan of a building. Our architects have felt the importance thereof, and in those grand and magnificent works wherein their talents have been unshackled by expense, have produced works of this kind, equal at least, to any of those in the great palaces on the continent.

In producing examples of the different modes of treating the staircase I shall begin with the most simple.

In London houses with two rooms on a floor, the staircase is sometimes placed between the two rooms, as Figure 1 in this drawing. In this way both convenience and appearance are sacrificed; occasionally a passage of communication is made at the back of the staircase, as Figure 2, and by this arrangement the inconvenience is in some degree removed; and if the staircase is placed as in Figure 3, in this drawing, perhaps as much convenience and effect is gained as such limited spaces will admit.

Inigo Jones, whose superior knowledge in architecture I have often had the pleasure of noticing in these lectures, was particularly happy in his staircases, both as to convenience and artistlike effect, even when confined to very small spaces. How superior is the decoration in these staircases to what we are accustomed to see in modern houses of a similar class. What comparative magnificence in the former, what poverty and meanness in the latter; whatever we have gained in lightness of effect, we have lost more in importance and character.

At Ambresbury in Wiltshire, a well-known work of Inigo Jones, [Amesbury, by John Webb] the great staircase contains a smaller one within its wellhole which has strong claims on our attention. It has been copied with success by the late Sir William Chambers in Lord Bessborough's villa at Roehampton. This double staircase is of singular invention and particularly useful in application; for, wherever it is practicable, it offers the best security in the event of fire, as it admits of both ends of the steps of stone staircases being confined in walls: if this be not done, a stone staircase is of little more real security than a staircase entirely of wood.

At Coleshill the staircase is singularly simple and admirably adapted to the general style of that house.

There is another example of the picturesque effect of his [Inigo Jones'] staircases, situated in one of the prebendal houses in Dean's Yard, Westminster,[18] and yet, strange to tell, this staircase, although so situated and so full of rich fancy, is scarcely known.

The staircase in Buckingham House, the residence of her late Majesty Queen Charlotte, with its magnificent hall, was worthy to form part of a royal residence. This magnificent hall and staircase has, however, recently been destroyed.

The staircase by Kent in Lord Clermont's House in Berkeley Square is a splendid specimen of what may be done even on a small scale, by a man of genius. In this celebrated work, the space being very confined, that great artist availed himself in some small degree of the twisted steps so much praised by Palladio.

The staircase in Wardour House by the late Mr. Paine is grand in outline, and convenient as to situation; it possesses most of the requisites of a good staircase.

The staircase at Worksop Manor House by the same artist differs materially from that at Wardour House in its form, but is equally convenient and magnificent.

The late Sir William Chambers was likewise very happy in the composition of his staircases, and here I cannot refrain from expressing my regret at the entire demolition of one of his great works of this kind, the beautiful staircase of Melbourne House which was once the boast of the pupils of Sir William Chambers, and an ornament to one of the best planned houses in this great metropolis. But the spirit of parsimony entered this once noble mansion, laid it waste, and stripped it of all its beauty.

Fortunately for the fame of Sir William Chambers, another of his great works in the same way exists in a house built by that architect for the late Earl Gower at Whitehall.

To these examples of magnificent and uncommon staircases I shall add one more, whimsical in its composition and uncommon in its effect, but worthy the attention of the artist from its singularity and the boldness of its construction. It is in the church of St. Etienne, near the Pantheon in Paris.[19]

[18] Ashburnham House, Westminster, now attributed to John Webb.

[19] Soane referred to the great rood screen with double staircase, attributed to Philibert de l'Orme, which he illustrated in a drawing made for him by Henry Parke when they were in Paris together in 1819.

LECTURE IX

❧

MR PRESIDENT, – I have endeavoured in these lectures to impress upon the mind of the student in architecture the necessity for close, unremitted, application, of deep, indefatigable, research, and that not a moment must be lost from study, even from earliest youth, by him who is desirous of attaining superior excellence in architecture. He must search deeply into the great elementary principles on which the artists of antiquity produced such mighty monuments of powerful imagination, elegant fancy, and refined taste. Those monuments of human talent that have never been equalled, and the ruins of which have been the admiration of the most enlightened minds in all ages and in all countries, these ruins should be the first object of our consideration and the basis of our taste. The values and importance of them can only be estimated by referring to elementary principles and primary causes. From an intimate acquaintance within these noble remains the uncertain wanderings of genius will be restrained, and the artist enabled to seize the spirit that produced them, and infuse the same feeling into his own compositions.

The students must not only be well acquainted with the buildings erected in different ages and in different countries, but they must endeavour, from the remains of ancient works, to learn what the Grecian and Roman architects would have done in their situation. By such a course of study we shall become artists, not mere copyists. We shall avoid servile imitation. Armed with fixed principles, which can only be derived from the sources pointed out to you, we shall not be led astray by fashion and caprice, or by a vain and foolish pursuit after novelty and paltry conceits so fatal to art in the lower ages; a period wherein buildings were erected of great magnitude and expense, and although objects of admiration at the time, they are not subjects for imitation. They reflect no honour on those who raised them, nor will they ever be referred to as standards of taste.

For want of those principles (so prominent in the works of the ancients) even men of genius and talent have only occasionally caught by chance, or rather stumbled on, what caused our admiration of the ancients.

Continuity of character, and harmony in proportion, are the great charms in the compositions of the ancients, whether they are surrounded with magnificent peristyles, as in the temples of Minerva and Theseus, or in those buildings wherein the two fronts have insulated columns, and the flanks decorated with three-quarter or semi-columns, as in the Temple of Fortuna Virilis. Or if the fronts have porticoes and pilasters at the angles, as in the Temple on the Ilissus; and lastly if isolated columns are in the fronts, and a series of pilasters at equal distances to connect them together, as was practised in the decline of taste in various places as, for example, in one of the temples at Palmyra.

In all these different compositions the same general elementary principles are preserved. In each of them this powerful, this unerring principle, is visible under different degrees of character; strongly marked in the first example, and gradually diminishing to the last. Even the last arrangement appears comparatively interesting in those buildings wherein doors and windows are not necessary between narrow intercolumniations. When that is the case the unavoidable repetition of small parts destroys the grandeur of the work, particularly if the columns and pilasters are of large dimensions; this is particularly obvious in the front of St. Peter's at Rome.

The student in architecture must likewise remember that continuity will not be sufficient in the exterior alone, there must be a similar feeling, and an attention to elementary principles throughout the interior likewise.

Nothing is of greater importance than the preserving this great principle of continuity in each part of a building. And it is worthy of our consideration how it happens that this principle of symmetry, with which all of us are pleased (those who know the cause of their satisfaction as well as those who are pleased without knowing why) is so frequently observed only in one part of a building, and not continued throughout.

In the exterior of the church of St Martin-in-the-Fields, there is an admirable keeping. The majestic Corinthian portico in the front with a noble flight of steps reminds us of an ancient temple of the best times. In the flank elevations the deeply recessed columns produce a contrast with the pilasters, and a breadth of light and shadow that satisfies the classical eye. We only regret the interruption occasioned by the discordant unmeaning, clumsy rustications of the doors and windows. In this building there is sufficient variety to keep the mind employed with such uniformity and simplicity as reminds us of the temples of the ancients.

Gibbs seems to have no fixed principles. If he occasionally rose to the grandeur of the antique, it is rather the effect of accident. For want of fixed principles, he sometimes mistook confusion for variety. Thus in the new church in the Strand he placed order upon order and crowded together so many small parts without sense that the mind is fatigued and embarrassed by their smallness, whilst the number of them prevents the eye from resting upon any of them. Thus we see that even variety of parts may be carried so far as to be disgusting instead of pleasing. This work, however, with all its defects, is

entitled to praise. It exhibits the same principles of composition in every part of the exterior.

The principles of interior distribution and arrangement of buildings having been explained in the last lecture, and exemplified by the best examples I could select, I shall now proceed to the consideration of the exterior of edifices.

The exterior of buildings of every description should be composed of larger and less decorated masses than those which form the interior. The fronts of houses in the country, where space is not limited, will be, of course, extended and composed on principles widely different from houses in towns where, from the value of space and the difficulty of obtaining it, the front of each is necessarily as much contracted as possible.

Houses of three or four stories above the level of the ground, with offices sunk entirely or at least half their necessary height below the pavement of the street,[1] may be admissible in great cities, but compositions of this description are unfit for country residences. Yet villas with such lofty elevations are not uncommon where motives of economy and convenience alone are consulted,[2] but never where character as to situation is duly attended to, and still less where magnificence is attempted.

The most extensive front of this kind, however rich in decoration, is rather calculated to give the idea of a large manufactory than of a royal residence, the hotel of a nobleman, or the dwelling of an opulent merchant.[3] It will be readily admitted that without prodigious expense it is not possible to have all the principal apartments on the same floor; but wherever magnificence is consulted, the idea of one storey only should be preserved.

In another respect, besides as to magnificence, there is a reason why a palace should present the appearance of only one storey in height. An ingenious French writer on the arts has observed that it is not suitable in a royal palace to have any apartments over those in which the sovereign resides.[4]

To preserve the appearance of one storey the chambers on the second floor should be lighted from inner courts, as at Holkham or as at Petersham Lodge, an elegant production of the celebrated Earl of Burlington. In that villa the chambers are so arranged as to receive their lights from the entrance court, whilst the exterior towards the lawn having only one tier of windows, an air of magnificence is thereby given to spaces not in themselves considerable, and when coupled with the simplicity of the well-proportioned front, the most pleasing effect is produced.

The garden front of Wilton House is another example of what may be effected even in the plainest building when treated by the man of genius and taste.

[1] Soane showed as an example Robert Adam's Wynn House, no. 20, St James's Square (1771–74).

[2] Soane showed as an example Cusworth Hall, Yorkshire, as remodelled in 1749–53 by James Paine.

[3] Soane showed as an example the Palace of Caserta, Naples (1751), by Luigi Vanvitelli.

[4] Laugier, *Essai*, p. 152.

The interior effect of doors and windows, having been noticed in the last lecture, the exterior appearance of these parts is now to be considered. It is of great importance to the general effect of every building, whether for public or private purposes, that the doors and windows should be, in form and dimension, such as the magnitude and destination of the edifice requires, so that they may correspond with the character of the rest of the exterior.

To determine the proper quantity and style of decoration, the exact limits and just points of decision, between what is too complicated and too simple, too high or too low, too narrow, or too wide, is no easy task. Natural taste and good sense, joined to great practice and close observation, can alone guide the architect in this difficult part of his profession.

The ancients paid the greatest attention to the proportions of their doors; indeed much of the character of a building depends on this feature in the front.

The principal door of entrance, as the poet says, should not be so low that it

'Instructs you how to adore the heav'ns, and bows you
To morning's holy office
Nor arch'd so high that Giants may get thro'
And keep their impious turbans on without
Good morrow to the sun,'[5]

The ancients on all occasions seem to have been sensible of the powerful effect of large entrances into their temples. The door into the Pantheon is nearly twenty feet wide and forty feet high, yet it appears no larger than is necessary to make it harmonize with the magnitude and general character of the entire work. The door into the temple at Tivoli is another fine illustration of the practice of the ancients. This door, which leads into a space not quite twenty-four feet in diameter, is nearly eight feet wide at bottom, and seven and a half at top, and eighteen feet high. Nevertheless, it does not appear too large or out of proportion; it assimilates with the magnificent peristyle of this celebrated little temple.

The door into the Temple of Hercules at Cora is of the same character as the preceding, and so, from what remains, we may conclude, was the door into the Temple of Vesta in Rome. To these examples may be added one of the doors in the Palace of Diocletian at Spalatro and, if time would permit, many others might be produced.

Vitruvius has been very particular in his observations as respects doors, and assigns different proportions and decorations to those which accompany the Greek orders.

Doors, he says, are to be made narrower at the top than at the bottom in proportion to their height: thus, if the height of the aperture is not more than sixteen feet, it must be equal to one-third part of the breadth of the architrave; if the height is from sixteen to twenty-five feet, the upper part of the aperture is to be contracted one-fourth; if from

[5] *Cymbeline*, III. iii. lines 3–7. Soane's imperfect transcription has been corrected.

twenty-five to thirty feet, one-eighth of the breadth of the architrave; and if higher the sides are to be made perpendicular. It is to be regretted that Vitruvius does not give us any reason for this seeming whimsicality in which he has been followed by others.

Jean Bullant likewise directs doors to be formed in this manner, and assigns different proportions for them when they accompany either of the orders of architecture.

Philibert de l'Orme gives the proportions of an antique doorway at St. Sabina on the Aventine Mount, which he describes as being broader at top than at bottom, a circumstance, considered by him worthy of praise, because the door being very lofty, the upper part would be lessened to the eye.

I shall now show examples of doors from St. Peter's at Rome, St. Paul's Cathedral, and St. Martin's Church in London. In these and in most other modern buildings, we may observe a total deviation from the practice of antiquity. The apertures are comparatively small with respect to the entire structure, and instead of the marked simplicity of the ancients they are surrounded with panels, recesses, and ornaments of various kinds, filling up the space in a manner that destroys whatever might have been expected from the large columns in the front of St. Peter's Church, and the magnificent porticoes of the other buildings.

The usual practice as to external doors in modern buildings corresponds with these examples. They are generally very small, calculated merely for use, without sufficient regard to harmony in quantity with the general masses and character of the building, as in the front of Lord Spencer's superb mansion, of Sir Watkin Williams Wynn's house, and these houses in Mansfield Street.

The forms of the panels, the mouldings and other enrichments of the doors, should always be well considered. I am not so well prepared as I could have been with examples of the practice of the ancients, or the moderns thereon, excepting one very curious specimen by Inigo Jones.[6]

The forms of the openings of doors, and windows are by no means arbitrary. Doors and windows with semi-circular heads are never to be used in the same form with columns. The spaces between the columns being always square are not properly filled, but the semi-circle leaves on each side of the arch an irregular, and unpleasing form.

Windows and doors with semi-circular heads can only be placed, with propriety, under vaulted ceilings. Harmony and analogy both require a straight line under a straight line, and a curved line under a curved line.

Doors and windows with circular heads, although inadmissible with the orders of architecture, yet they are very frequently used in simple fronts, sometimes in each storey of the building,[7] and sometimes they are confined to the ground floor only.

[6] Here Soane illustrated carved panels from no. 4, Chandos Street [now Place], Covent Garden, London.

[7] Soane showed as an example his own New Bank Buildings, Princes Street (1807), which featured a centrepiece with four storeys of round-headed windows.

Windows are sometimes decorated with an architrave round the entire aperture, at other times with an architrave, frieze, and cornice, to which are added circular or pointed pediments, and at other times alternately pointed and circular, but bad taste only can sanction these uses of the pediment.

Windows with architraves, friezes and cornices, resting on plain zocles or pedestals, were frequently used by Palladio and Inigo Jones, and have a most pleasing effect. In the works of Gibbs and his contemporaries, the dressings of the windows are finished with plain cills supported by clumsy consoles: a sort of false bearing, offensive to every just principle.

It may perhaps be thought superfluous to caution the student that the principal door of entrance, like the nose in the human face, must be in the centre of the building, and yet examples of the contrary practice sometimes occur, as in the front of Cusworth House and some others. And perhaps it may seem still less necessary to point out to him the impropriety of placing a column in the centre of a portico; such examples, however, are to be found in modern buildings. Some religious mystery or other circumstance of paganism might require this deviation from the usual practice of the ancients, but there can be no reason, either of convenience or beauty, to account for such preposterous fancies in modern buildings.

In the exterior of private buildings, particularly those wherein utility and simple regularity are the chief objects of consideration, if the parts are well proportioned, if the solids are not less in width than the voids, if the external or angular piers be somewhat larger than the others, if the solids and voids are thus duly balanced, if the fronts are well proportioned in their lengths and heights, such works cannot fail of being highly interesting to the judicious observer. But if the windows are too large and too numerous, if the piers between them are very small (as was the almost general practice in this country about a century and a half since), if the external, or angular, piers are narrower than the others[8] as is frequently to be seen, even in the works of Palladio, such compositions appear to be wanting in solidity. And as to internal comfort, they appear more calculated for occupation during a few hours of the finest summer days than for permanent and regular habitations.

These, contrasted with the immensely large piers and the diminutively small apertures in deep reveals, so prevalent in the old buildings of this country, will show the impropriety, and comparative defects of both of these systems.

Pilasters. The remains of antiquity offer various examples of pilasters on the walls of the exteriors of buildings, such as the Monument of Caius Bibulus in the Corso at Rome, likewise of half and three-quarter columns as in the Temple of Fortuna Virilis, La Maison Carrée at Nîmes, the Theatre of Marcellus, and the Colosseum. Examples of columns,

[8] Soane showed as an example Wren's Marlborough House, St James's (1709–11).

merely just detached from the walls, may be seen in the triumphal arches. Yet notwithstanding these, and other examples that might be adduced, it is evident from the best works of the Greeks and the Romans that they considered portions of original objects as imperfect forms; and therefore confined them almost always to their theatres and amphitheatres; a species of building that did not require, or admit of the majestic and impressive effect of temples sacred to the immortal gods. And although in the exterior of the Temple of Jupiter at Agrigentum, parts of columns are used, yet the student must not be misled, either by this great example of semi-columns, or by another of three-quarter columns in the remains of the Temple of Esculapius also at Agrigentum.

The young student must not consider such compositions as conceived in the true sublimity and austerity of architecture; nor, because all these different applications of the orders have been sanctioned by Palladio and the other great restorers of architecture in their works, must he conclude that he will be justified in adopting them in his own.

The exterior of buildings decorated with pilasters, half, or three-quarter columns, or even columns merely detached from the walls can only be looked on as architecture in basso relievo, as art in its dotage, a sort of bastard progeny, unconnected with the legitimate offspring of antiquity. And it may be observed that if the Greeks and Romans, in the decline, or rather decrepitude of art, made use of these mutilations, it was because all the patrons of architecture did not possess the mind of Pericles, nor were all architects endowed with cultivated understandings.

Modern architects, who use the remains of antiquity without reference to first principles are like those writers who, in their imitations of the old poets, are satisfied with selecting words that have become obsolete from time, and with adopting some few of the particular modes of expression used by the author whose style and manner of thinking they profess to imitate.

Authorities and examples, however sanctioned, whether by the practice of the ancients or the works of the great modern masters, if they deviate from the first and pure principles on which our art is established, must be rejected by all those who wish to work in the same quarries with the ancients, and who are anxious to seize their spirit and use the rich, the invaluable, materials they have left us. We must never judge of the works of the ancients without referring to their origin. Experience shows how vain it is to attempt, and still more so to expect to see the beauties of ancient temples transposed into modern houses, either by preserving their external appearance entirely, or by mangling them and transferring parts into our own compositions.

The late Earl of Bristol when in Rome gave every stimulus to the young artists of every description by his love for the fine arts and by his uniform endeavour to promote their welfare. Thus whilst the rising powers of [James] Durno and [Henry] Tresham were called forth in historical composition, the energies of [Philip] Hackert, [Thomas]

Jones, and Moore, were employed in realising on canvas the scenery of those places, once the delight of Horace, Cicero, Pliny and Lucullus. Nor was architecture overlooked, neglected or forgotten. The same cultivated mind, the same, enthusiastic love for the arts of design suggested to the students in architecture magnificent ideas of buildings of various kinds.

Minds accustomed in early life to feel the beauties of classical knowledge are naturally led to imagine whatever the ancients produced must be excellent. The noble Earl was fully impressed with this sentiment, and sought every occasion to inculcate the same correct principles into to the minds of the young artists around him.

With this feeling for ancient examples and from his desire to see the effect of ancient temples transferred to modern dwelling houses, the following dreams arose.[9] In the first drawing, the resemblance to the temple which was to be the model is faint indeed. It is mere patchwork. In the others, although more of the temple is preserved, yet still the great effects of light and shadow are not obtained. The designs, however, gave satisfaction at the time they were made, and it having been noticed that a magnificent hunting casine without an appropriate house for the dogs and their attendants, and stables for the horses, would be incomplete, the lively mind of that elegant classical scholar whose name I have presumed to mention, took a decided part on the occasion, and it was suggested that the exterior of those buildings should partake of the character of ancient structures with columns and basso relievos of every kind. In the house for the dogs, fountains were to be continually playing to refresh the air and to preserve cleanliness. In the interior, expense was not to be considered. The walls and ceilings were to be painted with arabesques, the rooms paved with marble, and the beds for the animals supported by sphinxes, griffons and lions. From such badinage originated the designs now before you. Such were the sportive efforts of youthful days which were soon to give way to disputes about party walls, the endeavouring to cure smoky chimneys, and all the other miseries to which the professors of architecture are liable in the active practice of their profession.

Of the exterior of buildings, the roof and some other parts are yet to be considered.

To secure by proper roofing a building effectually and permanently against the repeated attacks of weather and inclement seasons is an important part of the duty of the architect. In the construction of the roof, he shows his skill, experience and judgement in the most conspicuous manner. Even the foundations themselves, owe their stability and

[9] Soane compared a drawing of a Roman temple with designs he had made in Rome for the Bishop of Derry for a templar villa or 'cascine'. For a related design, see *Catalogues of Architectural Drawings in the Victoria and Albert Museum*, Pierre de la Ruffinière du Prey, *Sir John Soane*, London 1985, pl.5 and p. 33. As an indication of his obsession with the same themes throughout his career, Soane included a similar design, made for Thomas Pitt, later 1st Baron Camelford, and Henry Bankes, in his *Designs for Public and Private Buildings*, 2nd extra illustrated edn, London 1832, pl. XXXIV**.

duration to the soundness and protection of the roof. And although it may be less difficult to correct defects in the roofing than in the foundations, yet to prevent defects in the roof is particularly necessary because they generally begin in those parts of the building where they cannot be noticed until the mischief has extended far beyond its original source.

It is therefore most important to attend to every part of the roof, as to its form, and the means of conveying away the water from it, for wherever there is the smallest crack or defect, water, by its subtlety will soon penetrate, and by its humidity, if suffered to continue, will in a short time rot and destroy the very nerves of the most substantial edifice, even to the foundations themselves.

In determining the heights of roofs, climate and materials must be duly considered, and their figures on the plan must on all occasions be as simple as possible.

Roofs are covered either with straw, reeds, tiles of various kinds, slates, iron, lead, or copper.

Straw is generally considered the most humble of all coverings, yet at Norwich, in the very heart of the city is a church, the roof of which is of thatch. Straw requires the pitch of the roof to be very high, so as in many cases to overpower the building, and is indeed now seldom used as a covering excepting barns, sheds and out-houses, and to the ferme ornée of the present day.

Even for buildings for the purposes above named, reeds are more durable than straw, more pleasing to the eye, and far preferable, as they require the roof to be less elevated than what is necessary for straw.

Plain tiles, and tiles of every description, have many of the disadvantages of straw and reeds. They make a very durable covering, although they are ugly and vulgar in the extreme; moreover, when the additional strength, and consequently greater quantity of timber and labour is considered, tiles are not the least expensive covering.

Slated roofs require less height than those covered either with straw, reeds, or tiles, and are in every respect preferable to them. But where the first expense is not an important consideration, iron, lead, and above all tinned copper, is the most desirable, both as to elegance and beauty, and, what is even of greater consequence, for durability.

With these latter mentioned materials, as far as utility is concerned, roofs may be of any height.

In modern buildings we have not always exercised sufficient discrimination with respect to the forms of our roofs.

It seems as if this part of the structure has been considered as to its utility only, without looking at its capability of increasing the beauty of the edifice. Hence it follows that we have been too often satisfied with adopting the simple form of roof, so well suited to the character of the ancient rectangular temple, but which gives to other compositions, where inferior materials are used, a barn-like appearance. From the nature of the materials,

and the high pitched roof of St. Paul's, Covent Garden, the late Lord Orford would only allow Inigo Jones the credit of having built the finest barn in Europe.[10]

Simplicity of form, to a certain extent, is always pleasing and generally useful, and it is peculiarly necessary to the character and durability of every roof. But in buildings of great extent, composed of various masses and subdivisions of parts, variety is likewise required in the form of the roofing.

Simplicity may, however, be carried so far as to become monotonous, and disagreeable. Many of the long, continued, and unbroken lines of the roofs of different buildings, both in England and on the continent, have an unmeaning and tiresome appearance, as in the garden front of the palace at Versailles, whilst the inequalities and breaks in the heights in the roofs of the Tuileries, and the chimneys rising above them, give a richness and variety to the exterior of the entire composition. It is a mistaken idea to consider roofs as mere matters of convenience and utility. Roofs on the contrary assist materially in embellishing or in destroying the general effect of the entire building. The greater the opposition and contrast in their forms, in buildings of considerable extent, the greater and more pleasing will be the effect, not only of the roofing, but of the whole external appearance. And it may be added that if the fronts of two houses are equally decorated, and the one has a simple roof, like that of an ancient temple, it will give the idea of a very common dwelling, whilst the other, having its roofing diversified with different heights and different forms, will claim general attention.

In like manner, if the fronts of two houses are of equal dimensions and similarly decorated, one with a roof so disproportioned as seemingly to oppress and overload the front, whilst the other having its roof duly proportioned to the height of the building, it will increase in an equal or even a great degree the general effect of the whole elevation.

The forms or figures of roofs depend not on elegance of outline only, but likewise on climate, and the materials with which they are covered. And although Pausanius speaks of having seen temples in Attica covered with straw, the Greeks were generally very expensive in the roofs of their buildings. They were often covered with marble and gilded metals; indeed in later times, roofs became part on which they bestowed very great attention. Thus the roof of the Tower of the Winds and that of the Parthenon were of marble, most beautifully formed; and the domes of some Italian buildings are particularly beautiful.

The different forms of roofs are almost infinite; they are generally either domical, polygonal, terraced, or pointed. These figures admit of numerous modifications and combinations. Roofs are likewise formed with two inclined sides, with a gable or pediment at each end, as in the ancient temples. Roofs are also made inclining from each front. There are likewise curved, or mansard roofs, why so called I know not, this kind of roof having been used long before the Mansards were in existence. Roofs of this sort are often adopted

[10] Horace Walpole, *Anecdotes of Painters in England*, vol. ii, 1765, p. 175n.

from their affording more space for rooms within them than the simple and more elegant pointed roof. And the former, of modern invention, is considered by some as more agreeably varied in its appearance than the roof of the ancient rectangular temples. The low pointed roof is admirably suited to the climate of Greece, and particularly adapted to the rest of the architecture of their temples. Its fitness to the climate constitutes a large portion of its beauty, and consequently it cannot be transplanted into different and less mild climates.

Accordingly in the Roman temples, the pediment or roof assumes a character totally distinct from those in the Greek temples. And in northern climates the roofs of buildings are necessarily made higher; thus Inigo Jones made the roof of the church of St. Paul, Covent Garden, much higher than those in the works of Palladio. This was done not alone with regard to climate and character, but likewise in consequence of the materials employed, for it should be recollected that this church was originally covered with tiles. It is now covered with slates, and is thereby materially altered from its original character, a circumstance that cannot but be regretted by every admirer of Inigo Jones.

In Gothic structures, the height of the roof is determined by the internal decoration, for although covered with lead, they are notwithstanding made considerably higher than in other buildings, whether covered with slates or tiles.

Roofs of every description differ as much in their heights as in their ichnographic forms, and which, it may be repeated, must be regulated by character and climate and by the quality of the materials used in covering them.

The roofs of buildings of every kind should offer some sort of protection to those who walk near them. In Holy Writ it is said: 'When thou buildest a new House then thou shalt make a battlement for thy roof, that thou bring not blood upon thy House, if any man fall from thence.'[11]

This admonition can only be applicable to flat roofs and terraces so common in the buildings in the East, a part of the world where it has been always considered not only a species of luxury but of intellectual enjoyment to walk in the cool of the evening by the silvery light of the moon.

The inhabitants of Syria, both for health and pleasure, pass whole nights, in summer, on the tops of their houses, which are for that purpose made flat and divided from each other by walls. Travellers also find this way of sleeping extremely agreeable as they thereby enjoy the cool air, above the reach of gnats and vapours, without any other covering than the canopy of the heavens which, upon every interruption of rest, presents itself in many different and pleasing forms when silence and solitude dispose the mind to contemplation.

Flat roofs in every country must be looked on as beautiful; in warm climates they are useful also, but, as they must always indicate places calculated for walking upon, they

[11] *Deuteronomy*, 22, 8.

require safe-guards of some kind, lest in the language of scripture, 'Blood is brought upon the House if any man fall from thence.' These safe-guards may be either the plain parapet of modern times, or the high and solid parapet, as in many of the ancient bridges, or balustrades, which are equally useful, and being better suited to private buildings are more beautiful. But then they should be confined to flat roofs or terraces. If they are used with pointed or sloped roofs, as is frequently done,[12] the great principle of Grecian architecture, so strongly insisted on by Vitruvius, which interdicts the introduction of any ornament, or other thing into the exterior or interior of a building which the architect cannot satisfactorily account for, is violated. But when the balustrade is placed on an inclined plane, we may then be said to have reached the acme of absurdity.[13]

The balustrade,[a] however beautiful, was, I believe, unknown to the ancients, certainly never used by them as the termination of any building, although some have fancied that they have traced the outline of the baluster on the lateral walls in the arched openings of the exterior of the Colosseum in Rome. I have carefully sought again and again for the indication to justify this assumption, but in vain.

In examining the works of ancient times it behoves the young artist to investigate closely those parts which are of the original construction, and those which have been the effect of alterations, either of early times or of later periods.

Thus when in modern times the ancient Mausoleum of Cecilia Metella, now called 'Capo di Bove', was converted, like many other ancient buildings, into a place of defence, its comical covering was probably (for we have no remains to speak positively from) destroyed, and battlements with embrasures added. Would, however, an architect in our days be justified from this, or any such example, in introducing similar ornaments into a mausoleum, and then quoting the 'Capo di Bove' as a precedent?

Embrasures, if they do not owe their origin to, at least, are always used as parapets to the square towers of Norman structures, with terraced roofs, but never in buildings covered with pointed roofs. The reason is obvious: they were for the purpose of observing the approach of an enemy and of annoying him the more effectually, the assailed being protected behind the solid parts of the parapet.

If this was the origin of embrasures in Gothic towers and castellated buildings how are we to reconcile the use of them as ornaments in modern Gothic buildings, not only in those with terraced roofs, but likewise in those with pointed roofs?

What can be less consistent than to see the upper part of a building so constructed

[a] Note. Balustrades may be traced to a Gothic origin. They were first used in Roman architecture by Palladio, at first as little columns, which I should consider their origin.

[12] Soane showed as an example a building on which he had worked as a young man, Claremont House, Surrey (1771–74), designed by Capability Brown and Henry Holland.

[13] As an example, Soane showed a drawing of Carlo Maderno's S. Susanna, Rome, with its balustraded pediment.

as to give an idea of defence and security whilst the parts nearer the ground are composed of small piers and large windows? Where is the sense of propriety of adopting in the least accessible parts the means of defence, whilst the lower and more accessible parts of the buildings have large apertures in them and thereby offer an easy admittance to an intruding enemy?

In speaking of the balustrade an example was shown of its being placed on the inclined side of the pediment of an Italian church. In this [Gothic] design, for the church at Long Ditton,[14] embrasures [crenellations] are used in a similar situation.

Thus much for the roofs of buildings with which there is another feature of the exterior very closely connected, viz., the chimney shaft, which frequently proves a great stumbling block to the regularity which modern buildings of regular architecture require, and which must be attended to, to preserve that symmetry so necessary in works of Grecian architecture; although of less consequence in what are called Gothic buildings wherein irregularity is, I think, too generally admitted.

Inigo Jones at Coleshill and in other of his buildings, and Sir John Vanbrugh in most of his designs, have given importance to chimney shafts and made them contribute materially to the general effect of their works, so as to leave an impression on the mind of the young artist of the importance of these parts, of the possibility of making them really beauties instead of defects. This has been already noticed in a former lecture, and of course will not be pursued further at the present time.

There is another feature in the exterior of buildings, particularly in the palaces of Italy, and the hotels of France (pl. 15), I mean the mezzanine or entresol, a low story, squeezed in between two very lofty ones.[15] In large buildings, the great disparity in the magnitude of the rooms often makes the arrangement very desirable and useful, but on such occasions the mezzanine should be so contrived as not to interfere with the principal front of the building. This entresol is not confined to buildings on the continent, there are examples of the mezzanine in some of our buildings, particularly in Somerset House, and the Radcliffe Library at Oxford, where there are two storeys in the height of the column, and what is particularly strange the mezzanine is placed below, and the lofty storey over it. This arrangement is not confined to the Radcliffe Library; in other buildings we see the upper windows considerably higher than the lower ones.

Such dispositions may be useful, but certainly they are not beautiful. Convenience alone can reconcile us to such disproportionate divisions of the general height of any building, and the reason is obvious: solidity requires the walls of every building to be thinner in proportion as they are elevated. This diminution should be made regularly on

14 Long Ditton church, Surrey, by Sir Robert Taylor, 1778 (dem. 1880).
15 Here Soane illustrated Borromini's Palazzo di Propaganda Fide, Rome, and an elegant modern house in Paris with a concave façade.

every floor in proportion to its height. On this necessary principle the walls of the mezzanine would be of less substance than those of the walls above, but this cannot be in practice: it would be contrary to every sound principle of construction. This is one reason therefore why mezzanines, or entresols, can only be tolerated by necessity, never on the principle of beauty, or even of propriety.

In some of the most beautiful of the Italian palaces the windows are nearly of the same dimensions in both the principal stories; so they are in the Banqueting House at Whitehall; Fishmongers' Hall (now taken down), and in many other of Inigo Jones' best works.[16]

If the upper windows are considerably less in height than those beneath them there is the same objection to the variation in size as in the case of mezzanine windows, unless they form part of a regular attic as in this design from Palladio.

I have dwelt on these proportions and dispositions of windows because they are often introduced, not from necessity but from a false idea of taste that they add variety to an elevation, whereas, in point of fact, when they are not justified by internal convenience, they are extremely reprehensible.

In the exterior of many of our villas and other buildings the principal floor is raised considerably above the level of the ground. This occasions the necessity of large flights of steps on the outside to lead to the hall of entrance. However suitable and magnificent external steps may be in mild and southern climates, they ill accord with the ice, the snow, and rains of more northern regions. Various modes and suggestions have been adopted to make these large flights of steps suitable, safe, and convenient as well as magnificent.

At Holkham Hall, originally the magnificent residence of the Earl of Leicester, the only entrance from the principal front into one of the most magnificent vestibules that this country could boast of, is from a doorway of very inadequate dimensions in the basement storey. This is much to be lamented, for not all the grandeur of this truly classical composition removes the first impression of meanness, restraint, and insufficiency which the entrance creates in the mind. Indeed, it is impossible from the exterior appearance to suppose that you are at the principal entrance to the mansion.

The principal entrance into Wardour House is likewise from a low basement storey, as are also those into many other houses, designed and raised by different architects, buildings in other respects of the most magnificent kind wherein expense has not been a consideration.

In the principal front of the splendid mansion of Lord Scarsdale at Kedleston, the grand flight of steps being double, the space between admits of a doorway leading into a

[16] Soane compared the dimensions of the windows of the Banqueting House and of old Fishmongers Hall (by Edward Jerman, not Inigo Jones), with those of the Palazzo Farnese in Rome.

sub-hall, communicating with the principal hall of entrance: in this case the door in the low basement can only be considered as a convenient entrance to be used in bad weather.

The inconvenience of external steps has been generally felt in this country. At Houghton Hall, after great expense had been incurred, and various expedients resorted to without success, the large and magnificent flights of steps at the principal front were entirely removed, and the entrance made from the low basement only, as had been previously done in so many other magnificent mansions.

In the front of the Mansion House the inconvenience of the large flight of steps is so sensibly felt that on all great occasions a temporary awning is erected, which totally destroys for the time the effect of the portico.

These, and most other expedients have been generally entirely ineffectual, and if in some cases the object of convenience has been partially attained, propriety and magnificence have been more or less sacrificed. Of this, the entrance into the late Duke of Queensberry's house in Piccadilly is a striking example. Indeed this kind of descending into the cellar to reach the principal apartments is carrying our ideas of convenience (if convenience it can be called) to a great extent, particularly in wet weather when, if the ladies' head-dresses are spared, their draggled petticoats would suffer. And at best this expedient is assuredly extremely ugly; even one species of convenience may be bought too dear at the expense of another. General convenience in buildings for domestic purposes must, however, always take the lead, and certainly in most cases we shall be justified in sacrificing magnificence and even appearance to convenience, where both cannot be obtained. But that both may be obtained, and the grandeur of the entrance preserved, has lately been shown in the north entrance into Stowe House. For this noble conception the lovers of architecture are indebted to the late Marquess of Buckingham, whose taste and skill in designing can only be equalled by the other distinguished talents and superior intellectual attainment which that noble encourager of the fine arts so pre-eminently possessed.

Every one is impressed with the effect produced by a large flight of steps forming the approach to the principal entrance to a building. The best way perhaps to unite convenience with magnificence is to extend the pedestals on each side of the steps, and to form doorways therein on the level of the ground (as shown in this drawing)[17] leading into a sub-hall, communicating with the principal staircase.

I shall not at present add anything further on the orthography of buildings, but proceed to point out some of the different modes in which architects have connected together the main buildings and the offices of villas.

In buildings for domestic purposes considerable difficulty arises in the disposing of the offices, with respect to the main building, so as to preserve both beauty of appearance and convenience of arrangement.

[17] A design for a royal palace by Soane.

In several of the designs of Palladio, Scamozzi, Serlio, and others of the Italian school, villas frequently consist of one single mass of buildings without any visible attached offices to disturb the regularity of the four fronts, as in the Villa Capra by Palladio. In such designs the necessary offices for servants and culinary purposes are in the basement storey, while the apartments for the family and guests are arranged on the ground floor, somewhat raised, and in another storey over it. This is the most simple mode possible, and one wherein the architect has great scope to display more of the ancient architecture than in other modes of composition. Inigo Jones has followed the examples of these great masters in one of his most celebrated works, Coleshill. This house, to the honour of its different possessors, has undergone no material alteration from its original state as left by that great architect. Each of the four fronts is almost equally unencumbered, the greater part of the offices being disposed in the basement storey.

I cannot but recommend this house to the attention of the young artist: its simple plan, its elegant staircase, its magnificent drawing room, and the noble and well arranged simplicity of the exterior, cannot fail of being highly interesting, and can never be too much admired. Moreover, it is, I believe, the only work now remaining of that great man who first made us acquainted with the magical beauties of Grecian and Roman architecture.[18]

Hagley, the residence of the classical Lord Lyttelton, has in like manner its offices in the basement storey, the whole villa forming a regular mass of building, convenient and elegant in the extreme.

In other designs of villas by Palladio and his countrymen, the whole mass of the building forms a large quadrangle with a spacious area or court in the middle, from whence many of the rooms receive their light, and thereby afford the architect full scope to give the exterior in every part an uninterrupted grandeur.

The fronts and parts of the sides, are devoted to the use of the family, and the remainder for the different offices. This kind of arrangement is particularly calculated to produce a uniform grandeur of effect, as the fronts may appear to consist of one storey only, the chambers and the inferior rooms receiving their light from the inner courts.

There is likewise another distribution employed by Palladio which is extremely beautiful, wherein the main building is connected with four pavilions by circular corridors.

In this country the immediate domestic offices are variously situated. Some are arranged in the front of the main building, and connected therewith, as at Buckingham House and Montagu House, but I cannot think it advisable to contract a large front, as in these examples, but would rather leave the opening clear and spacious.

In other buildings the offices are connected with the house by a circular colonnade,

[18] One wonders whether Soane would have been quite so ecstatic in his praise of Coleshill had he known that it may not have been the work of Inigo Jones but of Roger Pratt.

as at Kedleston; in others the offices are connected by rectangular corridors, as at Holkham Hall where the main building contains the state apartments, one of the pavilions the chapel, another the apartments for the family, a third for the visitors, and the fourth comprehends the various domestic offices which, although removed from the main building, are notwithstanding most conveniently connected therewith.

Another arrangement, very common in this country at the beginning of the last century, was to place the mansion house between two corresponding wings containing the offices and connected together with rectangular or circular corridors. The effect of this distribution is by no means equal to the last: it appears as if three families of different fortunes had agreed to live near each other but not under the same roof.

At Danson, a seat of Sir John Boyd's near Welling in Kent, is a villa erected by the late Sir Robert Taylor. It consists of a main building, and two detached pavilions without any visible connection with the main building. Communications there certainly are, but of a strange kind, being entirely underground. This does not lessen, on the contrary it increases, the objection to detached wings for the offices. This kind of building must always appear unfinished, and be damp and inconvenient.

At Claremont, in Surrey, after pulling down the magnificent villa of its former possessor, the Duke of Newcastle, a large square building was erected by the late Lord Clive, wherein the kitchen, and many of the other offices are placed in the half-sunk basement storey, and the others placed beyond the general outline of the house: the latter being entirely underground, and thick planting over them, the irregularity was partly hid. And thus, in the language of the author of 'Essays on the Picturesque,'[19] 'the wretched square mansion house is left to exhibit its pert bald front, between dwarf shrubberies, which seem like whiskers added to the portico.' This mode of insulating the mansion was a favourite disposition of the late Mr. Brown, who certainly was much less successful in his architectural rambles than in his bolder essays in gardening.

The observation of the author of 'Essays on the Picturesque' is correct in the abstract but not as a general principle. On the contrary, if the building is stretched out as at Coleshill, or as at Sir Gerrard Vanneck's at Heveningham where a large part of the offices are in the main building, and yet not sunk under ground, some very material points are gained: quantity, simplicity, and largeness of parts. But situation must determine in particular cases.

I shall only notice one other method now much in use although fatal to composition. I mean that of placing the offices on one side of the mansion, these consisting either of a single range of buildings or forming an entire quadrangle, in both cases attached to the mansion and trusting to the irregularity being, in time, masked by plantations.

This mode may be, and is, I believe, a very convenient distribution and applicable to

[19] Sir Uvedale Price.

particular situations, but at the best it is but a paltry makeshift and one seldom resorted to by any great artist.

These are the most usual methods of distributing the different masses of which villas are composed. Many others might be enumerated but these show those most generally used. In the application of these or any other arrangements much must depend on situation. Some, at least, of these distributions have been adopted, more from the prevailing fashion of the day than from any just regard to locality or convenience. All have had their advocates, but as a general principle it will be admitted that the more important offices of a villa should never be sunk entirely underground, either from a desire to obtain great compactness, or from too strict a regard for economy. Many inconveniences are to be apprehended: smells from the kitchen and scullery, and noise from the servants hall. If the several offices are situated in detached wings, in the first place that arrangement will not accord with every situation. If they are too far off, the most serious inconveniences are felt, and, if too near, and considerably lower than the main building, the best apartments are liable to be annoyed with smoke from the offices. The worst arrangement of all is when the pavilions containing the offices are connected with the centre or corps-de-logis by a circular corridor.

A circular corridor to connect the main building and the offices may be pleasing in its appearance, but in all cases it must be inconvenient and expensive, and involve a great waste of space.

The plans in the Vitruvius Britannicus of Colin Campbell, and those in the continuation of that work by Wolfe and Gandon, together with those in the 'Architecture Française,' by Blondel, will afford the students much useful knowledge. And not to pass by the present opportunity of laying before them examples of the general taste of some of the architects who have distinguished themselves by works really executed, I shall for that purpose select Blenheim, Castle Howard, and Seaton Delaval, by Sir John Vanbrugh; Sir Gregory Page's house at Blackheath, by James of Greenwich (a mansion which I lament to say has been taken down); Holkham Hall, built by Mr. Brettingham, from the designs of Kent; and Wardour House in Wiltshire, designed by Mr. James Paine. To these might be added, if time would permit, many other splendid examples both of grandeur and convenience. I must not, however, pass by Kedleston which, although begun by Mr. Paine, may notwithstanding be considered as one of the great works of my late friend Mr. Robert Adam. In this superb structure he has united in no inconsiderable degree the taste and magnificence of a Roman villa with all the comforts and conveniences of an English nobleman's residence, and though some hyper-fastidious critics may endeavour to wrest from that great artist his well-earned fame, and smile at his efforts to reconcile the idea of blending an ancient triumphal arch with the exterior of a modern building, for myself I can only regret that more such happy attempts are not made to display the powers of pure architecture.

An intimate knowledge of the principles on which Palladio and the other great Italian

artists composed those masterpieces of art which Italy has to boast of, will essentially assist the young students, and give them correct ideas of simple grandeur and elegant composition. They must not, however, suppose that the plans of those great men can be transplanted into this country. Climate, custom and manner of living alike forbid it. The attempt has been made, and the celebrated Villa Capra by Palladio, has been unsuccessfully copied at Footscray and Mereworth Castle, as before noticed. On all occasions we must avoid servilely copying either the Greeks or the Romans, the Italians or the French; so much depends on locality, climate, materials, and mode of living.

Of the villas of the ancients we have many useful and important particulars, but of which we cannot avail ourselves on every occasion in the distribution of English villas, for independently of the amazing extent, and the consequent enormous expense of such mighty works, the difference in climate, customs, and manner of living would make them inconvenient in the extreme, and indeed scarcely habitable. For however extensive and magnificent many of the villas exhibited this evening may be, yet it is manifest that they fall very far short indeed of the magnitude of those of the ancients.

Of the villas of the ancients, Vitruvius speaks in a cursory manner only; indeed he does little more than notice the villa rustica. But Varro, Columella, and the other Roman writers on agriculture have entered fully into the subject. The Roman villa, according to Columella, seems to have consisted of three distinct parts, the urbana, rustica, and fructuaria.

The urbana, or first part, was appropriated to the use of the master; the rustica, or second part, contained the farm house and the sheds for the cattle; and the fructuaria, or third division, consisted of buildings for the reception of the produce of the farm.

The rustica and fructuaria were either joined to the master's house, or else placed very near it. At least such we are told was the general distribution of the villas of the early Romans. But in later times, when luxury had made its appearance and the Romans had become more refined and artificial, another species of villa was then introduced, wherein the farm house and its appurtenances were entirely removed apart from the villa of the master, although at the same time it was near enough to supply it conveniently with all necessaries.

Of this species of villa, Claremont, in Surrey, as designed by Sir John Vanbrugh with its Palladian farm, was a magnificent example.

In considering the villas of the Romans, the remains of the villa rustica at Pompeii are peculiarly interesting, and I trust these drawings have given you some tolerably correct idea of its present state.

The attention is next to be directed to the description given by Pliny of his villa at Laurentinum, of his other more considerable residence on the Lago di Como, and also his summer villa at Tusculum, each of which he has fully described: the first in his Epistle to Publius Cornelius Gallus, and the last in an Epistle to his friend Apollinaris.

Various different architects have exercised their talents in endeavouring to give an idea of Pliny's villa at Laurentinum as it was in his time.[20] Of Scamozzi's design I have given the plan and section. There is likewise a plan by Fossati; the designs by Castell, and to which I refer the students, are entitled to their attentive consideration.

This elevation is from a design made by Stevens, a pupil of the late Sir William Chambers and an artist of great promise, whilst pursuing his studies in Rome.

As an architectural study, this composition is entitled to great praise, but whatever its merits may be, it abounds with anachronisms, and has but little of the character of the architecture of the age in which the building was erected.

What Pliny's Villa Laurentinum was, it is now difficult to determine; he tells us that it was contrived agreeably to the strictest rules of art, and the several rooms were arranged for the full enjoyment of all the benefits of the different seasons. These observations, from so elegant and learned a writer as Pliny, makes it very important for the young student to be as well acquainted as possible with every part of this elegant retreat, for which purpose I must refer him to Pliny's own words.

Laurentinum seems to have been the villa urbana first spoken of by Columella answering to our villa in its general acceptation, such, for instance, as the elegant retreat of the late Lord Burlington at Chiswick.

Laurentinum seems to have been his country house of pleasure in the neighbourhood of Rome to which, after the fatigue of a public life, he could easily retire. This villa, in contradistinction to another of his villas on the Lago di Como, he calls his villula or little villa, to which he retired expressly to unbend his mind, for he observes that his library consisted of books more for amusement than study. If such be the designation of a Roman villa, wherein between forty and fifty rooms for different purposes have been enumerated and many parts left totally undescribed; if the word 'villula' is really to be understood 'a small villa,' what ideas are we to form of the magnitude, expense and magnificence of those villas which, we are told, contained rooms for every purpose of splendour and convenience: eating rooms for different seasons, and chambers to different aspects, such as those of Lucullus, Pliny, Pompey, Cicero, and others?

If the villas of individuals were so extensive, what must the villa of Hadrian at Tivoli have been? Hadrian, eminent in literature, science, and the fine arts, having visited the most distant provinces of the extensive empire of the Romans, and erected public monuments in all of them, he then adorned his villa with an infinity of buildings peculiarly characteristic of the taste and manners of the different nations. Temples, theatres, circuses, baths, porticoes, the Lycaeum of Aristotle, the Academia of Plato, the Prytaneum of Athens,

[20] For a general history of paper restorations of Pliny's villas, see *La Laurentine et l'invention de la villa romaine*, Institut Français d'Architecture, Paris 1982, and Pierre de la Ruffinière du Prey, *The Villas of Pliny from Antiquity to Posterity*, Chicago 1994.

the Canopus of Egypt, the Poecile of the Stoics, the Temple of Thessaly, the Elysian Fields, and the Infernal Regions, all these, surrounded with distinct and appropriate scenery, were to be seen in Hadrian's Villa. This villa in its perfect state must have presented an inexhaustible source of variety, a superb monument of imperial glory. Of the effect of this great combination we may form some faint idea from the buildings in Kew Gardens.[21] There, the confined space, it must be admitted, does not allow of the different buildings being seen to advantage. So many are visible from the same point that the eye is rather fatigued than satisfied. But at the same time that we regret that smallness of the objects, and their being so crowded together, it should be observed that many of them display so much elegance and classical purity that the young students in architecture will find these works of great use to them on their studies. For them and many other advantages the artist is indebted to the munificence of the late Dowager Princess of Wales, and to the taste of His Majesty, King George the Third the patron of the arts and sciences, the founder of the Royal Academy, and the father of his people.

[21] Chambers cited Hadrian's Villa as a source for Kew Gardens in his *Designs of Chinese Buildings*, London 1757, p. [ii].

LECTURE X

~

Mr. President, – Having in the preceding lectures treated of villas, I shall now direct the attention of the young student to the consideration of ornamental buildings suited to parks and pleasure grounds; and, as decorative gardening is part of the practice of the architect and is, in fact, so treated on the continent, it may not be improper to say a few words on that subject.

Gardening or, as it is sometimes called, decorative landscape gardening, if not an art, is an imitation of nature which has the power of giving highly finished touches: happy finishings to the picture the architect has begun.

Gardening is particularly associated with architectural decoration; not only does much of the effect of the mansion house itself depend upon the propriety and suitableness of the surrounding scenery, but likewise of the various buildings that custom now requires for the adornment of extensive parks and pleasure grounds. Buildings, whether for use or decoration only, when well adapted and appropriately disposed, in situations corresponding with the natural or artificial scenery, extent, and character of the place, cannot fail to heighten the general effect of the prospect, and give interest and variety to the whole domain.

The scenery of every different place requires its architecture to partake of its character and features. The landscape and buildings connected therewith, whether for use or ornament, must mutually assist each other: the taste and effect of ornamental buildings depend very much on the landscape about them.

Architecture being thus identified with gardening, it becomes a necessary part of the education of an architect that he should be well acquainted with the principles of modern decorative landscape gardening.

For this purpose it may not be useless to the young student briefly to trace gardening to its state antecedent to that period when

'Kent and Nature vied for Pelham's love.'[1]

Sir Francis Bacon, in one of his Essays observes that 'planting a Garden is a goodly prospect, tempting to the view; the purest of human pleasures, the greatest refreshment of the spirit of Man; without which Buildings and Palaces are but gross handy-works.'[2]

Such, according to the poet, was the first garden we read of, planted and formed by the Almighty Architect of the Universe, the Garden of Eden, where,

'Out of the pleasant ground he caus'd to grow,
All Trees of noblest kind for sight, smell, taste.'[3]

In the time of Henry the Seventh so little progress had been made, and so little attention had been given, to gardening that twelve acres, formed into various square plots for orchards, vegetables, and herbs, with grass or gravel walks bordered with low elms, neatly clipped, constituted the royal garden at Sheen.

In the sixteenth century the fashion was nearly the same: according to Lord Bacon, thirty acres was sufficient for a princely garden, the entrance consisting of a green plot, heath, or a natural wilderness of ten acres; the main garden, a square space of twelve acres, besides alleys of four acres each on both sides; the four sides of the garden encompassed with a stately arched hedge, ten feet high, with pyramids and fair columns upon frames of carpenters' work, and fountains spouting water from gilded or marble images.

Sir William Temple, writing about eighty years after Lord Bacon, tells us that the French and Dutch manner of gardening had made progress in this country, and probably, was not unlike this drawing of the garden at Herrenhausen near Hanover. When noticing the garden at Moor Park, he describes it as the most perfect he had ever seen, speaks of a square or oblong plot of ground of six or eight acres, on a descent with terraces, as sufficient for a garden, which, besides the parterres near the house, should, he adds, be cast into grass plots and gravel walks with fountains and statues.

This account of Sir William Temple's brings the history of gardening to about the latter end of the sixteenth century, and in this state it continued until the Revolution in 1688. From that period we must pass on to the time of Lords Bathurst and Cobham.

Those noblemen at Oakley [Cirencester Park] and Stowe first conceived and made considerable progress in that species of gardening which Sir William Temple more than glanced at when, after expressing his entire approbation of the system then in use, conform-

[1] Alexander Pope, *Epilogue to the Satires of Dr Donne Versified*, Dialogue II, line 67.

[2] Soane's paraphrase of *The Essays, or Councils, Civil and Moral, of Sir Francis Bacon*, London 1701, Essay XLVI, 'Of Gardens', p. 123.

[3] *Paradise Lost*, book IV, lines 216–17.

ably to the strict regularity of the continental garden, he adds 'there may be other forms, wholly irregular, that may have more beauties than any of the others, but they must owe it to some extraordinary disposition of nature in the site, or to some great race of fancy or judgement in the contrivance, which may reduce many disagreeing parts into some figure, which shall yet upon the whole be very agreeable.'[4]

This vision of what gardens might be, together with Milton's description of the Garden of Eden, already acted on by Lord Bathurst and Lord Cobham, was subsequently successfully pursued by Kent, and Bridgeman, and particularly by the late Mr. Brown whose natural powers, genius, taste, and judgement, under the auspices and guidance of Lord Cobham, were brought into full action at Stowe, and finally produced a total change in the manner of decorating parks and pleasure grounds which effectually destroyed every feature of the prevalent Dutch and French system of Le Nôtre and others.

The dress and high finish which this new order of things gave to every situation, aided by the love of variety, led to the introduction of ornamental buildings of different kinds. The Bower of Fair Rosamond, the hermitage, the grotto, and the cave, were entirely banished to make way for Grecian temples and Chinese pagodas.

Unfortunately for art, the taste of the buildings to be raised depended generally on the gardener who knew enough of architecture to think with Mr. Brown and some of his followers that 'the architect might spoil his work, but could never add to its improvement.' It sometimes happened that his buildings were not very analogous to our customs and climate, nor much resembled what they professed to be. Sometimes, when the ancient model was insulated and environed with columns, correctly rich in every part of its exterior, the copy only presented the front and a small part of each flank, and the rest of the exterior left with plain walls, hid in some degree by planting.

If miniature representations of Grecian or Roman temples are placed in our gardens without consulting the genius of the place, and without proper attention to those circumstances and scenery which made the architects of antiquity prefer one style of building to another; if correct representations of the temples at Segesta and Paestum were placed on a fine dressed lawn, surrounded by beautiful shrubberies, from the want of appropriate scenery, they would appear clumsy and misapplied.

Nor will objects, however beautiful in themselves, satisfy the classical mind unless they are likewise judiciously placed. If the beautiful Doric portico, the elegant Palladian bridge, or the elevated Chinese pagoda are improperly situated, they may surprise the stranger, but will soon lose their interest, cease to please, and only surfeit the eyes of those who are compelled to see them daily.

Besides entire buildings of different kinds, ruins are frequently introduced into orna-

[4] *The Works of Sir William Temple, Bart.*, 2 vols, London 1740, vol. I, 'Upon the Gardens of Epicurus', p. 185.

mental gardening, and when they are congenial with the scenery of the place and its historical character, they increase the variety and cause a pleasing diversity. When in Italy or Greece we see the mouldering remains of mausolea, temples, amphitheatres, and aqueducts, when the scene is enriched with 'nodding Arches, broken Temples spread,'[5] such objects fill the mind with the most serious and aweful reflections. The mausolea of Hadrian, of Cecilia Metella, and Plautus, point out most forcibly the departed grandeur of their former magnificence, and dazzling splendour. Works that might have defied the efforts of time are now with their battlements and embrasures become mere monuments of the insufficiency of our endeavours, and of the mutability of all human expectations.

The monument of the Horatii and Curatii (pl. 4) fills us with respect for the patriotic and heroic deeds to which it refers, whilst the remains of many towering structures, broken arches, and massive walls, bring back to our recollections interesting, important, and instructive incidents of history which call forth all the nobler feelings of the sympathetic mind; and when the mighty ruins of a column, whose enormous dimensions first excite our attention, and then point out the fatal spot where the unhappy Nicias threw himself at the feet of the conqueror, beseeching Gyllippus to stop the further slaughter of the brave Athenians, his comrades in defeat, (thousands of whom were then bleeding before his eyes), when such sensations are raised, if the ruins of buildings bring the recollection of such deeds fresh to the mind, as if then acting, we are only anxious for time to spare such monuments, that the same effect may be produced to the latest ages. Here there is no delusion, no imaginary colouring: the effect on the mind is complete. And if artificial ruins of rocks and buildings are so cunningly contrived, so well conceived, as to excite such reflections and convey such useful, though melancholy, lessons, too much cannot be said in favour of their introduction on every occasion. Like the buildings of the Egyptians, covered with their hieroglyphics, they may be considered as histories open to all the world.

Ruins, to please the beholder, must present to the mind the recollection of some particular event or some known fact of importance. They must appear to be the remains of what once really existed in the very place, or at least be analogous to it. They must tell their own story or they will appear trivial and uninteresting. If the remains of a castle are seen in a valley or plain, we cannot by any stretch of the imagination suppose it to have been placed there for any other purpose than mere decoration.

If the representations of Roman buildings are seen in places that were not known to the Romans, no emotion of satisfaction can be produced by such inefficient agents. But if, instead of Roman buildings, remains of Gothic towers rise majestically among forest trees, 'whose high tops are bald with dry antiquity,'[6] these are pleasing features. And if we see the superb remains of an old baronial castle, an abbey, a cloister, or the tower of a church

[5] Alexander Pope, *Moral Essays*, Epistle V, line 3.

[6] *As You Like It*, IV. ii. 106 (*variatim*).

(as at Coventry), of such forms and so situated as to present to the mind the idea that they are really part of something of great extent, which time and circumstance had spared, we are led to enquire into their history, and we then feel all the proper emotions of respect and reverence. We experience all those fine effects, that noble enthusiasm, which the sight of Roman buildings in ruins, in the pictures of Claude and Salvator Rosa, present to the mind, and we are brought back to the recollection of the struggles for power and revolutions in religious thinking which caused the destruction of so many noble efforts of superior greatness, which so many of the pages of our history have recorded.

But in order that these artificial ruins, these mimic representations, these portraits of objects, should produce pleasing sensations there must be an appearance of truth. A picture of any kind to please must be correct as to what it proposes to represent. In like manner ruins should not be so strikingly out of character, as respect form and situation (I mean the representation and the original must have the same scenery), as to show at once that it is but a representation and not a reality. In a word, ruins must recall to the mind the idea of real objects and not be considered as mere pictures.

Nor is it sufficient that objects are picturesque in their forms and combinations, and enriched with a variety of tints, softened and harmonized into each other by the hand of time. Ruins, evidently constructed for decoration only, in situation and character such as not to pretend to represent anything more than a heap of materials, broken into a great variety of agreeable forms, can produce no satisfactory sensations. It is from the association of ideas they excite in the mind that we feel interested.

When we see in our parks and pleasure grounds the representations of buildings in ruins, with all the evidence of a laboured, artificial construction, and perceive at once that they are for embellishment only, the mind revolts at once at the impropriety and we are unable to restrain a smile at the futility of the imitation.

Ruins representing the remains of Grecian or Roman buildings, however beautiful and picturesque, can never be introduced into the decorative gardening of this country: nor perhaps can any other style of composition so effectively as the Gothic, of which we have so many striking examples in the mouldering ruins of castles, the religious houses, magnificent priories, and extensive cathedrals, still existing in so many parts of England.

The importance to the state of preserving the venerable monuments of the piety of our ancestors, and of the patriotic application of their wealth, has not at all times been duly appreciated.

Warburton, Mason, Essex, Bentham, and other eminent men of the last century, perceived the great science and beauty of those works, and endeavoured to instil into the public mind the same enlightened sentiment and correct feeling. Their observations, however, were at first but little attended to, although ultimately they excited enquiry and created a desire to preserve those noble vestiges from further dilapidation and to protect them from suffering by innovation and modern improvement.

The public mind having been impressed with the value of these works of art, Milner,

Carter, Britton, Buckler, Mackenzie, and Repton, with other admirers of our ancient buildings, by their researches and publications, have since established the distinctive character of each age. These gentlemen toiled successfully in the vineyard, and let us hope that as their labours have been sanctioned by public approbation and patronage, that lectures, confined entirely to the illustration of the principles and effects of the architecture of the middle ages, will be publicly given, and premiums offered for models and drawings sufficiently large to show the great ingenuity and the uncommon boldness contained in the well combined constructive system of the architecture of that period; and likewise to convey correct ideas of the combination and general effects of a species of composition whereof this country exhibits so many splendid examples. What a field would then be opened for displaying all the magical effects of those works, whilst the development of the admirably combined constructive system they contain would be of the greatest advantage to the young student in the practice of his profession.

In the course of these lectures the great superiority of the ancients over the moderns has been frequently noticed. On the subject of gardening, however, it must be admitted that the modern style is decidedly superior. It leaves the gardens of the ancients, from all we know of them, completely in the background.

There can be no comparison between the stiff formal art, unnaturally applied, of the one, and the finest effects of nature, happily assisted by art, in the other. The far-famed garden of Alcinous, enclosed within a quick-set hedge, was no more than a small orchard and vineyard, and a few beds of herbs, and two fountains that watered them.

Pliny's garden at Laurentinum, of which he boasts so much, is described as bounded by a hedge of box, and his walks of planes with canals and box trees, cut into monsters, animals, letters, and the names of the master and gardener. In his Tuscan villa he talks of slopes, terraces, a wilderness, shrubs methodically trimmed, a marble basin, pipes spouting water, a cascade falling into the basin, bay trees alternately planted with planes, and a straight walk, from whence issued others, parted off by hedges of box, and apple trees with obelisks placed between every two.

Such was Pliny's description of his garden, such in a great measure are the gardens of Italy to this day, and if we examine the old writers, wherever a garden is spoken of, it seems to have been nearly of the same kind, the orchard and potagerie for use and pleasure.

From Shakespeare we learn it was the same in Denmark,

'Tis given out that sleeping in my Orchard
A Serpent stung me.'[7]

How great a contrast between the ancient gardens as described to us, and Milton's Garden of Eden, or Brown's great works at Blenheim Park, Claremont and many other places

[7] *Hamlet*, I. v. 35–36.

where the genius of the situation has been consulted, where hill and valley falling imperceptibly into each other, where the gentle swell, the concave and varied shape, the rudest waste, and the richest landscape are all combined; where the artist successfully,

'helps the ambitious hill, the Heav'ns to scale,
Or scoops in circling Theatres the vale;
Calls in the Country, catches opening glades,
Joins willing woods, and varies shades from shades,'[8]

the whole combining so beautifully with the varied scenes of nature that we cannot hesitate to give the palm of pre-eminence to modern gardening.

I must now leave that part of my subject which relates to villas and their appurtenances, and proceed to the consideration of town houses and public buildings. Here the young architect will expect a wide field to roam in, with full scope for the exercise of his imagination and for the display of his taste. But London is now so overgrown and crowded, and the best situations occupied by slight buildings, raised on speculation, for a term of years, that it is become scarcely possible, at any price to obtain, in perpetuity, a spot of ground so situated as to justify the architect in recommending the purchase of it to an employer of rank and fortune, sufficient to erect on it a magnificent mansion for himself and his family.

By the prevalent and now almost general system of leasing out large portions of ground for the purpose of raising buildings on speculation, as long as it was confined to houses on a small scale, the individual was sometimes benefited and no great injury was done to architecture. But now that this system is extended to the erection of noblemen's hotels and mercantile residences of the first consideration, nay, meeting houses and chapels, the system itself becomes abominable and fatal to the advancement of architectural taste, and, what is more important to sound construction, whereby not a year passes without lives being lost from this wretched practice.

From short-sighted views of immediate gain many of our streets are miserably narrow and confined with cramped and crippled houses, whilst the monotony of the exterior and the too general system of bad construction is thus made familiar to the student, and the public mind is vitiated, and ultimately reconciled to such miserable productions.

It has been contended by the admirers of this system of letting large tracts of land on building leases that, whilst the old parts of London as well as most old towns, seem to have been produced more by accident, whim, or caprice than from any regard to individual convenience or grandeur of appearance; by this new system many of our streets and squares are formed with all possible attention to strict regularity: true, but then it must be remem-

[8] Alexander Pope, *Moral Essays*, Epistle IV, *To the Earl of Burlington of the Use of Riches*, lines 58–61.

bered that by this very regularity we have exchanged the grand effects of architecture for disgusting insipidity and tiresome monotony. The Old Town of Edinburgh by the variety and breaks in the outlines of its buildings is more beautiful, and possibly not less convenient, than the New Town, with all its regularity and polish. But why should we not unite the variety of figure, the wild effects, the bold combinations of cultivated art, with all the regularity displayed in the ancient architecture?

The late Mr. Gwynn, in his ideas for the improvement of London, has, with great ingenuity and labour, shown how many parts of this great metropolis might be improved.[9] Unfortunately, his work has been too much overlooked, his noble ideas have been treated as Utopian, and his useful hints entirely unnoticed with the exception of one general suggestion, namely, the increasing the widths of the streets at their entrances by cutting off the angles. This, at first view, may appear a trifling circumstance, yet it often increases very considerably the beauty of the perspective. It breaks in a great degree the monotony, and in point of utility, its advantages in many cases are not to be calculated, particularly when instead of Gwynn's oblique lines, portions of the circle are used, as may be seen in many parts of the City of London, and from thence copied in some of the streets westward of Temple Bar.

The artists of antiquity had many advantages over those of modern times. The general taste of the ancients for great works, and the attention they paid to talent of every description combined to give a decided superiority and importance to the fine arts; thence;

' Egypt saw,
Her second Ptolemy give science law,
Each genius waken'd from his dead repose,
The column swell'd, the pile majestic rose,
Exact proportion, borrow'd strength from ease,
And use was taught by elegance to please;
Along the breathing walls, as fancy flow'd
The sculpture softened, and the picture glow'd.[10]

Thence arose the Colossus at Rhodes and the gigantic exertions of Dinocrates who conceived the stupendous idea of transforming a mighty mountain into an immense city. This great architect, we are told, having completed his design, and being worn out with the disappointments he had received from the couriers of Alexander, boldly rushed into the royal presence with his plan for cutting Mount Athos into a city. And instead of giving offence to the mighty monarch by his presumptuous intrusion, although he was

[9] John Gwynn, *London and Westminster Improved*, London 1766.
[10] *Annual Register*, vol. 5, 1762, p. 217, 'from Mr W. Whitehead's *Charge to the Poets*'.

unknown, he was well-received; and being asked his name and business replied, I am Dinocrates, the architect, who comes with plans worthy of Alexander. And notwithstanding this idea, so calculated to flatter the great mind of Alexander, was found to be impracticable, yet it determined the fortune of Dinocrates and led him to the building of Alexandria.

In later times, Constantine, by transferring the imperial residence from Rome to Byzantium gave the artists of that period the most effectual means of realising every idea that architecture could boast. With what enthusiastic delight do we run over the account of the numerous palaces, bridges, temples, colonnades, triumphal arches, and other public and private works of every description with which he adorned his new city? And if the barbarism of succeeding ages has destroyed those proud monuments of human wisdom and grandeur; if their costly materials have been converted to the most ignoble uses, yet from the writings of Procopius, and the historians of that period, and from the mighty ruins still remaining of Palmyra and Baalbec, we may still form some idea of Byzantium in its original splendour.

Instead of seeing such magnificent examples of rich fancy and bold imagination; instead of those flights of powerful mind and magical genius realised in this country, the artists of our days must, I fear, be more moderate in their expectations.

In the great metropolis of this mighty empire to whom Europe owes its choicest blessings, we in most cases can only contemplate a prodigious extent of buildings of various descriptions formed without any general plan of beauty and convenience, and with an almost total disregard to national grandeur.

These are not the most pleasing pictures and may perhaps occasion to the young artist and to the lover of architecture melancholy reflections, particularly when it is recollected that London is the place where the impression as to the state of art is first made, from whence art itself is expected to emanate. It is the place wherein the wealthy and enlightened of every class are congregated. It must therefore be considered as the great theatre best suited for displaying the abilities and calling into action the talents of the learned of every description. But in all ages, business and pleasure in great cities and populous towns have been too often more attended to than the beauties of architecture. And at the same time that the truth of the observation of the philosopher and moralist that 'Every good has its attendant evil' is fully established, the professors of the fine arts are left with little cause for exultation.

In this country, building has become so expensive, and the architect necessarily so confined, that most houses are of moderate dimensions wherein convenience and economy are alone to be consulted. Magnificence, taste, and beauty must be restricted to great national buildings, noblemen's hotels, and the mansions of a few rich individuals. And even in such buildings magnificence and uniformity are too often confined to the interior only.

In many of our private and even in some of our public buildings, on which immense

sums have been expended, it has been on the interior. It has seldom happened that the exteriors of them have in manner indicated the great expense that has been incurred in their construction, either as respects the architecture, or the extent of the building. And even when it is otherwise, they are frequently placed in narrow streets so as not to be seen. Who would expect to find a magnificent building in Warwick Lane,[11] or one of the finest pieces of architecture this country possesses behind such an enclosure as is here represented, or a magnificent hotel shut out by such a gloomy foreground as this drawing exhibits.[12]

Some of the most expensive and highly decorated houses in London are confined to three windows in front: such is the noble mansion of Sir Watkin Williams Wynn in St. James's Square, and Lord Clermont's in Berkeley Square. Who from the sight of this plain, confined front would suppose it preceded the magnificent staircase and highly enriched ceilings by the pencil of Kent and other masters?

Many other similar examples might be produced, and even in houses whose fronts are more extended, as the Earl of Derby's house in Grosvenor Square, Devonshire House in Piccadilly, the late Duke of York's house in Pall Mall (now the Ordnance Office), the Duke of Leeds in St. James's Square, Camelford House in Oxford Street, the Marquess of Buckingham's in Pall Mall, Chandos House near Cavendish Square; and in many others there is the same disregard to external appearance.

Some of these otherwise superb mansions have brick or plastered fronts destitute of architectural ornaments and suitable character. Another is distinguished by a fair stone facing, and the centre marked with a small porch of two or perhaps four columns reaching only to the height of the ground floor. None of these façades lead us to expect any internal grandeur; they only present a melancholy picture of the want of regard to architectural effect in the exterior of buildings, the internal distribution and decoration of which are frequently of the most expensive and elegant kind, and such as, in those respects, entitled them to the highest consideration and most serious attention of the student in architecture.

This deficiency of invention, this want of mass, quantity, and contrast of light and shadow in the exteriors of these buildings, and the general poverty in the materials and their arrangement, may be traced in some of them to want of due consideration in making the fronts of buildings accord in their general character with the internal finishings. That variety at least can be produced in limited fronts, the exterior of the British Coffee House at Charing Cross (pl. 25), noticed in a former lecture, is a striking example.

The frequent neglect of composition in the external appearance of our buildings appears to arise from an improper view of the subject, for it cannot be supposed that those

[11] In Soane's day, the Royal College of Physicians, Warwick Lane (1672–78), by Robert Hooke, was believed to be by Christopher Wren.

[12] Here Soane showed the forbiddingly plain screen walls of Burlington House, Piccadilly; old Montagu House, Bloomsbury; and Harcourt (ex-Bingley) House, Cavendish Square.

who bestow immense sums on internal decorations and suitable furniture would be so totally indifferent to external appearance.

I am aware that it has been urged that by keeping the exterior very plain and very subordinate, more contrast is produced and an additional value given thereby to the interior. Be it so, but it cannot be imagined that architects, unless controlled by their employers, would be so indifferent to the keeping up of that proper correspondence in every part of their compositions which alone can create by imperceptible degrees in the mind of the observer a greater interest as he proceeds through the building, and ultimately show him that no part is unsuitable, but all combined and making one uniform design.

Will such an exterior as this drawing represents lead any person to imagine it to be one of the principal fronts of a nobleman's residence?[13] Does it not rather indicate the exterior of an hospital or an extensive manufactory? Will any person expect from such an exterior of plain masses of brickwork, washed over to find under its roof any features of magnificence, anything like such noble spaces and such highly finished rooms as are shown in these drawings? Yet these drawings are faithful representations of a villa near London on which forty thousand pounds at least have been expended, and where princely splendour and true old English hospitality were alike conspicuous during the life time of the late Marquess of Abercorn.

It is not only the contracted front, the vulgar plainness, and indication of poverty of invention, in the exterior of so many buildings that gives the appearance of meanness and inconsistency in our architecture with which foreigners reproach us. There are many other causes, particularly the general prevalent practice of placing several storeys one over the other, which is fatal to every idea of grandeur.

This must be the case occasionally, and particularly in large cities and populous towns, but it is a defect that necessity alone can sanction, for such buildings can only appear like so many boxes or chests of drawers placed one upon the other, like the steeple of St. Bride's church. There is as much monotony in this steeple as in some of our streets of new houses.

To reconcile the eye to this sort of composition and to make its defects as little felt as possible, architects have had recourse to various expedients. In some cases each floor is distinguished by a fascia continued along the whole extent of the front, as at Coleshill by Inigo Jones,[14] and at St. Luke's Hospital (pl. 27). In this and in many other respects these two examples are models to which the artist will do well to give the fullest attention.

In other buildings the decorations of the windows are connected together, without

[13] Soane enjoyed the irony of showing his own mean exteriors at Bentley Priory, Middlesex, which he remodelled in 1788–1801.

[14] Or Roger Pratt.

any separation between the different floors, as was the case in Fishmongers Hall by Inigo Jones.[15]

Palladio in many of his designs has used in the same front, two, three, or even four orders of columns with a regular entablature over each of them, that each storey may be strongly marked and sufficiently distinguished. This may be, and is, an effectual mode of separating the different storeys, but it must be remembered that as the cornice was originally intended to support and protect the necessary projection of the roof, and to discharge the water, it follows therefore that to place several cornices in the front of any building between two, or more storeys is to present the idea of a roof where no roof could possibly exist. It is not only defective in principle, but it produces that littleness and repetition of small parts that cannot be reconciled with any of the fundamental principles deduced from the ancient architecture.

There is likewise another reason against this mode, in that as it becomes necessary to make each series of the columns more slender than that immediately below, the uppermost entablature becomes so small as to render the component parts scarcely visible from the ground. To obviate this defect, in many instances the upper cornice has been made an imitation of that of the Colosseum and of the Theatre of Marcellus, of a height proportioned, not to the order itself, but to its distance from the eye of the spectator.

Palladio is not the only one of those great artists who assisted in restoring architecture to its ancient splendour, who fell into the practice of using several orders in the same front. Michele san Michele in his works has occasionally given examples of this littleness of manner; but at the same time he seems at least to have felt the impropriety it occasions by making the cornice to the uppermost order the smallest. Accordingly, at the Palazzo Grimani and in other places, he has obviated this defect by proportioning the height of the entablature of the upper order, not to the height of the column itself, but to the entire height of the building. In this particular he has most judiciously followed the examples of our almost unerring guides, the ancients.

Inigo Jones, after the example of Palladio, has on many occasions distinguished the different floors by the orders of architecture. At the Banqueting House at Whitehall he has introduced two orders of columns, and in other parts of the different fronts of his design for a royal palace, of which that building, raised as a specimen, made but a small part, he has increased the number of the orders used. The defects of such compositions were noticed in a former discourse. In these designs by Inigo Jones, the floors being very lofty, some of the objections to the use of several orders in the same front are removed, but in other works of that great artist he has introduced three or more orders, as at Castle Ashby, already noticed.

The front of the Tuileries, and the exterior of the inner courts of the old Louvre are

[15] Edward Jerman.

composed in this style, and although the respective parts of these buildings, as well as the buildings themselves, are considerably larger than those at Castle Ashby, the relative magnitudes retain the same character. The defects therefore are rather increased than lessened, and when the grand fronts by Perrault are contrasted with these filigree works, how much is the greater superiority of this noble composition is apparent.

Inigo Jones having set the example of this feeble kind of composition to the artists of this country, it has been too often followed, both by his contemporaries and by succeeding architects. Some indeed have surpassed him. In the front of the Public Schools at Oxford (pl. 19), as well as in some other places, the five orders of architecture are jumbled together one above the other, and since the erection of that building, we have had an example of three orders of columns in the same front with little better success than those in the Schools at Oxford.

The Circus at Bath,

‘A circus that three ranks of Columns boasts,
Three ranks of Columns, like three ranks of Posts.’

may please us by its prettiness and a sort of novelty, as a rattle pleases a child, but the area is so small, and the height of each of the orders is so diminutive, that the general appearance of the entire building is mean, gloomy, and confined, and very inferior in effect to the crescent in the same city. What is justly admired on the large scale of the Colosseum, becomes uninteresting, nay even ridiculous, when reduced to the dimensions and extent necessary for a few modern dwelling houses.

If we compare these miniature buildings, having several orders of diminutive columns one above the other, with the great works of antiquity we shall immediately feel the disadvantage, at least if we are not convinced of the absurdity of using more than one order in the same front, excepting in buildings whose magnitudes keep pace with the amphitheatres and theatres of the ancients.

From the examples produced of buildings with several orders, it must appear clear that unless a building has something like the height of the Colosseum or the Theatre of Marcellus, not more than one order of columns can be used without the artist being censured for creating expense to little purpose; and it may be added that columns in the fronts of small houses can seldom produce much effect.

From the examples exhibited this evening and in former lectures it will be seen how unsuccessful our attempts have been to transfer into private dwellings features which the ancients used in great public works only. Wherever columns are expected to produce all their effect, there should be no indication of storey above storey, but they should occupy the entire height of the edifice as in ancient temples and in some modern works. Nor should columns of different dimensions be seen in the same front, whether placed on the

same line, or on different levels: like comparing giants and pigmies, both must suffer by the comparison.

If we look to the origin of columns, and the different manners in which the ancient architects used the orders of architecture, it will be seen that they should always be placed near the ground and not on high basements, and further that they should really, or at least appear, to comprehend only one storey in height. If, however, the height of the column admits or requires two, or more series of windows, their decoration should be supported from the bottom and be connected together by tablets and mouldings. In such cases the different floors cannot be distinguished without sacrificing the beauty and propriety of the column, by fascias passing from one column to the other and stopping against their shafts; these projections at the same time destroying the beautiful and flowing entasis of the column, so much insisted on by Vitruvius.

Imposts, dying against the shafts of the columns, to arched windows and openings, as in the Theatre of Marcellus and in the cortile of the Farnese Palace, are particularly open to this objection which Palladio does not appear at all times to have felt, for in some of his works, where the columns are made to take in two storeys (making peristyles below and open galleries above, for the purpose of communication), he has used a singular invention to support the floors of the galleries, a species of pilaster attached to the column, as shown in these drawings.[16]

Something of this kind seems, according to the translators and commentators on Vitruvius, to have been used by that great architect in his Basilica at Fano. If the fascias and imposts with their small projections are supposed (and most justly they are so) to injure, or rather to destroy, the simple beauty of the entasis and flowing outline of the column, how much more licentious must this kind of wen or excrescence be? It destroys entirely the beauty of the shaft of the column, and points out most powerfully indeed the impropriety of using columns in such situations.

Palladio has sometimes avoided this defect by using two orders of columns, as in the Chiericati Palace at Vicenza and in others of his works.

In various buildings wherein the columns include the height of several storeys, the impropriety has been so far felt that many architects have avoided the use of large columns in private dwellings and have had recourse to high basements on which they have raised columns of considerable magnitude. Of this species of composition, so very frequent in the works of the great Italian architects, an example may be seen in the Thiene Palace by Palladio.

Palladio who on most occasions introduced into his designs for private houses, as well as into his churches and other public works, whatever he had collected from the ancient temples of paganism, has, however, in the use of basements adopted a practice

[16] A design for a house in Palladio, *I Quattro libri*, vol. II.

totally different. In the works of this great artist we find many examples of this deviation from the classical purity of the ancients, as well as in those of Michele san Michele, Scamozzi, and Vignola.

Inigo Jones, treading in the steps of Palladio, introduced them [high basements] in Ambresbury House in Wiltshire, the Queen's House at Greenwich, and in many of his other works. Lord Burlington likewise adopted them, and many succeeding architects, satisfied with following the examples of those great men, have on many occasions done the same, as may be seen in Lord Burlington's celebrated villa at Chiswick, Holkham Hall in Norfolk, Kedleston in Derbyshire, and in many other places. In London, Burlington House, Uxbridge House, Lord Irnham's house,[17] and Lansdowne House, are instances wherein the beauty and effect both of columns and pilasters have been materially injured by the great elevation of the basements on which they are raised. It must be remembered that columns, according to all the great examples of antiquity, are always best placed near the ground, and it may be set down as an axiom that a column is never properly situated unless it unequivocally proclaims itself the principal object, which it can never do when its base is raised far above the level of the ground. But this is not the only objection to high basements, for if the basement (of whatever height it may be), when columns are placed upon it, can only be considered (as many great architects have asserted), as a zocle, or support for them, how can we justify any perforation for doors and windows therein? Will not its apparent solidity be materially lessened, and one of the great principles of Grecian art, on which all good architecture is established, be entirely neglected?

Other examples of high basements might be produced in buildings of importance, such as the Treasury next St. James's Park, various parts of Somerset House, particularly the front next the Strand, where Sir William Chambers (in imitation of Palladio in the Thiene Palace), in order that the great cornice which crowns the basement should not, in certain points of view, seem to hide the bases of the columns, has raised the columns on a low pedestal whereby, although the columns comprehend two lofty storeys, yet from the relative smallness of their height to that of the basement and their distance from the eye, they appear merely as secondary objects.

This adoption of high basements with columns placed upon them, however general, like many other rooted defects in our architecture, arises out of a neglect of first principles; to the facility of copying what has been so often done; and to our paying a greater deference to the practice of the restorers of architecture in Italy than to the works of the ancients.

If basements are used with columns they must be regulated by the diameter of the column. The basement of the little temple at Tivoli, and those of the Temple of Fortuna Virilis at Rome, La Maison Carrée at Nîmes, and of many others in the best examples of

[17] No. 17, Bruton Street, Mayfair, probably by Isaac Ware, *c.* 1740, dem. 1939; birthplace of HM Queen Elizabeth II.

ancient times, are all low and happily proportioned to the height of the columns placed upon them.

When basements, whether high or low, are introduced into the fronts of buildings, if half, or three-quarter columns are placed on them, every principle of good architecture condemns the perforation of the basement with doors or windows. And be it added, if there is great impropriety (as has been already noticed) in perforating basements when they serve as supports to half, or three-quarter columns, or even pilasters, how much greater the defect, and how much more censurable must it be, when those very basements support porticoes and colonnades, as in the celebrated front of the Louvre, the Queen's House at Greenwich, the Earl of Burlington's villa at Chiswick, and the Mansion House in London?

However general the practice may be, nothing can justify it in the eyes of those who attend to first principles, and who feel the beauties of ancient architecture. To be fully impressed with the truth of what is here advanced we need only examine the practice of the ancients. In the Temple of Fortuna Virilis and La Maison Carrée, the basements support half, or three-quarter columns, but there are no perforations of any kind in either of them, nor in any of those which support the bases of the ancient peristyles. I wish to impress this as forcibly as possible on the minds of the young students, and I shall therefore endeavour to render the impropriety of the practice more obvious by contrasting the temple at Tivoli, as it is, with a drawing of the same beautiful edifice with windows in the basement. This example will be sufficient: the slightest view of the two drawings will show how completely the perforations in the basement destroy the character, the elegance, and simplicity of the original work, and such will always be the effect of engrafting modern improvements on ancient works.

Our attachment and sometimes too close regard to the precepts of Palladio, without referring to first principles, have made very high basements so generally adopted in our compositions, and the respect with which we are early taught to look on the Greek orders, have in like manner made us desirous of introducing them indiscriminately on every occasion.

In the early ages the orders were confined almost exclusively to the decoration of temples, that the utmost effect of pomp and dignified majestic character should be given to structures raised for the great purposes of pagan worship. Before therefore we apply the orders of architecture in the exterior of buildings for domestic purposes, we shall do well to pause for a moment and reflect that they were first used in climates where it was desirable to exclude the too powerful rays of the sun, and to produce shade and fresh air about the building. To these causes we owe the peristyles of Greece and Italy, as well as those of Hindostan and China. But in our cloudy atmosphere there are not many days wherein the full force of the all cheering rays of the sun are not desirable. Thus, peristyles and porticoes which contribute so essentially to the beauty and convenience of architectural

compositions in warm climates, round our houses would be more disadvantageous than useful.

Porticoes in modern buildings are sometimes useful though seldom magnificent: if they do not produce both these effects it is because they are improperly situated. The portico in the entrance front of Carlton House partook both of magnificence and utility for, by making the intercolumniation which determines the depth of the portico twice as wide as the spaces between the columns in front, sufficient space was given for carriages to draw up to the hall door. If the object, as to utility, is thus gained, it must be admitted that the beauty of the portico is destroyed. Nor is the idea original: it is worthy of observation that such a portico exists at Palmyra. For what purpose it was constructed in such a climate, and at a period when the luxury of carriages was unknown, I am not able to determine.

If columns, when applied as in the examples referred to, do not satisfy the eye, how much less do those in Lord Archer's house in Covent Garden,[18] and in the front of the Surgeons Theatre in Paris. It is much to be regretted that our attachment to the Greek orders of architecture sometimes occasions our employing them very improperly.

The difficulties and expense attending the use of peristyles and porticoes in the exterior of private buildings, whether in town or country, are not always to be surmounted. And if expense is not an object, and the artist restrains himself to a very feeble appearance of ancient peristyles and places his columns, comprehending one story in height, merely detached from the wall, other difficulties present themselves. The projection obstructs the light and takes away some part of the pleasure of the prospect and thereby, in the opinion of many, renders the use of detached columns almost, or entirely, incompatible with our ideas of comfort. To obviate this difficulty the beauty of insulated columns is sacrificed, and half or three-quarter columns are substituted in their place. Nay, sometimes, from economical motives we descend even to the use of pilasters, to preserve some faint glimmerings of architectural effect.

Semi-columns or three-quarter columns may be accounted for on principles of economy, but how are we to justify the practice of Michael Angelo, and others of the great painter architects, who in many of their works have buried a large portion of the entire columns in the wall, with small vacuity round about them? Surely this is as reprehensible as a sculptor would be who, instead of placing his statue on a zocle or pedestal so that every part might be seen, should prefer burying half of it in the thickness of the wall.

These mutilations of the column, these substitutions of the pilaster for that noble decoration, are not to be justified on any principle of beauty or taste. To reconcile them to the eye of the artist, it may be said that, if they are less beautiful than the entire column, they are at least less expensive and furnish the architect with the means of showing greater variety in his compositions. And perhaps it may be added that, as in sculpture there are

[18] No. 43, King Street, Covent Garden, 1716–17, probably by Thomas Archer.

different degrees of relief, the basso-relievo, the alto-relievo, and figures entirely relieved, in like manner architecture may have its pilasters, its semi, and three-quarter columns, and columns entirely detached. And if three different degrees of relief in sculpture are permissible in order to show the excellence of the sculptor's art, it may be asked why should not modern architecture likewise, as well as the ancient, be equally allowed its pilasters, its half and three-quarter columns, and columns entirely attached?

From what has been said by different writers on architecture, and from the examples of modern buildings, it is to be feared that the column (the great feature in all the orders of architecture), can seldom be used with success in private works of limited dimensions, for although it will be admitted that there are no positive dimensions for the columns (as in the human figure), and that its diameter must be determined by the extent and character of the building, yet if columns are less than of certain dimensions they can never please. If they are too large as at the Admiralty, or too small as in chimney-pieces, alcoves, etc., the eye is offended. Hence it follows that it is in our great public works that we must chiefly look for those grand effects, those noble decorations which all admire in the great works of antiquity. And when it is considered that the highest effects of architectural composition are chiefly confined to great public and national works, how much must the lovers of architecture regret that they are so often crowded together, choked up with houses and shops, and frequently placed in such narrow and confined places that no sufficient space is left to view them?

If descriptions are to be trusted, the great works of Babylon, Memphis, and Troy were disposed in the most advantageous manner, whilst the superb edifices of imperial Rome must have suffered very materially from the irregular manner in which, according to the ancient marble plan of the city, they appear to have been placed. This irregularity in disposing great public works was not confined to Rome: the remains of the cities of Palmyra and Baalbec and even Athens itself evince that they partook of the same defects.

In modern cities, the same defects and inconveniences as to the situations of public buildings are almost always visible. Those of London and Paris are full of examples of the most unaccountable neglect and inattention in this particular.

St. Paul's Cathedral, from a superstitious regard to its being placed due east and west (which, by the by, it is not after all), is seen obliquely and distorted from Ludgate Hill and from a small opening at the upper end of Cheapside, and many of its beauties are obscured by the proximity of the houses with which it is surrounded.

If to place public buildings in narrow confined streets is an evil, how much greater is the inconvenience when the passages over bridges in populous cities are choked up with houses? The triumphal arch raised in honour of Augustus on one of the bridges over the Tiber increased the beauty of the bridge itself, and occasioned no obstruction. This cannot, however, be said of the buildings that were on old London Bridge until they were taken down by a noble sacrifice of property made by the Corporation of London.

In the original construction of this bridge there was only a chapel in the centre, but the saint being neglected and profit more attended to than devotion, the chapel was afterwards converted into a house which soon after led to the erection of two rows of houses, with a narrow street between them, to the entire exclusion of the sight of the river, except at the space occupied by the draw-bridge. A measure more prejudicial to the health of the inhabitants could not have been devised, for the air that surrounds a river, being continually renewed by the current of the water, must carry with it those noxious exhalations which constantly arise from the filth of a great city.

How much it is to be lamented that there should be no regular and well arranged plan, first for the general and systematic improvement of this great city, and secondly to insure that all the new streets and squares should be properly connected with those already formed.

The dreadful conflagration in the year 1666 afforded a fine opportunity of rebuilding the City, in a manner that would have added to its beauty and convenience, and at the same time have contributed to the health of the inhabitants. We can only lament that disputes about private property and other causes prevented the execution of Sir Christopher Wren's noble design for giving London that importance from its buildings it possesses from its commerce. Although the great plan of Sir Christopher Wren was not adopted, yet to his design for restoring London, and the labours of Gwynn, may be attributed that spirit of improvement which, amongst many smaller effects, has produced the alteration of the streets about Snow Hill and of those in the neighbourhood of Temple Bar and of Westminster Abbey.

That ingenious though neglected artist, Mr. John Gwynn, in the year 1766 published a work entitled 'London and Westminster Improved, Illustrated by Plans.' That work, the production of an humble and modest architect, laid the foundation of many of those great improvements that have been made by succeeding and more fortunate artists who, enlivened by public patronage and the cheering smiles of royalty, have worked in the same quarry with poor neglected Gwynn, and by the exercise of their talents made London and Westminster, as far as regards the character of their streets and squares, to rival the most celebrated cities of Europe.

LECTURE XI

❧

MR PRESIDENT, – I concluded the last lecture by expressing a hope that the spirit of improvement, which had so happily shown itself in many parts of the cities of London and Westminster, would be extended, not only to every part of the metropolis but to the utmost confines of this mighty Empire. To this spirit of improvement, embellishment, and utility, we owe the new bridges over the River Thames, the extensive and magnificent approaches thereto, and the other improvements now in progress.

The want of due attention in the placing of our great public buildings was noticed in the last lecture. It is not less to be lamented that in this great metropolis, this emporium of wealth, public monuments of national greatness are so few in number that it seems as if it were the general opinion that architecture is unworthy of consideration. This was not the feeling of the Greeks and Romans. They duly appreciated painting and sculpture, but architecture was not neglected. Their temples exhibited all the splendour of architectural effects; and in their mausolea, whilst the highly sculptured sarcophagus contained the body of the deceased, or the magnificent urn decorated with bassi-relievi the ashes, the remainder of the funereal pomp rested on the power of the architect's mind, as is proved by the pyramids of Egypt, and of Caius Cestius, the Mausoleum of Hadrian, and the innumerable sepulchral buildings on the Appian Way and other public roads leading to Rome, those in the south of France, and other places. It is humiliating indeed to see how much more numerous, more extensive, and more magnificent the public buildings are in all the great cities on the continent than in London and Westminster. Even St. Paul's, so justly venerated by those who feel the powers of architecture, when compared with St. Peter's in Rome, although infinitely superior in all its external details, loses much of its importance when compared with that building and is, as must be admitted, very inferior to St. Peter's as respects its interior. How superior in magnificence are the churches of St. Carlo at Vienna, St. Sulpice, and St. Roche, in Paris, when compared with most of our churches.

Unfortunately for the architecture of this country, instead of the Fifty Churches directed to be built in the reign of Queen Anne, we have erected a series of economical churches, chapels, and meeting houses, in their external appearance indicative rather of buildings designed for mere utility, than those dedicated to the purposes of devotion.

If we look at the palaces of the Louvre, the Tuileries, and Versailles, they present an assemblage of elegant forms and an appearance of princely magnificence such as cannot fail of making a strong impression on the minds of foreigners. If those truly royal residences are contrasted with St. James's Palace, and Buckingham Palace, what a falling off is apparent. The buildings in which our kings, princes, and noblemen are lodged are not very honourable to the architecture of this country. How justly do we merit the sarcastic observation of the foreigner who, on seeing Greenwich and Chelsea Hospitals, exclaimed, 'the English lodge their Sailors and Soldiers in Palaces, and their Kings in Hospitals'!

If we continue the comparison perhaps we shall not have any greater cause for triumph. The Garde Meuble in Paris (pl. 14), the Surgeons' Theatre, the Theatre at Bordeaux, and the other great works on the continent are models for our imitation. Alas! we have not anything to compare with them. The overwhelming grandeur of Paris and other great cities in France is not produced by the churches, palaces, hotels, and public squares alone: the fountains and reservoirs, in number and magnificence, are only inferior to those of Italy. What a contrast between these works and our wooden pipes and pumps! (pls. 26 & 31–32).

It now remains to resume one of the subjects which in these lectures has hitherto only been briefly touched on, namely, external and internal decoration. The subject of embellishment opens a wide field for the exercise of the taste, fancy, and inventive talent of the artist. On this part of his studies the young architect is too often led astray, thinking that a profusion of ornaments always increases the beauty of a building. This is a mistake: it is in simplicity that all real decoration is to be found. A multitude of ornaments may materially injure, but can never improve the effect of any composition. The great beauty of architectural composition consists more in a due regard to proportion, symmetry, and propriety of form, both general and detailed, and in apposite decoration, than in a great profusion of enrichments.

The decorative system amongst the ancients was held of such importance that their architects were forbidden to use any ornaments for the introduction of which they could not account. Accordingly nothing was introduced into their buildings which did not relate immediately to the mysteries and rites of their religion, to their political institutions, or to the imitation of nature, as exhibited in the vegetable and fossil world, in foliage, fruit and flowers.

That whatever appertained to the sublime mysteries of religion might be properly

represented, we are told in Holy Writ that none but the priests were to be allowed to work on certain parts of the Temple of Solomon. Ictinus also, and other great artists, were in like manner duly initiated into the Eleusinian Mysteries to enable them to execute certain parts of the Temple of Ceres at Eleusis and other edifices sacred to the divinities of paganism.

The ancients assigned a totally distinct species of decoration and character to every different description of building. Thus temples were of various forms, placed in different situations and decorated with ornaments in all respects suitable and analogous to the peculiar divinity to whose worship and honour the edifice was raised, and very different from those used in buildings destined to other purposes.

In the decorations of ancient buildings we frequently see the representations of the heads and sculls of oxen, with festoons suspended from them, and likewise the heads of rams, goats, and other animals which had been presented as propitiatory offerings or in honour of the gods. These, as well as the garlands, wreaths, and festoons of fruit and flowers with which the altars of the temples and the sacred animals had been adorned, are frequently represented, not only in different parts of ancient temples, but likewise in the decoration of the altars, candelabra and utensils belonging to them. We likewise have the representations of winged figures which, in the mythology of the Persians and other ancient nations, were added as attributes to those aerial beings that were considered as intermediate agents between the gods and men.

Sphinxes, likewise, emblematical of the mysteries of the Egyptian theology, were held in such veneration by the people of that country that entire rows of those chimeras of colossal dimensions formed avenues leading to their superb temples.

In the remains of ancient temples we find likewise the representations of lions and the heads of lions. Piranesi has given an example of rows of these animals which, like the sphinxes already mentioned, formed an avenue at the entrance of an ancient temple. This custom, which originated with the Egyptians, is by some thus accounted for: the astronomers and people of Egypt in general, being great observers of the seasons, and the fertility of their lands depending on the overflow of the Nile, that event was to them of the greatest importance; they therefore watched with attention every change in that beneficial agent, and observing that the greatest increase was on the sun's entering the constellation of Leo, the lion was from that circumstance first considered as the type of an inundation, and afterwards that noble animal became one of the characteristic emblems of every effusion of water, and the water from cisterns and reservoirs, as well as from the roofs of buildings, was contrived so as to pass through the mouths of lions, as was exemplified in a former lecture, by a drawing of the Tower of the Winds at Athens. This latter circumstance is mentioned by Vitruvius, but he does not assign any reason for the adoption [of the lion's head].

Sphinxes and lions were used in decoration at a very remote period, as was likewise

the serpent, that reptile being considered an emblem of the sun, of time, and of eternity. The serpent was likewise sacred to Esculapius, and by the Egyptians in particular was worshipped as a divinity.[a]

The acanthus being considered an emblem of fire, and a symbol of the primitive being who, according to the cosmogony of the Scythians, created the world, the leaves of that plant were frequently used as ornaments in the decoration of the candelabra and other utensils of ancient temples.

The lotus is another decoration much used by the architects of antiquity in sacred structures. Of this plant there are various species: the yellow and the white grow in the rivers and ditches of this island; the nymphaea alba is found in abundance on the banks of the Nile; and the nelumbo which grows both in the East and West Indies, are the principal kinds. The Egyptians held the lotus in high veneration, and having observed that it always appeared on the surface of the water when the sun shone, and re-plunged into it when the sun set, they conceived that there must be some considerable affinity between the plant and that great luminary: it was therefore dedicated to the sun.

The lotus was held sacred, not only in Egypt, but in the heathen world in general, and Sir William Jones tells us that it is still held in the highest veneration in Hindostan. For these reasons, in all the great works of the Indians, Persians, and Egyptians, we constantly find their temples and altars crowdedly embellished with the flowers of the [lotus] plant, and their gods are frequently represented sitting on the leaves of it.

Amongst the almost infinite variety of ornaments used in the ancient works, eggs and darts, and eggs and anchors occur more generally perhaps than any other. The frequency of these ornaments has been supposed by many to have been occasioned by their reference, in the ancient mythology, to the worship of the sun, the egg being supposed to represent the mundane system, and the darts placed between them, the rays of the sun. The anchor was in like manner used between the eggs in the temples dedicated to Neptune, one of his attributes, viz., presiding over the sea.

The patera, being one of the symbols of goodness and benevolence, is therefore very often represented in the hands of their gods as one of the attributes of divinity.

However anxious the ancients were to do honour to their gods, they were not less so to show respect for the illustrious dead. In the early times, mounds of earth were raised over the dead (particularly those who fell in battle), decorated with groves of cypress and

[a] Note. The Persians worshipped the serpent, being the symbol of their god Mithras.

The snake and the lizard apparently comprise the analysis of the dragon. Preface to the Tales of the 12th and 13th Centuries [*Fabliaux or Tales, abridged from French MSS of the XIIth and XIIIth centuries by M. Legrand*, 2 vols, Paris 1796–1800. sm gl 14a].

laurel, rising majestically one above the other. These mounds were frequently of enormous size although only one corpse was deposited therein.[b]

Many of the mounds or barrows in this country, on being opened, have been found to contain the remains of only one person, and it is worthy of remark that this same form and species of decoration was used in later times when marbles of various kinds were substituted for the less noble though not less honourable monuments of earth; when expense was not spared and when the most magnificent monuments were raised to perpetuate not only the memory of great public characters but of individual friends. Hence arose the pyramids of Egypt, and of Caius Cestius, the mausoleum of Mausolus, those of Hadrian, Augustus, and Cecilia Metella, as well as an innumerable assemblage of monuments on the Via Appia, on the great public roads of Italy and other parts of the Roman dominions, drawings of some of which have already been exhibited.

In the interior of the mausolea, sepulchral chambers, and other buildings destined by the ancients for the reception of the dead, the ceilings and walls are generally enriched with various kinds of grotesque forms. We find likewise that the fronts of many of the sarcophagi, vases, and cinerary urns are decorated with representations of grape vines, fig and ivy leaves, griffons, and sphinxes, with wings of birds, and tails of fishes, satyrs, birds of various kinds, and grotesque figures of different descriptions. But we must not conclude from any seeming incongruities and apparent want of analogy in these ornaments that they were used arbitrarily, according to the whim and caprice of the artist, for if traced to original causes, they will be found to be conformable to some custom or ceremony, particularly or expressly relative to the practice of ancients towards their dead.

The ancients were equally attentive to propriety in the character and decoration of their great public structures and the mansions of their illustrious heroes and citizens. None of the ornaments devoted to the religious rites and mysteries of paganism, nor those used conformably to the customs and ceremonies of sepulture were ever seen in buildings raised for other purposes.

Instead of ornaments so consecrated (if I may use the expression), the curia and basilica were decorated with pictures and basso-relievos recording striking instances of heroic fortitude, patriotic sacrifice, and severe public justice: here a Mucius Scaevola, there a Curtius, and in another part a Brutus offering up his son to the severe justice of his country.

[b] Note. Mounds of earth are very ancient, indeed the most ancient mode of showing honour to the dead. Over the burial place of illustrious persons they raised a kind of tumulus of earth – 'ingens aggeritur tumulo tellus.' Virgil [*Aeneid*, 3.63].

This practice of raising barrows over the bodies of the deceased was almost universal in the earlier ages of the world.

Homer mentions it as a common practice amongst the Greeks and Trojans, Virgil likewise alludes to it, and Zenophon relates that it obtained amongst the Persians. Beloe's Herodotus, Vol. 3, p. 125.

Among the insignia of magistracy which assisted to characterise the fabric, the axes and fasces were prominent objects which, according to Plutarch, were tied together in order to indicate the slowness in using them implied by the necessary delay in untying them, whilst the binding up the axe with them (not in them as some suppose) indicate that what the rod could not correct, the axe must, and likewise that he who was to suffer death by the axe was previously to be punished with the rods.

On the same principle, if a general obtained a triumph, his garland of oak, his golden crown, all his trophies of honour, after the procession, made the great distinctive decorations of his house where they were hung up as lasting memorials of his worth and of the gratitude and regard of his country towards him. So likewise, those who distinguished themselves in the public games, religious, or political, were allowed to decorate their houses with the wreaths and crowns conferred on them by the applauding multitudes. The same distinction of character in decoration may likewise be traced in the private houses in Pompeii and Herculaneum, and in the Villa Negroni.

Upon these immutable principles of truth and propriety, the ancients, always anxious to honour their gods, to respect their deceased heroes and statesmen, and to inspire others with a love of military glory and true patriotism, raised temples, mausolea, trophies of conquest, and public buildings of every kind, of the most grand and imposing character, infinite in number, boundless in extent and decorated with all the costliness that art could devise, but without confounding together the different styles appropriated to each.

All the riches of architecture and her sister arts were thus called into action in a manner most wise and politic, calculated to be the delight and admiration of their own citizens, as well as to attract the attention and excite the surprise and wonder of strangers. Whilst such was the magnificence of these public works, the private houses of individuals of all classes were more distinguished by their elegant simplicity than by the costliness of their architecture, or the sumptuousness of the furniture. This did not, however, always continue. In the times of the emperors, the distinctive characters of different buildings were blended together, and profusion in everything became so general that luxury and ostentation were then considered necessary, and had made such gigantic strides as to become destructive of every principle of true taste.

Individuals of every rank were tempted to expenses far beyond their means, and some of the richest patrician families were ruined by the number, magnitude, and extent of their houses, and by the sumptuousness of the furniture which those superb buildings then required; and in which they indulged themselves without calculating the expenses they were incurring, but blinded by an inordinate passion to surpass their neighbours in parade and show.

Such was the progress of luxury and extravagance in the buildings of the Romans, that in their villas, and baths, intended at first for use, more than for ornament, we are told that they were not satisfied unless the floors were of silver and the ceilings shining with

glass and glittering with precious stones. Nay more, the walls were incrusted with the marbles of Numidia and with the most expensive and magnificent inlaid works, the various colours of which resembled paintings. To all this magnificence were added innumerable columns, supporting nothing, statues, and a profusion of ornaments of every kind. Such, according to Cicero and Seneca, was the progress and effects of luxury and dissipation.

Having endeavoured to trace the principles upon which the decorative system of the ancients was formed, let us now see how the great restorers of architecture considered decoration.

On the revival of architecture we shall find that three distinct modes of decoration, taken chiefly from the remains of ancient edifices, were adopted: the grand and massive enrichments found in the soffits and other parts of temples and mausolea; the light arabesques in stucco; and the variety of painted embellishments, of which extensive remains existed in the ancient sepulchres, the baths, the imperial palace and villas.

Each of these different modes were used in the buildings of the fifteenth and sixteenth centuries, according to the fancy of the architects, without always considering the principles on which they were first employed by the ancients.

Palladio, Scamozzi, and Vignola, established this decorative system chiefly on the enrichments they observed in the remains of ancient temples, and which they introduced into many of their works, whether public or private; they were seen alike in churches, palaces, and villas. Those great architects appear too often to have overlooked or neglected the lighter and more fanciful decorations of the ancients with which Raphael was well acquainted, and which were occasionally transposed by that great painter, his scholars, and contemporaries, into the Loggia of the Vatican, the Villa Madama, the Palazzo del Te, and other works of those happy days wherein painting united her powers with architecture. Paltry ornaments and barbarous conceits were banished, whilst the classical domes, ceilings, and walls of churches, chapels, and palaces shone with all the noblest powers of graphic art.

It is much to be regretted that the great restorers of art in the fifteenth and sixteenth centuries had not visited Greece.[1] At that period many of the glorious works of that highly gifted people, which have since disappeared, or which are daily now sustaining injury from the barbarism of the Turks and the rapacity of connoisseurs, were then in being, and in a comparatively perfect state. And it is still more to be lamented that so late as the time of Piranesi, Grecian architecture with all its superior elegance was neglected, or rather so entirely misunderstood by the Italians. Had it been otherwise, that great artist could never have drawn such a parallel as he did between the Roman works and the finest monuments of Greece.

It should be remembered, however, in extenuation of the architectural blasphemy of

[1] It is ironical that both Winckelmann and Soane had never visited the country they praised so much.

Piranesi, that he quotes not from the accurate and laborious representations of Stuart and Revett, who measured those proud remains of ancient glory to the thousandth part of an inch, but chiefly from the loose and imperfect representations of Le Roi, who visited Greece more as an historian, than as an architect. Piranesi is not the only great artist who has been blind to the charm of Grecian architecture. The late Sir William Chambers, having formed his taste on the buildings of Italy, was unable to eradicate early prejudices and fell into the same error. It is well known that even the most correct drawings of ornaments can convey but a faint idea of the taste, spirit and effect of the originals. It is therefore particularly to be regretted that accuracy of delineation was not thought necessary by those who have given us representations of ancient buildings.

Palladio visited Nîmes when many of the remains of ancient structures were doubtless in existence which have since been destroyed, but his representations of the buildings and their ornaments are so unlike those of Clérisseau that at the first sight of them we can scarcely believe that they were taken from the same models.

In like manner by comparing the frieze of the temple at Tivoli, as shown by Palladio and Desgodetz, with what it really is, it would seem as if each of these representations had been made from different works, from recollection, or from a transient view only of the object.

Having thus briefly considered how the artists of the fifteenth and sixteenth centuries availed themselves of the works of the ancients, let us now see whether those of this country have given more attention to the principles on which the ancients composed their buildings and ornaments. The architects of modern times have done no better. They appear to have contented themselves with copying those who a few centuries before had transferred indiscriminately into their works whatever they found in the remains of antiquity. For the first glimmerings of Roman art we are indebted to Holbein and others, whose works being little more than copies of what they had seen in their own countries, I shall pass them over and proceed to the time of Inigo Jones.

That great architect, brought up in the school of Palladio, saw everything through the same medium. Accordingly his deference and respect for the example of his master was such that he overlooked the lighter and more fanciful discriminative decoration of the ancients in their private dwellings, and saw beauty only in the remains of ancient temples and in the works of Palladio. Whatever he there found was indiscriminately introduced into all his works, whether public or private, alike in the church, villa, and palace: everything was Roman.

Inigo Jones having introduced the taste for heavy ceilings (the compartments of which were formed with regular entablatures taken from the interiors of ancient temples), monumental chimneypieces, and every other kind of interior decoration; the same taste was blindly followed by Lord Burlington, whose regard for the works of Palladio and Inigo Jones got the better of the refined and classical taste, so often seen in other parts of the

works of that accomplished nobleman. And such was the influence of Lord Burlington's example that the same taste for heavy decorations continued, occasionally mixed with a most strange and preposterous attempt at something new in internal decoration imported from France.

This species of decoration consisted of flat surfaces scrawled over with short arched lines and twisted curves, with simple and inverted C's and tangled semi-circles. These poor, fantastic and awkward conceits, however, satisfied the Frenchmen of that day, and were much in vogue in this country, sometimes in plaster and at other times in 'papier maché'.

At the very time when these miserable apologies for decoration seemed to have become general, fortunately for art, Stuart and Revett, those great luminaries, returned from Athens, and began to overturn the dreadful bad taste in decoration, which was spreading its baneful influence in every direction.

But it is to the activity of the Messrs. Adam that we are more particularly indebted for breaking the talismanic charm which the fashion of the day had imposed, and for the introduction from ancient works of a light and fanciful style of decoration, better suited for private buildings and the elegance of modern refinement. This taste soon became general: everything was Adamitic, buildings and furniture of every description. But however adapted this style might be to internal embellishment, it was ill-suited to external grandeur. The Messrs. Adam had not formed their taste on the best examples of antiquity, and therefore using the same style in public and private buildings, internally and externally, they did not retain the favourable opinion of the public to the extent expected. But if, in no instance, amongst the various opportunities afforded by their numerous and extensive works, did they ever reach the sublimity of the great restorers of architecture, and if they did not sufficiently distinguish the difference of character between public and private works, at least they banished from the interior of our buildings, the clumsy tabernacle frame, the heavy cornice, the ponderous entablature, and the monumental chimneypiece of Inigo Jones, Kent, Gibbs, and the whole train of their humble imitators. And if Mr. Adam occasionally, in his flights of fancy, descended to trifles, and gave an elegance and an importance to a sedan chair or to the keyhole of a lady's escritoire, let us, in candour and justice to departed merit, remember that in the preceding age, the great portrait and landscape painter of his day, Kent – Kent, the father of modern gardening – Kent, who was respected for his architectural productions, was likewise consulted for designs for state coaches, city barges, and children's cradles. Nay, he was so far the oracle of the day, the arbiter of taste, that the very petticoats of the ladies were under the observation of the architect, and embroidered from his designs, whereof two are particularly mentioned by the late Lord Orford: the one, decorated with the five orders of architecture, the other, a copper-coloured satin with Roman ornaments worked in gold! Before we censure the improper use of the ancient decoration, and smile at Kent's extravagant and ridiculous application of the orders of

architecture and his golden ornaments, let us examine whether in later works, in those of our contemporaries, or even in our own, we may not discover improprieties in the use of the inventions of the ancients at least as great, although of a different kind.

It has been already observed that the ancients paid strict regard to the preserving their decorations on all occasions distinct: those which related to religious rites and ceremonies were appropriated by the ancients exclusively to the external and internal decorations of their temples, whilst those which had a direct or indirect allusion to the state of the dead and to the ceremonies observed towards them were as cautiously confined to places of sepulture. And however beautiful in form, none of those decorations are to be seen (at least in the best times of antiquity) in any other description of building or for any other purposes. The ancients well knew the necessity of preserving them inviolate, and of making distinctions in the forms, decorations, and embellishments of sacred, of sepulchral, of public and of private buildings. Without these marked distinctions, no difference of character would have been seen in their works, and whatever their merit, they would never have been objects of admiration in succeeding ages.

If such was the practice of the ancients whom we profess to copy, how is it possible to reconcile our decorative system? In the ancient works everything is consistent. In modern works, in this country and on the continent, the whole system seems founded on principles entirely arbitrary, the offspring of chance and fancy uncontrolled by rules, ancient or modern. Thus the sphinxes, the lions, and other ornaments sacred to the temples of paganism, the various embellishments peculiar to the mausolea of antiquity, and likewise the vases and urns wherein the ashes of the dead were deposited in the catacombs and sepulchral chambers, all these different decorations are now used, not only in the exterior and interior of our buildings, sacred or secular, public or private, but in our furniture also. Even semi-vases, a species of decoration unknown to the ancients, are now very frequently stuck against the flat surfaces of walls as substitutes, or rather as the shadows of embellishment. And such is the rage for the ornaments of the ancients that whatever the Greeks and Romans used is become so common with us, that not only our public buildings, but the fronts of half the shops in this great metropolis, are crowded with the imitations of those very crowns and wreaths which in ancient times decorated the victor in the Olympic Games. Such trophies, such honourable marks of distinction, were perfectly consistent with ancient customs, and wherever they were seen, they indicated the achievement of some praiseworthy deed and thereby attracted the attention and gratitude of the citizens, but as usually applied by us they are absurd in the extreme.

I trust enough has been said in this and in the former course of lectures on the subject of architectural decoration in the exterior and interior of ancient and modern buildings, to call forth a spirit of enquiry in the minds of the young artists, and prevent them from blindly copying into modern works whatever they find in the remains of antiquity, without first recurring to the principles on which the ancients composed and

applied their various embellishments, and thereby assist in fixing a correct standard of taste in architectural decoration.

If such strict regard to character and variety is to be found in the decorations, plans, and exteriors, of ancient buildings, how much more it is to be lamented that we have neglected to follow such excellent examples.

There is a fashion even in architecture: the building of any great house gives, for a time at least, in its neighbourhood, an impression, and others follow the example, be it good or bad.

Colin Campbell, an architect of the last century, the well-known compiler of the *Vitruvius Britannicus*, has in that work given designs after the Palladian fashion, and others in imitation of Inigo Jones. Imitations of masters is not required in architecture. Poets amuse themselves in this way, but I know not why architects should. It may make them humble mannerists, but this method of study will never make a great artist. It is the road to mediocrity but not to Fame's most dignified niche. He that only copies or imitates will always be left behind. Garrick himself at second hand would not be admired, and, what is more important, could not produce originality in others. Besides these imitations of Palladio and others, Colin Campbell has given us a composition which, to prevent the possibility of the character proposed to be represented being mistaken, he tells us is 'a Design in the Theatrical Style,' in imitation, it may be supposed, of some of the early painters who, in their representations of animals and human figures, added a scroll whereon was written 'I am a dog' – 'I am a Man.' Without these examples quoted and some other similar efforts to be found in different publications, such has been the almost general neglect of attention to destination and character in English buildings that the students in architecture might have concluded that character was not expected, or even thought necessary, in modern works.

It has been said by foreigners (and perhaps with too much truth), that the architecture of England is in general so very deficient in variety that it seems as if all our architects had but one mind and manner. Whoever examines our buildings, public and private, with due attention and critical accuracy, will soon be satisfied of the justice of this charge, and will perhaps at the same time be astonished to find so little movement in the plans, such a general deficiency of variety in the outlines of the exterior, and such neglect of distinctive character in the general divisions and forms of which they are composed, together with a total inattention to that discrimination so essentially requisite to designate the intentions of great artists. The ichnography of many of our buildings consists of a series of squares and parallelograms, and the exterior is formed of discordant parts without that due connection, so necessary to constitute an entire and perfect whole.

Sameness and monotony are too general in most of our homes. If the principal front admits of three apertures in a line, it is usually divided into three parts, a door in the centre, and a window on each side. If the front admits of space for five apertures in a line,

it is divided into three parts, with a door and two windows in the centre, and one window on each side. If the front is of sufficient extent to receive seven apertures in a line, it is divided into three parts, and the centre takes three of the openings, and each of the sides two. If the front is of greater extent and admits of nine apertures on a line, it is sometimes divided into three and sometimes into five parts: in the first case, three of the apertures are given to the centre, and three to each side, and in the other, three to the centre, two on each side [of] the centre, and one at each extremity. If the front is still further extended and sufficient to contain eleven apertures on a line, and few corps-de-logis exceed that number, the whole space is divided into five parts, and five of the apertures are in the centre, one on each side, and two at each extremity; or sometimes three of the apertures are given to the centre, three on each side, and one at each extremity. All these fronts,[2] which are those of buildings actually erected, have a pediment in the centre, and at a small distance appear as on the same plane with perforations for light, ingress, and egress.

The last drawing is a representation of Devonshire House, Piccadilly, which, although the residence of the Duke of Devonshire and the production of Kent, is notwithstanding constructed entirely with bricks, and with stone dressings merely for its external decorations. How inferior in magnificence to the Chigi Palace in Rome, the residence of a personage of similar rank.

If the corps-de-logis is extended so as to admit thirteen apertures, the division in front is usually like the last design: five of the apertures are assigned to the centre; three on each side, and one at each extremity.

If our attention is directed to fronts of more importance and of greater magnificence we shall find in nine out of ten, no greater variety or deviation from the designs before you than the addition of porticoes. These porticoes in the old school generally consisted of four or six columns of the Ionic or Corinthian order. According to the fashion of the present day, the columns are of the early, heavy, massive Doric, exploded by the Greeks in their later works, even in their temples. The deep entablature with its great projection, shuts out the light and sun from the upper rooms, and certainly, however appropriate the solemnity and gloom of a heathen temple, it ill accords with the character of an English villa.

In some of the more extended fronts of eleven or thirteen apertures in the same line, the centre is not only adorned with a magnificent portico, but the extremities are likewise enriched with corresponding columns or pilasters. Whether the one or the other is made use of, the entablature, however heavy, is the same by necessity, so that the same quantity and form which required and was originally designed to be accompanied and supported by

[2] Soane here illustrated a range of houses including Kingsweston House, Bristol, Hampton Court, Herefordshire, and Cholmondeley Hall and Eaton Hall, Cheshire.

columns only, is here placed over slender pilasters which, thus overloaded, seem pressed and sunken into the wall itself by the weight imposed on them.

This impropriety of application from the antique must strike every person, and teach us the necessity of thinking before we blindly adopt what we find in the remains of antiquity.

In these buildings the general feeling is the same: the same insipidity and want of variety is apparent in a greater or lesser degree, both in outline and in decoration. In many, even of those constructed with stone and decorated with the orders of architecture, the doors and windows are sunk in plain square recesses without any relief, whilst in the Gothic buildings we constantly see the most picturesque, fanciful, and ingenious play in the outline, and a variety and breadth of effect in the decoration of the subordinate parts. Words of explanation are unnecessary: the drawings sufficiently show how poor these modern examples appear when viewed together with the Gothic. The door of the Gothic church is noble and full of effect, and gives an idea of strength and dignity; the door of the nobleman's palace is mean and trifling. The Gothic window is of the same superior design. Every part is equally studied and superior to the modern window with which it is contrasted.

These considerations, amongst many other more important motives, will lead the architect to a study of the Gothic buildings for effect, as well as with respect to construction.

Having shown the general style of the composition of the exteriors of different houses, the interiors of which abound with comforts and conveniences (however destitute their outsides may be of taste and architectural effect), candour itself must admit that the frequent repetitions of such buildings as these examples must be extremely tiresome, and finally disgusting. The numbers of them, either constructed or to be met with in books of ideal designs, are such as no person could imagine without looking closely into the subject; whilst the number of those wherein any character and variety are to be met with, is comparatively small indeed.

Having shown different fronts of houses finished with a pediment in the centre of each, very different from the practice of the ancients, I shall now offer two specimens of elevations more congenial to first principles.

The house of the volatile and witty Sir John Vanbrugh at Whitehall was on so limited a scale that it excited the mirth and derision of the contemporary wits. Their criticisms, however, were not just; even Swift, with all his antipathy, or rather jealousy, of Vanbrugh, was compelled to say, speaking of this very house,

'........ 'tis owned by all,
Thou'rt well contrived, tho' thou are small.'[3]

[3] Jonathan Swift, 'Vanbrug's House: Built from the Ruins of Whitehall that was Burnt', lines 115–16, in *The Complete Poems*, Harmondsworth 1983, p. 99.

The front, however small, contains the same number of general divisions, and at least as much variety of outline as the magnificent Palladian mansion in Piccadilly of the late Lord Burlington. The straight line which terminates each of these buildings accords most admirably with the general style and features of the architecture, and this indication of a flat roof or terrace will always succeed wherever quietness of character is aimed at, and the building is viewed at a small distance or confined with projecting wings.

This is not, however, the general character of Sir John Vanbrugh's architecture who, for invention, has had no equal in this country. Boldness of fancy, unlimited variety, and discrimination of character mark all his productions. He had all the fire and power of Michael Angelo and Bernini, without any of the elegant softness and classical delicacy of Palladio and his followers. The young architect, by studying the picturesque effects of his works, will learn to avoid the dull monotony of minor artists, and learn to think for himself and acquire a taste of his own. Having spoken of this great architect in the first course of lectures, I shall present to your observation some of his designs to exemplify what I have advanced.

These works are inimitable examples of the power of variety of outline to please. A building to please must produce different sensations from each different point of view. These effects will never be completely attained without variety in heights as well as in the projections. It is chiefly the inequalities of height which produce that prodigious play and movement in the outline, and make the edifice important in very distant points of view, and more so as we approach nearer to it; and finally it still improves upon us when we are sufficiently close to perceive all its parts in detail. Such was the manner in which our forefathers designed their buildings, such was the effect they frequently produced.

Many other examples besides these might be selected, but time will not permit, and indeed these, I trust, will be found sufficient for the information of the student, and for the illustration of what I have advanced. I must add, however, that every building, notwithstanding its front being extensive and rich, without these varieties in the heights, will always, when viewed at a distance, be regarded as a heavy, uninteresting lump.

Too great a variety of parts and movement in the exteriors of buildings, as well as in their plans, is to be avoided as much as monotony. Variety may be carried to excess by too many breaks and divisions: by a repetition of curves and undulating forms running into each other without proper repose, the general effect is weakened, and the whole becomes confused instead of producing that movement and variety which creates the most pleasing sensations and gives the spectator an interest in the work before him. A composition overcharged, although it may please the ignorant, will not fail to make the judicious grieve. This false taste, or rather want of taste, has not been confined to the works of Borromini, Vanvitelli, and Fuga; the new church [of St. Mary] in the Strand is a very forcible example of it. This building is divided and subdivided into so many parts, and so crowded with decorations of every kind that it justly provoked the poet's observation,

'As when the wit of some great genius shall
So overflow as to be none at all.'

The small portico of this church, however beautiful in itself, is disproportioned to the rest of the building, and unmeaningly placed. There is no principal feature to arrest the attention of the spectator, which is as necessary in a building as in any other composition. In every poem we seek for a distinguishing and chief object; in every picture, a principal figure or group, a principal colour, a principal light, to which every other must be subservient; from these as so many radii, the other parts diverge.

That Gibbs had no fixed principles is most clear, when it is recollected that he not only built this church, but likewise that of St. Martin in the Fields. The first of these buildings imitated, or rather was copied from, the Basilica of San Giovanni Laterano in Rome; the other, exclusive of the noble portico, partakes of the fashion of the day, to which Gibbs himself contributed greatly by his rustics, consoles, and other incongruities. Between these two structures there is no similarity in the composition, none of that legitimate resemblance that generally occurs in the works of every artist.

Homer stands confessed, not in the Iliad only, but also in the Odyssey, and so is Milton in his 'Paradise regained,' and in his other poems, as well as in the 'Paradise Lost.' So will the particular manner of the architect be seen in all his works if he have taste and genius, for every artist must form a style of his own.[4]

The new church in the Strand[5] is a striking example to show how effect and interest are destroyed by breaking the surfaces of the work into a great number of parts. The surface of this building is broken into a multiplicity of heterogeneous forms and crowded with every possible variety of decoration, entire columns, portions of columns, pilasters, pediments, niches, semidomes, and other ornaments.

It is not sufficient that the principal masses of the composition are well considered. The attention, study and labour of the architect must extend to the smallest, subaltern and accessory parts of his work. It is by particular consideration of the most minute parts of a building in its decoration, distribution and construction, that the architect displays his talents and renders his work perfect in solidity, convenience and magnificence. The man of a common mind, when entrusted with the execution of any building, will give his attention chiefly to the great points only, the parts which every one sees; the man of genius and true science looks further: he considers the most minute parts of consequence, and his attention will be directed accordingly:

[4] This was the advice given by Sir William Chambers to his pupil, Edward Stevens, and hence to Soane.
[5] He is still referring to St Mary-le-Strand (1714–17), by James Gibbs, scarcely very 'new' by the time of these lectures.

'Still follow Sense, of ev'ry Art the Soul,
Parts answ'ring parts shall slide into a whole.'[6]

The young artist must feel the importance of avoiding too much as well as too little variety in the parts of his composition; both extremes are bad: too much, will lead him to adopt the extravagant forms in the works of barbarous times, and to imitate Piranesi's design for a Roman College before noticed, wherein want of space, inconvenient distribution, and increase of expense without a corresponding effect are the characteristic marks. The artist must not be too tame either; he must suit the building to the place, and the place to the building. In all his compositions there should be a playful variety in the exterior, and as many successions of different figures in the plan as convenience will permit and proper economy sanction.

In extenuation of the monotonous appearance of modern buildings, the ancient works have been charged with the same defects. There are persons, says Sterne, who will travel from Dan to Beersheba and cry 'it is all barren';[7] so there are some men, who in the mighty ruins of antiquity can discover nothing beyond large masses of marble, stone and brick. We complain, but most unjustly, of the want of variety in the ancient works, for whoever looks at the Pantheon, the Temple of Minerva Medica, the marble plan of Rome, the remains of the Imperial Palace, the ruins of the villa of Hadrian, will probably draw a different conclusion, and favourable to the wonderful variety and enchanting combinations of the various parts of those stupendous works yet remaining. And if any credence is to be given to the existence of the temples and other buildings described by Soria, as partly existing in his day, we may condemn many of them for extravagance of design, but we can never ascribe monotony to them. And if the plans of some of the Greek and Roman temples in many respects resemble each other, may not this similarity of form be ascribed to their veneration for religious customs, and sacred rites, or other causes?

Sir Christopher Wren's favourite design for St. Paul's, which consisted of one order of columns only in height, we are told was rejected by the bishops because it was not in their opinions sufficiently in the style of a cathedral. On this head the artist can have no opinion. Regard for the great emblem of Christianity, the cross, determined the form of all the cathedrals that have been erected from the days of Constantine to Ste. Geneviève at Paris: not one of them but what is in the form of a cross, either Latin or Greek.

It is true that in the plans of some of the old churches we have occasionally deviated from the cross and borrowed from the temples of paganism, the elegant figures of the circle

[6] Alexander Pope, *Moral Essays*, Epistle IV, lines 65–66.
[7] Laurence Sterne, *A Sentimental Journey through France and Italy*, 2 vols, London 1774, vol. I, p. 85, citing *Judges*, 20, 1.

and polygon. In later times there are, I know, several examples extant of this adaptation, effected, however, with great difficulty and exertion on the part of the artist to show the beauty and superiority of those figures.

Besides the defects arising from this monotonous appearance of many of our buildings, and a general want of invention, there is another which grows out of the want of that correctness and distinctive character, so visible in the works of the ancients and without which architecture becomes little more than mere routine, a mere mechanical art.

So requisite did the ancients consider this attention to distinctive character to make a perfect and beautiful composition, that even in the very steps to their buildings they regarded it. Those to the temples of the early Doric order were of larger dimensions, both as to rise and tread than those which were afterwards used when the Doric order became less massive. In like manner the steps to the temples of the Ionic order were still less, and upon the same principle those of the Corinthian were lower in their rise and narrower in the tread.

Too much attention cannot be given to produce a distinct character in every building, not only in the great features but in the minor details likewise: even a moulding, however diminutive, contributes to increase or lessen the character of the assemblage of which it forms a part.

Character is so important that all its most delicate and refined modifications must be well understood and practised with all the fine feelings and nice discrimination of the artist. He who is satisfied with heaping stone upon stone, may be a useful builder, and increase his fortune. He may raise a convenient house for his employer, but such a man will never be an artist, he will not advance the interests or credit of the art, nor give it importance in public estimation. He will neither add to its powers to move the soul, or to speak to the feelings of mankind.

Notwithstanding all that has been urged to the contrary, be assured my young friends, that architecture in the hands of men of genius may be made to assume whatever character is required of it. But to attain this object, to produce this variety, it is essential that every building should be conformable to the uses it is intended for, and that it should express clearly its destination and its character, marked in the most decided and indisputable manner. The cathedral and the church; the palace of the sovereign, and the dignified prelate; the hotel of the nobleman; the hall of justice; the mansion of the chief magistrate; the house of the rich individual; the gay theatre, and the gloomy prison; nay even the warehouse and the shop, require a different style of architecture in their external appearance, and the same distinctive marks must be continued in the internal arrangements as well as in the decorations. Who that looks at the interior of St. Martin's church, and observes its sash-windows and projecting balconies at the east end, but is inclined rather to imagine himself in a private box in an Italian theatre than in a place of devotion?

Without distinctness of character, buildings may be convenient and answer the

purposes for which they were raised, but they will never be pointed out as examples for imitation nor add to the splendour of the possessor, improve the national taste, or increase the national glory.

The want of proper character and appropriate magnificence in the buildings of this wealthy metropolis is not confined to the exterior form and interior distribution of single structures, but is almost general.

In the outlines of our public places or squares, we seldom venture beyond the rectangular shape: the crescent, the circus, or polygon are seldom used. The reason is obvious: when a large tract or parcel of ground is to be applied to the purposes of building, or if a neighbourhood of houses is to be new modelled, the architect is seldom consulted. It is usually left to the pleasure of the builder or person who takes the ground upon a lease for building. When on such occasions, by some fortunate circumstance, an architect is consulted, he naturally feels desirous to avail himself of the opportunity, and recollecting the great squares and magnificent buildings in Rome, Vienna and Paris. He endeavours to form a design that shall do honour to the national taste, yet at the same time he will not forget economy so far as to form his squares and principal streets with buildings that might vie with the Tuileries, the Louvre, and the Garde Meuble at Paris (pl. 14). His compositions will, however, display as much of the true spirit of architecture as practicable magnificence will permit. I say practicable magnificence, for magnificent our new buildings might be, were it not, sometimes, from the interested dispositions of landowners, but more frequently from the rapacity of the builders to whom, unfortunately, the designs of the artist are often submitted, whose object being to raise the largest possible rental, our buildings are limited to mere heaps of bricks with perforations for light and the purposes of ingress and egress, without the least regard to elegance of composition. Thus the character of our architecture and the higher feelings of art merge into the system of profitable speculation.

In the former discourses the state of our architecture was considered until the time of Lord Burlington. After his death the principle on which buildings had been raised was soon changed. The master workmen were no longer contented to follow the directions and be controlled in their charges by the architect; they now assumed a different character under the general appellation of builders. To give efficacy to this new order of things the most eligible situations for building upon were selected, and the landowners tempted with offers of much larger rents than could be obtained so long as the land was used for gardens, pastures, or such purposes. This mode, so advantageous to all the parties immediately interested, gained an ascendency rapidly, assumed a gigantic appearance, and ultimately became so fashionable that it is now the almost universal practice.

Before I briefly point out, agreeably to my duty, the progress of this system, and its baneful effects on architecture, it may not be foreign to the purpose, nor altogether useless, to digress a little, and show some of the spaces originally laid out on a regular plan, such as Covent Garden. Three sides of the piazza as originally designed by Inigo Jones made

one regular mass of building, the church completed the other side. Two sides of this beautiful plan existed in my time, but a part of one side having been burnt down, the increased value of the site occasioned re-building in a more productive manner.

The general plan of Lincoln's Inn Fields and Great Queen Street was the work of the same great artist. Lindsey House was built by his nephew, Webb, from his designs, as well as some of the houses on the same side of the square, and others in Great Queen Street, of which a few are still standing. When one entire side of Great Queen Street was formed of houses, like those shown in the drawing before you, what a noble effect must have been produced. Italy might have boasted of the work.

Grosvenor Square and the streets surrounding and leading thereto, were among the first grand essays of the speculative system of building. The houses in Grosvenor Square are on a large scale: three of them on the north side westward, are of a superior class, and at the time they were erected were much noticed. In them we trace an imitation of Palladio, in them we see that Inigo Jones was not quite forgotten: the other houses, although large and possessing some dignity of character, are yet of an inferior class.

The general appearance of the houses in Cavendish Square is not inferior to those in Grosvenor Square. Bingley House, as one of its first buildings, is a grand feature, notwithstanding the dead wall gives it an air of gloom, and Mr. Tuffnell's two houses add to the importance of this area. The scenery from thence is much heightened by the view of the church and other buildings in Hanover Square.

Thus far the new system of building seems to have done no mischief. Portman Square has some houses that would have done honour to Grosvenor Square, but the general mass of them are of a kind not much superior to those in Bedford Square. Here the spirit of speculation begins to show itself more decidedly: the buildings appear less important and less substantial. The houses in Portland Place and in Mansfield Street held out some prospect of a return to a better style of building, and those on the south and east sides of Fitzroy Square, in their architectural appearance, promised still more; so did those on the west side of Finsbury Square and Chiswell Street. But all these appearances quickly faded and our hopes of better architecture were destroyed by the monotonous houses forming many of the streets and squares, which have been built since that time. These will be found to consist, not only of thin, flimsy walls, perforated for use, so many brick-heaps piled one after the other, but in many cases, so far in open defiance of the principles of sound building that our ephemeral publications are constantly recording the melancholy events occasioned by their instability.

Such have been the effects of the speculative system of building, a system which in its progress has swept away so many of our ancient and extensive mansions by holding out to their owners the prospect of increasing the value of their property by miserably parcelling out the inheritances of their ancestors into streets of monotonous and, it may be added, of ill-constructed houses. If this system be continued it will eventually destroy all relish for

substantial construction, and finally root out every vestige of good architecture. I am sorry to have to add that some architects have materially assisted in establishing this revolutionary system in architecture by prostituting the credit of their profession, sometimes by taking large tracts of ground and parcelling it out to the tradesmen employed by them, and at other times by taking the ground and becoming builders themselves.

It has been generally asserted that architecture in this country, during the last fifty or sixty years, has rather been declining than making any progress towards perfection, although on the continent it has been rapidly improving. These unpleasant truths must create the most galling reflections in the minds of our young architects. If the great masters of music, with a small number of simple sounds, with a few scanty materials, have produced such an infinity of different kinds of harmony, as have called forth the universal admiration of mankind; if painters with a very limited number of original natural colours have produced an innumerable variety of tints and effects whose combinations charm and astonish the admirers of the graphic art, it is because they have had enlightened patrons and liberal protectors who, by giving importance to those arts, raised up able professors. What might not be expected then from the powers of our art, whose elements are numerous and whose resources are infinite, if architecture were as well understood and appreciated by men of enlarged and cultivated minds as the rest of the sister arts are? Our great public and private works would no longer be left, as they now are too frequently, to the guidance of men of moderate talent. Give architecture patrons with intellect as well as wealth, let taste, and the mind of genius, and not necessity alone, direct our public and private works, we shall then see, not only mere convenience and comfort attended to, but our buildings will exhibit an infinite variety of combinations suitable to the respective characters of the works, and thereby fully establish the pretensions of our art to that high rank which it possessed in the best times of the Greek and Roman architecture.

To conclude, it has been observed that in the highest state of polished society in all ages, painting, sculpture, and architecture were almost equally admired and understood. Nothing appears more rational than that this should be the case, since in the exercise and display of the highest excellencies of the fine arts they must depend on and mutually assist each other. The artist who truly feels and appreciates the beauties of either [any] of the arts of design must possess sufficient taste for and knowledge of the others, although it cannot be expected, from the shortness of life and the difficulties and extent of art, that the mind of one man should be so comprehensive as to embrace them all in an equal degree. This was not attained even by any of the great masters of the fifteenth and sixteenth centuries, yet many of them had acquired that competent knowledge of each which must be seated in the same individual before he can hope to rival them, or achieve such superiority as will endure to posterity. It may be added that when the higher excellencies of art are felt by an enlightened public, taste and elegance will become generally diffused. The light and elegant ornaments, the varied compartments in the ceilings of Mr. Adam,

imitated from the ancient works in the baths and villas of the Romans, were soon applied in designs for chairs, tables, carpets, and in every other species of furniture. To Mr. Adam's taste in the ornaments of his buildings and furniture, we stand indebted, inasmuch as manufacturers of every kind felt, as it were, the electric power of this revolution in art. Our printed linens and paper hangings exhibited such specimens of decoration that the admirers of the Loggia of the Vatican could not see without their rendering due praise to them.

To the spirited and patriotic exertions of Mr. Wedgwood we owe, if not the introduction of Etruscan ware, at least an amazing improvement in the manufacture thereof, as by his liberality in employing Webber[8] and other distinguished artists in forming designs from the antique, he gave a celebrity to the productions of modern Etruria only to be surpassed by those of the ancient Etruria. The novelty and elegance of this manufacture was not confined to vases and other ornamental works, but the spirit of refinement became general, and the whole of the pottery of Etruria became an assemblage of models of delicacy and exquisite taste. Even the plates of Etruria displayed such simplicity of form and correctness of drawing in their varied decorations, as to dispute the palm of merit even with those of Raphael himself.

If such be the power and effect of novelty, how cautious ought we to be in what we offer for imitation? For although in the instances mentioned, fortunately true taste and elegant refinement generally prevailed, perhaps, had that not been the case, and had novelties of an inferior and less classical kind been ushered into the world by some amateur of taste, they might have spread for the time their baneful influence full as wide, and as extensively, and have been as destructive to the diffusion, and establishment of good taste, as in this case they proved advantageous and beneficial to the arts in general.

[8] Henry Webber (1754–1826), chief modeller to Josiah Wedgwood.

LECTURE XII

⤳

MR PRESIDENT, – In the last lecture I pointed out that in the exercise and display of the great excellencies of the fine arts each must depend upon and mutually assist the other; and that in a superior state of polished society the value of painting, sculpture, and architecture has at all times been duly appreciated, and each of those arts equally admired and cultivated. The artist who truly feels and appreciates the beauties of either of the arts of design must possess a competent taste for, and knowledge of, the others, although it cannot be expected from the shortness of life and the extent and difficulties of art that the mind of one man should be so comprehensive as to embrace and excel equally in the practice of all. This was not attained even by the great masters of the fifteenth and sixteenth centuries, yet many of them possessed that complete knowledge of the fine arts in general which must be seated in the same mind in order to attain such excellence as to command the admiration of posterity.

If the higher excellencies of art are felt by an enlightened public, taste and elegance soon become generally diffused. The light and elegant ornaments, the varied compartments in the ceilings of Mr Adam (imitated from the baths and villas of the Romans), were soon applied in designs for chairs, tables, carpets, and other species of furniture.

Manufacturers also of every kind felt, as it were, the electric power of this revolution in art. Our printed linens and paperhangings exhibited such specimens of decoration as the admirers of the Loggia of the Vatican might regard with satisfaction.

The taste for elegant forms thus kindled, the works of the Etruscans were not overlooked. The patriotic exertions of Mr Wedgwood, aided by the talents of Flaxman, Devaer,[1] Webber and other distinguished young artists of that day, soon have a celebrity to the productions of modern Etruria, only surpassed by the labours of the ancient Etruscans.

The novelty and elegance of this manufacture was not confined to vases and other

[1] John Devaere (1755–1820), who succeeded Webber as one of Wedgwood's chief modellers.

ornamental works. The spirit of refinement became general, and the whole of the pottery of Etruria was an assemblage of delicacy and elegant taste.

Among the various studies which have been pointed out to the attention of the students in these lectures, none is of greater importance in the interest of the employer and to the professional character of the architect, or so well calculated as to ensure his success in life, as a thorough knowledge of construction, and of the nature and quality of the different materials applicable in the formation of buildings of different descriptions, together with the most durable, substantial, and economical modes of applying them. Without this knowledge, which can only be obtained by great experience and attentive observation formed on real practice, all other acquirements in the architect will be of little avail.

The attention of the student should be steadily directed to these objects. He cannot be too strongly impressed with their importance, and I feel the more anxious on this subject because, from some unaccountable fatality, this part of architectural study, this duty of the architect, is considered by many of the young artists as of less utility and more easily attained than it really is, a mistake seldom discovered until it is too late.

If we search into the historical records of different countries and ages respecting the construction of buildings in very early periods as well as in later times, we shall trace many fatal effects that have arisen from the use of bad materials, defective construction, and presumptuous ignorance.

The ancient architects seem to have been extremely anxious to leave to the most distant periods testimonials of their great powers of construction. They accordingly spared neither labour nor expense in order to give their different buildings that stability, strength and solidity, which might triumph over all common accidents, and bid defiance to the reiterated efforts of time. Nay, many of the works of the middle ages likewise, after a lapse of six or seven hundred years, have shown not much greater symptoms of age and decay than the alteration in the colour of the different materials, whilst many edifices of more recent date afford the most melancholy examples of the too general disregard of solidity of construction, and to the due selection and application of materials.

It has been stated by some writers on architecture that, after the magnitude of any composition, together with the forms of the component parts, and the style of the decoration is determined, the chief remaining duties of the architect consist in raising the edifice, not in the most substantial manner, but with the greatest lightness of construction and the least practicable expenditure of labour and materials and, some have added, with the greatest expedition possible.

However plausible this may be in theory, it will be found deceptive in practice. Had the great masters of our art in the ancient world formed their practice on these principles, where could we have found those noble works which, notwithstanding the ravages of time, the fury of barbarians, and the prejudices of fanatics are still in existence? If the modern

system of false economy, false mechanism, and great celerity is persisted in, it must eventually destroy every principle of real economy. It will extinguish the love of our art, it will destroy all true feeling and consideration for that solidity of construction so happily practised by the Greeks and Romans, and place the flimsy, paste-board erections of speculative visionaries far beyond, not only the best examples of modern times, but the most sublime conceptions and successful efforts of antiquity.

The admirers and advocates of the system of extreme lightness of construction and least possible consumption of materials refer us to some of our Gothic cathedrals. In these, say they, the immense vaulted ceilings are often only four or five inches in thickness, whilst those of the ancients are frequently two feet or more. Be it so, in the first place it must be noted that the vaultings of the former are only secondary coverings, there is uniformly over them an elevated roof of timber, usually covered with lead, whilst the Roman buildings had none of this roofing.

In a former lecture of the first course, when speaking of arches, amongst other causes of the origin of the Gothic or pointed arch, it was presumed that it might possibly owe its origin to their intersection of the boughs and branches of trees. In support of this idea, the ingenious and poetical opinion of the author of 'The Divine Legation of Moses' was quoted, that giant in literature and learned research who contributed most essentially to the revival of the Gothic architecture, and likewise in giving it an importance in the estimation of the most zealous admirers of Grecian art, expressed himself to this effect:

'The architecture of the Holy Land was entirely Grecian but greatly fallen from its ancient elegance. Our Saxon performances were indeed bad copies of it, yet still the footsteps of ancient art appeared in the circular arches, the entire column, the division of the entablature, into a sort of architrave, frieze and cornice, and a solidity equally diffused over the whole. Such was the origin of our Saxon buildings. Our Gothic ancestors, however, not satisfied with this mode, struck out a new species of architecture upon original principles derived from the custom of worshipping the deity in groves, the appearance of which they imitated so successfully in their buildings that no attentive observer ever viewed a regular avenue of well-grown trees, intermixing their branches overhead, but it presently put him in mind of the long vista through a Gothic cathedral; or ever entered one of the large and more elegant edifices of this kind, but it represented to his imagination an avenue of trees. Under this view of the subject, all the irregular transgressions against art, all the monstrous outrage against nature disappears. Everything has its reason, everything is in order and an harmonious whole arises from the studious application of means proper and proportioned to the end. For how could the arches be otherwise

than pointed when the workman was to imitate that curve which branches make by their intersection with one another? Or how could columns be otherwise than split into distinct shafts when they were to represent the stems of a group of trees?

On the same principles was formed the spreading ramification of the stonework in the windows and the stained glass in the interstices, the one being to represent the branches, and the other the leaves, of an opening grove, and both concurring to present that dim light, inspiring religious gloom.'[2]

This I have always considered a rational and ingenious account of the origin of what is usually called Gothic architecture.

Sterne says, 'if a man speaking of Locke's Essay on the Human Understanding should only say it is a history book of what passes in a man's own mind, he would make no contemptible figure in a circle of metaphysicians.'[3] So he that says so much and no more of the Gothic architecture from what is here quoted from the learned prelate will be looked upon as an oracle in an assembly of antiquarians; and if he will act upon the origin of Gothic architecture in his works he will be able to account for what he does, and will then deserve the mead of higher praise.

If we examine the remains of ancient buildings it will be found that, as far as was consistent with correct ideas of stability and duration, the ancients were [as] equally attentive to the economising of labour and materials, not only in their private but likewise in their great public edifices, as we are. And it must be admitted even by the coldest and most superficial observer of ancient works that, as far as guarding against the effects of time and the convulsions of nature on their edifices, the object of durability was completely attained. What is the state of the Pantheon after a lapse of two thousand years? This noble structure, the glory of the ancient and the admiration of the modern world, still exists, notwithstanding it was exposed to all the seasons and the convulsions of nature from about the year 655 when Constantine the Second took away not only the silver and bronze ornamented panels of the interior of the dome, but likewise the plates of gilded bronze which covered the exterior of the dome of this mighty fabric. Thus dilapidated, this stupendous structure remained exposed (or at best defended only with tiles) until Benedict the Second caused it to be covered with lead. Then came Urban the Eighth who robbed the portico of its ancient magnificence by taking away the bronze which so profusely covered the beams and ceiling, sufficient indeed not only to make the Baldaquin of St. Peter's, but likewise several pieces of artillery for the Castle of St. Angelo. With Raphael,

[2] William Warburton in *The Works of Alexander Pope, Esquire*, London 1751, vol. III, pp. 266–69.

[3] A paraphrase of Laurence Sterne, *The Life and Opinions of Tristram Shandy, Gentleman*, 6 vols, London 1772–73, vol. I, p. 175. Sterne wrote 'man's own world', not 'man's own mind'.

however, this noble structure had experienced a different treatment for, to his eternal honour, at his death he left a considerable sum of money for the reparation of the Pantheon.

Thus exposed, neglected, and repeatedly plundered, such was the original sufficiency of the construction of the Pantheon that it exists to this day in a state comparatively perfect as to solidity.

So likewise the marble roof of the Temple of Minerva at Athens remained almost unimpaired until Athens was besieged by the Venetians when, by the bursting of a bomb, a large part of the beautiful roof of the temple was destroyed.

Whilst such is the effect of the ancient construction, our great Gothic cathedrals, without experiencing the various spoliations or casualties of war to the extent which befell the ancient buildings, many of them after a lapse of only a few centuries are in a most dilapidated state. Sir Christopher Wren, after a most accurate investigation,[4] has declared that most of the slender pillars in the naves of our cathedrals have been forced out of their perpendicular bearing by the pressure of the vaults of the side aisles against them, occasioned by the light manner of construction practised in those buildings which, although in many instances of a superior kind and conceived on true mathematical principles, yet are not always so. The passion of the builders of those days for the too great economising of materials and labour, added to their desire for boldness of construction and lightness of effect, tempted them to the over frequent use of iron, the fatal effects of which not properly prepared and properly confined, are but too visible in many of the buildings of this metropolis, as well as in that shown in this drawing.[5]

In the use of iron we should do well to follow the practice of the ancients. They were cautious of connecting together the different parts of their buildings with iron, although at Baalbec the columns of one of the temples whose shafts are in three pieces, are connected together with iron axes or pins of a foot in length, and as much in circumference. Yet copper, being less liable to rust and consequently not so likely to injure the stone, the ancients preferred that metal for cramping their work together, as appears not only from various records but, when a part of the Colosseum was thrown down by an earthquake, several metal cramps, run with lead, were found therein. Writers, likewise, speak of the use of large cramps of wood in ancient buildings, which assertion is strengthened by the testimony of Monsieur Le Roi, who tells us that at the foot of Mount Laurium he saw two parts of a very ancient column connected together with dovetailed keys, made of a hard red wood, well preserved, let into holes three inches wide and four inches deep.[6]

[4] In Stephen Wren, *Parentalia, or Memoirs of the Family of the Wrens*, London 1750, p. 306.

[5] Soane here illustrated iron railings between columns in the Threadneedle Street front of the Bank of England.

[6] J.-D. Leroy, *Les ruines des plus beaux monuments de la Grèce*, 2 vols, Paris 1770, vol. I, p. 4.

If modern buildings have suffered by this deviation from the practice of the ancients, we have much more cause to lament the neglect of their precautions with respect to the foundations of our buildings. Even some of the great architects of the fifteenth and sixteenth centuries were too often led into fatal error from precipitancy, and from the affectation of too much lightness of construction.

The tower and baptistry in the great piazza at Pisa are proofs of a want of attention to the foundations.

The walls of the first Basilica of St. Peter, built by Constantine, were charged partly on the foundations of the Circus of Nero, and Bramante was in such haste to begin the new church of St. Peter that he not only proceeded before any plan was absolutely determined on, but he likewise neglected to take up the old foundations of the Basilica of Constantine and of the Circus of Nero. And by this precipitancy he prepared the way for those mighty failures which have called forth all the knowledge of the numerous architects who have succeeded him in unsuccessful endeavours to correct the original defects. And what is still more remarkable there was no settled plan for this stupendous structure until Michael Angelo gave it the form of a Greek cross. This plan was afterwards changed by Carlo Maderna who made use of the old substructions, and by his haste and inattention increased the mischief which the precipitancy of Bramante had occasioned.

Bernini felt the effects of the ignorance of that patronised blockhead, that self-created architect, when after Maderno's death, it was determined to erect a tower at each end of the front. Bernini, without having properly examined the substruction, began one of the towers, but before it was finished its great weight proved so fully the insufficiency of the foundation that the work was suspended and, after every effort to strengthen the base, it was found absolutely necessary to take the tower entirely down. To this misfortune, soon after succeeded another, an effect of the haste used in the building of St. Peters. The great dome which had occupied six hundred workmen night and day for twenty-two months, in one hundred and fifty years showed such symptoms of decay that finally it was resolved to secure it from destruction by encircling the dome with four bandages of iron of about five inches in thickness, and from six to seven inches broad. These bandages were fixed with fifty wedges of iron driven by as many workmen who by a signal all struck at the same time.

To build on a rock is strong to a proverb, but even rocks are not always to be depended on, vents and chasms may lurk beneath, and eventually endanger the most perfect superstructure. The Greeks and Romans were fully aware of these facts, and Pliny tells us that the great Temple of Diana at Ephesus was placed by choice on a marshy ground that it might not be subject to injury from the effect of earthquakes.

Wells should be dug in different places, and every other precaution taken to ascertain the nature of the soil on which the edifice is to stand. This information acquired, the

architect can proceed with certainty, either by piling or planking, or without either, as the nature of the soil may require.

The duration and perfection of all buildings depend so much on the strength and goodness of the foundations that too much attention cannot be given to securing in the most perfect and complete manner the base whereon the superstructure is to be raised. Let not therefore any improper consideration of economy induce the young architect to lose sight of (for a moment) the necessity of securing in the most solid and perfect manner every part of the foundation of his building. The smallest defects in this essential part are irretrievable and almost inexcusable.

But it is not only the goodness of the foundation that must be consulted; the general solidity likewise requires great attention and knowledge in the selection of good and fit materials, and the proper application thereof. It therefore behoves the architect by practical experiments on stone, wood, iron, lime, and sand, to ascertain their properties and powers to resist, support and connect. Materials of the same description and quality are not alike fit on all occasions: in every building some parts require the best materials, whilst in others, those of an inferior and coarser quality are even more suitable.

In these cases the judgement and experience of the architect should be exercised in discriminating the choice and propriety of application [of materials] to the different purposes of the building. He must be careful to distinguish the accessory from the principal, and never confound those parts which have great weights to support, or the thrust of arches to resist, with those which have none of these services to perform. The remains of ancient buildings offer examples of many different modes of blending or bonding together the several parts of the walls.

Vitruvius says the thickness of walls ought to be half the height up to the rise of the wall out of the ground. In modern works we are generally satisfied with spreading the footings somewhat beyond the walls which are to be placed upon them.

The Greeks, and after them the Romans, to render their works eternal, frequently, at least in their public buildings, excavated the whole superficies until they reached a firm stratum. The whole space was then covered with solid masonry to nearly the level of the ground. This practice prevailed in later times. The architects of the great Gothic cathedrals, both here and upon the continent, seem generally to have been not unmindful of the sufficiency of their foundations. They did not fail to consolidate them with considerable care: under each row of pillars separating the nave from the aisles there was a continued wall of masonry; from each pillar of the nave a wall was extended to the outside walls of the edifice; walls were likewise built under the union of the arms of the cross to join together the piers of the angles; and if the cathedral had two towers, then a continued mass of regular masonry connected the whole of the building at the base, and thereby formed that just equilibrium calculated to ensure durability and solidity to the whole structure.

The moderns in their buildings of importance have sometimes used the manner prescribed by the ancients, as in the Sacristy attached to St. Peter's Church in Rome, and at other times followed the examples to be found in the Gothic structures. On other occasions they have contented themselves with single piers instead of continued walls, and with turning inverted arches from one to the other, as a less expensive mode of uniting the different parts of the foundations, so as to produce equal solidity, with a much less quantity of materials, and considerably less labour.

These different modes of laying the foundations of buildings are unalterable: they are all derived from general principles.

Of all foundations, those under water are the most difficult to execute, for in these the most skilled architect, like the physician, is compelled to grope in the dark. When the water is very deep the foundations are formed by driving in long beams at proper distances, and connecting them together with other beams placed transversely. If the river be too deep and too rapid to admit of this mode, then the foundation is made by throwing in a great quantity of large stones without mortar, the one upon the other, raised as high as the level of the water.

Foundations thus formed must be very expensive, and what is worse, superstructures raised on bases composed of stones heaped confusedly together without connection, with the water constantly filtering through them, can have but little solidity.

The celebrated bridge of Trajan over the Danube is supposed to have been built in this manner. When the amazing dimensions of this bridge are considered and compared with that over the Thames at Westminster, it is not surprising that a superstructure raised on such an uncertain basis should be anything but durable. Hadrian could have had but little trouble in destroying it.

To build in water with more solidity we generally make use of timber caissons well secured with iron and filled with stones and masonry. These caissons are then sunk with care, one upon the other as nearly level as possible. This species of construction, though better than the preceding, cannot have any great consistence: the different caissons cannot form one body, nor can the mortar unite itself with the wood.

When the water is not very deep, the foundations are sometimes placed on an open platform of carpentry, which is supported on the surface of the water by cables and machines. On this platform (or grillage) are arranged large blocks of stone well cramped together, sufficiently high to reach from the bottom to the top of the water, which are then sunk.

Vitruvius relates that the ancients to build moles or the jetties of ports formed in the place they intended to build an enclosure with a single row of piles, the intervals between which were filled with thick planks. Then, without taking out the water, they threw into the enclosure stone and mortar of Pozzuoli, so that these materials, occupying the space of the water driven out by their weight, filled the space enclosed by the piles; and having

taken out with hydraulic machines the remnant of the water contained therein, if they considered the ground solid, they then built on it, or they otherwise drove piles into it.

It is certain, however, that no foundations except upon piles can be considered really solid. The usual process of forming a foundation with piles is by making a batardeau enclosure round the space each of the piers is to occupy; and then, by the assistance of chain pumps to force the water out of the enclosure, the piles being driven till they reach the solid bed of earth can be forced no further.

If the difficulties in the construction of bridges are great, the honour of directing and the satisfaction arising from tracing the progress of such works is commensurate with the anxiety they occasion.

In the bridges of the ancients we trace the same grandeur of mind as in their temples and other public works.[a]

To enable you to form some faint idea of their magnitude I have shown Trajan's bridge over the Danube, together with Westminster Bridge, drawn to the same scale. Some remains of this stupendous work it is said are still to be seen, but what it was when perfect can only be known from the authority of ancient writers.

The ruins of the bridge built by Augustus over the Nar are sufficiently considerable to convey an idea of its ancient grandeur. The bridge at Rimini and the ruins of many others might be here adduced in proof of the great attention paid by the ancients to this species of building so admirably calculated to show the utility and the mighty genius of architecture.

In the construction of bridges the architects of France, by their close application to the science of 'La coupe des pierres,' have given a high degree of lightness to their appearance and, by the flatness of the arches, an ease of ascent unknown before Perronet's celebrated work at Neuilly.

Of this noble structure, that great artist has given such very accurate details and scientific representations, that we can trace readily, with pleasure and profit, his arduous undertaking from its commencement to its completion.

The bridges of Switzerland must not be unnoticed. They are entitled to the attention of the students in architecture and show as much deviation from the general system of bridges which are constructed with wood, as the bridges of France do from those of the ancients. In the Swiss bridges, utility has been studied more than beauty: they are very peculiar in their construction. Many of these suspended bridges are of considerable dimensions, and as they generally extend from the abutment on one shore to the corresponding abutment on the other, two great advantages are obtained: there are no piers to

[a] Note. Anciently when they wanted to construct a bridge, they began by adding another channel to the river to turn off the waters, and when the ancient bed was dry, or nearly so, the bridge was erected. (Beloe's Herodotus, vol. I, p. 123.)

interrupt the navigation, and the passage above is made nearly level, the floor being supported by the superstructure.

On the construction of buildings, the French artists have, as has been already noticed, greatly the advantage over our students. Nor will it be possible to remedy this evil until schools are established in this country, not only for students to acquire a facility in drawing in all the departments necessary to the architect, but wherein likewise every branch of the mathematics connected with our noble art will be explained, and the principles and practice of construction detailed to them, not by lectures, drawings, and models only, but by ocular demonstration, and the practical explanation of whatever is made from time to time the object of their studies. Until such schools are established (and I trust the time is not far distant when such will be the case) for the education of those who are destined to be architects, I should advise the young student to examine from time to time the construction and progress of every building into which he can gain admittance. By attending carefully, even to the defective construction of the speculative economists, he will at least gain experience of what is to be avoided; nay, he would by such observations be enabled to account for many of their defects, and perhaps be enabled to point out the best means of stopping the progress of the evil. The greatest difficulty oftentimes is to ascertain the cause of defects in buildings. By attending the progress of buildings and by making drawings of them in their different stages of progress,[7] the student will not only attain great skill in the mechanism of buildings, but at the same time discover many effects of light and shade which a close observation of nature alone can give. By this mode of study he will acquire a facility and freedom in drawing, and at the same time observe and treasure up in his mind a variety of forms and ideas that the same buildings when finished would not convey. The young artist must not stop with making such drawings: he must at the same time consider and make his remarks on every part of the construction, and if, after the work is completed, defects appear in the building, he will then be enabled to account for them, and what is still more important, he will be able eventually to avoid similar ones in his own works.

This mode of study unites the 'Utile and Dulce,' and I should expect that the student who adopts it will gain a very considerable advantage in drawing, composing, and constructing.

The drawings here exhibited show what has been the general practice of my pupils, by whose unremitting exertions and anxious zeal I have been enabled to exhibit so many drawings in elucidation of the principles and opinions advanced, and for which I here offer them my best thanks.

The first three of the drawings just exhibited are of the Picture Gallery and Mausoleum of the late Sir Francis Bourgeois at Dulwich College. The next are of the Infirmary

[7] Soane here showed drawings, made for him on site visits by his pupils, of his Dulwich Gallery under construction.

attached to the Royal Hospital at Chelsea, and the others are descriptive of the Three per Cent Consols Transfer Office at the Bank in its different stages of progress until its completion. This room, although of large dimensions, is, like the rest of the large offices at the Bank, constructed with incombustible materials.

To enter as fully as I could wish into all the useful and necessary details of construction would require more time than can be taken for the whole course of lectures. I have therefore only made some general and disjointed observations on these points, yet I trust they will be sufficient to impress the minds of the young students with the importance of the subject. It was my intention likewise to have shown the students the method of construction in use in some of the principal cities raised in ancient and modern times in different countries, under the various effects of climate, materials, and other local considerations, and whether in the Grecian, Roman, or Gothic styles.

The student must attentively peruse and well digest the writings of Vitruvius, Palladio, Scamozzi, and Vignola; and after them, the best modern authors of every country must likewise be diligently read. Thus prepared, his road will be easy and direct, difficulties will vanish, he will be honoured whilst living and when dead, Fame will enrol his name in her fairest page, transmitting his memory to the latest posterity.

In the long train of evils to which modern houses are subject, fire, is of all others most to be dreaded, more particularly in great and populous cities.

It has been observed that fires are much more frequent and fatal in England than they are on the continent. The reason is obvious: their buildings are frequently constructed of incombustible materials. Here our builders are satisfied with timber, and instead of walls for separation we have wood partitions from the cellars to the garrets. Instead of floors formed of flat arches, composed of bricks or cones, or of other incombustible materials, we have only floors of timber. Pointed roofs, it must be admitted, cannot be so easily constructed with solid materials, but why not substitute flat roofs? And at all events make as much use as possible of incombustible materials. Is it not painful to observe walls of thirty, or even forty feet high, in some of the most populous situations, supported on the most paltry timber mechanism, when they might be so easily charged on iron cradles with iron columns under them? It should be an axiom in building that timber should never be employed in any part of an edifice where incombustible materials can be substituted. The use of timber and other perishable materials may give a facility and expedition in raising the edifice, but as a general principle it should never be resorted to except from absolute necessity.

Whoever looks at St. Paul's Cathedral without trembling for the fate of that noble fabric, should lightning or any other cause communicate fire to the timber work of the dome? However admirable the carpentry may be in its construction, and however easy of reparation in all its parts, yet it must be lamented that the whole of the dome and vaulted ceilings were not constructed with incombustible materials as at St. Peter's in

Rome, Sta Maria del Fiore at Florence, and many other of the great structures on the continent.

It is the general adoption of timber that occasions so many of those great fires whose ravages cannot be looked at without shuddering on account of the number of lives that are annually sacrificed, as well as the buildings, together with the valuable works of art of every description contained in many of them which the world is thus deprived of.

Within a few years, the church of St. Paul, Covent Garden, fell a sacrifice to this consuming element, and although it has been partially restored, the admirers of Inigo Jones have much to lament. The Pantheon in Oxford Street affords another melancholy example of the fatal effects of fire. Even a slight inspection of this drawing will cause every lover of architecture to lament the destruction of this masterly composition.[b] This loss was followed by the destruction of Covent Garden Theatre, Drury Lane Theatre, the English Opera House, and many other costly structures.

Notwithstanding these dreadful examples, and many others that might be enumerated, such is the power of prejudice and the force of example, and such the influence of interested motives, that the old system of building is still suffered to continue. Yet let us hope that the time is not far distant when the legislature, reflecting on the number of lives that are annually sacrificed by the ravages of fire, and roused by the repetition of the dreadful miseries occasioned by the too general use of timber, and by bad construction of every kind, will revise the Act for the better preservation of buildings against fire, and cause such enactments to be made as will render it the duty and interest of every builder to guard by every means of good construction against the effects of that dreadful and all consuming tyrant who spares neither age, nor sex, neither lives nor property.

After fire the next great enemy to buildings of every kind is a species of decay called the dry rot. This pestilential disease, this noisome defect, now become so general in the buildings of the present age, was scarcely known in those of former times. How does it happen? Is it from ignorance or neglect that this evil is now so severely and generally felt? Are the builders of these days less informed, or less moral than those of earlier times? I answer, certainly not. The principal causes of this evil are easily explained, and the bare mention of the causes will at once suggest the remedies.

The building even of a country gentleman's residence was formerly a work of consideration. The materials were collected together and arranged long before they were used, and when the walls were raised and the work roofed in, the building remained in that state for a considerable time, whereby the walls became perfectly dry and the timbers duly seasoned. In modern works some of the walls, from false economy, or rather from improper parsimony, are so thin that the weather beats through them, and others, in damp situations,

[b] Note. The chapel of Greenwich Hospital destroyed by fire is another instance of a prodigious sum expended in rebuilding which by a different mode of construction might have been avoided.

left unprovided with vacuities to resist the effects of damps, as particularly directed by Vitruvius. The stone, instead of being, as that great architect recommended, two years out of the quarry before it is used, and the timber, instead of being felled for years before it is worked, are hurried from the quarry and the forest into the building, the finishings, frequently begun even before the building is secured from the weather, and continued to its completion without intermission and with all possible expedition. Thus the damps are shut up in the walls, and the moisture in the timbers. Structures that would have occupied the attention of our forefathers years in raising, are now built, finished, and inhabited in as many months, and thus the foundation of speedy decay is laid by the original sin of construction. And probably the rot has made considerable progress even before the house is fit for habitation.

It may be further observed that every part of the work is made so perfectly close that no air is allowed to enter; and hence many of the miseries and annoyances from smoke and its troublesome attendants whose effects are frequently improperly attributed to the ignorance or neglect of the architect, and the dishonesty of the workmen.

Besides these difficulties, the architect has others to combat with; the cold of our apartments, particularly when they are of large dimensions, is often a subject of complaint. When we changed the small doors and windows of our old houses into others of very large dimensions, we admitted the sun, and with that glorious luminary came cheerfulness also. But when copying French fashions too closely without due consideration, windows in every aspect have been made preposterously large, and the piers between them, comparatively speaking, ridiculously small. When doors were made to occupy the greater part of the entire side of the room; when, for the thick walls of houses of early times we substituted walls barely sufficient to support the floors and roofing, and to receive the flues of the chimneys, walls so thin and so loosely constructed that the air penetrates them and the smoke issues from crevices far removed from the seat of the fire or the direction of the flues; we then begun to complain of the inferiority in these respects of modern buildings, and with reason. Is it possible, with such false economy and such miserable construction, to be surprised that our houses are damp, cold, and uncomfortable, as well as continually requiring reparation in their most essential and constituent parts?

These, it must be admitted, are among the sore evils to which buildings are liable, and which it behoves the architect to employ the most attentive and unremitting exertion of his talents and experience to avoid all such defects in the works with which he is entrusted, and wherein after all his care and diligence, his efforts cannot always be successful. Let us, before we censure, distinguish between the unavoidable failings of the intelligent and scientific, the ingenuous and modest, artist whose best exertion of his talents and experience have been diligently called into exercise in the honest discharge of the great trust reposed in him, and those of the ignorant and uninformed, 'not only of architecture, but of everything relating to Fabrics': persons who think that no man can be skilful who is

not rich, persons who by joining assurance to riches, and aided by craft and political cunning, together with servility, by perseverance, often find powerful patrons, thereby robbing the real artist of the well earned reward of his labours, leaving him, with all his modest merit and sterling worth, to pine in that indigence as to employ[ment], and that dignified obscurity which attended our great master Vitruvius: who with all the pride of an ingenuous mind, feeling for the dignity of our noble art, exclaims 'I have learnt from authors that it is proper to be requested, not to request the care of any building; I have, (continues he), not endeavoured to obtain great wealth by my art, having preferred a little with a great name, to an abundance attended with infamy.'[8]

I trust by this digression not to be here supposed as apologising for the defects of the architect, nor endeavouring to screen him from any of the effects of the great but necessary responsibility attached to his profession, and for which he is liberally remunerated. No such idea will ever enter the mind of our young architects, the legitimate offspring of Vitruvius, who tremblingly alive to the honour of their profession will never shrink from the most severe duties, but readily and cheerfully brave all the difficulties as well as the mortification of seeing themselves too often supplanted by the unlearned and unworthy.

Many of the most serious disappointments that attend those who build would be avoided if models were previously made of the edifices proposed to be raised. No building, at least none of considerable size or consequence, should be begun until a correct and detailed model of all its parts has been made. Such models would be of great use not only to the workmen, but to the architect likewise. Formerly models were considered as essentially requisite in civil, as in military architecture, and no building was begun without a model having been previously made thereof.

Of the basilica of St. Peter in Rome there was a very large and expensive model which was carefully preserved. There is likewise a large model of the original design by Sir Christopher Wren for St. Paul's Cathedral which is still preserved. In later times there was not only a general model of the Mansion House, but likewise many of all the cornices and other enrichments of their full size. In my own practice I have seldom failed to have a model of the work proposed, particularly of those large rooms at the Bank constructed entirely of incombustible materials, such as these and those already exhibited in the course of these lectures. And I must add that wherever the model has been dispensed with, I am afraid the building has suffered in consequence thereof, either in solidity or convenience, and perhaps in both.

Models have generally been considered as expedient on most occasions. My late worthy and intelligent friend, the author of Oikidia[9], was so fully persuaded of the advantages of this practice (although he has prefaced his recommendation of their use with some

[8] *De architectura*, VI, Preface, 5.

[9] James Peacock, *Oikidia or Nutshells: Being Ichnographic Distributions for Small Villas*, London 1785.

satirical though just observations) that he tells us, 'When the person who wishes to build is possessed of the design, with a correct and detailed calculation of the estimated and probable expense, his next step should be to cause to be made, not a gaudy eye trap, to dazzle and confound the ignorant and to take in the unwary, but a complete plain model shewing all the parts of the design he has approved.'

'In this model if he places a few blocks of wood, cut out by the scale of the model to the proper dimensions and shapes of bedsteads, tables, chairs, and other useful pieces of furniture, he will find himself amply rewarded for the trouble, by the facility of construction and the various circumstances of convenience, which, without a model, would in most cases be overlooked.'[10]

It is much to be lamented that of the remains of the great structures, once the pride of Greece and Italy, and of the Gothic buildings, we should possess so few models; and even those, so far as I have seen, are insufficient to explain their different modes of construction.

Drawings and prints of them we have, it is true, varied ad infinitum, but they only convey certain ideas and make certain impressions. If premiums were to be given for the best executed and most accurate models made from actual mensuration of some of those works, on a scale calculated to show the manner in which the walls are built, the Coupe des Pierres of the arches, the vaultings, the framing and dimensions of the timber roofings, with the iron ties, cramps, and minute parts detailed, what a rich field of information and improvement would thereby be laid open to our artists and the different mechanics concerned in building. Large models, faithful to the originals in every respect, not only as to form and construction, but likewise to the various colours of the materials, would produce sensations and impressions of the highest kind, far beyond the powers of description, sensations and impressions which can only be surpassed by the contemplation of the buildings themselves which, unfortunately for the artist, many causes frequently combine to prevent his enjoying.

The student in architecture, having duly contemplated such models, and diligently read the writings of Vitruvius and those of the great Italian architects to whom in a great degree we owe the restoration of the ancient architecture, if he have made himself thoroughly acquainted with that eccentric work of Francisco Colonna, 'Il sogno di Poliphilo,' the works of Piranesi, Desgodetz, Le Roi, Stuart, Belidor,[11] Gautier[12] and a few others of those who have written on the principles of building and of taste; if he have made himself so far acquainted with painting and sculpture as to feel their importance, if not their beauties, the student has then only to complete his studies by visiting foreign countries.

[10] Soane's loose paraphrase of Peacock, *ibid.*, pp. 55–56.

[11] Bernard-Forest de Bélidor, *Architecture hydraulique*, 4 vols, Paris and Strasbourg 1737–39, pp. 55–56.

[12] H. Gautier, *Traité des ponts, ou il est parlé de ceux des Romains et de ceux des modernes* (1716), 2nd edn, Paris 1765.

Thus prepared, the young architect may be reasonably expected not only to receive every possible advantage to be derived from the study of the extensive remains with which Rome and its Campagna, as well as many other parts of Italy, abound. During his stay on the continent he should mix as much as possible with artists of different nations. He should not only reflect on what he has read in his study but he must, from actual mensurations taken by himself, make finished sketches of such structures as are most valuable; he must closely meditate upon the original purposes for which they were raised; he must consider how far situation and materials influenced the architects of those structures. The mouldings, the ornaments, the most minute details, must not escape his observation. Now is the time, the golden opportunity, to treasure up in the mind as many ideas as possible, and which once neglected can never be recalled. The young artist, anxious to attain to superiority and truly emulous of fame, must go further: he must determine what part of his satisfaction or dislike grows out of each circumstance, and why. He must repeatedly observe and make himself familiar with the particular effects which result from each of the parts, and the general effect produced by their accord and combination. This is the only way to study the architecture of other countries, and to attain just ideas of that which is really beautiful and worthy of admiration in modern buildings and in those prodigious works of antiquity wherein we look to something beyond the taste in which they were conceived. The difficulty of constructing edifices of such astonishing grandeur and magnitude, the total disregard of expense where great national advantages were to be obtained so far beyond anything that modern times have produced, cannot fail to present themselves to the imagination of the artist.

Modern works in general must indeed appear small when compared with those of the ancients.

The construction of Stonehenge even, which is considered as a mighty effort, appears trifling when compared with the labour and difficulty of moving the rock which serves as a pedestal to the equestrian statue of the Czar, Peter the Great, raised to his glory by Catherine the Second at St. Petersburg, and which was effected under the directions of the Chevalier Lascaris. This immense block of granite, forty-four feet long, twenty-seven feet wide, and twenty-two feet high, was removed to St. Petersburg, partly by land and partly by water. By land it was rolled in the depth of winter a considerable distance on balls of copper, five feet in diameter, running on grooves of the same metal. Levers, four feet in diameter and sixty feet in length, were used to raise it out of the bog in which it lay. It was afterwards conveyed to St. Petersburg by water in a vessel built expressly for the purpose. This was no common task: it required a mind strongly fortified, and nerves well braced, to undertake such an Herculean labour. But even this falls short indeed of the means employed, the precautions taken, and the expense incurred, in raising the Obelisk in the Piazza of St. Peter's at Rome.

When we recollect that this very Obelisk of one entire piece of red granite, 107½

palms in height, 12 palms at the base, and 8 palms at the top, weighing upwards of one million pounds avoir-du-pois, had been brought from the quarry in Egypt a considerable way by land and then by water, we are really lost in admiration and astonishment. Fontana's account of this great work is so interesting that I cannot help giving it in abstract.

This Obelisk, which formerly stood in the Circus of Nero, was thrown down by Constantine to make room for his Basilica of St. Peter. It remained entire however, and Pope Sixtus Quintus conceived the idea of having it removed from the place where it lay and set it up in the middle of the Piazza in front of St. Peter's Church, a distance of about one hundred and fifteen yards. This was considered so very difficult an undertaking that His Holiness was advised to invite all the great architects, engineers, and mathematicians to consider of the best means of effecting the object. The learned and scientific of every country being assembled together for this purpose, some required months, nay years, for consideration before they could presume to offer any opinion. Others suggested a variety of different ideas on the subject as in their opinions best calculated to accomplish the object. After months of deliberation and repeated experiments on the different models presented, the most rational were selected, and ultimately that offered by Fontana was adopted.

Fontana then commenced his operations by assembling mechanics of every kind and collecting together an immense quantity of materials and implements of every kind, ordering a great number of cables to be made of hemp, one third of a palm in diameter, and two hundred yards long, with pullies, levers, and capstans without number. As many bands of iron were made to surround the Obelisk as together weighed at least forty thousand pounds. A platform was likewise formed of prodigious strength, sufficient to receive the Obelisk which, being secured with amazing quantities of timber and iron, increased the weight of the Obelisk to about one million and a half of pounds.

Machines were next contrived and a great quantity of pullies, levers and capstans provided for raising the Obelisk on the platform prepared to receive it. There being a considerable inequality in the level of the ground, a trench was dug, and a bed made of strong timbers the whole extent, on which the Obelisk, by means of rollers, might be moved from the place where it was to that of its final destination.

Such extraordinary and extensive preparations created the most lively sensations among the Romans, and brought such an immense concourse of people from all parts into Rome that, to prevent confusion, the Pope commanded that on the day on which the Obelisk was to be raised, no person whatever, the workmen only excepted, should be admitted within the enclosure. Moreover, all persons were commanded not to make the least noise, no, not even to speak to each other under pain of death.

On the 30th April 1586 was the day fixed for the great exhibition of Fontana's skill. Before daybreak the concourse of spectators was so great that all the streets and avenues leading to and about St. Peter's were filled, the roofs of the houses looking upon the Piazza

before the church were covered with an anxious multitude, all waiting in the deepest silence, attentive to observe the effect of such immense works of every description. High Mass had been performed at an early hour, and His Holiness, in giving his benediction to Fontana, reminded him of the greatness of the enterprise in which he was engaged. All the workmen likewise received the Pope's blessing. Every preparation being completed, orders were then given for the operations to begin at the first sound of the trumpet, and to cease when the clock of St. Peter's Church struck. The trumpet sounds, and in an instant nine hundred workmen, seventy-five horses, and an innumerable quantity of capstans, levers, and pullies, with the other appurtenances are all in motion. The effect was so great that the earth shook, and most of the large timbers which formed the machine for raising the Obelisk were pressed into each other. At length after twelve efforts, this mighty mass was raised sufficiently high from the ground to place it on the platform previously prepared to receive it. Here it was fixed with iron wedges and strong timbers. The guns of St. Angelo's fired to announce this happy event which spread general joy throughout Rome. The Obelisk was then placed horizontally on rollers, put on the bed of carpentry already described, on which it was taken by four large rollers worked by as many capstans to the place of its final destination. On the 10th day of September, the pedestal being erected, the same ceremonies were repeated as in the first operation, and with the power of eight hundred men and one hundred and forty horses, this Obelisk which the ancients had brought from Egypt, after fifty-two efforts was safely placed on its pedestal. This event was then announced from the Castle of St. Angelo by the discharge of all the artillery. The workmen, overjoyed, took Fontana on their shoulders and carried him home in triumph amidst shouts of joy and the sounds of drums and trumpets. Fontana was then made a Knight of the Order of the Holy Ghost and ennobled, with an annual pension of two thousand golden crowns to descend to his heirs; and medals were also struck in honour of the great work he had so successfully completed.

If all these gigantic preparations, if all these solemnities were used, to move the Obelisk a few paces only and to set it upright, what a mind must that man have possessed and what honours and rewards did he merit, who first conceived and perfected the idea of bringing such an immense mass of granite across mountains and seas from Egypt into the precincts of Imperial Rome? And what machines were made use of now fill the mind with awe and respect for the great architects of antiquity.[c]

The transporting such an object as this Obelisk by land and sea must have been attended with enormous expense; it speaks volumes as to the high consideration of its influence over the best political interests of nations. Architecture, whilst it dazzled and surprised by the sublimity and splendour of great public buildings in ancient times, raised

[c] Note. The Shrine of Latona at Butos was of one immense stone. Beloe's Herodotus, vol. II, pp. 97–8. The edifice built by Psammetichus. Beloe's Herodotus, vol. II, p. 123.

the mind to the highest pitch of enthusiastic reverence for the gods of paganism. And in later ages its powers have been felt equally both in church and state, witness the great religious buildings throughout Europe.

How highly architecture and its professors were held in ancient times, we have many testimonials. After the destruction of the Temple of Diana at Ephesus, Alexander, with that truly noble and elevated mind which always characterised him, requested the Ephesians to permit him to be at the whole expense of rebuilding the temple, provided he might have the gratification of inscribing his name on the work to that effect. This offer was as nobly rejected by the Ephesians, and the temple was rebuilt of such extent and splendour as employed Ctesiphon, Metagenes, his son, and their successors two hundred and twenty years in its construction, and exhausted all the wealth of Asia.

Having said so much in honour of architects and architecture, I must not in candour pass over the records of ancient writers of a contrary bearing.

Pausanias speaks of two celebrated architects, Trophonius and Agamedes, who were employed by Ilyricus in building a royal treasury at Libadia, a city of Boetia. In erecting this structure they contrived a secret entrance known to themselves only, and by which they could enter the place without being seen. Ilyricus, having missed his money from time to time, although the place always seemed secure and no injury had been done to the building or any of its fastenings, he placed a snare amongst the vases which contained his treasure. Agamedes going as usual was caught in the trap, and Trophonius seeing there was no possibility of extricating him, cut off his head, intending to carry it away, that the body should not be known. Such was the end of Agamedes. As for Trophonius, Pausanias goes on to state that the gods being shocked at his dreadful act, the earth opened and swallowed him up, leaving a large cavern upon which a column was placed, and which gave rise to the poet's 'Cave of Trophonius.'

There is another trait of bad faith recorded by Pliny and Strabo, not so atrocious as the former, but at the same time not very honourable to the architect. Sostratus, amongst other great works, having by the command of Ptolemy Philadelphus erected on the Isle of Pharos near Alexandria a stupendous lighthouse, and wishing posterity to give him the entire credit of the undertaking, placed on the building an inscription to the following effect, 'Sostratus of Gnides, the son of Dessifanus dedicated this building to the Gods, Protectors of Navigators.' This inscription he covered over with mortar, and placed another on it in honour of Ptolemy, which in time, it was presumed, would decay and leave the original inscription visible.

This building was hexagonal, each side extending six hundred and twenty-five feet, and it was four hundred and twenty-five feet high. When we compare this immense mass with the Cordouan (pl. 13) or with the Eddystone Lighthouse, we cannot be surprised that it was ranked among the wonders of the world.

If these bad examples of ancient times present instances of cupidity and vanity, let us

oppose to the conduct of Trophonius and Sostratus, that of Michael Angelo who gave up his labour and talents without any fee or reward but the honour, to the building of St. Peter's Church.

Architecture owes most of its importance to the refined policy of princes and the greater influence of the priesthood, to whom we are indebted for many of those great works which have been raised all over the globe. Indeed the power of the church seems to have been superior in all ages to that of the state, until our Henry the Eighth broke the charm. In his reign the pretensions of the church were pushed too far, and Henry seized their temporalities. From that period architecture lost much of its consequence, and its most powerful pillar, the support of the church.

Since the reign of Henry the Eighth we can only boast of the erection of one college, one cathedral, and a few churches of moderate dimensions. A regard for the national glory and gratitude to those who have achieved great actions, have occasionally given a stimulus to sculpture, but little has been done for painting, and still less for architecture except in the instance of Blenheim, the monument of Marlborough's glory.

We must now therefore look to other causes for the exercise of architecture on any large scale. It is to the patriotism and humanity of well disposed individuals that we are indebted for so many charitable and useful establishments. It is chiefly to great commercial spirit and enterprise on the part of the liberal and opulent merchants of London and Liverpool that we owe the immense harbours, docks, and warehouses for the East and West India Trade, and for the general commerce of this great empire, as well as the many great bridges, and numerous canals in every part of the kingdom. Many of these works, by their extent at least, would have done honour to Greece and Italy. Of some of them it may be truly said,

'These are Imperial Works, and worthy Kings.'[13]

To attain with the greatest facility correct ideas of architecture, the subject must be stripped as much as possible of its technical terms and sometimes an unavoidable dryness.

He that wishes to show his zeal and love for art, whether he volunteer his opinions to the world, or is called on to declare them, unless he can divest himself of early prejudices and root out every propensity to envy, spleen, vanity, and sour eyed disdain, however correct his motives may be, he will over-shoot his mark. Thus the advocates for Roman architecture, because it is said,

'Learning and Rome alike in Empire grew,
And Arts still follow'd where her eagles flew,

[13] Alexander Pope, *Moral Essays*, Epistle IV, line 204.

From the same foes, at last, both felt their doom,
And the same age saw Learning fall, and Rome,'[14]

they have therefore given no credit to the works of the Greeks, although even Vitruvius himself admits that the Romans borrowed their best notions of architecture from that enlightened people.

An ingenious writer on our art, whose name will ever be revered by those who duly appreciate the fine arts, was so fully satisfied of the superiority of the Roman architecture, and dreading the mischievous consequences of innovation, has thus, somewhat hastily, spoken of Grecian architecture: 'The famous Parthenon, which had for its architects Phidias, Callicrates, and Ictinus, was the boast of Athens, and excited the envy and murmurs of all Greece, was not so considerable as the Church of St. Martin in the Fields, exclusive of its elegant spire.' Judging from the drawing before you, this appears to be inaccurate; nor is the ingenious author more successful when he says: 'I am inclined to believe that many of the deformities observable in the Grecian buildings must be ascribed to their deficiency in the constructive part of architecture, such as their gouty columns, their narrow intercolumniations, their hypaethral temples which they knew not how to cover, and their temples with a range of columns running in the centre to support the roof.'[15]

The term 'their gouty columns' can only apply to those of the Doric order. If in the temples to Jupiter, the massive Doric was used, in other temples lighter proportions were adopted such as were more suitable to the character of the edifice. The 'narrow intercolumniations' in Grecian architecture, adopted by the Romans, among whom, according to Alberti, architecture attained its maturity, might not arise out of any want of constructive knowledge: they may be traced to other causes as probable at least.

If we compare two rows of large trees, one row having small regular intervals, and the other large spaces between the trees, although both are the same in extent, the first will produce infinitely more variety and beauty, and more apparent quantity than the latter. Can it be supposed that the Grecian architects, whose acuteness led them to make the external columns of their porticoes larger than the others, because they observed that the different quantity of air which surrounded them, made them appear smaller; having perceived this increased beauty, variety and enlarged quantity in the trees planted close, did not transpose the effect into their buildings?

'Their hypaethral temples which they knew not how to cover.' It is true the temples to Jupiter and other divinities were partly uncovered, not for the reason here assigned, but

[14] Alexander Pope, *Essay on Criticism*, line 683.
[15] Chambers, *Treatise*, pp. 19, 23–24.

because the ancients did not think it suitable that particular divinities should be confined in temples.

The dome of the Pantheon was not left with a hole in the centre from any deficiency in constructive knowledge, nor for light only, but rather it may be presumed in compliance with some religious mystery. The Temple of Minerva Medica was not lighted from the top; nor do I believe there is any other ancient temple lighted from a hole in the centre of the dome.

The criticisms just alluded to, are, however, only venial sins, the result of early prejudices, and zeal for established opinions. They may have arisen from errors of the head, but not from a defect in the heart.

In these lectures I have laboured to methodize and to bring into the smallest compass whatever information on our art I have attained by reading, observation, and long practice, that appeared to me worthy the attention of the students and calculated to assist them in their studies. I have likewise endeavoured to give the reasons for the opinions delivered. The principles laid down in most of the books on architecture are too often found to be so much at variance with each other, even upon very essential points, arising, apparently, more out of fancy and caprice than from the result of sound judgement and accurate reflection, and oftentimes in contradiction to first principles and the practice of the Greeks from whom the warmest admirers of other systems will not hastily depart when they reflect for a moment that whilst the various inventions of every kind in different ages and in different countries, have been constantly fluctuating and frequently changed by a succession of alterations and improvements, the works of the Greeks have remained to the present time the standard of taste and elegant refinement. To their three orders of architecture, after a lapse of two thousand years, as has been before noticed, no addition has been made, nor even one single moulding added to those we have received from that highly intellectual people.

Genius, theory, and practice must be combined to make a great artist. The seeds of genius, the candidate for architectural fame must receive from nature. Theory in a great degree may be acquired in his study by unremitting application and deep research, by close application and well regulated attention. Experience and the knowledge of the practice of building, can only be fully attained by time. No opportunity of improvement must be lost. The students in architecture should confer together on every occasion, and converse on the beauties and powers of architecture. They should communicate to each other, reciprocally, the knowledge they have attained, the discoveries they have made, and by every effort endeavour to make this first of the liberal arts as perfect as possible.

In this and the preceding lectures I have endeavoured to render the students in architecture every assistance in my power in the pursuit of their studies of that noble art. Much, however, remains to be done. I have only been able to speak cursorily of many

things of high importance, particularly as respects construction and the great use and advantage to be derived from seeing and comparing buildings of different descriptions.

To accomplish these objects several additional discourses on construction, accompanied not only with explanatory drawings and models, together with the results of practical experiments, would be necessary, but likewise some lectures on comparative architecture would also be desirable. Without these additional lectures, the labours of the professor will be still very incomplete. For these purposes I have collected a large quantity of materials, which I trust on some future occasion to be able to digest, and arrange for the use of the students.

Let me conclude by assuring the students that if my labours should prove useful to them, and are calculated to promote the knowledge and love of architecture, to make its worth and beauties and its true principles more generally known, the utmost extent of my ambition will be gratified, and the dearest and warmest wishes of my heart most completely attained.

> 'Content, if hence, th'unlearn'd their wants may view,
> The learn'd reflect, on what before they knew,
> Careless of censure, nor yet too fond of fame,
> Still pleased to praise, yet not afraid to blame,
> Averse alike to flatter or offend,
> Not free from faults, not yet too vain to mend.'[16]

At the close of the lecture on Thursday 21st March 1833, the following address was read by Mr Howard.

Mr President, At the close of the lecture this evening it was my wish to have addressed a few words to the members of the Royal Academy, but being fearful that it would not be in my power to give adequate expression to my sentiment, I have committed them to writing and requested my worthy friend, the Secretary, to read them.

On this occasion, I beg to state that in furtherance of my desire which was communicated to you last year of rendering the labours of a long life subservient to the promotion of art and science, and of giving to the public at large, and especially to my young friends around me, the students of the Royal Academy, facilities and access to a collection of works of art which has not been formed without exertion or obtained without expense, I have lately sought the aid of Parliament, without whose sanction my intentions could not be realised, of perpetuating for the public my museum and library in Lincoln's Inn Fields.

I had thought that a Bill for effecting so high a national object without injustice to any part of my family, and without any cost to the public, could have encountered no

[16] Alexander Pope, *Essay on Criticism*, lines 739–44.

difficulties. But the Bill not having yet passed into a Law, evinces that it has not proceeded without some opposition to which I aver with sorrow and regret.[17] The Bill, however, has passed at the House of Lords and has been read a second time in the Commons, and will, I hope, before Easter, have received the Royal Assent.

I will add that the hour which records this Assent will be amongst the happiest of my life.

When this is accomplished, that collection which is now my absolute property, I shall hold only as a trustee for the country; and when I can no longer give my personal care to its protection and enlargement, that duty will devolve on others who will exercise this trust under such regulations as will ensure the perpetuation of those national advantages to the promotion of which I have dedicated a large portion of an active and an anxious life.

[17] It would have been uncharacteristic of Soane not to have introduced a note of self-pity, even on this happy occasion. His Bill, opposed by his son, George, and by William Cobbett, received Royal Assent on 30 April 1833.

BIBLIOGRAPHY

~

PRIMARY SOURCES

Books are cited, wherever possible, in the editions which Soane read in his own library, annotating them, taking notes from them, and sometimes translating them. The reference numbers at the end of the entries are thus to the shelf-numbers in the Library of Sir John Soane's Museum. The initials 'AL' and 'GL' which follow these references indicate, respectively, the Architectural Library, housed on the first floor of the Museum, and the General Library, on the ground floor. This arrangement was introduced by A. T. Bolton, Curator of Sir John Soane's Museum from 1917 to 1945. However, in Soane's lifetime the library formed an intellectual unity in which books on different subjects were housed next to each other, though access must have been impeded by the fact that many of them were not shelved.

Adam, Robert, *Ruins of the Palace of the Emperor Diocletian at Spalatro*, London 1764 (AL 6C)

Adam, Robert and James, *The Works in Architecture*, 3 vols, London 1773–1822 (AL 6B)

Addington, Henry, *An Essay on the Affinity between Painting and Writing in Point of Composition*, Oxford 1779 (GL 22D)

Addison, Joseph, 'The Pleasures of the Imagination', *Spectator*, nos. 411–21, 21 June–3 July 1712 (GL 22G)

Aikin, Edmund, *Essay on the Doric Order*, London 1810 (AL 24)

Alberti, Leon Battista, *The Architecture of Leon Battista Alberti in Ten Books . . . Translated . . . into English . . . by James Leoni, Venetian, Architect*, London 1726 (AL 4A)

Albertolli, Giocondo, *Alcune decorazioni di nobili sale ed altri ornamenti*, Milan 1787 (AL 30)

Corso elementare di ornamenti architettonici, Milan 1805 (AL 44A)

Miscellanea per i giovani studiosi del disegno, Milan 1796 (AL 30)

Ornamenti diversi, inventati, disegnati ed eseguiti da Giocondo Albertolli, Milan 1782 (AL 29E)

Alison, Archibald, *Essays on the Nature and Principles of Taste* (1790), 2 vols, Edinburgh 1811 (AL 2C)

Allais, Guillaume-Edouard, Athanase Détournelle, and Antoine-Laurent-Thomas Vaudoyer, *Grands Prix d'Architecture. Projets courronés par l'Académie d'Architecture et par l'Institut de France*, Paris 1806 (AL 15)

André, Yves, *Essai sur le beau, par le père André J., avec un discours préliminaire et*

des réflexions sur le goût par M. Formey, Amsterdam 1759 (AL 37C)

Angell, Samuel, 'Sketch of the Professional Life of George Dance, Architect, R.A.', *The Builder*, vol. 5, 1847, pp. 333–35

Annals of the Fine Arts, 5 vols, 1817–20

Annual Register, 69 vols, London 1758–1824 (GL 8C–F)

(Anon.), *A Concise Review of the Concise Vindication of the Conduct of the Five Suspended Members of the Council of the Royal Academy*, London 1804 (PC 67/3)

A Concise Vindication of the Conduct of the Five Suspended Members of the Council of the Royal Academy, London 1804 (PC 67/1)

Apuleius, *'Cupid and Psyche' a Mythological Tale from 'The Golden Ass' of Apuleius*, London 1800 (GL 39B)

Archaeologia or Miscellaneous Tracts relating to Antiquity published by the Society of Antiquaries of London, 19 vols, London 1796–1835 (GL 39)

Aristotle, *Ethics and Politics . . . translated from the Greek by John Gillies*, 2 vols, London 1779 (GL 29D)

The Poetics of Aristotle translated from the Greek, with notes, by Henry James Pye Esq., London 1788 (GL 43B)

La Poetique d'Aristote, traduite en François . . . par M. Dacier, Amsterdam 1733 (GL 33B)

Ashe, Jonathan, *The Masonic Manual*, London 1814

Atkinson, John Augustus, and James Walker, *Manners and Customs of the Russians*, London 1812 (AL 21D)

Avril, Louis, *Temples anciens et modernes; ou observations historiques et critiques sur les plus célèbres monumens d'architecture grecque et gothique*, London 1774 (AL 43A)

Bacon, Francis, *The Essays, or Councils, Civil and Moral*, London 1701 (GL 15C)

Bannister, James, *A View of the Arts and Sciences, from the Earliest Times to the Age of Alexander the Great*, London 1785 (AL 32E)

Barry, James, *The Works of James Barry, Esq., Historical Painter*, 2 vols, London 1809 (AL 31A)

Barthélemy, Abbé Jean-Jacques, *Voyage du jeune Anacharsis en grèce dans le milieu du quatrième siècle avant l'ère vulgaire*, 4 vols, Paris 1789 (GL 26D)

Bartoli, Pietro Santi, *Gli antichi sepolcri, ovvero mausolei Romani, ed Etruschi* (1697), Rome 1768 (AL 6A)

Batteux, Charles, *Les Beaux Arts reduits à un même principe*, Paris 1746 (AL 2C)

Bélidor, Bernard-Forest de, *Architecture hydraulique*, 2 vols, Paris 1737–39 (AL 10C)

Bentham, James, *The History and Antiquities of the Conventual and Cathedral Church of Ely*, Cambridge 1771 (AL 29C)

Bernardin de Saint Pierre, Jacques-Henri, *Paul et Virginie* (1788), Paris 1795 (GL 33I)

Bianchini, Francesco, *Camera ed inscripzioni sepulcrali de'liberti, servi, ed ufficiali della Casa di Augusto scoperta nella Via Appia*, Rome 1727 (AL 44A)

Blondel, François, *Cours d'architecture*, 2 vols, Paris 1675 (AL 14C)

Blondel, Jacques-François, *Architecture françoise ou recueil des plans, élévations, coupes et profils des églises, maisons royales etc de la France*, 4 vols, Paris 1752–56 (AL 14C)

Cours d'architecture, 9 vols, (vols v–ix edited by Pierre Patte), Paris 1771–77 (AL 35A)

De la distribution des maisons de plaisance, et de la décoration des édifices en général, 2 vols, Paris 1737–38 (AL 14B)

Boffrand, Germain, *Livre d'architecture contenant les principes généraux de cet art*, Paris 1745 (AL 14D)

Boileau-Despréaux, Nicolas, *Oeuvres complètes . . . contenant . . . sa traduction de Longin*, 3 vols, Paris 1810 (GL 13C)

The Works, 4 vols, London 1712 (GL 13C)

Borlase, William, *Antiquities, Historical and Monumental, of the County of Cornwall, consisting of Several Essays on the First*

Inhabitants, Druid Superstitions, Customs, etc. London 1769 (AL 4C)

Bos, Lambert, *Antiquities of Greece*, London 1772 (AL 34B)

Bosse, Abraham, *Aux curieux de l'art de l'architecture, de la peinture, et de la sculpture*, Paris 1653 (AL 36D)

Britton, John, *The Architectural Antiquities of Great Britain*, 5 vols, London 1807–26 (AL 29B)

'Brief Memoirs of Sir John Soane, R.A., F.R.S.', *Fisher's National Portrait Gallery*, London 1834 (ML 48D)

The Union of Architecture, Sculpture, and Painting . . . with descriptive Accounts of the House and Galleries of John Soane, London 1827 (Soane Case 66)

Britton, John, and Pugin, Augustus Charles, *Illustrations of the Public Buildings of London*, 2 vols, London 1825–28 (AL 31C)

Brown, Richard, *Domestic Architecture*, London 1841

Bruce, James, *Travels to Discover the Source of the Nile, in the Years 1768–1773*, 5 vols, Edinburgh 1790 (GL 12B)

Brunet, François, *Dimensions des fers qui doivent former la coupole de la halle aux grains*, Paris 1809 (AL 16C)

Bryant, Jacob, *A New System – or, an Analysis of Ancient Mythology wherein an attempt is made to divest tradition of fable; and to reduce the truth to its original purity*, 3 vols, London 1774–76 (GL 24D)

Brydone, Patrick, *A Tour through Sicily and Malta* (1774), 2 vols, London 1775 (GL 24D)

Burke, Edmund, *A Philosophical Enquiry into the Origin of our Ideas of the Sublime and Beautiful* (1757), 9th ed., Edinburgh 1782 (AL 2C)

The Works of the Right Hon. Edmund Burke, 8 vols, London 1801 (GL 22E)

Cameron, Charles, *The Baths of the Romans Explained and Illustrated*, London 1772 (AL 60)

Campbell, Colen, *Vitruvius Britannicus*, 3 vols, London 1717–25 (AL 4D), continued by J. Woolfe and J. Gandon, 3 vols, 1767–71 (AL 4B)

Carburi, Maria, *Monument élevé à la gloire de Pierre le Grand*, Paris 1777 (AL 16D)

Carter, John, *The Ancient Architecture of England*, 2 vols, London 1794–97 (AL 31E)

Castell, Robert, *The Villas of the Ancients Illustrated*, London 1728 (AL 4B)

Catalogue of the Library in the Royal Academy, London, London 1802

Cataneo, Pietro, *I quattro primi libri di architettura*, Venice 1554 (AL 6A)

Caylus, Anne-Claude-Philippe de Tubières, Comte de, *Recueil d'antiquités, égyptiennes, étrusques, grecques et romaines*, 7 vols, Paris 1752–67 (AL 12B)

Chambers, William, *Designs of Chinese Buildings*, London 1757 (AL 4D)

Dissertation on Oriental Gardening, London 1772 (AL 49A)

Plans . . . of the Gardens and Buildings at Kew, London 1763 (AL 4D)

A Treatise on Civil Architecture, London 1759 (AL 4D); 3rd edn, *A Treatise on the Decorative Part of Civil Architecture*, London 1791 (AL 4D)

Choiseul-Gouffier, Marie-Gabriel-Auguste-Florent, Comte de, *Voyage pittoresque de la Grèce*, 3 vols, Paris 1782–1809 (AL 11)

Christie, James, *A Disquisition upon Etruscan Vases; displaying their probable connection with the shows at Eleusis, and the Chinese Feast of Lanterns, with explanations of a few of the principal allegories depicted on them*, London 1806 (AL 46D)

An Essay on that Earliest Species of Idolatry, the Worship of the Elements, Norwich 1814 (AL 46D)

Churchill, Charles, *Works*, 4 vols, London 1774 (GL 31I)

Cicero, Marcus Tullius, *De oratore. Or, his Three Dialogues upon the Character and Qualifications of an Orator*, London 1742 (GL 23D)

Select Orations translated into English, London 1756 (GL 23D)

Clérisseau, Charles-Louis, *Antiquités de la France. Premier partie*, Paris 1778 (AL 15)

Colonna, Francesco, *Hypnerotomachia Poliphili*, Venice 1499, reprinted Venice 1545 (AL 25B)

Hypnerotomachie, ou discours du songe de Poliphile, etc. Paris 1561 (AL 25B)

Columella, *De re rustica*

Commission des monuments d'Egypte, *Description de l'Egypte*, 25 vols, Paris 1809–28 (AL 42a; g, H)

Condillac, Etienne Bonnot de, *Traité des sensations*, Paris 1754

Contant d'Ivry, Pierre, *Les œuvres d'architecture de Pierre Contant d'Ivry*, Paris 1769 (AL 28)

Cordemoy, Jean-Louis de, *Nouveau traité de toute l'architecture ou l'art de bastir; utile aux entrepreneurs et aux ouvriers* (1706), 2nd edn, Paris 1714 (AL 14A)

Court de Gébelin, Antoine, *Monde primitif, analysé et comparé avec le monde moderne, considéré dans son génie allégorique et dans les allégories auxquelles conduisit ce génie*, Paris 1777 (GL 12A)

Coussin, Jean-Antone, *Du génie de l'architecture. Ouvrage ayant pour but de rendre cet art accessible au sentiment commun en le rappelant à son origine, à ses propriétés, à son génie . . .* , Paris 1822 (AL 23B)

Craven, Keppel Richard, *A Tour through the Southern Provinces of the Kingdom of Naples*, London 1821

d'Alembert, Jean le Rond, *Reflexions on the Use and Abuse of Philosophy*, London 1759, *see* Alexander Gerard, *An Essay on Taste*, London 1759 (AL 37A)

Discours préliminaire, Encyclopédie, vol. I, Paris 1751, pp. i–xlv (GL 39D)

Dallaway, James, *Anecdotes of the Arts in England or Comparative Observations on Architecture, Sculpture, and Painting chiefly illustrated by specimens at Oxford*, London 1800 (AL 3A)

Daniell, Thomas, and William Daniell, *Antiquities of India. Twelve Views*, London 1800 (AL 20)

Oriental Scenery, 3 vols, London 1795–1801 (AL 20)

Daniell, Thomas, and James Wales, *Hindoo Excavations in the Mountain of Ellora*, London 1803 (AL 20)

d'Aviler, Augustin-Charles, *Cours d'architecture* (1691), Paris 1760 (AL 14B)

De Bruyn, Cornelis [Corneille le Brun], *Voyages de Corneille Le Brun par la Moscovie, en Perse, et aux Indes Orientales*, Amsterdam 1718 (AL 21C)

Voyage au Levant, Paris 1714 (AL 21D)

De la Roche, Peter, *An Essay on the Orders of Architecture*, London 1769 (AL 39A)

De la Rue, Jean-Baptiste, *Traité de la coupe des pierres*, Paris 1728 (AL 16C)

Denon, Dominique Vivant, Baron, *Voyage dans la basse et la haute Egypte, pendant les campagnes du Général Bonaparte*, 2 vols, Paris 1802 (AL 20)

Desgodetz, Antoine, *Les édifices antiques de Rome dessinés et mesurés tres exactement*, Paris 1682 (AL 12D)

Dictionnaire abrégé de peinture et d'architecture, 2 vols, Paris 1746 (AL 37E)

Dilettanti, Society of, *Ionian Antiquities*, London 1769; part 2, *Antiquities of Ionia*, London 1797 (AL 8D)

Diodorus Siculus, *Histoire universelle de Diodore de Sicile, traduite par M. l'Abbé Terrasson*, 7 vols, Paris 1737–44 (GL 33G)

The Historical Library of Diodorus Siculus in fifteen books . . . translated by G. Booth, 2 vols, London 1814 (GL 23A)

Dodsley, James, ed., *A Collection of Poems in Four Volumes, by Several Hands*, 4 vols, London 1783 (GL 27B)

A Collection of Poems in Six Volumes, by Several Hands, with Notes, 6 vols, London 1782 (GL 27B)

Donaldson, Thomas Leverton, *A Review of the*

Professional Life of Sir John Soane, Architect, R.A., London 1837 (ml2B)

Dryden, John, *Works, edited by Walter Scott*, 18 vols, London 1808 (GL 31a–B)

Dubos, Jean-Baptiste, *Critical Reflections on Poetry, Painting, and Music by the Abbé Du Bos . . . translated into English by Thomas Nugent, Gent.* (1719), 3 vols, London 1748 (AL 2C)

Dufresnoy, Charles-Alphonse, *The Art of Painting . . . with an original Preface, containing a Parallel between Painting and Poetry: by Mr. Dryden*, London 1750 (AL 37A)

Duppa, Richard, *Illustrations of the Lotus of Antiquity*, London 1813 (AL 41E)

The Life of Raffaelo Sanzio da Urbino, by the author of the Life of Michael Angelo, and the Characters of the most celebrated Painters of Italy, by Sir Joshua Reynolds, London 1816 (AL 37F)

Durand, Jean-Nicolas-Louis, *Précis des leçons d'architecture données à l'école polytechnique*, 2 vols, Paris 1802–5 (AL 16A)

Recueil et Parallèle des édifices de tout genre, anciens et modernes, Paris 1799–1801 (AL 20)

Durandus, William, *The Symbolism of Churches and Church Ornaments: a Translation of the First Book of the* Rationale Divinorum Officiorum, John Mason Neale and Benjamin Webb, eds, Leeds 1843

Dutens, Louis, *Itinéraire des routes les plus frequentées, ou journal d'un voyage aux villes principales de l'Europe*, London 1777 (AL 34B)

Recherches sur le tems le plus reculé de l'usage des voûtes chez les anciens, London 1805 (PC 58/5)

Duval, Amaury, *Les fontaines de Paris*, Paris 1812 (AL 16D)

Elmes, James, 'History of Architecture in Great Britain', *Civil Engineer and Architect's Journal*, vol. 10, 1847, pp. 166–70, 209–10, 234–38, 268–71, 300–2, 337–41, 378–83

Lectures on Architecture . . . delivered at the Surrey and Russell Institutions, London 1821 (AL 2A)

New Churches. A Letter to the Right Honourable the Earl of Liverpool, London 1818 (PC X/10)

Elmes, James, ed., *Annals of the Fine Arts*, 5 vols, London 1816–20

Elmes, James, and Thomas H. Shepherd, *Metropolitan Improvements*, London 1827 (AL 31C)

Elsam, Richard, *Essays on Rural Architecture*, London 1803

Emlyn, Henry, *A Proposition for a New Order in Architecture*, London 1781 (AL 4D)

Encyclopédie ou dictionnaire raisonné des sciences, des arts et des métiers, 33 vols (including Supplement, 4 vols, and Plates, 12 vols), Paris and Amsterdam, 1751–77 (GL 39–40D)

Espie, Félix-François, Comte d', *The Manner of Securing all Sorts of Buildings from Fire*, transl. by Louis Dutens, London 1756 (AL 35F)

Eustace, John Chetwode, *A Classical Tour through Italy*, 2 vols, London 1814 (AL 21A)

Everard, Thomas, *Stereotomy or the art of guaging made easy*, London 1721 (AL 34I)

Fabliaux or Tales, abridged from French MSS of the XIIth and XIIIth centuries by M. Legrand, 2 vols, Paris 1796–1800 (GL 14A)

Farington, Joseph, *The Diary of Joseph Farington, 1793–1821*, Kenneth Garlick, Angus Macintyre, *et al.*, eds, New Haven and London 1978–98 (17 vols)

Félibien, André, *Entretiens sur les vies et sur les ouvrages des plus excellens peintres anciens et modernes avec la vie des architectes*, 6 vols, Trévoux 1725 (AL 37E)

Félibien, Jean-François, *Recueil historique de la vie et des ouvrages des plus célèbres architectes*, Paris 1687 (AL 16B)

Ferguson, Andrew, *Medical Researches and Ob-*

servations *Being a Series of Essays on the Practice of Physic*, Aberdeen 1801 (GL 36B)

Fielding, Henry, *The Works of Henry Fielding with the Life of the Author*, 10 vols, London 1784 (GL 22D)

Fischer von Erlach, Johann Bernhard, *Entwurff einer historischen Architectur*, Vienna 1721; Leipzig 1725 (AL 29E)

Flaxman, John, *Lectures on Sculpture . . . As delivered before the President and Members of the Royal Academy. With a brief memoir of the author*, London 1829 (AL 31A)

Fontana, Domenico, *Della trasportatione dell'obelisco Vaticano*, Rome 1590 (AL 7A)

Forsyth, Joseph, *Remarks on Antiquities, Art, and Letters, during an Excursion in Italy in the years 1802 and 1803*, London 1813 (AL 48A)

Fossati, Giorgio, *Storia dell'architettura nella quale, olte le vite degli architetti, si esamina le vicende, i progressi, la decadenza, il risorgimento e la perfezione del'arte*, Venice 1747

Fréart de Chambray, Roland, *Parallèle de l'architecture antique et de la moderne* (1650), Paris 1702 (AL 12D), transl. by John Evelyn as, *A Parallel of the Antient Architecture with the Modern* (1664), London 1707 (AL 41D)

Frézier, Amédée-François, *La théorie et la pratique de la coupe des pierres et des bois pour la construction des voûtes . . . ou traité de stéréotomie*, 2 vols, Strasbourg and Paris, 1737–38 (AL 10D)

Fuseli, Henry, *Lectures on Painting, delivered at the Royal Academy March 1801*, London 1801 (AL 31A)

Galiani, Berardo, *L'Architettura di M. Vitruvio Pollione nella tradizione Italiana e commento del Marchese Berardo Galiani*, Naples 1758 (AL 4C)

Galt, John, *The Life and Works of Benjamin West . . . Subsequent to his Arrival in this Country . . . compiled from Materials Fur-* nished by Himself . . . *Part II*, London 1820

Ganganelli, Giovanni Vincenzo Antonio, *Lettres intéressantes du pape Clément XIV (Ganganelli)*, 2 vols, Paris 1776 (GL 19D), transl. as *Interesting Letters of Pope Clement XIV (Ganganelli) to which are prefixed, Anecdotes of his Life*, 2 vols, London 1777 (GL 28G)

Gautier, H., *Traité des ponts, ou il est parlé de ceux des Romains et de ceux des modernes* (1716); 2nd edn, Paris 1765 (AL 35F)

Gentlemen's Magazine, 134 vols, London 1736–1829 (GL 2A–b, gl 44)

Gerard, Alexander, *An Essay on Taste with three dissertations on the same subject by Mr de Voltaire, Mr D'Alembert, F.R.S., Mr de Montesquieu*, London 1759 (AL 37A)

Gibbon, Edward, *The History of the Decline and Fall of the Roman Empire*, 12 vols, London 1783–90 (GL 17A)

Gibbs, James, *A Book of Architecture*, London 1728 (AL 4B)

Gilles, Pierre [Petrus Gyllus], *The Antiquities of Constantinople*, London 1729 (AL 34A)

Gilpin, William, *Observations on the Western Parts of England, relative chiefly to Picturesque Beauty*, London 1798 (AL 19B)

Girardin, René-Louis, marquis de, *De la composition des paysages*, Geneva 1777

Goethe, Johann Wolfgang von, *Italienische Reise* (1816–17), in *Goethes Werke*, Erich Trunz, ed., 14 vols, Munich 1981–89, vol. xi, 1989

Sorrows of Werter: a German Story, 2 vols, London 1784 (GL 28B)

Goguet, Antoine-Yves, *The Origin of Laws, Arts, Sciences, and their Progress among the most Ancient Nations* (1758) 3 vols, Edinburgh 1775 (GL 2C)

Gondoin, Jacques, *Description des écoles de chirurgie*, Paris 1780 (AL 26)

Gregory, John Mack, *An Account of the Sepulchers of the Antients, and a Description of their Monuments from the Creation of the*

World to the Building of the Pyramids, and from Hence to the Destruction of Jerusalem, London 1712 (AL 33C)

Grigson, Joseph, *Essay on the Defects of Buildings dependent on the Nature and Properties of Air*, London 1816

Guignes, Joseph de, *Mémoire dans lequel on prouve que les Chinois sont une colonie égyptienne*, Paris 1759

Gwynn, John, *An Essay on Design: Including Proposals for Erecting a Public Academy . . . (till a Royal Foundation can be obtain'd) For Educating the British Youth in Drawing, and the several Arts depending thereon*, Dublin 1749 (AL 36A)

London and Westminster Improved, London 1766 (AL 31C)

Haggitt, John, *Two Letters to a fellow of the Society of Antiquaries on the subject of Gothic architecture . . . and an enquiry into the Eastern origin of the Gothic or Pointed style*, Cambridge 1813 (AL 46B)

Halfpenny, William, *A New and Complete System of Architecture*, London 1749 (AL 27A)

Hancarville, *see* Hugues, Pierre-François

Haydon, Benjamin Robert, *New Churches: considered with respect to the Opportunities they offer for the Encouragement of Painting*, London 1818 (PC 116/15)

Helvétius, Claude-Adrien, *De l'esprit* (1758) 3 vols, Paris 1768 (GL 26H)

De l'homme, des ces facultés intellectuelles, et de son éducation (1772) 2 vols, London 1775 (GL 33H)

Herodotus translated from the Greek by William Beloe, 4 vols, London 1806 (GL 23B)

Hirschfeld, Christian Cay L., *Théorie de l'art des jardins traduit de l'allemand*, 3 vols, Leipzig 1779–81 (AL 23C)

The Historical, Political and Literary Register, vol. i, 1769 (GL 6F)

Hittorff, Jacques-Ignace, *Précis sur les pyramidions en bronze doré*, Paris 1836 (PC 115/13)

'Rapport fait par M. Hittorff, sur la Maison et le Musée du Chevalier Soane, Architecte à Londres', *Annales de la Société Libre des Beaux-Arts*, 1836, pp. 194–205 (SM Archives Private Correspondence XIV.a.10)

Hittorff, Jacques-Ignace, and L. Zanth, *Architecture antique de la Sicile*, Paris 1827–28 (AL 38B)

Architecture moderne de la Sicile, Paris 1826 (AL 38B)

Hoare, Prince, *Epochs of the Arts, including hints on the rise and progress of painting and sculpture in Great Britain*, London 1813 (AL 36B)

Hoare, Prince, ed., *The Artist*, 1807-9, published as 2 vols, London 1810

Hodges, William, *Select Views in India*, London 1785–88

Travels in India during the Years 1780, 1781, 1782 and 1783, London 1793 (AL 21A)

Hogarth, William, *The Analysis of Beauty, written with a view of the fixing of the fluctuating ideas of taste*, London 1772 (AL 29A)

Home, Henry (Lord Kames), *Elements of Criticism* (1762), Edinburgh 1785 (AL 2C)

Homer, *Iliad* (transl. by John Ogilby), London 1660 (GL 40C)

Odyssey (transl. by John Ogilby), London 1669 (GL 40C)

Hope, Thomas, *Household Furniture and Interior Decoration*, London 1807

Observations on the Plans . . . By James Wyatt, Architect, for Downing College, London 1804 (pl 103/3)

Horace (Horatius Flaccus Quintus), *The Works of Horace* (transl. by D. Watson), 2 vols, London 1760 (GL 43E)

The Works of Horace (transl. by C. Smart), 2 vols, London 1774 (GL 43E)

The Odes, Epodes, and Carmen Seculare of Horace, 2 vols, London 1746 (GL 43E)

The Satires, Epistles, and Art of Poetry, London 1748 (GL 43E)

Hugues, Pierre-François, 'baron d'Hancarville', *Collection of Etruscan, Greek and Roman*

Antiquities from the Cabinet of the Honble Wm Hamilton, 4 vols, Naples 1766–67 (AL 4C)

Monuments du culte secret des dames romaines pour servir de suite aux monuments de la vie privée des XII Césars, 1785

Recherches sur l'origine, l'esprit et les progrès des arts de la Grèce; sur leur connexion avec les arts et la religion des plus anciens peuples connus; sur les monuments antiques de l'Inde, de la Perse, du reste de l'Asie, de l'Europe et de l'Egypte, 3 vols, London 1785 (AL 10A)

Hume, David, *Essays and Treatises on Several Subjects*, London 1777 (GL 22E)

Hume, David, and Tobias Smollett, *The History of England, from the Invasion of Julius Caesar to the Revolution in 1688*, 16 vols, London 1803–5 (GL 2E)

Ireland, Samuel, *Picturesque Views, with an historical account of the Inns of Court in London and Westminster*, London 1800 (AL 31B)

Isocrates, *The Orations of Lysias and Isocrates*, translated by *John Gillies*, London 1778 (GL 29E)

Jachin and Boaz; or, an authentic Key to the Door of Free-Masonry, both ancient and modern, London, 1812 (GL 11D)

Jombert, Charles-Antoine, *Architecture moderne, ou l'art de bien bâtir pour toutes sortes de personnes*, 2 vols, Paris 1764 (AL 14A)

Jones, Inigo, *see* Webb, John

Johnson, Samuel, *The Works of Samuel Johnson LL.D. A New Edition in Twelve Volumes with an Essay on his Life and Genius by Arthur Murphy Esq.* London 1792 (GL 22F)

Josephus, Flavius, *The Genuine Works of Flavius Josephus, translated from the original Greek, according to Havercamp's edition, by William Whiston*, London 1737 (GL 39G)

Juvenal, *D. J. Juvenalis et A. Persius translated by Barten Holyday*, Oxford 1673 (GL 29E)

Kaempfer, Engelbert, *Histoire naturelle, civile, et ecclésiastique de l'Empire du Japon*, 2 vols, The Hague 1729 (GL 24E)

Kames, Lord, *see* Home, Henry

Keate, George, *Poetical Works*, 2 vols, London 1781 (GL 32H)

Kent, William, *Designs of Inigo Jones*, London 1727 (AL 4B)

Kirby, Joshua, *The Perspective of Architecture . . . deduced from the Principles of Dr Brook Taylor*, London 1761 (AL 38B)

Kircher, Athanasius, *Turris Babel*, Amsterdam 1679

Kirk, Thomas, *Outlines from the Figures and Compositions upon the Greek, Roman, and Etruscan Vases of the late Sir William Hamilton*, London 1804 (AL 39B)

Knight, Richard Payne, *An Account of the Remains of the Worship of Priapus lately existing at Isernia, in the Kingdom of Naples . . . to which is added a Discourse on the Worship of Priapus and its connexion with the Mystic Theology of the Antients*, London 1786 (GL 41C)

An Analytical Inquiry into the Principles of Taste, London 1805 (AL 2C)

An Inquiry into the Symbolical Language of Ancient Art and Mythology, London 1818

The Landscape. A Didactic Poem, London 1794 (Colonnade Drawer 66)

Krafft, Jean-Charles, *Porte cochères et portes d'entrée de Paris*, Paris 1810 (AL 43E)

Recueil d'architecture civile, Paris 1811 (AL 9)

Laborde, Alexandre, *Description des nouveaux jardins de la France*, Paris 1808 (AL 13)

La Bruyère, Jean de, *Les caractères de Théophraste avec les caractères de La Bruyère*, (1688) Paris 1765 (GL 13E)

The Works, 2 vols, London 1712 (GL 34G)

Labruzzi, Carlo, *Via Appia illustrata ab urbe Roma ad Capuam*, Rome 1794 (AL 30)

Lacombe, Jacques, *Le spectacle des beaux-arts, ou considérations touchant leur nature, leurs objets, leurs effets, et leurs règles principales*, Paris 1758 (AL 37G)

Lafitte, Louis, *Description de l'Arc de Triomphe de l'Etoile*, Paris 1810 (AL 16B)

Lafiteau, Joseph-François, *Mœurs des sauvages amériquains comparées aux mœurs des premiers temps*, Paris 1724 (GL 12A)

Lassells, Richard, *The Voyage of Italy, or a Complete Journey through Italy, in Two Parts, with the Characters of the People, and the Description of the Chief Towns, Churches etc.* Paris and London 1670 (AL 33H)

Laugier, Marc-Antoine, *Essai sur l'architecture* (1753), 2nd edn, Paris 1755 (AL 36C)

Observations sur l'architecture, The Hague 1765 (AL 36C)

Lavater, Johann Caspar, *Essays on Physiognomy*, 3 vols in 5, London 1789–98 (GL 40C)

Le Fevre, L.-C. *Grand escalier du château de Versailles, dit Escalier des Ambassadeurs*, Paris n.d. (AL 27D)

Le Brun, Charles, *Conférence sur l'expression*, Paris 1698, transl. as *The Conference of Monsieur Le Brun . . . Upon Expression, General and Particular*, London 1701

Le Camus de Mézières, Nicolas, *Le génie de l'architecture; ou, l'analogie de cet art avec nos sensations*, Paris 1780 (AL 35B)

Le guide de ceux qui veulent bâtir; ouvrage dans lequel on donne les renseignements nécessaires pour se conduir lors de la construction, et prévenir les fraudes qui peuvent s'y glisser, 2nd edn, 2 vols, Paris 1786 (AL 35B)

Recueil des différens plans et dessins, concernant la nouvelle Halle aux Grains, située au lieu et place de l'ancien Hôtel de Soissons, Paris 1769 (AL 30)

Le Comte, Florent, *Cabinet des singularités d'architecture, peinture, sculpture et graveure*, 3 vols, Brussels 1702 (AL 34H)

Ledoux, Claude-Nicolas, *L'architecture considérée sous le rapport de l'art, des mœurs, et de la législation*, Paris 1804 (AL 15)

Prospectus: L'architecture considérée sous le rapport de l'art, des mœurs et de la législation, Paris 1802 (PC 32/1 and 53/5)

Leeds, William Henry (anon.), 'Remarks on the Architectural Museum of Sir John Soane', in John Claudius Loudon, ed., *Architectural Magazine*, vol. ii, 1835, pp. 247–49

Legrand, Jacques-Guillaume, *Collection des chefs-d'œuvre de l'architecture des différens peuples, exécutés en modèles sous la direction de L.-F. Cassas*, Paris 1806 (AL 36A)

Lenoir, Alexandre, *La Franche-Maçonnerie rendue à sa véritable origine, ou l'antiquité de la franche-maçonnerie prouvée par l'explication des mystères anciens et modernes*, Paris 1814 (GL 11E)

Musée des monumens Français, 8 vols, Paris 1800–21 (AL 19B)

Leroy, Julien-David, *Histoire de la disposition et des formes différentes que les chrétiens ont donnés à leurs temples depuis le règne de Constantin le Grand jusqu'à nous*, Paris 1764

Les ruines des plus beaux monuments de la Grèce, Paris 1758 (AL 42B); 2nd edn, Paris 1770 (AL 11)

Le Virloys, Charles-François Roland, *Dictionnaire d'architecture civile, militaire et navale*, 3 vols, Paris 1770–71 (AL 10B)

Lewis, James, *Original Designs in Architecture*, 2 vols, London 1780–97 (AL 5D)

Ligorio, Pirro, *Pianta della villa tiburtina di Adriano cesare*, Rome 1751 (AL 6A)

Locke, John, *The Works of John Locke*, 4 vols, London 1777 (GL 15F)

l'Orme, Philibert de, *Le premier tôme de l'architecture*, Paris 1576 (AL 43C)

Louis, Victor, *Salle de spectacle de Bordeaux*, Paris 1782 (AL 28)

Lubersac, Abbé Charles-François de, *Discours sur les monumens publics de tous les âges*, Paris 1775 (AL 43E)

Lumisden, Andrew, *Remarks on the Antiquities of Rome*, London 1797 (AL 21A)

Lysias, *The Orations of Lysias and Isocrates, translated by John Gillies*, London 1778 (GL 29E)

Maffei, Scipione, *La Verona illustrata*, 2 vols, Verona 1771 (AL 33C)

Macpherson, James, *The Poems of Ossian*, 2 vols, London 1773 (GL 31H)

Maitland, William, *History of London*, 2 vols, London 1756 (AL 39E)

Major, Thomas, *The Ruins of Paestum otherwise Posidonia in Magna Graecia*, London 1768 (AL 8D)

Malton, Thomas, *The Architectural Designs of Sir Robert Taylor. Drawn and Executed in Aquatint by Thomas Malton*, London 1792 (AL 31E)

Marquez, Pietro, *Delle case di città degli antichi Romani secondo la dottrina di Vitruvio*, Rome 1795

Mason, William, *The English Garden. A Poem in Four Books*, York and London 1783 (AL 32E)

Mataplana, Pietro, *Vita, e miracoli di Santa Rosalia, vergine Palermitana*, Palermo 1693 (GL 30B)

Mauclerc, Julian, *A New Treatise of Architecture According to Vitruvius . . . Set forth in English by Robert Pricke*, London 1669 (AL 47B)

Maurice, Thomas, *Indian Antiquities: or, dissertations, relative to Hindostan*, 7 vols, London 1800 (AL 2B)

Michaelis, Adolf, *Ancient Marbles in Great Britain*, Cambridge 1882

Milizia, Francesco, *Dizionario delle belle arti del disegno*, 2 vols, Bassano 1797 (AL 36H)

Memorie degli architetti antichi e moderni, 2 vols, Bassano 1785 (AL 2A)

Principii di architettura civile, 3 vols, Bassano 1785 (AL 2A)

Roma delle belle arti del disegno: parte prime, dell'architettura civile, Bassano 1787 (AL 33D)

Vies des architectes, 2 vols, Paris 1771, transl. by Jean-Claude Pingeron (AL 37G)

Le vite de' piu celebri architetti d'ogni nazione e d'ogni tempo precedute da un saggio sopra l'architettura, Rome 1768 (AL 45A)

Miller, Anna Riggs, *Letters from Italy*, 2 vols, London 1771, 2nd edn, London 1777 (AL 2D)

Montaigne, Michel de, *The Essays of Michel de Montaigne*, 3 vols, London 1776 (GL 35B)

Montano, Giovanni Battista, *Li cinque libri di architettura*, Rome 1664

Montesquieu, Charles-Louis, *The Complete Works of Montesquieu translated from the French*, 4 vols, London 1777 (GL 13C)

Montfaucon, Bernard de, *L'antiquité expliquée et représentée en figures*, 15 vols, Paris 1719–24 (AL 12 c and D)

Morel, Jean-Marie, *Théorie des jardins*, Paris 1776

Morris, Robert, *The Art of Architecture: a Poem in Imitation of Horace's The Art of Poetry*, London 1742 (PC 104)

An Essay in Defence of Ancient Architecture: or, a Parallel of the Ancient Buildings with the Modern: Shewing the Beauty and Harmony of the Former, and the Irregularity of the Latter. With Impartial Reflections on the Reasons of the Abuses introduced to our present Builders, London 1728 (AL 39A)

Lectures on Architecture (1734–36), 2nd edn, London 1759 (AL 36B)

Rural Architecture, London 1750

Select Architecture, London 1755 (AL 39A)

Murphy, James, *Plans, Elevations, Sections, and Views of the Church of Batalha in the Province of Estremadura in Portugal*, London 1795 (AL 23E)

Nattes, Jean-Claude, *Versailles, Paris, et S. Denis*, London n.d. [1820] (AL 9)

Newton, Isaac, *The Chronology of Ancient Kingdoms Amended. To which is prefix'd a short chronicle from the first memory of things in Europe, to the Conquest of Persia by Alexander the Great*, 1728 (GL 24A)

Newton, William, *The Architecture of M. Vitruvius. Pollio: Translated from the Original Latin, by W. Newton*, London 1771 (AL 4C)

Commentaires sur Vitruve . . . par W. Newton architecte, London 1780 (AL 4C)

Niebuhr, Carsten, *Voyage en Arabie et en d'autres pays circonvoisins*, 2 vols, Amsterdam, 1776–80 (GL 12B)

Noli me tangere [pseud.], 'Observations on the House of John Soane, Esq., Holborn Row,

Lincoln's Inn Fields', *European Magazine*, vol. 62, November 1812, pp. 381–87 (GL 41A)

Norden, Frederic Louis, *Voyage d'Egypte et de Nubie*, 2 vols, Copenhagen 1755 (AL 21E)

O. M. and R. H. [pseud.], 'On the Sixth, or Boeotian Order of Architecture', *Knight's Quarterly Magazine*, vol. 4, January –April 1824, no. 2, pp. 446–63

Opie, John, *Lectures on Painting, delivered at the Royal Academy of Arts*, London 1809 (AL 31A)

Ouvaroff, Serge Semenovitch, Count, *Essay on the Mysteries of Eleusis, translated from the French by J. D. Price. With Observations by James Christie*, London 1817 (AL 46D)

Ouvrard, René, *Architecture harmonique, ou l'application de la doctrine des proportions de la musique à l'architecture*, Paris 1679

Ovid's Epistles with his Amours, London 1754 (GL 43B)

Ovid's Metamorphoses, London 1797 (GL 43C)

Paine, James, *Plans . . . of Noblemen and Gentlemen's Houses*, 2 vols, London 1767–83 (AL 31E)

Palladio, Andrea, *The Architecture of Andrea Palladio in Four Books . . . by Giacomo Leoni*, 3 vols, London 1715 (AL 4A)

I quattro Libri dell'architettura, Venice 1570

Pancirollus, Guido, *The History of Many Memorable Things Lost, which were in Use among the Ancients*, 2 vols, London 1715 (AL 36H)

Patte, Pierre, *Discours sur l'architecture*, Paris 1754

Mémoires sur les objets les plus importans de l'architecture, Paris 1769 (AL 14B)

Monumens érigés en France à la gloire de Louis XV, Paris 1765 (AL 14D)

Pausanias, *An Extract out of Pausanias, Of the Statues, Pictures and Temples in Greece; Which Were remaining there in his Time*, London 1758 (AL 48A)

Pausanias, ou voyage historique de la Grèce, traduit en françois, avec des remarques. Par M. l'Abbé Gedoyn, 2 vols, Paris 1731 (AL 21A)

Pauw, Cornelius de, *Philosophical Dissertations on the Egyptians and Chinese*, 2 vols, London 1795 (GL 35H)

Peacock, James, *Oikidia, Or, Nutshells: Being Ichnographic Distributions for Small Villas*, London 1785 (AL 36B)

Pennant, Thomas, *The View of Hindoostan*, 2 vols, London 1798 (GL 7B)

Perrault, Claude, *Les dix livres d'architecture de Vitruve, corrigez et traduits nouvellement en François, avec des notes et des figures*, Paris 1673, 2nd edn, Paris 1684 (AL 4C)

Ordonnance des cinq espèces de colonnes, selon la méthode des anciens, Paris 1683 (AL 43D), transl. by John James as, *A Treatise of the Five Orders of Columns in Architecture*, London 1708 (AL 41D)

Perronet, Jean-Rodolphe, *Description de projets et de la construction des ponts de Neuilly, de Mantes, d'Orléans etc.; du projet du canal du Bourgogne . . . et de celui de la Brièvre à Paris*, 2 vols, Paris 1782–83 (AL 38B)

Peyre, Marie-Joseph, *Œuvres d'architecture*, Paris 1765, 2nd edn, Paris 1795 (AL 13)

Piles, Roger de, *Abrégé de la vie des peintres*, Amsterdam 1767 (AL 37B)

The Art of Painting and the Lives of the Painters, London 1706 (AL 37A)

The Principles of Painting, London 1743 (AL 37A)

Pindar, *The Odes translated into English verse by E. B. Greene*, London 1778 (GL 29D)

Pingeron, *see* Milizia, Francesco

Piranesi, Giovanni Battista, *Le antichità Romane*, 4 vols, Rome 1756 (AL 7C)

Il Campo Marzio dell'antica Roma, Rome 1762 (AL 6C)

Capric di carceri all acqua forte, Rome *c.* 1745 (AL 7C)

Della magnificenza ed architettura de' Romani, Rome 1751–53 (AL 6C)

Diverse maniere d'adornare i cammini, Rome 1769 (AL 6C)

Le magnificenze di Roma, Rome 1751 (AL 7C)

Le vedute di Roma, Rome 1753 (AL 7C)

Opere varie di architettura prospettive grotteschi antichita, Rome 1750 (AL 7B)

Prima parte di architectture, e prospettive, Rome 1743

Trofeo o sia magnifica colonna coclide di marmo, Rome 1774–9 (AL 30)

Pliny the Elder, *The Historie of the World*, transl. by Philemon Holland, 2 vols, London 1634–35 (GL 40C)

Pliny the Younger, *The Letters of Pliny the Younger*, 2 vols, London 1751 (GL 29D)

Pluche, Noel-Antoine, *Spectacle de la nature* (1732), 8 vols, Paris 1771 (GL 38B)

Plutarch's Lives, transl. by John and William Langhorne, 6 vols, London 1774 (GL 20B)

Pococke, Richard, *A Description of the East, and Some Other Countries*, 2 vols, London 1743–45 (AL 21D)

Polybius, *The General History of Polybius translated from the Greek by Mr Hampton*, 2 vols, London 1772 (GL 29E)

Pope, Alexander, *The Works of Alexander Pope, Esquire*, 9 vols, London 1751 (GL 31E)

Prado, Jernimo, *see* Villalpando, Juan Bautista, *In Ezechielem Explanationes et Apparatus Urbis ac Templi Hierosolymitani*, 3 vols, Rome 1596–1604 (AL 5A)

Preston, William, *Illustrations of Masonry*, London 1812 (GL 11D)

Price, Uvedale, *An Essay on the Picturesque*, London 1794 (AL 2B)

Pugin, Augustus Welby, *An Apology for the Revival of Christian Architecture in England*, London 1843

Contrasts: or, a Parallel between the Noble Edifices of the Fourteenth and Fifteenth Centuries, and Similar Buildings of the Present Day, shewing the Present Decay of Taste, Salisbury 1836

The True Principles of Pointed or Christian Architecture, London 1841

Quatremère de Quincy, Antoine-Chrysostôme, *De l'architecture égyptienne considéré dans son origine, ses principes et son goût, et comparée sous les mêmes rapports à l'architecture grecque*, Paris 1803 (AL 10A)

Dictionnaire d'architecture (from the *Encyclopédie méthodique* (166 vols, Paris 1781–1832)), 3 vols, Paris 1788–1825 (AL 23B)

Histoire de la vie et des ouvrages des plus célèbres architectes du XIe siècle jusqu'à la fin du XVIIIe, 2 vols, Paris 1830 (AL 16B)

Le Jupiter Olympien, ou l'art de la sculpture antique considéré sous un nouveau point de vue, Paris 1815 (AL 27D)

Lettres à Miranda sur le déplacement des monuments de l'art de l'Italie, Paris 1796; edition with notes by Edouard Pommier, Paris 1989

Quintilian, *Institutes of Eloquence: or, the Art of Speaking in Public, in every character and capacity*, 2 vols, London 1805, transl. by William Guthrie (GL 23A)

Ralph, James, *A Critical Review of the Publick Buildings, Statues and Ornaments in, and about London and Westminster*, London 1734 (PC 39)

Redivivus, Ralph [pseud.], 'Our house in Lincoln's Inn Fields', *Civil Engineer and Architect's Journal*, vol. 2, 1839, p. 204

Repton, Humphry, *Designs for the pavillon at Brighton*, London 1808

Reynolds, Joshua, *Discourses delivered to the Students of the Royal Academy*, London 1769–77 (AL 31A)

Discourses delivered to the Students of the Royal Academy, London 1779–93 (AL 31A)

The Works of Sir Joshua Reynolds, Knight, 3 vols, London 1798 (AL 37H) *and see* Duppa, Richard

Richardson, Charles James, *A Popular Treatise on the Warming and Ventilating of Buildings*, London 1837, 3rd ed., 1856, pp. 54–55 and pl. 10

Richardson, George, *The New Vitruvius Britannicus*, London 1802 (AL 4D)

Richardson, Samuel, *Clarissa, or, the History of a Young Lady*, 7 vols, London 1748 (GL 22B)

Rickman, Thomas, *An Attempt to Discriminate the Styles of English Architecture, from the Conquest to the Reformation* (1815), 2nd edn, London 1819 (AL 19A)

Riem, Andreas, *Uber die Malerei der Alten. Ein Beitrag zur Geschichte der Kunst* (1781), Berlin 1787

Riou, Stephen, *The Grecian Orders of Architecture*, 1768 (AL 8C)

Rollin, Charles, *The Ancient History of the Egyptians, Carthaginians, Assyrians, Macedonians and Grecians, translated from the French*, 10 vols, London 1754 (GL 24A)

Rondelet, Jean, *Traité théorique et pratique de l'art de bâtir*, 8 vols, Paris 1802–17 and 1812 (AL 10E)

Roquet, Jean-André, *L'état des arts en Angleterre*, Paris 1755 (AL 37E)

Rossi, Domenico de, *Studio d'architettura civile*, 3 vols, Rome 1702–21 (AL 8B)

Rossi, Giovanni Giacomo de, *Insignium Romae templorum prospectus*, Rome 1684 (AL 8B)

Rousseau, Jean-Jacques, *Les confessions de J. J. Rousseau, suivies des rêveries du promeneur solitaire*, 2 vols, Geneva 1783 (GL 26H)

Emilius and Sophia, or a New System of Education, 4 vols, London 1783 (GL 13C)

Lettres de deux amants, habitans d'une petite ville au pied des Alpes: Julie, ou la nouvelle Héloise, Amsterdam 1775 (GL 26H)

Œuvres complètes, 36 vols, Paris 1788–93 (GL 13 A and B)

Royal Academy, London, *Abstract of the Instrument of the Institution and Laws of the Royal Academy of Arts in London*, London 1797 (Soane Case 19)

A Catalogue of the Library in the Royal Academy, London, London 1802

Laws Relating to the Schools, the Library, and the Students, London 1814

Ruggieri, Ferdinando, *Studio d'architettura civile*, 3 vols, Florence 1722–28 (AL 38A)

Rusconi, Giovanni Antonio, *Della architettura di Giovanni Antonio Rusconi, secondo i precetti di Vitruvio, libri dieci*, Venice 1590 (AL 45B)

Ruskin, John, *The Poetry of Architecture; or the Architecture of the Nations of Europe Considered in its Association with Natural Scenery and National Character*, in *Architectural Magazine*, John Claudius Loudon, ed., vols iv–v, 1837–38

Sappho, *The Works of Anacreon, Sappho, Bion, Moschus and Musaeus, translated by F. Fawkes*, London 1789 (GL 28F)

Savary, Claude-Etienne, *Letters on Greece: being the Sequel to Letters on Egypt*, London 1788 (GL 5A)

Lettres sur l'Egypte ou l'on offre le parallèle des mœurs anciennes et modernes de ces inhabitans, 3 vols, Paris 1786 (GL 5A)

Scamozzi, Vincenzo, *L'idea della architettura universale*, Venice 1615 (AL 45C)

Seneca, *The Epistles edited by Thomas Morell*, London 1786 (GL 29C)

Œuvres de Sénèque, 6 vols, Paris 1794 (GL 19F)

Serlio, Sebastiano, *The Five Books of Architecture*, London 1611 (AL 47B)

Scott, George Gilbert, *Personal and Professional Recollections*, London 1879

Séroux d'Agincourt, Jean-Baptiste-Louis-George, *Histoire de l'art par les monumens, depuis sa décadence au IVe siècle jusqu'à son renouvellement au XVIe*, 6 vols, Paris 1823 (AL 23E)

Shaftesbury, Anthony Ashley Cooper, 3rd Earl of, *Characteristicks of Men, Manners, Opinions, Times . . . with the addition of a Letter Concerning Design*, 3 vols, London 1737 (GL 17F)

A Letter Concerning the Art or Science of Design, London 1712 (PC 12)

Shanhagan, Roger [pseud.], *The Exhibition, or a second anticipation; being remarks on the principal Works to be exhibited next Month*

at the Royal Academy, By Roger Shanha-
gan, Gent., London [1779]

Shute, John, *The First and Chief Groundes of
Architecture*, London 1563

Sir John Soane's Museum, London, *Catalogue
of the Library in Sir John Soane's Museum*,
London 1878

Smollett, Tobias George, *Miscellaneous Works,
with Memoirs of his Life and Writings by
Robert Anderson M.D.*, 6 vols, London
1796 (GL 22a–F)

Soane, George, 'The Present Low State of the
Arts in England, and More Particularly of
Architecture', *The Champion*, 10 and 24
September 1815

Soane, John, *An Appeal to the Public: Occa-
sioned by the Suspension of the Architec-
tural Lectures in the Royal Academy. To
which is subjoined an Account of a Critical
Work, Published a Few Years Ago, entitled
'The Exhibition; or, a Second Anticipation:'
With Observations on Modern Anglo-
Grecian Architecture; and Remarks on the
Mischievous Tendency of the Present Specu-
lative System of Building, &c. In Letters to
a Friend. Illustrated with Engravings*,
London 1812 (Soane Case 24)

*A Brief Statement of the Proceedings respect-
ing the New Law Courts at Westminster,
the Board of Trade, and the New Privy
Council Office etc*, London 1828 (Soane
Case 108)

*Description of the House and Museum on the
North Side of Lincoln's Inn Fields*, London
1830, 1832 (Soane Case 69); 1835–36
(Soane Case 67)

*Designs for Public Improvements in London
and Westminster*, London 1827 (Soane
Case 89)

Designs for Public and Private Buildings,
London 1828 (Soane Case 119); 2nd ex-
tra-illustrated ed., 1832 (Soane Case 123)

*Details respecting the Conduct and Connex-
ions of George Soane . . . and also of Fred-
erick Soane*, London n.d. (ML 48D)

*Memoirs of the Professional Life of an Archi-

tect between the years 1768 and 1835 writ-
ten by Himself*, London 1835 (ML 48D)

*Memoirs relating to Mr. John Soane, Junior,
Mrs. John Soane, and Captain Chamier*,
London 1835 (ML 48D)

*Observations respecting a Royal Palace, Na-
tional Gallery, British Senate House etc.
extracted from the Professor of Architec-
ture's Fifth and Sixth Lectures*, n.d. (Soane
Case 107)

'On the Causes of the Present Inferior State
of Architecture in England', *The Artist*, no.
14, 13 June 1807, pp. 1–8

*Plans, Elevations, and Perspective Views of
Pitzhanger Manor-House, and of the ruins
of an edifice of Roman architecture, situ-
ated on the border of Ealing Green*, Lon-
don 1802 (Soane Case 70)

*Plans, Elevations and Sections of Buildings
erected in the Counties of Norfolk . . . &c*,
London 1788 (AL 4D)

Sketches in Architecture, London 1793
(Soane Case 88)

*A Statement of Facts respecting the Designs of
a New House of Lords*, London 1799
(Soane Case 9/2)

'The Soanean Museum', *Civil Engineer and
Architect's Journal*, vol. 1, 1837–38, p. 44

Sobry, Jean-François, *Poétique des arts, ou
cours de peinture et de littérature compa-
rées*, Paris 1810 (AL 36B)

Soufflot, Jacques-Germain, *Salle des spectacles
de Lyon*, Paris 1782 (AL 13)

Spectator, The, 8 vols, 1767 (GL 22G)

Spon, Jacob, and George Wheler, *A Journey
into Greece*, London 1682 (AL 21C)

Sterne, Laurence, *A Sentimental Journey
through France and Italy*, 2 vols, London
1774 (GL 28H)

Stewart, John, *Critical Observations on the
Buildings and Improvements of London*,
London 1771 (PC 69)

Stuart, James, and Nicholas Revett, *The An-
tiquities of Athens*, 4 vols, London 1762–
1816 (AL 8D)

Stukeley, William, *Abury, a Temple of the Brit-

ish Druids, with some others described, 1743 (AL 41D)

A Collection of Sacred Antiquities, consisting of drawings and prints, manuscript, 4 vols, 1732–61 (AL 45 C and D)

Itinerarium Curiosum, London 1724 (AL 441D)

Palaeographia Britannica: or, Discourses on Antiquities in Britain, Stamford 1746 (AL 41E)

Palaeographia sacra: or, Discourses of Sacred Subjects, London 1763 (GL 24A)

Stonehenge, a temple restor'd to the British Druids, 1740 (AL 41D)

Tacitus, *Works, by Arthur Murphy,* 4 vols, London 1793 (AL 29D)

Tappen, George, *Professional Observations on the Architecture of the Principal Ancient and Modern Buildings in France and Italy,* London 1806 (AL 39B)

Taylor, George Ledwell and Edward Cresy, *The Architectural Antiquities of Rome, measured and delineated by G. L. Taylor and E. Cresy,* 2 vols, London 1821–22 (AL 5C)

Temanza, Tommaso, *Vita di Sansovino,* Venice 1752 (AL 6A)

Vite dei più celebri architetti e scultori Veneziani, Venice 1778

Temple, William, *The Works,* 2 vols, London 1740 (GL 14B)

Theophrastus, *see* La Bruyère

Thomson, James, *The Seasons,* London 1730

Tournefort, Joseph-Pitton de, *A Voyage into the Levant,* 2 vols, London 1718 (GL 5B)

Valadier, Giuseppe, and Filippo Visconti, *Raccolta delle più insigni fabbriche di Roma antica, e sue adjacenze,* Rome 1810 (AL 31E)

Vasari, Giorgio, *Le vite de' piu eccellenti architetti, pittori, e scultori,* 3 vols, Florence 1550 (AL 45A); 7 vols, Florence 1767–72 (AL 45A)

Viel, Charles-François, *Décadence de l'architecture à la fin du dix-huitième siècle,* Paris 1800 (AL 14B)

Viel de Saint-Maux, Jean-Louis, *Lettres sur l'architecture des anciens, et celle des modernes, dans lesquelles se trouve développé le génie symbolique qui préside aux monuments de l'antiquité,* Paris 1787 (AL 36B)

Vignola, Giacomo Barozzi, *Regola delli cinque ordini d'architettura,* Venice 1582 (AL 44A)

Villalpando, Juan Bautista, and Jerónimo Prado, *In Ezechielem Explanationes et Apparatus Urbis, ac Templi Hierosolymitani,* 3 vols, Rome 1596–1604 (AL 5A)

Virgil, *Works in Latin and English, the Aeneid translated by the Rev. Mr Pitt; the Eclogues and Georgics, with notes on the whole, by the Rev. Mr Joseph Warton,* 4 vols, London 1753 (GL 43D)

Vitruvius, *The Architecture of M. Vitruvius. Pollio: Translated from the Original Latin by W. Newton,* 2 vols, London 1791 (AL 4C)

I dieci libri dell'architettura di M Vitruvio tradutti e commentati da Monsignor Barbaro, Venice 1556 (AL 4C)

Volney, Constantin-François Chasseboeuf, comte de, *Les ruines, ou méditation sur les révolutions des empires,* Paris 1792 (AL 33C)

Travels through Syria and Egypt, 2 vols, London 1787 (AL 34B)

Voltaire, François-Marie Arouet de, *Oeuvres complètes,* 70 vols, Basle 1789 (GL 37 A–F)

Walpole, Horace, *Aedes Walpolianae, or, a Description of the Collection of Pictures at Houghton Hall; a Sermon on Painting, 1742; a Journey to Houghton, a Poem [by The Revd. C. Whaley],* London 1767 (AL 39A)

Anecdotes of Painting in England, 5 vols, London 1782 (AL 37F)

Ware, Isaac, *A Complete Body of Architecture,* London 1756 (AL 4B)

Warton, Thomas, *et al., Essays on Gothic Architecture,* London 1802 (AL 19A)

Webb, John, *The Most Notable Antiquity of Great Britain, Vulgarly called Stone-Heng*

on Salisbury Plain. Restored by Inigo Jones Esquire*, London 1655 (AL 29C)

A Vindication of Stone-Heng Restored (1665), 2nd edn, London 1725 (AL 4A)

Whately, Thomas, *Observations on Modern Gardening*, London 1770 (AL 32A)

White, John, *Some Account of the Proposed Improvements of the Western Part of London, by the Formation of the Regent's Park &c*, London 1815 (AL 41A)

Whittington, George D., *An Historical Survey of the Ecclesiastical Antiquities of France with a view to illustrate the rise and progress of Gothic architecture in Europe*, London 1809 (AL 29C)

Wightwick, George, 'The Life of an Architect – My Sojourn at Bath – The Late Sir John Soane', *Bentley's Miscellany*, vol. 34, 1853, pp. 108–14, 1855, pp. 402–9

The Palace of Architecture: a Romance of Art and History, London 1840

Wilkins, Bishop John, *A Discovery of a New World, or a discourse tending to prove that 'tis probable there may be another habitable world in the moon etc.* London 1684 (GL 15A)

Wilkins, William, senior, 'An Essay towards a History of the Venta Icenorum of the Romans, and of Norwich Castle, with Remarks on the Architecture of the Anglo-Saxons and Normans', *Archaeologia*, vol. 12, 1796, pp. 132–80 (GL 39)

Wilkins, William, junior, *The Antiquities of Magna Graecia*, Cambridge 1807 (AL 8D)

Winckelmann, Johann Joachim, *Geschichte der Kunst des Alterthums*, Dresden 1764, transl. as *Histoire de l'art chez les anciens*, Paris 1766; 2 vols, Leipzig 1781; Yverdon 1784 (AL 36H); and 3 vols, Paris 1808–9 (SM AL 12A)

Monumenti antichi inediti, 3 vols, Rome 1767 (AL 45D)

Remarques sur l'architecture des anciens, Paris 1783 (AL 3B)

Wood, John, the elder, *Choir Gaure, vulgarly called Stonehenge, Described, Restored and Explained*, Oxford 1747 (AL 32D)

The Origin of Building: or, the Plagiarism of the Heathens Detected. In Five Books, Bath 1741 (AL 41E). Also original manuscript (AL 41E)

Wood, Robert, *The Ruins of Balbec, otherwise Heliopolis in Coelosyria*, London 1757 (AL 4D)

The Ruins of Palmyra, otherwise Tedmor, in the Desart, London 1753 (AL 4C)

Wotton, Henry, *The Elements of Architecture*, London 1624 (AL 35G)

Wotton, William, *Reflections upon Ancient and Modern Learning. With a Dissertation upon the Epistles of Phalaris, etc. by Dr Bentley*, London 1697 (GL 2F)

Wren, Christopher, junior, ed., *Parentalia: or, Memoirs of the Family of the Wrens*, London 1750 (AL 39E)

Zanini, Gioseffe Viola, *Della architettura di Gioseffe Viola Zanini*, Padua 1629 (AL 47A)

SECONDARY SOURCES

Abramson, Daniel M., 'C. R. Cockerell's "Architectural Progress of the Bank of England"', *Architectural History*, vol. 37, 1994, pp. 112–29

Money's Architecture: the Building of the Bank of England, 1731–1833, Harvard University Ph.D. thesis 1993

Aldridge, A. Owen, 'Ancients and Moderns in the Eighteenth Century', in *Dictionary of the History of Ideas*, vol. i, ed. Philip P. Wiener, New York 1968, pp. 76–87

Altick, Richard D., *The Shows of London*, Cambridge, Mass., and London, 1978

Antal, Frederick, *Fuseli Studies*, London 1956

Archer, John, 'The Beginnings of Association in British Architectural Aesthetics', *Eighteenth-Century Studies*, vol. 16, 1983, pp. 231–64

'Character in English Architectural Design', *Eighteenth-Century Studies*, vol 12, Spring 1979, pp. 339–71

The Literature of British Domestic Architecture: 1715–1842, Cambridge, Mass., and London 1985

Archer, Mildred, *Early Views of India: the Picturesque Journeys of Thomas and William Daniell 1786–1794*, London 1980

Les Architectes de la Liberté: 1789–1799, Exhibition Catalogue, Ecole nationale supérieure des Beaux-Arts, Paris 1989–90

Armayor, O. Kimball, *Herodotus' Autopsy of Fayoum: Lake Mœris and the Labyrinth of Egypt*, Amsterdam 1985

Arntzen, Etta Mae, *A Study of* Principii di Architettura Civile *by Francesco Milizia*, Ph. D. thesis, Columbia University 1970

Ballantyne, Andrew, 'Downton Castle: Function and Meaning', *Architectural History*, vol. 32, 1989, pp. 105–30

'First Principles and Ancient Errors: Soane at Dulwich', *Architectural History*, vol. 37, 1994, pp. 96–111

Bannister, Turpin C., 'The Roussillon Vaults, The Apotheosis of a "Folk" Construction', *Journal of the Society of Architectural Historians*, vol. 27, October 1968, pp. 163–75

Barrell, John, *The Political Theory of Painting from Reynolds to Hazlitt: 'The Body of the Public'*, New Haven and London 1986

Becker, Carl L. *The Heavenly City of the Eighteenth-Century Philosophers*, Yale 1932

Bell, C. F., *Annals of Thomas Banks, Sculptor, Royal Academician*, Cambridge 1938

Benhamou, Reed, 'Continuing Education and Other Innovations: an Eighteenth-Century Case Study', *Studies in Eighteenth-Century Culture*, vol. 15, Madison 1986, pp. 67–76

'*Cours Publics*: Elective Education in the Eighteenth Century', *Studies on Voltaire and the Eighteenth Century*, no. 241, 1986, pp. 365–76

Bennett, J. A., 'Christopher Wren: the Natural Causes of Beauty', *Architectural History*, vol. 15, 1972, pp. 5–22

The Mathematical Science of Christopher Wren, Cambridge 1982

Berger, Robert W., *The Palace of the Sun: The Louvre of Louis XIV*, University Park, Pennsylvania 1993

Berman, Morris, *Social Change and Scientific Organization: The Royal Institution 1799–1844*, London 1978

Betts, Richard J., 'Structural Innovation and Structural Design in Renaissance Architecture', *Journal of the Society of Architectural Historians*, vol. 52, March 1993, pp. 4–25

Bingham, Neil, 'Architecture at the Royal Academy Schools, 1768–1836', in *The Education of the Architect*, Neil Bingham, ed., Society of Architectural Historians Symposium, London 1993, pp. 5–14

Bizzarro, Tina Waldeier, *Romanesque Architectural Criticism, a Prehistory*, Cambridge 1992

Blunt, Anthony, 'The *Hypnerotomachia Poliphili* in 17th-century France', *Journal of the Warburg Institute*, vol. 1, 1937–38, pp. 117–37

Sicilian Baroque, London 1968

Bolton, Arthur T., *Architectural Education a Century Ago. Being an account of the office of Sir John Soane, R.A., with special reference to the career of George Basevi*, London n.d.

The Architecture of Robert and James Adam, 2 vols, London 1922

The Works of Sir John Soane, F.R.S., F.S.A., R.A. (1753–1837), London 1924

Bolton, Arthur, T., ed., *Lectures on Architecture by Sir John Soane . . . As delivered to the Students of the Royal Academy from 1809 to 1836 in Two Courses of Six Lectures each*, London 1929

The Portrait of Sir John Soane, R.A., London 1927

Bouchard, Marcel, *L'Académie de Dijon et le premier discours de Rousseau*, Paris 1950

Boyle, Nicholas, *Goethe: The Poet and The Age*, vol. i, *The Poetry of Desire (1749–1790)*, Oxford 1991

Braham, Allan, *The Architecture of the French Enlightenment*, London 1980

Brown, Ian G., 'Atavism and Ideas of Architectural Progress in Robert Adam's Vitruvian Seal', *Georgian Group Journal*, London 1994, pp. 70–73

Brownell, Morris R., *Alexander Pope and the Arts of Georgian England*, Oxford 1978

Brownlee, David B., *The Law Courts: the Architecture of George Edmund Street*, Cambridge, Mass., and London 1984

Carr, Gerald L., *The Commissioners' Churches of London, 1818–37*, Ph.D. thesis, University of Michigan 1976

'Soane's Specimen Church Designs of 1818', *Architectural History*, vol. 16, 1973, pp. 37–53

Cassirer, Ernst, *The Philosophy of the Enlightenment* (1932), Princeton 1951

Chafee, Richard, 'The Teaching of Architecture at the Ecole des Beaux-Arts', *The Architecture of the Ecole des Beaux-Arts*, Arthur Drexler, ed., London 1977, pp. 61–110

Christiansen, Thomas, *Rameau and Musical Thought in the Enlightenment*, Cambridge 1993

Church, Henry W., 'Corneille de Pauw, and the Controversy over his *Recherches* philosophiques sur les Américains', *Publications of the Modern Language Association of America*, vol. 51, March 1936, pp. 178–206

Clarke, Michael, and Nicholas Penny, eds, *The Arrogant Connoisseur: Richard Payne Knight 1751–1824*, Manchester 1982

Clayton, Peter A., *The Rediscovery of Ancient Egypt: Artists and Travellers in the 19th Century*, London 1982

Collins, Peter, *Changing Ideals in Modern Architecture 1750–1950*, London 1965

Colton, Judith, *The Parnasse François: Titon du Tillet and the Origins of the Monu-* ment to Genius, New Haven and London 1979

Colvin, Howard M., *Architecture and the After-Life*, New Haven and London 1991

A Biographical Dictionary of British Architects, 1600–1840, 3rd edn, New Haven and London 1995

Colvin, Howard M., ed., *The History of the King's Works*, vol. vi, *1783–1851* (by J. Mordaunt Crook and M. H. Port), London 1973

Colvin, Howard M., and John Harris, eds, *The Country Seat*, London 1970

Conner, Patrick, *Oriental Architecture in the West*, London 1979

Connor, Peter, 'Cast-collecting in the nineteenth century: scholarship, aesthetics, connoisseurship', in *Rediscovering Hellenism: The Hellenic Inheritance and the English Imagination*, G. W. Clarke, ed., Cambridge 1989, pp. 187–235

Crocker, Lester G., *An Age of Crisis: Man and World in Eighteenth Century French Thought*, Baltimore 1959

Crook, J. Mordaunt, *The Dilemma of Style: Architectural Ideas from the Picturesque to the Post-Modern*, London 1987

The Greek Revival: Neo-Classical Attitudes in British Architecture 1760–1870, London 1972

Cruickshank, Dan, 'Soane and the Meaning of Colour', *Architectural Review*, vol. 185, January 1989, pp. 46–52

Crozet, R., 'Le Phare de Cordouan', *Bulletin monumental*, vol. 113, 1955, pp. 153–71

Curl, James Stevens, *The Art and Architecture of Freemasonry: an Introductory Study*, London 1991

A Celebration of Death (1980), London 1993

The Egyptian Revival (1982), 2nd edn, *Egyptomania: the Egyptian Revival as a Recurring Theme in the History of Taste*, Manchester 1994

Darley, Gillian, *John Soane: An Accidental Romantic*, New Haven and London 1999

Darnton, Robert, *The Business of the Enlight-*

enment: a Publishing History of the Encyclopédie *1775–1800*, Cambridge, Mass., and London 1979

Davies, Maurice, *Turner as Professor: the Artist and Linear Perspective*, Tate Gallery, London 1992

Davies, Paul, and David Hemsoll, 'Sanmicheli through British Eyes', in *English Architecture Public and Private: Essays for Kerry Downes*, John Bold and Edward Cheney, eds, London and Rio Grande 1993, pp. 121–34

Deming, Mark K., *La Halle au Blé de Paris, 1762–1813*, Brussels 1984

Charles de Wailly: Peintre architecte dans l'Europe des lumières, Exhibition Catalogue, Caisse Nationale des Monuments Historiques et des Sites, Paris 1979

De Zurko, Edward R., *Origins of Functionalist Theory*, New York 1957

Dixon, Susan M., 'Giovanni Battista Piranesi's *Diverse maniere d'adornare i cammini* and Chimneypiece Designs as a Vehicle for Polemic', *Studies in the Decorative Arts*, vol. I, no. 1, Autumn 1993, pp. 76–98

Dobai, Johannes, *Die Kunstliteratur des Klassizismus und der Romantik in England 1700–1840*, 4 vols, Bern 1974–84

Dorey, Helen, 'Sir John Soane's Acquisition of the Sarcophagus of Seti I', *Georgian Group Journal*, 1991, pp. 26–35

Downes, Kerry, 'John Evelyn and Architecture: a First Enquiry', *Concerning Architecture*, ed. John Summerson, London 1968, pp. 28–39

Drexler, Arthur, ed., *The Architecture of the Ecole des Beaux-Arts*, London 1977

Du Prey, Pierre de la Ruffinière, 'Eighteenth-Century English Sources for a History of Swiss Wooden Bridges', *Zeitschrift für schweizerische Archaeologie und Kunstgeschichte*, vol. 36, 1979, pp. 51–63

'John Soane, Philip Yorke, and their Quest for Primitive Architecture', *National Trust Studies*, London 1979, pp. 28–38

John Soane's Education 1753–80, Ph.D. thesis, Princeton University 1972; New York 1977

John Soane: the Making of an Architect, Chicago and London 1982

'Soane and Hardwick in Rome: a Neo-Classical Partnership', *Architectural History*, vol. 15, 1972, pp. 51–67

The Villas of Pliny from Antiquity to Posterity, Chicago and London 1994

Egbert, Donald Drew, *The Beaux-Arts Tradition in French Architecture: Illustrated by the Grands Prix de Rome*, Princeton 1980

Egyptomanie: L'Egypte dans l'art occidental 1730–1930, Exhibition Catalogue, Musée du Louvre, Paris 1994

Einaudi, Mario, *The Early Rousseau*, Ithaca, New York 1967

Erffa, Helmut von, and Alan Staley, *The Paintings of Benjamin West*, New Haven and London, 1986

Etlin, Richard A., *The Architecture of Death: the Transformation of the Cemetery in Eighteenth-century Paris*, Cambridge, Mass., and London 1984

'Grandeur et décadence d'un modèle: l'église Sainte-Geneviève et les changements de valeur esthétique au XVIIIe siècle', *Soufflot et l'architecture des lumières*, Actes du colloque, Paris 1980, 2nd edn, 1986, pp. 28–31

Feinberg, Susan G., 'The Genesis of Sir John Soane's Museum Idea: 1801–1810', *Journal of the Society of Architectural Historians*, vol. 43, October 1984, pp. 225–37

Fleming, John, *Robert Adam and his Circle in Edinburgh and Rome*, London 1962

Ford, Brinsley, 'The Earl-Bishop, An Eccentric and Capricious Patron of the Arts', *Apollo*, vol. XCIX, June 1974, pp. 426–34

Fothergill, Brian, *The Mitred Earl: an Eighteenth-Century Eccentric*, London 1974

Fox, Celina, ed., *London – World City 1800–1840*, New Haven and London 1992

Frankl, Paul, *The Gothic, Literary Sources and Interpretations through Eight Centuries*, Princeton 1960

Frew, John M., 'Gothic is English: John Carter and the Revival of the Gothic as England's National Style', *Art Bulletin*, vol. LXIV, June 1982, pp. 315–19

Funnell, Peter, 'The Symbolical Language of Antiquity', in *The Arrogant Connoisseur: Richard Payne Knight 1751–1824*, Michael Clarke and Nicholas Penny, eds, Manchester 1982, pp. 50–64

Gage, John, *Colour and Culture: Practice and Meaning from Antiquity to Abstraction*, London 1993

Colour in Turner: Poetry and Truth, London 1969

J. M. W. Turner: 'A Wonderful Range of Mind', New Haven and London 1987

Gallet, Michel, *Claude-Nicolas Ledoux, Unpublished Projects: with an Essay by Michel Gallet*, Berlin 1992

Gallet, Michel, and Jorg Garms, *Germain Boffrand 1667–1754. L'aventure d'un architecte indépendant*, Exhibition Catalogue, Ville de Paris 1986

Joseph Michael Gandy (1771–1843), Exhibition Catalogue, Architectural Association, London 1982

Gay, Peter, *The Enlightenment: an Interpretation*, vol. i, *The Rise of Modern Paganism*, London 1966, vol. ii, *The Science of Freedom*, London 1969

Gibson, W. A., 'Literary Influences on Robert Morris's First Excursion in Architectural History', *Rendezvous*, Idaho State University Journal of Art and Letters, vol. 7, 1971, pp. 1–14

Gilly, Friedrich, *Essays on Architecture 1796–1799*, trans. by David Britt, with intro. by Fritz Neumayer, Santa Monica 1994

Godwin, Jocelyn, *Athanasius Kircher: A Renaissance Man and the Quest for Lost Knowledge*, London 1979

Gonzalez-Palacios, Alvar, 'The Prince of Palagonia, Goethe and Glass Furniture', *Burlington Magazine*, vol. 13, August 1971, pp. 456–60

Griener, Pascal, *Antichità etrusche, greche e romane 1766–1776 di Pierre Hugues d'Hancarville: la pubblicazione delle ceramiche antiche della prima collezione*, Rome 1992

Gropius, Walter, *The New Architecture and the Bauhaus*, London 1935

Hampson, Norman, *The Enlightenment* (1968), Harmondsworth 1982

Harrington, Kevin, *Changing Ideas on Architecture in the* Encyclopédie, *1750–1776*, Ann Arbor 1985

Harris, Eileen, 'Batty Langley: a Tutor to Freemasons (1696–1751)', *Burlington Magazine*, vol. 119, May 1977, pp. 327–33

'Burke and Chambers on the Sublime and Beautiful', in *Essays in the History of Architecture Presented to Rudolf Wittkower*, London 1967, pp. 207–13

'Sir John Soane's Library: "O, Books! Ye Monuments of Mind" ', *Apollo*, vol. 131, April 1990, pp. 242–47

'The *Treatise on Civil Architecture*', in John Harris, *Sir William Chambers*, London 1970, pp. 128–43

Harris, Eileen, and Nicholas Savage, *British Architectural Books and Writers: 1556–1785*, Cambridge 1990

Harris, John, *Catalogue of British Drawings . . . in American Collections*, New Jersey 1971

'C. R. Cockerell's *Ichnographica Domestica*', *Architectural History*, vol. 14, 1971, pp. 5–29

Sir William Chambers, Knight of the Polar Star, London 1970

'Soane's Classical Triumph: a Lost Westminster Masterpiece Revealed', *Apollo*, vol. 135, May 1992, pp. 288–90

Haskell, Francis, 'The Baron d'Hancarville: an Adventurer and Art Historian in Eighteenth-century Europe', in *Oxford, China and Italy*, Edward Chaney and Neil Ritchie, eds, Oxford 1984, pp. 177–91

Head, Raymond, *The Indian Style*, London 1986

Hegel, Georg Wilhelm Friedrich, *Aesthetics:*

Lectures on Fine Art (1835), transl. by T. Malcolm Knox, 2 vols, Oxford 1975

Henrickson, G. L., 'The Origin and Meaning of the Ancient Characters of Style', *American Journal of Philology*, vol. 26, 1905, pp. 249–90

Herrmann, Luke, *Paul and Thomas Sandby*, London 1986

Herrmann, Wolfgang, 'Antoine Desgodets and the Académie Royale d'Architecture', *Art Bulletin*, vol. 40, March 1958, pp. 23–53

Laugier and Eighteenth Century French Theory, London 1962

'The Problem of Chronology in Claude-Nicolas Ledoux's Engraved Work', *Art Bulletin*, vol. 42, September 1960, pp. 191–210

The Theory of Claude Perrault, London 1973

Hersey, George, 'Association and Sensibility in 18th century Architecture', *Eighteenth-Century Studies*, vol. 4, 1970–1, pp. 71–89

High Victorian Gothic: a Study in Associationism, Baltimore and London 1972

The Lost Meaning of Classical Architecture, Cambridge, Mass., and London 1980

Hilles, Frederick W., *The Literary Career of Sir Joshua Reynolds*, Cambridge 1936

Hipple, Walter J., *The Beautiful, the Sublime, and the Picturesque in Eighteenth-century British Aesthetic Theory*, Carbondale 1957

Hittorff, un architecte du XIXème, Musée Carnavalet, Paris 1986–87

Hodgson, J. E., and F. A. Eaton, *The Royal Academy and its Members 1768–1830*, London 1905

Hutchison, Sidney C. *The History of the Royal Academy* (1968), 2nd edn, London 1986

'The Royal Academy Schools, 1768–1830', *Walpole Society*, vol. 38, London 1962, pp. 123–91

Irwin, David, *John Flaxman 1755–1826, Sculptor, Illustrator, Designer*, London 1979

Jackson, Anthony, 'The Façade of Sir John Soane's Museum: a Study in Contextualism', *Journal of the Society of Architectural Historians*, vol. 51, December 1992, pp. 417–29

Jackson, Wallace, 'Affective Values in Later Eighteenth-century Aesthetics', *Journal of Aesthetics and Art Criticism*, vol. 24, no. 2, Winter 1965, pp. 309–14

Jenkins, Ian, 'Adam Buck and the Vogue for Greek Vases', *Burlington Magazine*, vol. 130, June 1988, pp. 448–57

'James Stephanoff at the British Museum', *Apollo*, vol. 131, March 1985, pp. 174–81

Joyce, Hetty, 'The Ancient Frescoes from the Villa Negroni and their Influence in the Eighteenth and Nineteenth Centuries', *Art Bulletin*, vol. 65, September 1983, pp. 423–40

Kaufmann, Edgar, 'Lodoli Architetto', in *In Search of Modern Architecture: a Tribute to H.-R. Hitchcock*, Helen Spearing, ed., Cambridge, Mass., and London 1982, pp. 31–37

Kaufmann, Emil, *Trois architectes révolutionnaires: Boullée, Ledoux, Lequeu*, Georges Teyssot and Gilbert Erouart, eds, Paris 1978

Von Ledoux bis Le Corbusier: Ursprung und Entwicklung der autonomen Architektur, Vienna and Leipzig 1933

Keay, John, *India Discovered*, 2nd edn, London 1988

Kejariwal, Om Prakash, *The Asiatic Society of Bengal and the Discovery of India's Past, 1784–1838*, Delhi, 1988

Kelly, Alison, *Mrs Coade's Stone*, Upton-upon-Severn 1990

Kennedy, George A., 'Rhetoric', in *The Legacy of Rome: a New Appraisal*, Richard Jenkyns, ed., Oxford 1992, pp. 269–94

King-Hele, Desmond, *Shelley: his Thought and Work* (1960), 3rd edn, Rutherford 1984

Klibansky, Raymond, et al., *Saturn and Melancholy: Studies in the History of Natural Philosophy, Religion and Art*, London 1964

Knight, Isabel F., *The Geometric Spirit: the*

Abbé de Condillac and the French Enlightenment, New Haven and London 1968

Kohane, Peter, *Architecture, Labor and the Human Body: Fergusson, Cockerell and Ruskin*, Ph.D. thesis, University of Pennsylvania 1993

Kunoth, George, *Die historische Architektur Fischers von Erlach*, Düsseldorf 1956

Kruft, Hanno-Walter, *A History of Architectural Theory from Vitruvius to the Present*, London 1994

La Laurentine et l'invention de Villa Romaine, Institut Français d'Architecture, Paris 1982

Lang, S., 'Richard Payne Knight and the Idea of Modernity', *Concerning Architecture: Essays on Architectural Writers and Writing presented to Nikolaus Pevsner*, John Summerson, ed., London 1968, pp. 85–97

Laugier, Marc-Antoine, *An Essay on Architecture*, transl. by Wolfgang and Anni Herrmann, Los Angeles 1977

Lavin, Sylvia, *Quatremère de Quincy and the Invention of a Modern Language of Architecture*, Cambridge, Mass., and London 1992

Lawrence, A. W., *Greek Architecture*, 4th edn, Harmondsworth 1983

Leatherbarrow, David, 'Architecture and Situation: a Study of the Architectural Writings of Robert Morris', *Journal of the Society of Architectural Historians*, vol. 44, March 1985, pp. 48–59

Le Camus de Mézières, Nicolas, *The Genius of Architecture; or, the Analogy of that art with our sensations*, transl. by David Britt, with intro. by Robin Middleton, Santa Monica 1992

Lee, Rensselaer W., 'Ut Pictura Poesis': *the Humanist Theory of Painting* (1940), New York and London 1967

Lemonnier, Henry, ed., *Procès-Verbaux de l'Académie Royale d'Architecture 1671–1793*, 10 vols, Paris 1911–29

Levine, Neil, 'The Book and the Building: Hugo's theory of Architecture and Labrouste's Bibliothèque Ste-Geneviève', in *The Beaux-Arts and Nineteenth-century French Architecture*, Robin Middleton, ed., London 1982, pp. 138–73

Liscombe, Rhodri Windsor, 'The "Diffusion of Knowledge and Taste": John Flaxman and the Improvement of the Study Facilities at the Royal Academy', *Walpole Society*, vol. 53, 1987, pp. 226–38

'Economy, Character and Durability: Specimen Designs for Church Commissioners 1818', *Architectural History*, vol. 13, 1970, pp. 43–57

William Wilkins 1778–1839, Cambridge 1980

Lorch, Richard, 'The Architectural Order of Sir John Soane's House', *International Architect*, vol. 2, no. 9, 1982, pp. 43–48

Lough, John, *The Encyclopédie in Eighteenth-century England and Other Studies*, Newcastle-upon-Tyne 1970

Lovejoy, Arthur, et al., *A Documentary History of Primitivism and Related Ideas*, Baltimore 1935

Lovejoy, Arthur O., *Essays in the History of Ideas*, Baltimore 1948

Lukacher, Brian, 'John Soane and his draughtsman Joseph Michael Gandy', *Daidalos*, vol. 25, September 1987, pp. 51–64

'Joseph Gandy and the Mythography of Architecture', *Journal of the Society of Architectural Historians*, vol. 53, September 1994, pp. 280–99

Joseph Michael Gandy: the Poetical Representation and Mythography of Architecture, Ph.D. thesis, University of Delaware 1987, Ann Arbor 1993

'Phantasmagoria and Emanations: Lighting Effects in the Architectural Fantasies of Joseph Michael Gandy', *AA Files*, vol. 4, 1983, pp. 40–48

McCarthy, Michael, 'Thomas Pitt, Piranesi and John Soane: English Architects in Italy in the 1770s', *Apollo*, vol. 34, December 1991, pp. 380–86

McCormick, Thomas J., *Charles-Louis Clérisseau and the Genesis of Neo-Classicism*, Cambridge, Mass., and London 1990

Mackenzie, Catherine M., 'The *Ut Poesis Architectura* of Germain Boffrand', Ph.D. thesis, University of Toronto 1984

McClellan, Andrew, *Inventing the Louvre: Art, Politics, and the Origins of the Modern Museum in Eighteenth-century Paris*, Cambridge 1994

Macmillan Encyclopedia of Architects, 4 vols, London and New York 1982

Manuel, Frank E., *The Eighteenth Century Confronts the Gods*, Cambridge, Mass., 1959

　Isaac Newton, Historian, Cambridge, Mass., 1963

Mason, Eudo C. *The Mind of Fuseli: Selections from his Writings with an Introductory Study*, London 1951

Mathieu, Mae, *Pierre Patte, sa vie et son œuvre*, Paris 1940

Mellinghoff, G.-Tilman, 'Soane's Dulwich Picture Gallery Revisited', *John Soane*, London 1983, pp. 77–99

Mezzanotte, Gianni, *Architettura neoclassica in Lombardia*, Naples 1966

Middleton, Robin, 'The Abbé de Cordemoy and the Graeco-Gothic Ideal: a Prelude to Romantic Classicism', *Journal of the Warburg and Courtauld Institutes*, vol. 25, 1962, pp. 278–320, vol. 26, 1963, pp. 90–123

　'Cordemoy', in the *Macmillan Encyclopedia of Architects*, 4 vols, London and New York 1982

　'The French Connection in Eighteenth-century England', *AA Files*, vol. 16, 1987, pp. 46–56

　'French Eighteenth-century Opinion on Wren', in *Concerning Architecture: Essays on Architectural Writers and Writing Presented to Nikolaus Pevsner*, John Summerson, ed., London 1968, pp. 40–57

　'Hittorff's Polychrome Campaign', in *The Beaux-Arts and Nineteenth-century French Architecture*, London 1982, pp. 174–95

　'Jacques François Blondel and the *Cours d'architecture*', *Journal of the Society of Architectural Historians*, vol. 18, December 1959, pp. 140–48

　'Perfection and Colour: the Polychromy of French Architecture of the Eighteenth and Nineteenth centuries', *Rassegna*, vol. 7, no. 23, 1985, pp. 55–67

Middleton, Robin, ed., *The Beaux Arts and Nineteenth-century French Architecture*, London 1982

Middleton, Robin, and David Watkin, *Neo-Classical and Nineteenth Century Architecture*, New York 1980

Millenson, Susan Feinberg, *Sir John Soane's Museum*, Ann Arbor 1987

Mitter, Partha, *Much Maligned Monsters: a History of European Reactions to Indian Art* (1977), Chicago 1992

Monk, Samuel H., *The Sublime: a Study of Critical Theories in the XVIII-Century* (1935), Ann Arbor 1960

Montagu, Jennifer, *The Expression of the Passions: The Origin and Influence of Charles Le Brun's Conférence sur l'expression générale et particulière*, New Haven and London 1994

Morgan, Humphrey C., *A History of the Organisation and Growth of the Royal Academy Schools from the Beginning of the Academy to 1836, with Special Reference to Academic Teaching and Conditions of Study*, Ph.D. thesis, University of Leeds 1964

Morley, John, *Regency Design 1790–1840*, London 1993

Mosser, Monique, and Georges Teyssot, eds, *A History of Garden Design: the Western Tradition from the Renaissance to the Present Day*, London 1991

Mowl, Tim, and Brian Earnshaw, *John Wood: Architect of Obsession*, Bath 1988

Mukherjee, Soumyendrah Nath, *Sir William Jones: a Study in Eighteenth-century British Attitudes to India*, Cambridge 1968

Murphy, James J., ed., *Renaissance Rhetoric: Studies in the Theory and Practice of Renaissance Rhetoric*, Berkeley and London 1983

Newman, John, 'Adam and Chambers', in *The Contemporaries of Robert Adam*, Giles Worsley, ed., Symposium Papers, The Georgian Group, 1992, London 1993, pp. 14–23

Newman, John, *Somerset House: Splendour and Order*, London 1990

Nicolson, Marjorie Hope, *Mountain Gloom and Mountain Glory: the Development of the Aesthetics of the Infinite*, New York 1959

Newton Demands the Muse: Newton's Opticks and the English Eighteenth Century Poets, Princeton 1946

Nyberg, Dorothea, intro. to *Œuvre de Juste Aurèle Meissonnier* (*c.* 1750), reprinted New York 1969, pp. 6–43

'*La Sainte Antiquité*: Focus of an Eighteenth-century Debate', in *Essays in the History of Architecture Presented to Rudolf Wittkower*, Douglas Fraser et al., eds, London 1967, pp. 159–69

Oechslin, Werner, '*Emouvoir*. Boullée und le Corbusier', *Daidalos*, 30, December 1988, pp. 42–55

'Milizia', in the *Macmillan Encyclopedia of Architects*, 4 vols, London and New York 1982

Oncken, Alste, *Friedrich Gilly, 1772–1800*, Berlin 1935

Onians, John, *Bearers of Meaning: the Classical Orders in Antiquity, the Middle Ages, and the Renaissance*, New Jersey 1988

Paatz, Walter and Elisabeth, *Die Kirchen von Florenz*, 6 vols, Frankfurt am Main 1952–55

Palaces of Art. Art Galleries in Britain 1790–1990, Exhibition Catalogue, Dulwich Picture Gallery, and National Gallery, Scotland, 1991–92.

Palestrina: The Temple of Fortune as an Inspiration to Architects, Exhibition Catalogue, RIBA Drawings Collection, Heinz Gallery, London 1989

Palmer, Susan, 'The Papers of Sir John Soane', *Apollo*, vol. 81, April 1990, pp. 248–51

Panofsky, Dora and Erwin, *Pandora's Box: The Changing Aspects of a Mythical Symbol* (1956), 2nd edn, Princeton 1962

Le Panthéon, symbole des révolutions: de l'église de la nation au temple des grands hommes, Exhibition Catalogue, Centre Canadien d'Architecture and Caisse Nationale des Monuments Historiques et des Sites, Paris 1989

Paulson, R., *Hogarth's Graphic Works*, 3rd rev. edn, London 1989

Pelletier, Michael, *Claude Perrault's Politics, Religious Belief and Philosophy and their Impacts on his Notions of Beauty: The Jansenist Hypothesis*, M. Phil. thesis, University of Cambridge, Department of Architecture, 1989

Pérez-Gómez, Alberto, *Architecture and the Crisis of Modern Science*, Cambridge, Mass., and London 1983

Pérouse de Montclos, Jean-Marie, *L'Architecture à la française, XVIe, XVIIe, XVIIIe siècles*, Paris 1982

Etienne-Louis Boullée 1728–1799: De l'architecture classique à l'architecture révolutionnaire, Paris 1969

'Le sixième ordre d'architecture', *Journal of the Society of Architectural Historians*, vol. 36, December 1977, pp. 223–40

Perrault, Claude, *Ordonnance for the Five Kinds of Columns after the Method of the Ancients*, transl. by Indra K. McEwen, with intro. by Alberto Pérez-Gómez, Santa Monica 1993

Peschken, Goerd, *Karl Friedrich Schinkel Lebenswerk, Das architektonische Lehrbuch*, Berlin and Munich 1979

Picon, Antoine, *Architectes et ingénieurs au siècle des lumières*, Marseilles 1988, transl. as *French Architects and Engineers in the Age of Enlightenment*, Cambridge 1992

Picon, Claude, *Claude Perrault, 1613–1688, ou la curiosité d'un classique*, Paris 1988

Pinto, John A., *The Trevi Fountain*, New Haven and London 1986

Piranèse et les français, 1740–1790, Exhibition Catalogue, Académie de France à Rome, Rome 1976

Pollitt, J. J., *The Art of Rome c.753 B.C.–A.D. 337: Sources and Documents* (1966), Cambridge 1983

Ponte, Alessandra, 'Architecture and Phallocentrism in Richard Payne Knight's Theory', in *Sexuality and Space*, Beatriz Colomina, ed., New York 1992, pp. 273–305

Potts, Alex, *Flesh and the Ideal: Winckelmann and the Origins of Art History*, New Haven and London 1994

'Schinkel's Architectural Theory', in Michael Snodin, ed., *Karl Friedrich Schinkel: A Universal Man*, New Haven and London 1991, pp. 47–56

Winckelmann's Interpretation of the History of Ancient Art in its Eighteenth-century Context, Ph.D. thesis, Warburg Institute, University of London, 1978

Pressly, William L., *The Life and Art of James Barry*, New York and London, 1981

Puttfarken, Thomas, *Roger de Piles' Theory of Art*, New Haven and London 1985

Quatremère de Quincy, Antoine-Chrysostôme, *Lettres à Miranda sur le déplacement des monuments de l'art de l'Italie*, with intro. and notes by Edouard Pommier, Paris 1986

Raspi Serra, Joseph, ed., *La fortuna di Paestum e la memoria moderna del Dorico*, 2 vols, Florence 1986

Paestum and the Doric Revival 1750–1830, Florence 1986

Reichwein, Adolf, *China and Europe: Intellectual and Artistic Contacts in the Eighteenth Century*, London 1925

Richardson, Margaret, *Concise Catalogue of Architectural and Ornamental Drawings at Sir John Soane's Museum*, forthcoming

'Learning in Soane's Office', in *The Educa-tion of the Architect*, Neil Bingham ed., Society of Architectural Historians Symposium, London 1993, pp. 15–21

'Model Architecture', *Country Life*, vol. 183, 21 September 1989, pp. 224–27

'Soane's Use of Drawings', *Apollo*, vol. 131, April 1990, pp. 231–41

Rietdorf, Alfred, *Gilly: Wiedergeburt der Architektur*, Berlin 1940

Roberts, Jane, 'Henry Emlyn's Restoration of St George's Chapel', *Report of the Society of the Friends of St George's*, vol. 5, no. 8, 1977, pp. 331–38

Robinson, John Martin, *Georgian Model Farms: a Study of Decorative and Model Farm Buildings in the Age of Improvement 1700–1846*, Oxford 1983

Ross, Stephanie, 'Painting the Passions: Charles LeBrun's *Conférence sur l'Expression*', *Journal of the History of Ideas*, vol. 45, January–March 1984, pp. 25–47

Rousseau, George S., 'The Sorrows of Priapus: Anticlericalism, Homosocial Desire, and Richard Payne Knight', in *Sexual Underworlds of the Enlightenment*, George S. Rousseau and Roy Porter, eds, Manchester 1987, pp. 101–53

Royal Institute of British Architects, London, *Catalogue of Drawings Collection*, 20 vols, 1969–89

Ruddock, Ted, *Arch Bridges and their Builders 1735–1835*, Cambridge 1979

Ruskin, John, *The Works*, E. T. Cave and Alexander Wedderburn, eds, 39 vols, London 1903–12

Russell, Terence M., *Architecture in the Encyclopédie of Diderot and D'Alembert: the Letterpress Articles and Selected Engravings*, Aldershot 1993

Rykwert, Joseph, *The First Moderns: the Architects of the Eighteenth Century*, Cambridge, Mass., and London 1980

'Lodoli on Function and Representation', in *The Necessity of Artifice*, London 1982, pp. 114–21

On Adam's House in Paradise: the Idea of the

Primitive Hut in Architectural History, New York 1972

St. Clair, William, *Lord Elgin and the Marbles*, Oxford 1967

Saisselin, Rémy G., 'Architecture and Language: The Sensationalism of Le Camus de Mézières', *The British Journal of Aesthetics*, vol. 15, no. 3 Summer 1975, pp. 239–54

The Rule of Reason and the Ruses of the Heart: a Philosophical Dictionary of Classical French Criticism, Critics, and Aesthetic Issues, Cleveland and London 1970

'Some Remarks on French 18th-century Writings on the Arts', *Journal of Aesthetics and Art Criticism*, vol. 25, Winter 1966, pp. 189–95

Taste in Eighteenth Century France: Critical Reflections on the Origins of Aesthetics, New York 1965

'*Ut Pictura Poesis*: Du Bos to Diderot', *The Journal of Aesthetics and Art Criticism*, vol. 20, Winter 1961, pp. 145–57

Sandby, William, *Thomas and Paul Sandby, Royal Academicians: Some Account of their Lives and Works*, London 1902

Savage, Nicholas, 'The Academicians' Library: a Selection, not a Collection', *Apollo*, vol. 128, October 1988, pp. 258–63, 297

Schinkel, Karl Friedrich, *'The English Journey': Journal of a Visit to France and Britain in 1826*, David Bindman and Gottfried Riemann, eds, New Haven and London 1993

Schumann-Bacia, Eva, *Die Bank von England und ihr Architekt John Soane*, Zurich and Munich 1989, transl. as *John Soane and the Bank of England*, London and New York 1991

Shanes, Eric, 'Dissent in Somerset House: Opposition to the Political *Status-quo* within the Royal Academy around 1800', *Turner Studies*, vol. 10, no. 2, Winter 1990, pp. 40–46

Sidlauskas, Susan, 'Creating Immortality.

Turner, Soane, and the Great Chain of Being', *Art Journal*, vol. 52, no. 2, Summer 1993, pp. 59–65

Smart, Alastair, *Allan Ramsay: Painter, Essayist and Man of the Enlightenment*, New Haven and London 1992

Soane and After: the Architecture of Dulwich Picture Gallery, Exhibition Catalogue, Dulwich Picture Gallery, 1987

Soufflot et l'architecture des lumières, Actes du colloque, Paris 1982; 2nd edn, Ecole Nationale Supérieure des Beaux-Arts, Paris 1986

Stafford, Barbara M., *Voyage into Substance: Art, Science, Nature, and the Illustrated Travel Account, 1760–1840*, Cambridge, Mass., 1984

Stampfl, Claudia, ed., *Richard Payne Knight Expedition into Sicily*, London 1986

Steele, H. Rooksby, and F. R. Yerbury, *The Old Bank of England, London*, London 1930

Stillman, Damie, 'British Architects and Italian Architectural Competitions, 1758–1780', *Journal of the Society of Architectural Historians*, vol. 32, March 1973, pp. 43–66

English Neo-classical Architecture, 2 vols, London 1988

Stillwell, Richard, *The Princeton Encyclopedia of Classical Sites*, Princeton 1976

Stroud, Dorothy, *The Architecture of Sir John Soane*, London 1961

George Dance Architect, 1741–1825, London 1971

Sir John Soane, Architect, London 1984

'Sir John Soane and the Rebuilding of Pitzhanger Manor', in *In Search of Modern Architecture: A Tribute to H.-R. Hitchcock*, Helen Searing, ed., Cambridge, Mass., and London 1982, pp. 38–51

'Soane's Designs for a Triumphal Bridge', *Architectural Review*, vol. 71, 1957, pp. 121–22

Stutchbury, Howard E., *The Architecture of Colen Campbell*, Manchester 1967

Summerson, John, *Architecture in Britain 1530–1830* (1953), 9th edn, New Haven and London 1993

The Classical Language of Architecture (1963), 3rd edn, London 1980

'The Evolution of Soane's Bank Stock Office at the Bank of England', *Architectural History*, vol. 27, 1984, pp. 135–49

Georgian London (1945), new edn, London 1988

A New Description of Sir John Soane's Museum (1955), 9th rev. edn, London 1991

'Sir John Soane and the Furniture of Death', in *The Unromantic Castle*, London 1990, pp. 121–42

'Soane: the Case-history of a Personal Style', [paper read before the RIBA, 12 December 1950], *RIBA, Journal*, 3rd series, vol. 58, January 1951, pp. 83–91

'Soane: the Man and the Style', *John Soane*, London 1983, pp. 9–23

'Union of the Arts: Sir John Soane's Museum-house', *Lotus International*, 35, 1982, ii, pp. 64–74

Summerson, John, ed., 'The Book of Architecture of John Thorpe in Sir John Soane's Museum', *Walpole Society*, vol. 40, 1966

Survey of London, 1896 – in progress (44 vols to date)

Szambien, Werner, *Jean-Nicolas-Louis Durand 1760–1834: de l'imitation à la norme*, Paris 1984

Le musée d'architecture, Paris 1988

'La Rue des Colonnes, une spéculation immobilière de l'époque révolutionnaire', *Bulletin de la Société de l'Histoire de Paris et de l'Ile-de-France*, 1986–87, Paris 1988, pp. 303–38

Symétrie, goût, caractère: théorie et terminologie de l'architecture à l'âge classique 1550–1800, Paris 1986

Tait, Alan A., *Robert Adam: Drawings and Imagination*, Cambridge 1993

Tanner, Lawrence E., *Unknown Westminster Abbey*, Harmondsworth 1948

Taylor, J. E., 'Sir John Soane: Architect and Freemason', *Ars Quatuor Coronatorum*, vol. 95, 1982, pp. 194–202

Teyssèdre, Bernard, *Roger de Piles et les débats sur le coloris au siècle de Louis XIV*, Paris 1957

Teyssot, Georges, *Città e utopia nell'illuminismo inglese: George Dance il giovane*, Rome 1974

'Emil Kaufmann and the Architecture of Reason: Klazzisismus and "Revolutionary Architecture",' *Oppositions*, vol. 13, 1978, pp. 46–75

Teyssot, Georges, 'John Soane and the Birth of Style: Notes on the Architectural Project in the Years round 1800', *Oppositions*, vol. 14, 1978, pp. 61–83

The Wren Society, 20 vols, Oxford 1924–43

Thomas, John Meurig, *Michael Faraday and the Royal Institution: the Genius of Man and Place*, Bristol, Philadelphia, and New York, 1991

Thornbury, Walter, *The Life of J. M. W. Turner, R. A.*, 2 vols, London 1862; rev. edn, 1877

Thornton, Peter, 'Lit up with Gorgeous Hues: More Light on Soane?', *Country Life*, vol. 178, no. 19 December 1985, pp. 1978–80

'An architectural kaleidoscope: Sir John Soane's Museum in London', *Antique*, January 1987, pp. 264–77

'The Soane as it Was (and Will Be)', *Apollo*, vol. 81, April 1990, pp. 228–33

Thornton, Peter, and Helen Dorey, *A Miscellany of Objects from Sir John Soane's Museum*, London 1992

Tigerman, Stanley, *The Architecture of Exile*, New York 1988

Tillotson, Giles, 'The Indian Travels of William Hodges', *Journal of the Royal Asiatic Society*, vol. 2, part 3, November 1992, pp. 377–98

Tsigakou, Fani-Maria, *The Rediscovery of Greece*, London 1981

Turner, Frank M., *The Greek Heritage in Vic-*

torian Britain, New Haven and London 1981

Turner and Architecture, Exhibition Catalogue, Tate Gallery, London 1988

Tuveson, Ernest L., *The Imagination as a Means of Grace: Locke and the Aesthetics of Romanticism*, Berkeley and Los Angeles, 1960

Tuzet, Hélène, *La Sicile au XVIIIe siècle vue par les voyageurs étrangers*, Strasbourg 1955

Tzonis, Alexander, and Liane Lefaivre, *Classical Architecture: the Poetics of Order*, Cambridge, Mass., and London 1986

Van Zanten, David, 'Architectural Polychromy: Life in Architecture', in *The Beaux-Arts and Nineteenth-century French Architecture*, Robin Middleton, ed., London 1982, pp. 196–215

The Architectural Polychromy of the 1830s, New York 1977

Victoria and Albert Museum, London, *Catalogues of Architectural Drawings in the Victoria and Albert Museum, Sir John Soane*, Pierre de la Ruffinière du Prey, ed., London 1985

Vidler, Anthony, *Claude-Nicolas Ledoux: Architecture and Social Reform at the End of the Ancien Régime*, Cambridge, Mass., 1990

The Writing of the Walls: Architectural Theory in the Late Enlightenment, Princeton 1987

Villari, Sergio, *J. N. L. Durand (1760–1834): Art and Science of Architecture*, New York 1990

Walker, Richard, *Regency Portraits*, 2 vols, National Portrait Gallery, London 1985

Wasserman, Earl R., ed., *Aspects of the Eighteenth Century*, Baltimore 1965

Watkin, David, 'Archaeology and the Greek Revival: a Case-Study of C. R. Cockerell', in *Late Georgian Classicism*, Roger White and Caroline Lightburn, eds, Symposium Papers, The Georgian Group (1987), London 1988, pp. 58–72

Athenian Stuart, Pioneer of the Greek Revival, London 1982

The English Vision: the Picturesque in Architecture, Landscape and Garden Design, London 1982

'Freemasonry and Sir John Soane', *Journal of the Society of Architectural Historians*, vol. 54, December 1995, 402–17

'George Dance and Character in Architecture', in *The Contemporaries of Robert Adam*, Giles Worsley, ed., Symposium Papers, The Georgian Group (1992), London 1993, pp. 50–54

The Life and Work of C. R. Cockerell, R. A., London 1974

The Rise of Architectural History, London and Westfield, New Jersey 1980

'Soane and his Contemporaries', *John Soane*, London 1983, pp. 40–59

Thomas Hope (1769–1831) and the Neo-Classical Idea, London 1968

'The paths of glory lead but to the grave', Introduction to *Soane and Death*, Exhibition Catalogue, Dulwich Picture Gallery, 1996

'Soane and the Picturesque: The Philosophy of Association', in *The Picturesque in Late Georgian England*, Dana Arnold, ed., Symposium papers, The Georgian Group (1994), London 1995, pp. 45–50 & 73–4

Watkin, David, ed., *Sale Catalogues of Libraries of Eminent Persons*, vol. iv, *Architects*, London 1972

Watkin, David, and Tilman Mellinghoff, *German Architecture and the Classical Ideal 1740–1840*, London 1987 and see Middleton, Robin

Webster, Christopher, *R. D. Chantrell, Architect: His Life and Work in Leeds 1818–1847*, The Thoresby Society, 2nd series, vol. 2, Leeds 1992

'The Influence of John Soane', in *Late Georgian Classicism*, Roger White and Caroline Lightburn, eds, Symposium Papers, The Georgian Group (1987), London 1988, pp. 28–44

Wedgwood, Alexandra, 'Soane's Law Courts at Westminster', *AA Files*, vol. 24, Autumn 1992, pp. 31–40

White, James F., *The Cambridge Movement: the Ecclesiologists and the Gothic Revival*, Cambridge 1962

Whiting, Frederick A., 'The Committee of Taste', *Apollo*, vol. 82, October 1965, pp. 326–30

Whitley, W. T., *Artists and their Friends in England 1700–1799*, 2 vols, London and Boston, 1928

Wiebenson, Dora, 'Greek, Gothic and Nature: 1750–1820', in *Essays in Honour of Walter Friedlander*, New York 1965, pp. 187–94

The Mark J. Millard Collection, vol. i, *French Books: Sixteenth through Nineteenth Centuries*, Washington, DC 1993

The Picturesque Garden in France, Princeton 1978

Sources of Greek Revival Architecture, London 1969

Wiebenson, Dora, ed., *Architectural Theory and Practice from Alberti to Ledoux* (1982), 2nd ed., Chicago 1983

Willmert, Todd, 'Heating Methods and their Impact on Soane's Work: Lincoln's Inn Fields and Dulwich Picture Gallery', *Journal of the Society of Architectural Historians*, vol. 52, March 1993, pp. 26–58

Wilton, Andrew, *Painting and Poetry: Turner's 'Verse Book' and his Work of 1804–1812*, Exhibition Catalogue, Tate Gallery, London 1990

Wilton, Andrew, *Turner in his Time*, London 1987

Wilton-Ely, John, 'The Architectural Models of Sir John Soane: a Catalogue', *Architectural History*, vol. 12, 1969, pp. 4–38

Giovanni Battista Piranesi: The Polemical Works, Farnborough 1972

The Mind and Art of Giovanni Battista Piranesi, London 1978

Piranesi as Architect and Designer, New Haven and London 1993

'Soane and Piranesi', in *Late Georgian Classicism*, Roger White and Caroline Lightburn, eds., Symposium Papers, The Georgian Group (1987), London 1988, pp. 45–57

Wilton-Ely, John, ed., *Giovanni Battista Piranesi: The Complete Etchings*, 2 vols, San Francisco 1994

Wittkower, Rudolf, 'Hieroglyphics i: the Conceptual Impact of Egypt from the Fifteenth Century Onward', in *Selected Lectures*, Cambridge 1989, pp. 94–112

'Federico Zuccari and John Wood of Bath', *Journal of the Warburg and Courtauld Institutes*, vol. VI, 1943, pp. 220–22

Gothic vs. Classic: Architectural Projects in Seventeenth-Century Italy, New York 1973

'Imitation, Eclecticism, and Genius', in *Aspects of the Eighteenth Century*, Earl R. Wasserman, ed., Baltimore 1965, pp. 143–61

Woodfield, Richard, 'The Freedom of Shaftesbury's Classicism', *The British Journal of Aesthetics*, vol. 15, Summer 1976, pp. 254–66

Worsley, Giles, *Architectural Drawings of the Regency Period 1790–1837*, London 1991

'Soane was no Faint-hearted Classicist', *Georgian Group Journal*, London 1994, pp. 43–50

Wortham, John D., *British Egyptology 1549–1906*, Newton Abbot 1971

Youngblood, Patrick, 'The Painter as Architect: Turner and Sandycombe Lodge', *Turner Studies*, vol. 2, no. 1, 1982, pp. 20–35

INDEX TO LECTURES

～

Abercorn, 1st Marquess of, 230
Acanthus, symbolism of, 242
Adam, Robert, 67, 185, 216, 258-9, 260
 see Edinburgh, Register House; Kedleston; London, Adelphi, Admiralty, British Coffee House, Chandos House, Derby House, Lansdowne House, Mansfield Street, Old Drury Lane Theatre, St James's Square, no. 20
Adam, Robert and James, 247
Adams, James, pl. 23
Addison, Joseph, 137
Aegina, Island of, 75
Aeneid, see Virgil
Aesculapius, 146, 242
 Temple of, *see* Agrigentum
Agamedes, 278
Agrigentum, Sicily
 Temple of Aesculapius, 79, 93, 205
 Temple of Concord, 73-4, 80
 Temple of Jupiter (Olympian Zeus), 124, 205
 Tomb of Theron, 59
Aholiab, 175
Akenside, Mark, 151
Albani, Cardinal, 69
Albano, Italy, Tomb of the Horatii and Curiatii, 233, pl. 4
Alberti, Leon Battista, 61, 86, 125, 280
Alcinous
 garden of, 225
 palace of, 32, 144
Alexander the Great, 39, 114, 142, 161, 228, 278
Alexander VII, Pope, 141
Alexandria, 228
Amasis, King of Egypt, 177
Amesbury Abbey, Wilts., 100, 197, 234

Ammanati, Bartolommeo, 161
Amphion, 30
Ancona, Italy, Arch of Trajan, 79
Anne, Queen of England, 122
Annual Register, 227
Aosta, Italy, Triumphal Arch, 59-60
Anthemius of Tralles, 141, 181
Antoninus and Faustina, Temple of, *see* Rome
Apaturius of Alabanda, 103
Apelles, 61, 92
Apollo, Temple of, *see* Delos
Apollodorus, 40
Aqueducts, 113
Archer, 1st Baron, 236
Archer, Thomas, *see* London, King Street, Covent Garden, no. 43
Arches, 137-8
 Triumphal, 79, 216
 see Ancona; Aosta; Athens; Beneventum; Orange; Paris; Rome
Ariccia, Italy, S. Maria dell'Assunzione, 129
Aristotle, 133
Artaxerxes, King of Persia, 76
Artemis, *see* Diana
Artemisia, wife of Mausolus *(q.v.),* 31, 110
Asinaro, column [Assinaro/is], 90
Assisi, Italy, Temple, 79, 96
Association, philosophy of, 220-1
Athena, *see* Minerva
Athens, 237
 Arch of Hadrian, 83, 153
 Choragic Monument of Lysicrates, 56, 82
 Choragic Monument of Thrasyllus, 80
 Erechtheum, 67, 79, 82, 184
 Gateway to the Roman Agora, 48

Athens (*cont.*)
 Parthenon, 39, 48, 80, 81, 124, 200, 208, 264, 280
 Propylaea, 80, 164
 Stoa Poikile, 56, 57, 79, 96
 Temple of Athena Nike (Wingless Victory), 73, 93
 Temple on the Ilissus, 53, 91, 94, 200
 Temple of Jupiter Olympius, 74–5
 Theseum, 39, 48, 95, 200
 Tower of the Winds, 56, 81, 100, 141, 150, 208, 241
Augustus, Emperor, 39, 43, 57, 59–60, 64, 138, 237

Baalbek, 32, 73, 76, 77, 228, 237, 264
Babel, 31
Babylon, 31, 40, 237
Bacon, Sir Francis, *Essays,* 189, 221
Baiae, Italy, chimney, 180
Bailey, George, 155
Balconies and verandahs, 146–7
Balustrades, 103–4, 210
Banks, Thomas, 173
Barrows, 243
Basements, columns on, 149, 233–4
Basevi, George, pl. 31
Bath, Somerset, 66
 Circus, 232, pl. 6
Bathurst, 1st Earl, 222
Beaumont, Sir George, 86
Beaumont Lodge, Surrey, 65
Beersheba, 254
Bélidor, Bernard-Forest de, *Architecture hydraulique,* 274
Bell, Edward, 143
Bénard, Pierre-Bénard, *see* Paris, rue des Colonnes
Benedict II, Pope, 263
Beneventum, Italy, Arch of Trajan, 79, 85
Bentley Priory, Middlesex, 230
Bernini, Gian Lorenzo, *see* Ariccia, S. Maria dell'Assunzione; Rome, Palazzo Chigi, St Peter's, Baldacchino, colonnade, Vatican, Scala Regia
Bezaleel, 175
Bianchini, Francesco, *Camera ed inscripzioni sepulcrali,* 147
Blackheath, Wricklemarsh House, 133, 167, 216
Blenheim Palace, Oxon., 132, 216, 225, 279
Blondel, François, Porte St. Denis, Paris, pl. 5
Blondel, Jacques-François, 180
 Architecture françoise, 216
 Cours d'architecture, 182

Bohemia, King of, 65
Bolingbroke, 1st Viscount, 132
Bologna, Italy, "S. Agostino", 128
Bonomi, Joseph, *see* London, Uxbridge House
Bordeaux, France, Theatre, 240
Borra, Giambattista, 132
Borromini, Francesco, 61, 71, 161, 193, 252
 see Rome, S. Carlo alle Quattro Fontane, S. Giovanni in Laterano
Boulton, Matthew, 181
Bourgeois, Sir Francis, 269
Boyd, Sir John, 215
Bramante, 92, 126, 265
 see Rome, Cortile del Belvedere, St Peter's, Tempietto
Brettingham, Matthew, *see* Holkham Hall
Brettingham, Robert Furze, *see* London, St James's Square, no. 21
Bridges, 138–40, 267–8
 Swiss, 268–9
 triumphal, 135
 see Sandby, Soane
Bridgeman, Charles, 222
Brioude, France, bridge, 139
Bristol, 4th Earl of, 169, 205
Britton, John, 148
Brown, Lancelot (Capability), 222
 see Claremont, Surrey
Brunelleschi, Filippo, 124–5, 154
Brutus, 243
Bruyn, Cornelis de, 116, pl. 8
Bubastis, Egypt, Temple of Diana, 35, 76
Buckingham, 2nd Marquess of, 182, 213, 229
Buckingham, 3rd Duke of, 86
Buckler, John, 225
Bucrania, *see* rams' and ox heads
Bullant, Jean, 203
 see Sunderland, bridge over Wear
Burlington, 3rd Earl of, 86, 133, 148, 171, 246
 see Chiswick House; London, house for General Wade; Petersham Lodge; York, Assembly Rooms
Butos, shrine of Latona, 277
Byzantium, *see* Constantinople

Caduceus, 146
Caducifer, *see* Caduceus
Caesar, Julius, *see* pediment, granted to
Cain, 31
Cairo, Great Pyramid, 107, 108, 138
 Pyramids, 35, 107
Callicrates, 280

Callimachus, 44, 55–6, 65

Cambridge, King's College Chapel, 121

Camden, 1st Marquess, 143

Camelford, 1st Baron, *see* Pitt, Thomas

Campbell, Colen, 249
 Vitruvius Britannicus, 216, 249
 see Mereworth

Canons House, Middlesex, 133, 167

Caprarola, Italy, Palazzo Farnese, 128–9, 143, 195

Caria, 67

Carter, John, 34, 225

Caryatids, *see* Orders

Caserta, near Naples, palace of, 93, 201

Cassius, Dion, 89

Castel, Louis-Bertrand, 148

Castle Ashby, Northants., 84, 131, 231–2

Castle Howard, Yorks., 216
 Mausoleum, 132

Catherine the Great, 275

Cave, appropriate to hunters and fishermen, 30–1

Chambers, Sir William, 54, 130, 155, 197, 246, 253
 design for Marylebone church, 130
 design for mausoleum, 130
 Designs of Chinese Buildings, 149, 219
 drawing of Trevi Fountain, 130, pl. 12
 Treatise on the Decorative Part of Civil Architecture, 74, 104, 130, 280
 see Kew Gardens; London, Gower House, Melbourne House, Somerset House; Roehampton

Chantrell, Robert, pl. 25

Chantrey, Sir Francis, 173

Character in architecture and ornament, 243–4, 247–9, 255–6

Charlotte, Queen of England, 198

Cheltenham, Glos., 66

Chimneys, 181–3, 211, 272

Chinese architecture, 149–50

Chiswick House, Middlesex, 102, 133, 149, 170, 181, 218, 234

Choiseul-Gouffier, Marie-Gabriel-Auguste-Florent, Comte de, *Voyage pittoresque de la Grèce,* 94, 110

Cholmondeley Hall, Cheshire, 250

Churches
 Act for Building Fifty Churches, 122
 meanness of modern, 121

Cicero, Marcus Tullius, 108, 111, 180, 206, 218, 245

Cirencester Park, Glos., 221

Circe, Palace of, 89

Claremont, Surrey
 garden building, 82
 gardens, 225
 House, 210, 215, 217

Claude Gellée (Lorraine), 167, 224

Clement XIV, Pope, 69

Cleophantus, 114

Clérisseau, Charles-Louis, 130, 246

Clermont, Lord, 143, 198

Climate, its relation to architecture, 47, 98, 167–8, 192, 206–10, 235–6

Clitumnus, Italy, Temple at, *see* Spoleto

Clive, 1st Baron, 215

Cobbett, William, 283

Cobham, 1st Viscount, 222

Cobham, Kent, mausoleum, 110

Colbert, Jean-Baptiste, 87

Coleridge, Samuel Taylor, 114

Coleshill House, Berks., 182, 198, 211, 215, 230

Colonna, Francesco, *Hypnerotomachia Poliphili,* 125, 274

Colour, 114

Columella, Lucius Junius Moderatus, 179
 De re rustica, 217

Columns, *see* Orders

Constantine the Great, Emperor, 109, 228, 265, 276

Constantine II, Emperor, 263

Constantinople, 228
 Column of Theodosius, 90
 Santa Sophia, 116–17, 141

Construction, 157
 inadequacy of modern, 270–2, pl. 29
 study of, 154
 see iron

Contractors, condemned for acting as architects, 41, 154, 257–8

Conway, Wales, bridge over, *see* Llanrwst

Cora (Cori), Italy, Temple of Hercules, 50, 202

Cordouan, France, lighthouse, 278, pl. 13

Corinth, Greece, 42

Corneto, Italy, Etruscan tombs, 34

Cortona, Pietro da, 161

Costume, compared with architecture, 62, 104

Cottages, 185–6

Cotte, Robert de, *see* Paris, St. Roche

Coupe des pierres, 268, 274

Coventry, Warwicks., St Michael, 142, 224

Cowper, William, *The Task,* 122

Crecy, Battle of, 65

Cresy, Edward, 87

Crowe, William, 114

Ctesiphon (Chersiphon), 61, 96, 175, 278
Curtius, Mettius, 243
Cusworth Hall, Yorks., 149, 201, 204
Cybele, 170
Cymon, 102

Damer, Anne Seymour, 86
Dance, George, the Elder, *see* London, Mansion
 House
Dance, George, the Younger, 87
 see London, All Hallows, London Wall, Newgate
 Prison, Shakespeare Gallery, St Luke's Hos-
 pital
Daniell, William, and Thomas, *Oriental Scenery,* 33
Danson Hill, Kent, 215
Danube, Trajan's bridge over, 139, 267, 268
Darnley, 4th Earl of, 110
David, King, 175
De Bruyn, Cornelis, *Voyages,* 33, 142, pl. 8
Decebalus, King of Dacia, 90
Decoration, 159, 240–5
De la Roche, Peter, *Essay on the Orders of Architec-
 ture,* 65–6
Delos, Greece
 Pillar raised by Nicias, 90, 223
 Temple of Apollo, 160
Delphi, Greece, Oracle of, 69
Demosthenes, 111
Denon, Dominique Vivant, baron, *Voyage dans . . .
 Egypte,* 34
Derby, 12th Earl of, 229
Derry, Bishop of, *see* Bristol, 4th Earl of
Desgodetz, Antoine, *Edifices antiques de Rome,* 58,
 69, 87, 163, 246, 274
Desprez, Louis-Jean, pl. 23
Dessifanus (Dexiphanes), 278
Destruction of historic buildings, 133–4, 186, 198
Deuteronomy, 209
Devaere, John, 260
Devonshire, 6th duke of, 250
d'Hancarville (Hugues, Pierre François), 109
Diana, Temples of, *see* Bubastis, Ephesus
Dinocrates, 40, 61, 131, 227
Diocletian, Emperor, 43, 113
Diodorus Siculus, *Histoire universelle,* 31, 105
Distribution, 157–8, 185
Domes, 140–1
Domitian, Emperor, 40
Doors, 185–6, 202–4, 272
Dorus, King of Achaia, 48
Dover, 1st Baron, 184

Downton Castle, Herefs., 163, 186
Drawing, importance of, 28
Dry rot, reasons for, 271–2
Duilius, column dedicated to, 89
Dulwich, Surrey, Picture Gallery and Mausoleum,
 269
Durno, James, 205

East India trade, 279
Eaton Hall, Cheshire, 250
Eddystone Lighthouse, 278
Eden, Garden of, 221–2
Edfu, Egypt, Temple of Horus, 34–5
Edinburgh
 Old and New Towns, 227
 Register House, 174
Edward III, King of England, 65
Edwards, William, 140
Egyptian architecture, 35–7, 55, 68
 modern imitation of, 37, pl. 30
Elephanta, India, 33
Eleusinian mysteries, 241
Eleusis, Greece, Temple of Ceres, 53, 241
Elizabeth I, Queen of England, 122, 131, 190
Ellora, India, 33
Elphenor (Elpenor), 89
Ely, Bishop of, 134
Emlyn, Henry
 Proposition for a New Order, 65
 see Beaumont Lodge
Ephesus, Turkey, Temple of Diana, 53, 73, 75, 96,
 114, 175, 265
Esna, Egypt, 34
Essex, James, 224
Etruria, 63, 259, 260
Etruscan tombs, 34
 mosaics, 76
 vases, 34
 ware (modern), 259
Euclid, 56
Euphilites, house of, 143
Euphrates, bridge over, 138
Euripides, 49, 73
Evelyn, James, 89
Evelyn, John, 54
Exhibition, The, see Shanhagan, Roger
Exodus, 175

Fabliaux or Tales, 242
Fano, Italy, basilica, 95, 111, 233
Fasces, 244

Featherstonhaugh, Sir Matthew, 184
Felbridge Place, Surrey, 89
Ferme-ornée, *see* cottages
Festoons, *see* garlands
Fire, prevention of, 270–1
Flaxman, John, 34, 173, 260
Florence, Italy
 Bibliotheca Laurenziana, 127
 Cathedral, 124–5, 271
 House of Zuccaro, 161–2
 Palazzo Pitti, 161
 Ponte S. Trinità, 139
 S. Lorenzo, 127
 S. Romolo, 59
 S. Spirito, 128
Fontana, Domenico, *Della trasportatione dell'obelisco Vaticano*, 276–7
Fonthill Abbey, Wilts., 123
Foots Cray Place, Kent, 217
Fortuna, Virilis, Temple of, *see* Rome
Fossati, Giorgio, *Storia dell'architettura*, 218
Foundations, 265–6
Fountains, 192
Franklin, Benjamin, 180
Fréart de Chambray, Roland, *Parallèle*, 51, 54
Fuga, Ferdinando, 61, 193, 252
Furniture, designs for
 by Adam, 185, 247, 259
 by Kent, 247–8
Fuseli, Henry, 128

Gabriel, Ange-Jacques, *see* Paris, Place de la Concorde
Galiani, Berardo, *Architettura di M. Vitruvio Pollione*, 147
Galileo, 137
Gandon, James, *see* Woolfe, John
Gandy, Joseph Michael, 130, 155
 describes Praeneste, 76
Garden design
 ancient, 225
 modern (i.e. landscape), 29, 220–1
 role of ruins in, 222–4
Gardens, *see* Blenheim; Claremont; Herrenhausen; Kew; Sheen
Garlands, festoons and wreaths, use of, 240–1, 244
Garrick, David, 249
Gautier, H., *Traité des ponts*, 274
Genesis, 31
George II, King of England, 144
George III, King of England, 219

Gerbier, Balthasar, *see* London, York Watergate
Gibbs, James, 200, 203, 247, 253
 see London, St Martin-in-the-Fields, St Mary-le-Strand; Oxford, Radcliffe Library
Gloucester, Cathedral, screen, 186
Gloucester, Duke of, 134
Glycon, 61
Goldsmith, Oliver, 76
Gorhambury House, Herts., 189
Gothic
 construction of, 119–20, 122, 261–2, 266–7
 effect on spectator, 120–1
 origin of, in groves of trees, 119, 262
 study of, 224–5, 251
Gothic Revival, criticised, 210–11
Goujon, Jean, *see* Paris, Louvre
Gower, 2nd Earl, 198
Greek architecture, 37–40
 evolution from primitive hut, 37–8, pl. 2
 see Orders
Greenwich, Kent, Hospital Chapel, 271
 Queen's House, 104, 131, 149, 234, 235
Grenville, Richard, 132
Griffins, *see* Sphinxes
Grotesques, 245
Guarini, Giovanni Battista, *Il Pastor Fido*, 128
Gunnersbury House, Middlesex, 133, 149
Gylippus, 223
Gwynn, John, *London and Westminster Improved*, 227, 238

Hackert, Philip, 205
Hadrian, Emperor, 39, 40, 267
 see Tivoli, Hadrian's Villa
Hagley Hall, Worcs., 214
Halicarnassus, Turkey, Tomb of Mausolus, 31, 110, 243
Hampton Court, Herefs., 250
Handel, George Frideric, 128
Hardouin-Mansart, Jules, *see* Paris, Invalides, Place Louis XV (de la Concorde); Versailles
Hardwicke, 2nd Earl of, 86
Hawksmoor, Nicholas, *see* Castle Howard, Mausoleum; London, St George, Bloomsbury
Heating, 179–83
Heliocaminus, 180
Henri IV, King of France, 150
Henry VII, King of England, 221
Henry VIII, King of England, 130, 279
Herculaneum, Italy, 164, 244
Hermogenes, 61, 74 131

Herodes Atticus, 96
Herodotus, 35, 81, 268
Herrenhausen, near Hanover, 221
Hervey of Ickworth, Baron, 133
Heveningham Hall, Suffolk, 215
Hindus, 137
Hindustan, 235, 242
Hindu temples, 118
Hiram, King of Tyre, 43
Hogarth, William, *Analysis of Beauty,* 66
Holbein, Hans, 246
Holkham Hall, Norfolk, 140, 201, 212, 234
Holland, Henry, *see* Claremont House; London, Albany, Carlton House, Drury Lane Theatre
Home, Henry, *see* Kames, Lord
Homer, 69, 111, 138, 142, 144
 Iliad, 253
 Odyssey, 89, 253
Hooke, Robert, *see* London, College of Physicians, Montagu House
Hope, Thomas, 83
Horace, 180, 187, 206
Howard, Henry, 282
Hut, primitive, 37–39, pl. 2

Iakli, Turkey, Temple, 56, 90
Ictinus, 241, 280
Ilyricus, 278
Indian architecture, *33,* 137
Ion, followers of, 52
Ionic capital, pl. 1
Irnham, Baron, 234
Iron, use of, 264, 270
Isidorus, 141
Isis, pl. 1
Islip, Abbot, 52, 190
Ispahan, bridge, 138–9

Jackly, *see* Iakli
Jacob, builder of first recorded house, 31
James I, King of England, 190
James, John, *see* Blackheath, Wricklemarsh House
Jerman, Edward, *see* London, Fishmongers' Hall
Jerusalem, 175
 Church of the Holy Sepulchre, pl. 8
 Temple of Solomon, 43–4, 56, 60, 64, 114, 175
 Temple of Venus, 116
Jones, Inigo, 95, 131–2, 148, 190, 198, 203, 247
 design for Whitehall Palace, 69, pl. 20
 see Greenwich, Queen's House; Llanrwst, bridge (attrib.); London, Banqueting House,
Covent Garden, Covent Garden Piazza, Old St Paul's, St Paul; Winchester Cathedral
Jones, Sir William, 242
Julius II, Pope, 126
Jupiter (Zeus), Temples of, 280
 see Aegina; Agrigentum; Athens; Baalbek; Olympia; Pozzuoli; Rome; Selinunte; Spalatro
Justinian, Emperor, 116

Kames, Lord, *Elements of Criticism,* 120, 122
Kedleston, Derbys., 102, 170, 212–13, 234
Kent, William, 143, 222, 247, pl. 20
 see Gloucester Cathedral; Holkham Hall; London, Berkeley Square, no. 44, Devonshire House, Treasury
Kew, Surrey, Gardens, 77, 219
Kings Weston, Gloucs., 250
Kingtung, China, bridge, 139
Kirby, Joshua, 66
Knight, Richard Payne, 145, 186
 see Downton Castle, Herefs.
Knuphis, 80, 146

Labelye, Charles, 139
 see London, Westminster Bridge
Lacedaemonians, Persian Porch of, 67
Lapi, Jacopo, 124
Lascaris, Chevalier, 275
Laugier, Marc-Antoine
 Essai, 45, 201
 Observations, 96, 109
Laurentinum, Italy, Pliny's villa at, 218, 225
Le Camus de Mézieres, Nicolas, *Génie de l'architecture,* 184
Ledoux, Claude-Nicolas, *see* Paris, Hôtel de Thélusson
Leeds, 5th Duke of, 229
Leicester, 1st Earl of, 212
Le Nôtre, André, 222
Leoni, Giacomo, *see* London, Uxbridge House
Leroy, Julien-David, 246, 264, 274
Libadia, Greece, Treasury, 278
Licinius, *see* Licymnius
Licymnius, 103
Lighting, role of of, 123–4, 170–1, 183–4
Ligorio, Pirro, 54
Linternus (Liternum), Italy, 179
Lion masks, correct use of, 81, 100, 103, 146, 150, 241
Liverpool, 2nd Earl of, 37

Liverpool, merchants of, 279
Livy, 111
Llanrwst, Wales, bridge, 140
Locke, John, *Essay concerning Human Understanding,* 263
London
 BANK OF ENGLAND
 work by Soane
 facades, 150, 264; Princes Street vestibule,
 140; Rotunda, pl. 7; 3% and 4% Offices, 270;
 materials employed, 273
 work by Taylor
 Threadneedle Street front, pl. 24
 BRIDGES
 Blackfriars, 97, 104, 139, 153
 London, old, 237–8
 Westminster, 104, 267
 CHURCHES
 All Hallows, London Wall, 81
 Old St Paul's, 186
 St Dunstan-in-the-East, 107, 132, 142
 St George, Bloomsbury, 92, 144
 St George, Hanover Square, 92, 142
 St Leonard, Shoreditch, 142
 St Martin-in-the-Fields, 92, 102, 142, 184, 200,
 203, 252–3, 255, 280
 St Mary-le-Bow, 132
 St Mary-le-Strand, 101, 200, 252–3
 St Paul, Covent Garden, 63, 82, 101, 131, 153,
 208, 271
 St Paul's Cathedral, 69, 94, 123–4, 132, 137,
 141, 142, 162, 203, 237, 254, 270
 St Stephen Walbrook, 132
 Westminster Abbey, 108, 120,152
 COMMERCIAL BUILDINGS
 Auction Mart, 102
 British Coffee House, 174, 229, pl. 25
 Courier Office, Strand, 37, pl. 30
 New Bank Buildings, 203
 CONDUITS, PUMPS AND PIPES
 Newgate pump, pl. 26
 New River Company waterpipes
 in Bagnigge Wells, pl. 31
 in Spa Fields, pl. 32
 Fire of, 132, 238
 HOUSES AND STREETS
 Adelphi, 135
 Albany, 68
 Arlington Street, 143
 Ashburnham House, 143, 198
 Bedford House, 133

Bedford Square, 257
Bedford Street, 95
Berkeley Square, no. 44, 143, 198, 229
Bingley House, 257
Bruton Street, no. 17, 234
Buckingham House, Green Park, 182, 198,
 214
Buckingham House, Pall Mall, 229
Burlington Gardens, 94
Burlington House, 229, 234, 252
Camelford House, 229
Carlton House, 93, 236
Carrington House, *see* Gower House
Cavendish Square, nos 17–18, 257
Chandos House, 229
Chandos Street, no. 4, 203
Chiswell Street, 257
Cleveland House, 101, 178
Covent Garden Piazza, 131, 256-7
Derby House, 229
Devonshire House, 101, 250
Dover House, 184
Duchess Street, 83
Ely House, Holborn, 133
Finsbury Square, 257
Fitzroy Square, 257
Foley House, 134
General Wade's house, 148
Goosepie House, Whitehall, 132, 251
Gower House, 178, 198
Great Queen Street, 95, 257
Grosvenor Square, 257
Harcourt House, 229
King Street, no. 43, 236
Lansdowne House, 105, 178, 234
Leicester House, 133
Lindsey House, 95, 131, 148, 257
Mansfield Street, 257
Marlborough House, 204
Melbourne House, 143, 178
Montagu House, 214
Peterborough House, *see* Wallingford
 House
Portland Place, 257
Portman Square, 257
St James's Square
 no. 20, 201, 203, 229
 no. 21, 229
Shaftesbury House, 95, 132, pl. 21
(Old) Somerset House, 130, 133, 186
Spencer House, 101, 203

London (*cont.*)
 Stafford House, *see* Cleveland House
 Temple Gardens, 135
 Uxbridge House, 94, 105, 234
 Wallingford House, 167
 York House, 229
 PALACES
 Buckingham Palace, 182, 240
 St James's Palace, 240
 Whitehall Palace, 69, 131
 PUBLIC BUILDINGS
 Admiralty, 70, 162, 237
 Banqueting House, 84, 95, 153, 179, 183, 212, 231
 Chelsea Hospital, 240
 Infirmary, 269–70
 College of Physicians, 229
 Fishmongers' Hall, 212, 231
 Ironmongers' Hall, 104
 Mansion House, 149, 213, 235, 273
 Newgate Prison, pl. 26
 Pantheon, 102, 178, 271
 St Luke's Hospital, 101, 230, pl. 27
 Shakespeare Gallery (British Institution), 67, 86, 94
 Somerset House, 130, 211, 234, pl. 23
 Temple Bar, 227, pl. 5
 Treasury, 95, 234
 West India Docks, 279
 York Watergate, 131, 174
 THEATRES
 Covent Garden Theatre, 100, 105, pl. 28
 Drury Lane Theatre, 93, 97, 271
 Opera House, Haymarket, 271
Long Ditton, Surrey, church, 211
l'Orme, Philibert de, 51, 203
 see Paris, S. Etienne-du-Mont
Lotus, 242
Louis XIV, King of France, 65
Loyang, China, bridge, 139
Lucullus, 114, 206, 218
 villa of, 170
Lumière mystérieuse, 184
Luxor, Egypt, Temple of Ahmenhotep III, 35
Lysias, 143
Lyttelton, 1st Lord, 214

Mackenzie, Frederick, 225
Maderno, Carlo, 265
Mammisi Temple, Island of Elephanta, Egypt, 80
Mansard roofs, 208

Mantua, Palazzo del Te, 128, 245
Marathon, Battle of, 48
Marlborough, 1st Duke of, 132, 279
Mars, Temple of, *see* Rome
Mascherino, Ottaviano, 195
Mason, William, 224
Mausolaea, *see* Tombs and mausolaea
Mausolus, Satrap of Caria, 110
Maxentius, Emperor, 116
Maximian, Emperor, 113
Medicis, the, 51
Memphis, Egypt, 68, 237
Mereworth Castle, Kent, 217
Metagenes, 278
Mexico City, "House of Affliction", 122
Mezzanines, 211–12
Michelangelo, 54, 66, 161, 236, 279
 see Florence, S. Lorenzo; Rome, Palazzo Farnese, St Peter's
Miletus, Turkey, Temple of Apollo, 53
Milizia, Francesco, 51
Miller, Anna Riggs, 191
Milton, John
 Paradise Lost, 221
 Paradise Regained, 253
 Il Penseroso, 121
Minerva (Athena), Temples of, *see* Athens, Priene, Syracuse
Mithras, 242
Models, recommended by Peacock, 273–4
 by Soane, 273–4
Modena, Italy, Ducal Palace, 128
Moeris, Egypt, Lake of, 32
Montezuma, 122
Moor Park, Surrey, 221
Morris, Robert, *Lectures on Architecture,* 101
Moses, 70, 144
Mount Athos, Greece, 227
Mount Laurium, near Athens, Temple of Thoricion, 264
Mucius Scaevola, 243
Mummius, 42, 56
Music and architecture, 147–8
Mylasa, Turkey, tomb, 94

Narni, Italy, bridge, 139, 268
Nelson, Admiral Lord, 173
Neptune, 242
 Temple of, *see* Rome
Nero, Emperor, 40
Neuilly, *see* Paris
Newcastle, 1st Duke of, 215

Nicias, 90, 223
Nile, 241–2
Nîmes, France, 246
 Maison Carrée, 74, 79, 96, 204, 235
Nineveh, 40
Ninus, mausoleum of, 31
Noah, 175
Nollekens, Joseph, 173
Norden, Frederic Louis, *Voyage d'Egypte*, 34
Norman architecture, 117–19
Norwich, church with thatched roof, 98, 207
Numa Pompilius, King of Rome, 145
Numidia, marbles of, 245

Oakley Grove, *see* Cirencester Park
Obelisks, 105–7, 141
 in Rome, 275–7
 on pedestals, 106
Offices, disposition of, 188, 213–16
Olympic Games, 147, 248
Orange, France, Triumphal Arch, 99
Orders of architecture, 44–62
 Corinthian the finest, 55
 DETAILS OF THE ORDERS
 (1) antae, 91–3; caryatids and Persians, 67–9,
 89; entablature, 38, 46; metope, 49; pedestal,
 96–7; pediment, 97–8, 99–100; pilaster, 91–
 6, 204–5
 (2) Columns
 compared to trees, 280
 engaged, 79, 82, 236–7; twisted, 71, 103
 used as memorials, 89
 see Peristyles
 different orders combined, 231–3
 invention of new, 63–6
 not unalterably fixed, 84–5
 origin of Composite, 63–4
 of Corinthian, 55–6
 of Tuscan, 63
 use in interiors, 82–3, 163
Orestes, 49, 73
Orford, 4th Earl of, *see* Walpole, Horace
Ornaments, *see* Caduceus; Fasces; Garlands; Lion
 masks; Paterae; Rams' and ox heads; Ser-
 pents; Sphinxes
Osymandias, 68
Ouroboros, *see* serpents, symbolism of
Ouvrard, René, *Architecture harmonique*, 147
Ovid, 32
Oxford
 Botanical (Physic) Garden gateway, 132
 New College, 114
 Radcliffe Library, 211, pl. 7
 Schools Quadrangle, 232, pl. 19

Padua, Italy, S. Antonio, 117
Paestum, Italy, 48, 74, 79, 84, 138, 163, 222
Page, Sir Gregory, Bt., 133
Paine, James, *see* Cusworth Hall; Kedleston Hall;
 Wardour Castle; Worksop Manor
Painting, combined with architecture, 258
Palazzolo, Italy, Tomb of Scipio, 34
Palestrina, *see* Praeneste
Palladio, Andrea, 51, 54, 61, 87, 94–5, 97, 154,
 169
 see Venice, Cloister of the Carità, Il Redentore, S.
 Giorgio, Villa Malcontenta; Vicenza, Basilica,
 Palazzo Chiericati, Palazzo Thiene, Teatro
 Olimpico, Villa Capra
Palmyra, Syra, 32, 73, 90, 92, 200, 228, 237
 Temple of the Sun, 35, 76
Pancirollus, Guido, 180
Paris
 ARCHES
 Arc du Carrousel, pl. 5
 de Triomphe, 174
 Porte St. Denis, pl. 5
 CHURCHES
 Invalides, 141
 S. Etienne-du-Mont, 198
 Ste-Geneviève, 75, 173, 254
 St. Roche, 239
 St. Sulpice, 239
 PALACES
 Louvre, 69, 95, 101, 148, 231–2, 235, 256
 Luxembourg, 161
 Tuileries, 208, 231, 240, 256
 PUBLIC BUILDINGS
 Père la Chaise, Cemetery, pl. 18
 Pont de Neuilly, 139, 268
 Surgeons' Theatre, 236, 240
 SQUARES, STREETS, AND HOUSES
 Garde Meuble (Place de la Concorde), 149,
 240, 256, pl. 14
 Hôtel de Thélusson, pl. 16
 rue des Colonnes, pl. 17
Parke, Henry, lecture illustrations by, 198, pls 15, 17–
 18
Parma, Italy, Academy, 191
Patera, 242
Pausanias, 90, 98, 208, 278
Peacock, James, *Oikidia*, paraphrased, 274
Pécheux, Laurent, pl. 12
Pedestal, *see* Orders

Pediment
 granted to Caesar, 97
 see Orders
Pembroke, 9th Earl of, 86
Pennsylvanian Stove, 180
Percier, Charles, and P.-F.-L. Fontaine, Arc du Car-
 rousel, Paris, pl. 5
Pericles, 39, 40, 59, 114, 174, 205
Peristyles, 235
Perrault, Claude, 148, 149, 163
Perronet, Jean-Rodolphe, 139
 see Paris, Pont de Neuilly
Persepolis, 33, 142
Peruzzi, Baldassare, 127
 see Rome, Palazzo Massimi, St Peter's
Peter the Great, *see* St Petersburg
Petersham Lodge, Surrey, 201
Petrarchus, 91
Pharos, Alexandria, lighthouse, 278
Phidias, 61, 74, 280
Piacenza, Italy, 128
Picturesque, the, 215
Pilasters, *see* Orders
Piranesi, Giovanni Battista, 67, 68, 86, 91, 241, 245,
 274; pl. 3
 design for college, 191, 254
 see Rome, S. Maria del Priorato
Pisa, Italy, Baptistry and Leaning Tower, 265
Pitt, Thomas (Lord Camelford), 86, 206
 and *see* London, Camelford House
Platea, Battle of, 67
Pliny the Elder, *Natural History*, 32, 67, 69, 76, 78,
 89, 110, 114, 265, 278
Pliny the Younger, 206
 Letters, 83, 143, 179, 218
 reconstructions of his villas, *see* Castell, Scamozzi,
 Stevens
 see Laurentinum, Tusculum
Plutarch, *Lives*, 90, 175, 244
Pocicke, Richard, *Description of the East*, 34
Pompeii, Italy, 143, 164
 Temple of Isis, 35, 77
Pompeiian wall painting, 244–5
Pompey the Great, 78, 89
Pontypridd, Glamorganshire, bridge, 140
Pope, Alexander, 101
 Essay on Criticism, 75, 280, 282
 Essay on Man, 118
 Moral Essays, 93, 108, 133, 171, 223, 226, 254,
 279
 Satires of Dr Donne, 221
Porticoes, 236, 280

Poussin, Nicolas, 167
Pozzuoli, Italy, 267
 Temple of Jupiter Serapis, 35, 77
Praeneste, Italy, Temple of Fortune, 75–6
Pratt, Roger, *see* Coleshill House
Praxiteles, 61
Priam, King of Troy, 32
Price, Uvedale, *Essays on the Picturesque*, 215
Priene, Turkey, Temple of Minerva Polias, 53
Procopius, 120, 228
Procrustes, 160
Proportions, of rooms, 178–9
Protagenes, 174
Psammetichus, 68, 277
Pylades, 49, 73
Pyramids, 35, 107–9, 176, 239, 243
Pythagoras, 56, 143, 194

Quatremère de Quincy, Antoine-Chrysostôme, 52,
 55, 91, 109
Queensbury, 4th Duke of, 94, 100, 213

Rams' heads, correct and incorrect use of as orna-
 ment, 147, 241
Raphael, 93, 103, 263–4
 see Rome, Palazzo Stoppani (Vidoni Caffarelli),
 Villa Farnesina
Ravenna, Italy, Mausoleum of Theodoric, 110, 140,
 177
Repton, Humphry, 145
Rhodes, Greece, Colossus, 227
Rimini, Italy
 bridge, 139, 268
 S. Francesco, 125
Ripley, Thomas, 70
Roehampton, Surrey, Bessborough House, 97, 102,
 197
Rome
 1. *Ancient buildings:*
 ARCHES AND GATES
 Constantine, 111, 153; Goldsmiths, 112;
 Porta Maggiore, 161; Septimius Severus,
 112, 153; Titus, 63, 79, 85
 Basilica of Constantine, 81, 265
 BATHS
 Agrippa, 99; Caracalla, 171; Circus of Nero
 (Gaius), 265, 276; Diocletian, 50, 52, 54, 64,
 81, 140–1, 162–3, 171; Titus, 171
 Cloaca Maxima, 138
 Colosseum, 50, 54, 79, 83, 84, 94, 111, 204,
 231, 264, pl. 6

COLUMNS
 Antonine (of Marcus Aurelius), 89; Trajan, 89–90, 111, 194, pl. 3
Curia of Tullus Hostilius (Curia Hostilia), 90, 94, 161
Flavian Palace, 112, 172
FORA
 Nerva, 69, 161; Trajan, 111
Marble Plan, 237, 254
OBELISKS
 at Monte Cavallo, 106; in Piazza S. Pietro, 275–8; at S. Maria Maggiore, 106
PORTICOES
 Argonauts, 90; Octavia, 57, 80, 90, 93; Pompey, 90, 195
Septa, 90
Septizonium, 111
TEMPLES
 Antoninus and Fuastina, 57, 87, 97; Concord, 54, 81, 97; Fortuna Virilis, 53, 74, 79, 96, 97, 200, 235; Jupiter Feretrius, 42; Jupiter Stator (Castor), 58, 59, 60; Mars Ultor, 57, 59, 60, 81, 161; "Minerva Medica", 77, 141, 254, 281; Neptune, 90; Pantheon, 57, 59, 60, 67, 69, 71, 75, 80, 82, 84, 93, 98, 124, 141, 177, 194, 202, 254, 263–4, 281, pl. 7; Peace, 61, 77, 81, 163; Vespasian, 57, 60; Vesta, 57, 74, 92, 161, 202
Theatre of Marcellus, 50, 54, 79, 83, 84, 204, 231
TOMBS AND MAUSOLAEA
 Augustus, 106, 109, 243; C., Poplicius Bibulus, 93, 94, 204; Caecilia Metella, 109, 210, 223, 243; Hadrian, 109, 116, 141, 239, 243; Plautii, 223; Pyramid of Cestius, 107, 108, 239, 243
2. *Modern buildings:*
CHURCHES
 Gesu, 129; S. Andrea in Via Flaminia, 129; S. Carlo alle Quattro Fontane, pl. 10; S. Giovanni in Laterano, 253; S. Maria del Priorato, 191; S. Paolo fuori le Mura, 109, 116; St Peter's, 78, 126, 141, 162, 200, 203, 239, 265, 270–1, 273, 279, pl. 7, Baldacchino, 71, 75, 129, 263, Sacristy, 267; S. Pietro in Montorio, *see* Tempietto; S. Sabina, 203, S. Susanna, 210; Tempietto, 92
FOUNTAINS
 Four Rivers, 107; Trevi, 129, pl. 12
PALACES
 Barberini, 143; Cancelleria, 111; Chigi, 250; Colonna, 57; Farnese, 95, 111, 212,

233; Massimi, 127; Propaganda Fide, 211; Quirinal, 195; Vatican, 78, Cortile del Belvedere, pl. 24, *logge,* 245, 259, Museo Pio Clementino, 69, Sala a Croce Greca, 69, Scala Regia 97, 143, 195; Vidoni-Caffarelli, 95, 127
 Piazza S. Pietro, 78, 129, 275
VILLAS
 Albani, 69; Farnesina, 95, stables in Via della Lungara, 127; Madama, 128, 245; Negroni, 244; Papa Giulio, 128
Roofs, 98, 206–10
Rosa, Salvator, 167, 224
Rousseau, Jean-Jacques, *Discours sur les sciences et les arts,* 27
Royal Academy, London
 exhibition of drawings at, 114
 Professor of Architecture, duties of, 27–8, 105, 136, 156
Rubens, Peter Paul, 103
Ruins, *see* gardens
Rustication, 161–2, 184

St Matthew, Gospel of, 161
St Petersburg, Russia, statue to Peter the Great, 275
Saint-Rémy, France, 79, 141
Salisbury, Wilts., Cathedral, 120
Salmathius, 180
Salonika, Greece, Incantada, 68, 96
Salsette, India, 33
Salvi, Nicola, 129
 see Rome, Trevi Fountain; Viterbo, S. Maria in Gradi
Sandby, Thomas
 Bridge of Magnificence, 134–5
 Lectures on architecture, 28, 167
Sanmicheli, Michele, 128, 161, 231, 234
 see Venice, Palazzo Grimani; Verona, Gran Guardia, Madonna di Campagna, Porta Palio, S. Bernardino
Saxon architecture, 117, 262
Scaevola, Mucius, 243
Scamozzi, Vincenzo, 51, 54, 61, 94, 129, 169, 182, 214, 234, 245
 L'idea dell'architettura universale, 196
 Ionic capital, 54
 restoration of Pliny's villa, 129, 218
Scarsdale, 2nd Baron, 212
Scaurus [Sauras,], 91
Scipio Africanus, 179
Screens in Gothic churches, style of, 186

Seaton Delaval, Northumberland, 216
Segesta, Sicily, Temple, 124
Selinunte, Sicily, Temple of Jupiter, 75, 124
Semiramis, 31
Seneca, 179–80, 245
Septimius Severus, Emperor, 27, 111
Serlio, Sebastiano, 94, 128, 169, 214
Serpents, symbolism of, 146
Shakespeare, William
 As You Like It, 223
 Cymbeline, 202
 Hamlet, 225
 Henry IV, 145
 King Lear, 167
 Midsummer Night's Dream, 122
 Richard III, 134, 172
 Tempest, 36, 176
 Winter's Tale, 173
Shanhagan, Roger [pseud.], *The Exhibition,* 159
Sheen, Surrey, 221
Shotesham Park, Norfolk, 133
Simonetti, Michelangelo, 69
Sixtus V, Pope, 276–7
Skulls, incorrect use of, *see* rams' heads
Smirke, Robert, *see* London, Covent Garden Theatre
Soane, George, 283
Soane, Sir John
 attacks modern buildings in London, 122, 239–40,
 255–8, pl. 29
 criticises his own designs, 140, 150, 203, 230,
 264
 Designs for Public and Private Buildings, 206
 gift of house to nation, 282–3
 UNEXECUTED DESIGNS
 British Senate House, 152
 Canine Residence, 206
 House of Lords, 152–3, pl. 35
 Opera House, pl. 34
 Triumphal Bridge, 135, pl. 33
 Villa in form of temple, 206
 WORKS
 See Dulwich College; *London,* Bank of England,
 Chelsea Hospital Infirmary
Solomon, King, Temple of, *see* Jerusalem
Solon, 108
Soria, Giovanni Battista, 78, 254
Sostratus, 278
Soufflot, Jacques-Germain, 75
 see Paris, Ste-Geneviève
Spalatro, 43, 79, 83–4, 113, 172, 202
 Temple of Jupiter, 84

Speculative system in building, evils of, 133–4, 226–
 7
Sphinxes, 68, 147, 241
Spires, *see* steeples
Spoleto, Italy, "Temple of Clitumnus", 73, 93, 94,
 97, 100
Spon, Jacob, and George Wheler, *Journey into
 Greece,* 39, 164
Stafford, 2nd Marquess of, 101
Staircases, 142–3, 195–8
Steam heating, 181
Steeples, 141–2, 230
Sterne, Laurence
 Sentimental Journey, 254
 Tristram Shandy, 28, 263
Stevens, Edward, 253
 reconstruction of Pliny's villa, 129, 218
Stone, Nicholas, 148
Stonehenge, Wilts., 275
Stowe, Bucks.
 Gardens, 221–2
 House, Saloon, 170, North front, 213
 Temple of Concord and Victory, 132
Stuart, James, 53, 67, 274
 and Revett, Nicholas, *Antiquities of Athens,* 39, 68,
 164, 246, 247
Suetonius, 180
Swift, Jonathan, 188, 251
Syene, Temple, 34
Syracuse, Sicily, Temple of Minerva, 50, 80

Taaffe, bridge over, *see* Pontypridd
Tacitus, 111
Tarquinius Superbus, King of Rome, 34
Tarragona, Spain, tomb, 60
Tatton Park, Cheshire, 145
Taylor, George Ledwell, 87
Taylor, Sir Robert, *see* Danson Hill; Gorhambury
 House; Heveningham Hall; London, Bank of
 England, Ely House
Temple, Sir William, 221–2
Teniers, David, 102
Tent, home of shepherd, 30
Tentyra, Egypt, 49
Teos, Turkey, Temple of Bacchus, 53, 74
Termessus, Turkey, tombs, 34, 36
Terminus, 145
Terms, 144–5
Thebes, Egypt, 30
Themistocles, 102
Thoricion, *see* Mount Laurium